ORACLE BONES

ALSO BY PETER HESSLER

River Town

"Mr. Hessler has stepped off the treadmill of events-driven journalism to produce one of the most profoundly original books about China since, well, since his first book, *River Town*. . . . Everywhere, the book is shot through with sensitivity, insight, and rollicking good humor too."
—*The Economist*

"Deeply engaging. . . . Hessler has achieved something quite special in *Oracle Bones*, conveying the idiosyncrasies of China in a way that makes its people palpably human and distinctly memorable."
—*Los Angeles Times*

"*Oracle Bones* will firmly establish Mr. Hessler as one of the Western world's most thoughtful writers on modern China. . . . A page-turner with great insight into Chinese society. . . . A richly humanistic portrayal of contemporary China."
—*Wall Street Journal*

"Timely and necessary. . . . Beautifully delivered. . . . An informative read for those interested in a nation bound to occupy more time on our twenty-four-hour news channels as the twenty-first century progresses."
—*Rocky Mountain News*

"*Oracle Bones* melds the multiple personalities and tangled story lines into a kaleidoscopic vision of a country surging toward an uncertain future. . . . The society that emerges from its pages is one buffeted by conflicting currents, confident and yet deeply insecure, and haunted by its recent past."
—*San Francisco Chronicle*

"Hessler gets the stories that no one talks about and delivers them in a personal study that informs, entertains, and mesmerizes. Everyone in the Western world should read this book."
—*Publishers Weekly* (starred review)

"Insightful. . . . Hessler is a wry and witty writer who manages to bring humor even to tense situations." —*Christian Science Monitor*

"Engaging. . . . Acutely observed, moving, frequently funny, and a perspicacious X-ray of China's zeitgeist."
—*South China Morning Post*

"Wonderful. . . . Intimate. . . . The book reads like a really good novel."
—*Minneapolis Star Tribune*

"A stunning book. . . . Hessler is a wonderful guide. . . . One conclusion is certain: Americans and Chinese need to better relate across gigantic cultural barriers. Hessler is a near-perfect intermediary."
—*Sunday Oregonian*

"Excellent. . . . Hessler has a gift for graceful first-person storytelling. . . . Those who seek to understand the real China—rather than the cartoonish threat—would do well to pick up *Oracle Bones*. It offers an intelligent rumination on China, both ancient and modern."
—*USA Today*

"Serenely confident, Hessler has a marvelous sense of the intonations and gestures that give life to the moment. . . . Today's China could have been made for him. If you don't believe me, dip into the chapters in *Oracle Bones*. . . You will be hooked."
—*New York Times Book Review*

"*Oracle Bones* achieves an emotional and intellectual intensity that one usually associates with fiction. . . . Peter Hessler creates a vivid and complex picture of a society in rapid transition." —*The Guardian*

"An extraordinary, genre-defying book. . . . Beautifully constructed. . . . Hessler's reportage is vivid." —*Daily Telegraph*

"Compelling. . . . Hessler moves engagingly back and forth between narratives and characters. . . . Offers unusual insights into the yearnings and frustrations of the country's young adults. One of the book's main pleasures is its language; Hessler writes clearly and sympathetically." —*Washington Post*

"Remarkable. . . . To get a feeling for the texture of life in China right now, in Beijing and elsewhere, there isn't a better book in English than *Oracle Bones*." —*Salon.com*

"A brilliant observer with a novelist's ear for character and dialogue, Hessler is both fascinating and funny, whether talking to the dove keeper at a Nanjing monument or chasing a would-be robber down a Dandong hotel hallway in his underwear." —*Entertainment Weekly*

ORACLE BONES

A Journey Through Time
in China

PETER HESSLER

HARPER PERENNIAL

NEW YORK • LONDON • TORONTO • SYDNEY

HARPER ● PERENNIAL

Map courtesy of Angela Hessler. "Outline of Ancient Chinese History" courtesy of Nanjing University Press. Illustrations courtesy of Ho Wei. Oracle bone rubbings on pages 136 and 250 are reproduced from David N. Keightley's *Sources of Shang History*.

A hardcover edition of this book was published in 2006 by HarperCollins Publishers.

HarperCollins books may be purchased for educational, business, or sales promotional use. For information please write: Special Markets Department, HarperCollins Publishers, 10 East 53rd Street, New York, NY 10022.

FIRST HARPER PERENNIAL EDITION PUBLISHED 2007.

Designed by Elliott Beard

The Library of Congress has catalogued the hardcover edition as follows:
Hessler, Peter.
 Oracle bones : a journey between China's past and present / Peter Hessler.
 p. cm.
 ISBN: 978-0-06-082658-1
 ISBN-10: 0-06-082658-4
 1. China—Description and travel. 2. China—Civilization. I. Title: Journey between China's past and present. II. Title.
DS712.H458 2006
951—dc22 2005052607

ISBN: 978-0-06-082659-8 (pbk.)
ISBN-10: 0-06-082659-2 (pbk.)

08 09 10 11 ❖/RRD 10 9 8 7

for my sisters:

Amy

Angela

and Birgitta

Contents

PART FOUR

Author's Note

THIS IS A WORK OF NONFICTION, AND I HAVE USED REAL NAMES WITH one exception: Polat. The pseudonym is used at his request, because of political sensitivities in the People's Republic of China.

This book was researched from 1999 to 2004, a period whose events are still resonating. I expect that in the future we will learn more about these occurrences, and my depiction is not intended to be comprehensive or definitive. My goal has been to follow certain individuals across this period, recording how their lives were shaped by a changing world.

These people led me to many places—some in China, some in the United States, and others, such as Xinjiang and Taiwan, that are in dispute. Boundaries and definitions often seemed fluid, and so did time itself. The main chapters of this book are arranged chronologically, but the short sections labeled "artifacts" are not. They reflect a deeper sense of time—the ways in which people make sense of history after it has receded farther into the past.

Polat means "steel" in the Uighur language, and he chose that name because of the qualities that he believed are necessary for anybody far from home.

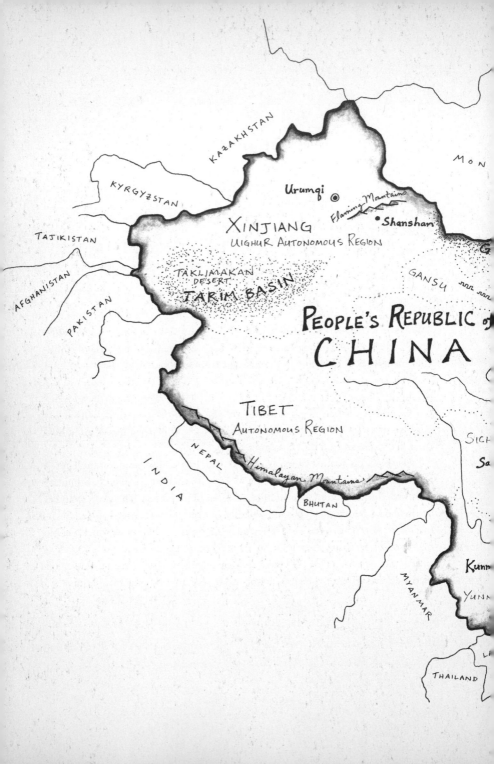

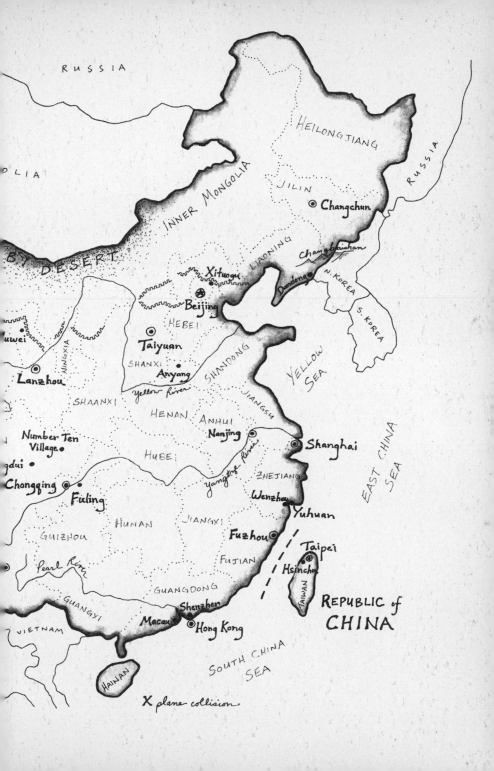

PART ONE

The Underground City

历史

FROM BEIJING TO ANYANG—FROM THE MODERN CAPITAL TO THE CITY known as a cradle of ancient Chinese civilization—it takes six hours by train. Sitting by the window, there are moments when a numbness sets in, and the scenery seems as patterned as wallpaper: a peasant, a field, a road, a village; a peasant, a field, a road, a village. This sense of repetition is not new. In 1981, David N. Keightley, an American professor of history, took the train to Anyang. Afterward, he wrote in a letter to his family: "The land is generally flat, monotonous, one village much like another. . . . Where are the gentry estates, the mansions, the great houses of England and France? What was it about this society that failed to produce such monuments to civilized aristocratic living?"

Move back in time, and it's the same: a peasant, a field, a road, a village. In the 1930s, a foreign resident named Richard Dobson wrote: "There is no history in Honan." Today, that seems an unlikely remark, because this region is known as the archives and the grave of the Shang dynasty. The Shang produced the earliest known writing in East Asia, inscribed into bones and shells—the oracle bones, as they are called in the West. If one defines history as written records, this part of Henan is where it all began for China.

But visitors have often wondered about something other than origins. Move back in time once more, to the 1880s, when an American named James Harrison Wilson wrote: "They have stood absolutely still in knowledge since the middle ages." He explained, "The essence of their history can be told in a few short chapters." It has to do with trajectory, progress—expectations of the West. In the traditional view of the Chinese past, there is no equivalent of the fall of Rome, no Renaissance, no Enlightenment. Instead, emperor succeeds emperor, and dynasty follows dynasty. History as wallpaper. In *A Truthful Impression of the Country,* an analysis of Western travel writing about China, Nicholas R. Clifford describes this nineteenth-century foreign perspective: "China had a far longer past than the West—no one would think of denying

that—but the past and history are not the same thing. Here in China's past there was no narrative but only stories."

IN ANYANG, AT an archaeological site called Huanbei, a small group of men work in a field, mapping an underground city. The city dates to the fourteenth and thirteenth centuries B.C., when the Shang culture was probably approaching its peak. Nowadays, the Shang ruins lie far beneath the soil, usually at a depth of five to eight feet. Peasants have planted crops for centuries without realizing that an entire city waited beneath them.

The layers of earth accumulated over time. This site is bordered by the Huan River, and periodic floods have deposited alluvial soil onto the field. There is also loess: thin, dry particles that originated from the Gobi and other deserts of the northwest. Loess is easily windborne, and over the centuries, layers of it have been blown south and then redeposited in places like Anyang. In northern China, the yellow earth can be as deep as six hundred feet.

Elsewhere in the world, archaeologists search for ridges and mounds, visible signs of buried structures. But here the naked eye isn't adequate; a two-dimensional view of Anyang reveals only flatness. The men in the field work under the direction of a young archaeologist named Jing Zhichun, who explains the challenges of research in a place like this.

"You have to look at the landscape in a dynamic way," he says. "You have to see the landscape evolving. It might be completely different from what it was three thousand years ago. We're looking at human society in three dimensions; it's not just the surface that matters. We had to add another dimension: the time dimension. You can look all around here and see nothing, but in fact this was the first city in the area. If you don't add time, you'll find nothing."

The workers are local peasants, and they dig with Luoyang spades—the characteristic tool of Chinese archaeology. In Luoyang, one of China's many former capital cities, generations of grave robbers practiced their craft to the point of technical innovation: a tubular blade, cut in half like a scoop and then attached to a long pole. If you pound the blade straight into the earth and twist it slightly, you extract a core of soil about half a foot long and less than two inches in diameter. Do it again and again—dozens of times—and the hole becomes a tiny shaft that penetrates six or more feet, bringing up deeper cores. When the shaft is deep enough, the dirt samples might contain bits of pottery or bone or bronze, or perhaps the hard tamped earth that was traditionally used to construct buildings.

Thieves developed the Luoyang spade, but during the first half of the twentieth century, Chinese archaeologists adopted the tool for their purposes. An experienced archaeologist can take a core from the deep earth, examine its

contents, and determine whether he stands above an ancient buried wall, or a tomb, or a rubbish pit. The dirt plugs reflect the meaning of what lies below; they are like words that can be recognized at a glance.

For years, Jing and the others have been reading the earth in this part of Anyang. They began with a systematic survey, digging holes across the fields and checking for signs of buried structures. One series of random corings turned up an object: tamped earth, twenty feet wide, lying six feet beneath the surface. As they surveyed the underground structure, they realized that it ran as straight as an arrow. They followed it across the soybean fields, accumulating tiny holes and piles of cores in their wake. Three hundred yards, a thousand yards—more holes, more cores. When the object suddenly stopped, they discovered a ninety-degree bend: a corner. At that point they realized that it must have been a settlement wall, and since then they have continued tracing the boundary and other interior structures. They are mapping a city that no living person has ever seen.

This is an early stage of archaeology; after the coring is finished, they will undertake more extensive excavations. But Jing never seems rushed to get there. He moves slowly, deliberately. He is thirty-seven years old, a friendly man with a quick smile, and his face is a work of simple geometry: round head, round cheeks, round-rimmed glasses. He grew up in Nanjing, but he studied archaeology at the University of Minnesota. His cultural references are broad and sometimes they catch me by surprise. During one of our walks above the underground city, he tells me to avoid thinking of the Shang as a dynasty in the political sense.

"A lot of people talk about the Shang as if it was very big," he says. "They're looking at the ancient state as if it were a modern state. People find Shang artifacts everywhere and they think, well, this region was part of the Shang state. But you have to make a distinction between cultural and political control. I would say that in terms of political entity it was actually very small—maybe no bigger than three river valleys. But the cultural influence was much bigger. It's like if I buy McDonald's here, you wouldn't say that I'm in America. It's the culture."

THE PEASANTS SWEAT in the autumn sunshine. Their poles move in an uneven line, following the invisible path of a buried wall. The men dig a hole, take a few steps, dig another hole. If you watched from a distance, without any concept of the underground city, the work would appear to be a meaningless ritual: peasants with poles, marching across the dry soil. A hole, a few steps, another hole. A peasant, a field, a road, a village. A hole, a few steps, another hole.

Outline of Ancient Chinese History

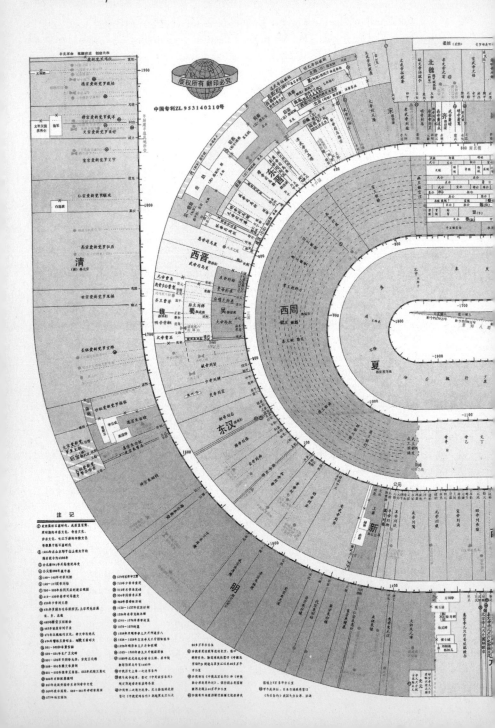

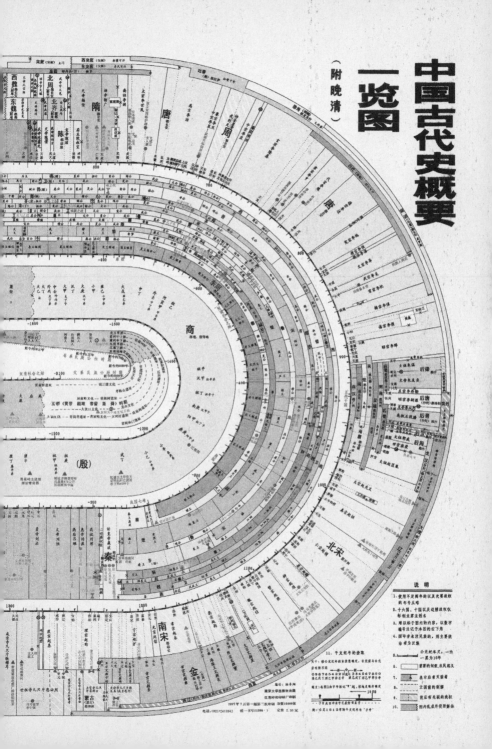

中国古代史概要一览图（附晚清）

The Middleman

May 8, 1999

I WAS THE LAST CLIPPER AT THE BEIJING BUREAU OF THE *WALL STREET Journal*. The bureau was cramped—two rooms and a converted kitchen—and the staff consisted of two foreign correspondents, a secretary, a driver, and a clipper. The driver and I shared the kitchen. My tools were a set of box cutters, a metal ruler, and a glass-covered desk. Every afternoon, the foreign newspapers were stacked above the desk. If an article about China seemed worthwhile, I spread the paper on the glass, carved out the story, and filed it in the cabinets at the back of the main office. They paid me five hundred American dollars every month.

The bureau was located in the downtown embassy district, a couple of miles from Tiananmen Square. In a neighborhood to the north, I found a cheap apartment to rent. It was a mixed area: old brick work-unit housing, some traditional *hutong* alleys, a luxury hotel. On one corner, next to the sidewalk, stood a big Pepsi billboard illuminated by floodlights. It was still possible to live quite simply in that part of the capital. Restaurants served lunch for less than a dollar, and I biked everywhere. When the spring evenings turned warm, young couples played badminton by the light of the Pepsi billboard.

At most other foreign bureaus in Beijing, clippers had already become obsolete, because everything was being computerized. In the old days, paper files had been necessary, and young people accepted the job because it provided an introduction to journalism. A clipper sometimes helped with research and, if a big news event broke, he might do some spot reporting. On the average, the

job required only a few hours a week, which left plenty of time for travel and freelance writing. A clipper could learn the ropes, publish some stories, and eventually become a real China correspondent. I had some previous experience in the country, teaching English and studying Chinese, but I had never worked as a journalist. I arrived in Beijing with three bags, a stack of traveler's checks, and an open-ended return ticket from St. Louis. I was twenty-nine years old.

The small bureau was pleasant—the crisp smell of newspapers, the smattering of languages that echoed off the old tiled floors. The foreign staff and the secretary spoke both English and Chinese, and the driver was a heavyset man with a strong Beijing accent. While filing the clipped stories, I thought of the subject headings as another language that I would someday learn. The folders were arranged alphabetically, by topic:

DEMOCRACY
DEMOCRACY PARTY
DEMONSTRATIONS
DISABLED
DISASTERS
DISSIDENTS

Complicated topics were subdivided:

U.S.–CHINA—EXCHANGES
U.S.–CHINA—RELATIONS
U.S.–CHINA—SCANDAL
U.S.–CHINA—SUMMIT
U.S.–CHINA—TRADE

During my early days on the job, I hoped that the files could provide useful training. I often pulled a folder and read through dozens of stories, yellowed with age, all of them circling around the same topic. But inevitably I started skimming headlines; after a while, even the headlines bored me. To amuse myself while working, I read the file labels in alphabetical order, imagining possible storylines to connect them:

SCIENCE & TECHNOLOGY
SECRETS & SPIES
SECURITY
SEX

One section of *Ps* read like a tragedy, complete with hubris, in all of six words:

PARTY
PATRIOTISM
POLITICAL REFORM
POPULATION
POVERTY

Another series seemed scrambled beyond comprehension:

STUDENTS
STYLE
SUPERPOWER—"NEW THREAT"
SUPERSTITION
TEA

Once, I pointed out this sequence to the bureau chief, who remarked that sooner or later every China correspondent has to write an article about tea. In May of 1999, when a United States B2 plane took off from Whiteman Air Force Base in Missouri, flew to Belgrade, and dropped a series of satellite-directed bombs on the Chinese embassy, killing three Chinese journalists, the *Wall Street Journal* created a new file: U.S.-CHINA—EMBASSY BOMBING. It fit next to EXCHANGES.

I HAPPENED TO be in the southern city of Nanjing when the attack occurred. That was my first research trip: I planned to write a newspaper travel article about the history of the city, which had been the capital of China during various periods. Nanjing was the sort of place important events always seemed to march through on their way to some other destination. Over the centuries, various armies had occupied the city, and great leaders had come and gone, leaving nothing but tombs and silent memorials of stone. Even the name itself—"Southern Capital"—was a type of memory.

Artifacts had been strewn everywhere around Nanjing. Outside of town, the emperor Yongle of the Ming dynasty had commissioned the carving of the biggest stone tablet in the world as a memorial to his father, the dynastic founder. In 1421, Yongle moved the capital north to Beijing, for reasons that remain unclear, and his engineers left the tablet unfinished. Supposedly they had never figured out how they were going to move the object.

When I visited the stone tablet, there were only a handful of tourists at the site. The quarry was mostly overgrown, with young trees and low bushes creeping up the rolling hills. The abandoned memorial consisted of three parts: a broad base, an arched cap, and the main body of the tablet itself.

The limestone object lay on its side, as if some absentminded giant had set it down and then wandered away. It was 147 feet long, and the top edge stood as high as a three-story building. Over the centuries, straight streaks of rain runoff had stained the stone face, like lines on a child's writing pad. Apart from those water marks, the surface was completely blank; nobody had ever gotten around to inscribing the intended memorial. Visitors could walk freely on top. There weren't any rails.

A young woman named Yang Jun staffed the ticket booth. She was twenty years old, a country girl who had come to Nanjing to find work. Young people like her were flocking to cities all across the nation——more than one hundred million Chinese had migrated, mostly to the factory boomtowns of the southern coast. Social scientists described it as the largest peaceful migration in human history. This was China's Industrial Revolution: a generation that would define the nation's future.

At this historic moment, Yang Jun had found a job at the biggest blank slate in the world. When I asked her about the object, she looked bored and rattled off some statistics: it was fifty feet wide and fifteen feet thick, and supposedly the project had required the labor of one hundred thousand men. It weighed twenty-six thousand tons. I asked if there were many visitors, and she stared at me as if I were an idiot. "Tourists go to the Sun Yat-sen Mausoleum." It sounded like an accusation: Why are you here?

I tried another angle. "Does anybody ever fall off the top?"

A light flickered in the woman's eyes. "Two people did the year before last," she said. "One of them jumped and one of them fell. The one who jumped had just been dumped by his girlfriend. Actually, he survived, but the guy who fell died."

We chatted for a while, and the young woman kept returning with relish to those same details: the accident had resulted in death, whereas the attempted suicide had lived. Yang Jun seemed to be in a much better mood when I left. She told me that the heartbroken man had been permanently disfigured by his leap from the tablet.

IN NANJING, I collected everything in my notebook—scraps of conversation, museum labels, random observations. At the mountaintop mausoleum of Sun Yat-sen, an English sign caught my eye:

THE MAP OF THE WHOLE MAUSOLEUM LOOKS LIKE AN ALARM BELL, WHICH SYMBOLIZES THE NEVER-ENDING STRUGGLING SPIRIT OF DR. SUN YAT-SEN

AND HIS DEVOTION OF HIMSELF TO THE CAUSE OF
WAKING UP THE MASSES AND SAVING THE CHINESE
NATION AND STATE

Sun Yat-sen had been a key leader in the movement to overthrow China's last imperial dynasty, the Qing, which ruled until 1911. At the mausoleum, vendors sold a set of commemorative lapel pins dedicated to what the People's Republic believed to be the trinity of great twentieth-century Chinese leaders: Sun Yat-sen, Mao Zedong, and Deng Xiaoping. Each man's profile was accompanied by his most distinctive slogan, and the three sentences lined up neatly on a strip of cardboard:

THE WHOLE WORLD AS ONE COMMUNITY
SERVE THE PEOPLE
BE PRACTICAL AND REALISTIC

That was the trajectory of twentieth-century idealism, compressed into thirteen characters. The modern artifacts often worked like that; they simplified the chaos of the past. At one Nanjing museum, I bought a poster labeled OUTLINE OF ANCIENT CHINESE HISTORY. The poster featured a timeline twisted into the shape of a spiral. Everything started in the center, at a tiny point identified as "Yuanmou Ape-man." After Yuanmou Ape-man (approximately 1.7 million years ago), the timeline passed through Peking Man and then made an abrupt turn. By the Xia dynasty, the spiral had completed one full circle. The Shang and the Zhou dynasties wrapped up a second revolution. The spiral got bigger with each turn, as if picking up speed. Whenever something ended—a dynasty, a warring state—the spiral was marked with a line and a black X, and then something new took its place. There weren't any branches or dead ends. From Yuanmou Ape-man, it took three turns of the spiral to reach the revolution of 1911, where the timeline finally broke the cycle, straightened out, and pointed directly up and off the page.

THAT EVENING, I was eating dinner with a friend when we heard a sudden roar from the street outside. By the time we settled the bill, the protestors had already swept past. From a block away their voices echoed into the night.

A group of foreigners stood on the sidewalk, looking stunned—major street protests were unheard of in a city like Nanjing. One of the foreigners told me that late last night the North Atlantic Treaty Organization had bombed the Chinese embassy in Yugoslavia. NATO claimed that the bombing had been

an accident, but some Chinese had died in the attack. The news had just been broadcast in China.

In the wake of the protestors, the street was empty—no cars, no bikes. I ran after the crowd, figuring that I should check out the scene and then telephone the bureau. As I drew closer, the chanting voices became clear:

"DOWN WITH AMERICAN IMPERIALISM!"
"DOWN WITH AMERICAN IMPERIALISM!"

I jogged along the side of the street, moving past uneven lines of protestors. There must have been thousands; they held signs and Chinese flags, and after chanting the slogans they sang the national anthem. Suddenly the crowd broke into a run, and then slowed again at the intersection called Xinjiekou, where a statue of Sun Yat-sen stood on a pedestal at the heart of a traffic circle.

I slipped into the marching crowd, hoping to watch for a while and then interview somebody. For a moment, the young people stared at me, but then their attention returned to the marching and the chanting. A single student called out a phrase, and then the rest echoed:

"DOWN WITH NATO!"
"DOWN WITH NATO!"

It reminded me of the Chinese students I had taught a year earlier—the way they memorized lessons by reciting in unison during study time before class. And these marchers also looked like my former students: mostly skinny men in glasses and button-down shirts.

"GO FORWARD, GO FORWARD!"
"GO FORWARD, GO FORWARD!"

We made a turn, then another, and I was lost; these nighttime streets all looked the same. Once more, the crowd broke into a run, and I figured that we must be nearing some destination. But a moment later we slowed again. After a couple more turns, I finally recognized a landmark: the Sun Yat-sen statue. We had doubled back to Xinjiekou.

I chose a student on my left—a friendly face, sweating beneath wire-rimmed glasses—and asked where we were going. He gestured ahead vaguely and then turned to me.

"Where are you from?"

I told him that I was an American journalist.

"DOWN WITH NATO!"
"DOWN WITH NATO!"

"What's your opinion about what happened in Belgrade?" the student asked.

"I don't know anything about it," I said. "I'm just here to report on the protests."

"DOWN WITH AMERICAN IMPERIALISM!"
"DOWN WITH AMERICAN IMPERIALISM!"

"Your government needs to stop the war in Yugoslavia," the student said. "Why does America have to be the world police?"

I stammered and shrugged apologetically; I hadn't expected to be talking about Yugoslavia in Nanjing. In March, NATO had started a bombing campaign in support of Albanian Muslims who had been attacked after pushing for greater autonomy in the province of Kosovo. Even before the Chinese embassy had been bombed, the government-controlled media had adamantly opposed the NATO campaign, defending President Slobodan Milosevic as a victim of "American hegemony." The Chinese seemed concerned mostly about how the Yugoslavia issue might affect independence movements in Taiwan, Tibet, and Xinjiang, a region in the far west.

As we marched, students came over to me, one by one. In the beginning, they were polite—invariably they told me that it wasn't personal; they didn't blame me for being American. Often they were curious about my reaction, but mostly they wanted to express their opinions. They knew that the attack had been intentional; there had been three bombs; they had come from three different directions. I had no idea of the source of this information, but everybody said the same thing. Three bombs, three directions. It couldn't have been accidental. American technology was the most advanced in the world and it was impossible to make mistakes like that.

"DOWN WITH AMERICAN IMPERIALISM!"
"DOWN WITH AMERICAN IMPERIALISM!"

One young man introduced himself as Wu Ming, an undergraduate at the Aeronautics University in Nanjing. The name might have been fake; many of the students refused to give their identities, and Wu Ming is a common pseudonym in the Chinese press (it sounds the same as "nameless"). But this student looked earnest and he asked if he could express his feelings in writing. Happily,

I handed him my pen and paper; I was growing dizzy from trying to take notes amid all the shouting and marching.

It was a warm spring night; the weather had not yet turned hot but the trees were already full, arching over the streets. Nanjing still has an ancient city wall, and occasionally I caught a glimpse of the structure, looming dark against the sky. Everywhere, people lined the sidewalks. Cops stood at intersections, watching the protestors, who had settled into certain rhythms. The steady chanting: one voice, a beat, the voice of the crowd; one voice, a beat, the voice of the crowd. We marched, and then we broke into a run, and then we marched again. Wu Ming stopped writing whenever the pace picked up. At one point, a new chant emerged:

> *"BU CHI KENDEJI!"*
> *"BU CHI KENDEJI!"*

I wasn't sure that I heard correctly, and I asked Wu Ming what they were shouting. "Don't Eat Kentucky," he said. We slowed in front of a KFC franchise—in Chinese, the name is simply "Kentucky"—and then the crowd surged again. Soon I caught a glimpse of the gates of Nanjing University, followed by the golden arches.

> *"BU CHI MAIDANGLAO!"*
> "DON'T EAT MCDONALD'S!"

It wasn't until later that I realized the protests were happening all across China—the most violent anti-American demonstrations since the 1966–76 Cultural Revolution. In Beijing, the Communist Youth League had bused groups of university students into the embassy district, where they marched past the American and British compounds. The national television news ran footage of the Beijing demonstrations, and students across the country quickly organized. In Chengdu, the capital of Sichuan province, protestors set fire to the home of the American consul-general. Using an iron bicycle rack as a battering ram, they attempted to break the bulletproof front door of the consulate. In Beijing, students pelted the American and British embassies with rocks and bricks and paint bombs. The vandalism spilled over to a few other embassies, including the Albanian compound. Apparently the protestors were angry because the Albanians were the ethnic group whose plight had inspired the NATO campaign.

But Nanjing's days as a political center were long gone, and the city had no foreign embassies or consulates. For hours, our crowd circled the downtown district, searching for targets. Sometimes we marched; sometimes we ran;

sometimes we stopped to shout at the yellow arches. Wu Ming returned my notes, and I put them in my pocket; there wasn't any point in writing when the same thing kept happening over and over. A turn, a brief sprint, another turn: the Sun Yat-sen statue. Another student at my elbow: American technology, three bombs, three directions. Down with America, Down with NATO. Three directions, three bombs. Don't Eat Kentucky, Don't Eat Kentucky. We marched, we ran. Sun Yat-sen again.

THE ANGER DEEPENED as the evening wore on. Conversations became shorter, more staccato; fewer people asked for my opinion. Finally I stepped out of the crowd and watched from the sidewalk.

"DON'T EAT KENTUCKY!"
"DON'T EAT KENTUCKY!"

Around midnight, a group of protestors smashed the windows of a KFC. By the time I got there, police had cordoned off the restaurant—lights off, windows gaping. Bystanders told me that the cops had dispersed the attackers by explaining that the restaurant was actually Chinese-owned.

"DON'T EAT MCDONALD'S!"
"DON'T EAT MCDONALD'S!"

Another mob attacked a statue of Ronald McDonald that was sitting quietly on a bench in front of a franchise near Nanjing University. The following morning, I talked to a McDonald's employee, who told me that the crowd had used sticks and poles to destroy *Maidanglao Shushu*. The Chinese name translates directly as "Uncle McDonald." The worker looked nervous; she said that the restaurant would be closed that night, in case there was more violence. Outside, a single jagged piece of bright yellow fiberglass was still stuck to the bench—the final remains of Uncle McDonald's butt.

"DOWN WITH AMERICAN IMPERIALISM!"

Later that week, when I asked the Chinese assistant at the *Wall Street Journal* to help me read the comments that Wu Ming had scrawled in my notes, she couldn't decipher a single complete sentence.

BY THE SECOND day of protests, it was no longer necessary to ask people any questions. If I stood on the sidewalk, they confronted me, and exchanges always started the same way: "What country are you from?" Usually, the lectures didn't end until I finally shrugged and walked away. For me, the excite-

ment of the first evening had worn off; there was a difference between chasing information and having it chase you down. I wanted to tell people that I was only a clipper—I wasn't a real journalist, and I couldn't publish all the angry things that Chinese people said to me.

Overnight, red national flags had sprouted above restaurants and shops, and groups of student protestors marched through Nanjing all day long. Television coverage was nonstop: images of the ruined embassy in Belgrade, photographs of the three Chinese journalists who had died. The state media described the attacks as intentional, the work of "the American-led NATO." NATO and the United States had issued statements claiming that the bombing had been accidental, but they hadn't been broadcast on the Chinese news. It was unclear how the government planned to respond to the attack.

In the afternoon, hoping for a distraction, I tried to continue research on my article about history. I visited the Memorial to the Nanjing Massacre, which commemorated the violence that had swept the city in 1937 and 1938. That winter, the invading Japanese army had occupied Nanjing, forcing the Kuomintang government to abandon the capital and flee to the interior. After the victory, Japanese soldiers ransacked the city, killing and raping civilians.

Six decades later, historians still argued about what had happened, and the death toll was a sensitive subject. Chinese scholars claimed that three hundred thousand died, although many foreign historians believed this statistic to be an exaggeration. In Japan, some right-wing groups denied that the massacre had taken place at all (and even relatively liberal Japanese history books preferred to call it an "incident"). For the Chinese, it remained one of the most sensitive wounds of the past, and they hated the idea of any outsider telling them what had or hadn't happened.

The memorial featured signs in Chinese, English, and Japanese:

DON'T FORGET HISTORY

THE PAST KEPT IN MIND IS A GUIDE TO
THE FUTURE

Several enormous signs were wordless:

300,000

Inside the main memorial hall, glass cases displayed bones of victims. Another section featured black-and-white photographs—a monument to the soldier's ability to document his own worst moments. Many Japanese troops had been stupid enough to take pictures and get the film developed at Shanghai

camera shops. Chinese technicians gave duplicates to foreign correspondents, which was one way that the outside world first received photographic evidence of the Nanjing Massacre.

I made my way through the silent hall of pictures. In one section, I found myself gazing at a three-photo series of a Chinese man getting beheaded—a kneeling figure, an upraised sword, a head rolling in the dust like a hairy ball—and then I realized that I couldn't bear to do any more research in Nanjing.

I walked outside and sat in the open courtyard of the memorial. I wanted to leave Nanjing; it was a bad time to be in a strange city, and a travel article was the last thing I wanted to think about. But I dreaded the overnight train ride back to Beijing, with the inevitable angry conversations. I sat alone on a bench, trying to steel myself to walk back out into the city.

Across the courtyard, a flock of doves waddled in the sunshine. They were part of the memorial, and there was an employee who cared for the birds. The man had erected his own makeshift sign, the characters scrawled roughly across a sheet of plywood:

DO NOT PUSH, GRAB, SCARE, OR SHOUT AT THE DOVES.

I walked over to read the sign, and the dove-keeper struck up a conversation. His name was Gong Bangxing, and he was sixty years old; he had accepted the museum job after retiring from a local glass factory. He earned a little more than eighty dollars a month. He liked to talk, and the only thing he wanted to talk about was doves. I had never been so thrilled to hear about birds.

Mr. Gong explained that the doves were an important part of the memorial, because, quite frankly, the massacre exhibits were depressing. He told me that if one of the birds got sick, the others quickly caught it, so he spent a lot of time cleaning up feathers and dove droppings. It was not an easy job but he liked it. I asked him how many birds there were at the memorial.

"More than a hundred," Mr. Gong said. "But I don't know exactly, because I'm afraid to count them. It's bad luck to do that. What if one day I counted and it was a different number? I'd be worried all the time."

He scribbled his contact information in my notebook and told me to call if I ever returned to Nanjing. He wore big black rubber boots and a khaki cap. The cap had a single white spot of dove shit on the brim. He was the only person I met that day who did not mention the NATO bombing.

IT WAS A relief to return to Beijing. In the bureau, newspapers had stacked up during my absence, and I carved out the foreign stories, reading headlines:

PROPAGANDA—STOKED PROTESTS HIGHLIGHT
HOW CHINA'S LEGACY STILL LOOMS LARGE

BEHIND THE CLAMOR, A WARPED
CHINESE WORLDVIEW

ANGER AT U.S. REACHES INTO
CHINA'S PROVINCES: ATTACK ON
EMBASSY CAPPED TENSIONS

The bureau also subscribed to *China Daily,* the Communist Party's English-language paper, and I clipped those articles as well:

PEOPLE AGONIZED BY CRIMINAL ACT

HEGEMONY DOOMED TO FAIL

SURVEY: EMBASSY BOMBING INTENTIONAL

Every night at seven o'clock, the correspondents and I watched the Chinese news. We also followed the foreign broadcasts and checked the wires, where information appeared in bits and pieces. NATO claimed that they had been trying to bomb a headquarters of the Yugoslav military-supply system, but an outdated map provided the wrong location. During the first day of protests, the most powerful Chinese leaders made no public statements or appearances. James Sasser, the U.S. ambassador, was barricaded with his staff in the Beijing embassy, eating Marine rations, unable to leave while protestors pelted the building with rocks and bricks and paint. Chinese police stood passively out in front, waiting for some unknown command.

ON MAY 9, a high-ranking Chinese official spoke in public for the first time. He was an obscure vice-president named Hu Jintao—black hair, black suit, dark tie. Nervous eyes. It was noon: special nationwide broadcast. In his brief speech, Hu made one reference to the protestors:

> "We believe the broad masses will, proceeding from the fundamental interests of the nation and taking the overall situation into account, carry out the activities in good order and in accordance with law."

Late that evening, the People's Armed Police surrounded the American and British embassies, and it was clear that the worst was over. The next day, speaking to television cameras in front of the White House, President Clinton publicly used the word "apology" for the first time:

"I have already offered my apologies to President Jiang and the Chinese people. But I think it is very important to draw a clear distinction between a tragic mistake and a deliberate act of ethnic cleansing."

The following day, at noon, the Chinese national television news ran a clip of Clinton's apology. But they cut it off after "the Chinese people"—no reference to ethnic cleansing. On the twelfth, the U.S. ambassador was finally able to leave the embassy compound. That day, the ashes of the three victims were returned to Beijing. The news ran footage from the airport: solemn music, sad-faced officials, tearful relatives. The mood in the Chinese media shifted from anger to grief; finally, the incident began to slip into the past. A story appeared on Xinhua, the government's English-language news agency:

> *Beijing (Xinhua)—Things left behind by the three Chinese journalists who were killed during the missile attack by U.S.-led NATO last Friday will be collected by the Chinese Revolution Museum, said the Museum's deputy director Ma Junhai today.*
>
> *"These things are actually relics that have great significance for education," he said. . . . These objects include blood-soaked cotton quilts, bags, pens, notebooks, and recorders. Zhai Huisheng, deputy editor-in-chief of the Guangming Daily, showed two bags of his killed colleagues today. The bags still give off the obvious smell of gunpowder smoke.*

I DIDN'T LIKE leaving the bureau for home. Every evening I lingered, trying to find any kind of distraction—another news program to watch, another story to read. But the truth was that I could devote only so much time to a five-hundred-dollar-a-month job, and there were limits to my two-hundred-dollar apartment: no television, no air-conditioning. The kitchen was too small to use; I had brought almost no books from the States. Whether I liked it or not, I had to spend much of my time out in the city.

Meals were the hardest part. In China, I had always liked the intimacy of cheap restaurants, and I had studied Chinese by hanging out in noodle shops and teahouses. But now I had to learn a new body language: I kept my head down, and I smiled and tried to look friendly. I nodded at all the comments, even the most ridiculous ones. Sometimes, people mentioned the Taiwan issue, and they fixated on the 1839–1842 Opium War and the historical mistreatment of China by foreign powers. A few Chinese told me that America was a nation without history, which resulted in the lack of a moral core. Whenever somebody asked my nationality, I told the truth—I intended to live in these neighborhoods, and any lie might become a future complication.

I began eating mostly in Yabaolu, which was halfway between home and the bureau. Yabaolu was the Russian district—traders from the former Soviet Union and Central Asia gathered there to cut wholesale deals for clothes produced in Chinese factories. Of all the places near home, Yabaolu was the best bet for a white man hoping to avoid drawing attention, but I wasn't going to truly blend in. Most of the Russians were big, with heavy torsos and short skinny legs that scissored along as they stalked the sidewalks. They had tough faces, often with misshapen noses that obviously had been broken in the past. Their eyes sagged under some weight—maybe the pressure of business, maybe the shadow of vodka. They carried their cash in plastic pouches strapped beneath bulging stomachs.

The Russian traders dominated the neighborhood, but there were plenty of other ethnic groups in Yabaolu. The Han Chinese—ethnic Chinese—ran most restaurants and shops, but a few places had been opened by members of native Muslim minorities. After the bombing, I figured that these restaurants were safest; if Chinese ate there, they'd be less likely to cause trouble. And the Muslims probably wouldn't be angry about NATO's actions in Kosovo.

One evening, I walked into a small Muslim dumpling joint. The other diners stopped talking when I entered. Three tables were occupied by Han Chinese; at another table sat two Uighurs, members of an ethnic group that is predominately Muslim and originates from the western region of Xinjiang. I vaguely recognized one of the Uighurs—in previous days, I had seen him at other restaurants in the neighborhood, but we had never exchanged more than a quick hello. There were many Uighurs in Yabaolu, usually working as trade middlemen. From a Chinese perspective, some of the Uighurs looked as foreign as I did.

I sat down alone and ordered dumplings and a beer. The waitress smiled when she brought the bottle and the plate. It didn't take long for one of the Chinese to ask, "What country are you from?"

Everybody looked up after I answered. The man asked why Americans had to act as if they were the world police; another diner muttered something about the Opium War. A third got stuck on the inevitable issue of technology. "If America is such an advanced country, how could it possibly say that the bombing was a mistake?" he said. "They claim that they used an old map—that's ridiculous."

I admitted that the events had confused me as well, and then I tried to turn my attention to the dumplings. The man repeated his question. "Americans can see anything from space," he said. "With such great science, how could they bomb the wrong building?"

I stared at my plate, hoping that he would get bored. The man was about to say something else when the Uighur whom I had recognized spoke up.

"With such great science," he said, "how could America kill only three Chinese?"

The restaurant became very quiet. The Chinese man asked the Uighur what he meant, and the man smiled. "I'm just saying that if America is such a great country and has such advanced technology," he said, "they should be able to kill more than three Chinese people when they want to."

"*Feihua!*" one of the Chinese shouted. "That's garbage!"

But the Uighur kept talking. "Don't be an idiot and believe all that stuff on television," he said. "If Americans were trying to kill Chinese, you'd be dead right now."

The others jumped in and an argument swelled for ten minutes. Forgotten, I ate in peace and then settled the bill. As I was preparing to leave, the Uighur walked over and introduced himself. On a scrap of paper, he jotted down his name and cell phone number; he invited me to meet him for dinner sometime. Everybody else watched in silence. The discussion flared up again as I headed off into the night.

THAT SPRING, WE followed a regular routine. I'd call his cell phone and arrange to meet for dinner in Yabaolu. Neither of us ever saw the other's apartment; we were too proud for that. He rented a room directly next door to the dumpling restaurant, where lodgings were so basic that he had to use the public toilet across the street. I wasn't much better off; whenever my bathroom acted up, I went down the street to the Swissotel. We never said as much, but our friendship benefited from the fact that both of us dreaded going home at night.

His name was Polat, and he worked the margins in Yabaolu. Like many Uighurs, he was good with languages; Xinjiang is one of the most ethnically diverse parts of the country. There are thirteen non-Chinese ethnicities native to the region, and the Uighurs, who number around eight million, are the largest group. (The name is pronounced "Wee-gur," and in English it is sometimes written as "Uyghur.") Polat could converse in Uighur, Chinese, Russian, Uzbek, Kazak, Kyrgyz, and Turkish. He used his language skills to work as a middleman for deals between foreign traders and Chinese wholesalers, and he also changed American currency on the black market. Sometimes, he converted tens of thousands of dollars in a single deal, earning a commission of a tenth of a percent. But private currency exchange was illegal, and it was dangerous to move that much cash; in 1999, two Uighur money changers were murdered in Yabaolu. Polat preferred dealing in name-brand clothing.

He was in his mid-forties, and he had been doing business since 1990. In the beginning, he traveled internationally, often in Central Asia: Uzbekistan, Kyrgyzstan, Kazakhstan, Turkmenistan. In those years, it was difficult for average Chinese citizens to secure passports and visas, but Polat learned that he could get the right documents for the right bribes. He made trips to Russia, Romania, Bulgaria. He spent a lot of time in Turkey, where the language is close to Uighur, and he went to Pakistan, where business was poor. Once, he tried to transport Xinjiang grapes through Tibet to Kathmandu, but the fruit spoiled when he got caught by the monsoon season on the Nepal side. Iran was another bad memory—a Tehran art dealer convinced Polat that he could make money selling ancient Chinese paintings that had been found in Iran, but the paintings turned out to be neither ancient nor Chinese. After losing money on that deal, Polat generally stuck to wholesale clothing, but there was always a risk when travel was involved. In 1993, after saving ten thousand American dollars, he invested most of that stake in an overland shipment of Chinese-produced clothing bound for Kazakhstan. He lost it all when insects infested the crates.

In 1997, he moved to Beijing and established himself as a middleman in Yabaolu. The neighborhood had become a center for black-market wholesalers who traded clothing that was produced in the factory towns of eastern and southern China. The foreign brands were the most popular: The North Face, Nike, Tommy Hilfiger. Often, the dealers sold fakes and factory rejects, but it didn't matter as long as the labels looked good. Nautica, Adidas, Timberland. The cheap versions sold well in Russia and Eastern Europe, as well as across the wide swath of Central Asia where borders had always been uncertain and ethnicities were indistinguishable to the untrained eye. Kazaks, Uzbeks, Tatars—all of them came to Yabaolu. There were few women in the neighborhood. The most obvious ones were the prostitutes—Russian, Mongolian, Chinese—who sauntered past restaurants where traders closed deals.

Polat sold just about anything. In 1998, he cleared two thousand dollars by arranging the sale of two truckloads of fake 555-brand shoes to a consortium of traders from Poland, Romania, and Yugoslavia. On another day, he earned a grand by helping some Russians purchase a shipment of knockoff Nautica clothes from an underground factory in Tianjin. There had been a lot of good days in 1998. That was the year he talked some Russians into buying twenty thousand bogus brassieres, made in Guangdong, with labels that said Pierre Cardin. The margin on that deal was nearly a quarter a bra.

I couldn't see the money on Polat. He dressed simply, and he didn't brag after closing a deal, unlike the other Yabaolu traders. They were businessmen

of the purest sort, dealing in fakes and playing the margins, and I learned not to take their stories too seriously. But Polat seemed different. He had wavy black hair flecked with white, and his eyes were brown and sad. He didn't smile much. His skin was dark brown, and he had the solid jaw and prominent nose of a Middle Easterner. When he did smile, his face lit up. He often used the Chinese word *jiade*—"fake"—and he was deeply scornful of the products that he sold. According to him, the knockoff clothes were garbage, crap, shit—*jiade*. Not long after we met, he mentioned that he had originally taught Uighur language and literature at a secondary school in Xinjiang. He spoke so disparagingly of his business deals that I couldn't understand why he had left teaching. He was handsome in a rugged way, but his cheeks had lines so deep they looked like seams. He was slightly overweight. He smoked cigarettes constantly. He often looked tired. I had no idea what he did with his profits.

ONE EVENING IN late May, Polat invited me to dinner with another trader. We met at a small Uighur restaurant on North Ritan Road, which had become my favorite spot. The restaurant was fronted by a broad outdoor platform where we took our meals, watching the traders and the prostitutes walk past. Usually, we ordered Yanjing beer. The restaurant manager would step down from the platform, open a manhole cover on the sidewalk, and pull out two bottles. The cool water inside the manhole served as the restaurant's beverage refrigeration system. Meals there did not cost very much.

That night, Polat's companion was a trader from Azerbaijan. He had a very small face, dark long-lashed eyes, and a tiny toylike mustache that played lightly above his lip. He wore a cheap gray suit. He had come to Yabaolu in order to purchase clothes at wholesale, and Polat was providing contacts with Chinese dealers.

"My friend apologizes that he cannot speak to you in English or Chinese," Polat said, after we had all shaken hands. "And he wants to know if we can drink *baijiu* tonight instead of beer."

Baijiu is Chinese grain alcohol, and nobody drinks it for the taste. Reluctantly I agreed, and the restaurant owner set a bottle on the table. I assumed that the young man was Muslim, but most of the Central Asian traders drank anyway. They seemed to leave their religion at home when they traveled for business.

At our table, the languages switched back and forth, with Polat in the middle. He conversed in Turkish with the young man, and then he turned to me and talked in Chinese about the embassy bombing. He was obsessed with it—the protests had died out in less than two weeks, but he continued to bring

up the topic, often with strangers. His earlier outburst at the dumpling restaurant hadn't been unusual; he loved to goad the Han Chinese.

"They have a problem with their brains," he said, after pouring each of us a second shot of *baijiu*. "The students are all so stupid—they don't understand anything."

"Do you agree with what NATO is doing in Yugoslavia?" I asked.

"Of course I agree with them. The Albanians are being killed because they're an ethnic minority. I listen to the Voice of America and I know what's happening there. And I think it's important because I am a Uighur from Xinjiang. Do you understand what I'm saying?"

I nodded, but he looked hard at me.

"*Mingbai le ma?*" he said. "Do you understand?"

"I understand," I said.

"Many things are difficult to talk about openly in Beijing," he said. "*Mingbai le ma?*"

"I understand," I said. He studied me carefully, and then he smiled and raised his glass. All three of us drained our cups and made that face that men make when they drink *baijiu*. The young Azerbaijani asked, through Polat, if Americans often drank this sort of alcohol. I shook my head and then Polat mentioned the drinking habits of the Russians. This was an easy topic of international conversation; each of us had stories about Russian drunks, which turned out to be remarkably similar regardless of whether seen from the perspective of Uighurs, Azerbaijanis, or Americans. Polat translated the stories back and forth. The young trader remarked that the average Azerbaijani could not drink as much as the average Russian, but the best Azerbaijani drinkers were better than the best Russian drinkers. He made this point carefully and with great pride. The waiter brought us barbecued lamb. The lamb was spicy and quite good; it would have been even better with beer. I glanced longingly at the manhole.

After a while, the conversation turned to the Uighurs, and Polat mentioned how some of them look like Europeans. "One of my closest friends is blond," he told me. "He looks more foreign than you. He looks so much like a foreigner that he sometimes plays them in Chinese movies. Did you see *The Opium War*?"

I nodded. The government-financed epic had been released in 1997, shortly before Hong Kong was returned to China. That had been a good year for nationalism and the movie consisted of two hours of evil British imperialists and heroic Chinese resistance.

"Do you remember the scene where the foreigner gets his throat cut by the Chinese person?" Polat asked.

"Not specifically," I said. "But I probably saw it."

He said that I couldn't have missed it—they cut his friend's throat right in the middle of the screen. Later this year the man was scheduled to appear in another government movie that celebrated the return of Macau to the Motherland.

"There's a group of Uighurs and Kazaks who often play foreigners in those patriotic movies," Polat explained. "They have real foreigners for the big roles, but they use the Uighurs and Kazaks for the smaller parts."

"Do they pay them well?"

"Not particularly. My friend made three thousand yuan. But it wasn't difficult work."

The money was the equivalent of less than four hundred dollars. Polat laughed when I asked if he had enjoyed the movie.

"Of course not," he said. "You know what those Chinese history movies are like—everything is *jiade*. It's not what really happened."

The young Azerbaijani sat silently while we spoke in Chinese, but he seemed to be observing me intently. Polat continued. "I prefer American movies," he said. "The *Godfather* movies are my favorite. And I like any movie with *De Ni Luo*."

The moment he said it, I realized that he vaguely resembled the actor: worn features, a solid jaw, and a certain weight that lurked behind his eyes. He was a Uighur Robert De Niro. The young Azerbaijani was still studying my face and finally he spoke to Polat.

"My friend would like to know something," Polat said. "Are you a Jew?"

Sitting in the Muslim restaurant, I was taken aback by the question. The young trader leaned forward, and Polat explained: "He says that you look very much like a Jew."

"I'm not," I said. "Actually, I'm Catholic. Some of my ancestors were German and some were Italian. *De Ni Luo* is Italian, too."

He translated and the young man's face fell. There was a torrent of Turkish and then Polat said, "My friend is interested because he is a Jew."

"Oh," I said. "I didn't know there were Jews in Azerbaijan."

"There aren't very many," Polat said, and a moment later he raised his glass again.

POLAT WAS THE first person who made me think about the sheer size and range of China. When you compared the Uighurs and the Han Chinese, they seemed a world apart in every respect: geography, culture, language, history. They were like antipodes contained within the borders of a single country.

Xinjiang lies directly north of Tibet, and it's nearly as remote and forbidding. It constitutes one-sixth of China's land mass—as much territory as the states of Alaska and New York combined—and the geography includes some of the highest mountains and most expansive deserts in the world. Ancient history is uncertain; the earliest residents were nomadic tribes who didn't leave written records. Occasionally, the early Chinese dynasties established military garrisons, but the landscape was incompatible with Chinese agriculture and the emperors didn't control the area with much consistency. It wasn't until the ninth century that the ancestors of today's Uighurs began to settle there in significant numbers. Even then, they were usually based in the oases, leaving large stretches of mountains and deserts to the nomads.

The Uighurs were often middlemen. They taught the Mongols to write using the Uighur alphabet (at an earlier stage, the Uighurs had used a runic script), and they served as intermediaries between the court of Genghis Khan and other Central Asian powers. Uighur religion was pragmatic, often shifting when some new military force arose: at various times, the Uighurs believed in shamanism, Manichaeanism, Nestorian Christianity, and Buddhism. In the tenth century, they began to convert to Islam, and after that, for a period of nearly a millennium, they stopped using the word "Uighur" to describe themselves. Their writing changed as well, to the Arabic script.

Whereas the Chinese prided themselves on continuity, many basic characteristics of the Uighurs were fluid—their name, their writing, their religion, their political allegiances. But they always seemed capable of surviving on the margins. That quality was still evident in modern times, when Uighurs did business in every Chinese city. Often, they opened restaurants or sold Xinjiang produce, such as raisins and melons, and they dominated the black market for currency. In China, it was rare for members of a minority group to establish themselves in predominately Han economies. Some of the Yabaolu traders used to tell me a popular Uighur saying: When the Americans landed on the moon, they found a Uighur there, doing business.

Polat and I had a second-language friendship—we communicated entirely in Chinese. I couldn't understand the groups of Uighurs who patronized the restaurant, but their body language was eloquent. They were bigger than the Chinese, and they moved with a swagger. They were great handshakers—a rarity in China. If a woman came to the table, the Uighurs stood up. They refused to touch pork. They drank heavily—that particular Islamic restriction wasn't deep-rooted. They had long sunbrowned noses and a hard gaze, and they carried themselves with a physical confidence that made the Chinese nervous. The few Chinese who ate at the Uighur restaurant minded their own

business, and I did the same if Polat wasn't around. In particular, there was one large Uighur trader with a heavy brow who intimated a capacity for violence that I did not want to test. Once, he told me that he had just closed a big deal, selling half a million Tianjin-made condoms to an Uzbek. As far as I was concerned, that sounded as impressive as the Uighur on the moon. Another evening, the heavy-browed man stayed late in the restaurant, drinking vodka with a Uighur friend. As the alcohol disappeared, the two men took turns burning holes into their own forearms with cigarettes. Afterward, whenever they met, they would shake hands and each would touch the other's scarred wrist, smiling at the memory of whatever shared demons had brought them together that night.

THE MODERN PERIOD had been hard on the Uighurs. In the eighteenth century, the Qing dynasty sent armies westward, hoping to formally incorporate the territory into the empire. Resistance was fierce, but in 1884 the Qing formally annexed the region and renamed it Xinjiang (New Frontier). After the Qing fell, in 1911, Xinjiang became one of many parts of the empire that threatened to slip away. In the 1920s, some Turkic residents began to push for independence, describing themselves as "Uighur"—a name that hadn't been used for almost a millennium. In 1944, with the Kuomintang government weakened by the Japanese invasion and the struggle against the Communists, a group of Uighurs, Kazaks, and White Russians in northern Xinjiang attacked and defeated the local Chinese garrison. The rebels declared the foundation of a multiethnic state called the East Turkestan Republic.

For the next five years, the East Turkestan Republic functioned essentially as an independent country, with close links to the USSR. But the Soviets never gave open support, and they probably saw the new republic as a bargaining chip for future negotiations with whoever happened to win the Chinese civil war. That was the risk of surviving on the margins: powerful neighbors always had a use for pawns. In 1949, after the Communists gained control of China, they invited the most charismatic leaders of the East Turkestan Republic to come to Beijing for meetings. The men left Xinjiang for their flight from Alma Alta, in the Soviet Union, and were never heard from again. Months later, after the People's Liberation Army had gained control of Xinjiang, the Chinese announced that the plane had crashed. Many Uighurs believed that in fact their leaders had been executed, the victims of a secret agreement between Mao Zedong and Joseph Stalin.

Since then, Xinjiang had remained firmly under Chinese control. After the 1980s, when new oil and gas reserves were discovered in the region, Han Chi-

nese migration increased dramatically. Much of the Uighur unrest came from a fear that they were becoming outsiders in their own homeland. Throughout the 1990s, there was periodic violence: bombed buses, derailed trains. People assumed that the attacks were the work of Uighurs resentful of Chinese rule, but no organizations claimed responsibility. The violence, like so much else in Xinjiang, remained a mystery.

In Yabaolu, I watched the traders—the Central Asians, the Middle Easterners, the ones I couldn't identify—and wondered how many belonged to some obscure ethnic group that had slipped in and out of the histories of great nations. Often, the Uighurs' fate hadn't been shaped by language, culture, or tradition; the whim of great foreign leaders mattered much more. Mongolia had recently become independent, a path that probably would have been open to Xinjiang if it had originally fallen under the control of the USSR instead of the People's Republic of China. In the Great Game of Central Asia, the Uighurs were one of the losers.

After I came to know Polat well, he told me more about his family background. During the mid-1940s, his father had joined the army of the East Turkestan Republic. Like many of his fellow soldiers, Polat's father had the image of a rifle tattooed onto his left shoulder. That had been a dangerous mark to carry into the Cultural Revolution, and by the end of that period the man was a cripple. Polat said that he wished he could write about this in a true history of the Uighurs. He also wanted to write about his own personal experiences, which included a prison term in 1985 for protesting against Chinese rule. He told me that that was why he could no longer teach in Xinjiang; he had left the province because of political pressure. He also said that he had saved forty thousand dollars, and he swore that sometime soon, when the money and the time were right, he was going to find a way to flee to America.

I TRIED TO write my travel article about Nanjing but finally gave up. I swallowed the expenses, attributing the failure to bad timing, and then I turned to other projects. By summer, the embassy bombing already seemed like a distant memory. Occasionally, Chinese people brought it up in conversation, but they rarely pushed the topic. When they did, they tended to be more disappointed than angry, because their government had accepted the American apology and a financial settlement for the damage to the embassy in Belgrade. I almost never met a Chinese who believed that the attack had been accidental.

While clipping in the bureau, I would at times come across a follow-up story. In July, George Tenet, the director of the CIA, testified before Congress. He acknowledged that, of the nine hundred sites targeted by NATO's bombing

campaign, only one had been researched and selected solely by the CIA: the Chinese embassy. Tenet emphasized that it had been mistaken because of the outdated map.

Three months later, the *Observer,* a London newspaper, published an investigative article claiming that in fact the bombing had been intentional. The story was based on interviews with three NATO officers stationed in Europe, all of whom spoke to the newspaper on the condition of anonymity. They alleged that American military officials had deliberately targeted the Chinese embassy because it had been secretly assisting Milosevic. The newspaper claimed that after an earlier NATO bombing had destroyed the Serbs' radio transmitter, the Chinese allowed their compound to be used as a backup, broadcasting military commands to Kosovo.

The *Observer* speculated that the Chinese might have helped Milosevic in exchange for access to the wreckage of a Stealth fighter, which had been shot down earlier. The downed American plane would have had great value to Chinese intelligence. In any case, there had been a history of cooperation between the militaries of the Chinese and the Serbs. And it was also true that the NATO bombing had seemed quite precise for an accident. All three bombs struck the southern end of the Chinese embassy, where the defense attaché's office and the intelligence center happened to be located. The rest of the compound was untouched; casualties were remarkably low. Like many other foreign publications, the *Observer* claimed that two of the three dead Chinese "journalists" had in fact been intelligence officers, a common role in the state-run media.

But that was it—no named sources, no proof. NATO denied the allegations, and few American newspapers picked up the story. In the bureau, I clipped a copy and filed it away:

U.S.-CHINA—EMBASSY BOMBING

U.S.-CHINA—EXCHANGES

U.S.-CHINA—RELATIONS

U.S.-CHINA—SCANDAL

U.S.-CHINA—SUMMIT

U.S.-CHINA—TRADE

The Written World
塔塔儿族

QIN SHIHUANG BURNED BOOKS. IN THE YEAR 221 B.C., HE BECAME the first ruler to declare himself *Huangdi,* emperor. He standardized currency, weights, and measures; he commanded the construction of roads and canals and the first version of the Great Wall. He destroyed classics of history, philosophy, and poetry. He buried scholars alive. Under his reign, all Chinese were forced to write characters the same way.

The chief minister advised his emperor to destroy not only the books, but even the *idea* of the books: "If there is anybody who dares to mention the *Songs* or *Documents* in private conversation, he should be executed. Those who, using the old, reject the new, will be wiped out together with their clans."

All of this was recorded more than a century later by a historian of the Han, the dynasty that followed the Qin. The book, *Historical Records,* became a classic for two millennia.

IMRE GALAMBOS IS thirty-five years old, with a pedigree that is unusual for a scholar of ancient Chinese. On his mother's side, he is Central Asian: a Tatar grandfather, a Kazak grandmother. The grandmother was born in Harbin, in the northeast of China, and as an adult she moved west. She gave birth to Galambos's mother in the Ural Mountains. The girl moved farther west, attending college in Moscow, where she fell in love with a Hungarian. West again: Imre Galambos was born in northern Hungary, near the Danube River.

He is half Hungarian, quarter Kazak, quarter Tatar. He is short and stocky, dark-haired and long-lashed. He is shy. On the telephone, he is reticent to the point of monosyllables; first meetings can be awkward. But once you get to know him well, the fluency of his thoughts is remarkable, and he has already established himself as an innovative scholar in his field.

At the University of California at Berkeley, Galambos wrote his dissertation about the development of ancient Chinese writing. His primary texts were two-thousand-year-old strips of bamboo that had been inscribed with characters. These were old texts, but new sources: most had been excavated during the latter part of the twentieth century. In the past, scholars didn't have access to such materials. They studied classics such as the *Historical Records*, which had been copied repeatedly and passed down through the centuries.

The bamboo strips were inscribed during the centuries after Qin Shihuang's reign, but the written characters still aren't uniform. A single word is written in different ways, as if the ancient culture lacked clear standards. With this evidence, Galambos theorizes that the Qin standardization of characters is an exaggeration and possibly a myth, and the same may be true for the other stories. In his dissertation, Galambos notes that centuries of historians have been obsessed with the tale of the book-burning, but they have ignored "the quiet but continuous process of selecting works for copying."

His point is simple: censorship captures the imagination, but the process of creation might be even more destructive. In order to write a story, and create meaning out of events, you deny other possible interpretations. The history of China, like the history of any great culture, was written at the expense of other stories that have remained silent.

In Galambos's opinion, China's most important literary unification actually took place during the Han. They produced their history book, as well as the first dictionary, and their emphasis on the written word established the foundation for two millennia of empire. "People talk about this idea of literary worlds," he says. "There are certain cultures, like the Byzantine and the Chinese, in which the written documents create a world that is more significant than the real world. The officials who ran the country in ancient China—they were selected through exams, through this process of memorizing the classics. They lived in this quasi world of letters. Whoever came in from the outside became a part of it. Even the Mongolian tribes that eventually became the Yuan dynasty—for God's sake, they were complete nomads, with very little written language. But they became like the Chinese for a time; they assimilated themselves. I think that this literary world is the link in time that permits this thing we call 'Chinese history.' It's not the number of people or anything

like that; it's the enormous written world that they produced. They produced this world that's so big that it eats them up and it eats up everybody around them."

GALAMBOS IS AN instinctive skeptic. He is suspicious of neatness, regularity, plot; in his view, stories are often a façade for chaos. This perspective may be genetic—Tatar DNA—or it may simply be what happens when your own story doesn't make sense. Apart from basic details, his family history is unknown. He has no idea why his Kazak grandmother lived in northeastern China, or why she left. He doesn't know how she met the Tatar, or which route they took to the Urals.

Galambos doesn't even have a good reason for his original dedication to Chinese studies. He grew up in Communist Hungary, which required mandatory military service from all young males. After high school, he joined the army and quickly learned that it was no place for an instinctive skeptic. As punishment, the military sent him to the hills of Bakony for six months of additional training. Galambos spent much of his time there on kitchen duty. At one point, he faked a hernia and underwent surgery, simply because that meant twenty-eight days' leave for recovery. The surgery was primitive and nowadays he still feels an occasional twinge in his gut.

After the hernia, the next escape involved higher education. In Hungary, the mandatory term of military service was shortened by half a year if a soldier entered college. Galambos applied, but he missed all the deadlines except one: a scholarship to study in China. He accepted, figuring that it was worth avoiding six months in the army. That was fifteen years ago. "I got sucked into this whole Chineseness," he explains.

One evening, I meet Galambos for a drink in Beijing, and the conversation turns to history. He explains that people have a natural tendency to choose certain figures and events, exaggerate their importance, and then incorporate them into narratives.

"That's how history is formed in their minds," he says. "It's through these important people and events. But while studying Chinese history, you learn that maybe some of these events didn't happen, or they were very minor, or a lot of other things happened that were in fact very important. The Chinese say that every five or six hundred years a sage appeared. In reality I would say it's more fluid, more complex; there's a lot more stuff going on. Obviously, that's no way to teach history. You can't just say, 'There's a lot more stuff going on.' It's inevitable that you have to pick out certain things."

We sit in a small anonymous bar near Houhai, a lake in central Beijing.

This is one of the capital's last intact old neighborhoods, and the bar's windows open on to the lake. It's a beautiful evening; the lights streak red and yellow across the nighttime water. Galambos talks about the power of perception, and then he points at me.

"That's why the Chinese worry about you, the correspondent," he says. "For the West, whatever you create is China. Otherwise it's just these random figures—they might publish some numbers about the GDP, and maybe people will think, 'Wow, that's really low.' Or maybe they'll think it's high. But you journalists explain it and spice it up and that's how it comes out. If you write about us sitting here in Houhai, people will think, 'Wow, China's a really cool place.' That's how the place is formed in their minds. But it might have very little to do with reality."

The Voice of America

May 1999

BEIJING WAS THE FIRST PLACE I HAD EVER LIVED AS A FULL-TIME writer. In the past, I had been either a student or a teacher, and previously in China, I had been both. From 1996 to 1998, I had served as an English instructor with the Peace Corps in a small city called Fuling, where I also studied Chinese.

At Fuling Teachers College, most of my students had come from peasant homes, and they trained to become English teachers in rural middle schools. A generation earlier, the subject had been taboo—any contact with foreign languages was risky during the political campaigns of the Cultural Revolution. But in today's China, English was compulsory from the sixth grade on, and the language had become an obsession among the younger generation. During my first year of teaching, I sometimes wondered if the knowledge would ever have any practical use. I was one of only two foreign residents in Fuling, and most of my students would end up teaching in even more remote places. Nevertheless, they worked hard, finding whatever English materials they could. In the evenings, they wandered around campus with shortwave radios, listening to the BBC or the Voice of America.

After I moved to Beijing, I was often lost in my new life: the chaos of the May protests, the petty details of freelancing, the file cabinets of the *Wall Street Journal*. But all of it disappeared whenever a former student wrote or telephoned. One afternoon that spring, I received a call from Jimmy, who was teaching in a village near the Yangtze River. He sounded thrilled; he had a girl-

friend now, and he enjoyed his new job. I asked how many students he taught.

"There are ninety-four," he said.

"How many classes?"

"One class."

"You have ninety-four students in one class?"

"Yes," he said. "It's very crowded!"

After the conversation, I tried to imagine what it would be like to teach English to ninety-four middle-school kids in a remote Yangtze village. From my perspective in the bureau, it was completely abstract:

STUDENTS

STYLE

SUPERPOWER—"NEW THREAT"

SUPERSTITION

TEA

Another day, I received a call from D.J. Like many of my former students, he had chosen his English name for mysterious reasons, and now he taught in one of the poorest parts of Sichuan. He earned less than forty dollars a month. A classmate told me that when D.J. received his first paycheck, he was so excited that he bought a new soccer ball and spent an entire afternoon kicking it around, all by himself.

"I have given my students English names," D.J. told me on the telephone. "Most of them I named after my classmates from Fuling. But I want you to know that I named one student Adam and another student Peter."

Adam Meier had been the other Peace Corps instructor who arrived with me in 1996. I was touched, and I thanked D.J. When he spoke again, I could hear his smile. "The student named Peter," he said, "is possibly the stupidest student in the class."

LIKE MOST CHINESE from the countryside, my former students tended to marry early, and that spring I often received letters describing their courtships. Freeman sent notes that had been printed out by computer, which was unusual in rural areas. He had named himself after seeing a photograph of the actor Morgan Freeman in an American magazine. In one of his letters, he described how he had relied on matchmaking relatives to find a wife:

From graduating Fuling Teachers College, my parents and relatives all wanted to introduce girlfriends to me. So they introduced one and one, but the one and one passed me and didn't become my wife. There were

nearly three dozen girls I knew through theirs introducing. Some were
very fat like pigs; some were so thin that they were the same as flag-sticks
and fishing-sticks; some were also very beautiful, but when they saw me,
they at once went away and left a word, 'The toad wants to eat the swan's
meat.' Of course my family had spent a lot of things and money on my
girlfriends.

Now I find a girlfriend finally, she will be my wife after 2000. She isn't
beautiful, there are many black points on her face, but I love her, because
she has more money than me, maybe I love her money more. . . .

I am teaching Grade Two, Junior English. I think teaching is very
difficult in this place, here is very poor, people don't still see the importance
of the education. . . .

I have many things to say, but I can't write out. This letter is typed
from my girlfriend's computer. I will write you again.

Yours,
Freeman

IN THE PAST, it was rare for Chinese to leave their home regions, and four-fifths of the population was rural. But this began to change after 1978, when Deng Xiaoping decided to institute free-market reforms. Eventually, this policy became known as *Gaige Kaifang,* "Reform and Opening." In the 1980s, capitalist-style changes first gained momentum in the coastal regions, where factory towns sprang up to serve the new foreign trade. Migrants flooded in from the interior, working construction and assembly-line jobs. By the late 1990s, one of every eleven Chinese was on the move.

It took guts to leave. Migrants tended to be more capable than the ones who stayed behind in the villages, and often the best rural students headed toward the coast after they finished school. Among my own pupils, the decision was particularly difficult, because the government provided stable teaching jobs if they remained in their hometowns. Every spring, the classroom buzzed with talk of going south or east, where salaries were higher but where migrants wouldn't have the safety net of a traditional *danwei,* or work unit. A lot of my students talked about it; few took the chance. The ones who left tended to share certain characteristics: they were at the top academically, and they were outgoing and lively. They spoke good English. Their ideas were different—usually, their compositions had shined.

William Jefferson Foster was one of the students who stood out. Originally, he had taken the English name "Willy," but in the spring of his last year, he

suddenly changed it to "William Foster." I had barely grown accustomed to seeing that signature on his compositions when the "Jefferson" materialized. He always signed his papers with a flourish, all three names stretched in huge script across the top of the page. He never asked for advice about the name changes, although he mentioned that he admired William Jefferson Clinton because the American president, like Willy, had come from a poor part of a big country. It didn't surprise me that after graduation in 1998, William Jefferson Foster went east to seek his fortune. He was twenty-three years old.

Willy was probably the brightest student in the class; certainly his spoken English was the best. The others preferred using Chinese when they telephoned, but Willy insisted on English—he was determined to learn the language. But I can't say for certain that his path was the most remarkable; it was simply the story that I came to know best. He was one migrant out of a hundred million.

WILLIAM JEFFERSON FOSTER was born on August 18th of 1975, in Double Dragon Township, Number Ten Village, Number Three Production Team. Nothing important had ever happened there. No famous people had come from Number Ten Village, and there weren't any ancient buildings or inscribed tablets. The oldest structure was Victory Bridge, which spanned the Snail River. The stone bridge had been constructed in the 1940s, destroyed almost immediately by a flood, and then half repaired so that it was just wide enough for a single person to cross. No particular victory had been won at the bridge, but that was a popular name for landmarks in New China. The Communists had used numbers to rename the local villages and administrative units, for the sake of simplicity. The population of Number Ten Village was less than one thousand.

Fifty miles away, across the low green hills and the shimmering rice paddies of northeastern Sichuan, was the town of Guang'an, where Deng Xiaoping had been born and raised. In 1975, Guang'an was just another obscure village, and Deng was just another once-promising political figure who had been purged twice during the Cultural Revolution. After 1977, when Deng was rehabilitated, he quickly rose to become the most powerful leader in the country, but he never returned to Guang'an. Probably, he wanted to avoid the sort of personality cult that had developed around Chairman Mao, whose hometown became a mecca for pilgrims. Deng protected the nation in part by allowing his corner of Sichuan to remain poor and forgotten.

Double Dragon Township was poorer than Guang'an, and Number Ten Village was even poorer than Double Dragon. It was a place without formal

history. Most residents, like Willy's parents, were illiterate, and the local past consisted of things that were remembered and things that were left unspoken. Willy's father had been born in 1941, and he told his sons that the worst period in his life had been during the Great Leap Forward. That political campaign had spanned the years from 1958 to 1961, when Mao Zedong's mad push for greater industrial production had resulted in a famine that killed tens of millions of rural Chinese. Some of Willy's father's relatives and childhood friends had starved to death during that time, but the man refused to talk about it. The details, as far as he was concerned, should be allowed to fade away.

He was willing to remember subsequent periods, like the Cultural Revolution. Unlike the Great Leap Forward, the Cultural Revolution affected primarily the cities and the educated class—this is one reason that the history is much better known today. And although the Cultural Revolution's political struggles were deadly in cities such as Beijing and Shanghai, the movement sometimes softened by the time it reached the countryside. Politics often worked like that—the campaigns were like a code that came from far away, in bits and pieces, and the villagers clung to some fragments while ignoring others. In the years after the Communist victory, one Number Ten resident named Li had three sons whom he proudly named Li Mao, Li Ze, and Li Dong. Whenever he called them to help in the fields, he shouted, "Mao, Ze, Dong, get over here right now!" He claimed that this was his way of expressing love for the Chairman. Nevertheless, the man became an easy target during the Cultural Revolution, when the peasants imitated the "struggle sessions" that they had heard about from the village propaganda loudspeakers. In Number Ten, the peasants hung Li from his wrists, criticized him for misusing the Chairman's name, and forced him to drink urine from a public latrine.

Willy's parents were too poor and uneducated to become targets during the Cultural Revolution. Actually, that became a period of relative good fortune for the couple, because during those years Willy's mother gave birth to three healthy sons. Dai Jianmin, the eldest, was born in 1971, and Dai Heping was born two years later. In 1975, the woman gave birth to their third son. They named the baby Xiaohong, "Little Red," because of his size and color. Red is an auspicious color in China, and sure enough the baby's first year coincided with great changes. Before Willy's tenth month, Chairman Mao passed away.

When the death was announced, Willy's father happened to be assisting with some construction work at a fertilizer plant in another part of the township. There were three other workers, and all of them stopped to listen when the news came over the loudspeakers. After hearing the announcement, none of the workers said a word about it. For years, they had repeated the chants—

Mao Zhuxi, wan sui! "Ten thousand years to Chairman Mao!"—and now it seemed unbelievable that he was dead.

That night they did not go home. The workers spent the evening in a shack at the construction site, all of them lying together on a broad rough bed. Willy's father couldn't sleep; he knew that this was different from the various political campaigns that had come and gone. It was impossible to predict what would happen, but he felt certain that everything was about to change. For much of the night, he wept quietly. It wasn't until later that he realized that the other workers had also spent the evening lying awake and weeping.

The Number Ten Village memorial service for Chairman Mao was held in the packed dirt yard of the local school. For seven days, nobody worked; they made white paper memorial wreaths and kowtowed before a poster of the departed leader. On the first day, a woman named Liu Yuqing distinguished herself by crying the hardest. By the second day, the other villagers began to wonder if there was something wrong with her. By the end of the year, she wandered aimlessly around the rice paddies, telling anybody who would listen that she had been Chairman Mao's secret lover. She claimed that, together with the Chairman and Premier Zhou Enlai, she had designed Victory Bridge. She often cut off conversations by saying that she had to hurry and attend an important Politburo meeting. When Willy was a boy, Liu Yuqing lurked around the Snail River, washing her tangled hair and singing traditional songs about Chairman Mao, to which she added her own lyrics that were full of sexual innuendo. She used the blunt dialect word for the act —I 睡磕睡 Chairman Mao. Willy and the other boys would laugh and shout out, "When's your next meeting with Chairman Mao? Are you going to 睡磕睡 him again?" After Liu Yuqing's sons reached adulthood, they generally locked their mother indoors before going out to work in the fields.

WILLY'S FATHER WAS right about the changes. Although he was illiterate— he hadn't attended a single day of school in his life—he was naturally intelligent, and he responded quickly when the economic reforms filtered down to the village. By the early 1980s, he was organizing private construction crews to work in Double Dragon Township. By the time Reform and Opening was five years old, Willy's family had become one of the most prosperous in Number Three Production Team.

There were other signs that the world was expanding. In 1980, one of Willy's uncles became the first villager to migrate for work. He traveled to Gansu province, in the far west, where he spent several months on a labor crew. Soon, other villagers began to leave, although they generally went in the opposite

direction, to the east. Another early migrant was Willy's neighbor, a man in his twenties who was the most literate person in the village. With his fifth-grade education, the man was able to find a job in a shoe factory in Heilongjiang province. After returning to the village, he told stories and wrote poems about his experiences abroad. As a child, Willy was fascinated by the man, and he loved to hear him recite his verses.

The first local television appeared in Number Four Production Team. Every night, Willy and his older brothers made the half-hour hike to Number Four. The owner had constructed a two-story home, and at night he placed the television high on his balcony so that everybody could see it. One evening, Willy and his brothers stared up at the balcony for more than four hours, transfixed by the new machine. Afterward, all of them felt the exact same pain in their necks, and that was when their father decided to take action.

One of Willy's most vivid childhood memories was from that day in 1982, when his family became the first in Number Three Production Team to own a television. Years later, he remembered the scene:

"I was very proud, very happy. When the TV was put inside, nobody knew how to use it. Everybody tried, but it didn't work; maybe it took about five or six hours. There were more than one hundred people at my home, mostly in the big room. It was just like a lobby, people sit in lines, one after another. Some of them sat outside. After they learned how to use it, there was only one channel, Sichuan TV station. The Hong Kong shows were popular, and we always watched one about Huo Yuanjia, a character from history. In the Qing dynasty, he mastered the *gong fu* and fought many Japanese who were good at Japanese *gong fu*. They came to China to challenge Huo Yuanjia, and he defeated them. It was near the end of the Qing dynasty. I can still remember the song:

> *China is like a dragon that has slept for hundreds of years*
> *Now it has woken up,*
> *Open your eyes, look carefully,*
> *Who wants to be a slave of fate?*
> *History has shown that evils from outside will be defeated.*"

The show about Huo Yuanjia was followed by a Mexican soap opera, which proved to be equally intriguing to the residents of Number Three Production Team. The Mexican soap was called, in Chinese, *Slander*, and its characters engaged in extramarital affairs at a dizzying pace. Invariably, the mistresses were wicked and conniving, while the wives were so unknowing that it was painful to watch. In Willy's home, the villagers often shouted out their unani-

mous allegiances: sympathy for the wives, contempt for the mistresses. *Slander* provided Number Three Production Team with its first introduction to the private lives of foreigners.

It often rains in Sichuan, and when the weather turned bad, the spectators who couldn't fit in Willy's house stood outside the window, holding umbrellas. The television screen measured fourteen inches. It wasn't long before another channel appeared:

"People would shout and say, 'Change the channel!' And I would say, 'No, it's up to me to decide!' I was just like a boss, very arrogant. I decided what we would watch. One night we were watching and suddenly the voice disappeared. There wasn't any sound. Some people were upset and went away. I went in front of the TV and turned it off. The people shouted, 'Don't do that!' But when I turned it back on, the voice came back. Later, it happened again, and I did the same thing. Sometimes once wasn't enough, and I'd have to do it twenty times, thirty times. We were likely to break the TV. Sometimes the picture was not good, so I held the antenna. Many people took turns holding it so that others could watch."

WHEN WILLY WAS small, he saw his older brothers go off to school every day. In the early morning, Dai Jianmin and Dai Heping walked south along the dirt road, carrying a simple wooden bench between them. They disappeared for a period of several hours and then returned with the bench. From Willy's perspective, that was school: a ritual involving brothers and benches.

The village school had mud walls, and the teachers were poorly trained local peasants whose first priority was farming. If an instructor had something to do in the fields, the kids ran free, and everything shut down during peak agricultural periods. Neither of Willy's brothers went beyond the fifth grade, and both became farmers and laborers.

By the time Willy was ten years old, Reform and Opening had already begun to leave his father behind. The new economy changed so fast that windows of opportunity were brief—sometimes a certain product or a particular set of skills were valuable for only a year or two. In the early 1980s, native intelligence and diligence were adequate for small-scale construction work, and Willy's father flourished. But soon there was more competition, and bidding for projects required shrewd calculation. Sometimes Willy's father organized a long job and actually lost money. He often warned Willy about the disadvantages of being uneducated: "My father said it was too bad to work without education; he said you would be cheated by anybody who is literate, who

knows something. If you don't study, you will just be a coolie."

The man decided to be more careful with the schooling of his youngest son. He paid extra to send Willy to the township school, which had a better reputation. Nevertheless, the key moment in Willy's education was a "miracle"—or at least that was how he remembered it, years later:

"When I was in primary school, the first four years I was not so good. The subjects were hard for me. But I think it was a miracle—from the fifth year, I was very, very good at math. I can't understand how the situation changed so fast. The teacher would write many questions on the blackboard and ask us to do it as quickly as possible, and I was always the first. In the examination to go to middle school, I got the second prize out of more than seventy students."

Soon, Willy's parents no longer required him to help out on their farm, which consisted of about a quarter of an acre. His brothers complained, but Willy's father sensed that the youngest child had better prospects. Willy often assisted with calculations for his father's construction work, but in middle school the boy discovered that he no longer liked math. Fortunately, there was a second flash of light:

"In sixth grade, we got the book for English class. I think this was another miracle. I studied very, very badly. We had a countryside teacher who had just graduated from high school; he had no college diploma. Tan Xingguo—'Tan Prosperous Nation.' I could not understand anything he said, and I always failed the examination. I never got sixty points. But at the end of that term, I studied by myself. I stole some chalks and I wrote words on the door at my home. I pretended it was a blackboard. I wrote words, and I read them. I liked that: I am the teacher, I am the student. That was the best way for me.

"At the end of the term, I was very astonished to find that when the test papers were sent to us, the problems were very, very easy for me. I got eighty points. At that time, I had confidence in myself."

In the spring of 1995, at the end of high school, Willy took the national exam and qualified to study in the English department at Fuling. He and two other boys were the first people from Number Three Production Team to enter college.

WILLY WAS THE kid in the back of the class with the open dictionary. He always scored well on my exams, and if I called on him, he answered questions quickly. But he wasn't one of the students who raised his hand at every opportunity. Class moved too slowly for him; if I walked along the back row

during a lecture, he'd quickly shuffle some papers so I wouldn't see that he had been studying his dictionary. He was short, stocky, and dark-skinned. He wore glasses. He dressed neatly, but his clothes—shirts with frayed collars, suit coats with the tailor's label still attached to the sleeve—were cheap. Like many of my students, his appearance could be described in Chinese as *tu*: "earthy, uncouth." He looked like a peasant, and he had the peasant's crude sense of humor. Once, after class was over and the other students had filed out into the hall, Willy sidled over to me and said, with carefully studied pronunciation, "How is your premature ejaculation?"

He was always trying out some new phrase, often obscene. Language obsessed him—he loved the word "yahoo," gleaned from *Gulliver's Travels,* and he often used "tonto," which had been acquired in Adam Meier's Spanish class. He was fascinated when I gave a lesson about foreign words that had been adopted into English, and after that he made "coolie" a regular part of his vocabulary. He liked the cynicism of the phrase "so-called": China's "so-called patriotism," the college's "so-called morning exercises." And he had a special affection for the dialect of Sichuan province. During my last year at the college, Willy and some of his classmates taught me various bits of *tuhua*—"earth speak," a Chinese phrase for local slang. In Sichuan, you could insult somebody by calling him a "son of a melon" or a "son of a turtle"; the local pronunciation of "hammer" meant "penis." *Yashua*—"toothbrush"—was for some obscure reason degrading when used as an adjective ("You are very toothbrush!"). In basketball games, if an athlete shot an air ball or made a bad play, the Sichuanese fans chanted *yangwei, yangwei, yangwei*—impotent, impotent, impotent. After I played basketball with Willy's classmates, he would often say, in mock earnestness, "I see that you still have a big problem with impotence."

But much of the crudeness was bluster, at least when it came to real life instead of language. During Willy's second year at the college, he began to notice another English student called Nancy. She was a tiny girl, dark-eyed and fine-featured; Nancy was so shy that if a boy spoke to her outside of class she simply froze. Willy was almost as hesitant, and it took him weeks to work up the courage to write Nancy a formal letter, in Chinese, that praised her beauty, quietness, and character. The letter requested permission to spend time alone with her.

The college was controlled by conservative cadres who criticized romance among students as an unnecessary distraction. Young people who engaged in courtship could be punished by an official demerit that would remain in their political dossier, subject to inspection by future employers. Nancy never re-

sponded to Willy's note, but the next weekend she silently joined him on a walk around the campus:

"Later we went to the cinema. We did not talk. We kept silent. It was embarrassed, I feel very embarrassed. I can't remember the movie now. I think it was a very big film from the U.S.A. I sent her home to her dormitory. This went on for a couple of weeks. She did not speak so much.

"One night, we went to the athletic field, and just sat on the stairs, and it was dark. We talked there; we talked happily. Suddenly the security guard came, and he asked why we were there. He wrote down our names. Nancy was frightened and said it was fate. She was very sad after that. I tried to date her out, but she refused. Maybe a month or more."

Unlike Willy, Nancy was a pessimist. She had inherited it from her father, a peasant from northern Sichuan who had never found his niche in the changing economy. Nancy's father dreamed of becoming rich, and he was always finding a new scheme to ride the reforms. In the mid-1990s, there was a boom in the Sichuanese pork industry, and feed mills sprang up all across the province. A town near Guang'an—Deng Xiaoping's birthplace—became known for its pig feed, and Nancy's father decided that he had to be the first from his village to use a new brand. He traveled more than seven hours by bus specifically to purchase the feed. Over the following weeks, all twenty of his piglets died, one by one. Probably, he had been tricked into buying a knockoff brand. In China's new economy, somebody produced a counterfeit of everything; there were fake cell phones and fake Pierre Cardin bras and even fake pig feed. A common trick was to dilute the feed with rapeseed hulls, which can't be digested.

There was always a logical explanation, but it didn't appear that way in the isolated villages. Miracles blessed Willy; fate cursed Nancy's father. One year, he bought a motorbike to transport goods, but the motorbike crashed. Then he tried to raise rabbits, but the animals caught a disease and died. Bad luck was everywhere.

By their last year of college, Willy had finally eased Nancy's fear of the anti-dating regulations. But the prospect of graduation posed an even greater threat. If they accepted the government-assigned teaching jobs, they would end up in their hometowns, separated by hundreds of miles.

That spring, a private-school headmaster from Zhejiang province arrived in Fuling to scout for new teachers. It was a yearly ritual—recruiters always showed up in April, hoping to exploit the income gap between the coastal re-

gions and the interior. In a place like Fuling, they could attract top talent for a fraction of the salary that would be expected back east.

The recruiting headmaster was named Mr. Wang. He wore a traditional Sun Yat-sen suit with brass buttons and a short stiff collar (foreigners sometimes call this a "Mao suit"). Mr. Wang told the students that he had joined the Communist Party at the age of sixteen. He had devoted his life to Chinese education, and in recent years he had founded the Hundred Talents High School on the island of Yuhuan. According to Mr. Wang, Yuhuan had a well-developed economy, and young people from all across China came there to find new lives in the island's factories and trade companies. For incoming teachers, Mr. Wang promised to provide free housing and a monthly salary of eight hundred yuan—nearly one hundred American dollars. It was more than twice as much as Willy and Nancy could earn if they taught in their hometowns. But in order for them to leave, the Party officials in the Fuling English Department had to agree to transfer the young couple's dossiers.

Willy and Nancy submitted their requests. Politically, their applications were weak: neither student had joined the Communist Party, and they had never been particularly well liked by the cadres. Both had been criticized for their romance, among other minor transgressions. As graduation approached, there still was no word on the dossiers.

Finally, Willy took action. He didn't ask anybody for advice—years later, he explained that he simply followed his "sixth sense." One evening, he escorted Nancy to the home of the English Department's Communist Party Secretary. The Party Secretary was not particularly friendly, and Willy had never liked him; but now the cadre smiled and invited the young couple inside. He remarked that Yuhuan sounded like a good place with a promising economy. But Zhejiang province was far away and transferring documents was not simple.

Willy explained that, more than anything in the world, he wanted to go east. He took out an envelope, placed it on the low tea table in front of him, and said, "Please do me a favor."

"I'll try," said the Party Secretary, and then he escorted the young couple to the door. Nobody said a word about the envelope.

Another official handled graduates' work assignments, and Willy and Nancy visited the man's apartment and performed the same ritual. Each envelope contained five hundred yuan; the total represented half a year's income for Willy's father. It was the first time in his life that Willy had bribed an official.

Shortly before graduation, the college informed Willy and Nancy that their dossiers were being sent east.

Peter Hessler
The Wall Street Journal
7-2-63 Jianguomenwai Diplomatic Apartments
March 12, 1999

Dear Pete,

I was perfectly glad to hear from you this time. In my view, it should be great news for China since there is an extra foreign Yashua [toothbrush] from the other side of the pacific ocean. Probably you are beding a Chinese birtch when my letter arrives. Anyway, please read it, it can be used as "viagra." . . .

The job in the school isn't so good. I feel too tired, in fact we are coolies in the school. We are discriminated. For there is an old birtch who is in charge of salary, she is undersexed and mean, she can never get any pleasure from anything except money. Half a year passed. I am feeling better and better, anyway I am glad that I can come to Zhejiang Province. After all, there are more opportunities here. While I am still working hard at English for I have Zealotry in this language, I have confidence in myself that one day I will be a VIP, not like toothbrush any more. Meanwhile my teaching here is extremely successful. You and Adam are somewhat my icoms in the teaching. . . .

Pete, I hope that you will seize a chance to visit me in Yuhuan. My yahoo students have itching desire to see you.

By the way, I have several questions for you.

I: what does "KTV" stand for?

II: what's the term (the proper Englihs) for the people who to go other city to earn living (especially farmers from sichuan)?

III: What's the full form of "DVD" "VCD"?

IV: Do you want to be Chinese-American?

V: How many wives do you want to have?

VI: Are you still impotent? (YOUR BIRD CAN NOT ERECT)?

Yours,

 Willy

AFTER THEIR ARRIVAL in Yuhuan, Willy and Nancy realized that Mr. Wang's description of the island had not been accurate. First of all, the place was relatively undeveloped; the city of Wenzhou, thirty miles away on the Ou River, was the region's boomtown. Second, there had been a problem with Willy and Nancy's jobs. In fact, the high-paying jobs did not exist. Mr. Wang apolo-

gized for the misunderstanding, and then he gave them teaching positions that paid roughly half of the promised salary. The guaranteed free housing also did not materialize. Willy and Nancy had to pay for private rooms in a building whose conditions were so bad that Willy referred to the place as "my so-called apartment."

Mr. Wang wore the Sun Yat-sen suit every day, buttoned all the way to the collar. He was in his mid-sixties, with short white hair, a bright red face, and a distinct limp. He intimated that this injury had been sustained in service to the Communist Revolution. His wife wore old-fashioned cloth "Liberation shoes," and she clutched a silk money bag so tightly that it had turned black and greasy. The woman handled the school's finances; whenever she paid Willy and Nancy's salaries, she deducted mysterious fees and penalties. She was the biggest birtch that Willy had ever met.

The Hundred Talents High School also did not exist, at least in any particular place. The campus location changed almost every year. Mr. Wang arranged short-term leases on buildings that were half-constructed, or old public-school facilities that had been abandoned. Most students came from outlying islands; their parents sent them to the private school out of desperation, because the children had failed the entrance examination for public high school. In China, compulsory education was only nine years.

The Wang economic empire was transitory but diversified: one of Mr. Wang's adult sons had a business nearby, raising attack dogs for the local police. Mr. Wang's office, like the rest of the school, was unfinished, and there were no furnishings, apart from a desk and a few books. The most substantial volume was entitled *A Record of the World's Famous People*, which featured biographies of successful individuals in a wide range of fields. The book sat prominently on Mr. Wang's desk, and he encouraged visitors to browse freely. When Willy scanned it, the only name that he recognized was Mr. Wang's. The biography detailed Mr. Wang's love for China, as well as his decorated career as a member of the Communist Party. The book described the many instances in which Mr. Wang had used his own money to help poor students who couldn't afford school fees.

Within two months, Nancy quit and returned to Sichuan. She found a teaching job in her hometown, where a neighbor, in the patient but determined manner of the countryside, began to court her.

WILLIAM JEFFERSON FOSTER lost weight that first year. He missed Nancy, and his hatred for the Hundred Talents High School deepened every day. The institution depended heavily on migrant teachers, who were paid a third as

much as the locals, because Mr. Wang knew that it was difficult for outsiders to search for new jobs. Meanwhile, students often dropped out once they realized the school was a fraud, and Willy's salary was docked for every kid who quit. He could barely save any money.

In the evenings, he distracted himself by listening to the Voice of America on his shortwave radio. Originally, the station had been a wartime creation of the American government; the first broadcast had been in German in 1942, shortly after the bombing of Pearl Harbor. Since then, the station had expanded to provide programming in fifty-five languages. According to its charter, the Voice was dedicated to providing reliable and authoritative news, and it described itself as "American" in a general, nonpolitical sense. But relatively few Americans had ever actually listened to it. U.S. law forbade the station from broadcasting domestically, because of a fear that any government-funded news source would become propaganda. It seemed a distinctly American paradox: create a Voice and then protect your own citizens from hearing it.

Overseas, however, there were an estimated ninety million weekly listeners. In China, the Voice of America had always been hugely popular—during the pro-democracy demonstrations of 1989, the station claimed that as many as sixty million Chinese tuned in every week. A decade later, Chinese in the big cities often had access to the Internet and cable television, but the Voice remained an important source of information in smaller places such as Yuhuan. It broadcast in Mandarin, Cantonese, and Tibetan.

The Voice of America also provided programming in English, including a form of the language known as "Special English." The best description of the tongue can be found on the Voice Web site, which is also Special:

> *Three elements make Special English unique. It has a limited vocabulary of 1,500 words. Most are simple words that describe objects, actions or emotions. Some are more difficult. They are used for reporting world events and describing discoveries in medicine and science. Special English is written in short, simple sentences that contain only one idea. No idioms are used. And Special English is spoken at a slower pace, about two-thirds the speed of standard English.*

Special English was a product of the cold war. In the late 1950s, when the Soviet Union frequently jammed the Voice of America, broadcasters decided that a simpler form of the language would be easier to understand through the static. It wasn't intended as a teaching tool, but that's what it quickly became. Millions of people around the world studied English through the Special broadcasts.

In Fuling, my students listened religiously, mimicking the rhythms, and

soon Adam and I learned to talk the same way whenever we needed to make ourselves understood. We were the only native English speakers in the city, and after a couple of months we began holding routine conversations in Special English without realizing it. During my first year in the Peace Corps, a friend from New York visited and wondered if Adam and I were losing our native tongue. He kept telling us to stop talking to him as if he were a child.

Sometimes I wondered if Special English was the linguistic equivalent of McDonald's—a slow-paced fast-food language. But I was studying Chinese myself, and soon I realized that I was developing my own Special Chinese. It was a natural method for picking up a new language: First, you established basic sentence structures and vocabulary, the way a painter might initially out-line a portrait's fundamental elements. Over time, you acquired more sophisti-cated words and phrases, attaching them to the existing foundation. It felt like living in a rough sketch of the world where new details appeared day by day.

In Yuhuan, Willy listened to the Special English broadcasts almost every night. In a lined notebook, he jotted down words and phrases from various programs, all jumbled together:

> *Most Americans like to sleep late on Saturday morning.*
> *Special English*
> *VOA*
> *Washington*
> *President end Kosovo*
> *present might fly to Belgrade*
> *depend on the meeting*

Usually, the topic was news, but occasionally an entry was sparked by some program about American culture, politics, or history:

> *First floor: Congress Library*
> *By the fireplace: George Washington*
> *132 rooms 20 bedrooms*
> *move on 34 bathrooms*
> *privacy = a-way from public*
> *rooms owned by presidents and their families are not allowed to visit*
> *but they never think that this rooms are theirs, thy don't own it.*
> *American people own the White House.*

One of Willy's favorite Voice of America programs was called *American Idioms*, which introduced new phrases that were too obscure or complicated for Special English. In his journal, Willy made lists:

> *turn over a new leaf*
> *see beyond one's nose*
> *turn up one's nose at*
> *on spin and needles*

Unfortunately, *American Idioms* was obscenity-free, but Willy tracked down supplementary materials. He found a Chinese-published book called *American Colloquialisms*, but his most valuable discovery, in a used-book store in Hangzhou, was *A Dictionary of English Euphemisms*. The volume was dedicated almost exclusively to the sexual, the scatological, the graphic. Once, when I visited Willy, I opened the book to a random page, whose first word leaped out at me:

Dominatrix *n.* (American) 1. A female dictator. 2. A female sadist. 3. A female commander-in-chief for activities of sexual sadism.

DURING THE CHINESE New Year's holiday of 1999, William Jefferson Foster made the long trip home. In Number Ten Village, most of his former elementary-school classmates had also migrated; the men usually worked construction, while the women found jobs in restaurants or factories. With his education, Willy had expected to do better than his peers, but he had barely saved enough to cover his trip. Across the province, Nancy wasn't finding life any easier. In the village school, she earned about twenty-five dollars a month. The peasant who was courting her was completely bald.

Nancy's perspective on destiny had changed dramatically since her return home. Now she sensed that fate was what happened when you stayed in the village: the dead-end job, the lifeless marriage. During the holiday, she traveled alone across Sichuan to visit Willy. Before Nancy's parents allowed her to make the trip, they forced her to promise that she would return once the vacation was finished. They believed that life in Zhejiang province was too unstable for an unmarried couple.

But once Nancy was reunited with Willy, it didn't take him long to persuade her to get back on the east-bound train. He promised that they wouldn't stay in Yuhuan for long; at most, they would finish out the semester at the Hundred Talents High School. Willy knew that there had to be better opportunities in Zhejiang.

After a week, Nancy's parents realized what had happened. They telephoned the so-called apartment in Yuhuan and shouted at Willy; if Nancy picked up the line, they wept and asked her who would care for them when they

grew old. After a while, they enlisted relatives to call and browbeat the young couple. Nancy's older cousin was the most persistent—the woman called daily for more than a week. Every time, she screamed at Willy, and then suddenly she would grow calm. "You will be responsible," she said. "You will be responsible for what you have done."

April 18th, 1999

Dear Pete,

 How is it going with you at present?

 I hope that you are not feeling lonely while in the city of Peking. Some chinese xiaojie will be sure to have hots for you. But better be careful that some Chinese girls always blow hot and cold.

 It has been raining all these days here, my feeling is just like the raining days. . . . Actually, I am a little bit bored and annoyed by the things around me in the school. For long I have no mood for teaching. As soon as I stand on the platform of the classroom, I hope that the bell rings. All the students are yahoos. Some of them are brutal and uneducated. Many of the students want to drop out of the school while I failed to block the way out for some students. . . . many yahoos notice that they have been had, surely more students will escape from the school. . . .

 What interests me most is that I can learn English via VOA and a dictionary of American Colloquialism. I hope that in a short time I could put them into use correctly and freely. Afraid that my strong will be damaged, I wish myself a way out. . . .

 Yuhuan is a very small place. In other word, it is somewhat isolated from wonderful outside world. I am afraid I will not be able to use English well as long as I stay here. You see, I have zealtry about the English language which is considered to be my better half all my life. . . .

 By the way, is your pager number 6491-1166—56599? Need I dial the zone code (010)? How do you think of the military from NATO against Yugoslavian Union?

 Take care!

 Yours,

 William Foster *[printed]*

 William Jefferson Foster [signed]

AT THE BEGINNING of the May Day holiday, Willy purchased a new notebook and carefully inscribed a title on the first page:

> *Listening Journal*
> *William Jefferson Foster*
> *Spouse: Nancy Drew*
> *May 1st, Nineteen Ninety-9*

Nancy's last name had been suggested by Adam Meier, during their final year at Fuling. In fact, the couple hadn't married, and they hadn't yet made formal plans to do so. In the past, their situation would have been scandalous: a young unmarried couple sharing an apartment. Occasionally, they ran into trouble; once, they were refused a room in a Wenzhou guesthouse because they couldn't produce a marriage certificate. But such problems were rare, and nobody at the Hundred Talents High School caused a fuss. One of the first things that migrants learned was that locals didn't want to think about them at all.

That spring, Willy continued to study English every night, maintaining his Voice of America journal:

> *Summit of NATO*
> *(1) Regard Milosovic as Hitler who wanted to make a people die away*
> *(2) Japanese*
>
> *Tibet issue Xinjiang issue*
> *objection to interference in internal affairs*
> *Tibet is just like Kosovo*
>
> *Research shows that homosexuality is not caused by gene*
> *Bill Clinton Colorado Denver*

After the NATO bombing, Willy's journal entries became even more chaotic:

> *May 8th, 1999*
>
> *We have no other intention*
> *military site*
> *express it's deep sorry*
> *war crime*
> *The missile attack on Chinese Ambassy in Yugoslavia has deeply intensified the Sino-American relation*

May 9th, 1999

It is said Belgrade transferred weapons into Chinese ambassy
Chinese give intelligence to Belgrade—collaboration.

humantiaratity community
mission access—cooperate
CIA

"Down with USA" "Down with NATO"

WILLY CALLED ME frequently that week. He was concerned about my safety in Beijing, and after the situation had calmed down, we continued to talk regularly. At one point, he mentioned the possibility of looking for work in the capital, and I told him I'd do my best to help if he came.

But he decided to try again in Wenzhou. He attended job fairs in the city, but nobody wanted to hire a young Sichuanese teacher with a degree from an obscure college on the Yangtze. One day, he happened to see an ad in the newspaper for a teaching position at a private school in Yueqing, a satellite city outside of Wenzhou. He visited the school, where a woman administrator asked him to teach a mock lesson. He was always good in such situations: he spoke English easily, and he felt comfortable in front of a classroom. After his performance, the woman offered him a job starting in September.

The administrator made a good impression on Willy, but the experiences of the past year had taught him to be wary of promises. Nevertheless, the school existed: it was fixed, with a campus that stayed in the same place every year. He figured that was a good sign. The more he thought about it, the more he realized that he couldn't do worse than the Hundred Talents High School.

Near the end of summer, William Jefferson Foster and Nancy Drew packed in secret. Mr. Wang expected them to teach the new semester, and Willy liked the idea of the headmaster having to find two substitute instructors at the last minute. Between them, Willy and Nancy possessed two bags, a television, a pile of old blankets, and a total savings of about two hundred dollars. They left Yuhuan without saying goodbye.

3

The Broken Bridge

June 4, 1999

THAT SUMMER MARKED THE TENTH ANNIVERSARY OF THE DEMONSTRATIONS in Tiananmen Square. During the latter part of May, the foreign newspapers ran commemorative articles. In the bureau, I clipped the stories and filed them under *T*:

TEA
THINK TANKS
TIANANMEN SQUARE
TRADE FAIRS
TRANSPORTATION

One of the problems with the anniversary was that it was hard to name an event that Chinese people couldn't talk about openly. While clipping, I kept an informal list of terms used by the foreign press:

the Tiananmen Square crackdown
the Tiananmen Square massacre
the Tiananmen Square clampdown
the bloody suppression of pro-democracy demonstrations in Tiananmen Square
the June 4 crackdown
the bloody crackdown in and around Tiananmen Square
the June 4, 1989, military crackdown on the demonstrations
the crackdown on student protestors near Tiananmen Square

There weren't any stories in the Beijing papers; since 1989, the state-controlled media had rarely acknowledged the event. The average Chinese simply called it *Liu Si*: June Fourth. In the provinces, impressions of the incident were particularly hazy; when I had lived in Fuling, some of my good friends asked me earnestly if students had actually died in the crackdown. In Beijing, where many citizens had been in the streets that year, there weren't any illusions about whether it had occurred. People vividly remembered specific scenes, but the big picture remained a mystery. Nobody knew exactly how the crackdown had developed or what the death toll had been. Most foreign publications estimated that at least hundreds had died.

There was just enough information to know that the most commonly used names for the incident were slightly flawed. The vast majority of casualties had been sustained outside of Tiananmen Square, in various streets around the city, particularly to the west. And the crackdown had actually started on the evening of June 3, not the fourth. In 1989, after violence had descended on the city, a brave Chinese journalist had broadcast a message over the state media's official English radio service: "This is Radio Beijing International. Please remember June 3, 1989. The most tragic event happened in the Chinese capital, Beijing. Thousands of people, most of them innocent civilians, were killed by fully armed soldiers . . ."

A decade later, most memorials had shifted the date slightly, and the location had become focused onto the Square. Even if the details had blurred, the basic memory was probably as much as the journalist had hoped for. Reportedly he had been punished by several years of reeducation outside the capital.

ON THE DAY of the fourth, the *Wall Street Journal* correspondents and I took turns going out to Tiananmen, to see if there were any commemorations. We missed the two most prominent demonstrations, each of which involved exactly one person and lasted only a few seconds. A middle-aged man opened a white umbrella decorated with handwritten slogans:

REMEMBER THE STUDENT MOVEMENT

DISTRIBUTE STATE ASSETS TO THE PEOPLE

Plainclothes officers quickly hustled the man away, but an Associated Press photographer captured the moment. A while later, a male university student threw leaflets into the air and was immediately detained. The leaflets contained antigovernment slogans, as well as the phrase DOWN WITH AMERICAN IMPERIALISM.

I took the late-afternoon shift. The Square itself had been cordoned off—conveniently, it was being refurbished for the upcoming fiftieth anniversary of the founding of the People's Republic. But there was still an open area in front of Tiananmen, the "Gate of Heavenly Peace." It was a sunny day, and tourists from the provinces chattered and took photographs with the Chairman Mao portrait in the background.

After a while, I began to notice that some people in the crowd didn't look like tourists. They were men, usually in their thirties and forties, and many of them had crew cuts. They were not well dressed: worn trousers, cheap windbreakers. They did not look educated. They did not look like they were enjoying themselves—they weren't smiling, or taking pictures, or buying souvenirs. They loitered and lingered; they lurked and looked. They dawdled. Sometimes, a man would stand directly behind a group of talking tourists, as if trying to overhear the conversation. Periodically, one of the crew-cut men sauntered over to another crew-cut man, said something, and then sauntered away. Several held rolled up newspapers. I saw one man raise his newspaper, hold it next to his face, and speak to it. Curious, I walked past and took a furtive look. Inside the rolled paper, I caught a glimpse of black plastic—walkie-talkie.

I watched the plainclothes men work for most of an hour, and that was the only visible commemoration of the anniversary. Afterward, I biked over to the Muslim dumpling joint in Yabaolu for an early dinner. While I was eating, a pedicab driver pulled over and asked if he could share my street-side table, which would allow him to keep an eye on his bike. He ordered a bottle of *baijiu* and a bowl of peanuts. He poured vinegar onto the peanuts and ate them while he drank. He drank the *baijiu* quickly and he did not make that face. His bare legs looked tough and knotted, as if they had been carved from some slab of ancient hardwood.

It was still early for dinner and we were the only customers. The boss, a Beijing native, dozed nearby, his arms crossed on a dirty tabletop. The pedicab driver told me that he could earn more than ten dollars a day during the summer. He was ethnic Manchurian and proud of it. He told me how the Manchurians had founded the Qing dynasty and ruled China for nearly three hundred years. They were a warlike people and the Han Chinese couldn't compare; even the Qing emperors had known how to fight. It was a hell of a thing, being Manchurian.

After finishing the peanuts, the pedicab driver woke up the boss and ordered a huge bowl of dumplings. He dipped the dumplings into the vinegar, just like the peanuts. I hadn't seen anybody eat that much in a long time. Out of curiosity, I asked the man what the date was. He didn't know, so he turned to the restaurant owner.

"June Fourth," the boss said immediately. He crossed two fingers, forming the Chinese character for ten: 十. His face was completely expressionless. He said, "Tenth anniversary."

IN YABAOLU, I learned to get information from Polat. He seemed to know everybody in the neighborhood, and his connections were excellent; in early July, when Heineken sponsored a foreign music festival in the local park, Polat acquired a stack of workers' passes. During a jazz set, a half dozen of us stood around the stage, the least convincing group of maintenance men that had ever been assembled in the capital: one American clipper, two Uighur middlemen, a Chinese clothes dealer, and two other Chinese who were employed as security guards at the Workers Stadium. By introducing the security guards to jazz, Polat was guaranteed free entrance to any upcoming soccer matches.

Often, the two of us spent hours on the platform of the Uighur restaurant, drinking beers from the manhole and watching people walk past. If a trader caught my eye, I'd ask Polat and usually he knew the person's story: which distant country, which unlikely product. It was always a bad sign if he didn't know somebody. The bearded Afghans were a mystery; there were rumors that they dealt in gems and opium, but Polat didn't know for certain. And the North Koreans were another puzzle. Their embassy was just down the street from the Uighur restaurant, a huge complex whose front gate was decorated with propaganda photographs: happy Korean children singing, happy Korean troops being inspected by Kim Jong Il.

Occasionally, North Korean diplomats walked past the Uighur restaurant. I never saw one alone; they always moved in pairs, dark-suited men who seemed stiff and foreign amid the steady stream of traders and wholesalers and prostitutes. Polat always pointed out the telltale Kim Il Sung badges that were pinned to their lapels, and he also picked out the North Korean embassy vehicles by the initial numbers on their diplomatic plates (133). The North Koreans drove black Chinese-made Audis and it was impossible to see anything through the tinted windows. The embassy was even more secretive—no sign of life behind the propaganda photographs. The big front gate was always closed.

One evening in June, I met Polat at the Uighur restaurant to change a couple hundred dollars. He ordered three beers, which meant that he planned to be there for a while. In the evenings, he often arranged his business appointments at the restaurant, where currency dealers could pull their cars right up onto the sidewalk. As long as Polat carried less than forty thousand dollars, he felt comfortable making deals in the cars, but for bigger business he used a friend's

office in the neighborhood. The most money he ever changed at a single sitting was two hundred thousand dollars.

The Uighur restaurant boss opened the manhole and took out the beers. I waited until we had started the second one before I put the money on the table. Polat told me that the morning Yabaolu rate had been 8.86 yuan to the dollar, but by afternoon it had dropped to 8.84. He offered 8.85, out of courtesy. At the banks you couldn't do better than 8.26, which was the official government rate. Chinese currency was nonconvertible and pegged to the dollar; the rate never changed significantly, except on the black market. A week earlier, the Yabaolu dealers had paid nine to the dollar.

"It dropped this week because one of the big Beijing bosses couldn't get a shipment of cash over to Hong Kong," Polat explained. "Those dollars are still in Shenzhen and the rate won't go up again until they cross."

The black market operated under a byzantine system of rumors and reports. It never made much sense to me, but to Polat it was completely rational; he often embarked on long explanations of how some corrupt border had been tightened in a place like Kazakhstan, sending a decimal-point ripple back to Beijing. I liked hearing the stories, especially after a day's clipping at the *Wall Street Journal*. Matt Forney, one of the *Journal* reporters, covered Qualcomm, an American telecom company that was trying to establish a new cell phone system in China. Sometimes the Qualcomm stock swung three or four points in a single day, entirely on the basis of Matt's stories. The reports always hinged on some subtle signal—a leak from a company contact, or an indirect statement by the government. The signs were inconsistent and the Qualcomm stock jumped around like crazy all year. If the freelancing didn't work out, I figured that I could do some kind of derivative trading that combined the inside information of a clipper with the Yabaolu money-changing rumor network.

We finished the second beer quickly. A white man and an Asian woman took a table on the far side of the platform. She didn't look Chinese and I asked Polat about her.

"She's actually North Korean," he said. "Her parents became orphans during the Korean War." He was careful to use that name for the war, instead of the standard Chinese phrase *Kangmei Yuanchao Zhanzheng*, "the War of Resistance Against America and Support for Korea."

"After the war, Stalin accepted a number of those orphans," Polat explained. "He moved a lot of them to Uzbekistan, where they were adopted. That's what happened to her parents; they grew up there and met as adults. That woman was born in Uzbekistan and now she comes to Beijing for trading."

I asked if she spoke Korean.

"All of them forgot their language," Polat said. "They're the same as Uzbeks now."

We ordered two more beers. A black Audi cruised in slowly from the east and pulled up onto the curb. Polat excused himself, picked up his leather money bag, and got into the car. The windows were dark and they kept the engine running. When he sat back down at the table, I could feel the coolness of the air-conditioning coming off his clothes.

"That was one of the biggest money changers in Yabaolu," he said. "His friend is a pilot for Air China and sometimes he helps him get the American dollars out of the country."

Twilight came, and we ordered noodles and barbecued lamb. The Korean-Uzbek woman and her companion finished eating, paid the bill, and left together. I wondered whether she was lucky that her parents had been transplanted to Uzbekistan. Probably it had worked out in her favor, but there were so many things in Yabaolu that you couldn't tell for certain.

Later that summer, I decided to make a research trip to a Chinese city called Dandong, which was just across the Yalu River from North Korea. I figured that I could find something to write about on the border of such an isolated country. When I mentioned it to Polat, he laughed and said that North Korea was the kind of place that made China look good.

ON MY THIRD day in Dandong, I woke up at two o'clock in the morning with a thief in my hotel room. It was a mid-range hotel, ten dollars a night, and Dandong was a mid-range Chinese city, the sort of place that wouldn't draw much attention if it weren't across the river from North Korea. But having the Hermit Kingdom next door changed everything. Dandong promoted itself as "China's Biggest Border City," and the riverfront was lined with telescopes that could be rented by tourists, most of whom were Chinese hoping to catch their first glimpse of a foreign nation. Signs beside the scopes promised: LEAVE THE COUNTRY FOR JUST ONE YUAN! For ten, you could catch a ride on a speedboat and get a closer look at the North Koreans, who, during the heat of the afternoon, swam in the shallows off their riverbank. On auspicious marriage days, it was a Dandong tradition for Chinese newlyweds to rent a boat, put life preservers over their wedding clothes, and buzz the North Korean shore.

There was a lot to think about in Dandong, which was probably why I had forgotten to close my window that night. Because my room was on the second floor, I'd thought I was safe from intruders, but I hadn't noticed the foot-wide

ledge that ran just below the window. I also hadn't bothered to put my money belt and passport under the pillow, which I usually did while traveling. I had left them on a dresser, along with my camera, wallet, reporter's notebook, and a pair of shorts. The thief was scooping everything up when I awoke. For an instant, neither of us moved.

When you live between two languages, there are moments when the boundaries disappear. Sometimes in China, a telephone call would wake me in the middle of the night, and it would take me a moment to understand the voice on the other end—an old friend from the States. Occasionally, I'd be conversing in Chinese, and suddenly an English word would spring to mind for no apparent reason. It wasn't unusual to have dreams that mixed the tongues. The strangest ones involved people I remembered from Missouri, speaking Chinese. After I awoke from those dreams, I'd lie in bed wondering how the subconscious sifted down through deep layers of language and memory. I figured that if I ever had a sudden crisis, I might learn what was at the very bottom.

In Dandong, I sat bolt upright in bed and screamed, "Motherfucker!" The thief turned and ran for the door, my possessions in his arms. I was out of bed before I'd finished shouting the word a second time. By the third "Motherfucker!" I was sprinting full-speed down the hallway. There weren't any lights; the shadowy hotel room doors flashed past. My voice boomed as it echoed off the walls: "Motherfucker!" The thief was running hard, but I gained ground with every stride; we rounded a corner, skidding across the cheap tile floor. I was barefoot, wearing nothing but a pair of boxer shorts. At the end of the hallway, there was an exit and a stairwell, and that was where I caught him.

I slugged the man as hard as I could. He didn't fight back; his hands were full of my belongings. Every time I punched him ("Motherfucker!"), he dropped something. I slugged him and my camera popped out ("Motherfucker!"); I hit him again and there was my money belt ("Motherfucker!"); another punch and my shorts flew up in the air ("Motherfucker!"). Wallet, notebook, passport—I left it all lying on the floor. The rage completely possessed me, and I kept punching him even after he had dropped everything. By now, he only wanted to escape, and he ran back down the hall, desperately trying doorknobs: locked, locked, locked. I followed: screaming, grabbing, punching. At last, he found an unlocked door that led to an open window, two stories up, and that was where he jumped.

I almost followed him out. I ran all the way to the window, my momentum carrying my torso out through the open space, and then suddenly it was if I had woken up. I looked down and saw that the thief had been lucky—there

was a broad overhang below this part of the second story. I stopped shouting; suddenly the night was quiet. I heard the man's footsteps as he rounded the corner of the building. He was still running hard.

AFTER THE RAGE was gone, the pain materialized. During the struggle, I had dislocated the third finger of my left hand—it must have been pulled out of the socket when I grabbed the man. The hotel's night manager accompanied me to the local hospital, where we woke up the graveyard-shift doctor. He yawned, popped the finger back in place, and took an X-ray. The joint still looked crooked, so the doctor yanked the finger out of the socket again and tried once more. This time, the X-ray machine failed to work; I'd have to return later in the morning, when a technician would be on duty. We went to the police station to report the crime. Dazed, I answered questions and filled out forms; my ability to hold a conversation in Chinese was rapidly deteriorating. Finally, at five o'clock, I returned to bed. I didn't sleep well.

A couple of hours later, the hotel owner arrived in order to escort me personally back to the hospital. He was a handsome man who gelled his hair so that it swept blue-black across his forehead. He wore a new white button-down shirt and well-pressed slacks. He apologized profusely about the robbery, and introduced himself.

"My name is 李鹏," he said.

I couldn't believe it: "Li What?"

"Li Peng."

"The same name as the former Premier?"

"Yes," he said. The man smiled in a tired way, and I could see that I wasn't the first person to have made this observation. In the summer of 1989, Li Peng had announced the official decree of martial law, and many average Chinese associated him with the crackdown. Afterward, a Hong Kong newspaper reported that angry citizens were telephoning and harassing twenty Beijing residents who also happened to be named Li Peng. At least one of them had applied for a legal change of name. Ten years later, Li Peng jokes had become popular among Chinese intellectuals.

"Do you like Li Peng?" I asked the hotel owner.

"No," he said, using English for emphasis. It was clear that he preferred talking about other subjects. He asked me about the robbery.

I had already told the police everything that I could recall about the thief: he had black hair, and he was somewhere between the ages of twenty and forty. He was smaller than me. I wouldn't recognize him if I saw him again.

This vagueness had bothered the cops: how could you break your finger on another human being and remember nothing about him? It bothered me as well. I could recall details of the chase with remarkable clarity—for some reason, I had a particularly vivid image of a darkened hallway with doors flashing past. In my mind, I could also see the stairwell, and my camera bouncing up in the air, and the open window. I could still hear the echoes of the word I had shouted. Mostly, I recalled the overwhelming rage, whose memory left me unsettled. And yet the thief himself was a blur in my mind. Li Peng wrinkled his brow.

"Was it a child?" he asked.

"No," I said. "It wasn't a child."

"But how did you catch him so easily?"

"I don't know."

"Do you have thieves in your America?"

I told Li Peng that there were thieves in America, but they carried guns and you didn't run after them.

"Most thieves here in China have knives," he said thoughtfully. "What kind of thief doesn't carry a knife? That's why I think he was a child."

"He wasn't a child. I know that for certain."

"But why didn't he fight back? Why did you catch him so easily?" Li Peng sounded almost disappointed.

"I don't know," I said.

The police had followed a similar line of questioning, and it was beginning to annoy me. As we replayed the event, it passed through layers of insecurity: first and foremost, people were ashamed that a foreigner had been robbed in their city. But after that unfortunate fact had to be admitted, it seemed even more shameful that the foreigner had caught the thief. Only a criminal of unusual ineptitude would be beaten by a foreigner at two in the morning, and so there must have been something seriously wrong with him. The police had offered various excuses. He must have been a drunk, or a cripple, or a migrant who was desperately poor. Dandong, the police emphasized, was a modern, orderly city, with a growing tourist industry. It wasn't the sort of place where a foreigner woke up in the middle of the night with a common thief in his room.

Nobody seemed to take seriously another possibility: that the man was a North Korean refugee. The police had assured me that there were few refugees along this part of the border, because Sinuiju, the North Korean city across the river, wasn't as poor as the rest of the country. People in Sinuiju ate twice a

day, according to Dandong residents who had relatives there. But farther east, where the combination of famine and mindless economic policies had been particularly brutal, an estimated seventy thousand North Koreans were fleeing to China every year. It seemed likely that at least a handful of them had made their way to Dandong. This possibility bothered me: If the locals wanted the thief to be disabled, I preferred him to be perfectly fit. I wanted him to be experienced, savvy, and fleet of foot—a worthy adversary. I wanted him to be Chinese, not North Korean. It disturbed me to think that I had viciously punched a man who might have been starving.

Both Li Peng and I were silent for a while, and then he thought of another possibility.

"Probably he was a heroin addict. That would explain why he was so weak."

"Are there a lot of heroin addicts around here?" I asked.

"Oh, no," Li Peng said quickly. "I don't think there are any in Dandong."

THE MAIN ATTRACTION in town was the Yalu River Broken Bridge, which had once connected Dandong and Sinuiju. In November of 1950, the first year of the Korean War, as General MacArthur's troops made their push toward China's border, American bombers destroyed most of the bridge. In 1993, after restoring their half of the structure, the Chinese opened it to tourism. Visitors could walk along the bridge, look at the bombed-out wreckage that ended in the middle of the river, and pay one yuan to stare through a telescope at the far side. The North Koreans hadn't restored their part of the structure. A line of empty pediments punctuated the clear-flowing Yalu and ended at the far bank.

One morning, I stood on the Chinese bridge and asked the telescope man what the North Koreans were doing.

"They're swimming," he said.

I paid and looked through the eyepiece. On the far bank stood a pretty North Korean girl in an old-fashioned bathing suit, skirted and striped in red and white. She shivered as she stepped into the river. Behind her, a group of children gathered around an adult—a teacher, perhaps. I picked out one mischievous boy and followed him with the scope. He bumped another boy, skipped around the group, and tossed sand at a girl. The teacher scolded him. Nearby, a soldier stood with a rifle slung over his back. All of the figures were framed by the scope's round lens, and for a minute I was lost in this compact world. Then the telescope man asked me what my nationality was. I stepped back from the eyepiece and answered him.

"If America and China had a war today, who do you think would win?" he said.

"I don't think America and China will have a war today."

"But if they did," he said, "who do you think would win?"

"I really don't know," I said. It seemed like a good time to ask him how business was going. He said that it was fine; next to the telescope, he had a photography stand where tourists could dress up and have their pictures taken with the wrecked bridge in the background. They could wear either a traditional Korean folk costume or a full Chinese military uniform, complete with helmet and plastic rifle.

Another vendor on the bridge ran a café where tourists could buy *Titanic* ice cream bars, with pictures of Leonardo DiCaprio and Kate Winslet on the wrappers. The café manager explained that although the bridge was state-owned, private entrepreneurs were allowed to rent space for their telescopes and snack stands. Next to the bridge, I stopped to talk with another tourist photographer. "Do you think that China will be able to join the World Trade Organization?" he asked. "Back in April, when Zhu Rongji went to America, all of the newspapers said that it would happen. But after the Yugoslavia bombing, it doesn't look so good."

We chatted for a while, and the photographer kept bringing up the WTO. I asked him why he was so interested. "The newspapers say that if we join the WTO, we'll have more foreign visitors coming to China," he explained. "And of course if China's economy improves, then there will be more Chinese tourists coming here, too. So it has an effect on me."

I had always liked traveling to small cities like Dandong, which had few foreign visitors. Locals were eager to talk—from their perspective, there was something momentous about a simple conversation with an American. And often these discussions reminded me of China's complex relationship with the outside world. It wasn't unusual for people to speak about war or conflict with a sense of inevitability, and they fully believed that the United States and other countries deliberately bullied China. But at the same time, people were incredibly friendly to foreigners, and they spoke enthusiastically of international trade links.

Initially, these contradictions had mystified me—I thought that eventually I would figure out what the people really believed. But over time I realized that conflicting ideas could exist simultaneously, even in the mind of a single person. The news of a distant bombing might trigger one response, while a conversation with a Chinese-speaking foreigner sparked something else. The sheer complexity of the modern landscape had a lot to do with it. If you visited

a bridge that had been bombed out by Americans, restored by Chinese, and then rented out to small-scale entrepreneurs who sold *Titanic* ice cream bars, it wasn't surprising that people reacted to the outside world in illogical ways.

The Yalu River Broken Bridge stood at one end of the Dandong Border Cooperative Economic Zone. Locals proudly called this the Development Zone, and the area illustrated how far Dandong had come during the past ten years, after Reform and Opening finally started to take hold in this part of the country. People told me that a decade ago the Development Zone had been nothing but peasant shacks and makeshift docks. Now there were restaurants, ice-cream parlors, karaoke halls, and a luxury apartment complex called the European Flower Garden. The eastern end of the Development Zone featured the Gateway to the Country Hunting Park and a new bridge that carried a thin stream of train and automobile traffic across the water to North Korea. Between the bridge and the luxury apartments, there was a twenty-four-hour venereal disease clinic and the Finland Bathing and Pleasure Center, a massage parlor whose marquee featured a photograph of a topless foreign woman taking a shower.

At the Gateway to the Country Hunting Park, tourists pursued "wild" quail, pigeon, pheasant, and rabbit. The birds were tethered to the ground, and for one yuan, tourists could shoot at them with either a .22-caliber rifle or a bow and arrow. For three yuan, they could take a potshot at a rabbit that was also tied to the ground. They were allowed to eat anything they killed.

One afternoon, I watched two visitors from Guangdong province hunt quail. The young couple were in their early twenties, nicely dressed, and the man was very drunk. He missed so badly that the quail didn't even strain at their tethers. They just sat there in the sunshine. They were the most bored-looking quail I'd ever seen.

"I'm too drunk," the man said. "I want you to shoot instead." He had originally grown up in this part of the country and now he had brought his girlfriend back for a visit.

"I don't want to shoot the gun," she said. "It's too loud."

"Here," he said. "You shoot it. I'm too drunk. I can't shoot straight."

"I don't want to."

"Go ahead. It's easy."

The man showed her how she could rest the gun on the fence so that it would be simpler to aim. Usually, customers weren't allowed to do that, because it wasn't sporting, but the park keepers were willing to make an exception for the woman. I sat nearby, listening to the conversation and trying to remember which Hemingway story it recalled. In the best stories there were always guns,

animals, women, and drunk people bickering. The only difference was that in Hemingway stories the animals were never tied to the ground.

Finally, the man persuaded his girlfriend to pick up the .22 and the keeper helped her prop the gun on the fence. She shot three bullets, and every time, after the gun sounded, she squealed and covered her ears. She missed badly. The quail appeared to have fallen asleep.

Later, after it got dark, the Development Zone was a riot of lights—neon and fluorescent blazing from the restaurants and karaoke bars and the Finland Bathing and Pleasure Center. Across the Yalu, there was complete darkness on the North Korean shore. There was no sign of electricity there and the North Koreans didn't go swimming at night.

IN DANDONG, I spent much of my time around the river. I got to know a couple of the local speedboat pilots, and several times a day they'd drive me along the banks of North Korea. We'd cruise by run-down tourist boats that were empty, and we'd pass factories that looked abandoned. On the sandy stretches, where the North Koreans swam, children smiled and waved when we passed. Armed soldiers stood stiffly at their posts, watching over the bathers. They were like lifeguards with guns.

Officially, China had good relations with North Korea, but the average people in Dandong were quick to say that their neighbors had bad leadership. When I pressed for more details, the Chinese shrugged. "*Meiyou yisi,*" they said. "It's not interesting." Even the photo vendor who was so enthusiastic about the WTO looked bored when I asked him about the possibility of traveling to North Korea. "What am I going to learn from them?" he asked. Nobody in Dandong seemed particularly intrigued by their neighbors' poverty or isolation; the Chinese had already experienced enough of that themselves during the first thirty years of Communism.

To me, North Korea was tragic, and I was fascinated by the fact that this country had been closed for half a century. Cruising past the shore, I picked out details: an empty tour boat, an armed soldier, a swimming child. From my perspective, every glimpse was heavy with significance, the same way that my brief conversations seemed meaningful to the people in Dandong. But the Chinese and I stared across the river for different reasons: I was looking in; they were looking out. Chinese tourists buzzed the North Korean shore simply because it was the closest they could get to international travel.

If they had money, they could cross. My hotel ran tours that started at around two hundred dollars, and passports weren't required; a Chinese identity card was adequate. It was easier for a Chinese citizen to visit North Korea

than Hong Kong, which had officially returned to the Motherland two years earlier. The Chinese government had established unusually lax rules in Dandong because it was pretty sure that anybody who crossed the Yalu River would want to come back.

Every morning, tour groups of middle- and upper-class Chinese met in front of my hotel before leaving for North Korea, and one day I watched a guide give a briefing. It reminded me of some of the things I had been told by the Peace Corps when I had first arrived in China. The guide explained that the Chinese tourists should be careful to show respect when they visited North Korean memorials, and they should avoid taking photographs of people laboring. The North Koreans are proud people, and the Chinese need to remember this. Also, when visiting the Demilitarized Zone, it was important that the Chinese not shout "Hello!" at any American soldiers on the other side.

"You'll notice that it's not as developed as China," the guide said. "You shouldn't tell the North Koreans that they need to Reform and Open, or that they should study the example of our China. And remember that many of their tour guides speak very good Chinese, so be careful what you say."

THE KOREAN WAR was the only conflict in which the People's Republic of China and the United States had fought directly against each other. The war began in June of 1950, when North Korea invaded the south. Along with other members of the United Nations, the U.S. quickly came to the assistance of South Korea, and General MacArthur's troops gained ground all the way to the Chinese border. In October of that year, Mao Zedong started sending "volunteer" soldiers to help their neighbors in the North. The war lasted three years, and claimed more than 54,000 American lives. Foreign historians estimated that Chinese casualties—injured and dead—were as high as nine hundred thousand. But it was impossible to know for certain, because Chinese accounts of the war were so unreliable. Dandong's local museum claimed that only eleven thousand Chinese died.

While hanging out on the Yalu River docks, I told one of the boat pilots that I was interested in meeting a veteran of the war. The pilot knew a man who had served—the father of a friend—and he arranged for the three of us to have a meal together. When we met on the sidewalk in front of the restaurant, the old man's eyes widened. "I thought you said he was an ethnic Chinese from America!" he said loudly, and then he spun on his heel. The pilot ran after him, trying to soothe the old man; after a long conversation, they returned. I explained that I was only interested in history, and I promised not to pub-

lish the veteran's name. Finally he agreed to join us in a private room at the restaurant.

The man had served in the Chinese navy, and he hadn't seen much direct action during the war, when his unit had been sent to the Taiwan Strait. Later, in 1964, his leg had been badly injured in a battle off the coast of Taiwan. He was sixty-four years old, and he had been a member of the Communist Party for four decades. He walked with a limp. The enemy who wounded him had been Taiwanese, but the weapon was American-made. The veteran made sure that I understood this detail clearly.

We ordered dinner and local beer, and soon the old man began to relax. He asked about my bandaged finger, and then he shook his head. "Nowadays too many things are uncertain," he said. "For example, some of the retired people don't get their pensions. And another difference is that China has some capitalist aspects. Some people are too rich while others are too poor. It's not like it was in Chairman Mao's time, when everybody was equal. There wasn't crime back then. This story about you getting robbed in your hotel—that wouldn't have happened in the past."

I asked him what the situation was like across the river.

"When Kim Il Sung was alive, he was like Mao Zedong," he said. "Everybody worshipped him because he was a great man. But Kim Il Sung's son isn't as great as his father. He's too young, but the main reason is that he hasn't been hardened by war; he hasn't experienced struggle. Kim Il Sung experienced war as a small boy; that's why he became a great man."

After an hour, the direction of the interview had shifted entirely. The old man shot questions across the table: What are salaries in America? What do Americans think of China? What do they think about the NATO bombing?

The veteran explained that his son, who had a college degree, had turned down a perfectly good government job. The young man had been offered more money in a private firm, but the position didn't provide complete security. And at twenty-six he was still unmarried! Why did he think this way? Did he learn it from the American teachers in his college? Do Americans believe that it's better to take a high-paying job over long-term security?

I explained that, in some ways, his son's thoughts were similar to those of young people in America. The old man kept returning to the same themes—a government job was perfectly good; China needed another Chairman Mao. He was drinking heavily now; he started to slur his words and then he got fussy. He complained about his son and he complained about the service in the restaurant. He said that a foreigner should be able to come to Dandong without

getting robbed. The boat pilot gently suggested that we leave, and the old man suddenly became angry.

"It's not every day I get to speak with a foreigner," he said sharply. "I'm not tired. I just need to go to the bathroom." He stood up and stumbled over his chair; the pilot caught the old man before he fell. A waitress entered the room, and the veteran shouted, "Bring the bill!"

I had already given money to the waitress, who explained that everything had been taken care of. "I've got plenty of money!" the old man shouted. "I can pay for dinner!" The pilot tried to guide him to the door. "I can pay!" the old man yelled again, waving a wad of cash.

At last, we steered him outside, where the night air sobered him a little. I thanked him for coming; the old man shook my hand and limped off toward home. He refused to be escorted.

The pilot watched him leave, and then he sighed. He was thirty-three years old. He said, "Many old people don't understand the way things are in China nowadays."

ON MY LAST afternoon in Dandong, the river was full of Chinese wedding boats. Wealthy couples hired big two-tier cruisers; others rented little motor launches. All of them followed the same route—a scoot out to the ruined bridge, a pause for photographs, and then a slow cruise along the banks of North Korea. Beneath their life preservers, the brides wore dresses of bright pink and orange and purple; they stood in the prows like flowering figure-heads. It was a hot afternoon and the North Koreans were swimming again.

A pilot named Ni Shichao took me out on the river, where we zipped in and out of the flotilla of wedding boats. Ni explained that it was an auspicious day on the lunar calendar—the sixth day of the sixth month. But on the whole, he said, there had been fewer weddings than usual this year.

"People think that years ending in nine are bad luck," he explained. "I don't believe it myself, but many people do. In eighty-nine, there was the disturbance in Beijing, and in seventy-nine there was the trial of the Gang of Four. Sixty-nine was the Cultural Revolution. Fifty-nine was when your America bombed the bridge."

He paused and thought for a moment. "No, that was in 1950," he said. "Anyway, something bad happened in fifty-nine."

That had been during the heart of Mao Zedong's Great Leap Forward, but history books brushed over this disaster. Like many Chinese, Ni Shichao had a shaky grasp of modern events; he had also made a mistake about the Gang of Four trial, which actually started in 1980.

"What about 1949?" I asked.

"That was when New China was founded," he said. We floated in the shadow of the ruined bridge; the slow-moving Yalu ran blue beneath us. "That year wasn't the same as the others," he continued. "That was a good year, of course."

FROM DANDONG, I followed the border east toward the Sea of Japan. These areas were lightly populated; the buses passed through forests of birch. I had packed a tent and a sleeping bag, and I camped at Changbaishan. It was an enormous volcanic crater, filled with clear blue water; the Chinese–North Korean border cut the lake in half like a ruined jewel. At night the wind blew hard from the south and I kept imagining footsteps outside the tent.

Locals had told me that the border was unguarded, and in the morning I followed a grassy ridge that skirted the lake. After hiking for half an hour, I saw a tiny white marker in the center of a green field, far below. Before descending, I carefully surveyed the land: no buildings, no people. The nearest city was dozens of miles away, over rugged terrain. It was the emptiest place I had seen in China for a long time.

The block of stone had Chinese characters on one side and Korean letters on the other. I was accustomed to linear borders—rivers, fences—and it was strange to see this single stone surrounded by emptiness. The boundary was just an idea, and the wilderness rendered it meaningless.

I dropped my pack and took a few steps into North Korea, where I balanced my camera on a rock and set the timer. In the photograph, the sky is a deep blue and white clouds hang low on the horizon. I am kneeling and my shadow falls across the stone marker. There is a dirty white bandage on my left hand. The mountains could be the mountains of any country.

The Wall
人民解放军

THE UNDERGROUND CITY CANNOT BE SEPARATED FROM THE OTHER layers that have accumulated in this part of Anyang. One might imagine the ancient Shang site as a whole, lying beneath the earth—the city wall, the interior structures. It's possible that oracle bones are buried here, having waited three thousand years to tell their stories. But above ground, there is an entirely separate patchwork of modern buildings, organizations, and land-use rights. If archaeologists hope to dig, they have to negotiate with whoever occupies the surface of the earth.

Fortunately, much of this region is farmland—soybean, corn, hemp—and it's generally easier for archaeologists to negotiate with local peasants. But during the modern period, various authorities have also left their mark in this part of Anyang. In the late-1930s, during the Japanese occupation, the invaders built an airfield, and cement runways still cut across the fields. Later, after the Communists gained control of China, the People's Liberation Army constructed a military compound next to the airfield. Even later, after Reform and Opening began, the old runways were converted into a site for private flight training. Ironically, many of today's clients are Japanese, who train in Anyang because it's much cheaper than in Japan. But what's cheap for a Japanese pilot is not necessarily cheap for a Chinese archaeologist. Local surveys have avoided extensive work on the airfield, because the flight school charges high rates for permission to dig cores with Luoyang spades.

Here in Anyang, and anywhere in China, the present controls access to the past. When the archaeologists first surveyed the wall of the underground city, it led them straight to the modern barrier of the PLA compound. Two walls: one ancient, one modern; one below ground and the other above. At that point, the modern barrier took precedence. The surveying stopped while the archaeologists submitted applications, paperwork, maps. It took almost a month before the military granted them admittance. After the archaeologists were finally allowed inside, they patiently continued digging cores with their Luoyang spades. The buried Shang wall cut diagonally across the military compound, running straight as an arrow. The archaeologists followed it to another modern barrier, where, without the slightest change in direction, the ancient wall exited the jurisdiction of the People's Liberation Army.

THE UNDERGROUND CITY wall is rectangular, and it encloses an area of nearly two square miles. Jing Zhichun and the other archaeologists have carefully surveyed the structure, and they have discovered that it is incomplete; many sections of the wall were only partly built up. The ancient settlement seems to have been abandoned; perhaps the residents moved to another location.

"Eventually, this kind of information will give us clues as to why the city was here and why it was an uncompleted one," Jing says. "We made six profiles of the walls, and we haven't found any of them that had been built up. They just finished the base. It's very strange. That's why I think it was probably an unfinished city."

4

The Overnight City

October 1, 1999

SHENZHEN WAS ALIVE. PEOPLE CALLED IT THE "OVERNIGHT CITY" because growth had been so fast; sometimes they compared its rising buildings to bamboo shoots after a good rain. Intellectuals in cities such as Beijing sneered at Shenzhen for all the usual reasons—no history, no culture, no class—but the city meant something entirely different to migrants from the interior. To them, it had a living character: strengths and flaws, cruelties and successes. In a nation of boomtowns, Shenzhen was the most famous of them all.

I'd heard dozens of Shenzhen tales before I went there. In Fuling, my students liked to write about the city; sometimes they used it as a fictional setting, or they described the experiences of Sichuanese migrants who had headed south. In my writing class, I taught a unit on dialogue, and I asked the students to transcribe a recent conversation. A woman named Emily remembered the day when her older sister made the biggest decision of her life:

> "I've decided to go to Shenzhen," said my sister.
>
> "Mother won't let you go."
>
> "I'll try to persuade her," she said.
>
> "I'll back you up," I said, "but have you taken all things into consideration?"
>
> "I'm fully aware of the situation. It means I'll never get a permanent stable work; I might be fired, or even worse, but to me, an energetic youth, what it matters?"

After a pause of silence, I said,

"All right, I agree with you. It must be a wonderful life to work in that changing city."

"Wish you good luck," I added.

"Thank you. Good night."

"Good night."

Now my sister has been in that prosperous city for five months. I wonder if she still remembers that conversation, and if she is still full of energy.

Emily was one of the first students I noticed, back when the class was still a blur of eager faces. I taught her section during my first semester in China (it wasn't until the following year that I taught Willy's class). In the early days, I had trouble coming up with assignments; often I'd jot a random question on the board and ask the students to write about it for ten minutes. One day, I asked: "Would you rather have a long life with the normal ups and downs, or an extremely happy life that ends after only another twenty years?"

Nearly everybody took the first option. That didn't turn out to be much of a dilemma in rural China; several students pointed out that their families were so poor that they couldn't afford to die in two decades, regardless of how joyful they were. I probably learned the most from the activity: after that, I was more careful about adapting American ideas about the pursuit of happiness to a Sichuanese classroom. But I noticed that Emily chose the short life. At nineteen, she was the youngest student in the class. She wrote:

> *It seems to me that I haven't been really happy for quite a long time. Sometimes I owe my being dispirited to the surroundings, especially the oppressive atmosphere in our college. But I find the other students can enjoy themselves while I am complaining, so I think the problem is in myself.*

Everything she wrote that year marked her as different. She contradicted her classmates; she skirted the Party line; she held her own opinions. She was one of the few students whose parents were well educated; her father was a math professor at the college. She wrote about his experiences during the Cultural Revolution, when he had been exiled to work in a rural coal mine. During our unit on "business writing," when I asked my students to compose a formal letter to an American organization, Emily chose the Country Music Association, in Nashville, Tennessee. She told me that she was curious to learn what country music was like. Another time, in a journal entry, she asked if I had any black friends, because she had never seen a black person, except on television.

When my literature class performed *A Midsummer Night's Dream*, she played Titania. She was a good actress, although she had a tendency to perform every role with a touch of a smile, as if she were watching herself from afar. She had high cheekbones, full lips, and dark, fast-moving eyes in a wide-open face. She had named herself after Emily Brontë.

She left home immediately after graduation. She went south with her boyfriend, Anry—one of the more mysterious "English" names in the department. He was among the best athletes in the class, a handsome young man from the countryside. He had a square face, bristly hair, and hard black eyes. His temper was quick—it seemed more than coincidence that his name was only one letter away from "Angry." Years later, Emily told me that he had often been critical of her.

"He used to tell me that I shouldn't smile when I talk with other men," she remembered. "I should keep my face completely expressionless. He always criticized me for that; he said I smiled too much. And he said that I had a way of blinking my eyes when I talked to a man, and it wasn't appropriate. I used to stand in front of a mirror and look at myself, trying to figure out how to act right. At that time, I believed anything he said. Later I realized that he was wrong about everything."

They had left home for different reasons. Anry's family needed money: a year earlier, his older brother had been fishing with explosives and got caught with a short fuse. After the accident, he was nearly blind and couldn't use his hands. He had a wife and child to support. Fishing with explosives was illegal but peasants still did it in the remote countryside.

For Emily, whose father had a stable position at the college, money wasn't so critical. In fact, she was never able to tell me exactly why she had left Fuling. "There was something in the heart," she said once. "My mother says that I won't be satisfied with a happy life. She says I'm determined to *chiku*, eat bitter." In any event, she couldn't imagine being content with life as a local schoolteacher in Fuling. "Teaching is a good job for a woman, and it's easy to find a husband, because men like to have teachers as their wives. It could have been a very comfortable life. But if it's too comfortable, I think it's like death."

Emily and Anry first went to Kunming, the capital of Yunnan province, where they found separate apartments and looked for jobs. The new economy had given rise to "talent markets," or employment centers, and Emily and Anry visited them all across Kunming. Neither of them had much luck. Emily had been one of the best English students in her class, but nobody at the talent markets asked her a single question about her degree. Many listings re-

quired female applicants to be at least 1.6 meters (five feet two inches) tall and *wuguan duanzheng*—literally, "the five senses are regular." The five senses are the ears, eyes, lips, nose, and tongue; essentially, the phrase means "beautiful." Emily knew that by classical standards of beauty, her eyes were a little small and her lips a bit big. She stood only 1.53 meters tall. After a few months in Kunming, she had found nothing better than a low-paying secretarial position, and she decided to try another city.

Shenzhen was the natural choice. Any young person from Sichuan had grown up hearing about the Overnight City, whose tales often had the ring of legend: the migrant who became a millionaire, the young secretary who rose to the top of a trading company. When Emily was a child, she often heard neighbors talk about a local girl who had moved to Shenzhen and become a great success, frequently sending money back to her parents. Emily's mother praised the woman as a model of independence; those stories had helped inspire Emily's sister to go south.

But Anry was determined to go to Shanghai, where he had connections. The couple argued about it bitterly and finally split up: he went east, she went south. In Shenzhen, Emily's sister had recently left a job, and the two of them spent half a month at the talent markets, where factory recruiters set up stands and interviewed workers. A ticket to the market cost ten yuan a day—a little more than a dollar. Between them, the sisters had only two hundred dollars to live on, and after a week they started buying one daily ticket. They combined other resources as well: Emily had better qualifications, but her sister was a better talker, so she usually entered the markets armed with Emily's résumé. Finally, she lined up a second interview for Emily at a Taiwanese trade company. The boss seemed impressed by Emily's English, and she got the job in November of 1997. Her starting monthly salary was 870 yuan—just over one hundred dollars. That fall, she sent me a letter:

> During the first two days, only one girl in our office showed her hospitality; others acted as if they didn't notice my exist. I felt very lonely. I thought of you—you must have felt very lonely in your early stay in Fuling. I encouraged myself to try to show my anxiety to make friends with them. My efforts ended in success; I was took as one of them soon.
>
> In our office there are only eight people. Except the boss (an old man), others are all young girls. They are from three different provinces. Lulu, Luyun, Xuli, Lily are from Jiangxi Province; Yi Xiaoying from Hunan, Linna from Sichuan. Lulu is the most beautiful, able and shortest girl, who is liked by everyone. Luyun is very kind, who reminds me of Airane [a

Fuling classmate]. Xuli is a classical beauty, most private telephones from boys are for her. But I don't like her very much, for her word sometimes hurtful. Lily is the other secretary, who came two days earlier than me. She leaves us an impression of stupid and irresponsible. So she is not very popular in the office. Xiaoying is the fatest girl concerning much about losing weight. She is very good at computer but poor in English. We have an oral contract that she teaches me how to use computer and I teach her English. Linna is the one I can speak Sichuan dialect with. But Sichuan dialect is so understandable by everyone that we don't have a sense of superiority when speaking it.

Oh! Till now, you still don't know what our company does. Our company was just moved from Taiwan several months before. It acts in the field of exporting fashion, costume and shell jewelry. My job is keeping touch with our customers by letters or faxes, receiving purchase orders, giving order to factories and finding the best company to ship products to our customers. Since I'm not familiar with my work, Lulu helps me a lot these days.

EMILY'S STORIES DRIFTED up from the south. She wrote letters, and sometimes at night she telephoned, if the boss had gone home. Often, she talked about her older sister, who was constantly changing jobs. Emily's sister had initially worked as an accountant at a factory that made plastic lawn furniture, and then she found a position as a traveling saleswoman. After that, she was recruited by a company that ran a pyramid scheme. She knew that it was a scam—the government was cracking down on pyramids, which had run rampant across southern China. But Emily's sister went to the recruiting meeting anyway, and she brought Emily with her. "A lot of the salespeople had low cultural levels, but they had learned how to talk," Emily told me later. "I didn't think it was a good way to make money, but it was a good way to improve yourself and improve your confidence."

One evening, during my last year in Fuling, Emily phoned and reported that she had gotten a raise to one thousand yuan. That was more than $120, and I congratulated her. But on the phone she sounded a little reserved, and finally I asked if something was wrong.

"The company has an agent in Hong Kong," she said slowly. "He often comes here to Shenzhen. He is an old man, and he likes me."

"What do you mean by that?"

Silence.

I tried again. "Why does he like you?"

"Because I am fat." She giggled nervously on the phone. I knew that since moving to Shenzhen she had gained a little weight, which probably made her prettier than before.

"What do you mean when you say that he likes you because of that?" I asked.

Silence.

"Does he want you to be his girlfriend?"

"Perhaps."

"Is he married?"

"He is divorced. He has small children in Taiwan, where he is from. But he usually works in Hong Kong."

"How often does he come to Shenzhen?"

"Twice a month."

"Is it a big problem?"

"He always finds a way to be with me. He says he will help me find a job in Hong Kong if I want one. The salaries are much higher there, you know. He says I can make much more money if I go to Hong Kong."

I chose my words carefully. "That sounds like a very bad idea," I said slowly. "If you want another job, you should not ask him for help. That will only cause big problems in the future."

"I know. I think I would never do that."

"You should try to avoid him."

"I do," she said. "And I tell my co-workers to always be with me if he is there."

"Do you think it is a big problem?"

"Not now."

"Well, if it becomes a big problem, you should leave the job. That can be a very bad situation."

"I know," she said. "I don't think that will be necessary. But it is not such a good job, and if I have to leave, I will."

SHENZHEN WAS THE only place in China with a modern city wall. It was about ten feet high, and made of chain link; some sections were topped by barbed wire. The entire structure was sixty-seven miles long. If you approached the city from the north, you entered one of the wall's checkpoints and followed a modern highway through low green hills. The new buildings grew taller as you approached the downtown area. At the intersection of Shennan and Hong-ling roads, there was a massive billboard that represented, at least in the spiri-tual sense, the heart of the city. The billboard featured an enormous image of

Deng Xiaoping against a backdrop of the Shenzhen skyline, with the phrase PERSIST IN FOLLOWING THE COMMUNIST PARTY'S BASIC LINE FOR ONE HUNDRED YEARS WITHOUT CHANGE. Locals and visitors often posed for photographs in front of the sign. In February of 1997, when Deng died, thousands of Shenzhen residents spontaneously gathered at the billboard to make offerings of flowers, written verses, and other memorials. They sang "Spring Story," which was the official Shenzhen song:

> *In the spring of 1979*
> *An old man drew a circle*
> *on the southern coast of China*
> *And city after city rose up like fairy tales*
> *And mountains and mountains of gold*
> *gathered like a miracle . . .*

Other Chinese cities celebrated their history, but Shenzhen's origins had the flavor of myth—the miraculous birth, the benevolent god. From 1949 until the late-1970s, the government had deliberately avoided developing the region, because it neighbored Hong Kong. The Communists feared political and economic contamination from the capitalist British colony, and they designated the Shenzhen region as a "political defense frontier." Few state-owned industries were located there; most residents relied on fishing and farming.

After 1978, when Reform and Opening began, Deng and the other leaders faced the problem of where to start. They didn't want to test radical changes in cities such as Beijing and Shanghai, where mistakes would be politically disastrous. Instead, Deng decided to experiment in distant, less developed areas, in what came to be known as Special Economic Zones. Through tax breaks and investment privileges, the government hoped to encourage foreign firms to set up shop in these zones. In 1980, China officially designated the first Special Economic Zones: Shenzhen and Zhuhai, a city that bordered the Portuguese colony of Macao.

Over the course of the 1980s, the government granted Special Economic Zone status to five cities and regions, but Shenzhen was always the most important. Officials labeled the city a "reform laboratory" and a "testing ground"; it was a "window to the outside world." They viewed the city as an experiment, and like a good petri dish, it had the benefit of being relatively uncontaminated by the past. Whereas other parts of China struggled to privatize inefficient state-owned industries, laying off workers and attempting to restructure factories, Shenzhen's economy was a tabula rasa. The government's development of the city was simple and straightforward: build infrastructure, invite foreign in-

vestment, and attract migrants. In two decades, the city's population exploded from around three hundred thousand to more than four million people. During the same period, Shenzhen's GDP had an annual growth rate of more than 30 percent. In the first five years of the 1980s, Shenzhen was given credit for testing more than two hundred economic reforms, many of which were subsequently adopted by other cities across China.

Everything about Shenzhen felt new. The average resident was less than twenty-nine years old; there were few elderly people. Shenzhen University didn't have a history department; students could major in Golf Management instead (the region had some of the best courses in China). At the Shenzhen Museum, some halfhearted exhibits paid lip service to ancient times and the Opium War, along with a dutiful inscription in Chinese and English: WHEN YOU ARE INTOXICATED WITH THE MAGNIFICENCE OF THE "OVERNIGHT CITY," HAVE YOU EVER THOUGHT OF BRAVE AND DILIGENT ANCESTORS WHO HAVE SHED BLOOD AND OOZED SWEAT FOR THE HOMELAND?

With that out of the way, the Shenzhen Museum undertook a far more enthusiastic documentation of modern history. One exhibit noted that on December 1 of 1987, the city held New China's first public auction for the right to use a piece of land. Nearby, a photograph commemorated the first talent market—another Shenzhen innovation that quickly spread. There were other photographic artifacts: the founding of China's first stock exchange, in 1990; the first transfer of state-owned housing to the private marketplace, in 1988. One museum display proudly marked the historic Shenzhen opening, in 1996, of China's first Wal-Mart.

DESPITE THE SLOGANS, none of this had actually happened overnight, or without opposition. If Deng Xiaoping was the city's god, it was in the Greek sense—a patron who was periodically resisted by other mysterious powers. Deng believed that the Special Economic Zones would help drive China's changing economy, but there was also a political dimension: in particular, he hoped to attract investment from Hong Kong and Taiwan, subtly bringing these regions closer to the mainland. But conservatives feared the opposite: they believed that cities such as Shenzhen allowed foreign companies to exploit cheap Chinese labor. Many of the new economic zones happened to be located in former treaty ports, the cities that had been forcibly opened in the nineteenth century after the Opium War. Opponents of Deng's strategy sometimes attacked it as an echo of foreign imperialism. In the mid-1980s, when a series of smuggling scandals broke out in the zones, the criticism intensified.

One response was to build the Shenzhen fence, which was completed in

1984. It was an age-old Chinese solution, with a new twist: in Shenzhen, one function of the city wall was to keep things in. Officials hoped to restrict the potentially dangerous effects of reform, and the wall provided a reassuring sense of control—a physical demarcation that showed where the experimental city began. In order to enter Shenzhen proper, citizens had to carry a border pass that had been approved by their home province.

After the summer of 1989, when the Beijing crackdown left conservatives with the upper hand, some feared that Shenzhen would lose its special status. But three years later, the benevolent god returned. In 1992, Deng made his famous "Southern Tour," which was intended to show that China's economic reforms would continue. The tour's key moment came in Shenzhen, where the eighty-eight-year-old leader delivered a speech, saying, "The important lesson of Shenzhen is to dare to charge into forbidden zones." And thus the second stanza of "Spring Story":

> *In another spring of 1992*
> *An old man wrote a poem on the*
> > *southern coast of China . . .*
> *Oh, China, China,*
> *You have opened a new scroll that will last for one*
> > *hundred years*
> *You hold up a springtime that is a blaze of color.*

In Shenzhen itself, few average residents seemed to realize that they were part of a massive experiment. But they sensed the uncertainty, and they tended to describe their city's development as the result of a powerful man's patronage rather than as the natural product of free-market economics. During one of my trips to Shenzhen, I met a businessman who told me that the offerings to the billboard after Deng's death had been a way of giving thanks. But he said that there had also been an element of fear and superstition; it was almost like traditional Chinese ancestor worship, in which the departed could still influence daily life. Another time, I chatted with a cab driver who had migrated there from Hunan province. "This place used to be a poor country village, and then Deng Xiaoping came and told them to build it," he said. "That's how things work in China—one person says something should be done, and it happens. That's Communism."

Despite the leaders' attempts to define and delineate their experiment, certain aspects of Shenzhen developed in their own way. The region came to be dominated by labor-intensive light industry, and factory managers preferred female workers, who could be paid less and were easier to manage. Although

there were no reliable local statistics, it was obvious that women in Shenzhen far outnumbered men. Locals often claimed that the ratio was seven women to every man. Shenzhen became famous for prostitution, and also for its "second wives," the mistresses of factory owners who already had families in Hong Kong or Taiwan.

Attempts at border control had unintended consequences. Many factories moved to the other side of the Shenzhen fence, where they took advantage of cheaper land and less rigorous law enforcement. The Shenzhen area became divided into two worlds, which were described by residents as *guannei* and *guanwai*—"within the gates" and "beyond the gates." In centuries past, these phrases had described regions on either side of Shanhaiguan, a famous section of the Great Wall that marked the border with Manchuria. But in Shenzhen the old terms were applied to the new boundary. Satellite towns sprang up beyond the fence, most of them squalid and unplanned. In this sprawl of cheaply constructed factories and worker dormitories, wages were lower. The typical workweek was six days instead of five. Labor accidents and factory fires were more frequent than they were in Shenzhen proper.

It was here, beyond the gates, where Emily found her first job, in a satellite city called Longhua. Shortly after she started work, the company added a production division, becoming a full-fledged factory, complete with workshops and dormitories. The factory produced pewter, brass, and low-grade silver jewelry, as well as cheap plastic beads that were painted and lacquered, packaged in ziplock bags, and exported to Hong Kong, Southeast Asia, and the United States.

EMILY'S STORY ABOUT the businessman from Hong Kong ended quickly. A couple of weeks after our telephone conversation, she called again, and I asked about the man.

"He likes all women he sees," she said with a laugh. "Because of that he is not such a problem."

She told me that her sister had found a new job with a lonely hearts hotline, talking on the telephone with people who felt lost in Shenzhen. She didn't earn as much as Emily, but the work was easy. She received bonuses based on volume, and there were plenty of callers. I asked Emily why so many people telephoned.

"Everyone in Shenzhen has many troubles," she said.

"Why is that?"

"There are many troubles about affections," she said. "Some people say

there is no real love in Shenzhen. People are too busy with earning money to exist."

She sounded a lot older than the student I remembered. After our phone conversations, I often found myself wondering how any young person could find her way in Shenzhen, or in any of the other boomtowns. The anonymity was unsettling: millions of faceless migrants heading south. It seemed inevitable that a young woman like Emily would lose her way.

IN THE SPRING, a man named Zhu Yunfeng came to work at the jewelry factory. He had been trained as a mold maker, and at his previous job he had miscalculated the weight of a metal part. Along with three other workers, he tried to lift the part, but it slipped. Zhu Yunfeng let go. The other workers did not, and they lost some of their fingers. The injured laborers were promised compensation, and Zhu Yunfeng wasn't blamed for the accident, but nevertheless he decided to leave the job. Seeing the maimed workers around the plant made him feel uncomfortable.

Emily didn't take much notice of Zhu Yunfeng when he first arrived in March of that year. He was quiet and there wasn't much about his appearance that initially caught her eye. He was of average height, with thick black hair, and his shoulders were broad from working with the molds. He wasn't handsome. But over time, Emily began to notice him more. She liked the way he walked—there was confidence in his gait.

Two months later, small gifts started appearing in her desk drawer. She received two dolls and a small figurine of a sheep. She didn't ask who had put them there.

In June, Emily and Zhu Yunfeng were out with their co-workers and somehow found themselves walking alone in the local park. She didn't know how they had become separated from the group. Suddenly, she felt afraid; things were happening too fast. She was twenty-two years old. He was twenty-six.

"I don't want to walk with you," she said.

"Who do you want to walk with?" he asked.

"I don't want to walk with anybody!"

They returned to the factory. Months later, Zhu Yunfeng would tell her that that was the moment when he knew there was a chance of success. He could see that she hadn't made up her mind yet.

The factory had fifty employees. The Taiwanese boss told the workers openly that the only reason he had come to mainland China was because of the cheap labor. The workers didn't like their boss very much. Some of them

made as little as one yuan an hour, or twelve cents, which meant that they had to work overtime to earn a decent income. When describing the boss, they often used the same two words that many workers in Shenzhen used to describe Taiwanese owners: stingy and lecherous. But the jewelry factory boss wasn't as bad as many of the others, and conditions at the plant were better than the average "beyond the gates" factory. The workers had Sundays off, and during the week they were allowed to leave after work hours, although everybody had to be back in the dormitory in time for curfew. Curfew was eleven or twelve o'clock at night, depending on the boss's whim.

The dormitory occupied the top two floors of a six-story building. There were four to ten workers to a room. It was a "three-in-one" factory—production, warehousing, and living quarters were combined into one structure. This arrangement was illegal in China, and the workers knew it, just as they knew that some of the production material stored on the ground floor was extremely flammable. What's more, an electrician had made an inspection, during which he told Emily and the other secretaries that the building had faulty wiring. Afterward, Emily mapped out an escape route for herself. If a fire happened to break out at night, she intended to run to the dormitory's sixth-floor balcony and jump across to the roof of the building next door. That was the extent of her plan—it was pointless to complain to anybody about the violations. There were many three-in-one factories beyond the gates, and workers couldn't do anything about it. All of them were far from home.

One Saturday night in October, Zhu Yunfeng took Emily's hand while they were crossing the road. Her heart leaped up in her chest. Zhu Yunfeng held on tightly.

"I'm too nervous," she said, once they had reached the other side of the street. "I don't want it to be like this."

"What's wrong?" he said. "Haven't you ever done this before?"

"I have," she said. "But I'm still scared."

"It's going to be like this in the future," he said. "You should get used to it."

Much later, when Emily told me the story, she couldn't help laughing. And she made a certain gesture that was common to Chinese women, covering her mouth with her hand, as if she shouldn't take too much pleasure in the memory.

EVERY SIX MONTHS, I took the train down to Shenzhen. In China, official journalist visas required a great deal of paperwork—with the support of a sponsoring publication, you had to apply for a bureau license and a journal-

ist card. These were things that I still lacked, and so twice a year I crossed into Hong Kong, where a travel agency sold six-month multi-entry business visas for fifty dollars, no questions asked. That became my migratory routine: whenever summer turned to fall, or winter to spring, it was time for me to head south once more.

I made my first visa run in April of 1999. The train journey was pleasant; I liked watching the dry northern plains give way to the lushness of the south. In Hong Kong, it took less than a day to process the new document, and then I crossed the land border back into Shenzhen. I caught a bus out to the satellite city of Longhua, where Emily's factory was located. She had told me to meet her at the local McDonald's, which was the only Western restaurant in town. When I arrived, she was already out in front, standing next to the statue of Uncle McDonald. She had asked for a day's vacation from the factory.

Two years had passed since we'd last met, but she looked much the same. She wore a simple blue silk dress, and her hair was tied back; she smiled and shook my hand, the way she knew Americans did. We spoke mostly in Chinese—she told me that she felt more comfortable if we talked in her native tongue. Her student shyness had disappeared; she was the guide now, steering me briskly through town to another bus stop, where we caught a ride to the gates of the Special Economic Zone. Uniformed guards at the fence checked our IDs—my passport, her border pass—and then the highway led us into the heart of the city.

A year earlier, when I was still in the Peace Corps, Adam Meier had visited Emily in Shenzhen. He told me that the highlight of his southern tour was the Opium War Museum, which was located on the coast nearby. To reach the museum, one had to hire a ride on a minibike; to hire the minibike, one had to negotiate with an entire pack of drivers. The pack was vicious and to them a foreigner was like a chunk of raw meat dropped bleeding onto the road. Dealing with the minibike drivers took half an hour, and it helped Adam get warmed up for the museum, which consisted of a series of "Living History" displays. One display featured a foreign warship manned by wax foreign devils who were using military force to wrest Hong Kong from China. Somehow, Adam became entangled in Living History, and a number of Chinese tourists were startled to see a flesh-and-blood foreign devil jump out from within the bowels of the warship. Emily had always appreciated her foreign teachers' sense of humor, and she generally liked it when we teased her. Nevertheless, Adam's role in Living History had tested the poor girl's patience.

Riding the bus into Shenzhen, she asked me what I most wanted to see.

"I want to go to the Opium War Museum," I said.

"I'm not going back there," she said.

"Mr. Meier really enjoyed it," I said. "He told me I should go. We can take a minibike."

But Emily was a lot tougher than I had remembered. She quickly narrowed our tourist options to three local theme parks: the Safari Park Shenzhen, which was billed as "interactive"; the China Folk Culture Village, where you could see every single ethnic minority in China dressed in their appropriate traditional costume; or Splendid China, which featured small-scale models of famous sites throughout the country. In the end, I left the decision to her. I had a strong intimation that regardless we were going to see yuppie Chinese entertainment at its worst.

She chose the Safari Park. The "interactive" description turned out to be accurate in the sense that you were allowed to feed the animals. Tourists fed the animals a lot of things—carrots, nuts, celery—and after the snacks were gone, they fed them the paper bags in which they had been packaged. Everywhere in the park, salespeople hawked one-yuan bags of food. They must have been working on commission, because they were almost as aggressive as the Opium War minibike gang. Only one yuan, the salespeople called out. Feed the deer. One yuan. Feed the deer. One yuan. And the deer, like every other animal in the park, staggered around looking glassy-eyed and bloated.

At Monkey Hill, the salespeople turned to threats. If you don't feed the monkeys, one man said, they will attack you. Monkey Hill is a dangerous place without a one-yuan bag of carrots. Feed the monkeys. One yuan. The monkeys must be fed.

Emily was about to buy some carrots, but I stopped her. "Don't you want to see what happens if we *don't* feed them?" I said, and then she cocked her head and grinned. Sure enough, one of the monkeys tried to snatch Emily's purse, and I had to hold tightly onto my baseball cap. The salesman gave us a triumphant look as we left.

By the time we reached the crocodile pond, there was only one duck left. He was crammed into a tiny cage, and he stared straight ahead, as if avoiding eye contact, the way I always do when I go through customs at an airport. The second-to-last duck had just been thrown in and the crocodiles were still tearing at the pieces. It cost twenty-five yuan per bird. I reached for my wallet.

"I don't want to throw the duck to the crocodiles," Emily said.

"You don't have to throw it," I said. "The worker will throw it. And he doesn't throw it to the crocodiles; he just throws it into the water."

"I don't like those animals," she said. "I don't want to feed them. You didn't feed any of the other animals."

"The crocodiles are friendly," I said. "Look, that one is smiling."

In the pond, one of the crocodiles had grabbed some pieces of the second-to-last duck and now he reared out of the water with feathers in his jaws.

"That's just the way their mouths are," Emily said.

Patiently, I tried to reason with her. I explained that it is cruel to keep a duck in a cage, especially in a Safari Park dedicated to Wild Animals. This is simply what Wild Animals do: they enter Dangerous Situations, and some Survive and others Do Not. And even if the duck Does Not it's not as if we are actually, physically, personally killing the duck. We never touch the duck at all; we just hand twenty-five yuan to a man. Three dollars—small price to pay for a duck's freedom.

Emily pointed out that the bird's wings had been clipped. Well, I said, he can still swim to shore and then walk away. Ducks can actually walk very quickly when they put their minds to it. And who knows, maybe they didn't clip his wings right; maybe he'll surprise us and fly away to freedom in a neighboring shoe factory. We won't know until we try.

After a while, my logic became even more desperate. I told her that crocodiles are rare, practically endangered, and they die if they aren't fed. Emily countered by saying that these crocodiles weren't going to starve anytime soon, and although I didn't want to admit it, she was obviously right. The crocodiles looked like they were about to explode. Even the second-to-last duck had been torn apart rather than eaten. Pieces of him floated near the bank.

Finally, I was reduced to the world's weakest moral argument: If we don't throw this duck to the crocodiles, then somebody else will do it. We're no better or worse—all of us are just *laobaixing*, average people. We are human beings, and it is perfectly human to enjoy a fair battle between a pond full of crocodiles and a duck with clipped wings. Anyway, what makes this particular duck so special? Why should he be treated differently from his comrades? On and on—but Emily was as tough as she had been about the Opium War Museum, and finally we left the duck in his cage.

Our safari experience ended with the Grand Meeting of One Hundred Animals, a parade that was held daily in the park's stadium. Continuing the interactive theme, the procession involved both animals and humans. A young woman wearing a swan costume led a line of trained swans that defecated as they waddled down the stadium's dirt track. She was followed by other women dressed as parrots, with real parrots on their shoulders. After that, men rode elephants and ostriches. One ostrich threw his jockey; the man sprinted away, chased by the furious bird, and the crowd cheered.

The entertainment culminated with a bear parade. There were bears in

costumes, bears on bicycles, bears staggering drunkenly on their hind legs. A bear wedding was held. The guest bears appeared first, pushing carts with enormous wood-and-paint models of wedding gifts of the new economy: a refrigerator, a television, a giant bottle of Great Wall wine. The happy couple came last. One bear wore a suit, the other a dress; they appeared on top of a float with a human trainer. There was a short ceremony during which the bears rose on their hind legs, to make their vows, and then the trainer nudged them into the float's bridal chamber. The man carried a whip. It was like a shot-gun wedding. The chamber's red door was decorated with the gold character for "double happiness." Almost all of the spectators at the park were young upper-class Chinese. Somebody told me that at night in that same stadium they raced greyhounds.

Before leaving the city, we stopped by the Deng Xiaoping billboard. The animal park had left me numb, and the visit to the billboard felt like a cleansing ritual—absolution for our trip within the gates. It was a hazy afternoon, and I photographed Emily. In the Chinese way, she didn't smile, striking a somber pose with the Great Leader's image in the background.

THE RIDE HOME felt long. Our bus cruised away from the downtown sky-scrapers: the glistening blue-green glass of the Stock Exchange, the twin-spired Land King Tower. Heading north, we passed through a few miles of brand-new apartment blocks, and then the neighborhoods started to thin out. The road cut through empty green hills just before the border—the long, low line of the chain-link fence. A billboard stood near the checkpoint: MISSION HILLS GOLF CLUB, THE FIRST 72-HOLE GOLF CLUB IN CHINA.

Beyond the gates rose a rough cluster of unfinished concrete buildings, with piles of dirt standing beside enormous foundation holes. We passed a sign for a low-security prison: THE SECOND LABOR CAMP. Our bus continued north, the factory towns coming one after another: dormitories surrounded by fences, smokestacks sprouting in dirty clumps. The urban landscape was marked by the type of premature aging that was characteristic of Chinese boomtowns. New sidewalks were already overrun by patches of weeds, and unfinished apartment blocks had been so cheaply constructed that their walls immediately became stained and cracked. Almost nothing was finished, and everything was of such low quality that it immediately looked old.

Roadside billboards advertised factory products, and most were aimed at wholesalers who purchased parts in bulk: alternators, air compressors, heat pumps. These weren't objects that you bought for daily use, and they would have posed a challenge for even a good advertising agency. But the billboard

design, like everything else, had been rushed, and often the ads consisted of nothing more than a photograph of some obscure part—a widget, a wonket—superimposed atop a sunny green field. Beneath the pastoral sprocket, there was a company name, often in awkward English: Professional Manufacture Various Hydraulic Machinery. Friendly Metal Working Lubricants. Good Luck Paper Products.

That night, we ate dinner at an outdoor restaurant near Emily's factory. In Chinese cities, evening was often the most pleasant time of the day, and this was especially true beyond the gates, where dusk finally made the place seem human. The monotony of the factory towns was brutal in daylight, and the streets seemed abandoned during working hours. But in the evenings, when most work shifts ended, there was a sudden rush of young people outside the factory walls. They moved in excited groups, like schoolchildren after the final bell. Sitting at the restaurant, I watched them walk past on the sidewalk, talking, laughing, flirting. Apart from their jobs, they had few obligations in this place—no families, no traditions. In that sense, they were free.

During dinner, Emily regaled me with stories about the factory owners. One of her boss's colleagues was a Chinese-American who, after recently arriving from San Francisco on business, had gone to Emily's office, faxed his wife a love letter, and then immediately gone out and hired a prostitute. Emily's own boss was always leering at the young women in his factory, and most of his friends were the same. In a nearby plant, another Taiwanese owner had become so distracted by his two Sichuanese mistresses that his company had gone bankrupt.

Emily laughed as she told the stories, and I imagined how quickly they circulated among young women who lived ten to a dorm room. Before coming to Shenzhen, Emily had never imagined that people acted this way. She told me that one of her biggest surprises had been receiving an update about her Fuling neighbor, the young woman who had always been portrayed as a great Shenzhen success. Emily's sister had learned that in fact the woman was a "second wife" to a factory owner from Hong Kong.

Emily had little respect for the businessmen who came to Shenzhen, especially the Taiwanese. Her boyfriend, Zhu Yunfeng, had recently left the jewelry factory for a new job, where he worked under a Taiwanese who treated employees fairly. But in Emily's opinion, that kind of boss was the exception, and most of the others were exploitative and sex-crazed. "All of them have failed somewhere else," she scoffed, explaining that her boss's old company in Taiwan had gone bankrupt years ago.

When I asked about the political climate, she said that Shenzhen had fewer

government restrictions than her hometown. But she pointed out that labor practices could be just as limiting. "Here it's not the government but the bosses who control everything," she said. "Maybe it amounts to the same thing."

She became particularly animated when talking about a Taiwanese-owned purse factory in a nearby city. Like most plants beyond the gates, the purse factory had a six-day workweek, but the owner kept his doors locked all week. Except on Sundays, the workers couldn't leave the complex.

"That can't be legal," I said.

"Many of the factories do that," she said. "All of them have good connections with the government."

One of Emily's friends had worked at the purse factory, where the Taiwanese boss often ordered everyone to stay on the production line until midnight, yelling when they got tired. One worker complained and got fired; when he demanded his last paycheck, the boss had him beaten up. The story made Emily so angry that she decided she had to do something about it. I asked if she had gone to the police, or another government bureau, or if she had told a journalist.

"No," she said. "I wrote a letter to the boss that said, 'This day next year will be your memorial day.' And I drew a picture of a *guge*."

I didn't understand the word, so she traced the characters on her palm, the way the Chinese often did when clarifying a phrase: 骨骼. But I didn't get that either. Finally she pushed aside her plate and sketched an outline on the table:

"A skeleton?" I asked.

"Yes," she said. "A skeleton. But I didn't write my name. I wrote, 'An unhappy worker.'"

She giggled and put her hand over her mouth. The waitress cleared the table. I didn't know how to respond—back in Fuling, my writing class hadn't covered death threats. Finally, I said, "Did the letter work?"

"I think it helped," she said. "Workers at the factory said that the boss was very worried about it. Afterward, he was a little better."

"Why didn't you complain to the police?"

"It doesn't do any good," she said. "All of them have connections. In Shenzhen, you have to take care of everything yourself."

After finishing the meal, Emily said, "Do you want to see something interesting?"

We walked to a small street near the middle of town. Below the road, a creek flowed sluggishly in the shadows. The street was unlighted, but dozens of men stood along the curb. The orange glow of their cigarettes hung like fireflies in the darkness. I asked Emily what was going on.

"They're looking for prostitutes," she whispered. A moment later, a woman passed through—walking slowly, glancing around, until a man came up and spoke to her. They talked for a few seconds, and then the man returned to the shadows. The woman kept walking. Emily said, "Do you want to see what happens if I leave you here alone?"

"No," I said. "We can leave now."

I SPENT THE night with Zhu Yunfeng in his one-room apartment. His new job allowed him to live in private housing, which was another reason he had left the jewelry factory. He earned more than Emily, but he was careful with money and the apartment was simple. Neighborhood buildings were covered with bold-faced flyers advertising private venereal disease clinics; we followed a trail of notices up the stairwell to Zhu Yunfeng's apartment, on the fourth floor. Unfinished walls, chipped plaster, incomplete plumbing. The water heater hadn't been installed yet. Like so many things beyond the gates, the building seemed to have been abandoned before it was completed. There was too much to build; contractors moved on once the bare essentials were in place. It occurred to me that the only things in this region that were actually finished were the factory products, which were promptly exported.

Zhu Yunfeng's apartment was furnished with two simple wooden beds covered with rattan mats. Nothing hung on the walls. Apart from a thermos and a few books, he didn't have many possessions. His current job involved making molds for a factory that produced household appliances to be sold overseas.

After Emily left for the evening, he talked about his new job. He told me that he wished he had studied English, like his girlfriend. I could tell that he ad-

mired Emily, and I knew that something about him made her feel secure. Once, she had bluntly told me that he wasn't handsome, and this was true—acne had badly scarred his face. But his plainness was attractive to her. She had a theory that handsome men weren't reliable.

MY SECOND VISA run was scheduled for October, which was an important month that year: October 1 marked the fiftieth anniversary of the founding of the People's Republic. Traditionally, major anniversaries had been celebrated by a military parade in the capital, with the nation's leader overseeing the ceremonies—Mao in the fifteenth year, Deng in the thirty-fifth. The fortieth had passed without a procession; Beijing residents had already seen enough of the military in 1989. But a peaceful decade had gone by, and now it was President Jiang Zemin's turn to review the troops.

The capital prepared all summer. Tiananmen Square was fenced off, for refurbishing, and some of the buildings along Chang'an Avenue improved their façades. On the evening of August 16, at 10:30 P.M., as my boss, Ian, and I were taking a cab back to the bureau after a late dinner, Chang'an Avenue was suddenly filled with the sweet strains of "Ave Maria." Traffic slowed to a crawl: drivers rolled down their windows; bicyclists pulled over. Everybody looked confused. By the time they played the second track—"The Christmas Song: Chestnuts Roasting on an Open Fire"—we realized that they were testing the new speaker system that had been installed for the parade.

The following afternoon, a stream of tanks, troop carriers, and self-propelled missile launchers suddenly appeared, heading west on Chang'an toward Tiananmen Square. There had been virtually no warning. That day, small notices in the Beijing morning newspapers had informed readers that parts of the downtown would be closed to traffic between the hours of 4:30 P.M. and 2:00 A.M., but they didn't mention the military hardware. I was in the bureau, doing some clipping, and I ran outside once I heard the roar from the street. Soldiers lined the sidewalks, keeping the gawkers back. Parents hoisted children onto their shoulders so they could see better.

The next evening, I met Polat for dinner in Yabaolu. He grinned and said, "It's been a while since there were tanks in Beijing." When I asked how he intended to celebrate the anniversary, he said that he was going to stay indoors as much as possible that week. He had heard rumors that the police would be hassling Uighurs, for fear that some separatist would set off a bomb and disrupt the festivities.

In Beijing, the government commanded the temporary closing of factories, to cut down on pollution, and they sent up cloud-seeding planes right before

the anniversary. It rained hard on the last day of September. On October 1, the day dawned a brilliant blue, and the parade proceeded without a hitch. Jiang Zemin wore a Sun Yat-sen suit, buttoned to the top, and while reviewing the troops he repeatedly shouted, "Comrades, you are hardworking!" Nothing was new—the emperor's old clothes, the same wooden phrase that had been used by leaders in the past. They played the national anthem instead of "Ave Maria." After an hour of watching the parade on television, I got bored and went to eat in Yabaolu. Polat had kept his word; he was nowhere to be seen. Except for me, the Uighur restaurant was empty.

The government had declared that all citizens would celebrate with a week's vacation. In Zhejiang province, William Jefferson Foster and Nancy Drew hadn't saved enough money to travel, so they spent a quiet week together in Yueqing. On the day of the anniversary, they visited the homes of four of Willy's students. It was a good way for a new migrant teacher to solidify his local relationships. One of the parents ran a shoe factory, and he gave Willy a new pair of leather loafers. Later, Willy wrote, half-jokingly, "Interesting enough, it was the first time for me to be corrupt getting something from the students' families."

Farther south, outside of Shenzhen, Emily's factory gave the workers only one day off. Within the gates, most companies granted the full week vacation, but production schedules were always more demanding outside the fence. And the workers at Emily's plant believed that their owner was particularly stingy about National Day vacations because he was a Taiwanese who hated the Communist Party.

Later that week, the seasons in my own private calendar shifted. I caught the train down to Shenzhen, crossed the Hong Kong border, and bought a new visa.

FOR OUR SECOND journey within the gates, Emily chose the Land King Tower. We followed the same routine: the meeting at McDonald's, the bus to the fence, the border check. After the low green hills and the rows of apartment blocks, the Shenzhen downtown appeared like a mirage: flashing towers of glass and steel, capped by the tallest of them all, the Land King.

We purchased tickets to the top. Glass elevators whisked us up; from the sixty-ninth floor, we looked out over the expanse of the Special Economic Zone. In other big Chinese cities, the congestion seemed more impressive the higher you went, until at last you gazed over a jumbled sea of concrete: so many buildings, so many years of haphazard development. But from the air Shenzhen looked different. Roads were broad and straight; generous patches of

green were sprinkled throughout downtown. Westward, the flooded fish ponds of rural neighborhoods shimmered skyward like enormous mirrors. The city had been planned; it wasn't just a place where years and decades and centuries had piled atop each other.

Inside the skyscraper, an exhibit celebrated the history of Shenzhen and Hong Kong. The brief Shenzhen section was headed by the phrase "The Overnight City."

The Hong Kong exhibit included life-size figures of Deng Xiaoping and Margaret Thatcher, the leaders who had negotiated the terms of the colony's return. The display ended with the British handover of 1997. There was a photograph of the last British governor, Christopher Patten, who had been despised by the Communist government for instituting tentative democratic reforms in the final years of British rule. The Land King's displays never mentioned these reforms, or even Patten's name. His photograph was accompanied by the simplest of captions: "End of Colonialism."

PART TWO

Starch

March 2000

DURING MY FIRST YEAR AS A FREELANCER, AFTER STRUGGLING THROUGH some initial dry months, I published stories in the *Hong Kong Standard*, the *South China Morning Post*, the *Asian Wall Street Journal*, the *New York Times*, the *Chicago Tribune*, the *Newark Star-Ledger*, the *Seattle Post-Intelligencer, Junior Scholastic Magazine*, and a Web site called *ChinaNow*. When the wizards from the World Economic Forum flew in from Geneva for their annual China conference, I wrote summaries of panel discussions, to be used in brochures. Every organization had its own rules and regulations, stipends and payments. The World Economic Forum required that I wear a suit and tie, but they paid three hundred dollars a day. Newspapers usually paid between three and four hundred for a story, and more if I could provide a publishable photograph. Nobody covered expenses. I signed any contract that was sent to me.

Of all these publications, the *Wall Street Journal* and the *New York Times* were the most prestigious, but neither newspaper paid as well as *Junior Scholastic Magazine*, which gave me nine hundred dollars for a single feature. *Junior Scholastic* asked me to write about three school-age children in Beijing, and the story had to include some basic background in Chinese history. It was intended for American junior high students; the editor requested that I limit my sentences to eighteen words or less. After finishing, I reread my draft and suddenly recognized Special English:

China's history is both its greatest strength and its greatest weakness. For much of its past, China was far more advanced than Western countries. The Chinese were the first to produce paper, printed books, gunpowder, porcelain, cast iron, silk, and the magnetic compass.

But the last two centuries have often been tragic, especially with regard to China's relations with the outside world. The result is that today's China is still a developing country with many problems.

The key to freelancing is separating yourself from the stories that bear your name, until you see them from a distance, like a person who suddenly faints and feels as if he is watching his body prone on the floor. Any writing is like that, to some degree, but it's especially true for a foreign freelancer living in a place like China. It felt strange to write for publications that were so far away; editors seemed to be nothing more than voices on the phone. Also, it was technically illegal—the People's Republic forbade any journalist from working without official accreditation. Nevertheless, there was a small cadre of young writers in Beijing and Shanghai, buying six-month business visas and hoping to get picked up by a bureau as a full-time correspondent. The odds of trouble weren't high, but occasionally something happened. Not long before I arrived in Beijing, ABC had broadcast a sensitive story about China, and the police responded by hassling the bureau's unaccredited foreign assistants until they finally quit.

Nevertheless, I published as widely as possible. It was a calculated risk: the stories might be noticed by the authorities, but they also might be noticed by editors. I sent off query letters every week, and I learned to take an experience like the trip along the North Korean border and break it down into multiple stories. (That journey produced five separate publications.) Meanwhile, I kept my eye out for any kind of regular work. Matt Forney at the *Wall Street Journal* gave me one of his old gigs, a weekly feature for the *Hong Kong Standard*. Every Tuesday, I submitted a story of six hundred words, for which I received one hundred and fifty dollars, as well as a clipped copy of the published article. That was the extent of my interaction with the newspaper: during the two years that I wrote the stories, I never met an editor or received a single note from a reader. I never visited the *Standard* offices during my visa runs to Hong Kong. There was absolutely no evidence that anybody ever read my stories.

In a way, that made it easier. I took long, unplanned trips, waiting for things to turn up, and sometimes I just wandered around Beijing and found a person or a neighborhood to profile. For a writer, the capital had reached a perfect stage of development—the free-market economy was booming, but it

hadn't yet become completely standardized and large-scale. Micro economies were scattered throughout the city, and each of them was worth a story. One alley in Yabaolu specialized in fur coats for the Russians; Xinjiekou had good bootleg CD and DVD shops. The subway stop at Qianmen was known for its dealers of bogus receipts; they served the corrupt cadres who had arrived from the interior on the Communist Party's business. The dealers hung around the subway exit, muttering, *fapiao, fapiao, fapiao*. Receipt, receipt, receipt. The men looked shady, with shifty eyes and hands jammed into their pockets—perverts of the expense report.

The market at Yuting Qiao was devoted entirely to unofficial electronics—used goods, display models, test units, smuggled sets, factory leaks, fakes, *jiade*. Every product came with a tale that was intended to soothe suspicions: a narrative warranty. One morning, I wandered through the market and talked to a man who sold Taiwanese-made Panasonic stereos; the price was cheap, he explained, because he saved on duties—his friend worked customs down in Xiamen. Another dealer told me that his Yangzi-brand washing machines had come straight from the factory in Anhui province; the only reason they had been rejected was because of minor dents and scuff marks. Nearby, a man sold CR2 Lithium batteries that had been used in display models at high-end department stores. He swore they still carried a half-charge—a bargain at one-sixth retail.

I felt a sense of brotherhood with anybody who peddled stories. Once, while traveling in Taiyuan, the capital of Shanxi province, I wandered through a street market. It was full of typical stuff: watches, lighters, Buddhist charms, handmade inner soles for shoes. Each dealer simply dropped a sheet on the ground and then arranged his goods on top.

A crowd had gathered around one man who sold pamphlets. He was in his early twenties, and you could tell from his appearance—dark skin, dirty collar, cheap blue suit —that he was a migrant. But he spoke beautifully, holding the crowd with his words. The key was tempo: never too fast, never too desperate. The spiel came calmly, as if he had all day, and it didn't feel over-rehearsed or mechanical. He sold pamphlets not because he needed to, but because the pamphlets deserved to be sold.

They were clearly illegal. On the ground, he had arranged a white cotton sheet with a series of handwritten questions:

Who Was Better, Mao Zedong or Deng Xiaoping?

An Important Piece of News That Was Never Reported

> With the World Changing So Quickly,
> Will China Still Be Socialist in Twenty Years?

"You'll get answers to all of these questions and more," the man said. "It only costs one yuan." He glanced up, noticed something unusual about the crowd, but didn't skip a beat. "It doesn't matter if you're a foreigner or a local. The price is the same—only one yuan. I won't cheat you. All topics are included; you'll get the answers to all of these questions."

The pamphlets were cheaply printed, two dozen pages stapled inside a blue paper cover:

> Science News and Selected Strange and Secret Treatments
> By Zhang Hong (Economist)
> Published by the Shenzhou Science News Publishing House

Undoubtedly, the publishing house had never heard of this pamphlet; the economist probably didn't exist. In a politically charged city like Beijing, the salesman might have been kicked out or hauled to a police station, his goods confiscated. But here in the provinces, one occasionally saw men of this sort, working the margins of the state-controlled media. They dealt in rumors, myths, folktales, conspiracy theories—that little voice in people's heads. I've always wondered about that. One yuan is not very much money. You never see this stuff in the newspaper.

In the pamphlet, twenty-one articles had been arranged according to some mysterious logic. "Why Did Mao Zedong Start the Cultural Revolution?" was followed immediately by "How to Tell If Your Baby Will Be a Boy or a Girl." "Ten Types of Short-Lived People" came before "Ten Problems That China Needs to Solve Quickly." One story profiled an imprisoned labor leader of the 1989 protests; another article discussed the wives of Liu Shaoqi, the former vice-secretary of the Communist Party. There were scandals: "The 500 Airline Stewardesses Who Became Pregnant." There was advice: "How to Cure Baldness and White Hair." Scams: "How to Cheat at Mah-jongg." Home remedies: "How to Avoid Getting Pregnant" (use baking soda and cotton); "How to Induce an Abortion" (fermented yeast and millet wine).

The articles were short; the sentences were simple and clear. Everything made sense in the end. There were three reasons why Mao had started the Cultural Revolution: he felt threatened by Liu Shaoqi; he wanted to continue class struggle; and he hoped to fully develop Marxism, Leninism, Mao Zedong Thought, and Communism. If a pregnant woman's right nipple is darker than the left, she's going to have a boy. Mao Zedong and Deng Xiaoping were

equally good. If you exercise regularly, you won't go bald. China will still be socialist in twenty years. It's a girl if the left nipple is darker.

IN MARCH OF 2000, I was commissioned to write a story about starch. A Dutch company called Dorr-Oliver was publishing an in-house magazine, and they wanted some publicity material about their work in the northeast, the part of the country that used to be known as Manchuria. Dorr-Oliver supplied centrifuges to two of the region's first corn milling factories, Yellow Dragon and Dacheng, and my assignment was to publicize the success of these operations. The Chinese word for "publicity" is *xuanchuan,* which is also defined in the dictionary as "propaganda." There isn't any distinction between the two meanings. In 1997, the government's Central Committee changed the official English translation of its *Xuanchuan Bu* from "Propaganda Department" to "Publicity Department." But the Chinese name remained exactly the same.

Dorr-Oliver paid me nine hundred dollars to write the story. They offered a thousand to my friend Mark Leong, a freelance photographer; he got more money because he guaranteed that he would shoot something suitable for the magazine's cover. The night before we left, Dorr-Oliver sent me a draft of another in-house magazine article, for background. The article had been written in Special English and it began with the sentence: "There are few raw materials as versatile as starch." The story continued to say that starch is used for everything from lipstick to paper to dried soup. A total of fifty-five to sixty million tons of starch are produced worldwide every year. A lot of it is used for sweeteners. This trend started back in the Napoleonic Wars, when the British blockade cut off sugar imports and the French were forced to manufacture sweeteners from starch. The French might have lost those wars, but they sure got the ball rolling for starch. Another sentence read: "Fast-food restaurants like Burger King are using starch to make their French fries crunchier."

I was interested in learning more. The next morning, Mark and I flew to Manchuria.

FROM THE AIR, you could see little yellow piles of corn sprinkled throughout Changchun. In the 1930s, the city had been the capital of Manchukuo, the puppet state established by the Japanese during their invasion of China. In the center of Changchun, there was still a palace that the Japanese had built for Puyi, the former Qing emperor. The Japanese had installed Puyi as a figurehead—a *jiade* emperor. It was possible to tour the fake imperial palace, but Mark and I wouldn't have time. Our handlers made it clear that the story was going to occupy us fully for the next eight hours.

The complications began immediately upon our arrival. It turned out that we could not tour both Yellow Dragon and Dacheng, although my original assignment had been to write about the two factories and how their close relationship was helping China produce more starch. One of our handlers said that I'd simply have to find another theme; we couldn't go to Yellow Dragon. He didn't explain why.

Once we arrived at Dacheng, we realized that the factory had purchased centrifuges from both Dorr-Oliver and Westfalia, which is the German competition. Both brands of centrifuge operated side by side, *mano a mano*, and this made things difficult for Mark. He had to find a way to photograph the Dorr-Oliver machines without including the Westfalia equipment in the background. The Westfalia machines were beige and the Dorr-Oliver machines were blue. Dorr-Oliver loaded the corn matter from the bottom and Westfalia loaded from the top. Both of them made a lot of noise. The factory smelled like malt. Workers wore tan jumpsuits with Communist-style red stars on the chest.

While Mark was photographing, I interviewed a worker who had been selected by our handlers. We sat in a factory conference room, and I asked him what the difference was between the Dorr-Oliver and the Westfalia machines.

"Dorr-Oliver loads from the bottom and Westfalia loads from the top," he said.

This was something that I had already noticed. I asked him if there were any differences in quality.

"They're basically the same," he said. "But the Westfalia machines are a little better."

Mr. Wang, the Dorr-Oliver chief representative in China, a former member of the Chinese State Economic Commission, and the main coordinator of our publicity mission, was sitting at the other end of the table. He was talking on his cell phone and I hoped that he couldn't hear us. I leaned forward and dropped my voice: "Why do you think that the Westfalia machines are better?"

"They just are," the worker said with a shrug. He was twenty-five years old, with short black hair and the barest shadow of a mustache. He made $125 a month. "The Dorr-Oliver machines are a little too complicated," he said. "It's easier to operate the Westfalia machines. The Dorr-Oliver ones require more watching."

I could see that we weren't acquiring good propaganda, and I worried about what might happen to the worker if Mr. Wang got off his cell phone. Changing my line of questioning, I asked the worker about his wife, who was employed in quality control at the factory, and about his daughter, who was ten

months old. He spoke much more enthusiastically about his daughter than he did about the Dorr-Oliver centrifuges. He expected her to start walking soon.

MY SECOND INTERVIEW was with Mr. Guo, who was a vice-chief engineer with the Jilin Petrochemical Design and Research Institute. In 1957, the organization had been founded as the Local Industry Technology Institute, and its purpose originally had been to research the refining of sugar from beets. But that was a period of great change in China, and it wasn't long before the institute shifted to the study of nylon thread production. Then the Cultural Revolution happened, and folks like Mr. Guo took more than five years off. He didn't say anything specific about how he had spent those years. He only made it clear that during that period he was no longer involved with the nylon thread industry.

In the early 1970s, as the Cultural Revolution cooled down, the institute changed its name to the Jilin Petrochemical Design and Research Institute. That was around the same time that it began working to improve cigarette filters. This was yet another new direction for Mr. Guo, but he embraced it wholeheartedly. In 1979, as Reform and Opening began, the institute's research focus changed again, this time to cornstarch. Nobody could give me a good reason why it was still called the Jilin Petrochemical Design and Research Institute.

Mr. Guo was sixty-seven years old, and he was one of those gentle, soft-spoken Chinese men who giggle whenever an uncomfortable subject comes up. Mr. Guo giggled when he mentioned the Cultural Revolution, and he giggled when talking about the poverty of Changchun during his childhood. He giggled when describing the six years that he had spent developing cigarette filters. Mr. Guo was one of the few nonsmoking men I met in Changchun.

He seemed slightly overwhelmed by being interviewed by a foreign propagandist in the restaurant of Changchun's five-star Shangri-La Hotel, and this also contributed to the giggling. But he was clearly intelligent, and he knew much more about cornstarch than you would expect for somebody who had found his true calling so late in life. All of the numbers came straight off the top of his head. He told me that since 1980, the production of Chinese cornstarch had increased by 1,150 percent. In China, 40 percent of the cornstarch was used to make MSG, whereas in the United States, 60 percent of the cornstarch was used to make artificial sweeteners. Those statistics seemed to say something profound about the differences between the two nations.

In the middle of the interview, Mark called from his cell phone. He was photographing outside the factory.

"There's this enormous pile of corn," he said. "You should check it out."

"I'm at the hotel," I said. "I'm interviewing a cornstarch expert. I'll be back later."

"It's like fifty feet high, and all of these peasants are bringing in their corn," Mark said. "I've never seen so much corn in my life. They have those big machines piling it up. You know what I'm talking about—are they called backhoes?"

"I think so."

"You should check it out," Mark said. Like many photographers, he was often mesmerized by the way the world appeared through a one-inch viewfinder.

"I think we're going back soon," I said. "But I have to finish interviewing this cornstarch expert first."

"Have him come here after you're finished," Mark said. "We might need a picture of him, too."

Mark hung up and I continued the interview with Mr. Guo. He provided more statistics: the per capita sugar consumption in the United States was fifty kilograms a year, whereas in China it was less than eight. With regard to worldwide starch production rankings, America was Number One and China was Number Two. The price of corn in China was dropping. In 1997, it cost almost two hundred dollars for a ton of corn, and now the price had plummeted to eighty-five dollars. Mr. Guo giggled. He had exhausted his starch numbers.

There was a lull, and I tried to think of a new propaganda question. Finally, I asked if he ever ate corn, and Mr. Guo giggled again.

"In the past, most of the corn was used for food," he said. "All through my childhood, we ate corn. It was like that all the way into the 1970s. But if I eat it nowadays, it's only if some restaurant happens to have a special dish. I'd never eat it at home. Nobody does; people have more money now."

Mr. Guo had ordered a fruit shake from the restaurant at the Shangri-La Hotel, but he was too shy to take food from the buffet. I kept inviting him to eat, but he only shook his head and giggled. He liked that shake, though.

IN NORTHEASTERN CHINA, the composition of corn is between 32 and 38 percent moisture. In central China, it's only 14 percent. That's why it takes so long for corn to dry in Changchun.

Mr. Wang told me this fact while we were driving back to the Dacheng factory. I wrote it down.

 * * *

MY FINAL INTERVIEW was with Mr. Xu, the general director of the Chang-chun Corn Industry Development Zone. Back in the 1980s, he had founded the Yellow Dragon factory, which was the first cornstarch processing facility in China. It took five years for Mr. Xu to collect all of the necessary government approvals, but after those hassles were cleared away he made a profit of more than seven million dollars in his first year of production. Later he started the Dacheng factory. He was essentially the father of modern Chinese cornstarch. I waited in his office while the man finished a meeting.

I was accompanied by Mr. Wang, the main Dorr-Oliver handler, and two Dutch representatives who were visiting China. Mark was still outside. Occasionally, he called to check if Mr. Xu had arrived, because he was Mark's best prospect for a cover shot. Mark really wanted that cover. In the meantime, however, he was obsessed with the pile of corn. The Dutch men were named Wim and Kees. They didn't talk much.

Mr. Wang and I chatted, and he told me about his background. At the age of fifteen, he had entered the Chinese Navy Submarine Academy, where he spent seven years. In 1976, he got out of the submarine corps and took a job with the Foreign Language Press. He studied English and eventually was placed in charge of distributing Communist publicity in Scandinavia. Later, he joined the State Economic Commission. He didn't explain what he had done for them.

After leaving the government, Mr. Wang took a job with Dorr-Oliver, selling centrifuges and other equipment in China. Like Mr. Guo, and like many other middle-aged and older intellectuals whom I met in China, Mr. Wang didn't perceive his career as a narrative. Instead, it consisted of a series of mostly unrelated vignettes. He spoke of these vignettes with bemusement, as if each had belonged to a different person, and as if now those people were gone, their traces fading with time.

He was most interested in the man who had once worked for the State Economic Commission.

"I could have become a minister," he said. "If I had stayed, that probably would have happened."

"How long would it have taken?" I asked.

"That depends on how well you play the politics."

He used Mr. Xu as an example of what happens when you involve yourself in politics. In the early 1990s, after the great success of the Yellow Dragon plant, Mr. Xu prepared to open the second location at Dacheng. He intended to name it Dragon Junior, and the two plants would represent the heart of China's cornstarch industy. Everything went according to plan—but then

there was a sudden political shakeout and Mr. Xu was essentially run out of Yellow Dragon. He lost control of the factory that he had worked so hard to establish.

"So he started Dacheng by himself," Mr. Wang told me. "He did it as revenge. And he didn't call it Dragon Junior—he called it Dacheng instead."

I was growing more interested in meeting Mr. Xu. I wanted to see exactly what kind of clearheaded, cold-hearted, calculating man would start a cornstarch plant as revenge against his enemies.

"It's always like that with politics," Mr. Wang continued. "You always get fucked by your deputies. That's politics. If you want to be president, you have to fuck up your competition. If you're a mild, nice guy, then you'll get moved out. They fuck you."

Wim and Kees jumped every time Mr. Wang used the word "fuck." Mr. Wang's English was excellent, but he was one of those foreigners who had learned the language without becoming aware of what happens when you use the word "fuck" three times in one paragraph. What happens is that Dutch people jump.

He was probably about to use it again when Mark telephoned.

"Has the director arrived yet?"

"No," I said.

"Some factory guy just got angry at me for taking pictures."

"What was the problem?"

"I was taking pictures of workers with dust on their faces and he didn't like that. He started yelling at me and he told me to leave. I explained and finally he left me alone."

"Did he think you were trying to make the factory look bad?"

"Maybe," Mark said. "Or maybe they thought I was a spy from another factory."

I considered telling Mark about the blood feud with Yellow Dragon, but it was too complicated. I figured that Mark could take care of himself. I promised to call when Mr. Xu arrived.

I wanted to learn more about Mr. Wang's role in the State Economic Commission, but he waved off my question. There was something else that interested him.

"When you interviewed that worker this morning, what did he say when you asked him to compare the Dorr-Oliver and Westfalia machines?"

For an instant I was caught off-guard, and then I answered: "He said they were basically the same."

"What did he say the difference is?"

I answered brightly, "He told me that the Dorr-Oliver machines load from the bottom while Westfalia loads from the top."

"No, no, no." Mr. Wang was growing impatient. "Which one did he say was better?"

"He said they were about the same."

"No, he didn't," Mr. Wang said. "He told you that the Westfalia machines were better, didn't he?"

I considered lying, but I realized that I was trapped, and so was the worker.

"Yes," I said. "That's what he told me. But he said it wasn't a big difference."

Now Wim and Kees appeared interested. Mr. Wang looked at me triumphantly.

"You know what?" he said. "He's right!"

Nobody said anything. Mr. Wang grinned.

"Our machines aren't designed as well as the Westfalia centrifuges," he said. "Those machines are better."

The two Dutchmen stared at the floor.

"That's important for us to know," Mr. Wang said. "How can we possibly do business if we don't know that our product is inferior?"

The room was dead silent. In my mind, I repeated his question twice over, but still I couldn't figure out how you could possibly answer it. It was one of the most intelligent questions I had heard in a long time.

"Everybody always says that their product is the best," said Mr. Wang. "They have to talk about how much better they are than the competition, and usually they believe it. But the truth is that it's much easier once you realize that your product is inferior. Then you can focus on just doing business!"

Now I realized what kind of work Mr. Wang had done for the State Economic Commission. Whenever I met people like him, I understood why the transition from Communism to a market economy had been handled so well by many Chinese.

The Dutch men seemed uncomfortable until Mr. Wang changed the subject. He talked about modified starch and how it is different from normal, unmodified starch. The distinction was subtle and I had difficulty grasping it; at last Wim spoke up. He wanted to clarify things. "Basically, modified starch is the same material as crude oil," he said. "It's a carbohydrate."

MARK FINALLY FINISHED with the pile of corn. He came inside the office, where he negotiated with Mr. Wang about the photograph of Mr. Xu, the director. The negotiations were not simple.

Mr. Wang wanted the director to be photographed in his office. He pointed to the wall, which prominently displayed framed copies of calligraphy by Li Peng and Zhou Jiqiu, both of whom had visited Dacheng. Li Peng was the former premier who had announced the official decree of martial law during the demonstrations of 1989. I had no idea who Zhou Jiqiu was, but Mr. Wang assured me that he was an important official. Zhou Jiqiu's calligraphy read: "The Brilliant Future of Industrial Corn Production." Li Peng's calligraphy read: "The Base of China's Changchun Corn Production." All across China, Li Peng was famous for having lousy calligraphy.

Mr. Wang wanted Mr. Xu to be photographed with the calligraphy in the background. Mark saw his cover shot evaporating.

"The light's bad in here," he said. "It's better in the factory, and I can take a picture of him in front of the Dorr-Oliver machines."

"You can't do that!" Mr. Wang exclaimed. "He'll never agree to that! You can't drag the chairman of such a huge company anywhere you wish! It's politics—it's not that simple!"

Mark was growing visibly frustrated. "Well, then I'll just have to use a photo of a common worker," he said. "Do you think he'll be happy if there's a common worker on the cover of the magazine?"

"I wouldn't recommend that," Mr. Wang warned. "With a high official it's not good to use a photo of somebody below him, especially not a common worker. You have to put the highest official on the cover!"

They argued for a while. Each had his own obsession: Mark worried about lighting and Mr. Wang worried about politics. It seemed that these forces were mutually exclusive, at least until the moment when Mr. Xu walked in. Everybody stood up. As if the argument had never taken place, Mr. Wang asked directly if Mr. Xu would accompany us to the factory to have his photograph taken next to the Dorr-Oliver machines. Without hesitating, Mr. Xu agreed.

We went outside. It was cold, and empty plastic bags blew across the factory grounds. You could see Mark's pile of corn in the distance. It was enormous. We walked into the machine room.

Mark was careful to keep the Westfalia machines out of the frame. Mr. Xu was barely over five feet tall and he wore a gray checked suit. He chuckled proudly while the picture was taken. He was fifty-seven years old.

Afterward, we returned to his office, where I interviewed him. He gave me his card, which listed his two main positions: vice-secretary-general of the Municipal People's Government of Changchun, and general director of the Changchun Corn Industry Development Zone. The development zone had been established after the Shenzhen model.

I asked Mr. Xu how things had changed since the 1980s, when he started Yellow Dragon.

"The biggest problem was administrative," he said. "In those days, I had to go through so many departments. And everything had to be approved by the state council. But now the approval system has been decentralized. I just have to go through the Changchun municipality—and there I can basically approve it myself, because I'm the vice-secretary-general. As long as I put my signature on the applications, the other departments will also approve."

Mr. Xu beamed after giving this explanation. I wrote it down.

He expounded on how much easier it was now that he could give official approval for the business projects. That cleared up a lot of hassles, and he was hoping to quadruple Dacheng's cornstarch production. Already they were making half a million tons a year. They benefited from the falling price of corn, which would drop even more after China joined the WTO. Mr. Xu smiled at the thought of the future. At the end of the interview, he remembered one more thing.

"I also want to add processing plants to make enriched starch," he said. "And I hope that through these new industries we can create job opportunities for the peasants who might have trouble because of the lower corn prices."

I WROTE THE story in two hours. The article was one thousand words long, and I stuffed it with as many statistics as possible. I didn't mention how the Dorr-Oliver machines sometimes jammed up, or the feud between Yellow Dragon and Dacheng, or how Mr. Xu's government position facilitated the factory expansion. In Manchuria, I had learned one important fact about propaganda: the key information isn't what you put in, but what you leave out.

A couple of weeks later, a woman from the magazine told Mark that they weren't going to use the picture of Mr. Xu for the cover. Instead, they wanted to publish the photograph of Mr. Guo, the man who had spent six years researching cigarette filters. They just had to put him on the cover, the woman said, because he had such a beautiful smile.

Hollywood

April 25, 2000

OVER THE WINTER, POLAT ARRANGED FOR ME TO HAVE A HOLLYWOOD VIP card. In cold weather, we couldn't sit on the outdoor platform at the small Uighur restaurant, and so our Yabaolu routine shifted. Sometimes we ate at Hollywood, which was a nightclub as well as a restaurant; the VIP card meant that they waived the cover charge. Polat knew the manager—he seemed to know the managers at all the Yabaolu clubs.

The Hollywood menu was printed in Russian as well as Chinese, and we almost always ordered the same thing: chicken Kiev for me, steak for Polat. He liked to get there early on weekend nights, so we could have a slow meal and watch the place steadily fill with people. Everybody who entered the club passed beneath an enormous statue of King Kong that loomed above the doorway. Inside, the place had been decorated as an imitation of the Planet Hollywood chain. Fake movie paraphernalia was displayed in glass cases, complete with detailed labels: a silver sheriff's badge that had supposedly been used in *Sidekicks* (Warner Brothers, 1991); a black cape with red lining (*Dracula*, Castle Rock, 1995), a leather whip (*Bullwhip*, Columbia, 1958). Just inside the door, encased in a huge glass tube, was a life-size statue of Arnold Schwarzenegger dressed as the Terminator. The statue, like many of the movie objects, had been so cheaply made that it was barely recognizable. The place felt like a museum dedicated to the concept of *jiade*: an exhibition whose artifacts reminded you how far you had slipped from reality. In a neighborhood of knockoffs, Hollywood was the biggest fake of them all.

It was also a prime hangout for Russian prostitutes in Yabaolu. Whenever Polat and I went there for dinner, I kept one eye on the progress of the evening's business. By eight o'clock, the women started to filter in; an hour later, potential customers arrived. Most were small-time Chinese businessmen, the type of men who might have some money but not much education. They wore cheap Buddhist beads on their wrists for good luck, and invariably they clutched the fake leather money bags that were standard for traders. Elsewhere in the city, such men tended to be loud—barking into cell phones, shouting orders at waitresses. But the presence of all those white women in Hollywood left them subdued. The Chinese men stayed in packs, talking in low voices, fiddling with their phones. Whenever a peroxide blonde walked past, the fidgeting increased. Sometimes, I'd watch a man work himself up to action: pick up the phone, put down the phone; light a cigarette, put down the lighter. The cycle gained speed—phone up, phone down; phone up, phone down—until finally he'd rise, walk across the room, and speak directly to a woman. And then I'd glance at my own phone, or turn back to the conversation with Polat, suddenly conscious of my voyeurism.

INCREASINGLY, POLAT TALKED about going to America. He'd mention the possibility of studying abroad, or finding some kind of job that would take him across the Pacific. For a spell, he was interested in Canada, because somebody told him that immigration was easy in Quebec, but then he decided that he didn't want to learn French. Our Hollywood discussions always returned to the same place: the United States.

Polat's desire to go there mystified me. He spoke no English, and I couldn't imagine how he'd qualify as a student or a businessman; the U.S. embassy would never give a tourist visa to somebody who worked as a middleman in Yabaolu. He had a wife back in Xinjiang, although he rarely spoke of her, and I sensed that there were complications with the relationship. He told me that he didn't want to bring her to a place like Yabaolu. They didn't have children, and I had the impression that the couple hadn't spent much time together. In China, that sort of situation wasn't unusual, especially when migration was involved.

I wondered if Polat's talk about America was just a reflection of his instability, but I also worried about possible misperceptions of the United States. In China, people who had never been to America tended to take extreme views, and often both sides were equally inaccurate. I met many Chinese who believed that America was evil incarnate, but I also met others who had complete faith in the wealth, opportunity, and freedom of the United States. In conversations,

I often tried gently to push people away from both extremes, but it was difficult without any context. America was an idea, not a place.

In a few parts of China, certain concepts about America had become so deeply ingrained that people would do almost anything to emigrate. In January of that year, three Chinese men died in a shipping container en route to Seattle. Along with other illegal immigrants, the men had come from Fujian province, in the southeast, which was famous for its "snakeheads"—people smugglers who arranged passage across the Pacific.

After the deaths, the *Seattle Post-Intelligencer* hired me to write a series about the snakeheads. For most of a week, I traveled along the coast near the city of Fuzhou. On an island called Langqi, I found the family of one of the Seattle survivors; the man was in detention, awaiting a hearing with the Immigration and Naturalization Service. Invariably, such immigrants claimed political asylum, although in fact most had left for economic reasons. In one of the Fujianese villages, I randomly met a young man who told me that he had spent four months in a detention center, in Jamaica, New York, before being denied asylum. The snakeheads generally charged between thirty and fifty thousand dollars to arrange transport, and usually the emigrants' debt ensured that they would spend years as indentured servants in Chinatown restaurants or sweatshops.

It might have been understandable in a poor part of the country, but Fujian was far better off than the average province. Nevertheless, many Fujianese weren't satisfied with a good life by Chinese standards. An entire industry had sprouted to support the local version of the American dream: snakeheads, shady visa services, pre-emigration English lessons. In the small village of Tantou, three private English schools offered courses such as "Restaurant English," "Life English," and "English for Leaving the Country." I saw one advertisement for a class that was simply called "Menu." Another sign promised: FOR THE MONEY YOU'LL MAKE IN A DAY AND A HALF WORKING IN AMERICA, YOU CAN STUDY A FULL SEMESTER OF "RESTAURANT ENGLISH." One school offered a course in Cantonese, because that was the dominant dialect in some of the Chinatown restaurant districts. The Fujianese were studying another Chinese language so they could work illegally in America.

A number of locals had made the trip, worked hard, and eventually became the owners of restaurants or some other business in the States. They remitted money to family members back in Fujian, who built enormous mansions in the villages. These structures tended to be narrow and vertical; they might be only three rooms wide but five stories tall. Usually they were faced with white tile, and often they had big glass windows in the shade of green that was so

common in modern Chinese construction. That color always made me think of *The Great Gatsby*—the glow at the end of Daisy's dock.

But in Fujian, it was like glimpsing light that had taken years to cross a galaxy. Some of these success stories had belonged to an earlier generation, when China's economy didn't provide much opportunity. In truth, nowadays the Fujianese might be better off staying at home; even if the immediate dollar figures were higher in the States, they'd probably be happier and have better long-term prospects in China. But the people kept seeing the mansions, and they kept leaving. They were chasing a star that might be dead by the time they got there.

In Tantou, I stopped at one brand-new six-story building whose gateway was inscribed with gold characters: 德聲園. The phrase meant: "Garden of Virtue and Prestige." Inside, I met an old woman who proudly told me that she had four children in America; one daughter ran a hotel. I asked where the hotel was located, and the old woman slowly inscribed five English words into my notebook. She didn't speak the language, and her handwriting had the odd angles of somebody who has memorized shapes rather than words. Nevertheless, she made only one mistake:

Vallege Inn Edison New Jersey

WHENEVER POLAT AND I had our Hollywood conversations, I mentioned the Fujianese, because I worried that he might overestimate the economic opportunity in the United States. And I knew that business in Yabaolu was slowly dying. In the past, there had been no shortage of traders from Russia and Central Asia, and many of them acquired visas by joining "tour groups" that stayed for a week. Special agencies arranged the trips; it was much easier to go to China as a tourist than as a businessperson. I imagined the charter flights that set off from Moscow, packed with hard-faced women and heavyset men with vodka-rimmed eyes. They were *jiade* vacationers—bad imitations of people going off on a holiday.

But by the end of 1999, the number of Russians and Central Asians in Yabaolu was dropping. Polat sometimes described these changes in the language of currency movement: he told me that the Kazak tenge had lost a third of its value, and most of his old customers from Almaty were staying at home. It was the same with the Uzbeks, the Kyrgyz, the Tatars. Polat's last big clothing deal had been in September of 1999, when he arranged for the sale of three thousand pairs of Guangzhou-made blue jeans to a Kazak. Around the same time, he had helped some Russians buy a shipment of *jiade* Nokia cell phone

batteries (they'd function for only fifteen days, he told me). After those sales, Polat's work as a middleman was essentially finished.

Part of the problem was the strength of the Chinese economy, which was hard on low-level foreign traders, and it also undermined the black market for U.S. dollars. Whenever Polat talked about currency rates, he emphasized the effect of government controls—a border problem in Shenzhen, or a crackdown on some corrupt Central Asian customs office. From the perspective of the money changer, these were the trends that mattered, but in fact larger economic forces shaped the exchange rates. The Chinese government wanted to maintain control over the economy, ensuring some stability during the transition years, and so they kept their nonconvertible currency pegged to the American dollar—at a bank, you received about 8.26 yuan to the dollar. But the artificial stability meant that a black market naturally flourished, serving as a proxy for other opportunities to earn money in China. When wealthy Chinese had no faith in domestic stocks or real estate, they saved American dollars or used them to invest overseas. But that situation was rapidly changing. Since 1999, property markets in Beijing and other cities had boomed, and people needed Chinese currency in order to invest. When I had arrived in the spring of 1999, I could get nine yuan to the dollar; a year later the street rate had dropped to 8.7. It was a good sign for China's economy, but that meant nothing to people like Polat. The country's growing prosperity was killing the black market.

Nevertheless, he still earned a decent living from money changing, and I knew that his language skills were far more useful in China than in the United States. I told him bluntly that, from an economic standpoint, he was better off in Beijing than in America. But he insisted that money had no bearing on his decision about where to live. "I'm not a businessman," he told me once. "I'm educated, and I used to be a teacher. This isn't my home, and this isn't the kind of life I want."

His detachment from business was remarkable. In China, everybody talked openly about money, and Polat was no different; many of our conversations revolved around exchange rates and wholesale prices. But he seemed to keep part of himself separate from that world. He spoke about his deals with bemusement, as if they had been conducted by a person he hardly knew. When he told me about the fake Nokia batteries, I asked if he worried that the Russians would get angry when they realized how bad the product was. "They know they're *jiade*," he said. "Otherwise, why would they be so cheap? Anyway, the Russians would never get mad at me. I'm just translating; I'm not producing any of this stuff."

His life was sharply divided between the pragmatic and the idealistic. He earned his living in the commercial environment of Yabaolu, but he spent much of his free time thinking about faraway places and people. His wife was over a thousand miles away; his teaching days in Xinjiang were a distant memory. When we talked about the place, he often referred to it as "East Turkestan," the name of the independent republic that had been crushed in 1949. And America seemed equally remote. He told me that he liked reading books about American history, especially Abraham Lincoln, because the president had freed an oppressed minority. Polat loved American culture; every summer he scored a worker's pass to the jazz concert in Ritan Park. He watched the *Godfather* movies over and over—even in a supporting role, *De Ni Luo* was fabulous.

Initially, I thought that these dreams were simply an escape from the grim reality of Yabaolu: the point wasn't actually to go to America, but rather to talk about it. Over time, though, I came to realize the complexity of Polat's position. The small-mindedness of business truly bothered him, and he could be remarkably snobbish about other Uighur traders. Whenever they met, Polat shook their hands warmly, but afterward he'd tell me frankly that they were uneducated and didn't understand politics. In Polat's mind, this was the quality that set him apart: he was an intellectual who had come to Beijing only because of his problems in Xinjiang.

Uighur culture had always been divided along class lines, with intellectuals holding themselves above peasants and traders. Since Reform and Opening, these divisions had become even sharper, and each group had developed its own relationship with the Chinese, who used economic development as a political tool in places like Xinjiang. Uighur peasants, who sometimes benefited from government-funded infrastructure and farming subsidies, could be passive or even amenable to Chinese rule. Uighur traders were also pragmatic, because they relied on access to Chinese goods. But many intellectuals fiercely opposed Beijing's control, and often they were bitter at what they perceived as the complicity of less-educated Uighurs.

For a man like Polat, who felt compelled to participate in trade, the anger was even more intense. And the opposite intellectual extreme—the point where idealism and faith reached orthodoxy—was equally threatening. As much as he hated the trader's small-mindedness, Polat was even more disdainful of people who, in his opinion, were obsessed with ideas. In Yabaolu, he was relentlessly critical of two groups. He despised the North Koreans—in his opinion, they were the worst Communists of all time. He also had no patience for the Afghan traders. Sometimes, they'd appear in the Uighur restaurant, usually in groups of three or four. None of the middlemen I knew had ever cut

a deal with them; the Afghans didn't come to Yabaolu to buy Tommy Hilfiger or North Face. The men were bearded, gaunt, and long-robed even in summer; there were rumors that they dealt in gems and drugs. Whenever they walked past, Polat curled his lip in disgust.

"They're the same as Communists," he told me once. "There's no freedom in Afghanistan. You have to believe in something, and you can't ask questions. That type of Islam and Communism are exactly the same."

It wasn't uncommon for Uighur intellectuals to be distrustful of Islam. In the past, the ethnic group hadn't been particularly devout, but that had also changed since Reform and Opening. In the early 1980s, the Chinese government had deliberately encouraged Islam in Xinjiang, funding mosque construction and even paying for Uighur religious leaders to make the *Hajj* to Mecca. The government hoped that religious growth would defuse unrest, but they were surprised by a series of protests in 1985. Thousands of Uighurs demonstrated in opposition to Han Chinese migration, and they also criticized the Chinese use of desert territories in Xinjiang for nuclear testing. Polat had participated in the protests, and afterward he received his first jail sentence.

The demonstrations had been primarily political, but Chinese leaders were convinced that Islam played a major role. After 1985, the government abruptly changed its strategy, responding to Uighur uprisings by clamping down on religious activities. But Islam continued to grow—many believed that both the government encouragement and the subsequent repression had precisely the same effect. And to Uighur intellectuals such as Polat, the rise of Islamic fundamentalism was almost as threatening as Maoism. He believed that the Uighurs were being driven from one orthodoxy to another.

The Uighur world was relatively small, and within that world there were few people whom Polat trusted. He regularly telephoned a couple of Uighur exiles who lived in the United States, and periodically in Yabaolu he organized dinners of close friends who worked in Beijing. All of them were intellectuals, and most had been compromised in some way—they had fallen to the level of traders, or they taught at local minority colleges, which were controlled tightly by the Communist Party.

One evening in the spring of 2000, Polat invited me to a dinner that he had arranged in honor of a close Uighur friend. In the past, Polat had told me about the man, who sometimes picked up extra cash by playing foreigners in Chinese movies. He had just worked on another film, down in the south, and now he was passing through Beijing on his way home to Xinjiang.

Polat reserved a long table in the Uighur restaurant at the Ritan Hotel, next to Hollywood. There were about a dozen men total, and I felt less out of place

than I usually did in China; most of the men, like me, had dark features and long noses. There was only one subtle sign that something was amiss—much of the conversation was in Chinese. I knew that these men didn't like speaking that language together, and I was touched that they would go out of their way to make me feel included.

All of them were Uighurs except for one, a Tatar who had been born within China's borders. He told me that, of the nation's fifty-plus minority groups, the Tatars were the only ethnicity that had no native land in the country. They were the descendants of people who had fled across the Soviet border in the first half of the twentieth century, mostly in reaction to Stalin's policies.

The Tatar was blond, and so was the part-time Uighur actor. "He's a *jia yangguizi*," Polat joked. "A fake foreign devil. You're the real foreign devil."

Usually, the phrase described Chinese who slavishly imitated Western things. I asked the man about his film work, and Polat teased him good-naturedly.

"How many times have you been killed by Chinese?" he said.

"A couple," the man said with a grin.

"That Chinese woman killed you in *The Opium War!*"

Another Uighur, a professor, spoke up. "They used a lot of students from the Nationalities University for extras in that movie. Somebody got injured on the set—I think a Kazak student."

One guest remarked that he had played a French imperialist in a propaganda film. "I executed a Chinese revolutionary," the man said proudly. He was also a professor. "That was a great day for me."

The others laughed and raised their glasses of vodka. The table filled with Uighur dishes: roast lamb, flat *nan* bread, skewers of fried meat and vegetables. As the evening progressed, and the men continued drinking, the language shifted away from Chinese, until at last I couldn't understand a word. I sat in silence, watching and listening. I liked the sound of the Turkic tongue, and the way the men's faces lit up when they spoke it. At the end of dinner, Polat stood up and slowly walked around the banquet, toasting the others one by one. On that night, at that table, in the heart of Yabaolu, it seemed as if he were at the center of the world.

AFTER A YEAR in the capital, I became more familiar with the rhythms of the city's calendar. Beijing time wasn't steady: occasionally, a week seemed to stretch forever, or it would require months to prepare for a single morning, like the National Day anniversary of 1999. There were days that the Party wanted to remember, and days that the Party wanted to forget. There were days when things had to happen, and days when nothing had to happen. And occasion-

ally there were days that created new moments to be commemorated in the future.

Often, the Beijing police made neighborhood sweeps in the prelude to some mark in the calendar. It might be an anniversary of June Fourth, or the birthday of the People's Republic, or a convocation of the National People's Congress. Either way, it felt the same—more police in the alleyways, making door-to-door checks for registration. These periods were hard on migrants, who often didn't have the proper papers, and Uighurs also had trouble. Polat always tried to lay low if an important date was coming up.

But for most people in Beijing, including the police, it was simply a nuisance. The command undoubtedly came from the top: some bureau told a lower-level bureau to be vigilant, and then the word filtered down through the layered bureaucracy. Eventually, it reached the neighborhood cops, who dutifully performed the sweeps. But usually their hearts weren't in it; they did what was necessary for appearances' sake and then moved on. Whenever they knocked on my door, I simply kept quiet and didn't answer. I never registered in the apartments where I lived, because they were technically off-limits to journalists.

Of course, any news reporter became particularly attuned to the city's calendar. For certain events, there would be preparatory articles, and then the day itself was marked by hours in Tiananmen Square, watching for protests. Most of it was uninteresting, and sometimes unpleasant; occasionally, I felt like the police—compelled to mark these days against my will. It was hard to make sense of events when everything was so scattered: a protest here, an anniversary there. And the fragmentation worked in the Party's favor. If one person went to the Square to commemorate June Fourth, and another went to mark a crackdown on Falun Gong, the two people never met. The days didn't overlap; the calendar lurched along without creating any kind of narrative.

But it felt different if you saw an event and then its echo. In that situation, a single thread stretched across the years, connecting two points in time. For me, the first day to happen twice was April 25.

April 25, 1999

The city is still new to me. In the mornings, I often ride my bicycle aimlessly, trying to get a feel for the streets. I am near the center of downtown when my pager goes off. I find a public phone and call the number: Ian Johnson, my boss at the *Journal*. He asks me to swing by Zhongnanhai, the central government compound next to the Forbidden City. There is a rumor that some people are protesting.

I head west on Wenjin Street, past Beihai Park, and then I see the crowd lined along the sidewalk, three and four people deep. Most seem to be middle-aged, and they wear simple clothes—provincials. My first instinct is to estimate the numbers: one hundred, five hundred, a thousand, two. Along that street alone, I guess five thousand, and there are more on Fuyou Street.

For a spell, I'm so wrapped up in the numbers that I notice nothing else, but then the silence strikes me. Nobody is shouting slogans; nobody is chanting; nobody is singing. No banners, no signs. The people simply stand there, staring calmly out at the street.

Passersby are confused. A few Beijing locals stop their bicycles and ask the protestors why they are there. No response. One man becomes angry. "You know what will happen," he says. "This is only going to cause trouble for everybody. Why are you doing this?"

Silence. I dismount and walk through the crowd, hoping to find somebody who will talk. I try to speak to a middle-aged woman: silence. An elderly man. Silence. A man, a woman, a man. Silence, silence, silence. Finally, a woman in her forties answers. She is better dressed than the others, and she speaks Mandarin with an accent that I cannot place. I sense that she is some sort of leader. "We practice Falun Gong," she tells me. "All we want is official recognition. People criticize us and misunderstand us, and they won't stop until the government recognizes us as a good group."

We talk briefly, and then a black sedan pulls up to the curb. The windows are heavily tinted; one of them rolls down. Somebody signals from within. The woman hurries over; a door opens, and she gets in. A couple of minutes later, she steps out and the car pulls away. But when I approach her again, she simply shakes her head. Without a word, she disappears into the silent crowd of protestors.

AFTER THAT INITIAL Falun Gong demonstration, time accelerated. In a sense, it already had: since the Communist Party came to power in 1949, there had been massive changes in China's religious climate. Initially, the Communists were critical of religion, and then they became deliberately destructive during the Cultural Revolution. Maoism was a faith that left room for nothing else—but Mao died in 1976, and the Cultural Revolution ended. Two years later, Deng Xiaoping initiated the reform period, and once more China was faced with the spiritual vacuum that had tormented the nation since the nineteenth century.

Nowadays, many Chinese seemed inspired by two semi-faiths: materialism and nationalism. But traditional religions also recovered; churches found new converts, and temples and mosques were rebuilt. Such faiths, however, were strictly limited, because the Communist Party recognized only five legal religions: Buddhism, Taoism, Islam, Catholicism, and Protestantism.

In the 1980s, a number of Chinese also became fascinated by *qigong*, exercises that involve traditional breathing exercises and meditation. These systems were never described as "religious"—any attempt to declare a new faith would have been tantamount to challenging the Party. Instead, *qigong* practitioners registered their systems as exercise and health routines. In the 1990s, a man from the northeast named Li Hongzhi started a new form of *qigong* that he called Falun Gong, or Falun Dafa. Like other systems, it featured meditation and exercise routines, but Falun Gong was clearly different. It had a charismatic leader; its books outlined points of faith as well as exercise; and many of Falun Gong's symbols and terminology were Buddhist or Taoist in origin. Regardless of how it was registered, it felt like a religion.

And it spread like one. Falun Gong outlined three basic principles—truthfulness, benevolence, tolerance—and this simple morality appealed to many average Chinese who were coping with the changes of Reform and Opening. During the 1990s, Falun Gong gained millions of believers, many of whom practiced together in morning sessions at public parks. When I had lived in Fuling, a group of Falun Gong practitioners had tried to recruit me after meeting in a teahouse. They gave me copies of Li Hongzhi's books, and they telephoned my apartment at all hours. The men impressed me as harmless fanatics—I was annoyed by the early-morning phone calls, but the believers were always polite. There was no question about their sincerity; the practice of Falun Gong gave structure to their lives.

In the late 1990s, skeptics in the Chinese media began to criticize Falun Gong as superstitious and unhealthy. A pattern emerged: if an article was unflattering, Falun Gong practitioners would organize a peaceful protest at the media outlet and demand a retraction. Many of the publications were lower-level ones, and they found it easier to back down rather than risk being blamed for stirring up trouble. In May of 1998, after Beijing Television broadcast an interview in which a professor criticized Falun Gong, more than two thousand protestors appeared at the station. This happened to occur during one of those sensitive moments in the Beijing calendar—June Fourth was approaching—and the station quickly aired another program that was sympathetic to Falun Gong. The demonstrators dispersed.

By that point, practitioners had learned that peaceful protest was an effec-

tive tool, and they had also become efficiently organized. In April of 1999, a journal at Tianjin University published unflattering comments about Li Hong-zhi, who had emigrated to the United States. Thousands of believers collected on the campus, but this time the journal refused to publish a retraction. Finally, the protestors traveled to Beijing, hoping to address the nation's leaders directly, and that was the April 25 demonstration that I had witnessed. On that day, high-ranking officials had finally agreed to meet with Falun Gong representatives, who made their case and then told the crowd to disperse peacefully.

The protest ended without incident, but a line had been crossed. For the first time, the nation's leaders realized how well organized Falun Gong had become. In the weeks that followed, the government responded with the sort of silence that was always a bad sign in China. Beijing newspapers didn't publish a word about the protest; nothing appeared on the television news. There was no debate, no public discourse, no commentary of any sort. For weeks the city waited.

And then the storm broke: on July 22, the government banned Falun Gong. There were more protests, followed by arrests; leaders were sentenced to labor camps. On October 26, the Communists stepped up the attack, initiating a shrill public campaign that declared Falun Gong an "evil cult." But practitioners kept demonstrating. Often they traveled to Tiananmen Square, where they unfurled banners, sat in the lotus position, or raised their arms over their heads—the starting point for Falun Gong exercises. Plainclothes cops staked out the square. Foreign journalists watched. Soon, Hong Kong–based human rights groups began to report incidents of practitioners beaten to death while in police custody.

In February, a grandmother named Chen Zixiu died while being held by the police in a small city in Shandong province. She was one of the many who had tried to come to Beijing to protest; a plainclothes officer nabbed Chen before she had even made it to the Square. (Practitioners refused to lie about their faith, so cops often patrolled the region around Tiananmen, asking people if they were believers.) After Chen Zixiu's death, her daughter searched for somebody to tell the story; through various connections, she eventually contacted Ian Johnson. He met the woman and published the article on the front page of the *Wall Street Journal*. After it appeared, Ian followed up by researching the Falun Gong structure, as well as the nature of the police response. He discovered that it was another instance of top-down commands: local police units were being fined for every believer who slipped through their clutches and made it to Beijing to protest. What started at the top as an idea—ban Falun Gong—materialized at the lowest levels as sheer brutality, for the stupidest, most pragmatic reason of all: money.

And then, before you knew it, April 25 had rolled around again, and the Bejing calendar had a new anniversary.

April 25, 2000

I take the mid-morning shift, just after Ian has left the Square. The sky is yellow: Beijing is in the midst of a spring sandstorm, one of those heavy-lidded days when the grit blows south from the Gobi. I can taste the wind in my teeth.

On the Square, plainclothes cops are everywhere—some pose as souvenir vendors; others pretend to be tourists. As usual, many seem to be crew-cut men in worn trousers and cheap windbreakers. Their clothes are bad, and they are bad at plainclothes: they linger and loiter; they stand and stare. They have a tendency to point. It takes only a moment to realize that these men have not been well trained, but their job is to intimidate, not infiltrate. They seem to have been given only one command: remove any protestor immediately, by any means necessary.

They watch for demonstrators, and they also keep an eye out for foreign journalists. The cameramen are doomed—guaranteed detention, almost every time. The only question is whether they can get a shot off and hide the film before the cops grab them. It's easier for print journalists, as long as we follow certain rules. Never write anything in public; don't pull out a notebook; avoid talking to anybody in Chinese. Try to blend in with the tourists. If you're detained, simply insist that you were visiting the Square.

I slip in with an American tour group. It's good camouflage—most of the men, like me, wear baseball caps. And I recognize their accent: the flat vowels and hard Rs of the Midwest. One man tells me he's from Illinois; another comes from Iowa. We gather around the young Chinese guide, who leads us to the flagpole at the north end of the Square. A lecture begins:

Red is the color of Communism. In China, it also has a traditional meaning of happiness. The big yellow star represents the Communist Party. The smaller yellow stars represent the four classes: the soldiers, the peasants, the workers, the scientists.

The lecture turns personal. The guide has a cousin who used to serve in the color guard on the Square. For hours on end, the cousin stood perfectly still next to the flagpole, and pride in the job kept him from getting tired. *Jiade* story, I think to myself, and then a small man directly in front of us drops into the lotus position.

Shouts, commands, people running: a half-dozen plainclothes cops. By the time they force the man to his feet, a van is already speeding toward us from a far corner of the Square. The protestor says nothing. He is about thirty-five years old, and he wears simple peasant clothes of blue cotton. His limbs go slack; they carry him into the van. Sheets have been tied over the windows so nobody can see inside. They drive back to the far corner.

"Goddamn," says one of the Midwesterners. "He was just sitting therre on the ground."

Another tourist, a fat man with a red face, had successfully taken a photograph.

"I got a picturr!" he shouts. "I got a picturr of that!" He grins and waves his camera. He sees me staring and walks over, face beaming. "Damn if I didn't get a picturr!"

"You should put the camera away," I say softly. But another van has already sped over. A uniformed officer points at the fat Midwesterner.

"Give me your camera," he says in Chinese.

The guide hurries over to translate. The Midwesterner hands it over without any resistance; the cop strips out the film. He speaks to the guide, who suddenly looks worried.

"He says we have to go with him," the guide says. "He wants us to go to a department. He has to ask you some questions."

The fat man stands therre with his mouth open. I decide that this is a good time to disassociate myself from Middle America. I wander off the Square for a few minutes, and when I return, a middle-aged woman tries to unfurl a banner in front of the flagpole. A plainclothes man tackles her hard. The next protestor is also a woman. She stands to the right of the flagpole and puts both arms over her head; two men run over and force her arms down.

Nearby, I spot an Italian tour group. It's hopeless—all of the men are nicely dressed—but I take off my baseball cap in a feeble attempt to appear European. The Chinese guide speaks in Italian, and I pretend to understand, imagining the words: "The big yellow star represents . . ." But a few feet away, a crewcut man watches me closely, and then he says something to another crewcut man. I decide that it's time to leave.

Suddenly, there is a commotion at the flagpole. A dozen at once: men and women, shouting slogans, raising their arms. Another banner. The plainclothes men rush over; punches are thrown; people cry out. A man falls to the ground and gets kicked. Kicked again. Kicked again. One by one, the demonstrators are dragged away.

At the end, a child stands there alone. She is about seven years old, and probably she came with her mother or father, but all the adults have already been forced into the van. The girl wears a green sweater, with matching ribbons in her hair. She hangs her head as the cops march her to the vehicle.

The Italian tour group stares at the van. Nobody says anything; the silence sits as heavy as the yellow air. The child is the last believer to be taken off the Square.

<p style="text-align:center">* * *</p>

CADRES

CENSORSHIP

CITIES

CIVIL SOCIETY

CONFUCIUS

CONSTITUTION

CONSUMER

CPPCC

CULTURAL REVOLUTION

Back in the bureau, I filed foreign reports of the protests, and I wrote stories of my own. But I couldn't make sense of it—neither the anniversary nor the scenes on the Square. Scholars often talked about the shift toward the rule of law, and I sensed that someday, after the changes in China had settled, it would seem like a progression that had moved logically from one point to another. But to live in the middle of this process felt entirely different. I could eat a meal in Hollywood, surrounded by prostitutes, black marketers, and illegal money changers; and then I'd bicycle for fifteen minutes and watch somebody get arrested for raising his arms over his head.

At the personal level, it was easier to figure out. Most simply, it was natural for individuals in China to break the law. There were endless regulations, and many of them were unreasonable; the country changed so quickly that even rational rules slipped out of date. Virtually every Chinese citizen whom I came to know well was doing something technically illegal, although usually the infraction was so minor that they didn't have to worry. It might be a sketchy apartment registration or a small business that bought its products from unlicensed wholesalers. Sometimes, it was comic: late at night, there were always people out walking their dogs in Beijing, because the official dog registration was ridiculously expensive. The dogs were usually ratlike Pekingese, led by

sleepy owners who snapped to alertness if they saw a cop. They were guerillas walking toy dogs.

Regardless of what kind of problem an individual had, it was his problem, and only he could do something about it. Without the sense of a rational system, people rarely felt connected to the troubles of others. The crackdown on Falun Gong should have been disturbing to most Chinese—the group had done nothing worse than make a series of minor political miscalculations that had added up. But few average people expressed sympathy for the believers, because they couldn't imagine how that issue could be connected to their own relationship with the law. In part, this was cultural—the Chinese had never stressed strong community bonds; the family and other more immediate groups were the ones that mattered most. But the lack of a rational legal climate also encouraged people to focus strictly on their own problems.

A foreigner inevitably felt even more isolated. I lived in the same environment as everybody else—the blurred laws, the necessary infractions—but I had even less stake in the system. Regardless of how much sympathy I might have for a protestor on the Square, I still viewed him through a screen, because there was no chance that I would ever be in that situation. I wasn't going to get beaten to death by the police or sent to a labor camp. The worst the government could do was kick me out of the country. Sometimes it bothered me, because my own Chinese life seemed a parody of certain things that I observed. But in the midst of events it was rare to find time for thoughtfulness; usually, I just had to get things done. That was one connection that I had with many citizens—all of us were coldly pragmatic.

That spring, after more than a year of query letters, I finally received an assignment from *National Geographic* magazine. They asked me to visit some archaeological sites in China, but I had to do so under official auspices, via a short-term journalist visa. The Chinese government wouldn't grant access to a writer who lived illegally in Beijing.

Fortunately, I had acquired a second U.S. passport. I flew to Hong Kong, switched passports, and applied for the journalist visa. After that, I crossed the border to Shenzhen, using my new visa, and then I continued to the archaeological sites. Once the research was finished, I returned to Hong Kong and then recrossed the border with my old passport.

I knew that this kind of routine would appear suspicious to any Chinese authority who happened to notice. If they examined me closely, they'd find other sketchy details: I didn't have a legal job, and I wasn't registered in my apartment. I spent a lot of time in Yabaolu, hanging out with Uighurs and middlemen. I had filed a police report after getting robbed on the North Korean

border. Four years ago, the United States government had sent me to China as a member of the Peace Corps, an organization that had been founded during the height of the cold war.

I assumed that the authorities knew everything—but that was different from knowing everything at once. This was only guesswork, but my sense had always been that the government was much better at acquiring information than analyzing it. Whenever I imagined their files, I thought of something infinitely bigger than those in the *Wall Street Journal* bureau, and organized according to some system that was far more whimsical than the alphabet. My journalist visa might be recorded in one place; my business visa in another; my bogus apartment registration was somewhere else.

But if I happened to attract attention, it might all come together at once. That fear was always in the back of my mind, especially now that I was finding more work as a journalist. In May, I sold my first story to the *New Yorker*, and then the magazine published my article about the robbery in Dandong. I proposed a feature about Shenzhen; the editors agreed. At last, I gave up the clipping, and after that year's World Economic Forum—another three hundred bucks a day—I swore that I was finished with brochures and propaganda. I was determined to write journalism full time, and I wanted legal status.

It was easier to get licensed with a newspaper than with a magazine, and that was one reason why I came to an arrangement with the *Boston Globe*. They wanted a Beijing stringer; there wasn't any salary or even a stipend, but the newspaper would sponsor my accreditation, as long as I arranged the necessary materials. The Chinese Foreign Ministry required endless documents: résumé, biography, business license, letter of introduction, certification of professional qualifications:

> *This document certifies that Peter Hessler is a fully-qualified journalist whose experience is commensurate with the demands of working as a foreign correspondent . . .*

I wrote everything myself. Ian showed me old applications that had been used by the *Wall Street Journal*, and then I created my own versions, sending them off to Boston to be signed by the editors. Language mattered—everything should be formal. And it was important to include details; I needed to create an official life that, even if it had no basis in reality, could be produced on paper if there were a problem. I claimed that I had spent the past year living in Hong Kong and the United States. In Beijing, I established an imaginary *Boston Globe* bureau at the *Journal*'s address; Ian signed the forms and stamped them with an official chop. At the police station, I registered as a

resident of a diplomatic compound where I had no intention of ever spending a single night.

In my biographical documents, I created a portrait of a journalist who combined remarkable qualifications with stunning naiveté. He held two university degrees, and he had a strong background in teaching and writing. He had pursued China studies without taking the slightest interest in politics, religion, or human rights. He cared nothing about Xinjiang or Tibet. He liked business stories. He was bright, but not so bright that he couldn't be dazzled by Reform and Opening:

> *Dear Press Attaché,*
>
> *For the past twenty years, China's economic reforms have resulted in dramatic changes, ranging from vast improvements in living standards to new contacts with foreign countries. With China's growing economic importance reflected by its coming accession to the World Trade Organization, the rest of the world can't afford to miss the story of today's China. As one of America's oldest and largest daily newspapers, the Boston Globe believes that covering China is critical to our international perspective. . . .*

* * *

BY MAY, THE black-market exchange rate had fallen to 8.6 yuan to the dollar. In the afternoons, Polat was rarely busy, and we spent hours on the outdoor platform of the Uighur restaurant. They no longer kept beer in the manhole; the owner had finally acquired a refrigerator. That was another dramatic change that had resulted from China's economic reforms, but the truth was that I already missed the old days. In Beijing, sentimentality was often just a year away.

Quietly, the city passed the anniversary of the NATO bombing. There weren't any protests or public commemorations; a few stories appeared in the foreign press, but that was all. The evenings turned warm, and we sat late in the restaurant, watching the traders. Some of them had also become old stories: the money changers in the black Audis, the Uighur trader who had burned his forearm with cigarettes.

One day, a group of men from the North Korean embassy stopped at the restaurant for lunch. Polat was eating with some Uighur friends, and they watched the North Koreans for a while. Finally, Polat stood up and walked over to the other table.

"I like that pin," he said, pointing to an image of Kim Il Sung on one of the men's lapels. "I'll give you one American dollar for it."

The North Korean ignored him. Polat said, "Two American dollars."

The North Koreans stood up and left without finishing their noodles. We never saw them in the Uighur restaurant again.

THAT SUMMER, POLAT purchased a new identity. One day, while visiting some clothing markets near the American embassy, he met a Chinese man who introduced himself as a "visa consultant." They struck up a conversation, and the man gave Polat his business card:

<div align="center">Cultural Exchange Company, Ltd.</div>

Polat visited the office, which was near Yabaolu. For eighty-eight hundred dollars, the man offered to arrange everything—paperwork, visa application, plane ticket. Polat returned a few times, to make sure that he could trust the company, and then he finally agreed.

The first step involved creating a believable story. The man studied Polat's passport, jotting down all previous international trips, and then he created a parallel identity that matched up perfectly. He decided that Polat should have an advanced degree from a Chinese university, and he should be involved in high-level trade with companies around the world. Most important, he should be rich.

Through contacts, the man acquired new documentation. One government-stamped paper certified Polat's advanced degree, and another document established him as the owner of a large trading company. A bank statement proved that he had the equivalent of nearly three hundred thousand American dollars in the bank. He received a new Chinese residence card that testified to the existence of four children. With so many kids to take care of, and so much money in the bank, Polat could be expected to return to China after a trip abroad. There was no reason for anybody in the U.S. embassy to suspect him.

He never told me about his new identity until everything had already been arranged. When he explained the plan, he emphasized that, technically, the documentation was not *jiade*. The papers themselves were completely authentic; it was simply the information conveyed within the documents that was false. Polat's new life was as real as paper could get.

For the American side, it was even easier—no need for government forms or bank statements. The Cultural Exchange Company had a contact in Los Angeles, who composed a letterhead for a fictitious company and prepared an invitation. The letter was brief, vague, and written in Special English:

Dear Mr. Polat,

I'm very glad to invite you to visit United States in October 2000 for two weeks.

The purpose of this visit is to inspect our product and meetings with some American companies. There are companies in the United States that are selling such products in wholesale quantity. However, you have to see the goods and negotiate the price.

The day before the visa interview at the U.S. embassy, the consultant grilled Polat for five hours, to make sure he had his story straight. The tale accounted for every trip that Polat had ever taken, claiming them for his new identity, until even the bad ones—the spoiled grapes in Nepal, the infested clothes in Kazakhstan—became the triumphant journeys of a shrewd businessman. Every step led naturally to where he was now: a rich man, a father of four, and a business owner preparing to make a routine two-week trip to Los Angeles.

The actual interview at the embassy took less than five minutes. Afterward, Polat remembered being asked only two questions: how long did he plan to stay in the United States, and had he been born, as his passport stated, in Xinjiang? Polat answered: Two weeks, and, Yes. The official stamped his passport and said, "Welcome to America."

The Voice of the Turtle

石璋如

THE UNDERGROUND CITY, LIKE SO MANY OTHER ARTIFACTS IN ANYANG, was rediscovered through the power of writing. During the twentieth century, this region became the most carefully excavated in China, and all of the work can be traced back to the oracle bones. Generations of Chinese—archaeologists with maps, peasants with Luoyang spades—have come here in search of the earliest known writing in East Asia.

The quest began with disease: a sick man, a sick nation. In 1899, in Beijing, a relative of Wang Yirong became ill with malaria, and a doctor prescribed a traditional Chinese medicine whose ingredients included "decayed tortoise shell." An old shell was purchased from a local pharmacy. Before grinding up the object, somebody noticed that it was inscribed with characters that resembled ancient Chinese writing. They showed it to Wang Yirong, who was a Qing government official, a director of the Imperial Academy, and an expert in ancient bronze inscriptions. He studied the object, and then he purchased others.

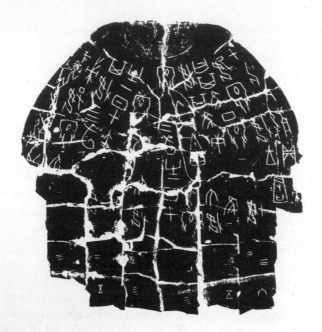

Nowadays, many historians believe that this tale of malaria is apocryphal, and there are disputes about the precise date of rediscovery. But there is no doubt that Wang Yirong was the first serious collector of the inscribed shells, and he certainly purchased them from Beijing medicine shops, where the objects were known as "dragon bones." In Chinese, scholars came to call them *jiaguwen*—"inscriptions on shell and bone."

The artifacts had uncanny timing. They appeared at the end of the nineteenth century, in the post–Opium War years, as the Chinese empire was steadily disintegrating, piece by piece: north Burma and Kowloon to Britain, Tonkin and Annam to France, Korea and Formosa (Taiwan) to Japan, Manchuria to Russia. The Germans took mining rights; the French took railroad concessions. The Americans renounced outright imperialism, and their Open Door Policy sounded protective of China, but in practice it meant more of the same. More foreign missionaries, more foreign businessmen. By the end of the nineteenth century, anti-foreign anger in Shandong province had inspired ragtag bands of peasants and laborers who called themselves the Boxers United in Righteousness. They targeted foreign missionaries and Chinese Christians; there were mobs and murders. The uprising spread across the country, and the

Qing government made halfhearted attempts to put it down, but secretly many leaders were pleased by the popular resentment.

Despite the instability, Wang Yirong made quick progress interpreting the oracle bone inscriptions. That was the true magic of the artifacts: from the moment of their rediscovery, they could be interpreted, unlike Egyptian hieroglyphics, which remained unintelligible for centuries until the excavation of the Rosetta Stone. Chinese characters are the oldest writing system still in use, and Wang Yirong suspected that the turtle shells might push back China's written history even farther. He believed that the objects dated to the Shang dynasty—a period that was sometimes described as mythical by nineteenth-century foreign scholars because no Shang writings had been found, apart from some brief inscriptions on bronze vessels.

But the Boxers worked faster than Wang Yirong. They slaughtered missionaries and foreign engineers; they cut telegraph lines and tore up train tracks. By the summer of 1900, foreign armies began to gather in the treaty ports, and there were clashes with Qing forces. In June, the empire finally sided with the Boxers, declaring war on the foreign powers. In the capital, mobs besieged foreigners who had retreated into churches and embassy compounds.

As a Qing official, Wang Yirong was asked to serve as commander of some of the Boxer forces in Beijing. He accepted, reluctantly: he knew that the Qing was too weak, but he also knew that duty was more important than reason. On August 14, an army of twenty thousand foreign troops—mostly Japanese, Russian, British, American, and French—easily captured Beijing. The foreigners entered the city from the east; the empress dowager and the young emperor fled to the west, heading toward Xi'an. But for Wang Yirong, flight was not an option, and neither was humiliation. In Xila Lane, near the heart of the old city, the scholar drank poison and leaped down a well. He was accompanied in death by his wife and eldest daughter-in-law.

After the suicides, about one thousand of Wang Yirong's oracle bone fragments were acquired by Liu E, a friend and fellow scholar.

The king, reading the cracks, said: "There will be harm; there will perhaps be the coming of alarming news."

If we raise 3,000 men and call upon them to attack the Gongfang, we will receive abundant assistance.

In the next ten days there will be no disasters.

* * *

THE BONES CONSIST of cattle scapula and turtle plastrons. These objects were probably used because they provide a flat surface for writing (the plastron is the undershell that protects a turtle's belly). In Shang rituals, the objects were deliberately weakened through the drilling of small notches into the back. Diviners then applied a hot object to the notches, until the surface cracked. Somehow, this moment captured the voices of the other world—departed ancestors of the Shang king, as well as various Powers that controlled the natural forces of wind and rain and flood. Sacrifices were offered, and the Shang often requested advice about upcoming events. In subsequent ages, this kind of scapulimancy was sometimes described as "the voice of the turtle."

The cracks were interpreted by the king and other diviners, and echoes of their statements can be found in the inscriptions. We often think of writing as history, and traditional Chinese culture is characterized by its tendency to idealize the distant past. But the irony of Chinese archaeology is that the earliest known writings attempt to tell the future:

In the next ten days, there will be no disasters.

The king goes to the hunting field; the whole day he will not encounter great wind.

Di will not put an end to this settlement.

The longest oracle bone statement is less than two hundred characters, and most are much shorter than that. Apart from some brief inscriptions on bronze vessels, this is the extent of known Shang writing. Archaeologists believe that the Shang also wrote on tablets made of bamboo, like subsequent cultures in this region—but bamboo deteriorates quickly in China's central plains. Rainwater passes easily through the dry soil, and perishable materials don't last long in a place like Anyang. This characteristic makes Chinese archaeology different from that in other parts of the world. Egyptian papyrus can survive for centuries, because of the arid climate. In the Near East, where ancient cultures wrote on durable clay tablets, excavations have uncovered a full range of documents: royal proclamations, tax records, schoolboy exercises. One can hear the words of Sumerian children as well as kings. But from the Shang, only the voice of the turtle still speaks:

Tonight there will be no disasters.

The king's dream was due to Grandfather Yi.

In performing an exorcism to Father Yi, we cleave
three bovines and pledge thirty decapitated victims and
thirty penned sheep.

The artifacts themselves have the beauty of old ivory. Centuries underground have left them with a slightly golden hue, and the years have also separated the objects from the trappings of craftsmanship. Nobody knows precisely what kind of tool was used to create the notches in the back. The Shang writing and carving implements have never been found. It's unclear exactly how the Shang acquired so many shells and bones. The artifacts have been completely disengaged from the act of creation, like a book sent from heaven.

LIU E DID a little bit of everything. He was a scholar and a physician; he ran a weaving factory and a salt business. He was known for his expertise in mathematics, mines, railways, and water conservancy. He advised the government on how to control the persistent flooding of the Yellow River. And he was a great collector of antiquities, which is one reason why he acquired Wang Yirong's oracle bones. Like his friend, Liu E worked fast, publishing the first book of oracle-bone rubbings in 1903.

But also like Wang Yirong, Liu E had bad luck when it came to foreigners and politics. Later that decade, he was punished for illegally selling government-stored millet to foreigners. The charges were trumped-up, and in 1908, he was exiled to Xinjiang—China's Siberia, the end of the world for an educated gentleman. A year later, Liu E was dead.

We should perform a beheading sacrifice at Qiu Shang.

We ritually report the king's sick eyes to Grandfather Ding.

There will be calamities; there may be someone bringing
alarming news.

* * *

A CURSE SEEMED to travel with the oracle bones; or perhaps the artifacts merely distilled a curse that had settled onto imperial China. These were hard times, as Liu E himself had explained in a novel called *Lao Can Youji*, "The Travels of Old Derelict." In his introduction, Liu E wrote:

*Now we grieve for our own life, for our country, for our society and for
our culture. The greater our grief, the more bitter our outcry; and thus
this book was written. The game of chess is drawing to a close and we are
growing old.*

Another victim of the curse was Duan Fang—viceroy of the Qing, provin-
cial governor, and one of the greatest collectors of antiquities in all of China.
He particularly loved ancient bronzes (some fine pieces originally from his col-
lection now reside in New York's Metropolitan Museum of Art and Kansas
City's Nelson-Atkins Gallery). The oracle bones also caught Duan's attention,
and reportedly he offered more than three ounces of silver for each inscribed
word. A middleman working on behalf of Duan was one of the first to trace
the artifacts back to Anyang.

Duan had a reputation for being open to foreigners; during the Boxer Up-
rising, he had sheltered a number of missionaries in Shaanxi, the province that
he governed. After the foreigners put down the uprising, the Qing government
was forced to apologize and pay indemnities, and they finally began to institute
significant modern reforms. In 1905, an imperial edict appointed five special
commissioners who would travel in Western countries, observe the foreign gov-
ernments, and return with ideas about how to create a Chinese constitution.
Along with another official, Duan Fang was chosen to lead a delegation to the
United States and Europe.

In January of 1906, he arrived in San Francisco with an entourage of sixty,
as well as 750 pieces of luggage, each of which had been labeled, in Chinese and
English, HIS IMPERIAL CHINESE MAJESTY'S SPECIAL MISSION. The timing
was slightly awkward. In the United States, racist exclusion laws prevented Chi-
nese from entering the country, but President Theodore Roosevelt declared the
Qing party exempt. Professor Jeremiah W. Jenks, acting as President Roosevelt's
personal representative, gave a speech to greet the delegation in San Francisco:

> *Of course, you will understand, as every one in the two countries does, that
> it is, and will be, the policy of the United States to exclude from this coun-
> try the Chinese laborers. On the other hand, the other classes, including
> scholars especially, and the distinguished officials who are conducting the
> affairs of the government, it does give us, and will give us, great pleasure
> to welcome. . . .*

According to contemporary newspaper reports, the Qing delegation used
the special exemption to smuggle in at least one Chinese laborer whom they
had befriended on the boat.

The trip went well. Duan Fang was part Manchu and part Chinese—sometimes, he carried two calling cards, one for each of his family names—and he cut an impressive figure. He wore a full-length fur coat during the commission's visit to West Point (where it was four degrees below zero, and where Duan Fang became particularly interested in an automatic door and a mechanical potato peeler). He met President Roosevelt in the Blue Room of the White House. He visited Harvard, Columbia, the United States Treasury, and Standard Oil. He stopped in Nebraska to see the state penitentiary. In Europe, he greatly admired the military uniforms, and after his return to China he adopted the practice of being photographed in the dress of the Chinese Imperial Guard.

But he also picked up some foreign habits that were less acceptable in China. He was dismissed from his post as provincial governor after being accused of disrespect during the empress dowager's funeral in 1909. Allegedly, Duan had permitted photographers to shoot the cortege, and a cinematographer had recorded the last solemn rites. (Duan also allowed trees within the mausoleum complex to be used as telegraph poles.) After his dismissal, he accepted a position as superintendent of a new nationalized railway, funded by foreign loans. By now, anti-Qing and anti-Manchu sentiment was building, and it finally exploded in October of 1911, when battalions of soldiers mutinied in Wuhan. The revolt quickly gained momentum, and the court ordered Duan Fang to transfer imperial troops to Sichuan province.

The leader of his own army turned against him. At the end, Duan Fang reportedly tried to convince the rebels that he was actually Chinese, not Manchu; but by then it was too late to switch calling cards. The rebels beheaded him, buried the body in Sichuan, and carried the head to Wuhan: a grim symbol of their commitment to overthrow the Qing.

On the other side of the world, on a train bound for Kansas City, Sun Yat-sen read about the Wuhan uprising in a Denver newspaper. By Christmas, he was back in China; on New Year's Day of 1912, he took office as "provisional president" of the new Chinese republic. The last Qing emperor, Puyi, abdicated on February 12. Shortly after that, Sun Yat-sen lost out in a power struggle with the warlord Yuan Shikai—a man who had married a son to Duan Fang's daughter. But neither Yuan Shikai nor Sun Yat-sen would be strong enough to lead the nation; by 1925, both were dead. China was left to the looming threats of the future—the warlords and the foreigners and the prospect of civil war.

We will pacify the Wind with three sheep, three dogs,
three pigs.

Today there will not be someone bringing bad news.

In the next ten days there will be no disasters.

<div align="center">* * *</div>

FROM THE BEGINNING, Beijing pharmacists had been smart enough not to reveal the source of their "dragon bones." They tried to corner the market, lying about the provenance of the artifacts, whose popularity quickly spread. By 1904, foreigners started collecting, inspired by Liu E's book. Many of these early collectors were missionaries: the Reverend Frank H. Chalfant, the Reverend Samuel Couling, the Reverend Paul Bergen. Often, they sold or donated the artifacts to museums: the Carnegie Museum, the British Museum, the Royal Scottish Museum.

It didn't take long for fakes to appear. In the curio markets of Beijing and Shanghai, artisans learned how to engrave Shang characters into bone, and they also learned how to spot suckers. The Reverend Paul Bergen proudly presented seventy oracle-bone fragments to the White Wright Institute, but most turned out to be forgeries: *jiade*. Meanwhile, Chinese collectors such as Duan Fang figured out the source for genuine oracle bones and sent middlemen to Anyang. Local peasants dug like crazy. In 1904, a visiting search party clashed with residents; there was a fight and then a lawsuit. Finally, a disgusted local magistrate decided: No more excavating for oracle bones.

But a ban was useless in a place like Anyang. The peasants followed the rhythms of weather and politics: they dug for bones during the hard years, when the floods ruined crops, or a drought hung heavy, or a warlord battle interrupted the planting season. Sometimes, a discovery happened by pure luck. In 1909, a local landowner named Zhang Xuexian harvested potatoes and stumbled upon an impressive cache of scapula fragments. Villagers often said that Zhang got rich by digging for vegetables. The story spread, and finally, in 1926, a group of bandits captured Zhang and held him for ransom.

Zhang's family had only one option for raising quick cash. They allowed other villagers to dig on their property, under the condition that all profits from oracle bones would be shared fifty-fifty. The peasants divided into three parties. After that initial division, however, there was no further attempt at central planning. Each group began to dig as quickly as possible, and all three happened to aim at a single spot beneath the earth. As they approached this invisible goal, and the trio of tunnels drew closer, the earth finally collapsed. Four men were buried alive; they were lucky to be rescued. That was the end of Zhang Xuexian's ransom dig.

*The king, [reading the cracks], said: "There will perhaps
be thunder."*

The king, [reading the cracks], said: "Greatly auspicious."

Tonight there will be no disasters.

* * *

THE ORACLE BONES appeared during a crisis that ran far deeper than politics or economics. By the early twentieth century, foreign armies had proved to be far more powerful than the Chinese, and foreign political systems were certainly more efficient. But some Chinese intellectuals believed that even history was a Western advantage. Westerners perceived change as natural: the pharaohs disappeared; Greece collapsed; Rome fell. Without the weight of a continuous history and the conservatism of Confucianism, Westerners seemed more likely to look ahead. And rather than being shortsighted—tonight there will be no disasters—the Western view of the future expected tangible, long-term progress.

Western history was also more fluid. There had been key moments during which Europeans had transformed their culture through an infusion of ancient values half-familiar and half-foreign, like the Renaissance and the neoclassical Age of Enlightenment. Even archaeology fit neatly into the Western tradition of change. In nineteenth-century Europe, the new discipline of archaeology was dominated by the rising middle class, whose descriptions of ancient ages—from stone to bronze to iron—reflected a modern faith in material progress.

In China, though, intellectuals looked back and saw nothing but more Chinese history. Emperors and dynasties, emperors and dynasties—the endless spiral of time. At the turn of the century, the culture suddenly felt suffocating, and radicals proposed doing away with almost everything traditional. In the early 1900s, one group of Chinese intellectuals called themselves the Doubting in Antiquity School, because they questioned the traditional historical texts that had been copied and studied repeatedly through the ages. To these skeptics, early "dynasties" such as the Xia and the Shang lacked evidence. The intellectuals perceived history as a trap—a set of hidebound traditions that had prevented China from modernizing.

These doubters dismissed the oracle bones as forgeries. In response, the defenders of traditional Chinese culture worked hard to interpret the fragments, hoping to prove their authenticity. One of the most brilliant scholars was Wang Guowei, who used the oracle-bone inscriptions to perform a breakthrough reconstruction of the Shang royal genealogy. By studying the names found on the

artifacts, and comparing them with classical histories, Wang proved that the books and the bones matched up. His work was a crucial step toward making the Shang truly historical—a culture that had left trustworthy documents.

For Wang Guowei, the oracle bones represented only one element of an obsession with the past. He was a committed monarchist; he believed with all his heart that the Qing should regain power. This vision was shared by Puyi, the last emperor, who, after his abdication, had remained inside the Forbidden City. Within the vermillion walls, life functioned as if nothing had changed. Time was still marked by the imperial calendar, dated by Qing rule, and Puyi continued the traditional rituals. In 1923, he appointed Wang Guowei as Companion of the Southern Study, a position that involved the cataloging of palace treasures. For one year, Wang lived in this last fragment of empire, studying old paintings, dusty scrolls, and bronzes that had turned green with the centuries. In 1924, a warlord finally forced the "emperor" to abandon his palace. Less than three years later, realizing that the empire was gone forever, Wang Guowei drowned himself in the former summer palace of the Qing. After his death, a fellow scholar wrote a memorial:

> *Whenever a culture is in decline, anyone who has received benefits from this culture will necessarily suffer. The more a person embodies this culture, the deeper will be his suffering.*

Later that decade, archaeology finally brought the doubters and the traditionalists together. The discipline had always appealed to skeptics, who pointed out that the oracle bones had not been "scientifically" excavated. Meanwhile, intellectuals all across China had been calling for the adoption of Western science and philosophy since the May Fourth Movement of 1919. Even the traditionalists supported archaeology, in the hope that excavations could uncover final proof of the Shang. In 1928, the newly founded Institute of History and Philology selected Anyang as the site of the first ever Chinese-organized archaeological dig.

The scholars knew that the nation was at risk and time might be short. Officially, the Kuomintang ruled China, but there were threats everywhere: brutal warlords in the north, dedicated Communists in the interior, Japanese invaders in the northeast. Over the next decade, events moved quickly, and so did the Anyang digs. In 1928, exploratory excavations near the west bank of the Huan River uncovered 784 pieces of inscribed oracle bones. That same year, the Japanese assassinated a northern warlord, as part of their campaign to establish military control in Manchuria. The Kuomintang officially established

their new capital in Nanjing, in part to avoid the chaos of the north. Under pressure from the Kuomintang, the young Mao Zedong fled to the Jiangxi Soviet, in the interior.

And so it went, year by year. 1929: Archaeologists in Anyang excavate carved ivories, animal bones, and inscribed turtle shells. 1930: Communist forces occupy the city of Changsha for ten days. 1931: the Japanese complete their takeover of Manchuria. In Anyang, archaeologists discover the lower jaw of an elephant, as well as a whale scapula and vertebrae. They marvel at the whale; Anyang is hundreds of miles from the ocean. 1932: Puyi, the last Qing emperor, agrees to become the "chief executive" of the new state of Man-chukuo—a puppet of the Japanese, a *jiade* emperor to be installed in a *jiade* imperial palace in Changchun. A year later, facing international criticism, the Japanese withdraw from the League of Nations.

In 1934, archaeologists in Anyang discover four huge tombs, most likely belonging to Shang kings. Everywhere, they see signs of well-organized human sacrifice: neat rows of skulls, careful arrangements of headless skeletons. To the south, under pressure from the Kuomintang, Mao and the Communists abandon Jiangxi and set off on what will become known as the Long March. In 1935, the Anyang expedition musters the largest work crew in the short history of Chinese archaeology: five hundred peasants a day. That year, they open ten royal tombs and a thousand graves. More skeletons, more skulls. Bones and bronze. The Long March ends in Shaanxi province.

In the next ten days there will be no disasters.

Tonight there will be no disasters.

<p style="text-align:center">* * *</p>

THE ORACLE BONES span a period of less than two centuries, ending around 1045 B.C., and the inscriptions create a powerful sense of time. The Shang follow a rigid calendar, devoting specific days to the memory of specific an-cestors. On these days, bones are cracked, sacrifices are made, and words are inscribed. Whenever important members of the royal lineage die, they acquire their own memorial days. The sacrificial calendar expands with every genera-tion that passes. In a sense, it foreshadows what will happen three thousand years later, when Beijing is ruled by the Communists: a constant accumulation of sensitive days.

During the Shang, the earlier-period inscriptions are more detailed. Often,

they reflect Shang fears: the names of enemy tribes, descriptions of royal ailments, problems with crops and weather. The rituals involve a substantial bureaucracy, and the names of many different diviners can be found on the bones. Sometimes, a bone includes both a statement about the future and an inscription noting whether that statement came true.

But such details become less common over time. On the later-period oracle bones, inscriptions tend to be simple and ritualistic: "In the next ten days there will be no disasters." Even the script changes: whereas the early characters are large and irregular, the late inscriptions are compact and uniform. There is a sense that these rituals have become well honed over the generations. By the last Shang king, history is already long—he offers sacrifices to Shang Jia, the founder of the royal lineage, who is at least twenty-two generations distant. In the next ten days there will be no disasters. This particular statement is repeated over and over, like a mantra. In truth, the Shang must have been struggling with enemies, because they were eventually conquered by a neighboring group known as the Zhou. But until the end, the inscriptions are regular; there's no written evidence that the Shang civilization is under threat. In the next ten days there will be no disasters.

IN 1936, THE spring excavation season in Anyang is scheduled to end on June 12. That final day, at four o'clock in the afternoon, excavators are surprised to find a large number of turtle shells in a pit that has been labeled H127. Within an hour and a half, they have uncovered an estimated three thousand fragments. The dig is led by a young archaeologist named Shih Chang-ju.

A year later, Shih and the others will leave Anyang for good. In December of 1937, the Japanese will take the capital of Nanjing, massacring tens of thousands of civilians. The Kuomintang will flee to the interior, eventually establishing a temporary capital in the Yangtze River city of Chongqing. And the archaeologists will become refugees, moving most of the important artifacts that they have found in Anyang. By train and boat, truck and cart, they will transport the ancient treasures across the country. Eventually, after the defeat of the Japanese, and after the rise of the Communists, the Kuomintang will flee once more, this time to Taiwan. Many of the archaeologists will follow, taking the oracle bones and other artifacts with them.

But in June of 1936, all of that remains in the future. The scene appears in an account written by Shih Chang-ju:

> *Naturally we postponed the work for one more day, anticipating that the extra time would be sufficient for the completion and clearance of the con-*

*tents of this amazing archive! But, indeed, facts are stranger than fiction.
The actual pleasure of discovery far exceeded our anticipations! The con-
tents of H127 were, unlike the other underground deposits, found to be
by no means mixed and disorderly; on the contrary they had been accu-
mulated in an orderly fashion, so it became obvious that a new method of
excavation and recording was needed.*

For four days and nights, archaeologists and peasants excavate the mass of
shells and dirt. It weighs three tons and contains more than seventeen thou-
sand fragments—by far, the largest single collection of oracle bones that has
ever been discovered. There is no road; the crew uses iron straps to fasten the
massive artifact to thick wooden planks. They carry it to the railroad station; a
train whisks it to Nanjing. Shih Chang-ju's description notes another detail:

*A human skeleton was also found accompanying these documented
antiquities.*

7

At Night You're Not Lonely

August 26, 2000

EVERY WEEKNIGHT, AFTER CURFEW, EMILY LISTENED TO THE RADIO program before falling asleep. In the jewelry factory, she shared a dormitory suite with four other women, and all of them sat together on Emily's bed, their attention tuned to a single radio. Because they were secretaries, they received better lodging than the assembly-line workers, who were housed ten to a room. But all of the women listened to the same show on Shenzhen Radio. It was called *At Night You're Not Lonely*, and each evening there were an estimated one million listeners. The host, Hu Xiaomei, was perhaps the most famous woman in the Overnight City.

From the perspective of Emily and her co-workers, Hu Xiaomei was a shadowy figure. Some details of the radio-show host's life had been published in Shenzhen magazine profiles: she was in her late twenties, and she had originally come to Shenzhen as a factory worker. She was not tall, and she was not stunningly beautiful. She was not married. She rarely spoke about her personal life, and when she did, her comments tended to be oblique. There were just enough details for a careful listener like Emily to come to certain conclusions. "I can tell that a rich man had loved her," Emily once told me. "She might have thought about it, but in the end she didn't stay with him. And even though it would have been more comfortable to be with him, she decided to rely on herself. If she hadn't done that, she wouldn't have the success that she has today."

Although she rarely spoke in detail about her own life, Hu Xiaomei had a

gift for talking about the experiences of others. *At Night You're Not Lonely* was a phone-in show; many callers were migrants who used a telephone in their factory dormitory. Some talked about work troubles, or problems with their families, but the vast majority discussed affairs of the heart. A caller might be worried about a lover back in the village, or she might talk about a bad breakup. Sometimes, a person called multiple times, her story stretching across a full week. In a city where the dorm rooms often looked the same, and factory schedules were rigid, the radio stories had endless variety. The most un-usual ones caught the attention of Emily and her co-workers: "There was one woman in her thirties who called and said that she had many one-night loves. She would meet a man in a bar and go home with him. She wanted to stop doing this; she wanted to find a stable relationship. But she just hadn't found it yet. Hu Xiaomei didn't criticize her for it. She just listened."

In Emily's view, that was the most remarkable thing about the radio host. "She doesn't make blanket judgments. She looks at each caller's specific situa-tion and then decides." Hu Xiaomei could be sharply critical, and she wasn't afraid to give specific advice, but she also knew when it was best to stay quiet. The host had a full, smoky voice, and she spoke slowly. She never got angry or frustrated. Many of the calls were of a certain type: young women asked for advice about whether they should live with their boyfriends before marriage. In the interior of China, this usually wasn't an option, because family pressure was so intense. But young people in Shenzhen had more freedom to make these decisions, as long as they weren't limited by the dormitory curfews. When-ever somebody called with a question about living together, Emily and her co-workers listened carefully. "Most traditional people say that you shouldn't do this. But if the person seems mature enough, and if she's considered the issues, then Hu Xiaomei says it's fine to live together."

By the end of 1999, Emily had worked at the jewelry factory for two years. At twenty-three, she was the oldest woman in her department. Over time, she had learned to understand the factory's social dynamics: the relations between different workers, the nature of the Taiwanese owner. He still pursued the pretty women who worked at the plant, and everybody knew that he often hired prostitutes. But the man was weak, and Emily could see it. She wasn't afraid of him.

During her second year, all of the workers from Hunan province banded together to demand higher wages. In the factory world, regional links were powerful; workers provided introductions for new arrivals from their home-towns, and sometimes an entire assembly-line staff might come from a single village. On the work floor, they could speak in their dialect and nobody else

would understand. Some managers avoided hiring too many people from one place. When Emily had looked for jobs, she occasionally saw notices: NO SICHUANESE WORKERS NEED APPLY, or NO APPLICANTS FROM JIANGXI.

At her factory, there were twenty Hunanese workers; most were men, and several were related. All of them worked on the production floor, where the unskilled laborers earned as little as twelve cents an hour. They made an acceptable wage only when an urgent order arrived, kicking off an overtime period.

Quietly, the Hunanese planned for a couple of weeks, and then all of them requested leave on the same day. Most claimed an urgent family crisis. They brought their formal request letters to Emily's office, and she passed them on to the Taiwanese boss, who didn't know what to do. Production would stop if all the Hunanese left.

The boss went to his neighbor for advice. Next door, at another jewelry factory, the Taiwanese owner was a more capable man who understood the migrant mentality. He came to Emily's plant and met with the Hunanese. At first, he listened to the men's complaints and established who were the leaders. After that, he spent some time criticizing the group for their actions. Finally, in private, he offered raises to the Hunanese leaders, as well as to their relatives.

Everybody went back to work. Some of the laborers still made twelve cents an hour. Steadily, over the next year, the boss fired certain workers, and he was careful about replacing those who left on their own, until finally the factory did not have a single male laborer from Hunan province.

THE TURNOVER WAS also high among the secretaries. All of them had some education, and there were so many things for a women in her twenties to think about: whether she wanted to get married and have a child, whether she wanted to return home. She might search for a new job or even go into business herself. Emily's letters often described movement and opportunity:

> Lulu may quit her job and start her own business in near future. Her one-person company's name will be Qian Qian Jewelry, Inc. Luyun is waiting for the coming of the day when she is above everyone except for the boss. It comes when all the other old stuff (Lulu and me) leave. Other than the three of us, there is another girl in the office named He Jinhua working as an accountant. She may not stay long as her family will help her find a job and a husband in Hunan province.

Luyun was a mystery to Emily. In the beginning, Emily's letters had described the woman as "very kind," but slowly her opinion changed. She sensed that Luyun did subtle things to undermine her colleagues, and she curried

favor with the boss, despite often criticizing him behind his back. After a year, Emily wondered what Luyun really cared about. The woman seemed entirely alone with her schemes.

One night, lying in bed in the dormitory, Emily found herself listening particularly closely to a caller on Hu Xiaomei's radio show. That week, the woman called back several times, and slowly Emily realized why this particular voice was so fascinating. It reminded her of Luyun:

"She said that she had an elementary-school education, and she had come to Shenzhen to work in a factory. Then she had a job as a maid. She felt that other people looked down on her because she came from the countryside, and she began to study on her own. Eventually, she took the self-study examination for a junior college diploma. But she didn't finish the exam series because of some problem, and so she bought a fake diploma—you can buy them here on the street. That's what she did, but it was true that she had studied hard. Her level was really that high.

"With the new diploma, she found a better job, and she worked hard, and her status got higher and higher. But she did things to make sure that others didn't threaten her. If a lower worker started to rise, she'd find a way to keep her down. She described this very honestly. And she did it only if she felt threatened. Otherwise, she was nice to everybody else at the company, and they all liked her. They didn't know what her heart was really like.

"She also talked about her family, and how she sent money home to her parents and often wrote them letters. She did all of these things, but in her heart she didn't like them. She cared nothing for her parents.

"She had telephoned the program only because she wanted to talk. It wasn't for advice, like the other callers. She just wanted to describe her experience. After she was finished, Hu Xiaomei asked, 'Aren't you afraid of other people knowing your true heart?' The girl answered that they would never understand, because she was very good at hiding things. And she said that she had no regrets about acting like this.

"After she hung up, Hu Xiaomei said that this kind of person is *wuke jiuyao*, somebody who can't be cured by any medicine. She said that the woman's heart was too hard and cold, and nothing could be done about that."

IN TRUTH, EMILY wasn't as close to her own parents as she would have liked. Her father was an accomplished mathematician, one of the highest-ranking professors at Fuling Teachers College. He had made two trips to the United States, to deliver papers at conferences, an experience that was extremely rare

in a place like Fuling. But even this success was but a shadow of what might have been. Once, when she was still an undergraduate, Emily had written an English paper that described her father's background:

> When my parents were of my age, the whole country was in a great confusion: politics went first, intellectuals were said to have the tendency to follow Capitalism, so they were assigned to basic units to accept reformation. My father was one of them. In the following eight years after he graduated from Sichuan university, he worked in a small coal mine.

The mine was located south of Fuling, in the remote mountains near the border of Guizhou province. Many intellectuals would have despaired, but Emily's father had grown up in the countryside, and he tried to make the best of the situation. At the coal mine, he repeatedly applied to join the Communist Party, which always rejected him. Like Emily, he had a broad face, high cheekbones, and friendly eyes. His quiet calmness put people at ease, whether they were educated or not:

> I'd say that it hadn't been too difficult for him working in the coal mine. As people there respected him and ordered him an easy job as an accountant. Even now his story is still spreading as a miracle among the workers that he calculated the balance just by looking through an account book.

Emily was born in 1976, while her parents were still at the mine. That year, Mao Zedong died, and the Cultural Revolution ended. When Emily was small, her family was allowed to return to Fuling. The children—two girls and a boy who had been born two years after Emily—grew up in a home that was decorated with pictures and statues of the Chairman. In the mid-1980s, Emily's father finally joined the Minmeng Party, one of the nation's nine authorized political parties. In Fuling, the Minmeng Party tended to attract intellectuals, but the organization, like all legal parties, answered to the Communist Party. "In truth they don't have any effect," Emily once told me. "My father says that once the Communist Party says something, the Minmeng Party immediately agrees. But in the meetings they can talk about their own ideas. They can't say these things openly, but at least they can talk about them with each other."

When Emily was a child, her father never spoke to her about politics, and she believed everything that was printed in her textbooks. She learned the Communist Party version of history, politics, and current events. Even the blank exercise tablets that she used in school weren't truly blank. On the back cover of every notebook, two phrases were printed:

Taiwan, the Soviet Union, and Vietnam
broadcast rumors and lies on their radio stations.
We urge everybody not to receive
the voice of the enemies.

Over time, the Chairman Mao portraits and statues disappeared from Emily's home. Occasionally, her father made a remark that suggested he didn't agree with the nation's politics, but he didn't speak at length. For Emily, college was the turning point. She was disgusted by the corruption of some of the English department cadres, and she believed that many policies were designed to prevent students from thinking or asking questions. She disliked the structure of dormitory life; during her first year at the college, she requested permission to live at home. She was the only student in her class who didn't stay in the dorm. After graduation, she wrote in one letter:

> I hate political cant because I used to believe in it. The fact that too many people in an influential position speak in one way and do in another has been revealed to me with time. I think my father was far more sad than I was when he came to realize this at last in his fifties.

*　　　　*　　　　*

THE PARENTS AND the daughters moved in opposite directions, across time. When Emily's father and mother had been young, the shift had been to the countryside, as part of the Communist Party's massive experiment in ideology. Twenty years later, Emily and her sister moved to the city—and not just any city, but Shenzhen, the "economic laboratory." The experiments of the two generations were completely different: one was political, the other economic; one happened on a national level, whereas the other took root person by person, decision by decision.

As a result, the experiences of the parents didn't provide a guide for the children. When Emily thought about her father, she realized that his professional life had been shaped primarily by decisions that had been made by others. "I think he has some regrets. Some of his classmates went overseas or did other things that are successful. He knows that he lost some opportunities." To the parents, Emily and her sister often seemed willful. In college, when Emily began dating Anry, her mother didn't approve. "She said that I was too young to have a boyfriend. I said, you got married even earlier than this! She said that wasn't the same."

But the generation gap seemed hardest on Emily's brother. He was bril-

liant—he had inherited his father's mathematical mind—but he was also painfully shy. The young man entered college to study computers but didn't finish. He preferred reading about philosophy and religion; for a spell, he was intrigued by Falun Gong. He often remarked that he loathed the concept of money. By the age of twenty-one, he had never held a job, and he still lived with his parents. Much of his time was spent playing *xiangqi*, Chinese chess, and he was a genius at this game—the logical harmony of the checkered board. After giving up on Falun Gong, he studied the ancient philosophies of Confucius and Mencius. Once, he told Emily that if she read Mencius, she would become more beautiful, because the truth would shine through in her face. She didn't know how to respond to that. The family was considering the possibility of psychological help. When asked about her brother, Emily once said, "He is a victim of modernization."

During Emily's first year in Shenzhen, her sister moved again, finding work in Zhejiang province. Soon she married, and then the parents began to worry about Emily. Emily found this funny: "When I was with Anry, they said that I was too young to have a boyfriend. Now they think I'm getting too old!" In August of 1999, Emily's father visited Shenzhen, and for the first time he met her new boyfriend, Zhu Yunfeng. Zhu Yunfeng had attended only one year of trade school, and now he was a floor-level supervisor at a plant that made hot plates, pressure cookers, rice cookers, and other kitchen appliances.

Emily's father let her know that he had hoped for a better match, but he didn't try to change her mind. He was not the bullying sort, and life had prepared him to accept circumstances that weren't ideal. In fact, his daughter hadn't decided about marriage to Zhu, or even about the concept of marriage: "I don't like the idea of having a wedding. There are always a lot of people who don't really care about you. They just want to see what the food is like, and how everything is prepared. They only go to the wedding to see what kind of wedding you have." In any case, she had no intention of seeking her parents' advice about such matters. When it came to personal issues, she listened far more closely to Hu Xiaomei.

The radio show host was the patron saint of Emily's Shenzhen. Whenever Emily talked about moral issues, she invoked Hu Xiaomei's advice as if it were infallible. Once, when we discussed the issue of unmarried people living together in Shenzhen, Emily gently told me not to question anybody directly about their situation. "Here we don't ask openly about that," she said. "For example, Hu Xiaomei usually recommends that you shouldn't tell others if you're living with a man. It could influence the way people see you, especially if you break up later. It's better if you just don't say anything about it."

Finally, after dozens of conversations—Hu Xiaomei, Hu Xiaomei, Hu Xiaomei—I contacted the radio station and arranged for an interview. Emily carefully prepped me, describing the most interesting callers, the ones who had touched her deeply in the dormitory. And she reminded me that Hu Xiaomei had once loved a rich man, but something had gone wrong.

THE RADIO SHOW host was petite, with small features and long black hair. She chain-smoked Capri menthol Superslims. We met in the private room of a Sichuanese restaurant in downtown Shenzhen. She brought another guest, introducing him as a friend who was interested in American journalism. The young man was slightly overweight, and he had longish hair—in China, a sure sign of an artistic temperament. He sat quietly, listening to the interview.

Hu Xiaomei described herself as a *ye maozi*, a "night cat." We had a late dinner; her day had just begun; she was scheduled to go on air at eleven. She told me that she was interested in American culture, even though she couldn't speak English. She admired the stories of Raymond Carver, which she had read in translation ("you can tell so much from a very small detail"). At the restaurant, she told the story of how she had come to the Overnight City.

She had grown up in a coal-mining town in Jiangxi province, where her parents worked as low-level engineers. They weren't poor, but they didn't make much money. From the time she was small, the girl wanted to leave. "I was always introverted. I used to talk to myself and pretend that I was on the radio. There were a lot of things that I wanted to say if I got the chance."

In 1992, at the age of twenty, she migrated to Shenzhen. Her first job was at a mineral water factory, where she earned seventy dollars a month. At night, she often listened to a local call-in show; such programs had become popular all across China in the early years of Reform and Opening. One evening, she finally called and got on the air. Unlike most people, she didn't want advice— she just wanted to tell listeners about her dream of becoming a radio show host. She was a good talker, and after she had finished she mentioned her work address and phone number.

"The next week, I got stacks of letters and more than a hundred phone calls," she remembered. "But the mineral water plant fired me for using their phone for personal reasons, so I had no job. I took all the letters, bundled them together, and brought them to the radio station. They asked me what I wanted to do, and I said I wanted to be the host of this show. They said that I was too young—I was only twenty years old, and I had no experience. But one official decided to give me a chance. I told him that I was only twenty and that I didn't

understand many things, but that many listeners were the same as me, and maybe I'd understand them."

She remembered the date of that first show: December 22, 1992. Less than eight years later, *At Night You're Not Lonely* was the most popular radio program in Shenzhen, and Hu Xiaomei had recently published a book. She believed that the show had aged her—listening to the stories every night—and she said that Shenzhen was a hard place for women. Divorce rates were higher than in the interior; life was less stable. "The pressure is higher here, because of the freedom," she said. "Your individual ideas are more important, because people don't know about your private life. It's not like the interior, where your family will tell you what to do. It's freedom, but that kind of freedom creates pressure."

She remarked that she was marrying late, by Chinese standards—a wedding was planned for the next year, when she would be thirty. After she mentioned the marriage, I asked about her fiancé, and the woman suddenly grew quiet. "He likes to write," she said softly. "He might not be so successful yet, but he cares about it, and that's all that matters. We care about each other." There was a pause, and then she continued:

"I don't want society's standards to be my standards. I used to date a very wealthy man, a developer in Shenzhen. All he cared about was business. Once, he installed some impressive stone lions, as part of an entrance to a new building, and he was able to charge them eight hundred thousand yuan instead of two hundred thousand. Is that supposed to be success? Selling something for four times the value?"

She lit another Superslim and inhaled deeply. "Anyway," she said, "he didn't like it that sometimes people knew him as Hu Xiaomei's boyfriend."

More than a year later, when I happened to pass through Shenzhen again, we met once more for dinner. On the telephone, she told me that this time she would bring her new husband.

I walked in the restaurant and saw the same young man who had accompanied her during our first interview: slightly overweight, longish hair. Hu Xiaomei smiled shyly and said, "I just didn't want to tell you the first time we met."

OVER THE WINTER of 1999, Emily often called and wrote. Before Christmas, she mailed me some samples from her factory: plastic beads of white, blue, and purple strung into bracelets and packaged in ziplock bags. She told me that I could give them to my sisters back at home.

But her letters grew steadily darker: "I'm afraid that I can't write more, as I have a headache from bad sleep recently." She complained that the routines of work had become numbing, and she feared that her unhappiness would hurt Zhu Yunfeng. She wrote: "Frankly, my boyfriend is smart and very good to me. Problem doesn't lie in him, but in myself. I just need time to recover from some kind of unexplicable depression. I'm trying."

She was always hard on herself. When I sent her something that I had written about her Fuling class, she responded:

> *Speaking of myself, I find it's the most difficult part to figure out. It seems you understand me more than most of my friends do—I'm just a good tempered or amiable girl in their eyes. But I'm not confident if I'm as respectable as it seems to you. It's true that I like to be alone. But partly it's because I don't know how to join the people; I can't share their joys and sorrows and cares.*

During my time as a teacher, I noticed that the top female students often seemed haunted by a sense of isolation that was rare among the boys. For the most part, the male students were less mature, and even the brightest ones enjoyed clowning around or making crude jokes. A student like Willy seemed to grow up quickly after graduating, but many of the women were already thoughtful during their student years.

One of the best freshman students in the English department had been a quiet girl who kept apart from her peers. Adam had taught her section, and after class she sometimes visited him for extra practice with her English. During the summer vacation, she returned to her hometown and jumped off a bridge. Adam and I never learned much about her death; nobody in the class had been close to her. In China, more women killed themselves than men, and the female suicide rate was nearly five times the world average—the highest of any country in the world. The suicides tended to be women from rural areas who had had some education. They weren't poor; if anything, the glimpse of a better life seemed to depress them.

Emily had always been well liked by her classmates—she was popular despite her sense of solitude. But I worried about her in Shenzhen, and at the beginning of 2000 her complaints seemed more insistent. For a while, she talked about going into business with Zhu Yunfeng, selling lathe-cutting machinery, but finally they had to abandon the idea; the initial investment was too high. She felt trapped in the factory and the dormitory. In one letter, she reported that she now earned $230 a month, more than double her starting salary. But the money didn't change anything:

I'm not happy with my job. My head aches sometimes, and mistakes happen often. Although my salary keeps raising, I have no interest in the job any more. . . .

 Do you know any kind of jobs that are interesting and do benefit to the whole sociaty? I hope to find one.

<p style="text-align:center">* * *</p>

EVERY TIME I visited Shenzhen, I tried to spend time on both sides of the city's fence. The structure had been erected as a political boundary, but it also served as a cultural divide: frames of reference changed dramatically once you crossed the barrier. In the world "beyond the gates," Emily and other factory workers often talked about Hu Xiaomei, but the middle- and upper-class residents of downtown Shenzhen rarely mentioned the radio show. A number of them told me that their world was better captured by a novelist named Miao Yong. She had also caught the attention of government censors, who banned her most recent book.

When I telephoned the writer, she suggested that we meet in a trendy Western-style café near her apartment in a downtown high-rise. She was twenty-nine years old, and she was unmarried. She chain-smoked Capri menthol Superslims. She was petite, with medium-length black hair, and she wore heavy makeup around her mouth and eyes. She told me that she admired the translated novels of Henry Miller ("his books were banned, too").

Miao Yong had grown up in Gansu province, in the west of China. Her parents were doctors from the east coast who had been sent to Gansu in the 1960s, during one of the Communist Party's campaigns to develop western China. Miao Yong attended a teachers' college in Gansu, and then migrated to Shenzhen, where she found a job as a secretary and wrote fiction on the side. In 1998, she published her first novel, *You Can't Control My Life*, which became a best seller. The book was set in Shenzhen, and it followed its migrant heroine from her first job, as a secretary, to a life of luxury and dissolution as the mistress of a wealthy Hong Kong businessman. After the book sold seventy thousand copies, it was banned by the government, which was concerned about the portrayal of drugs, gambling, and casual sex. Like many book bannings in China, this only sparked interest and boosted sales—although by then all the copies were bootlegs. In downtown Shenzhen, on street corners and pedestrian overpasses, vendors sold black-market versions. Along the sidewalk in front of the Stock Exchange, I saw one street vendor selling *You Can't Control My Life* next to Chinese translations of *Mein Kampf*.

"When I say 'you,' I mean society," Miao Yong told me when I asked about

her book's title. "I'm saying that my life is controlled by me; it's not something for other people to take charge of." She explained that materialism was a key force in the novel. "Everything has to do with money; it's the first thing for everybody. In Shenzhen, it's always a question of exchange—you can exchange love for money, sex for money, emotion for money."

Despite the ban, writing had made Miao Yong rich. After her royalties had been cut off, she turned her novel into a popular television series, purging the most sensitive material. For good measure, she changed *You Can't Control My Life* into a happier title: *There's No Winter Here*. Currently, she was writing other screenplays, both for television and film. In her next novel, she intended to be more careful about the setting—she wasn't going to identify it as Shenzhen or any other specific place. She believed that her first novel had been banned because cadres feared it gave the experimental city a bad name.

In the book jacket's author bio, the first detail was Miao Yong's blood type. Like many hip young Chinese, Miao believed that blood type helped determine character. She told me that individualism was what interested her the most about Shenzhen: "In the past, China was very collective. It was all about group thought. But now, in places like Shenzhen, you can decide exactly what kind of person you want to be." Miao Yong was type O. When I asked about Shenzhen's notorious hostess bars, she introduced me to her current boyfriend, who gallantly spent an evening escorting me to various establishments where, for a few hundred yuan, men could rent a private room, sing karaoke, and hire young women in miniskirts to chat, pour drinks, and place fruit directly into their mouths.

EMILY DIDN'T LIKE the novel. When I gave her a copy, she told me that it was aimed at the "white-collar" people who lived in the city center, within the gates. As far as Emily was concerned, that was a world apart from her Shenzhen. She told me that the book's heroine had no heart—all she cared about was money, and she went from one man's bed to another. "It's too chaotic," Emily said. "You need to control this part of your life."

Her judgment echoed that of Hu Xiaomei, who had told me bluntly that she disliked Miao Yong's writing because it was immoral. The novelist had been equally dismissive of the radio show host—in the writer's eyes, the radio program was of interest only to poorly educated women who lived in factory dorms. Despite their apparent similarities—young, independent women who had captured the spirit of the boomtown—it was clear that Hu Xiaomei and Miao Yong had nothing to say to each other. Each occupied her own separate world within the Overnight City.

Emily described herself as belonging to the realm of the factories. She lived beyond the gates, and her life was structured by the dorm; the freedom of Shenzhen repelled her as much as it attracted. She often talked about issues of morality, although she had difficulty articulating her values. Once, she told me that she had been deeply bothered by watching a Hollywood movie in which the heroine slept with multiple men. But when I asked her how Shenzhen's openness compared with the restrictions of her hometown, she said that the new city was an improvement. "It's better than it was in the past," she said. "But it shouldn't cross a certain line."

"What line?"

"It has to do with morality."

I asked her what she meant, and she rested her chin on her hand, thinking hard. "Traditional morality," she said. "Like when two people marry, they should be faithful to each other."

When we talked about *You Can't Control My Life*, I asked Emily where she thought the book's notions of morality had come from. "Most people say they came from the West, after Reform and Opening," she said. "I think there's probably some truth to this. Most people here in Shenzhen think that Western countries are better and Chinese traditions are backward." But in Emily's opinion, the book's philosophy was too dark. "It's saying that Shenzhen is a new city without any soul. Everybody in the book is in turmoil—they can't find calmness."

IN FEBRUARY, AFTER the Chinese New Year, Emily and Zhu Yunfeng started living together. They rented a three-room apartment in a small factory town about thirty miles beyond the gates, near the plant where Zhu Yunfeng worked. The concrete stairways were cracked, because of the hurried construction, but everything worked and the kitchen was well equipped. It was Emily's first non-dormitory home since arriving in Shenzhen.

Another young Sichuanese couple also lived in the apartment. Each couple had their own bedroom, but they shared the living room, which was furnished with a color television, a video disc player, a low table, and a bed that served as a couch. One bedroom featured a laminated poster of a topless foreign couple making out. A previous tenant had left the poster, and nobody had bothered to take it down. In China, such pictures were common; the fact that the featured couple was foreign seemed to make it romantic instead of offensive.

Emily didn't tell her parents about the apartment. During the week, she still stayed in the factory dormitory, but she spent her weekends with Zhu Yunfeng. One day, during a telephone conversation, her mother asked directly if

the young couple was living together. "I didn't say anything. She knew from my silence that it was true." After that, neither mother nor daughter mentioned it again.

Zhu Yunfeng had been promoted once more, and now he earned $360 a month. Combined with Emily's salary, it came to about $600 a month, and they were able to save at least half their income.

That April, on a weekday evening, Emily broke curfew for the first time. She left after work and didn't return until starting time the next morning. The boss called her into his office.

"He asked me what time I came back last night," Emily told me later. "That's the way he was—it was never direct. He didn't ask me whether or not I had come back; he just asked what time. I said, 'I came back this morning.' I didn't make any excuse or explanation. He didn't know what to say; I don't think he knew whether to get angry or laugh. He looked at me, and finally he just walked away."

A few weeks later, another young woman at the factory started to break curfew.

Not long after that, the boss took a pretty worker off the production floor and made her his "personal secretary." The woman was from Hunan, and she was eighteen years old. Emily warned the girl about the boss, telling stories about his indiscretions, and finally the man confronted Emily. First, he tried the indirect approach, asking her what people were saying about him. When that didn't work, he got to the point.

"Do you tell the other workers that I'm lecherous?" he asked.

Emily said, "Yes."

He tried to laugh it off, but it was clear that he no longer liked having Emily around. She spent her free time searching for another job, and it didn't take long for her to find a position as a nursery-school teacher. The school was also beyond the gates, but it involved no Taiwanese bosses, no factory dormitories, and no evening shifts. She was going to teach English.

In June, when she quit the factory job, the boss criticized her. "You've changed," he said. "You used to be obedient. Everything changed after you got a boyfriend."

"I didn't change," Emily said. "I just got to know you better."

THAT SUMMER, SHENZHEN turned twenty years old. The city had been designated as a Special Economic Zone on August 26 of 1980, and now it had reached a critical stage in its development. China was preparing to enter the World Trade Organization, which would mean the end of some of the corpo-

rate tax privileges that had been granted to companies in Shenzhen. And there had always been powerful enemies in the central government who believed that the special benefits contributed to corruption. In 2000, the Shenzhen vice-mayor had been arrested for his role in a real estate scam.

The local economy was still strong, but it had slowed in recent years. In the past, Asian countries such as South Korea and Taiwan had developed similar "special" cities and regions, generally known as export processing zones. These tended to follow a brief life cycle: initially, there was a boom of labor-intensive light industry, but then factories steadily moved to the country's interior, where wages were lower. Eventually, the zones shifted to high-tech industries, losing their status as a primary engine for the national economy. The cities were designed to flourish and then fade, like a flower that blooms only once.

But Shenzhen's experiment ran deeper than the economy; it also affected so many social issues. During the weeks before the anniversary, I traveled to Shenzhen and interviewed residents there about the history and culture of the Overnight City:

> "Shenzhen people are brave. The Chinese are usually afraid of new things, but the Shenzhen people aren't like that. They're willing to experiment and take a risk."

> "Shenzhen has no culture. The people here only care about money."

> "The young people here are optimistic, but the middle-aged ones are pessimistic. That's because this is a young person's city."

> "Shenzhen has a lot of similarities to America. America always offers opportunity, and Shenzhen is like that. Here you have a very free life. People don't put their nose into your personal affairs. Since I came here, I feel so happy and liberated. If I had stayed in the interior, I would never have gotten divorced."

> "People say it's like the American West, but that's not really accurate. The American West was just waiting to be exploited, and it became successful because of the railroad. Shenzhen is successful because of politics. It's all because of Deng Xiaoping. If he had wanted Yunnan to be the Special Economic Zone, then Yunnan would have succeeded."

> "I'm also an experimental object. Look at how young I went out on my own!"

"In Shenzhen nobody cares about your past or your background. They only care about your ability. Can you do it or not? That's the only question that matters."

I had never been in a Chinese city that felt as divided as Shenzhen. The fence split the factory world, but the social partitions were even more dramatic. Different generations rarely interacted, because most people's families had stayed in the interior. Emily, like other residents, frequently talked about the differences between "white-collar" and "blue-collar" people (she classified herself in the second category). Hu Xiaomei was a blue-collar heroine; Miao Yong belonged to white-collar life. In a country controlled by a single political party, and in a city where almost everybody considered themselves members of one ethnic group, it was remarkable how segregated the society could become in only two decades.

Some divides, though, were as artificial and as porous as the fence itself. Across China, Reform and Opening had introduced an entirely new framework of social class and upward mobility, but the system still felt incomplete. Even in America, which prided itself on egalitarianism, there were old families, old schools, old ways to succeed. China hadn't yet developed this, at least not in the new climate. It was hard to define how education, experience, and determination added up; success was a murky concept. The climate was perfect for impostors—even a politically sensitive city such as Beijing had plenty of bogus ID dealers. In Shenzhen, this particular trade had achieved industrial proportions. At the factory, Emily had handled worker registration, and she said that many of the employees used identity cards that were obviously false. In front of the local Wal-Mart, venders sold bogus bachelor's degrees for less than a hundred dollars. One Shenzhen ID dealer told me that he had used five different names during the past five years.

Despite the city's powerful sense of structure—the dorms and the assembly lines, the city wall and the class divisions—Shenzhen was full of people who didn't quite fit in. The Overnight City promised opportunity, but it was also true that many migrants left their hometowns out of restlessness ("there was something in the heart," as Emily once told me). In Shenzhen, a young woman might enter a factory, turn out cheap jewelry for a few months, and then move on to another job. Another migrant took her place, and on the surface, nothing changed—the factory kept producing cheap jewelry. But it was impossible to guess how the individual's ideas might change in the new environment.

It was equally hard to define what twenty years had meant in the life of this city. In the end, the government hardly tried to mark the anniversary—no

parades for the leaders, no holiday for the workers. Not a single member of the Politburo showed up to make a speech. Reportedly, an internal Communist Party directive had called for officials to downplay the anniversary.

On the day itself, the *Shenzhen Special Zone Daily* issued a commemorative edition of the newspaper. The top headline read, in huge characters

TREMENDOUS SOLICITUDE,
GREAT EXPERIMENT

The front page featured a reproduction of Deng Xiaoping's calligraphy, as well as a long proclamation from Jiang Zemin, who described Shenzhen as "a miniature of historic reforms being carried out during the last two decades." At the newsstand, I picked up two popular women's monthly magazines. The article titles didn't make a single reference to the anniversary:

ONE HUNDRED SHENZHEN FEMALE BOSSES'
EXPERIENCES IN STARTING THEIR OWN
BUSINESSES

THE END OF FIRST LOVE

WHY DO PEOPLE DECIDE TO LIVE TOGETHER
BEFORE MARRIAGE?
WHY DO PEOPLE DECIDE TO HAVE ABORTIONS?

A TRAP SET BY AN OLD MAN

ONE NIGHT'S BRIDE

INTERVIEWS WITH SHENZHEN WOMAN BOSSES

I AM NOT A LADY

* * *

ON MY LAST night in Shenzhen, Zhu Yunfeng returned home depressed after a bad day at work. That afternoon, a laborer under his supervision had been injured. The factory was working overtime on a new product, trying to fill orders, and such periods were always bad for accidents. The new product was a metal thermos. The injury hadn't been serious, but Zhu Yunfeng told Emily that he wanted to be alone for a while.

Sometimes Zhu Yunfeng talked to me about his factory, and he asked questions about life in Beijing, but for the most part he kept out of my conversations with Emily. In China, it was unusual for a young woman to have male

friends apart from her boyfriend, and Zhu Yunfeng had been exceptionally tolerant of my being around. He was a calm man, without the bullying insecurity that seemed common to many Chinese males. It helped that I was a foreigner, as well as a former teacher, but I knew that the situation was unusual. I expected that in the future I would hear less from Emily. That was a common pattern among my female students: Right after marriage, there was usually a period when they didn't make much contact. Once their lives settled—usually, after they had a baby—they got back in touch.

During my last night, Emily and I left Zhu Yunfeng in the apartment. We climbed a hill to a park that overlooked the town. It was a small factory settlement, the type of place that was common beyond the Shenzhen gates: a cluster of shops and apartment buildings wedged into a dusty cut in the hills, and then, fanning out along two main roads, strips of factories and dormitories. A number of local plants produced shoes and clothing, and there was one computer accessory factory whose top story had been gutted in a recent fire. The white-tiled walls were still streaked with black from the smoke. Emily said that nobody had been hurt in that fire, but down the road there was another plant where, a few years ago, some workers had died in a massive blaze. That factory had been producing plastic Christmas decorations and lawn furniture.

In two weeks, Emily would start her new teaching job. She worried that her English had slipped during the years at the jewelry factory, and she wondered if she would be able to discipline the children. But she liked the school campus, and she smiled whenever she talked about the new position. She kept her hair short now, her bangs pinned back with plastic barrettes. Around her neck she wore a simple necklace that Zhu Yunfeng had given her—a jade dragon, her birth sign.

It was a warm, clear night, and the stars were bright. From the top of the hill, we could see everything: the rows of blocky dormitories, their windows still glowing in the last hour before curfew. It was after eleven o'clock. I wondered how many people there were in each room, and how many rooms were tuned to the radio. Emily had brought her old battery-powered set, and we sat on top of the hill and listened to *At Night You're Not Lonely*. The volume control on the radio was broken, and Hu Xiaomei's voice crackled thinly in the night air. We strained to hear.

The first caller started crying because she regretted the way she'd treated her old boyfriend, who'd finally left her. Hu Xiaomei told her that the experience should be good for her; maybe next time she'd get it right. The second caller missed his high-school girlfriend, who was far away, working in another

part of the country. "Haven't any girls here smiled at you?" Hu Xiaomei asked. The third caller was upset because her boyfriend had recently asked for some time apart; he was a wonderful man who agreed with her even when she wasn't right. Hu Xiaomei said, "If a man listens to you when you're wrong, then there's something wrong with him."

Down below, the factory lights disappeared in groups. Sometimes, a row of windows along a floor suddenly became dark, or an entire building of illuminated squares shut off at once. It was never a matter of individual lights going out. The workers in the rooms didn't control the switches; everything followed the set schedules of the curfews.

The last caller was a woman who had been living with a man for years, but she continued to have affairs. She didn't know why—her boyfriend had money, a good career, good habits. When Hu Xiaomei pressed her to explain the infidelity, the woman asked if the host had read Miao Yong's novel.

"I don't like that book," Hu Xiaomei said sharply. "You shouldn't base your life on that. The question is, what's wrong with your principles?"

Emily looked at me and grinned. The show ended at midnight, the static crackling into a rush of advertisements, and then, down below, the last factory lights snapped off. The landscape disappeared into darkness.

For a while, we sat there in silence, and I remembered something else that Emily had said, a few days earlier. She had tried to put some historical perspective on the changes in cities like Shenzhen. "In original society, people lived in groups," she said. "Eventually, these groups broke down into families, and now they're breaking down again, into so many different people. Finally, it will be just one single person."

She paused and looked unhappy. "If you could have some kind of perfect socialism, that would be the best," she said. "But it's impossible. That was just a beautiful ideal."

I asked if she wanted to leave Shenzhen, and she shook her head. In her opinion, the isolation had some good aspects, because it pressured people to make decisions. "The result is that people will have more ability," she said. "And they'll have more creativity. Afterward, there will be more different ideas. It won't be a matter of everybody having the same opinion."

I said, "How do you think this will change China?"

She fell silent. I had no idea how I would answer the question myself, although I liked to think that once people learned to take care of themselves, the system would naturally improve. But I had seen Shenzhen's fragmentation—the walled city, the walled factories, the solitary people far from home—

and I wondered how all of it could ever be brought together into something coherent.

I looked at Emily and realized that the question wasn't important to her. Since coming to Shenzhen, she had found a job, left it, and found another. She had fallen in love and she had broken curfew. She had sent a death threat to a factory owner, and she had stood up to her boss. She was twenty-four years old. She was doing fine. She smiled and said, "I don't know."

Immigration

October 2000

THE LAST TIME POLAT AND I CHANGED MONEY, THE RATE HAD dropped to 8.4 yuan to the dollar. He was smoking heavily now, Hilton after Hilton, and his face was drawn. He wanted to get rid of his Chinese currency, so I brought 450 American dollars. After we finished the transaction, he introduced me to another trustworthy money changer in Yabaolu. It was a nice gesture, but I knew that my black-market days were coming to a close. The street rate had fallen so low that it was hardly worth it, and I didn't expect to spend much time in Yabaolu after Polat was gone. The neighborhood wouldn't be the same without him.

That week, we met several times at the Uighur restaurant. Polat told me that he was considering the possibility of settling in four cities in the United States: Los Angeles, New York, Washington, D.C., and Oklahoma City.

"Oklahoma City?" I said.

He saw the look on my face and quickly continued. "I've heard that Oklahoma is hot and the wind blows very hard," he said. "People say it's a bad place, like the southern parts of Xinjiang."

I told him that was more or less true. Polat explained that a number of Uighurs had settled near Oklahoma City, where some of them studied at a local college. A small community had also formed around Sidik Haji Rouzi, a Uighur intellectual who was based near Oklahoma City. He often contributed to Uighur-related broadcasts for the Voice of America. His wife, Rebiya Kadeer, had formerly been a successful entrepreneur in Urumqi, and for years

the Chinese government had praised her as a model of ethnic minority achievement. But then her husband's VOA broadcasts crossed some invisible line, and back in Xinjiang, she was arrested on charges of revealing "state secrets." Most people believed that she had done no more than send Chinese newspaper clippings to her husband. Since the arrest, Rebiya Kadeer had become the most famous Uighur political prisoner, but the efforts of foreign diplomats had failed to win her release (several years later, in 2005, she would finally be allowed to leave China).

Polat said that Oklahoma was just one option; there were also a number of Uighurs around New York City and Washington, D.C. The main thing he worried about was making it through immigration at the Los Angeles Airport. He planned to overstay his visa and then apply for political asylum, and friends had told him that his odds were better if he made it to Oklahoma City or Washington, D.C. In both places there were lawyers who had worked with other Uighurs in the past.

During our conversations, Polat often asked for advice, but he was planning to enter a world that was completely foreign to me as an American-born citizen. I intended to visit the United States in the winter, and I told him that I could introduce him to Chinese-speaking friends in the major cities. But I knew nothing about the asylum process. From the beginning, I had been skeptical of Polat's American plans, but now I feared serious trouble. I knew that if he failed to get asylum and was deported, there was a chance of his spending time in a Chinese prison. But he trusted the advice he was getting from Uighurs in America.

Often, it sounded like he was preparing for a game with obscure rules and frighteningly high stakes. Uighur safe spots were scattered around the country, from Los Angeles to Oklahoma City to Washington, D.C., and one of the game's fundamental rules was that making it past immigration at the airport improved one's odds at asylum. Later, I learned that Polat was actually right about this detail. If an individual requested political asylum at a U.S. airport, he could be placed in "expedited removal," a process that determined whether his application was credible. Even if the case was accepted for further review, the individual might be detained, which made it harder to consult with a lawyer. Sometimes, detainees were placed in the county jail, along with common criminals. One immigration lawyer told me that he had visited an applicant for political asylum who was being held in leg irons in a Pennsylvania county jail.

<p style="text-align:center">* * *</p>

TWO NIGHTS BEFORE Polat left Beijing, we met for dinner in the restaurant next to Hollywood, and I wrote out a personal check for two thousand dollars. The visa consulting company had warned Polat not to bring too much cash, which might arouse suspicion in the Beijing airport. I made the check out to a Uighur émigré who had a bank account in the States. At the restaurant, Polat counted out the dollars and handed them over. It was the first time that one of our exchanges had left me with a pocket full of American currency.

"What do you think that I should wear for the flight?" he asked.

"Well, your invitation says that you're a businessman," I said. "So you probably should look like a businessman. I'd wear a suit."

"What about this suit?" he asked. "Does it make me look like a business-man?"

The suit was dark blue, cheaply tailored, and shiny with use. It made him look exactly like a Uighur money changer.

"Do you have another one?" I said, as tactfully as possible.

"This is my best suit."

Polat's wife had flown in from Urumqi to see him off. She was a school-teacher in her late twenties; our conversation was limited because she didn't speak much Chinese. It was the first time I had ever seen Polat with a woman, and he was solicitous, taking her hand at dinner. She looked even more nervous than he did.

The last night, I met the couple for dinner once more, along with a group of Polat's Uighur friends. It was a Friday night; the visa consultants had sched-uled his trip for Saturday, because they believed that the immigration checks at American airports were looser on weekends. Polat didn't drink much, but he chain-smoked throughout the meal. Afterward, he made his way around the table, saying farewell to everybody. When he shook my hand, I said, "The next time we see each other, it will be in America." But I doubted the words even as I spoke.

HE DIDN'T SLEEP on the plane. He had packed only one small bag, a *jiade* Samsonite that had cost six dollars in Yabaolu. The bag contained his suit, two shirts, one pair of pants, and a few books. The visa consultants had told him to pack lightly (they also advised him against wearing the suit). He dressed in jeans and a new button-down shirt, another knockoff—Caterpillar brand.

After his plane landed in Los Angeles, he gathered his bag and joined the line for immigration. When he reached the front, he handed over his passport and tried to appear as calm as possible. The official took one look and pulled him aside for questioning.

He led Polat into a small room. There were six officials, including a Chinese-speaking interpreter. When asked about the trip's purpose, Polat told the story of his trade company and produced the *jiade* letter of invitation. One official left the room to telephone the number on the letterhead.

While Polat waited, another officer escorted a Chinese man into the room. The man had also been a passenger on the flight from Beijing. He was about forty years old, and he did not seem particularly nervous. But the officials appeared upset; they chattered in English to the interpreter, gesturing animatedly. Finally, the interpreter asked the Chinese man what had happened to his passport.

"I tore it up and flushed it down the toilet," the man said.

"Why did you do that?"

"Because I no longer want to be a citizen of the People's Republic of China," the man said calmly. "I am in the United States to apply for political asylum." He pulled some papers out of his pocket. "This is my testimony."

The officials left the room in order to discuss the matter. After a while, one of them returned.

"Mr. Polat," he said, "you can leave now."

Two Chinese contacts from the visa consulting company were waiting outside the terminal. They said that their colleague had answered the immigration officials' telephone call. Polat gave them five hundred dollars cash, the final installment of the fee, and they drove him to the Los Angeles Greyhound station. For October, it was unseasonably hot.

At the station, Polat bought a one-way ticket to Oklahoma City. He had a couple of hours to kill, and he spent them in the waiting room, watching people. Having grown up as a member of a minority in the People's Republic, Polat was naturally attuned to ethnic differences, and this sense had been further sharpened by years of trading. At the Greyhound station, he noticed that some of the people looked a little like Uighurs. He guessed they were probably Hispanic. The bus was not crowded and he found it to be a great improvement over the vehicles that he had known in China.

Polat enjoyed the trip, especially the scenery in New Mexico, but he didn't like Oklahoma. It was hot and the wind blew very hard. He met Sidik Haji Rouzi, the Uighur correspondent for the Voice of America, and he also spent time in Shawnee, where some Uighurs had settled after receiving scholarships to Oklahoma Baptist University. They hadn't become Baptists, but some of them worked at a small factory that manufactured credit cards. To Polat, life in Oklahoma seemed bleak; he sensed something unhealthy about the ethnic situation. Months later, he would explain bluntly: "There were lots of Indians

in Shawnee. The government gives them houses. They drink every day and they don't work."

After ten days in Oklahoma, Polat bought another one-way Greyhound ticket. The bus took him east through Arkansas. There were more trees in Tennessee than he'd ever seen. Back in Beijing, my cell phone rang early one morning.

"I'm in Washington," Polat said. He told me that he was staying with some other Uighurs in the nation's capital, and he expected to start English classes the next week. I asked if everything had gone smoothly.

"No big problems," he said. "There are some things I still have to take care of, but I don't want to talk about them on the telephone. *Mingbai le ma?*"

"I understand," I said. He promised to call back in a couple of weeks, and I told him I'd visit in January. Before hanging up, he asked me to say hello to his Uighur friends in Yabaolu.

9

The Courtyard

October 26, 2000
8:20 A.M.

AFTER A YEAR IN BEIJING, I FINALLY MOVED OUT OF MY OLD APART-
ment. Never in my life had a place been so acutely defined by everything that
hadn't happened there. I had never cooked a meal in my kitchen, and I had
never spent an evening watching television. I hadn't invited any of my Beijing
friends to visit me at home. I hadn't purchased any furniture, or hung anything
nice on the walls. I never received any mail there—in fact, I didn't even know
the proper address. I spent most of my evenings out, and I often took long trips
into the provinces, equipped with a tent and sleeping bag. It wasn't unusual for
me to be gone for two weeks at a stretch. That was the freelancer's life—wan-
dering and writing.

I always returned to a changed city. Once, I came back from a reporting trip
and went to my favorite noodle restaurant in a neighborhood near my home,
only to discover that the whole area had been cleared away to make room for
a new apartment complex. Beijing homecomings were jarring: a month-long
journey could make me feel like Rip Van Winkle. New districts were constantly
springing up throughout the capital, replacing old sections that were demol-
ished one by one. In the past, central Beijing had been characterized by neigh-
borhoods known as *hutong*. The word originally came from a Mongolian term
for "water well," and it had come to describe alleyways flanked by courtyard
homes. By the end of the 1990s, the *hutong* were fast disappearing, but there

wasn't a word for what replaced them. The pace of development was so intense that speed was always the first priority, and most new buildings were completely undistinguished: quickly designed, cheaply built, badly finished. They looked temporary, like awkward new neighbors who don't fit in and probably won't stay for long.

In a floating city, I led a floating life. I lived in an apartment where nothing had happened, in a city that was best defined by what no longer existed. Finally, after a year of being unmoored, I decided to search for a home with some stability. Beijing had recently passed a law protecting twenty-five *hutong* districts, and I found an apartment in one of these sections: Ju'er Hutong. It wasn't a legal address for foreign journalists, but I figured that I could dodge the cops whenever an anniversary rolled around. I was willing to do almost anything to live in a part of old Beijing that wouldn't be demolished.

Ju'er was located along the line of parks and *hutong* that stretched northward from the Forbidden City all the way to the site of the former Beijing city wall. The neighborhood was quiet—the streets were too small for buses, and big construction projects weren't allowed. Nothing was taller than a few stories, and many buildings were single-level structures known as *siheyuan*, or "courtyards." Unlike the high-rise sections of the city, there weren't many echoes in Ju'er, whose sounds were few and distinct: wind rustling in the scholartrees, rain slipping across tile roofs. In the mornings, vendors on bicycle carts rode through the alleyways, calling out the names of their products. Beer, vinegar, soy sauce. Rice, rice, rice. Freelance recyclers wheeled through the *hutong*, looking to purchase Styrofoam or cardboard or old appliances. Once I heard a man calling out, "Long hair! Long hair! Long hair!" He had come to Beijing from Henan province, where he worked for a factory that exported wigs and hair extensions, mostly to be sold to African-Americans. In the *hutong*, the hair dealer paid as much as fifteen dollars for a good ponytail. One woman came out of her home with twin black braids wrapped in a silk handkerchief— her daughter's clippings, saved from the last haircut.

Some residents kept makeshift pigeon coops on their roofs, and they tied whistles to the birds, so that the flock sounded when it passed overhead. In the old parts of Beijing, that low-pitched hum, rising and falling as the birds soared across the sky, was the mark of a beautiful clear day. In late afternoons, the trash man pushed his cart through the *hutong*, blowing a whistle. The sound faded as he made his way out of the neighborhood; usually he was gone just before sunset. Nights were silent. That was my oasis—a desk beneath a window in Ju'er Hutong.

But peace was fleeting in a city like Beijing. Shortly after I moved to Ju'er,

a neighbor told me that there was something I should look into. A few blocks away, beyond the border of the protected district, an old man was fighting to keep his courtyard home from being destroyed. The courtyard was possibly four hundred years old; the man was eighty-two. He had filed two lawsuits against the government. The neighbor warned me that these things often moved quickly, and he was right. It took exactly seventy-eight days.

August 9, 2000

The man was old, but he wasn't frail. He was taller than most young Chinese, and he carried himself like the soldier he once had been, more than half a century ago. At the age of eighty-two, he still played tennis at least twice a week. His eyes were tortoise-like: dark and hooded. But they sparked every time he talked about the doomed neighborhood.

"The *hutong* and courtyard homes are something that other countries don't have," he said. "This house is older than the United States of America!"

He often spoke in English. His name was Zhao Jingxin, and people called him Zhao Lao, a term of respect that means "Old Mr. Zhao." He belonged to a generation of the Beijing elite that was disappearing as fast as the *hutong*: the Mandarins of the Kuomintang period, who had grown up in a world both Chinese and Western. Old Mr. Zhao's father had been a Chinese Baptist theologian with an honorary doctorate from the Princeton Theological Seminary, and he had educated all four of his children in English as well as Chinese. Old Mr. Zhao, like his siblings, had spent time in the United States. During the Second World War, he worked for the U.S. Army in Honolulu, teaching Chinese to American troops who were preparing for an invasion of Japanese-occupied China.

The invasion never happened, and once that war ended, another one picked up—the struggle between the Communists and the Kuomintang. By the late-1940s, it was clear that Mao's troops would take the nation, and the young foreign-educated Chinese faced a crucial decision. Two of the Zhao brothers stayed in the United States, but Old Mr. Zhao and his sister returned to China. They eventually became English teachers at Beijing universities.

"My father wanted us to come back," Old Mr. Zhao explained. "He said that China was our home."

I interviewed him with Ian, who had also heard about the lawsuit. Old Mr. Zhao received us in his living room, where the windows faced south, toward the brick-lined courtyard that baked in the August sun. He shared

the home with his wife, Huang Zhe. They had been married in 1953—forty-seven years together in this patch of old Beijing.

Their home occupied less than a quarter of an acre. It consisted of two small courtyards surrounded by single-story buildings, their roofs topped with interlocking gray tiles. Red pillars of wood flanked the entrance to the main building. Certain details had been modernized: the windows were glass instead of the customary paper, and Old Mr. Zhao had installed plumbing. But the home's layout still followed the simple lines of tradition. The main compound was arranged on a north-south axis, with four separate buildings standing around a central courtyard. This outdoor space functioned in different ways, according to the season: in winter, when residents had to move from one building to the next, they crossed the courtyard quickly; in warm weather, they shifted some of their daily routines outside, enjoying the square patch of sky.

The outdoors connected the four buildings, but it also divided them. In traditional Beijing homes, that space sometimes defined the way that an extended family occupied a single compound. Old Mr. Zhao told us that, in the past, his father had lived in the western building, while Old Mr. Zhao's sister had occupied the one to the east. She had gone by the English name of Lucy Chao; her Ph.D. had been from the University of Chicago, where she had written a dissertation on Henry James. In China, she was a prominent translator. In that eastern wing of the courtyard, the woman had spent a decade translating the first complete Chinese version of Walt Whitman's *Leaves of Grass*. The book had been published in 1991, and Lucy Chao had died seven years later.

According to Old Mr. Zhao, the home was more than three centuries old, although the exact age was unknown. But the authorities had never designated the compound as a historic relic, and in 1998 the district government had informed Old Mr. Zhao that they needed to tear it down. He filed a lawsuit against the district Cultural Relics Bureau for failing to add the courtyard to the list of protected properties. For Old Mr. Zhao, it was particularly infuriating because they wanted to tear it down in order to build the most mundane of modern structures: a branch of the China Construction Bank.

"For more than a year, nothing happened," he said. "Before October 1 of 1999, they were careful about tearing things down, because it was the fiftieth anniversary of the country and they didn't want trouble. But after that, they started up again. With some of the people in this area, they just cut off the water or electricity, to make them leave."

In July of 2000, the case went to court. Old Mr. Zhao's lawyer accused the Cultural Relics Bureau of shoddy research—twice, officials had visited the home, and each time they had spent only a few minutes wandering through the buildings before declaring that the compound shouldn't be designated a relic. In court, independent experts testified that the home dated at least to the early Qing, and possibly the Ming (the dynasty that ended in 1644). They even located the complex on a map from the eighteenth century. But none of that evidence mattered: the court decided that the definition of a cultural relic depended strictly on the Cultural Relics Bureau's definition. If the bureau said it could be torn down, then nothing else mattered.

But the old man refused to give up. He was well connected—this was one reason why he acted so fearlessly—and he filed a second lawsuit against the district housing office. This department, in accordance with the rules for demolition, had offered to compensate Old Mr. Zhao according to the quality and size of his home. The settlement came to nearly three million yuan—over three hundred thousand American dollars. Old Mr. Zhao's suit claimed that the figure was too low, although he told us that this was just a legal tactic.

"It has nothing to do with money," he said. "This house is mine. My father bought it, and I've lived here for more than fifty years. Listen to what the famous architect I. M. Pei says—he says that Beijing has already razed too many courtyards. Ask any foreigner what he remembers about Beijing, and he'll say the *hutong*. Now, if the foreigners want to protect places like this, why don't the Chinese? Right now, in all of China, there are only two cities that are still intact: Pingyao and Lijiang. That's all that's left after five thousand years of history!"

He referred to two small cities, one in the north of China and the other in the southwest. Now the old man shifted back to English, speaking the words clearly. He held his head back—jutting jaw, flashing eyes.

"As a Chinese person, I have a responsibility to protect this place. I won't leave willingly. The court can come, the police can come, the ambulance can come. They can force me to leave, but I won't sign my name and agree. For them, I have just two words: Not moving."

<div style="text-align:center">✳ ✳ ✳</div>

IN CHINA, OTHER former capital cities had a longer history than Beijing, but none was so deliberately and carefully created. The city bore the imprint of the Ming emperor Yongle, who had a flair for big ideas. The fleets of Yongle's reign sailed all the way to Indonesia, India, and the southern tip of Africa. In Nanjing, the original Ming capital, it was Yongle who had attempted to carve out the largest stone tablet in the world.

His plan for Beijing was even more ambitious. In 1421, Yongle moved the capital north from Nanjing, to a city that had formerly been a center for northern people such as the Mongols. In the past, there had been cities on the site, but Yongle approached it more or less like he did the massive slab of limestone—as a blank slate. He organized the new capital along traditional Chinese notions of geomancy; everything was arranged on a strict north-south axis, with the imperial palace facing south. The city reflected a vision of a holy body: certain temples and landmarks corresponded to the head, hands, feet, and other organs of the god Nezha. Over the centuries, the city expanded, but it never lost its original layout.

In the first half of the twentieth century, as modernity transformed so many cities around the world, Beijing remained relatively intact. Political instability stunted China's growth, and then Nanjing became the capital once more, under the Kuomintang. Even during the Japanese occupation, Beijing's physical layout wasn't threatened. In fact, the Japanese planned to preserve the old city, concentrating all new development in a separate satellite district. This plan was never implemented, and in 1949, after the Kuomintang fled to Taiwan, the Communists made Beijing the capital of their New China. There was nothing else in the world quite like it—a major capital city, designed in the fourteenth and fifteenth centuries, that had hardly been touched by modernity or war.

But Mao Zedong, like Yongle, was a ruler with big ideas. He envisioned Beijing as an industrial center, and the city's old gates and walls were considered an impediment to progress. One by one, they were torn down, for various reasons. In 1952, Xibian Gate was destroyed, in order to harvest bricks. From 1954 to 1955, the Gate of Earthly Peace was demolished, in order to build a road. Chaoyang Gate, in 1956: condemned because of disrepair. Dongzhi Gate, 1965: a new subway line. Chongwen Gate, 1966: subway line. Before the Communists came to power, the fifty-foot-high city wall and its gates had been among the city's most distinctive features, but by the end of the 1960s virtually all of the structures had been torn down. During the Cultural Revolution, most of Beijing's remaining temples were either destroyed or converted to other uses.

But many *hutong* survived Mao. His vision of industrial development was basically just a vision: there wasn't an economic reality behind his theories.

He could tear down the city wall and the major gates, but he never created the prosperity necessary to change the neighborhoods where most people actually lived. After the Cultural Revolution, much of central Beijing's residential layout was still medieval.

Once the reforms gained momentum, however, the market did a much more thorough job of demolition than Mao. Beijing boomed—the population had been about seven hundred thousand in 1949, and it grew to more than twelve million by the end of the 1990s. Roads needed to be widened, and there was a financial incentive to replace *hutong* with apartment blocks. Banks made more sense than courtyards. In the life-span of old Beijing, the last decade of the millennium was the one that brought the greatest physical change to the city.

Despite the transformation, much of the ancient nomenclature survived. Along the Second Ring Road, there were subway stops and intersections known as Chaoyang Gate, Dongzhi Gate, Chongwen Gate, among others. None of these gates existed in the physical sense, but their names still represented important landmarks. If you went to the Gate of Earthly Peace, you saw traffic lights, pavement, and restless red cabs itching to pass through the memory of a building that had once marked Beijing's northern axis. A cabbie could take you to Hongmiao—"Red Temple"—but there wasn't a temple there anymore. Fuxing Gate didn't exist; Anding Gate was just a name. Old Beijing was becoming a city of words: an imaginary place that residents invoked when they went from one point of modernity to another.

The final word was always *chai*: "pull down; dismantle." In Beijing, that single character was painted onto structures that were condemned to demolition, and you saw the word everywhere in the old parts of the city. Usually, the character was about four feet tall, surrounded by a circle, like the *A* of the anarchist's graffiti:

As Beijing changed, that word gained a talismanic quality. Residents cracked 拆 jokes, and local artists riffed on the character. One shop sold baseball caps with encircled 拆 embroidered onto the front. When I hung out in Ju'er Hutong, a neighbor named Old Wang liked to make 拆 puns. "We live in *chai nar*," he used say. It sounded like the English word "China," but it meant "Demolish where?" Old Wang remarked that ever since he could remember, people had been tearing down ancient buildings in Beijing. In 1966, along with other schoolchildren, he had been enlisted in a volunteer brigade that helped 拆 the old city wall near Anding Gate.

September 21, 2000

Throughout the fall, a steady stream of Chinese reporters visited Old Mr. Zhao. His lawsuit was part of a new trend—during the late 1990s, there had been a number of significant private suits against the government, including some class-action cases. Whenever a suit was successful, it received prominent coverage in the Chinese press, as a sign that the government was fair. But most lawsuits failed, and those were the ones you never heard about. They remained in the purgatory of reform, where cases could be made but never won, and reporters could investigate but never publish. A few articles about Old Mr. Zhao's lawsuit appeared in minor provincial newspapers, but there was a strict media blackout in the capital. The Beijing reporters visited the courtyard as a kind of ritual: they paid homage to the story, even though they couldn't tell it.

Censorship of the press was one reason why relatively few Beijing residents seemed to worry about the destruction of the old city, but there were other factors that contributed to the passivity. In the *hutong*, many homes were without plumbing; residents used public toilets, and they were often happy to move to new apartment blocks. It was hard for them to conceive of the other option: modernize without destroying the ancient layout, the way European cities had. Finally, it was rare for a structure to embody a straight line of human history, like Old Mr. Zhao's courtyard. During the political campaigns of the 1950s and 1960s, squatters from the proletariat class had been encouraged to occupy the homes of the wealthy, and many courtyards had been subdivided by makeshift structures. After Reform and Opening, it wasn't hard for developers to remove these squatters, who generally didn't hold legal title to the property.

Even when contracts were well documented, as in Old Mr. Zhao's case, the law didn't provide complete protection. The national constitution—which had been adopted in 1982, after the Zhao family had already owned their home for more than three decades—stated clearly that all land belonged to the nation. Individuals could buy and sell land-use rights, but the government could force a sale if the property was necessary for national interests. But the national interest was a murky concept in *Chai nar*, where power was being decentralized. Often local authorities were the ones who really mattered, and they could twist the "national interest" to serve their own ends.

According to Old Mr. Zhao's lawyer, if the courtyard was demolished, the land-use rights would be sold three separate times. First, the district government would acquire the rights from the old man, and then it would

immediately resell them at a profit to the state-owned developer. Finally, the developer would raise the price again, selling them to the bank, which was also government-owned. In other words, three different government bureaus would buy and sell the land among themselves before anything was built. Along the way, the price would increase roughly ten times the amount that had been paid to Old Mr. Zhao.

The second lawsuit focused on this arrangement, accusing the government of not offering the true market value. The suit was decided on the morning of September 21, at the Number Two Intermediate People's Court. At 9:15, the judge entered the courtroom, told everybody to stand up, and read the decision: Old Mr. Zhao and his wife must vacate the courtyard within five days. If they refused, the local authorities had the right to forcibly remove the couple and tear down the structures.

Outside the courtroom, where a Beijing television crew waited, an argument broke out between the old man's lawyer and the government representatives. The lawyer swore he'd find a way to appeal; the two sides shouted back and forth. The television crew filmed the argument. It did not appear on the evening news.

September 25, 2000

Old Mr. Zhao and Huang Zhe still hadn't left. The old woman looked nervous; she told me that there were rumors the police might come any time. But her husband seemed invigorated. "They'll have to force me to move," he said. "Otherwise, I'm not leaving."

Late September is one of the best seasons in Beijing, and the temperature on that day was perfect. We met in the main courtyard, just as the afternoon shadows were starting to slip eastward, toward the building where Lucy Chao had translated Whitman. Some rose bushes stood out in front, bare for the coming winter. A huge yellow crane loomed high above us—construction was already under way on one of the bank buildings next door. Almost all of the neighbors had already moved out.

Earlier that morning, Old Mr. Zhao had played a tennis match at Tsinghua University, against some other retired teachers. He told me that he had won, six games to two. He seemed upbeat, showing me a number of anonymous letters of support that had been dropped into the mail slot of the courtyard's front door. One note had been signed "A Citizen of the Capital."

The couple had no children, and friends had told me that they suffered a great deal during the Cultural Revolution. Old Mr. Zhao never spoke in detail about that period; whenever the subject came up, he brushed it aside. When I asked about his brothers in the United States, he said that one was a retired freelance writer. The other brother was a retired geologist named Edward C. T. Zhao, who had spent his career with the U.S. Geological Survey.

"You know how the U.S. landed on the moon," Old Mr. Zhao said. "They brought back moon rocks, and there were many geologists who wanted to study them. Four geologists were chosen, and my brother was one of them. He was quarantined afterward for two weeks. They didn't know what kind of germs might be on the rocks."

The afternoon shadows crossed the courtyard, and we moved inside, to the main living room. I asked Old Mr. Zhao if he had ever had second thoughts about his decision to return to China after the war.

"None of us has any regrets," he said. "My brothers took their road, and I took mine. Of course, in 1998, when the government first said they were going to 拆 this home, my brothers invited me to go to America, but I didn't want to. I'm a Chinese, and even if I went to America, I'd still be a Chinese."

Throughout the 1950s and 1960s, Old Mr. Zhao hadn't seen his brothers. In 1972, the geologist made his first trip back to China, as part of an American delegation that arrived in the wake of President Nixon's visit to Beijing. Inside his living room, Old Mr. Zhao pointed out a gift from one nephew: a commemorative plate from Springfield, Illinois, with a sketch of Abraham Lincoln in the center.

Every time I passed through the courtyard, there was something soothing about its regularity: the right angles, the square buildings. I imagined what it had been like with the patriarch in the west, the daughter in the east, the son in the north. But the sense of order broke down once I entered the living room, whose walls reflected the different worlds that had passed through this single home. Alongside the Abraham Lincoln plate hung an award from the Beijing Tennis Center. Near that, an orange plastic Wham-O Frisbee dangled from a television antenna. Above that, two calligraphy scrolls, memorials to Old Mr. Zhao's father. A black-and-white photograph of the patriarch. A painting of Jesus teaching the Pharisees. A Chinese landscape. A plastic Santa Claus. More calligraphy. Another tennis trophy.

Outside, the September evening settled silently, and the old man kept talking, always shifting back and forth, English and Chinese, Chinese and English.

THE CHINESE TOOK enormous pride in their history, especially around foreigners. The descriptions of a continuous civilization could be lulling, and it took me a while to realize that in fact I had seen almost no buildings that were truly ancient. Initially, I believed that this was simply because they had all been demolished. The twentieth century had been destructive, and I assumed that architecture was one of many elements of Chinese culture that had suffered.

But when I saw old buildings that had actually survived the centuries, like Old Mr. Zhao's courtyard, they usually consisted of materials that had been replaced over the years. His home, like the Forbidden City or any traditional Chinese temple, was built of wood, brick, and tile. In China, few buildings had been constructed of stone. Some sections of the Ming dynasty Great Wall were faced with stone, but that was a defensive structure, not a monument or a public building. Chinese structures simply weren't designed to withstand the centuries.

Many of the people who seemed most concerned about architectural preservation had links with the West. Old Mr. Zhao spoke in terms of cultural preservation, and he put me in contact with another Beijing activist, a half-Chinese, half-French woman who was trying to preserve the *hutong*. But average residents of the old city seemed less interested in these issues, even when they were forced to vacate their homes. Often, they were angered by the corruption of local officials, and they complained that they had been unfairly compensated. But the issue tended to be personal rather than cultural; I rarely sensed a deep attachment to the *hutong*.

In the past, the Chinese had paid remarkably little attention to architecture. During the Song dynasty (960–1279), there had been some effort to identify and classify the features of traditional structures, but otherwise there wasn't much methodical study. Architecture remained an open field in the 1920s, when two young Chinese, a man named Liang Sicheng and a woman named Lin Huiyin, went to the University of Pennsylvania to study. In 1928, after completing their degrees in architecture, they married and returned to China.

For much of the following decade, the young couple developed the first systematic classification for native Chinese architecture. They traveled throughout the north, searching out old buildings and making painstaking sketches. Not far from Beijing, they found the Temple of Solitary Joy, which dated to 984. In Shanxi province, they located the Temple of Buddha's Light, which had

been built in 857. This remains the oldest known wooden temple in China. Later, after the Communists came to power, Liang Sicheng unsuccessfully campaigned for the preservation of the old city wall.

In 1940, he described the difficulty of his and his wife's research: "Since there existed no guides to buildings important in the history of Chinese architecture, we sought out old buildings 'like a blind man riding a blind horse.'"

Often, the couple depended on peasants for information:

My experience was that local people were not interested in architecture. When I told them I was interested in antiquities they would guide me to their stone stelae inscribed in earlier times. They were interested in calligraphy . . . , impressed by the written word, not the carpenter's handiwork.

After reading Liang Sicheng's comments, I thought of my former students in Fuling. Even in the English department, they had been assigned hours of practice in Chinese calligraphy; often I walked into the classroom and saw dozens of students hunched over their brushes, writing a single character over and over. They could tell me immediately who had the best calligraphy in the class, and who was second, third, fourth. And it had shocked them that my own English handwriting was so sloppy. They couldn't believe that somebody with my background—educated in literature at two universities—still couldn't write.

In Fuling, my students had recognized some beauty in the written word that wasn't apparent to a Westerner like me. And in Beijing, I sensed that I saw something in the old city that wasn't obvious to most locals. Ever since childhood, like any Westerner, I had learned that the past was embodied in ancient buildings—pyramids, palaces, coliseums, cathedrals. Ionic, Doric, gothic, baroque—words I could recall from junior-high lessons. To me, that was antiquity, but the Chinese seemed to find their past elsewhere.

October 20, 2000

The old man was irritable. He had dressed neatly, in a gray turtleneck and blue blazer, and he received me in his living room. But his eyes moved impatiently and he resisted my attempts at small talk. He had won a tournament match that morning, but he refused to tell me the score. "If I play eighty-year-olds, it's not interesting," he said with a wave of his hand. "They're too old."

All legal appeals had been exhausted. The final hope was that a top-ranking cadre would take a personal interest in the case, but that was unlikely. Old Mr. Zhao told me that some friends had arranged

another apartment, in case the 拆 command was made. All around their courtyard home, other buildings had already been reduced to bricks and dust; earlier in the day, the final neighbors had moved out. The elderly couple were the last people in the *hutong*.

He showed me some of the parts of the house that he hoped to preserve. The antique doors in the main building would be donated to the Modern Literature Museum, along with an ancient engraved decorative brick known as "Elephant's Eyes." We stepped outside, and the old man escorted me across the darkened courtyard. The afternoons were growing shorter now; the temperature was crisp. He pointed out a spot in the courtyard where, decades ago, a bomb shelter had been excavated.

"That's from the Cultural Revolution," he said. "Mao said that everybody had to have a bomb shelter. America was the number one enemy at that time."

He still insisted that he wasn't going to move until they forced him. "The law courts will come, the police will come, the ambulance will come," he said grimly. "It will be exciting."

A Chinese newspaper reporter arrived, and the three of us moved to the living room. The reporter was young, and she seemed intimidated by the old man and the foreigner. Or perhaps she struggled with the futility of documenting a story that couldn't be told. Stammering, she asked her first question: "Have you moved your things yet?"

"What do you think?" the old man shot back. "Can't you see that all of my things are right here?"

The woman looked at the walls: the calligraphy and the patriarch, Abraham Lincoln and the boy Jesus. She smiled weakly and tried another question: "Are you unhappy?"

"Of course we're unhappy! Wouldn't you be unhappy? We've been threatened by this for two and a half years, and now we're in our eighties!"

Politely, I excused myself and left the courtyard. The maid closed the door behind me. I headed north, walking back across the invisible line that marked the protected district. At home in Ju'er Hutong, everything was quiet.

October 23, 2000

At three-thirty in the afternoon, my cell phone rang.

"They're going to 拆 it on Thursday morning," the old man said. "There's nothing more I can do."

He explained that they would move in with some friends, temporarily. There was no emotion in his voice. He spoke in Chinese, and then he switched to English.

"That's all I have to say. There's no other reason for my phone call." He hung up before I could respond.

October 26, 2000

I awoke knowing that this would be a long, grim day. It happened to be a Falun Gong anniversary: at one o'clock, protestors were planning to demonstrate on Tiananmen Square. But first, in the morning, I walked south from Ju'er, listening to the early sounds of the *hutong*. The vendors were out—beer, vinegar, soy sauce. Rice, rice, rice. Birds whistled in the scholartrees, their voices thin in the autumn air.

The courtyard sat just south of Kuanjie intersection, on the east side of the street. An eviction notice had been glued to the front door. Nearby, on the old gray wall of the compound, somebody had pasted an advertisement for the Beijing City Economic Crimes Exhibition—a deliberate touch of *Chai nar* irony, perhaps.

Old Mr. Zhao and his wife had left the day before. They went quietly: no police, no ambulance. But even without their presence, the demolition became an event. Dozens of reporters, both Chinese and foreign, gathered before eight. At exactly 8:20, fifteen court officials arrived. They dressed identically: white shirts, black suits, black ties. Red badges pinned to their breasts. They secured the building, making sure that nobody was inside.

At 8:30, a flotilla of white police cars arrived. More than fifty officers surrounded the complex, assisted by plainclothes cops. They cleared the sidewalks, stringing up plastic yellow police barriers. They bullied passersby and harassed reporters. A couple of photographers had their film confiscated; a few foreign television reporters were detained. One Chinese journalist was slightly injured in a scuffle.

The workers came last. They were migrant laborers from Sichuan province; one of them told me that he had been hired for less than two and a half dollars a day. Each man carried a pickax. The Sichuanese started on the roof—chipping off tiles, spraying up dust. The walls were next: plaster, mortar, brick. Dust, dust, dust. 拆, 拆, 拆. A bulldozer swung in from the southern entrance. Dump trucks followed. It was a beautiful autumn day; the sky was high and blue and there was not a cloud in sight. By late afternoon the courtyard was history.

ARTIFACT E

The Bronze Head
发展中考古

THE PAST IS UNDER CONSTRUCTION. IT LIES UNDER HOUSES, BENEATH
highways, below building sites. Usually, it reappears by chance—somebody
digs, something turns up. In the end, luck discovers most artifacts in China.

This pattern is humbling to any archaeologist or historian, because even
the most magnificent discoveries have the most mundane derivations. Some-
body gets sick and the tortoise shell that he buys for a cure happens to be an
oracle bone. In 1974, during a drought in northern China, peasants outside of
Xi'an dig a well and strike the Terra-cotta Army of Qin Shihuang. In 1976, as
part of a national campaign to emulate the model commune of Dazhai, the
residents of Anyang are instructed to level all hills in order to create better
farmland. It's another genius idea of Mao Zedong's, and it has no agricultural
value—but the digging uncovers the tomb of Lady Hao, which contains the
richest collection of Shang bronzes and jades ever found.

The pace of rediscovery accelerates with Reform and Opening. Now the
driving force is economic rather than political—no more campaigns to "Study
Dazhai." And the market, which proves skilled at destroying old cities, is an
equally efficient excavator. This is the *yin* to the bulldozer's *yang*: old cities like
Beijing disappear, and courtyard homes like Old Mr. Zhao's are torn down,
but the construction opens up ancient tombs and underground cities at an unprec-
edented rate. *Chai nar*'s economy develops the past even while destroying it.

In Jinsha, a construction company is building a strip known as Commer-

cial Street when the workers stumble onto a cemetery that is at least three thousand years old. A highway crew outside of Xi'an uncovers pits containing the terra-cotta figures of Han Jingdi, the fourth emperor of the Han dynasty. In Luoyang, developers dig the foundation for a shopping mall and find a royal tomb that dates to the Eastern Zhou. Archaeologists work like salvage crews: whenever a construction project unearths an ancient site, the specialists are called in to finish the job.

On July 23 of 1986, at eight o'clock in the morning, in the Sichuan province village of Sanxingdui, a group of peasants are digging clay in order to make bricks when they suddenly uncover a cache of beautiful jade pieces. Archaeologists step in, and over the course of that summer they excavate two huge burial pits that date to around 1200 B.C.—contemporary to the Shang. The archaeologists find eighty elephant tusks; more than four thousand cowry shells; artifacts of gold, jade, stone, amber, and pottery. Most impressive are the bronzes, whose technical quality and artistic style are clearly the work of an advanced civilization. The bronze figures include a tree that is more than thirteen feet in height, a statue of a man that stands over eight feet tall, and more than fifty bronze heads. The style of the bronze figures is completely unlike anything ever discovered in China—in fact, the next known example of human statuary doesn't appear on the archaeological record for nearly a millennium. The Sanxingdui figures don't look remotely like the artifacts of Anyang, which is seven hundred miles away. The pits in Sichuan contain no oracle bones or inscribed bronzes—not a single word of writing. Nobody has any idea who made this stuff.

IN CHINA, WHERE political power traditionally derives from the center, it seems natural to imagine culture the same way. Chiang Kai-shek believed that minorities such as the Uighurs and Tibetans were originally Chinese; they had simply drifted away from the central plains, and then their language and customs changed because of centuries of isolation. During the early twentieth century, archaeologists described ancient China in roughly similar terms. Civilization developed along the middle Yellow River Valley, in parts of the central plains like Anyang, and then the culture spread outward. The Chinese envisioned their roots as unified—and a desire for unity motivated them to excavate in Anyang during the years of invasion and civil war. Archaeology helped hold China together.

Elsewhere in the world, during the middle of the twentieth century, such notions of cultural diffusion came under attack. In the Near East and the Mediterranean, many specialists recognized that such ideas could be politically

motivated, and they began to explore other possible explanations for cultural development, such as exchanges between different groups. China was slow to adopt such theories, in part because of its modern investment in the notion of unity and continuity. But there was also a narrow body of evidence: most archaeology had been focused on Anyang.

Beginning in the 1980s, however, the culture of Reform and Opening helps prepare people for different ideas. There's a sudden sense of discovery as migrants and travelers start to recognize the nation's diversity. In the 1980s, authors such as Gao Xingjian (*Soul Mountain*) and Ma Jian (*Red Dust*) take long journeys and later publish books that describe obscure corners of their country. By the late 1990s, Tibet and Yunnan are becoming popular tourist destinations for middle- and upper-class Chinese. Minority cultures are celebrated for their differences, albeit in a kitschy way—dance troupes, colorful costumes.

Meanwhile, construction sites uncover artifacts that don't fit neatly into the traditional perception of ancient China. In the 1980s, archaeologists in the southern region of Hunan and Jiangxi argue that their bronze vessels are so different from the Shang that they should be considered a separate culture. Initially, most Chinese scholars resist such theories, but the evidence of Sanxingdui marks the tipping point. After taking one look at the bronze heads, it's impossible to argue that the culture simply emanated from Anyang. There's an obvious artistic independence, and the same can be said for the artifacts in Hunan and Jiangxi. Archaeology helps break China apart.

In the end, so much depends on circumstance—what happens to be found, how the find happens to be perceived. A person's relationship to an artifact can be shaped by nationalism or regionalism. Perspective is critical: if one believes that he stands at the center, then diffusion seems natural. But a culture looks completely different if you approach it from the outside and then work your way back in.

Perspective I

Distance: 7,536 miles. Location: Room 406, McCormick Hall, Princeton University, Princeton, New Jersey. Commentator: Robert Bagley.

Professor Bagley is a scholar of ancient Chinese bronzes, and he has a reputation for brilliance and exactitude; often he criticizes the tendency of historians and archaeologists to make assumptions without evidence. He has clear blue eyes and a careful way of speaking. When I interview him for a *National Geo-*

graphic article, he emphasizes that traditional mindsets in China have been slow to respond to new discoveries.

"The classical historical tradition," he says, "is always interested in seeing a single line of development, from an early ruling empire that passes down legitimate rule to its successors, so they don't talk about anything outside that one line of descent. And the oracle bones of course see everything from the Anyang king's point of view—it's like that *New Yorker* map, where most of the world consists of Manhattan."

He continues: "One of the difficulties here is that archaeological funding has been concentrated on Anyang and other northern sites, because the written historical record tells you that this is what matters. But there is a real irony in that the really sensational finds have been accidental, in places like Sanxingdui. Sanxingdui is telling us something that we never saw the likes of before."

Scholars have theorized that the culture of Sanxingdui may have had links with Central Asia, or India, or Burma. But these aren't neat connections: the bronze heads don't closely resemble other known artifacts. It's possible that they are simply the work of an advanced civilization that developed in Sichuan and then disappeared.

"There is a point of view," Bagley explains, "in which you could say that no find outside the Yellow River Valley, no matter how strange or spectacular, is as important, because twenty-five hundred years of Chinese tradition says that the middle Yellow River Valley is where we all come from. Now, to a foreigner who doesn't have a psychological investment in what is China, then I can look and say, well, a lot of interesting things were going on around 1300 B.C. Some of those things became very central to Chinese history in later periods. Some of them, for reasons that aren't clear, don't seem to have a big afterlife. In Sichuan you don't have people continuing to make big bronze statues. But if you just look at 1300 B.C.—forget the word 'China,' because there's no yellow patch on the map. If you just look at the eastern end of the Asian continent, there are a lot of interesting things going on, and there's a lot of diversity. There are highly civilized societies in several places that are in touch with each other, related to each other—but distinctly different."

No writing has been discovered at Sanxingdui, but that doesn't necessarily mean that the culture was illiterate. The ancient people may have written on perishable materials. In Anyang, writing survived because it was inscribed into oracle bones and bronzes, which last for millennia. Most scholars believe that the Shang also wrote on bamboo or wood, but such materials wouldn't survive centuries underground. The only evidence for their existence is indirect: an

oracle-bone character that is believed to be an early form of 冊, *ce*, the modern character that means "writing tablet." The Shang form of this character resembles strips of bamboo or wood laced together with a leather strap. The object itself is long gone, but the word remains:

"The writing certainly contributes to the importance of Anyang in Chinese eyes," Bagley says, "because it's the ancestor of the writing system that's in use today. But the fact that we have writing in Anyang may be the merest fluke. What do we have? We have divinations on bones. You can imagine that the kings at Anyang are always keeping records, but on perishable materials. Then imagine that there's some king, around 1200 B.C., who says, why don't we carve on the materials we're using for divination? That's when the archaeological record begins. It could be simply the whim of some king."

Because most historical dynasties were based in the north, the traditional perception has always been that the south was backward. But archaeological finds indicate an early development of agriculture in southern regions such as Sichuan.

"I'm just deeply impressed by this evidence that there was early rice cultivation in the middle Yangtze," Bagley says. "The standard Chinese view has always been that the Yangtze region was the swamps, and it never got civilized until the northerners came, bringing civilization with them. My suspicion is that that's just radically wrong."

He continues: "In archaeology, you're reconstructing a picture of the past that is based on what has been found. But what has been found is a very accidental selection of stuff. It's been found by road building crews, and brick factories, and farmers digging in their fields. You know what's been found—but you don't know what hasn't been found."

PERSPECTIVE II

**Distance: 943 miles. Location: Office B1509, Eaglerun Plaza,
No. 26 Xiaoyun Road, Beijing. Commentator: Xu Chaolong.**

Xu Chaolong is a lapsed archaeologist. He has not been defrocked, and he has not lost his faith, but he has slipped away from academia. Not long ago, he was considered to be one of China's most promising young scholars. He grew up in Sichuan province, graduated from Sichuan University, and then, in 1983, received a scholarship to Kyoto University in Japan. Some of his graduate research involved the Indus Valley; later, he studied the archaeology of his home province. He won major Japanese awards and fellowships. In 1990, having completed his Ph.D., he accepted a faculty position at Ibaraki University.

He is a classically trained violinist; he met his Japanese wife while giving her lessons on the *erhu*, a Chinese stringed instrument. He speaks and writes Japanese fluently. He has published eight books on archaeology, mostly about the Yangtze River region, and each of these books was written and published in Japanese. Not a single one has been translated into Chinese. Xu Chaolong says that he has been too busy to do it himself. Since 1998, he has worked for Kyocera Corporation, a Japanese company that makes cell phones, cameras, and photocopiers. He researches archaeology in his spare time.

Other scholars view Xu Chaolong in vastly different ways, depending on their nationality. Some young Chinese archaeologists say that he went into business only to please his Japanese wife. Foreign archaeologists claim that he was frustrated by the narrowness and conservatism of the field in China. Everybody—both Chinese and foreign—agrees that his deep love for Sichuan is both an inspiration and a limitation. He is a regional patriot. And whereas a foreign scholar like Professer Bagley speaks of Sanxingdui in terms of culture and politics, Xu Chaolong's vocabulary is primarily economic—the language of a young man who grew up in Deng Xiaoping's China.

When we meet, he shows me one of his Japanese-published books: *The Fifth Great Civilization*.

"Traditionally, the four great ancient civilizations were the Egyptian, Mesopotamian, Indus Valley, and the Yellow River Valley," he says. "Now look at the importance of rice—the whole world eats it. But the civilization that came from the rice-producing region isn't recognized. And in fact, most of the modern Chinese leaders are from rice areas. Chiang Kai-shek, Mao Zedong, Deng Xiaoping, Zhou Enlai, Zhu Rongji, Li Peng, Hu Jintao—all from the south. Ever since the fall of the Qing, southerners have been leading this country.

"The northerners controlled China for two thousand years, and of course it has an effect on the way archaeology is approached. But we need to recognize that Chinese civilization has more than one heart. There were two ancient centers that eventually became unified."

We sit in a Japanese-minimalist room. There are four couches, a table, some silk flowers, and a plastic palm plant. There aren't any windows; nothing hangs on the white walls. The room seems to heat up as Xu speaks. He talks quickly in Chinese, using short, clear sentences, and he becomes more animated as the interview progresses. He shifts nervously; he cracks his knuckles. He speaks faster and faster. He wears a crisp white shirt and a blue-and-gold silk tie. Gold-rimmed glasses. Gold and silver Rolex. I ask him why he came to work at Kyocera.

"They sponsored a project I did at the International Research Center for Japanese Study. I was researching Yangtze culture. After a while, the boss here told me that I had some talent in business. He said I could be like Heinrich Schliemann, the German who discovered the ancient city of Troy. Schliemann did both business and archaeology. My boss said: You can be that guy.

"This is a period of great change in China—the economics are changing, the politics are changing. And where does the power for change come from? From the south. And the rediscovery of the Yangtze rice culture will have a great effect on the changes of China's economy. Why should the south lead Chinese economics? Because that's the way it was in the past. The Yangtze wasn't a barbarian region.

"The key word is: Rice. Thirty-three percent of the world's population survives on rice. The source of this crop should be considered the source of a great civilization; we can call it the Rice Civilization. Along the Yellow River, it was the Millet and Wheat Civilization."

At the end of the interview, he tells me again that politics have warped Chinese archaeology. "In the past, it was important for leaders to have a concentration of political control," he says. "But this is an economic century, not a political century. The economy speaks out, and it will change the concept of power. Jiang Zemin recently visited the Sanxingdui bronzes, and I know from a friend there that Jiang was very interested. Look at the rest of the government—why are so many leaders from the south? They have their own great ancient civilization, and they need to discover it, to explore it. Once they explore their past, the people will have more confidence. They'll have more power to develop their economy; they'll have more voice in the political system. Politics, economics, and culture are inseparable."

PERSPECTIVE III

**Distance: a few hundred feet. Location: a farmhouse in
Sanxingdui, Sichuan province. Commentator: Xu Wenqiu.**

Xu Wenqiu stands less than five feet tall, but she has a solidness that is common
for middle-aged peasant women. She has calloused hands, sturdy legs, and
wide feet. Her cheap tennis shoes are decorated with the American flag. When
I explain that I'm researching a story for *National Geographic*, she says that
she has never heard of the magazine. I ask her about the morning back in 1986
when she and the other villagers were digging clay.

"It was the eighteenth day of the sixth month, in the lunar calendar," she
says. "I remember it very well. People were digging, and they found the jade
at eight o'clock. The next thing I saw was everybody running away. They all
disappeared, and so did the jade!"

She laughs, and the crowd of neighbors joins in—interviews in the out-
doors are never private in a village like Sanxingdui. It's a cool morning, and
the rapeseed is in season; around us, fields shimmer a brilliant gold. The wom-
an's simple home is made of mud walls and a tile roof. Nearby, the modern
shape of the new Sanxingdui Museum rises above the fields like a mirage. The
woman tells me that back in the summer of 1986, all of the jade was returned
immediately.

"Some archaeologists came out to inspect it, and then they found that
famous gold mask," she says. "But Teacher Chen told us that it was bronze—
he tricked us. He had us cover up the pit, and then later that day the military
police came. Really, that mask was gold. Teacher Chen was just afraid that
something would happen. That was on the second day.

"That summer we helped them excavate. That was our job. Sometimes we
dug, or we used brushes to clean things off. They paid us less than one hundred
yuan a month, although they also gave us food. Well, I wouldn't really call it
food. It was more like crackers. They were cheap."

I ask her if she thinks that other artifacts are still underground.

"That's hard to say."

"Well, what sort of things do you think might still be there?"

The woman stares at me. There are moments when a journalist catches
himself fishing for quotes—leading questions, obvious setups. And then there
are moments when a peasant catches a journalist fishing. A sly smile crosses
the woman's face.

"Well, if you're so interested, then maybe you should start digging," she
says. "I'm not going to stop you."

The crowd laughs. I stammer and try to change the subject; I ask about her husband, who was one of the original excavators and does some part-time maintenance work at the museum.

"He's out today," she says. "You know, his photograph hangs in the museum. It's a picture of him and some of the other people who dug the pits. That photograph has been to many countries all over the world. But the museum still pays him only two hundred yuan a month."

"Well, that's not so bad, if he has to work only some of the time."

"What do you mean, it's not bad?" she says. "You probably make that much in an hour!"

More laughter. I ask about their farm: they have one-sixth of an acre; they grow rice in the summer, wheat and rapeseed in the winter, and the vegetables are—

"How much money do you make?" she says suddenly.

"Uhm, it depends. It's not the same every month."

"I bet it's a lot," she says. "You live in Beijing, right?"

I nod my head.

"I can dream for days and I still can't imagine Beijing!"

Laughter.

"Chongqing is the farthest I've ever been," she says. "It must be nice. I bet you never have to pay for anything yourself. Eating, traveling, going around in cars—your work unit pays for all of it, don't they?"

I admit that this is basically true.

"How much money do you make?"

My last hope for distraction is the digital camera. I take the woman's photograph and show her the screen. "It's a type of computer," I explain.

"My brain's a type of computer, too," the woman says, playing on the Chinese word for computer, *diannao*, "electric brain." She glances at her audience and then delivers the punch line: "But it doesn't work anymore!"

Later that week I meet with Chen Xiandan, the vice-director of the Sichuan Province Museum—"Teacher Chen" to the peasants. The man grins when I mention the woman's comment about the gold mask. "We stopped digging once we found that," he says. "At that point, I was worried." He tells me that they found the mask at 2:30 in the afternoon, and the military police didn't arrive until five. It was those two and a half hours that he worried about.

PERSPECTIVE IV

**Distance: one thin layer of cotton. Location: the storeroom of
the Sanxingdui Museum.**

The provincial museums are my favorites. Invariably, their curators are thrilled to see a foreign journalist, and they will do almost anything to make sure that I have good access. They seem to believe that writers work best through contact. Sometimes, they become excited and hand me a series of artifacts, one after another, moving faster all the time, until I'm afraid that I'm going to drop something. Feel the edge of this sword; see how heavy this one is. Look at this bowl. Check out this goblet. It's like drinking *baijiu* as the honored guest at a banquet: toast after toast, until finally I have to push myself away from the table. I'm afraid that I've had enough. My tolerance isn't what it used to be. Thank you for your hospitality.

At the Sanxingdui Museum, they won't let me handle the pieces with my bare hands. I'm provided with a pair of white cotton gloves, but they are as thin as linen; I can feel the texture of the bronze through the material. The metal is cool and roughened by the centuries—the bumps and irregularities that give ancient bronze its character.

They have arranged a half dozen heads on a table, lying on their side, and I walk around and pick up each one. Two caretakers watch; occasionally, I ask a question, but mostly we are quiet. It feels like a classy jewelry shop—they give me plenty of time; nobody has to push the sale.

After a couple of trips around the table, I decide on a favorite. The head is over a foot long, ending just beneath the chin. It weighs about twenty pounds. Some patches of bronze are still burnished, shining with a color that is even deeper than jade. The face is stylized, almost modernesque—sharp lines and bold angles. The ears: elongated, jutting outward. Brow: sweeping down in two arched ridges. Nose: creased in the center and then flaring out into strong cheekbones. Mouth: as straight as a line across a page.

The head is long and thin, and the exaggerated shape invariably draws your attention straight to the eyes. They are sharply angled, and instead of a pupil, a long horizontal crease runs through the center of each eye. That crease gives the object an otherworldly expression: maybe human, maybe not. The eyes could be blank or they could be full. This piece of metal was manufactured more than thirty centuries ago. I hold the bronze head in both hands and the room is completely silent.

10

Anniversary

October 26, 2000
12:50 P.M.

THE MESSAGE HAD ARRIVED THE DAY BEFORE. IT APPEARED IN AN encrypted e-mail, sent to foreign reporters:

> *There will be a big gathering on the square on Oct. twenty-six. People will go at any time. We know one of the big waves will be around one o'clock in the afternoon. Between flag and monument. This will be the biggest party ever. . . . There will be no big party like this in the foreseeable future. Have a good day!*

A Beijing-based Falun Gong adherent had sent the message. He was a computer expert who knew how to cover his electronic tracks; he was always careful about the encryption. Nevertheless, he was destined to be caught in less than two years, the victim of an Internet café stakeout—off to a labor camp. From the tone of the e-mail, though, you couldn't imagine what the "gathering" might involve, or that the author was at risk ("Have a good day!"). His use of the word "party" was particularly troubling. Throughout the year, the protests had gained strength, accumulating days like some brutal sacrificial ritual. April 25 had been followed by May 11, the birthday of founder Li Hongzhi. May 13 was next (the anniversary of the founding of Falun Gong), and then July 22 (the anniversary of the first anti–Falun Gong law). October 1 marked fifty-one years of the People's Republic.

Each anniversary had been commemorated by protests in the Square, where the participants quickly learned how to play their roles. The foreign journalists slipped into tour groups, never taking notes; often we just stood around with our hands in our pockets, watching and remembering. The photojournalists had to become more resourceful. One wire service photographer began draping multiple cameras around his neck; sometimes, he wore three or four, dangling prominently, and meanwhile he kept a small digital camera in one hand and shot from the hip. Before the inevitable detention occurred, and the police triumphantly stripped the film out of each obvious camera, the digital disappeared into a pocket. Somehow, a picture always made it into the next morning's paper.

The protestors had also become more adept. They still played by the same basic rules—if questioned, they always declared their faith—but they did everything possible to reach the Square without attracting attention. Sometimes they wore the cheap baseball caps that were standard for Chinese tour groups, and it wasn't unusual for them to purchase little Chinese flags, like proud provincials visiting their nation's capital for the first time. But the one thing they couldn't hide was their lack of money. They tended to be simple folk: many had spent their working lives in the state-owned factories and work units of the Communist era. Retirees often suffered in the new economy—old plants had gone bankrupt or been converted, and pensions were low or not paid at all. Reform and Opening was a difficult period for the middle-aged and elderly, and it wasn't surprising that a number of these people found solace in Falun Gong. In the Square, one could often pick them out by their clothes: cheap suits, cheap shoes, cheap padded cotton jackets. It was rare to see a well-dressed protestor. The majority of them seemed to be women.

Their demonstrations had become more elaborate. Occasionally, timing was involved—everybody acted at the stroke of the hour. They raised their arms over their heads, and sometimes they unfurled banners emblazoned with the three basic principles: TRUTHFULNESS, BENEVOLENCE, TOLERANCE. They tossed pamphlets into the air. Since May, they had taken to scattering chrysanthemum blossoms, because yellow was an auspicious color. Afterward, the police swept up the petals as if they were filthy things.

The cops hadn't improved. That was one part of the routine that hadn't changed: the plainclothes men still responded with brutal, pointless violence. Sometimes it seemed to be nothing more than cruelty. But over time, as the ritual was played out again and again, one began to recognize that the plainclothes men were simply ignorant. Like the protestors, they belonged to a

recognizable class: the undereducated, underemployed young Chinese male. Whereas their elders might have encountered the reform years and felt a spiritual vacuum, these men were simply losers. They had missed out on the opportunities of the new economy.

Whenever timing was involved—say, a one-o'clock start—then it began to seem like some awful sport, complete with pregame period. The journalists positioned themselves strategically among the foreign tour groups. The plainclothes agents tried to pick out protestors, looking for old women in bad clothes. But the women often recognized the cops, and they did their best to avoid the interaction. It became a slow-motion chase: a crewcut man walked toward a pack of middle-aged women; the women scattered. For a spectator, this was one of the most depressing sights in all of Beijing—the great chase of China's dispossessed, the used and the abused, the young men without education seeking older women without security. You knew whom to root for, but you also knew that nobody was going to win.

BY 12:30, EVERYBODY was there. The cops: lurking, loitering, lingering. The believers: *jiade* tourists, clutching Chinese flags, avoiding the plainclothes men. The journalists: *jiade* tourists, hands in pockets. I was already tired: the morning had begun with the demolition of Old Mr. Zhao's courtyard. This was turning into one of those Beijing days that felt like a week.

Most participants waited in the northern half of the Square. This expanse of flagstones was broken twice—first, by the Monument to the Revolutionary Martyrs, and then by the Mao Zedong Mausoleum, a squat, ugly block of granite that contained the Chairman's corpse. On either side of the mausoleum, fleets of vehicles had been parked. Quick count: fourteen vans, eleven buses. The Square was busy with authentic tourists who had no idea that anything was about to happen.

Somebody jumped the gun. At ten minutes before one o'clock, in the southeastern corner of the Square, a group of *jiade* tourists suddenly raised a banner and shouted, "Falun Dafa is good!" Cops came running; a van roared away from the mausoleum. Near the Monument to the Revolutionary Martyrs, another group of protestors followed suit, raising their banner. In front of the flagpole, somebody tossed a flurry of flyers; two more vehicles sped across the Square. More banners, more flyers; more buses and vans. On the eastern side, where I happened to be standing, a believer hurled white pamphlets onto the stone. Instinct: I stooped, snatched a piece of paper, shoved it into my pocket:

HEAVEN CAN'T CONDONE PERVERSE ACTS
RETURN OUR FELLOW ADHERENTS
AND RETURN THE PURE NAME OF FALUN DAFA

I stood up and the Square was unrecognizable. Movement everywhere: flyers scattering, banners unfurling, people running and shouting. It was impossible to stand still, and so I walked across the flagstones—instinctively, aimlessly. Glimpses: a man bleeding badly from the face, a woman in the fetal position, getting kicked. Another man tackled onto stone. An old woman shoved into a bus. And then at last, after all the anniversaries, all the protests, there was a plainclothes cop with education, speaking English, sent specifically to handle the foreigners. Public relations.

"Please leave," he said to me, with practiced pronunciation. "These people are disobeying the law."

Next to us, a woman holding a child suddenly unfurled a banner. The child was about two years old. The banner was yellow with red writing; it appeared for such a brief moment that I couldn't make out the characters: 什么什么 什么. The first plainclothes cop hit the woman. The second one snatched the banner. The third grabbed the child. The woman fell; the child screamed. One cop—the first, the second, the third, the fourth; what difference did it make?— kicked her hard. The educated cop said again, in English, "Please leave."

BY ONE O'CLOCK it was over. The police had successfully herded the tourists and journalists to the peripheries, and the Square was dead silent—an estimated three hundred people had been arrested. But it's hard to count with your hands in your pockets.

The last vehicles were the street sweepers. They sprayed water beneath revolving brushes that cleaned up the flyers and the blood. On the side, an English brand name had been painted in blue letters onto steel: China Tianjin Sweeper Special Automobile Company, Ltd. It was a beautiful autumn day; the sky was high and blue and there was not a cloud in sight. That was the first anniversary of China's anti-cult law.

11

Sichuanese

November 2000

WHENEVER WILLIAM JEFFERSON FOSTER AND NANCY DREW FELT homesick, they listened to the song together. The tune was familiar from childhood, when it had been known as "Wang Erxiao." That song's hero was an eleven-year-old boy who lived in the north of China during the Japanese occupation. One day, Japanese soldiers forced Wang Erxiao to serve as their local guide, but the boy led the enemy straight into an ambush. The Communist Party's Eighth Route Army slaughtered the invaders. Wang died in the battle, but the boy was immortalized in verses to be sung by millions of Chinese schoolchildren.

During the Reform era, a pop singer named Chi Zhiqiang rewrote the song for the new economy. The Japanese disappeared, and so did the war; the boyhero became an adult laborer from Sichuan. Migration replaced invasion, and the song received a new title: "Twelve Months of Migrant Labor."

> *In the first month I left my hometown*
> *Together with my friend Li Zhiqiang*
> *We spent two days on the train to Guangzhou*
> *And in the second month we met a man from our hometown*
> *He was working in a toy factory . . .*

In the third month, the narrator hears about a migrant who became rich:

> *And I thought that once he had been just like me*

In the fourth month, he loses contact with his friend Li Zhiqiang; in the fifth month, he sweats through hot days of construction work. He gets paid in the sixth month:

> My heart was trembling when I got the money
> In one month I had made seven hundred yuan
> I could see the light at the end of the tunnel
> In the seventh month I sent a letter to my parents
> And gave them a few hundred yuan
> I thought about how happy they'd be . . .

After Willy and Nancy left Sichuan without telling her parents, they didn't return home for a long time. They weren't willing to face the elders until they had some success, which wasn't going to happen in Mr. Wang's fraudulent school. Fortunately, Willy's second job in Yueqing turned out much better. Yueqing was a satellite city of Wenzhou, which was famous for its rapid development. The private school was well run, and eventually the administrators hired Nancy; every month the young couple was able to save most of their salary. But there was still something awful about spending an entire year away from home, especially through the holidays:

> During the Mid-Autumn Festival the moon was bright
> And the fat foreman sent us a case of beer
> He told us not to miss our families
> And he said that here was the same as home . . .

The young couple finally made it back to Sichuan for the second summer vacation. In eighteen months, they had saved more than thirty thousand yuan, or nearly four thousand American dollars. Their combined salary had risen to almost five hundred dollars a month. That was more than enough to inspire forgiveness in the hearts of Nancy's parents, whose farming income barely exceeded two hundred dollars a year. They welcomed the young couple as warmly as if they had left on the best of terms.

To Willy, it seemed remarkable—people in the countryside adjusted so quickly. In Nancy's village, virtually everybody from the younger generation had migrated to the factory towns, and the older people depended largely on wages that were sent home. The region was sprinkled with half-finished houses: the first story was complete, and people already lived there, but above them the bare frame for the second or third level rose like a skeleton. If migrants were lucky, they could add a story in a year. And if luck turned bad—well, then their elders waited patiently in half a home.

> *In the ninth month, disaster struck—*
> *A brick injured my hand*
> *I hadn't thought the foreman would fire me*
> *But he gave me a little money and let me go*

* * *

IN THE PAST, Sichuan had been the most populous province in China, with a geography that seemed designed for a Malthusian rise and fall. At the heart of Sichuan lay the Chengdu Basin, a fertile region of rivers and plains that naturally sustained a large population. (Sanxingdui is located on the western edge of this basin.) But the basin was ringed by mountains, which meant that conditions quickly deteriorated once the population passed a certain point. The landscape first nurtured and then it punished; success led to competition, and then competition became hopeless. There were millions of Sichuanese who simply needed to go elsewhere. But for decades the Communist Party's planned economy restricted individual movement, and there weren't any boomtowns in those days anyway. The rural Sichuanese, like others in the Chinese interior, waited in poverty until Deng Xiaoping finally threw open the economy.

Seven hundred miles to the east, the people in Zhejiang province also waited, but under vastly different natural conditions. Much of their land was poor—in the Wenzhou region, less than a fifth of the soil was arable. Mountains prevented early road links with the rest of China, and the natives had naturally turned to the sea. For centuries, they had been successful merchants, and many of them traveled abroad and established businesses in other countries. But after 1949, the Communist Party put an end to the private trade and the overseas contacts. The government was particularly concerned about Taiwan, which was only two hundred miles off the coast. Wenzhou became part of a buffer zone: Like Shenzhen, it was deliberately left undeveloped, with few state-owned enterprises. As a result, when the Reform period began, there wasn't much industry in Wenzhou that needed to be restructured, and the human population was like a coiled spring. Their native business skills had been suppressed for almost thirty years.

The people didn't start with much money, and the government never granted the special economic privileges of cities such as Shenzhen. But that wasn't necessary in Wenzhou, whose most valuable capital was instinct and overseas connections. In the early 1980s, families opened small-scale workshops, often with less than a dozen workers. They made small things: parts of shoes, pieces of clothes, bits of plastic. Over time, the factories expanded, but

the products stayed small. Wenzhou became one of the largest producers of buttons in the world. Low-voltage electronic parts were a specialty. They made shoe soles and they made pistons. They made cigarette lighters, and then they made more cigarette lighters. By the year 2000, between 60 and 70 percent of the world's lighters came from Wenzhou.

The city's economy was almost entirely private, and as living standards rose, Wenzhou and other Zhejiang cities needed laborers, assembly line workers, secretaries, and teachers. Sichuan was a perfect match, and it wasn't surprising that Zhejiang companies often recruited in places like Fuling. A number of my best students headed east, and one of the first things they noticed were the regional disparities. One former student named Shirley accepted a job in Yuhuan, the island off the Zhejiang coast, and she described her trip in a letter:

> It was the longest journey in my passed life. We were told that we were going to the "advanced region" to "do pioneering work." Reasonably speaking we should be excited. But I didn't have such feeling. On my whole way to Yuhuan I was unespectedly calm.
>
> We left Chongqing by train in the afternoon of July 5. When the train drove for nearly one day, I found a father with his baby. When I first saw them, I was shocked. It's because of the baby. It's such a tiny thing. His father said he was 70 days. But I thought he was not more than 10 days. It was so small, black and thin, I was sure I met the child from the kingdom of dwarfs. I can say it's a typical example of malnutrition. . . .
>
> The poor little thing cause much interest and care from people. Some kind people gave many help to the helpless father to quiet the child. But it didn't work. At the same time the child caused many guesses: "Where is the baby's mother?" Someone said his mother must have run away, leaving the husband with the child. Someone guessed the father and the mother must have quarreled. At last people decided determine that the baby was an illegitimate child. The train was driving ahead with a high speed. The guess and discussions were going on. The baby's cry was resounding in the train.

Shirley's journey took three days, by boat and train and bus. On the final leg, she met a young man who was a native of the island. In a letter to Adam, she described her fear of being perceived as yet another poor migrant:

> Then he asked me where I was from. I didn't tell him the truth, because I was told before that people of Yuhuan had strong ideas of excluding out-

siders. I made up a story about my identity. I told him that I was borned in Yuhuan, but I lived in Sichuan from childhood. I seldom went home so I was not familiar with Zhejiang. Fancy his believing it! Actually my story was far from perfect. It's so clumsy that I couldn't answer, "Which village I was born in," and I couldn't understand the dialect. Seeing I have no way to explain these, he helped me, "You lived in Sichuan for so many years. It's not strange that you can't remember these things so many years ago." He warmly introduced many things of Yuhuan to me, and gave me much advice on how to be used the life of Yuhuan, how to work in Yuhuan.

Compared with his honest and enthusiasm I regreted telling lies to an honest person. He was the first native of Yuhuan I met. From him I couldn't see any bad characteristic that I was told before. I remembered that the people here were told to be unbelievable, but the true story had proved that I was the one who was unbelievable.

In the following weeks, I was busy with another things and didn't care about this story. But later, when I calmed down I would remember it and blame myself. Many times I wanted to telephone the boy to tell him the truth (He gave me his number). But I never did that because I'm not brave enough. I'm a cowerd.

Adam, these stories are the ones that touch me deepest and make deepest impression on me. All of them are true.

Not long after settling into her new job, she wrote me a letter:

Peter, till now I never get the feeling of living in a completely different place. It's not good to feel. I can understand now what you and Adam said to us before. You said you are foreigners and that makes difference in people's heart. For the native, you are a stranger. It's hurt because they didn't group you in their group. You can't understand what they said. So the feeling of home clings to you so naturally.

Here we can't understand what the natives said. Their dialects are strange to us, because their tone and rhythm are so far different from ours. We can only speak standard Chinese but some natives can't understand standard Chinese, especially the old and uneducational people.

* * *

IT SEEMED THAT almost every student who left home wrote me a letter like that. The difficulties of adjustment took them by surprise; they had never

imagined that they could feel like foreigners in their own country. But China is enormous, and it has the linguistic diversity of a continent rather than a country. The official spoken language is *putonghua*, or "common speech," which in English is also known as Mandarin. Mandarin is the native tongue for people in Beijing and other parts of northern China, and it's the official language for schools, government bureaus, and most television and radio stations.

But hundreds of millions of Chinese grow up speaking something entirely different. The Chinese call these tongues *fangyan*: often the word is translated as "dialect," although literally it means "speech of a place." In fact, *fangyan* are often different spoken languages. The *fangyan* spoken in Beijing and Canton, for example, are actually languages as distinct as English and German. Linguists sometimes compare the diversity of spoken Chinese to that of the major Romance tongues. In addition, there are the languages of the other major ethnic groups—Uighurs, Tibetans, Mongolians.

Among the Chinese, Wenzhou is notorious for having some of the most difficult *fangyan*. Within the city, different regions have distinct sub-*fangyan*, and none of these tongues is similar to Mandarin. Even somebody like Shirley—a young woman naturally gifted with languages—could only pick up the basics. Nearly half a year after moving to the Wenzhou area, she wrote:

> *Coming to Zhejiang for many months, I have been used to many things here. I can understand some of simple sentences the natives say. I can basically deal with the trouble happened when went to the food market.*
>
> *Zhejiang and Sichuan are both big province in China. But they are different in many aspects, esp. in eating. Zhejiang is near the East Sea and people here like eating sea food. They think it very fresh. I don't like food from the sea although I know it has high nutrition. I taste it strange. People here don't like spicy food, so I often eat what we cooked ourselves.*
>
> *People here have differnet point of veiw from our inland people. Many people here give much more importance to money than education. I can't accept the idea. To tell the truth, the economy in Zhejiang is more advanced than in Sichuan. But they are usually proud of it and show their advantage before us. I'm angry at it but I had be admit the backward in economy in our Sichuan.*

<p style="text-align:center">* * *</p>

BEFORE THE FREE-MARKET reforms, it was rare for average Chinese to travel, and few people personally experienced their nation's diversity. China was unified, and the Han Chinese were supposedly a single ethnic group—

these seemed to be fundamental truths. But as people gained mobility, they began to experience the irregularities that lay beneath the surface of national unity. For William Jefferson Foster, every trip back to Sichuan was hard, because he passed through all the inequalities and prejudices that lay between Wenzhou and home. One year, after the winter holiday, he wrote:

> *During the Spring Festival I went back to Sichuan province. My experience in the trip back to school is very sad. I could hardly sleep well in the first few days, so far I am still thinking of that. On the boat, there were so many sichuan people who were going to coastal cities some of them slept in the toilet. At the railway station, the sichuan people were just like refugees or beggars. They slept on the ground in cold weather. I was overcharged everywhere I went. In Jiangxi province, the bus driver drove us into a motohotel where the shop-keeper drove us out of the bus with the night-stick. We were forced to use 40 yuan to buy fast-food which was just like swill. Two sichuan young men were beaten to the ground just for they did not have money to buy something with them. The driver said that they will beat you to death if you dare to quarrel with them.*

Most migrants quietly endured the unfairness, believing their new life was only temporary. They worked hard jobs—construction crews, factory assembly lines—and it was too bleak to imagine doing those things for the rest of your life in a place where you couldn't speak the language. And the economic divide between the coast and the interior was wide enough that you could hope to save money abroad and then spend it slowly at home. Almost everybody planned to return after their prime working years were finished; people talked about opening small shops or restaurants in cities near their home villages. In that sense, it was similar to many Mexicans and Central Americans who emigrate illegally to the United States but maintain homes and families in their native countries. They work in one economy and spend their earnings in another.

But Willy's parents lived with his brothers, who had done well enough in local construction to build a big two-story compound for the extended family. Willy didn't have to send money home, and it was feasible that he and Nancy could settle permanently in the east. He felt himself pulled by two opposing forces: the economic promise of Zhejiang, and the cultural familiarity of Sichuan. Someday it was a decision that he would have to make, but in the meantime he preferred to belong to neither place. He never tried to learn the Wenzhou dialect—that was impossible, especially given all the time that he devoted to English and the Voice of America. Instead, he concentrated on per-

fecting his Mandarin. By his second year, he spoke without a trace of a Sichua-
nese accent. When people asked him where he was from, he usually lied, telling
them some city in neighboring Jiangsu province, which had a good economy.
But it was harder to pull this off when Nancy was around. She still spoke like a
Sichuanese, and she resisted Willy's attempts to improve her Mandarin. In her
opinion, he was being pretentious.

To Willy, though, it was a matter of self-respect. His first boss in Zhejiang,
the terrible Mr. Wang, had often told Willy about a trip he had made to north-
ern Sichuan in the 1980s. Mr. Wang's journey had been eye-opening: the pov-
erty of northern Sichuan had touched him so deeply that he had wept. Years
later, he still became visibly moved whenever he spoke of the trip, which was
often; he liked giving Willy the opportunity to feel grateful for having escaped
such awful conditions. Of all the things that Willy hated about Mr. Wang—his
Sun Yat-sen suits, his stinginess, his birtch of a wife—the man's sympathy was
the worst.

Little remarks nagged at Willy, even after he moved to the better job in
Yueqing. In that town, people sometimes stole manhole covers and sold them
for scrap metal; residents had to be careful while walking at night. Once, Willy
and a fellow teacher passed a gaping hole in the street, and the man shook his
head in disgust. "The Sichuanese migrants steal those," he said. Willy didn't
respond, but he never forgot the man's remark. Willy also noticed that Yueqing
parents scolded their children by threatening them with stories of migrants.
During Willy's childhood, adults in his village had often told children that if
they misbehaved, the foreigners would come and eat them. But in Yueqing the
foreigners weren't bogeymen anymore. The parents said, "If you keep crying,
the people from Jiangxi or Sichuan will come and steal you."

> I completely understand what's your feeling when you were treated differ-
> ently in China. Obviously sichuan people were treated differently by other
> people, for sichuan is very famous for its being poor and backward. Here
> the same thing happen. People from sichuan and Jiangxi are always looked
> down by the natives. I don't care too much about that, I know that China
> is not their China only. Each citizen in China has the equal right to go
> anywhere in China. I am awefully joyful to hear that your writing goal is
> to write about average people in China, that's good. In my opinion, you
> will get success just like William Shakespears who always took access to
> common people and reached the literatural zenith in his life.
>
> In fact, I think it's the most difficult thing for one to find his own mis-
> take. So China always says all is ok in China. Everything in China is cor-

rectly and perfectly treated, America sometimes like China. So that's why China says America is a world police. America says China is a country full of problems.

<div align="center">* * *</div>

DURING THE 1980S, government slogans praised the "Wenzhou Model" of development. The city's tradition of bootstraps capitalism naturally appealed to officials, who liked the idea of investing nothing and watching families build factories on their own. But in fact few places could replicate the model, which had limitations even in Wenzhou. Successful factories expanded, but there was only so much money that people could make from buttons, cigarette lighters, shoe soles, and low-voltage electronic parts. These were low-margin commodities; it was hard to create a valuable brand or add value through research and development. Logically, the next step might have been a shift to high-tech products or multinational investment; these were common development strategies in places like Shenzhen.

But something about the Wenzhou mindset preferred to keep things simple. It was the same in education, which had also responded quickly to Reform and Opening. By the late 1990s, Wenzhou's private education sector had become one of the largest in the nation. Nearly 30 percent of the city's high school students, and roughly one-fifth of its college undergrads, were enrolled in private institutions.

In the city of Yueqing, Willy and Nancy taught at the Educating Talents School (it was only coincidence that this name sounded similar to the fraudulent Hundred Talents High School, where they had first worked). In Yueqing, the new school had nearly two thousand pupils, ranging from kindergarten to eighth grade, and nearly all of the children boarded. In China, the curriculum of all schools, both public and private, was standardized and strictly regulated. Certain courses and texts were mandatory, and all students took standardized exams at the end of middle school and high school. A private institution could hire instructors and attract pupils from the open market, but they were required to teach and study the theories of the Communist Party.

After the founding of the Educating Talents School, the institution distinguished itself by starting the English curriculum in the first grade instead of the third grade. Local public schools eventually followed suit, teaching English to first-graders, but the private school had found its niche. They started courses early, and then they crammed in as many hours as possible. One of the school's selling points was that preexamination students had class every day

of the week, including Sundays. Eighth-graders attended seventy-five weekly class periods—nearly double that of the average Chinese public school (forty-five). Essentially, they had applied the Wenzhou Model to education: it was the intellectual equivalent of squeezing out a profit on low-margin commodities. Instead of innovating the curriculum or improving texts, they simply taught the same stuff at a higher volume.

The private school thrived until 1998, when the local government founded a new public school. From the beginning, the public school's headmaster declared openly that he intended to drive the Educating Talents School into bankruptcy. After throwing down the gauntlet, his first tactic was to hire the best teachers that money could buy. He scouted the region for experienced instructors who had been distinguished as "first-rate teachers" by the educational authorities. The teachers arrived with awards and certificates, and they failed miserably. English instructors couldn't speak English; math teachers couldn't teach math. Students did poorly; parents became furious. Many suspected that the awards and certificates were *jiade*—you could buy that stuff anywhere. Regardless, the value of experience was basically nil, given how rapidly things changed in China. After a year, the new public school fired its instructors and began to hire only young teachers.

The competition grew more intense every year. This was particularly true with regard to exam preparation, which involved two distinct competitive strategies. The first strategy was based on a simple faith: by studying systematically, efficiently, and diligently, students could improve their odds of success. But the odds were even more in their favor if they knew the examination questions in advance. This was the second competitive strategy, and it was already well developed by the time Willy and Nancy arrived. Each year, teachers and administrators cultivated relationships with powerful people who might leak information about the exams.

One official in the Wenzhou city education bureau was notorious for his subtle hints. Schools across the region invited him to give lectures to their instructors, and he accepted only the ones that made it worth his while. Willy and the other English teachers made an annual ritual of going to downtown Wenzhou and listening to the man speak. Once, Willy described the scene:

"Our principal invited the man to give a lecture, to give so-called information about the high-school entrance examination. The speech was vague. The teachers wanted to get some useful information from him, but sometimes he keeps silent. For two hours we tried to ask some questions. We asked him what would be in the examination. He just said, maybe this will be involved, maybe that. For example, he said that this year maybe your students will be asked

to fill in two words, to make a sentence complete, instead of just one word.

"After that, the school invited him to go to the Red Sun Hotel, in Wenzhou. It's a very good hotel, and about fifteen teachers had dinner with him. After that, the school gave him two thousand yuan. Later, they invited him to karaoke with a xiaojie. She's prostitute, I think. A double room for them—what will happen? You can guess. I think this guy is very segui, very lecherous. He is fifty years old. One of his sons went abroad, to U.S.A."

The man often gave accurate information to the public schools, but his speeches were never helpful to Willy and his colleagues. Nevertheless, the Educating Talents School performed the ritual every year. When I asked Willy why they continued to pay for useless tips, he said, "But what if one year it's right?"

Every June, when exam season rolled around, I received a disgusted letter:

The same thing happened again in Yueqing. Many other schools got the info about the high school entrance examinations. Our school got a little second-hand or maybe third-hand info. So we are doomed to failure. Again the fucking guy from the eduationl administration let out the secret of examination of English.

* * *

THE CHEATING BOTHERED Willy, but he didn't know what to do about it. That was part of the migrant's new environment: when you left home, the basic rules of morality changed. Sometimes, Willy took it in stride, like the shifting marriage traditions. After two years in Zhejiang, Willy and Nancy still hadn't officially married. It seemed pointless; all of their family and friends were back in Sichuan. Willy noticed that many other migrants in Yueqing waited for years before holding a ceremony, because they wanted to save money and build up their social networks. He attended several weddings in which the couple's child was already school-age.

To Willy, that made sense: pragmatism trumped tradition. Whenever he and Nancy discussed the possibility of marriage and children, they usually ended up talking about money instead. Finally, Nancy came up with a specific figure. After they had saved at least one hundred thousand yuan—more than twelve thousand dollars—she would agree to have a child. After a year and a half in Yueqing, their combined savings were twenty-five thousand yuan. A quarter of a baby was already in the bank.

But there were some issues, such as the cheating and the prejudice against

migrants, that had no simple solution. Over the years, Willy never asked his parents for advice; he sensed that they couldn't provide guidance in the new climate. And although he still considered the possibility of someday returning to Sichuan, he knew in his heart that he would never really go home again. That world was gone—not because it had been destroyed like the Beijing courtyards, but rather because the countryside hadn't changed enough. In a nation on the move, there was no reason for young people to stay in rural regions that couldn't keep pace. Whenever Willy returned to Number Ten Village, the place felt deserted. After one visit, he wrote:

> When I am home, nothing has changed and the roads are still rough and people are getting older. It makes me sad that I can not find familiar people or friends who I knew well when I was young. Sometimes I think this kind of life, going out to coastal regions without a stable home is the saddest and the most stressful thing in the world.

Every trip home left him depressed. Back in Yueqing, he would find himself thinking about the dying village, even though he knew it was pointless. During such periods, he found solace in his English studies. The language was a distraction, but he also believed that English sources provided the best guidance for the new environment of Reform and Opening. He carefully followed the Web sites of foreign news organizations, and he read any kind of English advice column. Once he telephoned a medical call-in show at the Voice of America's Beijing bureau, to ask about how to handle sinus problems. Another time, when the Voice broadcast a program about home-schooling in the United States, Willy jotted careful notes in his journal. He was particularly interested in the idea that public schools might not feel threatened by an alternative education system:

> Fifty states 150 children stay home study
> their parents are their teachers
> as excellent as that in school
> stable family
> 1997 50000$
> Reasons: to keep in touch with
> to satify the need of
> to prevent the students from being
> influenced by violence sexual and so on
> problems with educ
> Public school provide the family with help—library even courses

Since leaving college, Willy had broken the spines of three English diction-aries. He still kept the old books lined up on his shelf, the way a good infielder never throws away a worn-out glove. In his spare time, he constantly translated and organized information: Voice of America broadcasts, newspaper stories, vocabulary lists. He often telephoned me with questions, usually about some random word or obscure grammar feature. Sometimes he asked about world events. In November of 2000, when the American presidential election failed to produce a clear winner, Willy called nearly every night with questions about the Electoral College.

He was particularly attuned to the world's irregularities. In Wenzhou city, the government sponsored a campaign to conserve water, with slogans in Eng-lish and Chinese. The English translation read:

STOP TO WASTE THE WATER RESOURCE

Willy didn't think that was correct, and he asked me about it. Whenever he called, I did my best to answer his questions, although I often wondered how he could ever process all of this material. When I asked him about his journals, he told me that he just wanted to keep track of everything. He said that he dreamed of someday creating an English dictionary that contained every word in the language.

> *boozy—drunk*
> *boorish*
> *bookstall*
> *bookrack*
> *bookmark*
> *booby-prize*

> *In 1998 Bill Clinton had an affair with Monikey Lewinsky and created an unprecend—*

> *Liverpool and London Riot (1981). During the early 1980—streets rioting returned to Britain, reminiscent of the 18th and early 19th centuries; and the first time by rising unemployment.*

Before the National Day holiday of 2000, Willy happened to be watching television when the anti-crime rally came on. In many Chinese cities, it was an annual event; offenders were sentenced on live television, in part to deter crime during the holiday. In the past, such rituals had often taken place in sports stadiums, and sometimes the executions were also public. Nowadays, though, only the sentencing was televised.

Willy watched as the criminals were marched forward, one by one: hand-cuffs, shaved heads, blue-and-white–striped prison outfits. A judge read out each individual's name, hometown, crime, and sentence. In front of the television, Willy wrote compulsively. Later, when he told me about it, he said that he had been "making statistics."

"Whenever the judge said somebody's name and hometown, I wrote it down," he explained. "Jiangxi province, Sichuan, and Hubei were the most. At the end I figured that 40 percent of the criminals were from Sichuan. It was the biggest percentage. That made me ashamed."

Another night, Willy and Nancy stayed up long past their usual bedtime, playing the pop song over and over, until finally they had translated the "Twelve Months of Migrant Labor" into English, all the way to the end:

> In the twelfth month I returned to my hometown
> My parents cried
> And together we ate dumplings
> How wonderful they tasted.

<p style="text-align:center">*　　　*　　　*</p>

Dear Peter,
　　How is it going in Beijing? . . . I want very much to change my situation here. Nancy and I have both thrown the iron-rice bowls and come here to seek fortune. Situation here is much better than that in my backward and yashua [toothbrush] hometown—Sichuan. However, I can't see any hope of becoming even a small rich man, making myself and improving myself. Nancy and I both have thought of buying an apartment here. But that's only a dream. Every cost of the house is 300,000 to 400,000 yuan which we can't afford to buy. When we are able to buy a new house then we two will have put one foot in the coffin. That's true. The long-cherished hope of mine is that after we two have enough money, we'll go back to our hometown and find a stable job for Nancy. And I can do something else but not teaching. . . . With China's accession to the WTO and the pending Olympic Games in 2008 I wish that I can have good luck.

In the fall of 2000, Willy entered an English-teaching contest. All across the country, such events had become part of the craze for competition that had swept Chinese education. In Wenzhou, each competitor entered a room full of students, with judges seated in the back. The officials evaluated the lesson plan, as well as the student response.

Willy never became nervous in such situations. After everything else that he had experienced, it seemed easy: The rules were clear, and they were applied to all participants. The judging generally seemed to be fair, and regardless the students were independent. It was impossible to cheat the spontaneous reactions of children.

The Wenzhou competition began with five hundred instructors, and the field was quickly narrowed to sixteen. Willy made the cut. For the finals, everybody traveled to downtown Wenzhou. The other finalists arrived with laptop computers, projection screens, and lesson plans that had been prepared with professional teaching software. Willy was the only competitor who did not have a computer. His materials consisted of things that he had made by hand: a few pictures to illustrate a dialogue, and dozens of little red paper apples. He wrote the English word "poison" on a bottle of water.

"When I taught them the word 'dangerous,' I had the bottle of water that I said was poison, and I asked a student to drink it. They thought it was very funny. Then I had them study the dialogue, and I made them very competitive, because they were trying to get red apples. I asked questions, and they got an apple if they were correct. I stood on a chair and shouted the questions. I was just like a commander; they thought that was funny, too."

It was a stroke of genius—creating a competition within the competition—and Willy walked away with first prize. The tournament awarded him one thousand yuan, which was nearly half of a month's salary. But he said that the money wasn't important. His school was proud, and he believed that he had won because nobody else in the competition had cared so deeply about English. In Willy's mind, he was victorious because of all the lists and transcriptions, the obscure words and the unusual phrases. "It was a good honor," he said. "I think I won because of my crazy style."

IN DOUBLE DRAGON Township, Number Ten Village, Number Three Production Team, one of the first migrants was a man named Liu Chengmin. He had completed the fifth grade, which made him the most literate person of his generation in Number Three. In the early 1980s, he migrated to Heilongjiang province. He spent a number of years working on the assembly line of a shoe factory, and then he returned to his farm.

In the village, Liu Chengmin was widely respected for his intelligence. And people knew that something about the experience abroad had changed the man. He never married, and he lived entirely on his own terms. During the mid-1990s, when the local government exorbitantly increased agricultural taxes, he refused to pay. He explained that his status as a single man merited

preferential treatment: he had no wife or son; everything depended on his own hands. His reasoning was clear, logical, and completely without precedent.

Periodically, rumors swept through the village: officials planned to detain Liu and have him beaten until he agreed to pay the taxes. This was a common procedure for dealing with extreme stubbornness, but nobody ever did anything. Local cadres seemed intimidated by the man's unpredictability.

During his years of migration, Liu had composed poems about his travels. As a child, Willy enjoyed listening to the verses, and years later, after the boy had grown to become a migrant himself, he could still recall details of Liu's writing. The poems had been composed in the style of Chairman Mao; often they described natural scenery. One verse celebrated the power of the Yangtze. And Willy remembered the final couplet of a poem about the Snail River, the local stream that passed beneath Victory Bridge:

> The river in my hometown is peaceful,
> But my heart is not.

PART THREE

The Book
打倒美帝

TODAY, THE ARCHAEOLOGISTS MAP A WALL OF THE UNDERGROUND city. The structure isn't far beneath the surface—about five feet deep—and the work team makes good progress across the yellow fields. There are seventeen men, armed with shovels and Luoyang spades; they work under Jing Zhichun. The young archaeologist believes that this wall may be part of the underground city's royal district.

In the early afternoon, Jing takes a break, and I interview him in the library of the Anyang Archaeological Work Station. The book-lined room is cool and quiet; we are the only people here. Jing describes some of the artifacts that have been discovered in Anyang, and then, after we finish, he idly points out an enormous old book that happens to be lying on a table in the library. The book's cover is torn and faded, but the title is clear:

美帝国主义劫掠的
我国殷周铜器图录

(*"Our Country's Shang and Zhou Bronzes*
Looted by American Imperialists")

The author's name is not listed. The book was published in 1962, edited by the Chinese Institute of Archaeology, and it contains more than eight hundred

black-and-white photographs of bronze vessels. There are squat three-legged *ding*, "cauldrons"; and graceful long-necked *gu*, "chalices"; and spindly-stemmed *jue*, which may have been used for warming wine. Most of the bronzes date to the Shang, and usually they are marked by that culture's characteristic *taotie* design: a stylized animal mask with curling eyes and mouth. In the past, some experts believed that the mysterious pattern portrayed a dragon; others proposed a tiger, or a crocodile, or a serpent. Some theories link the design to shamanism. But nobody knows for certain, and the *taotie* has slipped free from its meaning—a symbol gone mute.

The back of the book catalogs the American imperialists. The City Art Museum of St. Louis, Missouri, is listed as the owner of a slender Shang *gu*. In Grass Lake, Michigan, the Roumanian Orthodox Episcopate—the name seems neither American nor imperialist—has both a *ding* and a *gu*. Other owners are less surprising: Mrs. W. K. Vanderbilt, of New York City; Miss Doris Duke, also of New York City (according to the book, she looted nine bronzes); Avery C. Brundage, Chicago, Illinois (thirty bronzes); Alfred F. Pilsbury, Minneapolis, Minnesota (fifty-eight).

Flipping through the pages, it's possible to learn something about the archaeological tastes of prominent American imperialists. All nine of Doris Duke's vessels date to the Shang, and she clearly had an eye for the delicate: a pair of slender *gu*, an unassuming little *jue*. Pilsbury, in contrast, had a Midwesterner's appetite for solid vessels: a bloated square *ding* from the Three Kingdoms Period, a squat sullen cauldron that dates to the Warring States and looks every bit its age. Brundage is inscrutable. His collection spans the Shang, the Western Zhou, the Spring and Autumn; he has thick sober *ding* and narrow *gu*. His most distinctive piece is a whimsical Spring and Autumn wine pot, molded into the shape of a bird—an ancient bronze prepared for flight.

WHEN I ASK Jing about the book, he says that it was researched by Chen Mengjia, a scholar of oracle bones.

"He spent a lot of time in America," Jing explains. "Chen's wife was at the University of Chicago, studying American literature. But later they came back to China. Chen was quite a good poet, too."

I ask if Chen still lives in Anyang or Beijing.

"He's dead," Jing says. "He killed himself during the Cultural Revolution."

Once more, I check the title page: no name. Jing remarks that Chen had tried to kill himself twice. I close the book and ask if anybody here in Anyang had known the scholar.

"Talk with Old Yang," Jing says. "He's retired now, but he was with Chen when he killed himself. Old Yang and some others were supposed to be watching him, but it happened anyway. You can find Old Yang just across the courtyard."

THE ANYANG ARCHAEOLOGICAL Work Station is not far from the underground city. This region is still farmland, and corn fields surround the station; only a handful of people work here full-time, in nearly a dozen buildings. During the day, wind rustles through the parasol trees, and occasionally a train moans in the distance as it rolls toward Beijing, six hours away. Otherwise, the complex is silent. The high cement walls are topped by barbed wire.

Many of the buildings contain artifacts. There are rooms full of bronzes, and workshops strewn with pottery shards, and locked drawers packed with priceless jades. There are plenty of bones. In one exhibition hall, a display features a baby's skeleton squeezed into a jar—perhaps the relic of some grisly Shang ritual. Another building contains a chariot and four skeletons that were excavated from a neighboring field in 1987. The skeletons are paired: two horses, two humans. They were probably sacrificed in order to serve a lord in the next life; the two men may have been charioteers. One man's skeleton lies prone behind the vehicle. The other man rests facedown, directly beside the horses, his hands bound behind his back. His skull is turned to the side, as if biting at the dirt.

The chariot is no longer a chariot. Wood does not last when buried in the central plains of China, where rainwater passes quickly through the dry loess soil. Over time, the wood decays and is replaced by an earthen cast that retains the original shape. Thirty centuries slip by. In 1987, the excavation proceeds inch by inch, as archaeologists meticulously separate the exterior soil from the hardened cast, until at last the shape emerges. There are sideboards, an axle, a draft pole, and a chariot box big enough for three kneeling passengers. A curved yoke sits above the paired horse spines. The spoked wheels are over four feet in diameter. The chariot looks complete, as if it were still made of wood; but a few good shoves would reduce it to a pile of dirt. Archaeologists describe the object as a "ghost"—the earth's memory of something long gone.

* * *

NEXT TO THE chariot exhibition building, in a small conference room, I meet Yang Xizhang. He is sixty-six years old, with metal-rimmed glasses and thin white hair. His teeth have been silvered extravagantly and they startle me every time he smiles, like the glint of an unexpected relic.

Old Yang says that Chen Mengjia researched the book about "American imperialists" in the 1940s, before the Communists came to power. Back then, Chen lived in the United States with his wife. She came from a Western-influenced Chinese family; her father was a Christian theologian.

"That's one reason they had trouble later on," Old Yang explains. "Her family was closely connected to foreign things. When Chairman Mao's Cultural Revolution started, Chen was labeled a 'capitalist-intellectual.' That was because he had spent time in America and because of his wife's family. But he was especially criticized because of his *nannu jiaoliu shenghuo*."

The phrase is unfamiliar and I ask Old Yang to jot it down, to make sure I have it right. He pauses, as if regretting having mentioned it, but then he writes. The characters are clear but the phrase remains oblique:

<div align="center">Male-Female Relationship Lifestyle</div>

I ask, "What exactly does that mean?"

He glances away with an uncomfortable smile—a flash of silver. "It means this," he says reluctantly. "You have a relationship with a woman who's not your wife."

"So Chen did this?"

He looks away again. "I don't know about that," he says.

An awkward silence lingers for a moment. After we resume the conversation, I realize that Old Yang is far more comfortable discussing Chen's death. There is no change in his expression when I ask about the suicide.

"It happened in 1966, just as the Cultural Revolution started," Old Yang says. "When Chen first tried to kill himself, people saved him. After that, the Institute of Archaeology sent me and some other young archaeologists to watch him. We stayed with him in his home, and it was our job to make sure he didn't kill himself. But we couldn't be with him twenty-four hours a day. We tried, but it just wasn't possible. It lasted about a week."

To illustrate how they had lost track of the man, Old Yang rises and points out the window. It's a sunny afternoon; light streaks unevenly through the trees that stand outside the building. "Imagine that you're in Chen's Beijing home, looking out to the courtyard," he says. "One day, Chen walked outside, past the window." Old Yang makes a sweeping gesture, as if following the trail of

an imaginary figure moving beyond the range of our vision. "After a few minutes, we realized he was gone. We rushed outside, but it was too late—he had hanged himself."

Old Yang sits down. "It was a horrible loss," he says. "He was a great scholar."

From the man's expression, though, I can't tell if he feels guilt, or sadness, or anything at all. He wears a certain blank façade that is common among Chinese when they talk about bad memories—all emotion hidden somewhere far away. I ask what Chen had spoken about during the week that they were together.

"We didn't talk much. To be honest, I didn't know what to say. He was obviously very upset and it didn't seem right for me to speak to him."

Old Yang explains that Chen's wife hadn't been home, because Red Guards had been holding her across town, at Peking University. Later, after the Cultural Revolution was over, she resumed teaching English literature at the university. Old Yang tells me that she died a few years ago.

TOGETHER WE WALK across the courtyard to Old Yang's simple office, where he has a photograph of Chen. The office is furnished with a desk, a shelf of books, and a bed with a mosquito net. The floor is naked concrete. Old Yang pulls a faded Institute of Archaeology yearbook down from the shelf.

"I have another question about that book on bronzes in America," I say. "Why wasn't Chen's name on the title page?"

"In 1957, Chen had criticized some of the leaders' ideas," Old Yang says. "He was labeled a Rightist. Rightists weren't allowed to publish. But that book was very important, so they published it without his name. Of course, everybody knew who had actually written it."

Old Yang opens the yearbook to a page of photographs, including one of Chen as a middle-aged man. The inscription notes that he was born in 1911— the final year of the Qing dynasty. In the photograph, Chen has dimples and bright eyes and a shock of jet black hair. He wears a traditional high-collared shirt. He has the biggest smile of anybody on the page.

"He was very handsome," I say.

Old Yang chuckles, but this time he keeps the silver covered.

In Anyang, I try to learn more about Chen Mengjia, but the other archaeologists are too young to pick up the story's thread. Back in Beijing, I file the notebook and move on to other projects. It's part of the writer's routine, collecting half-told tales and then letting them slip away. But they always leave a mark in my memory, like the ghost of a buried artifact.

* * *

IN JANUARY OF 2001, my first book is published in the United States; it de-scribes the time that I spent teaching in Sichuan. Later that year, the Voice of America broadcasts a review, in Chinese. Afterward, the reviewer sends me a letter of introduction, along with a printed copy of his article. The tongue-in-cheek subtitle catches my eye:

讀洋鬼子何偉的新書
("Reading the Foreign Devil Peter Hessler's New Book")

The reviewer is a Chinese-born American citizen named Wu Ningkun. His postmark is Reston, Virginia. He writes in English:

> *The enclosed article is . . . based on a talk broadcast in the VOA Mandarin program America Today. If some of your former students happened to tune in to the program, they would have been thrilled . . .*

Wu Ningkun mentions that he studied American literature at the Univer-sity of Chicago in the 1940s, and then, after the Communist revolution, he returned to his homeland of China to teach English. In the early 1990s, he crossed the Pacific once more, this time for good. Since then, he and his wife have lived near Washington, D.C. I write back, asking if he happened to know Chen Mengjia during his years in Chicago.

The response comes quickly: Chen's wife actually helped convince Wu Ningkun to return to China after the Revolution. Wu suggests that I read his own English-language memoir, *A Single Tear*. One section describes Wu's return to Beijing in the early 1950s, before the start of the disastrous political campaigns:

> *I was put on the waiting list for a housing assignment, so I stayed as a house guest with Lucy and her husband, Chen Mengjia, who was a professor of Chinese at nearby Tsinghua University and a noted archaeologist. Lean and swarthy, Chen walked with a back bent under an invisible burden, which made him appear older than his forty-odd years. Lucy's father was Dr. T. C. Chao, an Anglican bishop and dean of the Divinity School. . . . Moving about gently among her elegant Ming dynasty furniture, choice objets d'art, and Steinway piano, she struck me as a heroine right out of a novel by Henry James (who was the subject of her doctoral dissertation) and thrust into a milieu as ill-fitting as her Mao jacket. I wondered what fine "moral consciousness" might be hidden under her poised presence.*

Unlike his naturally taciturn wife, Professor Chen was gruff and outspo-
ken. When it was announced that faculty as well as students were to take
part in daily collective calisthenics, he paced the floor in circles while com-
plaining loudly, "This is 1984 *coming true, and so soon!"*

When I see the name Lucy, I suddenly realize that part of this story is fa-
miliar: Lucy Chao is the sister of Old Mr. Zhao. She was the woman in the
courtyard's eastern wing, translating *Leaves of Grass*: the widow of Chen
Mengjia. I missed the connection while talking to Old Yang, who hadn't said
much about the woman and never used her English name.

Like the oracle-bone scholar, Lucy Chao is gone—she passed away in 1998.
But Old Mr. Zhao and his wife still live in Beijing, and I pay a visit to their new
apartment.

THE ONLY THING that has changed about the old man is the suntan. His
hooded eyes are the same—calm and deep and ageless—and he still carries
himself like a soldier. He continues to play tennis. "I run faster than those who
cannot run," he says dryly when asked about recent games. The tan is from
Thailand. The government paid the couple nearly three million yuan, or three
hundred and fifty thousand dollars, for the demolished courtyard; in China,
that sum is a small fortune. And in China, like anywhere else, you can't take it
with you. Old Mr. Zhao and Huang Zhe were just in Bangkok on vacation.

He seems completely unsentimental. He says that by accepting the settle-
ment, he acknowledged that the battle was lost, and now there is no point in
talking about the courtyard anymore. He feels the same way about the Cul-
tural Revolution—he doesn't want to discuss it. Initially, when I asked to meet
and talk about his sister and her husband, the old man refused. After some
prodding, he finally agreed, but he made it clear that there wasn't much to say.

Old Mr. Zhao and Huang Zhe have moved to the east side of town, near
the sprawling business complexes of the Kerry Center and the China World
Center. The elderly couple lives in a new building called the Golden Trade. The
windows are green-glassed—the light at the end of the dock.

The couple receives me in their living room. Some decorations are familiar:
a black-and-white photograph of the patriarch, a long scroll of calligraphy.
Jesus and the Pharisees. One new object catches my eye: a framed photograph
of the courtyard, also in black and white.

We chat for a while, and the old man tells me that Chen Mengjia had been
a member of the Crescent Moon Society, a group of popular poets in the early
twentieth century. I ask about Chen's writing style.

"It was romantic," Old Mr. Zhao says flatly.

"In what way? What sort of topics was he writing about?"

He dismisses the question with a wave of his hand. "You know, I don't really understand that stuff."

"Well, what was Chen himself like?"

"He passed away so many years ago that it's hard to remember," Old Mr. Zhao says. "But I do remember that he was an incredibly hard worker. He and my sister were both like that. They read books constantly, and they wrote all day long. They were literary people. Sometimes it seemed like they had no other activities."

I mention the book about bronzes in America, and the old man nods.

"Chen returned to Beijing from America in 1948—one year earlier than my sister. While he was in America, he traveled all over the country and took photographs of Chinese relics that people had in their homes. If he heard that somebody had a bronze, he'd ask if he could see it. That's how he researched that book. The collectors were all big shots, famous people. To buy bronzes like that, you have to have money."

I ask about the book's title—*American Imperialists*—and the old man says that Chen hadn't chosen those words. "His interests weren't political. He just wanted to study the bronzes. He often talked about how beautiful they were—many times, he said that it was remarkable that even three thousand years ago, people were creating something so gorgeous. He felt the same way about Ming dynasty furniture. He was a serious collector; he had more than twenty pieces of furniture from that period. After he and my sister returned to China, their salaries were about the same. They used her income for the household expenses, and they used his income to buy antique furniture."

The old man mentions that the couple's furniture is now part of a permanent exhibition in the Shanghai Museum. When I ask about Chen's political problems, Old Mr. Zhao says that in the 1950s, Mao Zedong initiated a campaign to change the Chinese writing system. During that period, Mao commanded that a number of characters be simplified, and he hoped to replace them entirely with an alphabet. Chen Mengjia wrote articles criticizing the proposal.

"He thought that Chinese writing shouldn't change," Old Mr. Zhao explains. "He was named a Rightist after that. There was a lot of criticism at that time, and then of course it got worse during the Cultural Revolution."

I ask why the man killed himself.

"He was a scholar, an intellectual," Old Mr. Zhao says. "He was a proud

man, and he couldn't bear the insult. You know, he tried to kill himself three times. My sister saved him twice. The third time, she was asleep—she was exhausted and she didn't find him until he was dead."

Huang Zhe has been listening silently, and now she shakes her head. "You can't understand what that pressure was like," she says. "They'd make you kneel in front of everybody and recognize your faults. They'd accuse you of nonsense, of wanting to kill somebody, of thinking something bad—anything. All of us went through it. But none of us had it as bad as Chen did, because he was a famous man who had been named a Rightist."

"That's why I don't like to talk about the past," her husband says. "*Mei banfa*. There's nothing to do about that now."

Their story contradicts Old Yang's. The archaeologist hadn't mentioned a campaign to change Chinese characters, and he had told me that Lucy wasn't with her husband when he killed himself. Old Yang described two suicide attempts, not three. And he had mentioned the accusation of a love affair.

"I talked with somebody at the Institute of Archaeology who knew Chen Mengjia," I say, choosing my words carefully. "He told me that during the Cultural Revolution, some people criticized Chen because they believed that he had some relationship with another woman. I know that many things were exaggerated at that time. Do you remember any criticism about this?"

A pause; the woman shifts uncomfortably. Old Mr. Zhao breaks the silence: "I don't know anything about that."

"Do you remember hearing anything about it at all?"

"I never heard about that." He speaks evenly, and his eyes show no reaction. I change the subject, and the tension passes; we talk about tennis. Old Mr. Zhao says that he still plays three times a week.

I KNOW THAT there is more to the story, but I won't learn anything else from Old Mr. Zhao. Despite all the times I've spoken with him, there is some part of his character that remains completely hidden. Many Chinese of his generation are like that, especially the ones who saw awful things. Their memories lie beneath a shell that has hardened with time.

Occasionally, though, there are glimpses of something deeper, and I remember another story that Old Mr. Zhao told me. Several months after the demolition of his home, on a winter afternoon, he found himself in the old neighborhood. On a whim, he stopped by the site of the courtyard. Along the street, the outside still looked the same: the gray-plastered wall and the red door. Old Mr. Zhao happened to be carrying his key, and he tried the lock.

It didn't work, so he stooped over and peered through the mail slot. Broken bricks, crushed tiles. Dust, dust, dust. The old man took a long look, and then he walked away, never to return.

When he tells the story, that's how it ends. The point is obvious: that chapter in his life is over. But there must have been some reason why Old Mr. Zhao still had that key.

12

Asylum

January 2001

WASHINGTON, D.C., LIKE BEIJING, IS A DELIBERATE CAPITAL. BOTH cities are square: straight streets, right angles. They are arranged strictly according to the compass, and each occupies a site that represented, in the eyes of a visionary ruler, a blank slate. The Ming emperor Yongle selected his location on the northern plain; George Washington chose the bend of the Potomac River. And each city's layout—the grid of monuments and broad streets—immediately tells a visitor that this is a seat of authority.

At the heart of each capital stands a political structure. In Beijing, the Forbidden City represents the center; in Washington, D.C., everything emanates from the domed building of the United States Capitol. From that point, the street names follow a strict logic, a testimony to American pragmatism: roads that run north and south are numbered; letters of the alphabet mark the east-west streets. Heading due north from the domed building, along North Capitol Street, one crosses the latter part of the alphabet—Q Street, R Street, S Street—before the intersection of Rhode Island Avenue. Rhode Island continues northeast (U, V, W) and then, after the first alphabet is exhausted, it begins anew with two-syllable names: Adams, Bryant, Channing. Douglas for D, Evarts for E, Franklin for F. On the corner of Franklin and Rhode Island is a dilapidated beige-brick apartment building. Inside that building, in an apartment on the third floor, five Uighurs found a temporary home in the fall of 2000.

For months, the apartment had served as a way station for recent arrivals from China. The rent was only four hundred dollars a month, and tenancy was passed from Uighur to Uighur. The apartment consisted of a small kitchen, two bedrooms, and a living room where a pair of mattresses had been laid out on the floor. One wall of the living room was decorated with framed verses from the Koran; across the room, on another wall, hung a multicolored map of the United States.

None of the current residents planned to stay in the apartment for long. One man had recently crossed illegally from Canada; another had already received political asylum and was applying for permanent-resident status; the others were preparing their own asylum applications. Each man found his own path through the city, acquiring jobs, lawyers, necessary documents. Along the way, they explored holes in the system. That was another link between Washington, D.C., and Beijing: beneath the grid of straight streets and impressive monuments, there was always an element of disorder.

Shortly after Polat moved into the apartment, he read the classified section of a Chinese-language newspaper and noticed an advertisement for "driver's license consulting." The service was based in the District's Chinatown, and for $150, the consultants offered to provide the paperwork for a Virginia driver's license. Among the immigrant community, Virginia was known for its loophole: applicants for driver's licenses and state identity cards didn't have to show proof of residence or even identity. The only requirement was a notarized affidavit testifying that the applicant lived in Virginia and had valid documents. It was possible for an out-of-state, illegal immigrant—in other words, somebody like Polat—to acquire a Virginia driver's license without ever showing his passport to a government official. Non-English speakers were also allowed to bring their own interpreters to the examination.

The Chinatown service arranged Polat's affidavit, no questions asked, and they also sent a Chinese man to accompany him during the written exam. Whenever the Chinese man came to the correct answer of a multiple-choice question, he muttered, "Da ge," which means "big brother." Big brother, big brother, big brother. Polat passed with flying colors. After receiving his license, he bought a silver 1992 Honda Accord for thirty-one hundred dollars.

One evening that winter, Polat tried to call his mother in Xinjiang, but the apartment's phone service was cut off. He decided to use the public telephone near the corner of Rhode Island and Franklin. It was almost midnight. The pay phone was right across the street from the Good Ole Reliable Liquor Store.

While he was punching the numbers, a man came up from behind and said something that Polat didn't understand. He ignored the man and kept dialing

Xinjiang. Before Polat could finish, he felt something pressed against his back. He whirled around and saw that the object was a handgun.

Two men: one with the gun, one in a car. "Lay down," said the gunman, and this time Polat understood. He dropped down; the gunman searched him. He found seventy dollars in a front pocket but somehow missed the three hundred that Polat had stashed in another pocket. The two muggers drove away on Rhode Island Avenue; Polat picked himself up and hurried back to the apartment. He had been outside for less than five minutes.

THAT WINTER, I visited the United States for a month. I spent Christmas with my parents and sisters in Missouri, and I saw friends and editors in various cities: Los Angeles, San Francisco, New York, Washington, D.C. None of these places felt truly familiar. I had grown up in one American small town and attended college in another; since graduation I had lived overseas. There wasn't a single big city in America that I could negotiate without a map.

To me, the capital seemed the most foreign. The layout felt intimidating because of all the broad streets and big memorials; there never seemed to be enough people to fill the District. In January, the monuments looked particularly deserted: empty paths, yellowed grass. The sky was the color of cold metal; the forecast called for snow. I took the metro to Rhode Island Avenue, surrounded by unfamiliar faces. The first person I recognized was a Uighur.

He had waited outside the station, on foot—his Honda was in the shop. We grinned and shook hands, just like the old days in Yabaolu. His face looked thinner; he had lost weight since coming to America. He still chain-smoked, but now he smoked Marlboro Lights instead of Hilton. Back in Beijing, he had preferred Marlboro but usually didn't buy them, because of all the fakes.

We walked to his apartment, and he laughed when I took off my coat.

"Your shirt's the same as mine," he said.

I looked down and realized that we had dressed identically: olive-green Caterpillar-brand denim shirts.

"Did you buy that in Yabaolu?" he asked.

"Yes. In that new market in Chaoyangmenwai."

"It's *jiade*," he said, laughing. "Same as mine. How much did you pay?"

That was a question that had no good answer in China; the moment anybody asked, you knew you had gotten ripped off.

"Maybe seventy yuan," I said, hopelessly.

"I paid forty," Polat said. "They probably charged you more because you're a foreigner."

His roommates were out, and Polat wanted to make a trip downtown. I

asked him to show me the neighborhood first, and he led me down Rhode Island Avenue. Along the street, flyers had been posted on the telephone poles, in preparation for that month's presidential inauguration:

DAY OF OUTRAGE!
Black Unity Rally Against George W. Bush
Sat. Jan 20 11:00 A.M.
Please wear all black in unity.
Sponsored by the Black Alliance Against the Bush Agenda, the New
Black Panther Party for Self-Defense
American Indian Movement and Other Peoples of Color

I copied one of the signs into my notebook, and Polat asked me what it meant. "Peoples of color" sounded awkward if translated literally, so I used the standard Chinese term for minorities: *shaoshu minzu*. Of course, that was just as odd in English: "small-number ethnic groups." Perhaps somewhere in the world there was a language that handled this issue gracefully, but it wasn't English or Chinese.

I asked Polat if the average American on the street seemed to lump him in with any particular group.

"They think I'm Mexican," he said.

"Does anybody try to speak Spanish with you?"

"Sometimes," he said. "But not so often in this neighborhood."

We came to the intersection of Rhode Island and Montana, and Polat remarked that on that corner drug dealers worked openly at night. He thought that some of the residents in his apartment complex were also selling drugs. People kept strange hours; he sensed that most of his neighbors were unemployed. He had noticed that sometimes they bought groceries with pieces of paper that weren't money.

Polat had been in the country for only three months, but already he had adopted the all-American habit of dropping your voice when you talk about blacks. He did this even though we spoke Chinese. Sometimes, he referred to them as "African," in English. He had heard people use the term "African American," but he had picked up on only the first part of the phrase. He also sometimes used the word "Spanish" to describe Hispanics.

"All of the Uighurs say it's bad to live in an African area," he told me. "To be honest, I haven't had a very good impression of them. Maybe they're better in other parts of America, but around here they drink and do drugs all the time. I'd say that less than half the people in this neighborhood have jobs."

He pulled out a Marlboro Light and we continued along Rhode Island

Avenue. The sidewalk was strewn with broken glass and litter; apart from the trash, there were few signs of life. Buildings lay in disrepair; shops were shuttered; the streets were empty. I couldn't remember the last time I'd been in such a silent city. In China, every urban landscape bustled with activity—street peddlers, repairmen, noodle stands, roadside shops, beauty parlors. Even in cities that had been decimated by the reform of state-owned enterprises, locals seemed to be on the move. And there was always construction—the endless clink of chisels and rattle of jackhammers.

But here on Rhode Island Avenue, the only sound was cars rushing by, and they weren't about to stop. Of the few local businesses, some hardly qualified as such: a Check 'n Go, a Star Pawn. Polat told me that a number of establishments were immigrant-owned, even though there were relatively few foreigners in this area. His car was being repaired at Metro Motors, which was run by an Ethiopian. Koreans owned both the Famous Fried Fish House and Tony's Neighborhood Market Grocery, which stocked more alcohol than food and had thick Plexiglas barriers protecting the cashier. Next to the Good Ole Reliable Liquor Store (Indian-owned) was the Wah Mee Restaurant, which was run by immigrants from Fujian. That was the province famous for people-smuggling—back in Fujian, the Wah Mee relatives were probably waiting to build a mansion of green glass. Here on Rhode Island Avenue, a battered sign faced the grim street:

WAH MEE RESTAURANT
CHINESE-AMERICAN RESTAURANT
POLYNESIAN COCKTAILS
CARRY OUT

"The blacks bully them," Polat said. "They eat and they don't pay."

THE METRO WHISKED us beneath the city's grid—back through the first alphabet, past the Capitol, and on to the Smithsonian station. We walked out onto the faded lawn of the Mall. The Washington Monument was closed for repairs; scaffolding clambered up the base, marble and metal disappearing into the gun-gray sky. While we stared up at the monument, two Asian men walked past. They were dressed identically: dark suits, khaki overcoats. Polat waited for them to move out of earshot.

"Those guys are North Koreans," he said.

"I think they're just Asian Americans," I said.

The men walked west, toward the reflecting pool. Polat watched intently.

"They're definitely not Asian Americans," he said. "I can tell by the way

they dress and the way they're walking. There's something different about them. I bet they're North Korean diplomats. They look the same as those guys around the embassy in Yabaolu."

"Are they wearing Kim Il Sung pins?"

"I didn't see," he said. "But in America they might take off the pins anyway."

We walked down the hill, toward the line of oaks that ran alongside the reflecting pool. Deliberately, I slowed, hoping that the Asian men would disappear. The day was depressing me: the ruined neighborhood, the old Yabaolu conversation about North Koreans. For five years, I had lived on the other side of the world, and so many times in China I had been called upon to talk about the United States—teaching classes, answering questions, holding conversations with curious Chinese. In the Peace Corps, that had literally been my job title: "foreign expert."

But now that I was finally here with somebody from China, almost nothing about my native country seemed recognizable. Even the monuments looked different, abandoned for the winter. Below the scaffolded obelisk, the reflecting pool was dull as slate. A few white seagulls carved their way across the surface, paddling sluggishly. We stood beside the pool for a moment, and Polat said he wanted to see the Lincoln Memorial. Up ahead, the Asian men had finally disappeared.

We climbed the steps to the memorial. Children's laughter rang off marble walls; the place was full of school groups. I couldn't remember the last time I had been here—probably when I was a child myself. Inside, the Gettysburg Address had been inscribed into a wall:

> *Fourscore and seven years ago our fathers brought forth on this continent a new nation, conceived in liberty and dedicated to the proposition that all men are created equal. . . .*

The words felt as soothing as a rediscovered Bible verse: half familiar and half new, like anything that was recited long before it was understood. I read the Address slowly, pausing at the rhythm of certain phrases—"the world will little note nor long remember"; "the last full measure of devotion"—and for the first time that day I felt calm. That was my language; this was my home.

Polat and I stood in front of Lincoln's statue. Children swarmed around us, giggling and talking, and their presence made the seated figure even more stately than he looked in photographs. For a moment we were silent.

"A lot of Uighurs admire Lincoln," Polat said. "I used to read history books about him. We admire him because of the way he handled the ethnic issues."

We returned to the cold January afternoon. Outside the monument, a simple wooden shack had been erected, along with a sign:

POW-MIA
You Are Not Forgotten
The Last Firebase Standing Vigil
Until They All Come Home

A middle-aged man in camouflage handed out pamphlets—the last full measure of devotion. I accepted one and thanked him, and then Polat touched my arm.

"There's the North Koreans," he said.

They walked side by side: black suits, khaki overcoats. This time I checked—no pins.

"I really don't think they're North Koreans," I said.

"I'm sure of it," he said.

The men walked to a taxi line. They shook hands and entered separate cabs.

"They're definitely up to something strange," Polat said. "Why else would they split up like that?"

The vision came to me as if from above: two men, one from Xinjiang, the other from Missouri, speaking Chinese at the Lincoln Memorial and wearing identical knockoff Caterpillar-brand denim shirts. I said that it was time to leave, and at last we did.

THERE WERE ONLY about five hundred Uighurs in the United States. In the early 1990s, some had arrived as university students, but in recent years there had been an increase in those who came independently. Generally, they applied for political asylum, which differed from the refugee program. Refugees represented a controlled group: every year, the White House determined the refugee numbers and nationalities, which shifted according to world events. Until the early 1980s, the majority of refugees came from Indochina; by the end of that decade, the former Soviet Union took the lead. In 2001, it shifted to Africans: Somalia, Liberia, Sierra Leone. Typically, refugee candidates applied overseas, and then the State Department provided a loan for transportation and initial resettlement costs.

But asylum was the wild card of American immigration. Unlike refugees, who arrived in the United States under government auspices, candidates for asylum found their own way to the country. Their numbers were low: in 2001, only 20,303 people were granted asylum. (That year, the United States admit-

ted a total of 1,064,318 legal immigrants.) It wasn't uncommon for asylum applicants to use bogus documents, or sneak across borders, or lie to U.S. immigration officials. None of these acts was held against a candidate who was deemed worthy. This created an odd moral environment: Polat's first act on American soil had been to deceive officials, but nevertheless he could apply for asylum without worrying about the ramifications of his deception. And the asylum program was notorious for false stories—many applicants actually came to the United States for economic reasons, and they exaggerated the political risks of their home country. Chinese applicants often cited the planned-birth policy, knowing that Americans were concerned about abortion.

By the time I visited in January, Polat had already hired a lawyer, who was preparing the asylum application. If successful, Polat would be allowed to seek employment, and he could also apply for his wife to come from Xinjiang and join him. After asylum, there were other stages: first, permanent-resident status (the "green card"), and then citizenship. Other Uighurs had told Polat that if everything went smoothly, he could become a real American in five years.

He had enrolled in an adult English class, in preparation for finding a job. He told me that at the beginning any employment would probably be unskilled, like driving. But for some reason he liked the idea of working at the post office after his English improved. "It's stable and you don't have to have a high degree from an American college," he explained.

That January, he asked if I would write a letter on behalf of his asylum application. I agreed; I hadn't directly witnessed Polat's political problems in Xinjiang, but I was well aware of his economic situation. In the letter, I wrote: "By no means should Mr. [Polat] be identified as an economic refugee who simply wants American job opportunities—as an educated person who speaks both Chinese and Russian, he had plenty of business possibilities in Beijing. . . ."

During one of my subsequent trips to Washington, D.C., I met with Polat's lawyer, Brian Mezger. In 1998, Mezger had been working for a nonprofit immigration organization in Philadelphia, and a potential client called and explained that he was a Uighur. Mezger responded, "What's a Uighur?" That year, he started his own practice, which soon became largely dedicated to Uighur clients. Mezger's office was in Bethesda, Maryland, and virtually every Uighur candidate in the Washington, D.C., area hired him. For each client, he charged fifteen hundred dollars, which was a relatively low rate by industry standards.

Mezger was a quietly intense thirty-one-year-old who had been born in Vicenza, Italy, to an American father and a Sicilian mother. He told me that

his mother's background had inspired him to pursue immigration law. For Mezger, the melting pot had worked quickly. His mother was a Catholic ("in the Sicilian sense"), but he had attended thirteen years of Quaker school. He voted Republican. At Oberlin College, he had majored in East Asian Studies; in his spare time, he still read Japanese and Chinese poetry. He also studied everything he could find about Uighurs. In 1998, he had attended the World Uighur Youth Congress, a meeting of the exiled community, in Ankara, Turkey. "I have a very high boredom threshold," he explained. "All the meetings were in Uighur or Russian. I just read books or doodled or whatever."

He had never traveled to Xinjiang. But even in Maryland, he had become familiar with certain aspects of Uighur culture. At one point, he had considered hiring an ethnic-Chinese secretary, but he realized that the Uighur distrust ran too deep for that. He had learned that many educated Uighurs didn't care for Islam. He had also become familiar with the Uighur class system, and in particular he was impressed by the resourcefulness of the traders ("you could probably drop them into a jungle and they'll find a way to do business"). And he had learned to be careful when asking question number five on the United States asylum application:

> *Do you fear being subjected to torture (severe physical or mental pain, including rape or other sexual abuse) in your home country or any country if you return?*

"I've had Uighurs say no, because they aren't afraid," Mezger told me. "They want to be tough. I have to explain that the question is asking whether there is a *possibility* of torture in a Chinese jail."

Of the estimated five hundred Uighurs living in the United States in 2001, nearly one hundred eventually won asylum with Mezger's help. But he told me that even when cases were successful, he worried about his clients' future.

"Every once in a while I think, I'm getting these people asylum, but I'm basically helping to destroy Uighur culture," he said. "Their kids adjust so fast. For the grandkids, it will just be an oddity that they were Uighur. But this happens with all groups in America. I'm sure the descendants of the German revolutionaries who came over in the 1840s weren't quite as keen on revolution. It's the same thing with any small, hunted group."

Every November 12, the Uighur community in the Washington, D.C., area gathered to celebrate the anniversary of the founding of the East Turkestan Republic. One year, I happened to be in town, and I attended with Polat, whose father had fought for the East Turkestan Army. The banquet was held in a rented room at George Mason University. About eighty Uighurs attended, in-

cluding a few who had come from overseas to mark the occasion. One eighty-year-old had flown in all the way from Kazakhstan. He was one of the few living Uighurs who had personal memories of the independent republic that had been crushed in 1949.

At the banquet, people gave speeches in Uighur, and then the younger members of the community performed dances in traditional costumes. One participant was an eighth-grader from Fairfax, Virginia; she spoke perfect American English and told me that she had agreed to dance only because her friend was doing it, too. When I asked the girl if her Virginia classmates understood what it meant to be a Uighur, she rolled her eyes. "They say I'm Chinese, because I'm from China," she said. After the dance, four adult Uighurs paraded into the hall dressed in the olive-green military uniform of the East Turkestan Republic. They marched to the front, saluted the crowd, and basked in a wave of applause. At exactly eleven o'clock, the loudspeakers crackled and a security guard announced that the room would be closed immediately, and then the Uighurs shook hands, bade each other farewell, and swept out of George Mason University.

POLAT NEVER MENTIONED the mugging during my visit in January of 2001. I didn't learn about it for more than a year, when a mutual friend informed me. Afterward, I asked Polat what had happened, and he told the story. He said that both the driver and the gunman were "African."

"At first I was frightened, but once he told me to get down I wasn't frightened anymore," he said. "At that point, he shoots me or he doesn't shoot me and there isn't anything to do. I didn't think he was going to shoot me. He was very skinny and I think he was a drug addict.

"I didn't tell the police, because I didn't have asylum yet. It wasn't worth the bother. That was an ugly scene—down on the ground like that."

Polat shook his head and laughed ruefully. I realized why he hadn't told me earlier: the mugging had humiliated him. Several times, he mentioned how ridiculous he must have looked on the ground beside Rhode Island Avenue. I tried to reassure him by saying that he had done the right thing; there was no reason to resist a man with a gun. But Polat disagreed.

"One of my Uighur friends was delivering for Domino's and a man held him up at gunpoint," he said. "He was also African. He pointed the gun at my friend, and my friend just grabbed the gun and pulled it away. There weren't any bullets. They began to fight, and soon a police car came and picked them up. The officer put handcuffs on both of them and took them to the station.

My friend called an interpreter, and once the interpreter arrived they let my friend go."

I told him that the Uighur had been lucky, and that it was always best to assume that guns come with bullets. Polat shook his head.

"It depends on the situation," he said. "If they don't seem like they know what they're doing, you can fight. That happened to me once in Yabaolu. It was in 1997—four money changers were murdered that year. Three guys must have been watching me for a while, and one evening they tried to rob me. The leader stopped me on the street and showed me his knife. He just flashed it and said, 'Friend, can you loan me some money?' You know how those guys talk—'Friend this, Friend that.' He had a northeastern accent."

Polat smiled proudly. "I didn't give him anything," he said. "I told him, 'I'm from Xinjiang, from Urumqi, and we know about knives. That knife you have is nothing special. I have friends in this neighborhood.' After that, they left me alone."

The Uncracked Bone
比较文学

AFTER TALKING WITH OLD MR. ZHAO, I SEARCH FOR THE STORY OF Chen Mengjia's life. The material is thin: no book-length biography of Chen has ever been published, and many of his works are out of print. The end of his life is a complete blank; there are no detailed accounts of the events that led to his suicide. In China, the Cultural Revolution is still a shadowy period. It's permissible to write critically about those years, but there is a tacit understanding that investigations should not be pushed too far. And few people kept diaries or saved letters during that time.

The beginning of Chen's life is clearer, because he published so precociously. He was born in 1911, in Nanjing, where his father was a schoolteacher and a Presbyterian minister. Ten Chen siblings lived to adulthood: five men, five women. Each graduated from college—an education level that was particularly unusual for women of that generation. Chen Mengjia was the seventh child, and by far the most brilliant. He published his first poem at the age of eighteen; by twenty, when his debut volume appeared, he was famous. As Chinese poets have traditionally done, he gave himself a pen name: Wanderer.

He became the youngest member of the Crescent Moon Society, a group of romantic poets who eschewed the rigid rules of classical Chinese verse. In 1932, when Japanese and Chinese armies clashed outside of Shanghai, Chen joined the resistance. The young poet sent verses back from the battlefield:

> *Blood flakes bloom in front of new ghosts' tombs*
> *and drip on muddy snow*
> *There lie our heroes—quietly . . .*

His poetic style was simple and well metered; critics compared him to A. E. Housman and Thomas Hardy. Chen abandoned Christianity after childhood, but he sensed a mysticism about the distant past which he described as an almost religious feeling. One early poem, "Smile of the Tang Dynasty," describes a thousand-year-old engraving of a female figure:

> *I peek at the side of her face*
> *Under her dignified appearance*
> *A cold, silent trace of a smile*
> *Is hidden.*

Artifacts have power; written characters breathe life into the distant past. In another poem, the narrator gazes at an old fort:

> *The tower seems content*
> *With dignity. Listening to the sound of the river*
> *Listening to the wind*
> *As it writes the three-thousand-year script*
> > *across a sheet of cloud*
> *They inspire me to gratify and respect antiquity.*

As a college student in Nanjing, Chen studied law, but after graduation he shifted fields. In 1932, he began to research classical Chinese literature, then religion, and finally he switched to ancient Chinese writing. The past drew closer; poetry drifted away. Verse had always seemed painful for Chen; in one poem he wrote: "I crushed my chest and pulled out a string of songs." He explained in a book preface that at twenty-three he was already becoming disenchanted with poetry. Later, he wrote:

> *Since I was seventeen, I have used meter to control myself. Everything I*
> *wrote could be measured by a string. . . . The chain was heavy on me, and*
> *in the slavery I learned to make fine words.*

By his early thirties, he had essentially stopped writing verse. At Yenching University, in Beijing, he spent hours studying the inscriptions of oracle bones and ancient bronzes. As he drifted into archaeology, the early poems seemed reminders of another life that had already passed:

Are you the one who really wants to know my story?
Embarrassed, flushed
Gently I turn over twenty blank pages.
 I want to write only one line:
I am a minister's good son.

<div align="center">* * *</div>

LUCY CHAO WAS also a minister's child who became a prodigy. At twenty-five, she published the first Chinese translation of T. S. Eliot's *The Waste Land*. She taught English at Yenching University, until 1937, when many Chinese fled Beijing in the wake of the Japanese invasion. Years later, in an autobiography, Lucy remembered:

> *We moved to the south, and my father stayed in Beijing with my brother Zhao Jingxin [Old Mr. Zhao]. . . . we moved to an old house in Deqing County in Zhejiang. At that time, I married Chen Mengjia. There everything was cheap and life was colorful. We had fish and shrimp every day. We didn't need to study, so we often watched the ducks crossing the water. . . .*

Along with many other Chinese intellectuals, the couple eventually relocated to Kunming, a city in the remote southwestern province of Yunnan. In Kunming, the key Chinese universities reorganized into a new entity known as National Southwest Associated University, where Chen Mengjia taught. Lucy wasn't allowed to serve on the faculty—rules forbade a couple from teaching at the same institution.

> *I was a housewife for eight years. I had traditional thoughts that a wife should sacrifice for her husband. But I was really well educated. While cooking, a copy of Dickens was always on my knee.*

In 1944, the Rockefeller Foundation granted the couple a joint humanities fellowship, to fund research in the United States. Theirs was a unique generation: despite the Japanese invasion and the civil war, a group of promising young Chinese were developing deep intellectual links with the West. Many went to America and Europe to be educated, and most intended eventually to bring their new skills home to China.

For Chen Mengjia and Lucy Chao, the trip began with a flight from Kunming to Calcutta. The journey "over the hump" inspired Chen to write poetry for the first time in years:

I cannot see the Himalayas
Clouds pile high like mountains . . .
Everything looks so lonely
This is a desert of heaven.

At the University of Chicago, Lucy researched a dissertation about Henry James. For years, she had studied English from afar; now literature was suddenly right at hand. During a trip to Harvard, she met T. S. Eliot, who gave her an inscribed copy of his poems.

It was said that I became the third biggest collector of Henry James' books. . . . My husband and I were determined to spare no efforts to enjoy the cultural education offered by the United States. We went to concerts, movies, and we visited all kinds of museums. We went to watch every sort of opera. When we returned from the States, our luggage was full of books and records; there wasn't much money left.

While Lucy studied literature, Chen hunted for bronzes. Many artifacts had been taken out of China during the chaotic nineteenth and twentieth centuries, and few pieces had been studied carefully. Chen hoped to write a definitive book on the subject, combining both Western and Chinese approaches to bronze studies. In addition to his Rockefeller grant, he received support from the Harvard-Yenching Institute.

28 May, 1945

My dear Miss Hughes,
 I shall be visiting Kansas City either this coming weekend or the weekend following. I would like to know the most convenient time to visit the Museum. . . .

The Wanderer earned his name. He traveled to Detroit, Cleveland, St. Louis, Minneapolis, New York, New Haven, Boston, Providence, Princeton, San Francisco. He went all the way to Honolulu. In every city, he contacted museums and private collectors, studying their artifacts. For two years he shifted between the worlds of ancient Chinese bronze and modern American culture:

14 June, 1945

My dear Miss Hughes,
 I enjoyed myself very much during my visit to Kansas City and wish to thank you again for your kindness. If time permits I may be able to

*make another visit before the Fall with my wife. . . . I spent some time in
downtown Kansas City my last evening and finally went to a movie. I feel
that the trip was very enjoyable from every point of view. . . .*

Outside of the United States, Chen visited Toronto, Paris, London, and
Oxford. In 1947, after a trip to Stockholm, he wrote a letter to the Rockefeller
Foundation:

*I was received by the Crowned Prince in his castle to see his own collection
and had the honour of talking and discussing with him for two hours.*

That year, Chen completed a draft of the book—photographs and de-
scriptions of 850 vessels. Before returning to China, he sent the manuscript
and photographs to Harvard; editing would be conducted by post. Langdon
Warner, a Harvard professor, wrote a letter to Chen: "It takes a brave man to
face the difficulties—political and financial—of Asia today and I admire you
for going back at this time."

In Chicago, Lucy stayed behind to finish her doctorate. By the time she
finally headed across the Pacific, at the end of 1948, the civil war in China had
passed the turning point:

*While I was on the boat [to Shanghai], I heard on the loudspeaker that
Tsinghua and Beijing universities had been liberated. [The Kuomintang
general] Fu Zuoyi's troops were in trouble. . . .*

*The traffic between Beijing and Shanghai had stopped, so I had to find
some way to get there. . . . Luckily, a plane that was carrying grain for Fu
Zuoyi was going to Beijing, so I took it. The plane landed at the Temple
of Heaven. When we passed Tianjin, the People's Liberation Army sol-
diers fired at us from the ground. There was no ladder for us to descend
. . . we just jumped onto a bunch of quilts that had been laid out on the
ground. . . .*

The capital was divided, with some sections under Communist control and
others still held by the Kuomintang. Chen Mengjia was in an area that had
already been taken by the Communists.

*I asked somebody to send a message to my husband saying that I had re-
turned, and when the gate of the castle was open I wanted him to meet me.
Three weeks later, the gate was open. Beijing was liberated.*

* * *

THE GATE SHUT almost immediately. In 1950, the Korean War broke out, and communication ended between China and the United States. In Cambridge, Harvard professors waited to hear from Chen about his book on bronzes; in Beijing, Chen waited for the political climate to soften. He kept busy by reading oracle bones. In 1956, he published *A Comprehensive Survey of the Divination Inscriptions from the Wastes of Yin*. The phrase "Wastes of Yin" refers to the Anyang region, where so many pieces of bone and shell had been excavated over the years. From these fragments, Chen re-created the Shang world: calligraphy, grammar, geography, astronomy. Warfare and sacrifice; gods and royalty. When the Beijing publishing house paid Chen, he used the fee to purchase an old courtyard home near the city center. Above the entrance, he erected an inscription: THE ONE-BOOK HOME. That turned out to be a sad divination: Within two years, Chen Mengjia would be banned from publishing in the People's Republic. And in the United States, his book about bronzes never appeared.

Despite the ban, the Institute of Archaeology printed its own version of the book, using the notes that Chen had brought back with him. The editing was sloppy; mistakes were made; many of the photographs had been stranded at Harvard. For good measure, the Chinese edition included an introduction criticizing Chen Mengjia. His name didn't appear below the title, which was unlike anything else ever produced by Rockefeller money:

> *Our Country's Shang and Zhou Bronzes*
> *Looted by American Imperialists*

<center>* * *</center>

NOWADAYS, THERE ARE only approximately thirty oracle bone scholars worldwide. In the United States, the most respected expert is David N. Keightley, a professor of history at the University of California at Berkeley. Keightley never met Chen Mengjia, and he knows little of his personal story. But the American has researched in the tracks of the Chinese scholar, and he still uses the Chen book that survived—the volume on oracle bones and the Shang world. "That book was supremely important," Keightley tells me during one of our conversations at his home in the Berkeley Hills. "It's a wonderful book. He lays everything out there—the rituals, the sacrifices, the time frame. It's very old, but it's still a very good place to start."

Like Chen Mengjia, Keightley has spent his academic career piecing together fragments. He compares the bone inscriptions to notes on a score—a type of code that, in the right hands, becomes music. There are snatches of

song, pieces of tunes. Melodies: certain themes recur so often that they create harmony. Keightley has perused some thirteen hundred divinations about rainfall, all from the period of the Shang king Wu Ding, who ruled from roughly 1200 to 1189 B.C.

This month there will be a great rain.

Today the king will hunt; the whole day it will not rain.

That we are not rained on means that for this settlement Shang some Power is making disasters.

The bones make music, and they also tell stories. The Shang are obsessed with the dead—in their world, departed ancestors have power. If neglected, they punish the living through sickness, misfortune, and natural disasters. When a ruler becomes sick, or if there is some problem with the weather, the royal court performs divinations, trying to discover which unhappy ancestor demands a sacrificial offering. Sometimes the Shang negotiate with the dead: on one excavated fragment, an inscription proposes sacrificing three human prisoners to an ancestor. But there must have been an unsatisfactory crack, because another inscription follows: five human prisoners. After that, the divinations end. The ancestor must have been satisfied with five deaths.

"Another nice example is the toothache divination," Keightley says, opening his own book on the oracle bones, *Sources of Shang History*. He turns to a black-and-white rubbing of an oracle bone that also dates to the reign of Wu Ding. The rubbing shows the reverse side of a cracked turtle plastron, whose oval shape is marked by drilled pits and inscribed characters. Some of the original Shang words are hard to make out, and Keightley's book reproduces the plastron with clearer, modern characters:

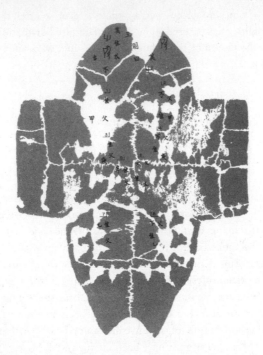

After opening the page, Keightley sets the scene. "The king is going on a campaign, and he has a sick tooth," he explains. "He's trying to figure out what to do about the tooth, and he needs to know which ancestor is responsible."

Four names have been carved into the object: Father Jia, Father Geng, Father Xin, Father Yi. All are of a single generation—the king's father and three uncles—and all are already dead at the time of the divination.

"It is Father Jia, it is not Father Jia," Keightley reads aloud, in Chinese, running a finger across the characters. "It is Father Geng, it is not Father Geng. It is Father Xin, it is not Father Xin. It is Father Yi, it is not Father Yi."

For each ancestor, multiple divinations have been performed—cracks across the plastron. The object is like a three-thousand-year-old detective's notebook, eliminating possibilities one by one.

"And then we have another inscription: 'Offer a dog to Father Geng and split open a sheep,'" Keightley says. "That's why I think it's Father Geng who was causing the illness."

Keightley pauses and looks up from the page. At sixty-nine years old, he is a tall, thin man with sharp gray-blue eyes. "Those are the notes," he says. "We have to supply the music ourselves."

＊　　　　＊　　　　＊

IN ANCIENT CHINA, it seems that somebody was always lining up the notes. Order, regularity, organization—these characteristics impress archaeologists and historians. Even three thousand years before the Shang, in Neolithic times, there is a striking regularity to the burial pits of the central plains. Those early cultures followed a practice that is described as "secondary burial." The dead were buried, and then, after a period of time, the bones were exhumed, cleaned, and arranged into patterns. Sometimes, bones were piled neatly, with the skull lying on top. In other tombs, skeletons were carefully laid out, their heads all pointing in the same direction. Order, regularity, organization.

When Keightley looks at such tomb diagrams, he sees art and writing. In his opinion, everything is connected: the same instinct is at work, the desire to regulate the world.

"If you look for the origins of the Chinese writing system, I think it's a mistake to look for naturalistic pictures," he says. "What you have to look for are diagrams—structures where they are abstracting, codifying. The same impulse that is working in the religious sphere is also working in the cultural sphere. If you want to see more evidence of impersonalization, look at the *taotie*.

"These are not naturalistic pictures; they are highly structured, dictatorial designs. Pattern and order are fundamental. They seem to be imposing a code. There is a shared cultural sense of what to do, how to think. My impression is that this is fairly unique to China. When do you see the first portrait of a king in China? I don't even know the answer to that. In Egypt you have early portraits of kings, of high officials. In China, you get nothing like that. Clearly they take pleasure in depicting important powers, forces, presences in an abstract way."

The Sanxingdui bronzes are different—even though they are stylized, they still depict the human form. When Keightley refers to "China," he means the central plains, where the Shang developed and where the modern Chinese have typically sought their roots. This region gave birth to Chinese ancestor worship, which is one of the culture's defining characteristics. And ancestor worship, in Keightley's opinion, naturally contributed to bureaucratic organization and the conservative thought of Confucianism.

"When you look at the Shang ancestors, you find that they have their jurisdictions," he says. "The more recently dead deal with the small things; the ones who have been dead for longer deal with the bigger things. They get more power as generations pass. My point is that this is a way to organize the world. People are in charge of different things. I describe this as generationalism, the sense that power accrues with age."

In classical Chinese literature, the hero is essentially a bureaucrat. He organizes and regulates; in battle, he is better known for making plans than he is for fighting. The early Chinese classics don't linger on descriptions of warfare—the gore of death, the muck of the battlefield. "You don't get that attention to dirty detail that you have in the *Iliad* and the *Odyssey*," Keightley says. "It's all about what the person does, what his talents are. It's very pragmatic, very existential."

Keightley has published a paper on this topic: "Clean Hands and Shining Helmets: Heroic Action in Early Chinese and Greek Culture." He compares the Greek classics to the closest Chinese equivalent—the texts of the Zhou dynasty, which followed the Shang. The Zhou are credited with establishing many of the philosophical foundations of Chinese culture, including some of the most important early works of literature: the *Book of Songs*, the *Book of Documents*, and the *Zuozhuan*. The composition of these texts ranged from around 1000 to 400 B.C. Confucius, who was born around 551 B.C., two centuries after the fall of the last Zhou ruler, idealized the dynasty as a model of appropriate culture and customs.

In contrast to the literature of ancient Greece, the moral world of the Chinese classics is remarkably orderly. In ancient China, the good are rewarded and the bad are punished. Gods do not come down to earth and behave badly. There is no tragedy in ancient Chinese literature. The dead function in essentially the same way as the living, except with greater power. Order, regularity, organization.

"The trouble with the dead in Homer is that they don't know beans," Keightley says. "They are described as 'the stupid dead.' They have no power; they can do nothing. In the *Odyssey*, Odysseus visits the underworld and talks with Achilles, who doesn't know what's going on back in Greece, or even if his son and father are alive. It's quite unlike the Chinese dead, who assume power as they become older. The Greeks don't do this. What the Greeks do is develop a hero cult, which is opposed to the ancestor cult. The Greeks are trying to build a city-state, as opposed to the lineage state, where you have a polity that is run by and for a group of powerful families. The Greeks did not encourage that."

Keightley's conversations are timeless. During our meetings, he shifts constantly: sometimes he touches on the Shang period, then the Zhou, and then modern China. Once, he remarks that the Chinese seem to produce bureaucracy as instinctively as the West creates heroes. But he emphasizes that this is not a value judgment; in fact, the need for Western-style heroism—decision, action—might naturally produce war. Historians have long theorized that Europeans educated in the Greek classics were particularly willing to rush headlong into the First World War. In one of his papers, Keightley quotes William Blake: *"The Classics, it is the Classics! That Desolate Europe with wars. . . ."*

Back again, to prehistory. When I ask how ancient China and the West developed such different worldviews, Keightley points to the landscape. In the central plains of ancient China, climate patterns were more regular than in the Mediterranean and the Near East. And China's two main river systems— the Yellow, the Yangtze—both flow from west to east. Each river is modular: there isn't much change in latitude, which means that crop patterns are similar upriver and downriver. There was little incentive for trade; ancient civilization was naturally agrarian. People who travel less are less likely to exchange ideas and technologies.

"Essentially I'm playing the role of the geographical determinist," he says. "I believe the climate of ancient China was very benevolent, and this encouraged the kind of optimism that we see in the culture. There is a flood myth, but the ancestor Yu solves the problem. Again, we have an ancestor who is competent; he does things. And in ancient China there is no evil act. There's no sense of original sin. There's no interest in theodicy, in explaining evil in the world.

"You look at the Mediterranean, the Middle East, Sumeria, where you have these sandstorms, these disasters—it's a very different world. Read the *Gilgamesh*; it's remarkable. The guy is going to die, and he's angry about it. He wants an explanation about death. There's nothing like that in China. You die and you become an ancestor. You have the same relationship: once a king, always a king; once a serf, always a serf. I believe that cultures that engage in ancestor worship are going to be conservative cultures. You're not going to find new things attractive, because that will be a challenge to the ancestors. There's no room in this culture for a skeptic."

I ask Keightley why this optimistic view is so different from what we know of China from the nineteenth and twentieth centuries—famines, floods, disasters, wars. And now, the migration of more than one hundred million people.

"It's the high-level equilibrium trap," he says, referring to a phrase used by the historian Mark Elvin in his classic, *The Pattern of the Chinese Past*. In Elvin's study of China's cultural continuity, early success, and subsequent

decline, he notes that relative geographic isolation was an important factor. Surrounded by deserts, mountains, and ocean, China was relatively protected from external threats, but that also limited contact with foreign innovation. Meanwhile, political stability combined with early advances in agricultural technology to allow the population to grow to dangerous levels.

"China has been pressing upon its natural resources for the past several hundred years," Keightley says. "They're so successful at what they are doing that they have been pressing the borders. The landscape, it seems to me, is exhausted."

The imaginative world, like the geography, was a trap. Ancestor followed ancestor; dynasty followed dynasty—an overpopulated history, the endless spiral of time. The Chinese tended to look farsightedly into the past, whereas Westerners, especially during periods such as the Renaissance, thought more about the future. In the Western view, even the ancient past had lessons that could serve modern progress. During the Age of Enlightenment, when contemporary political systems were changing, Europeans celebrated ancient Greek democracy. In the late 1800s, the modern Olympic Movement reflected the values of imperialism, which required an elite that was both well educated and physically capable.

But the Chinese view of history limited such redefinition. In the beginning of the twentieth century, some intellectuals attempted to explore their own past, but inevitably more Chinese turned to foreign concepts and values. It was a painful, clumsy process; inevitably they clutched at some of the worst Western ideas (such as Marxism). Today, the Chinese continue to struggle to incorporate Western traditions into their own culture. Keightley believes that this is one reason why they were so bitterly disappointed when, in 1993, they failed in their bid to host the 2000 Olympic Games. In "Clean Hands and Shining Helmets," Keightley writes:

> . . . Whether in the Marxism of Mao Zedong or the yearnings for democracy of student dissidents after him, the West has, for better or worse, now become, to a significant degree, China's Greece and Rome.
>
> The Asian Games, recently held in Beijing, like the Olympics that the Chinese hope to host . . . can thus be seen as the descendants of the games that Achilles held for Patroclus's funeral. . . . They serve as one example of China's attempt to appropriate part of the West's classical and now international heritage into China's modern culture.

<div align="center">*　　　　*　　　　*</div>

LIKE CHEN MENGJIA, David N. Keightley is an accidental oracle bone scholar. As a young man, he was determined to become a writer:

"I was contracted to do a book on the stock market. Eventually I gave that up, very happily. I wrote a novel that wasn't published, fortunately. But after that I studied all of the short stories in the fiction magazines, got the formula, and sat down and wrote a short story and sent it to the *Saturday Evening Post*. Sure enough they sent me a check for one thousand dollars, and I had the idea that I could do this every week. But the magazine went out of business before they published it.

"I was a freelance journalist, and I felt I was spreading myself too thin. I was paying the rent by writing book reviews for *Time* magazine, which was very nice, but I realized that that wasn't what a grown man should be doing. I wanted to find myself on one of the new frontiers. I wanted to become a free-lance writer about China, so I thought I wanted to learn Chinese, and I went to Columbia. And I got sucked into a Ph.D. program. By the end of my third year I had moved back to the nineteenth century. I wanted to do something about opium smoking—what was it about Chinese society in the south that led them to this British vice? Then I had an epiphany and realized that the really big questions were far back in the past. I wanted to look at public works in the Confucian period, and then I moved back another thousand years. It was a frontier. There was an awful lot of work to be done. I was thirty years old in 1962; I was a little old to be starting. But it was a very new field and you didn't have to worry, thank God, about the deconstructionism or the New Criticism.

"I went to Taiwan for two years, 'sixty-five to 'sixty-seven. Before returning to the U.S., I spent six weeks working in Japan, and one day I went to a bookstore in Tokyo. There was this book on the shelf—a book of oracle bone rubbings. The first entry was a character that looks like two hands raised:

"*Gong* men: 'Raise' men. There were seventy or eighty inscriptions, all about mobilizing a labor force. The king was making a series of forecasts—should he raise men? Raise men, three thousand; raise men, five thousand. Attack this; attack that. This was a revolutionary book. The title was *Inkyo Bokoji Sōrui*, by Shima Kunio. I dedicated my first book to him. It took him ten years to write this. I never met him."

A chance discovery, a found book—and then three and a half decades reading oracle bones. Keightley has published two books about the Shang, and he has been honored for his work; in 1986, he was granted a MacArthur Fellowship. In retrospect, his career makes perfect sense.

Of course, stories are always easier to tell after they're finished. It's the same with ancient Chinese history: order, regularity, organization. Keightley emphasizes that there's always another side to the story, and maybe we just haven't seen the "dirty" details: the irregularities and imperfections of everyday life.

"I associate it partly with the elite nature of the artifacts that we're getting," Keightley says. "In Chinese writing, we don't find the attention to 'dirty' detail until about the Song dynasty. But I'd say that they had that kind of literature all the time; it just wasn't recorded by the elites. The elites wanted a much more structured view of the world, where morality is rewarded and the ancestors are honored. It's a highly idealized picture of the world rather than a picture of the world."

During another conversation, he tells me that he still thinks about writing fiction. "I would love to write a novel about the Shang dynasty," he says. "But I just have these structural guides, the oracle bones and the artifacts. I'd have to make up the 'dirty' parts. What I mean is that we have the structure, the diagram; we have the written characters. But we don't have the emotional impact. We have to imagine that."

IN HIS BERKELEY home, Keightley keeps two fragments of cattle scapula. One bone is less than two inches long, and over three thousand years old. Ten characters are inscribed into the surface:

> *Crack-making on guihai, divined: The king, in the ten days,*
> *will have no disasters.*

A Russian émigré named Peter A. Boodberg, who also taught at Berkeley, gave the oracle bone fragment to Keightley. In China, back in the days when such artifacts were still traded freely, Boodberg had purchased it from a dealer of antiquities. Without question, it is one of the oldest cultural artifacts in the Berkeley Hills. Keightley keeps it wrapped in cotton inside an old film canister. Eventually, he intends to donate the bone to the university.

His second cattle scapula is circa 1978. Back then, Keightley was a research fellow at Cambridge University, and he decided to crack a bone in the Shang style. To his knowledge, this experiment had not yet been successfully accom-

plished by a modern scholar. He went to a butcher's shop and purchased the object that, nowadays, is better known as a t-bone steak.

"A professor in material science said that this is a simple problem," Keightley says. "He told me to bring it in, and we boiled it. Two hours later, the place stank. The score was Shang one, Modern Science, zero."

Today, that's still the score. Scholars have interpreted so much Shang music—the royal lineage, the patterns of warfare, the fears about weather— but they still don't know the simplest question of all: how to crack an oracle bone in the traditional manner.

"Ken Takashima and some graduate students tried it," Keightley says, referring to a scholar who now teaches at the University of Vancouver. "They tried to re-create Shang cracking with a soldering iron. And it didn't work. One of the problems is that you take a red-hot poker and apply it to the bone and the bone just sucks away the heat. Maybe the Shang heated the bone in the oven itself. I don't know."

Keightley's second bone is pale—whiter than old ivory. Three scorch marks scar the surface, but the bone is uncracked. Upon the surface nothing has been written.

13

The Games

February 21, 2001

THE CABBIE SMILED AND SAID "GOOD MORNING," IN ENGLISH, WHEN I got into his car. It was 3:30 P.M. He had tiny eyes in a cramped dark face and his yellow teeth showed when he smiled. He also knew how to say "hello" and "OK." Whenever he spoke English, the language gained a physical dimension—he leaned forward and gripped the wheel, pursing his lips, while the pitch of his voice rose and wavered. He said "Good morning" twice and then switched to Chinese. We were heading north, looking for the Olympics.

That was a good week to be a foreigner in Beijing. The International Olympic Committee's inspection commission was in town for a four-day tour to evaluate Beijing's bid to host the Summer Games in 2008. This would be the I.O.C.'s final assessment; half a year later, they would choose between Beijing and the other finalists: Paris, Toronto, Osaka, and Istanbul. Every day, special announcements were broadcast on the cabbies' radios, reminding them to be polite to foreign fares. The drivers had also been provided with a free two-cassette taped English course designed specifically for the inspection. The course consisted of useful sentences, including "The sun is shining," "The city will be more beautiful when it hosts the Olympic Games," and "Lacquerware was introduced to Japan from China during the Tang dynasty."

Every Beijing cabbie knew about Meng Jingshan, a driver who, just last year, had spoken about China's Olympic dreams to a reporter from the Atlanta *Journal-Constitution*. The Atlanta article was only 335 words long, but it caught the eye of the Chinese authorities, probably because it quoted Meng as having said, "The Olympics is not the venue for talking about human rights." Meng also

mentioned that if Beijing had succeeded in its 1993 bid to host the Games, the city would have demolished his neighborhood in order to construct new sporting facilities. The American newspaper quoted the man: "I kept my house, but I really want to move out so I was doubly disappointed that we lost."

Foreign journalists were obsessed with human rights and *hutong* preservation, and the Beijing government had rewarded Meng by designating him one of the capital's "Hundred Best Taxi Drivers." He received a bonus of a few hundred dollars, and the city's newspapers portrayed him as an exemplary common man (he reportedly gave some of the money to charity). The message was clear: every citizen must do his part for the Olympics.

My own role, I figured, was simply to ride the wave. All week, I told everybody that I was writing stories about the Olympics, and it was as if the city had suddenly been bathed in a soft light. Conversations were friendlier; people smiled more. When I requested interviews with government officials, they agreed, and then they actually answered questions. In China, I had learned to be discreet about notebooks, but now I flourished them shamelessly. When I got into the cab, I took out paper and pad and told the driver that I was a reporter who needed to visit potential Olympic sites. He promised that we would find them along the highway that leads to the Great Wall. He kept glancing over at the blank page. "The Olympics can help the Chinese people," he said. "I don't really know how to say it right, but it would improve our status in the world."

His name was Yang Shulin—he said I could call him *Yang Siji*, Driver Yang. He told me that two days earlier, at the airport, his fare had been a Chinese stewardess who had personally witnessed the arrival of the I.O.C. inspection commission.

"She saw them get off the plane," Driver Yang said. "She was at the door at the airport."

"What were they like?"

"She didn't tell me anything else about them," he said. "But *she* was pretty. All of the stewardesses are pretty."

I told Driver Yang that in three days I planned to accompany the I.O.C. commission on the final leg of its tour, and he nodded approvingly. The man was a throwback: he wore cloth shoes, white cotton driving gloves, and a polyester olive-green military uniform with brass buttons. He was fifty-three years old. A Mao Zedong pendant dangled from his rearview mirror. Beneath the Chairman's photograph were two sentences:

MAY THE ROAD BE SMOOTH

PROTECTION AGAINST ONE HUNDRED CURSES

We cruised along the Second Ring Road, where the old city wall used to stand. The pavement was lined with bright-colored banners that had been installed in honor of the visiting inspectors. According to the statistics of the Beijing Olympic Bid Committee, twenty thousand banners had been erected around the capital. In English, the banners read: NEW BEIJING, GREAT OLYMPICS. In Chinese, they proclaimed:

新北京, 新奥运

One adjective had been tweaked in translation. Literally, the Chinese signs said: NEW BEIJING, NEW OLYMPICS. When I interviewed Beijing's vice-mayor, Liu Jingmin, he explained that the Chinese "new" has a broader meaning that doesn't translate well. "We decided to translate it into English as 'great' instead because the Olympics has a classical meaning," he told me. "It didn't seem right to say 'new.'" But I talked with another Chinese sports official whose explanation was more frank, although he asked not to be quoted by name. "If they said 'New Olympics' in English, it would seem as if China wanted to change the Games," he said. "The I.O.C. wouldn't like that. They'd think, here's this Communist country that's trying to take over the Olympics."

For anybody living in Beijing, the reverse seemed true: the Olympics, or at least the idea of the Olympics, was taking over the city. Tens of thousands of workers, students, and volunteers had been mobilized to clean up streets, and the government had embarked on an ambitious urban beautification program. It involved a lot of paint. They painted the highway guardrails white, and they dyed the grass in Tiananmen Square green. They splashed Old World colors onto Brave New World housing projects. Shortly before the commission arrived, many of the city's proletarian apartment blocks seemed to march through a hot Italian palette: bitter greens, brilliant ochres, smooth pale blues. On Workers' Stadium Road, a cluster of old Soviet-gray buildings emerged in burnt sienna. Down the street, the façade of a squat six-story apartment building was doused in sunny Venetian pink. Its other three sides were still gray, but you couldn't see them from the road. The Chinese government, which had a penchant for statistics, announced that they had touched up 142 bridges, 5,560 buildings, and 11,505 walls, for a total surface area of 26 million square meters. They had painted something bigger than New Jersey.

Beijing was one of the most polluted capitals in the world, but even the air could be cleaned, at least for the short term. A friend of mine worked in an office building whose management distributed a cheerful notice:

Since the Olympic Committee's delegation will visit Beijing next week, some buildings around the Third Ring Road have been ordered to stop heating in order to reduce the smoke and dust. Therefore, please wear heavier clothes when you are in your office next week!

 * * *

DURING THE FIRST hour, Driver Yang stopped to talk with two other drivers, half a dozen bystanders, and two cops, and he used his cell phone to call information and get the number for the Beijing Olympic Bid Committee. The line was busy, so he telephoned the taxi communication station and asked the operators if they knew anything about potential Olympic sites. Nobody could name a specific location for any of the proposed sites north of town. Driver Yang told me not to worry; we'd get there fine. He looked worried as hell and by the time we got to the Sandy River, twenty miles north of Beijing, he asked if we could stop for a cigarette. The two cops had just told us that we needed to turn around and head to a suburb called Datun.

"You can smoke in the car if you want," I said.

"Smoking makes the car smell bad," he said. It was the first time I had ever heard a Chinese cabbie say that. We pulled over near a coal refinery and Driver Yang pissed in the dust while smoking a Derby cigarette. He seemed a little calmer after that. Down the road, a faded propaganda sign said: IMPROVING THE HIGHWAY'S ADMINISTRATION IS EVERYBODY'S RESPONSIBILITY. There weren't any Olympic banners out here and pieces of trash blew across the road. Walking back to the cab, Driver Yang put his arm on my shoulder.

"We're friends, right?" he said.

"Sure," I said.

On the way to Datun, he took off his driving gloves, and we chatted. Thirty years ago, Driver Yang had served in the People's Liberation Army in Inner Mongolia. He had two children, a son and a daughter; he told me proudly that both were enrolled in college. In Datun, we passed a McDonald's, a Popeye's, and a Kenny Rogers Roasters. At the intersection of Anli and Huizhong roads, two cops were ticketing another cabbie. The man had picked up a fare in a no-stop zone; it was a bad week to break rules. Driver Yang pulled over and started talking fast, before the cops could yell at him.

"This is a foreign journalist who is writing about the Olympics," he announced. "We're trying to find out where they're going to hold the events in 2008."

One cop had been writing the ticket, but now his pen froze in the air. The ticketee looked up expectantly. He was a small man in a dirty nylon jacket;

the cop was bulky and his ID badge was number 007786. The sun was a dirty red wafer hanging low in the sky. It felt like a scene from a painting in which every element had been arranged in such a way as to draw attention to a single detail—one brushstroke that carried a world of meaning. I took out my notebook. The cop smiled.

"Please wait a minute," he said. He spoke into his walkie-talkie, then turned back to me.

"Which country are you from, please?"

He barked again into the walkie-talkie: "We have an American reporter who is writing about the Olympic bid, and he needs to visit an Olympic site here in Datun!"

A pause; the man looked up: "They're calling my supervisor."

Everybody waited. The ticketee suggested that we head a few blocks to the west, where a field had been cleared for the Olympics. The cop told him to shut up. The walkie-talkie crackled.

"Go west and look for a field with banners around it," the cop said to Driver Yang, and then he turned to me. "You'll see that it's a very good location to build the stadiums. They're going to put soccer, badminton, and tennis there."

He saluted us both, first me and then Driver Yang. The ticketee wished us good luck, and this time the cop didn't tell him to shut up. We went west.

IN ANCIENT TIMES, some members of the Chinese nobility played *cuju*, a game that is remotely similar to soccer. There are Ming dynasty scrolls that feature women playing *chuiwan*—sticks, balls, holes. Chinese historians describe it as their own version of golf. There are other artifacts, other games. A Qing painting of Emperor Kangxi's inspection tour to the south shows, in an obscure corner of the scroll, three boys playing some form of handball. The Forbidden City Museum has a painting of a Tang emperor, Minghuang, involved in a polo-like game with the palace maidens.

But these were diversions—games, really. The true heart of the ancient Chinese athletic tradition consisted of *wushu*, "martial arts." In the nineteenth century, some elements of *wushu* contributed to the development of the meditative breathing exercises that became known as *qigong*. The activities of *wushu* and *qigong* are as much spiritual and aesthetic as they are physical; their goal is artistic expression and self-improvement, rather than winning. Traditional Chinese athletics had elements that Westerners might describe as philosophical or even religious. (*Qigong*, of course, eventually gave rise to Falun Gong.) Competition wasn't the primary goal of traditional athletics, and the ancient Chinese never built coliseums.

The modern term for "sports"—*tiyu*—didn't appear until the nineteenth century. Like other words that were introduced during this period, *tiyu* came from Japanese. The Japanese had originally imported Chinese characters in ancient times to write their own language, but Western contact moved faster in Japan, developing new vocabularies. As China attempted to catch up, they adopted the terms that the Japanese had innovated: *minzhu*, or "democracy"; *minzu*, or "ethnic group." Sometimes, a familiar phrase reappeared with a different meaning. *Kaogu* originally meant "investigation of the ancient"; in the twentieth century, it returned from Japan with a new definition: "archaeology." The characters themselves weren't new, but they described new ways of looking at familiar things. Artifacts had always been collected, but they hadn't been excavated and studied in a scientific manner. The Chinese had always had different ethnic groups; they just hadn't described them as such. Athletics hadn't been categorized and arranged into tournaments.

The language changed because the world was changing. After the Opium War, missionaries and other foreigners introduced Western ideas of athletic competition, often at Christian schools. In the early twentieth century, China began to take an interest in the Olympic Movement, and a single Chinese sprinter competed in the 1932 Games. Four years later, at the Berlin Olympics, China sponsored a delegation of sixty-nine athletes, among them a mixed-gender *wushu* exhibition troupe that performed before Hitler.

By then, the Chinese were committed to the Olympics, and they had come to see sports as a way in which the country could avenge the injustices of the past century. The goal was to beat the foreigner at his own game. After the Communists came to power, they established sports-training schools that were modeled after the Soviet system. The People's Republic competed in the 1952 Summer Games, but they boycotted the next Olympics because the I.O.C. recognized athletes from Taiwan.

It wasn't until 1979 that the mainland finally agreed to return to the Olympic Movement. The I.O.C. continued to allow athletes from Taiwan to compete, but the Taiwanese flag was banned. In 1984, in Los Angeles, a mainland Chinese team competed for the first time in nearly four decades. They finished sixth in the overall medal standings. But that year's Soviet-bloc boycott had weakened the field, and the Chinese were badly outclassed in such marquee events as swimming and track-and-field.

Over the next decade, China rapidly improved its medal count, largely through success in events where the competition was less intense. Chinese women athletes excelled, and the nation became particularly good at sports that involved routine-based activities, such as diving, gymnastics, and figure

skating. In such sports, bureaucracy pays: athletes can be created through careful organization and training rather than a combination of strength, hardcore competition, and performance-enhancing drugs. In the Atlanta Games of 1996, China ranked fourth overall. They moved up to third in Sydney, and by Athens they would be second, behind only the United States.

Despite the growing success, the key emotion behind Chinese athletics was still shame. On the surface, there was plenty of pride, but it was as shallow as pink paint on an old building. In 1993, when the I.O.C. awarded the 2000 Games to Sydney instead of Beijing, *China Daily* responded with an editorial linking the decision to the West's history of "brutal colonialist aggression and exploitation." During the month of Beijing's bid to host the 2008 Games, I visited the China Sports Museum, where historians explained that modern athletics had begun in the year 1840, when the arrival of the full British fleet marked the turning point of the Opium War. The Chinese Olympic Committee had prepared a book that described this great sports moment, in English:

> *The Opium War turned China from a feudal into a semi-feudal and semi-colonial society, in which sport came under the unavoidable influence of violent social upheavals and followed a tortuous path linked closely to the precarious national destiny.*

Sport was grim. It often showed on the faces of Chinese athletes: many of them looked tight, nervous. In highly competitive sports like soccer and basketball, they had a tendency to choke in crucial situations. It was rare to watch a Chinese athlete perform with true joy, which wasn't surprising; most had been trained in assembly-line sports schools since childhood. Their fans didn't help much, either. The average Chinese athletics observer didn't care much about understanding a sport or respecting individual effort; the victory was all that mattered. Fans were brutal toward losers, and they had a history of bad sportsmanship and even violence when foreign teams won matches on Chinese soil.

In a sense, the nation's wholesale transition—from their own athletic traditions to those of the West—had left China with the worst of both worlds. They had adopted the competiveness and nationalism, which were the bluntest and most obvious characteristics of Western athletics, but they had missed out on all the subtleties. In my own experience, these were the only things that actually had any true value. As a child, my participation in athletics had revolved around my father, not a sports school, and his most important lessons were often counter-intuitive: that it was better to lose with class than win at all costs, and that the final goal wasn't victory but self-improvement. For many people in the West, athletics are simply part of a well-rounded education and a healthy life.

Of course, that doesn't make for good television or public sporting events, which celebrate competition. It wasn't surprising that this aspect of Western sport was most accessible to the Chinese, who came to view their own traditions as if through a foreigner's eyes. Athletics such as *wushu*, whose spiritual, non-competitive qualities should have been seen as a healthy alternative to the excesses of Western sport, were instead described as embryonic stages in the Chinese march toward Olympic glory. The logo for the Beijing Olympic bid featured five interlocked rings twisted into the shape of a person practicing Tai Chi, an exercise that is profoundly non-competitive. Tai Chi is a hell of a lot closer to Falun Gong than it is to the Olympics.

Many Chinese sensed that something was wrong with national athletics, although they struggled to identify the problem. The failures nagged at them, and sometimes people fixated on philosophical or psychological explanations. During my Olympics research, I met a number of Chinese who were intrigued by a sort of net theory: the notion that the Chinese perform well at Ping-Pong, badminton, and volleyball because there is no contact between opponents.

"The Chinese aren't as good at direct competition," He Huixian, the vice-president of the Chinese Olympic Committee, told me. "We're better at sports where there's a net between the players." She described the Chinese as *xiaoqiao*—dexterous and coordinated rather than strong. But she added that mentality was just as important. "Confucianism makes people more conservative," she said. "Look at America—children are taught to be independent and creative. In China, it's all about discipline. There isn't enough creativity, and if you don't have creativity, then you can't adapt and change. You just follow the same old patterns and you don't get any better. That's true for sport as well as other things."

The Chinese also believed that the Olympics highlighted the differences between rich and poor countries. In Beijing, I met with Xu Jicheng, a former basketball player who had become a television announcer. Xu had accompanied the Chinese delegation to every Summer Games since 1988. "Developed countries see the Olympics as a kind of business," he said. "It's like they're saying, 'I have a big house, with all sorts of wonderful furniture, and I want to have a party and invite people to come.' And they sell tickets. But it's different for a developing country. The Olympics won't just change the economy and appearance of Beijing—the most important thing is that it will change our values and concepts."

I asked Xu if he had any reservations about China's adopting a Western view of sport. He brushed the question aside, explaining that the issue was political rather than cultural. "I went to Seoul in 1988," he said. "Korean people

told me that if it weren't for the Olympics, nobody would know what Korea is. Before the Olympics, foreigners only knew about the Korean War."

In Xu's opinion, China needed to emulate the Western model of sport as a business. He said that Chinese athletics were essentially twenty years behind Chinese economics. Because sport was so closely tied to nationalism, it hadn't yet been converted to the market, like a lagging state-owned enterprise. But the process had started; recently, Hilton cigarettes had funded the national basketball program, and Coca-Cola sponsored Chinese soccer. "After fifty years, we'll be just like the Western countries," Xu predicted. "The Olympics will be a kind of business to us. We'll be saying, 'We have a big house, and we want to invite you so we can show it off.'"

AT 5:30 P.M., Driver Yang finally found an Olympics site. We got out of the cab and walked over to an empty field. It was the size of four city blocks, smack in the middle of northern Beijing; any buildings that had formerly stood there had been cleared away. In *Chai nar,* that was a familiar sensation—the feeling that something had just been demolished. Pink flags on poles marked the field's perimeter.

"That's where they'll have soccer and tennis," Driver Yang said. He grinned and swung an imaginary racquet through the air.

"And badminton, right?" I said.

"Right."

We stood there staring at the empty field.

"Well," I said. "I probably should go back and get dinner."

On the Fourth Ring Road, we got stuck in traffic. The meter had been running for three hours, and by now the numbers might as well have been calculating the sense of anticlimax. Driver Yang was feeling the pressure once more. Finally, he asked what I was doing for dinner.

"I don't have any plans," I said.

"Do you eat Chinese food or Western food?"

"Chinese is fine."

He said it wouldn't take us long to get to his home in Tongzhou, on the eastern outskirts of Beijing. We went east on the Fourth Ring Road, and Driver Yang started talking about sports again. He told me that Mike Tyson was his favorite American athlete, because the boxer has Chairman Mao's face tattooed on his arm.

"Why do the Chinese people like *Tai Sen*?" Driver Yang asked rhetorically. "Because he likes China. If he likes China, China likes him. And he understands China."

"Does Tyson really understand China?" I asked.

Driver Yang said, "If he doesn't understand China, why would he put a tattoo like that on his arm?"

That was an excellent question and I had no response. Driver Yang smiled. "*Tai Sen* read four of Chairman Mao's books while he was in prison," he said. "I saw it on television."

He explained his personal theory about why athletes from the United States are dominant. "Americans are big," he said. "They eat very well from the time they're born, and also America is more scientific. If you take a country like China, a developing country, we can't compete with a country like America. Your health is important. Look at *Tai Sen*. If he wasn't so strong, how could he win?"

Driver Yang also admired Michael Chang, the tennis player. "He grew up in America, but his blood is Chinese," he said. "Obviously it doesn't hurt him. That shows that there's a problem with the system here."

It was seven o'clock by the time we reached Tongzhou. Driver Yang said that he was in the mood for Mongolian hot pot. Neon signs along the highway proclaimed BEIJING 2008, and WELCOME TO THE NEW CENTURY'S TONGZHOU. In the center of town they had a McDonald's and a big department store called Wu Mart.

ON THE FINAL day of the I.O.C. inspection, I joined the press pool that accompanied the commission. Five of us represented the foreign media: three television reporters, one photographer, and me. The reports that I filed would be distributed to the other journalists in Beijing, to use in stories about the inspection.

In order to join the press pool, I had to agree to a number of simple rules that had been established by the I.O.C. The first rule was that I could not ask questions. I was allowed to follow the commission members around, and I could quote them on anything they said during the inspection. If an I.O.C. representative happened to speak to me, I was permitted to respond. But under no circumstances could I take the initiative and address an inspector directly. If caught asking questions, I would be promptly expelled from the press pool. The I.O.C. also informed us that at some meetings we would only be allowed to observe the opening proceedings.

The rules were effective, at least in terms of creating a sense of drama. Wherever the inspectors went, journalists tagged along, notebooks and cameras ready. We moved in silence, as if struck dumb by the momentous occasion. After the morning session, I filed my first dispatch:

This is the pool report for this morning's meeting between the Chinese and the I.O.C. inspection commission, at the Beijing Hotel. . . . Members of the press were escorted to the back of the room, where we were kept behind a red velvet rope. Women in *qipao* dresses greeted the delegations at the door. The members of the delegations trickled in one by one. They appeared to be relaxed and greeted each other warmly. The I.O.C. members gave each other air kisses and the Chinese did not. The *qipaos* were of red silk.

One of the press handlers explained that this morning's press opportunity would be extremely limited. "When we're here, they won't say anything," she said. "When we leave, they'll speak."

I wrote it down. She told me not to use her name.

The only excitement was when one of the I.O.C. commission members, Robert McCullough, walked to the other side of the table and asked Chinese gymnast Liu Xuan to autograph his *International Herald Tribune* promotional insert. . . . The last page features a photograph of Liu Xuan in full dismount and this is what she signed. A photographer from *China Sports Daily* was in the press pool and he pointed out excitedly that he had taken the picture. He was not asked to sign it and he remained behind the velvet rope like everybody else.

Today the topic was Beijing's hotels and medical services, and the first speaker was Doctor Zhu Zonghan, Director of the Beijing Sanitation Bureau. He has a degree from Harvard and the moment he began to speak the press was escorted out.

Outside the hotel, bicyclists were riding down Chang'an Avenue as part of the "Ten Thousand Bicyclists Support Beijing's Olympic Bid Activity." The bicyclists wore red and white and black athletic outfits and they rode in formation, carrying flags that said, in English, "Applying for Olympic Games is My Hope."

It was a fine day with clear blue skies and the wind came hard from the north.

<p style="text-align:center">* * *</p>

THE INTERNATIONAL OLYMPIC Committee is a curious organization. It elects its own members, and for most of its history, the organization has not been particularly concerned with diversity. During the time of the Beijing inspection, the I.O.C. consisted of 123 voting members, of whom nearly half were European. The People's Republic of China had three members. That was the same number as the combined royal families of Liechtenstein, Luxem-

bourg, and Monaco, each of which had one I.O.C. member. Of the 123 total members, only 13 were women. Two of them were princesses and one was a Spanish infanta.

The I.O.C. was one of the few major international organizations where neither the United States nor China had any real political power. Nearly 70 percent of the I.O.C.'s operating funds came from American-based sponsors, but there were only four members from the United States. During Beijing's bid, I spoke with John MacAloon, an American anthropologist who specializes in the study of sport. He had recently served on an I.O.C. reform commission, and I asked him how much influence American opinion would have on the host city decision. "It doesn't mean beans," he said bluntly. "I can't tell you the number of times that I've been in a room with I.O.C. people and somebody from the American side comes in, and everybody smiles and says, oh, it's wonderful to have your support—and then the person leaves and everybody laughs behind his back. It's a colonial relationship. The Europeans colonize American money. The Americans are largely powerless."

The I.O.C. also has a history of troubled interactions with the developing world. In the early 1960s, nations from Asia, Africa, and Latin America attempted to create their own version of the Olympics, known as the Games of the Newly Emerging Forces—GANEFO. Organizers defined their event as "struggling against capitalism and trying to create a new world order." In 1962, the first GANEFO was held in Indonesia, and the People's Republic of China provided much of the funding. The I.O.C. responded by banning all GANEFO participants from future Olympic Games, and the fledgling event never held a second installment.

In the summer of 1968, a developing-world country hosted the Olympics for the first time. Prior to the start of those Mexico City Games, thousands of students gathered in protests; one of their complaints was that their country shouldn't spend money on an event that would scarcely benefit the millions of Mexicans who lived in poverty. The government called out the troops, who fired on protestors, killing hundreds. The Games went on as planned. The exact toll of the massacre was never determined, and since then, the event has essentially disappeared from the popular view of Olympic history. It's rarely mentioned in the Western press, and for the next three decades the Games didn't return to the developing world.

By 2001, though, the I.O.C. was struggling to improve its relationship with poorer nations. The organization had increased funding of developing-world sports centers, and it had expanded its membership to include more representatives from African, Asian, and South American counties. But progress in

this direction may have been slowed by the scandal that erupted in Salt Lake City in 1998, when the city, attempting to host the Winter Games, dispensed more than a million dollars in cash and gifts to I.O.C. members. Representatives of poor countries made easy targets: of the ten members who resigned or were expelled for taking bribes, nine were from the developing world. Most came from countries that hardly had winter—Mali, Sudan, Congo, Swaziland, Libya, Cameroon. It was easy to imagine how it happened: if you came from the Congo, would you really care who won the right to host the Giant Slalom? The scandal was a grim reminder that despite its claims of internationalism, the Olympics draws on the culture of only a tiny sliver of the world.

Since then, the I.O.C. had banned gift-giving from the application process. The search for the 2008 site represented the first time that these rules had been fully implemented, and it was also probably the last time in history that a Communist country would court the I.O.C. In a way, they seemed perfect for each other. When I spoke with Alfred Senn, a professor of history who had spent time in the Soviet Union, he noted some political similarities between the I.O.C and the Communists. "The I.O.C. is organized on the same principles as Lenin's Communist Party," Professor Senn said. "He organized the Communist Party on a series of concentric circles, and de Coubertin [founder of the modern Olympic Movement] said that there is a nursery that trains people so that they can eventually join the inner core. There is a structural similarity. You don't start voting democratically on the edge and start a faction; you have to get into the inner leadership, the executive committee. There's not going to be any dark-horse pope coming in to run the Olympic Games."

THE FINAL AFTERNOON of the inspection was perfect. Blue sky, bright sun: the NEW BEIJING GREAT OLYMPICS banners flapped in the wind. We moved through the city in a five-vehicle motorcade, with a police escort. Street cleaners lined the road, brooms in hand; bicyclists and pedestrians gathered at intersections, watching. A day earlier, the commission had visited Beijing's traffic-control center, where the Chinese demonstrated how signals could be monitored by remote control. Today, whenever we came to a traffic light, it turned green, as if by magic.

> *The city seemed to hold its breath, awed by the deep solemnity of the occasion. In absolute silence, the Sovereign made his journey and his sacrifice. Lest even the whistle of a distant train break the impressive stillness and thus profane the rites, there was no railway traffic in or out of Peking from the time he left his Palace until his return to it.*

In *Peking*, published in 1920, Juliet Bredon had described the emperor's annual journey to the Temple of Heaven. Eighty-one years later, our procession was almost as stately, and the ritual's possible benefits were far more tangible. The Beijing bid committee had promised that if the city won the Games, it would spend twenty billion dollars on infrastructure and athletic facilities. A recent Gallup poll had shown that 94.9 percent of Beijing's residents supported the bid, and for once, a Chinese statistic was probably accurate. Even dissidents had spoken out in favor of hosting the Olympics. In Hong Kong, Falun Gong practitioners had told the press that Beijing believers wouldn't protest while the inspection commission was in town.

For three hours, we made our way through the city, looking at potential sites: soccer, softball, weight lifting, water polo, modern pentathlon. On the average, we spent five minutes at each place, where commission members asked one or two specific questions about details that didn't yet exist. Will the pool for the modern pentathlon be at least 2.2 meters deep? Yes; it will be three meters. Can you walk from the water polo facility to the softball site? Certainly.

At the Beijing University of Aeronautics and Astronautics, the construction of an enormous new gymnasium was under way. Initially, the facility would be used for volleyball, but if Beijing hosted the 2008 Games it would be converted to weight lifting. We put on hard hats; an economist named Liu Lieli led the tour. With the other reporters, I scurried along, scavenging quotes.

"It looks like a beautiful butterfly or a lovely UFO," Professor Liu said, as we were standing outside the facility. His spoken English was poor but he handled that phrase perfectly, lingering on the last word like a weightlifter with the bar raised above his head. Another official handed out pamphlets about the new gymnasium. One sentence read: "The BUAA Gymnasium just looks like either a beautiful butterfly or a lovely UFO flying over from sky."

Inside, we stood on what would someday become a spectators' gallery. Down below, two workers fiddled with a tarp on an expanse of packed dirt: the future competition platform. An Australian I.O.C. inspector named Bob Elphinston spoke up.

"Is that the warm-up area?" he asked, pointing to another pile of dirt. The other reporters and I surged forward, trying to see.

"*That's* the warm-up area," Liu said, pointing to a different pile of dirt.

Peering into the shadows, Elphinston said, "Do the athletes go straight from there onto the competing platform?"

Professor Liu smiled. If Beijing was awarded the 2008 Games, there was no question but that the weight lifters would proceed straight from the warm-up area onto the platform. Elphinston nodded, satisfied. Professor Liu addressed

the group. The new gymnasium, he said, would feature "intellectualized management systems." He dropped the phrase and then gathered himself for a final clean-and-jerk. He said, "It looks like a beautiful butterfly or a lovely UFO."

The last stop was the Millennium Monument. In the west of Beijing, the monument had been completed at the end of 1999, to celebrate both the glories of Chinese history and the coming of a new age. At the entrance, an eternal flame was accompanied by an inscription:

THE EVER-BURNING FLAME IN THE MIDDLE OF THE PLAZA
IS THE HOLY FIRE OF CHINA. IT ORIGINATED AT THE SITE
OF PEKING MAN AT ZHOUKOUDIAN, BEIJING, AND IS FED ON
NATURAL GAS. THE FLAME IS A TOKEN OF THE UNCEASING
CREATIVITY OF CHINESE CIVILIZATION.

Behind the flame, a long walkway had been created out of hundreds of inscribed bronze plates. They formed a timeline; the first one was dated "Three Million Years Ago," and it noted: "The ancient people in China begin to use fire." After two and a half million years, things started to pick up: "People begin to have the characteristic of the yellow race." Sixteen hundred B.C.: "The Shang dynasty capital is located at Zhengzhou in Henan." Dynasties came and went: Zhou, Qin, Western Han. The British occupied Hong Kong in 1841; Sun Yat-sen became provisional president in 1912; the Japanese massacred 300,000 in 1937. People's Republic, 1949. Reform and Opening, 1978. Finally, the timeline reached the year 2000, where history dissolved into random statistics:

> Our nation's scientists succeed in deciphering the genetic code of the number three human chromosome. . . . The Project to Separate the Xia, Shang, and Zhou dynasties passes the national inspection. The National Statistics Bureau declares that for the first time the Gross National Product exceeds 1,000,000,000,000 American dollars. The Chinese national team wins twenty-eight gold medals at the Twenty-seventh Asian Games.

The I.O.C. inspectors moved past the timeline and into the monument itself, which was shaped like an enormous sundial. The foreigners watched an eight-minute promotional film that had been made by Zhang Yimou, China's most famous feature film director. Modern scenes flashed by: airplanes, subways, automobiles. Computer-generated images showed proposed stadiums and new highways; clover-leaf exchanges circled around brilliant fields of green. Virtually nothing was recognizable as belonging to the city where I lived.

<p style="text-align:center">∗ ∗ ∗</p>

DRIVER YANG'S HOME was a simple one-story courtyard. The place was unheated, apart from the coal-fired stove, and there was an outhouse near the gate. His wife prepared the hot pot while we drank tea in the main room. Driver Yang showed me photographs of his children, and he mentioned proudly that his daughter spoke good English.

I asked about the cabbie language lessons, and he handed me the Olympic-bid textbook. I leafed through the book, and he switched on the cassette player. A voice spoke in Special English:

1. Hello.
2. Good morning.
3. Good afternoon.

We sat down to dinner. Driver Yang gave me the seat of honor—in the countryside, that was the place with the clearest view of the television. Tonight, they showed a Chinese professional basketball game between the Beijing Aoshen team and the Shanghai Sharks. The Sharks had a twenty-year-old center named Yao Ming.

In the center of our table, burning alcohol heated a ring-shaped bronze cauldron filled with cooking oil. Once the fluid came to a boil, we dropped in pink rolls of mutton. Driver Yang said that the hot pot reminded him of the army. He had served from 1969 to 1973, in the border regions of Inner Mongolia. Soviet-controlled Mongolia was never far away; sometimes the situation had been tense.

"You wouldn't believe how cold it is there," he said. "It was all grassland, as far as the eye could see. The hardest part was when we had to camp outdoors. The local people used to take a whole sheep and put it on a spit. It wasn't as good as this kind of hot pot, but at least it was better than the grain they had up there."

The oil bubbled; rolls of mutton turned brown and rose to the surface. The room warmed up. Driver Yang and his wife ate happily, completely unphased by the burden of the foreign guest. In China, banquets with cadres were always awkward, and foreign affairs officials were inevitably the worst at handling outsiders. But the average Chinese made remarkable hosts, polite but informal. It was a simple truth—too simple to appear in something like the cabbie English book, which had included a section entitled "More Useful Expressions":

33. The city's traffic is getting better.
34. I'm attracted to Beijing's scenery.
35. Pollution is a global problem.
36. I am proud of being a Chinese.

14

Sand

March 21, 2001

THE FIRST SIGN WAS ALWAYS THE WIND. AFTER THAT, THE SKY DARKENED
and then, if you happened to be outside, your eyes began to burn. Once you
made it indoors, you could sometimes hear the particles rattling softly against
the window panes. The loess blew in from the dry landscapes of northwestern
China, as well as from both Mongolias, the Inner and the Outer, the places
that seemed far away and abstract until you felt the grit against your face.
Beijingers called them *shachenbao,* "storms of sand and dust." At night, when
a sandstorm was in progress, the particles reflected the glare of city lights and
the sky glowed orange-pink, as if it were about to catch fire.

March was a risky month for camping, but I was too impatient to wait
for April. On the map, I found a section of the Great Wall that I hadn't seen
before. After more than three hours of driving, the cabbie dropped me off;
I told him not to worry about coming back to pick me up. For the past two
months I had been desperate to escape the city.

The mountains were still winter-brown and empty; the farming season
wouldn't begin until April. It felt good to walk beneath a pack again. I followed
a dirt road to a village called Xituogu, where I saw a mostly intact stretch of
the Wall. A steep path led up to the structure. The wind picked up; the sky
darkened. By the time I reached the first tower, I knew that I was stranded for
the night.

The tower was more than four centuries old, made of brick and stone, and
the design was simple: perfectly square, with a single enclosed room. The floor

was gray Ming dynasty brick. Along the walls, arched windows overlooked the valley. Below, the red-roofed village huddled against the road; northward, past the stone-walled orchards, the mountains rose steeply. Trails twisted up to high passes that had already been overtaken by the storm.

From the tower, I watched it come in. Clouds of brown hung low to the ground, like the tendrils of a living thing that crept into the valley. It moved in spurts, pulsing with the wind, consuming everything in its path: first the high trails, then the orchards, and finally the village. My eyes began to burn and I moved away from the window. For the rest of the night I stayed close to the floor.

Sleep was difficult. Periodically, I woke up thirsty, and then the howling wind kept me awake. I remembered scenes from the mapping of the underground city in Anyang. One archaeologist had told me that the city had been buried mostly by alluvial soil, moved by the river, but there were also windborne layers of loess that had accumulated over the centuries. Lying in my sleeping bag, I consoled myself with literary images. Loess was general all over China. It was falling on every part of the dark central plain, on the treeless hills, falling softly upon the fields of Anyang and the city of Beijing. Around two o'clock in the morning, I tied a shirt over my face, zipped up the bag, and finally slept for a couple of hours. Jagged dreams. The loess made a clipped sound as it struck the tower and all night it fell, upon all the living and the dead.

DAWN WAS BEAUTIFUL. The storm might have been a bad dream, except for the film of dirt that shone red on the bricks in the morning sunshine. I ran a wet cloth over my face; the cotton darkened. My teeth crunched. When I shook my head, a soft sound pattered against the nylon of the sleeping bag. Sandruff.

I had planned to spend two nights along the Wall, but now I decided to return to Beijing before evening. I shook out the bag, packed everything up, and descended from the tower. At the valley floor I turned north. There was enough time for a short hike up into the hills.

One path led to an abandoned village. It stood at the edge of the steep slopes; the trees here were spindly and stunted. A pebbled creek lay as dry as a bone. Everything about this village was stony: stone fences, stone pathways, stone-walled houses. Most roofs were missing; originally they must have been made of wood. In the outskirts of Beijing, empty buildings weren't uncommon. For years, people had been moving steadily down the hillsides, and sometimes they left their former homes standing—ghost towns of the new economy.

Trash had been piled in some of the buildings. Cigarettes, food wrappers: most of the brand names were unrecognizable. One house was full of animal droppings, but they were so old that the place simply smelled of dust. Another house was bigger than the others, and its roof was intact. Inside, the walls were covered with old newspapers; traditionally, that had been a common form of wallpaper in the countryside. I wandered through the empty house, reading headlines:

March 9, 1976

SOVIETS PUT FORWARD SECOND PROTEST AGAINST THE U.S.

June 23, 1976

U.S. PREPARES TO SIGN A MILITARY ACCORD WITH JAPAN AGAINST THE SOVIET UNION

All the papers dated to 1976, and they were from *Cankao Xiaoxi,* or "Reference News." That was a Party newspaper that translated selected articles from overseas publications. In the past, it had been restricted to subscription only—it wasn't sold at newsstands, and foreigners couldn't buy it. Perhaps the abandoned house had once belonged to a Party secretary or some other local official. On one wall was an American cartoon that had been reprinted in the Chinese paper. The cartoonist's sketch had been torn away, but the English punch line was still there:

"Excuse me, which way is the unemployment line?"
"You're in it."

I continued up the path to the last building in the village. A big millstone sat in front, scarred from years of grinding. Inside, the walls were papered with the *People's Daily.* The headlines were eight years newer than those of the first house:

March 12, 1983

WE SHOULD DO MORE TO CREATE IMAGES OF MODERNITY FOR THE PEOPLE

CHINA TO HOLD THE 1983 NATIONAL MEETING FOR MACHINE TOOL PRODUCTS

April 14, 1983

EIGHT GRAIN-BASED PRODUCTS EXCEED
ONE BILLION POUNDS

Idly, I re-created the former hamlet in my mind: in 1976, the Party secretary refinishes his home. He covers the walls with the subscription-only newspaper—a subtle sign of the man's privilege. That same year, after the house is completed, Chairman Mao dies. The reforms begin. Seven years later, the other residents are improving their homes, papering them with the headlines of the changing economy. Some peasants go to the city in the off-season, earning extra money through construction; farming becomes less appealing. By the 1990s, they are leaving for good. First the young, then the middle-aged. The last ones are the elderly, who still remember the color of local life: which officials had authority, which people had more land, which families had lived there the longest. All of those details steadily slip down the hillside, swallowed by the bigger village, the township, the county seat, the city, the nation. Finally, the elderly pass on, and then the tiny hamlet settles into silence.

That was modern China—in ten years a place was ripe for archaeology. I picked up my pack and headed back down toward the living village.

A CROWD MILLED noisily around the courtyard of the government compound in Xituogu. At first sight, it looked like a festival, but then I saw the two officials. Dressed in neat blue blazers, they sat behind a wooden desk in the center of the courtyard. The desk supported a metal box. Periodically, a villager came forward, signed a book, and dropped a piece of paper into the box.

Chinese elections weren't infrequent. In the cities, voters selected representatives to their local people's congress, which was the lowest of three levels of representative government. The upper two levels weren't elected directly by the people, and none of the legal political parties could oppose the Communists. During the inspection for the Olympic bid, the Beijing committee had provided the I.O.C. with a brief introduction to Chinese politics:

> China is also a multi-party country. There are currently nine political parties in China. Before the state adopts important measures or makes major decisions, which affect national economy and the people's livelihood, the Communist Party of China, as the party in power, consults with other parties in order to reach the best solution.

That was the "people's democratic dictatorship": multiple parties and candidates were welcome, as long as they were approved by the Communist Party.

In the countryside, though, some regions were experimenting with freer elections. Instead of strictly controlling candidate lists, officials sometimes allowed villagers to choose their own leaders. The Party recognized the efficiency of this strategy: locals knew who was corrupt, and they tended to choose capable people. In the foreign press, this development was known as "village democracy," and it was sometimes hailed as a sign of future political reform. But nobody had any idea how many villages held truly free elections, and the Party hadn't yet adopted this strategy in urban areas. The topic was still sensitive; foreign reporters virtually never had free access to an election.

In Xituogu, a crowd of villagers quickly gathered around me. When I explained that I had camped last night, they laughed: "The sandstorm!" An excited middle-aged man showed me the wood-backed election roll. It listed five candidates: two had the family name of Peng, and two were Zhous. The fifth candidate was a Tang.

"Almost everybody here is named Zhou or Peng," the man explained. His name was Zhou Fengmin and his teeth were heavy with gold. When I asked whom he had voted for, the man became solemn.

"It's a secret," he said.

"Did you vote for somebody who is also named Zhou?"

"That doesn't matter," he said sternly. "It just depends on who's better."

I studied the election board. Three positions were listed: two "committee members," and the village director. Each candidate's name was accompanied by his or her political party and education level. The candidate list included two middle-school graduates and three high-school grads. Only two were Communist Party members. The other three were listed as simply belonging to *Qunzhong*, "The Masses." I liked the sound of that—it opened up the possibility of a whole new range of political parties: the Crowd, the Horde, the Mob.

While I was reading the board, one of the officials came over. He didn't look nearly as excited to see me as the villagers had. The official said, "Why are you here?"

I told the story about camping in the sandstorm.

The man said, "What do you do in Beijing?"

That was when I made the third major mistake of the trip. They could be ranked: First, camping in March; second, forgetting my passport; third, honestly answering an official's questions. I should have said that I was a student or a teacher, but perhaps the sand had slowed my mind.

"I'm a journalist in Beijing," I said. "I'm on vacation. I'm about to continue to the next village and then go home."

"Why don't you come inside the office and have some tea." The man smiled and spoke politely, but it wasn't a suggestion.

A SIGN ABOVE the office said, CONSUMERS' CENTER. The two officials escorted me inside and seated me on a worn sofa. Somebody poured tea into a plastic cup. Upon the wall hung two commemorative posters: CONSUMER DAY and MACAU RETURNS TO THE MOTHERLAND. A dusty calendar was marked with the slogan TOMORROW WILL BE EVEN BETTER. It seemed ominous that the calendar was three years old.

One official unlocked a desk drawer, which contained a telephone. He removed the object carefully, like a priest in the sacristy, and then he dialed. The other official spoke:

"Where is your identification?"

That was when I realized my passport was at home. Helplessly, I gave the man a name card.

"Do you have a car here?"

"No."

"How do you intend to leave?"

"I'll hike along the road and then catch a public bus."

"Have you ever been here before?"

"No."

The other man finished talking on the telephone and closed the drawer. For a moment, I thought that perhaps they would let me go. They seemed more relaxed; they asked me where I had learned Chinese, and we chatted. But then the telephone rang.

Everybody stared at the desk. The man opened the drawer and picked up the receiver.

"He's here," he said.

There was a pause.

"Only one."

Another pause.

"Do you think you'll be here before twelve thirty?"

He dropped his voice and said something else. He replaced the phone in the drawer, locked it, and pocketed the key. He leaned back as if nothing had happened.

"When will they come?" I asked.

"Who?"

"The police."

The official didn't say anything.

"It's OK," I said. "I wasn't doing anything wrong and I'm not worried about that. I'm just telling you that if it's fine with you, I can leave now. It will save everybody trouble."

"Wait and we'll give you a ride. It's safer."

"This is a very safe area and it's a nice day," I said. "I can leave the same way I came in."

The man looked away and said, "The car will be here soon."

I HAD BAD luck with detentions. In China, a foreign journalist was supposed to apply formally to local government bureaus before going anywhere to report, but nowadays almost nobody followed the rules. Usually, there weren't any problems, but every once in a while somebody got detained. I knew of one British reporter who had been detained while carrying classified government documents that he had recently acquired from a contact. The police had been tipped off, and when they caught him, a television crew was waiting. The cops triumphantly pulled out the papers—another foreign enemy exposed. That was a worthwhile detention: the police had the satisfaction of catching somebody who had broken the law, and the journalist at least knew that he had reported well enough to anger the government.

Twice in China, the police nabbed me while exiting a public toilet. In Fujian province, I was in the middle of a reporting trip that hadn't uncovered anything sensitive; in Gansu, I had simply wandered unknowingly into a county that happened to be closed to foreigners. These detentions were not satisfying for anybody. Ideally, there was an atmosphere of mutual antagonism: the journalist pursued the truth; the cops upheld the laws of the People's Republic. But it was hard to get inspired about a foreigner who was caught pissing in a town that was closed to outsiders.

The worst part was watching the stages of recognition. In the beginning, the police were often excited, and the interrogation moved briskly. After a while, though, it dawned on them that this foreigner simply had no clue what he was doing. Sometimes, by the end, I recognized pity in their eyes.

It was also true that I usually learned more about the region *after* being detained. In Xituogu, the villagers wandered freely in and out of the Consumers' Center, and we chatted; the official who was minding me didn't care. The villagers told me that Xituogu had a population of eight hundred, and chestnuts were the most profitable local crop. April was the prettiest month—in two weeks, the almond trees would bloom. The only question that nobody would

answer was whom they had voted for. Every time I asked a villager, his face became serious: "It's a secret."

One old man requested that I write an article about Xituogu. "If you describe it beautifully, then visitors will come," he said. "We can turn it into a tourist area."

I said that I'd think about it. After a while, the official opened another drawer and took out a microphone. His voice boomed over the village loudspeakers: "It is now ten minutes before twelve o'clock! If you have not voted, please hurry because after twelve o'clock the election will be closed!"

The sunshine was at its peak, and it seemed unnecessarily cruel to keep the American locked in the Consumers' Center. I walked outside and the official followed me.

"Please come back inside," he said.

"I don't want to," I said. "It's warmer out here."

He looked at the other official who was working the voting box; the man shrugged and left me alone. I joined an old woman in the sunshine.

"What's the purpose of the Consumers' Center?" I asked.

She said, "If you buy something and get cheated, then you can go there and complain."

At exactly twelve o'clock, the last voter sprinted up to the metal box. After a brief argument, the official allowed him to cast his ballot. A police car pulled up in a cloud of dust. The villagers became very quiet. I heard murmurs in the crowd.

"Why are they here?"

"What's happening?"

"It's because of the foreigner!"

The crowd pressed forward. Four officers stepped out of the car. I turned to get my pack and one of them barked: "Don't try to go anywhere!"

"I'm just getting my bag," I said. Suddenly I felt tired; the sand itched every time I moved. The villagers looked solemn as we pulled away.

SPINDLY POPLARS BORDERED the dirt road, which followed a dry creek through the valley. The other villages seemed devoid of life; the first vehicle that we met was another police car. Both drivers stopped for a moment, and then the second car turned and followed us. I wondered exactly how many officers had been dispatched to handle the sandy journalist.

The road was rough and the three of us in the back bounced against each other. They had seated me in the middle. An officer in the front seat turned around.

"When did you come here?"

"Yesterday."

"Why did you come?"

"I wanted to take a break from Beijing and I like to go camping."

"You camped alone?"

"Yes."

"Wasn't the wind strong?"

"Yes. But there wasn't anything I could do about that."

"What is your job in Beijing?"

"I'm a journalist."

"Where is your passport?"

"I left it in Beijing."

"Did you know they were having an election?"

"I had no idea. I've never been there before."

"How did you get there?"

"In a cab."

"Do you have a camera?"

"No."

The man paused for a moment and then spoke again: "Did you bring food?"

"Yes."

He was trying hard to think of other questions. There was a long silence and then the cop to my right spoke for the first time.

"How much is your salary?"

WE ARRIVED AT the Bulaotun Township police station, where I asked to use the bathroom. They sent an officer to accompany me. Afterward, he escorted me to the interrogation room, where three men in uniform waited. The name of the township translated directly as "Not-Old Station." They poured me another cup of tea. One cop asked questions and another wrote on a pad of paper.

"Why didn't you go to Simatai or Badaling?"

"There are too many people at those places and I like the unrestored parts of the Great Wall."

"Why were you at the election?"

"I came down to the village and there were a lot of people, so I asked them what was happening. I didn't think it was sensitive. There are elections all the time."

He became interested in chronology and I explained in detail exactly when

everything had occurred. Once that topic had been exhausted, we returned to the outdoors.

"Weren't you afraid to sleep alone?"

"No. It's a very safe area."

"But what about wolves?"

"There aren't any wolves there."

"Yes, there are."

I didn't believe that for a second, but I was in no position to argue. The cops were young—the oldest seemed to be in his forties. My friend Mike Meyer had a theory that Chinese cops never got any older, and he might have been right. In five years, I hadn't seen one who looked a day above fifty.

After a while the interrogating officer narrowed his eyes.

"You claim to have forgotten your passport," he said. "I think that's just an excuse."

"Why would that be an excuse?" I said. "It causes trouble for me as well as you. I told you that if you're really concerned, we can go to Beijing and I'll show it to you."

"Where's your camera?"

"I didn't bring a camera."

"I don't believe that."

"Search my bag," I said. "I don't have one."

"Why would you travel without a camera?"

"It's too much trouble."

"That's very strange. Wouldn't you want something to remember the trip?"

I thought: memories are not going to be a problem. For the next half hour he kept circling back to the imaginary camera. Chinese cops loved cameras; they made for productive detentions—rip out the film, throw it away. But it was far more complicated when nothing had happened and no device had recorded the nonevent. The questions kept coming.

THEY ALLOWED ME a break for lunch. The police station had a banquet room, and I was seated at a table that had been laid out for eight. It smelled strongly of grain alcohol. They served me bean curd, celery, and rice.

One official had been assigned to accompany me. He was not in uniform; the man's face was gentle and we began to talk. I asked him why this place was called Not-Old Station.

"It's because of a local legend," he said, and then he told the story: Once,

in ancient times, an immortal came down from the heavens. He visited Cloud Summit, the highest mountain in the area. A villager named Wang Zhi climbed the mountain and met the immortal, who gave the man a peach. Wang Zhi believed that it was a normal peach, given by a normal man. But after Wang Zhi ate the peach, he also became immortal.

Finally: an explanation for Chinese cops. I asked the young man what he did for the local government. He said, "I work for the Propaganda Department."

AFTER MORE THAN two hours, a policeman arrived from Beijing. I recognized the man; every year, he handled the visa applications for journalists. I also recognized a certain look of pity on his face, but at least he granted me the dignity of a few more questions. The other officers watched.

"Do you know that if you want to report, you have to apply to the government?"

"Yes, I know that. But I wasn't there to report. I was camping."

"It seems strange that you would happen to be there when they had an election."

"Look at me," I said. "There was a sandstorm last night. I'm carrying all of this stuff. Why would I do this in order to see an election?"

Now the pretense was gone and the cop asked, curiously, "What was the election like?"

"There were five candidates," I said. "Two were named Peng and two were named Zhou and one was Tang. They had to choose three. That's pretty much all I know."

"Have you ever seen an election in a village before?"

"In Sichuan, when I lived there."

"What's the difference?"

"There's no difference."

"What's the difference between this election and an election in America?"

It flashed across my mind: at American elections, they don't send two police cars when they see a reporter. But I swallowed the thought: "Hard to say."

The cop said, "They made a mistake with the ballot last year in America, didn't they?"

"Yes, in a few areas."

"There were other problems, too," he said. "Why did it take so long? Why didn't *Ge Er* win? He had the most votes."

In Chinese, I attempted a clear and concise explanation of the Electoral College. I should have known better; during my teaching years, I had never

been able to explain it in English. I had always believed that an excellent way to motivate American election reform would be to force each and every citizen to introduce the system to a Chinese classroom.

In the police station, my discourse on the Electoral College was particularly unsuccessful. The cops looked bored; finally, all of them left, except for the man who seemed the youngest. The moment that we were alone, he said, "How much money does a policeman make in America?"

THE LONGER WE were alone, the less friendly the young officer became. I tried to win points by saying that my brother-in-law was a policeman in Missouri, but that didn't seem to help. The Chinese cop started asking questions slowly, as if the notion of handling an interrogation were new to him, but soon he was shooting them across the room. He didn't seem to care much about what had happened in the village; most of the questions were about the United States.

"Which place is safer?" he said. "China or the United States?"

"China," I said. It hadn't been long since I'd visited Rhode Island Avenue.

"Why are there so many people living on the streets in America?" he said. "Why doesn't the government give them money?"

"The government gives some money to poor people," I said. "Not a lot, but some. Often the people on the streets are mentally ill."

"No, they're not. They're just poor."

I shrugged; the man spoke again: "Why do people in America have guns?"

"It's a right," I said. "It's in the Constitution."

"That doesn't make sense," he said. "Do you know that it's against the law to sleep on the Great Wall?"

"No," I said. "There wasn't a sign, and the locals said that other people had done it recently."

"They don't know the rules," he said. "You need to read the law. That's why you're in trouble. You've broken a number of Chinese laws. You aren't allowed to report without permission, and you didn't carry your passport. We can fine you fifty yuan for not having your passport."

"I'll pay it now," I said. It was the equivalent of six dollars. The cop shook his head and before he could ask another question I requested a trip to the bathroom.

HE STOOD NEAR the urinal, waiting. When we returned, his expression became even sterner.

"Why do they provide birth control to middle-school students in America?" he said.

For the first time that day, I was completely speechless. He repeated the question:

"Why do they provide birth control to middle-school students in America?"

"I think you mean high-school students," I said at last. "They don't give them to middle-school kids." I had no idea why I said that; for some reason the specific age group seemed extremely important to me at that moment.

"It *is* middle school," he said. "I've read about it. Why do they do that?"

This time I said nothing.

"That's a difference between China and America," he said triumphantly. "Things are much more open in America. Women are more open."

AT THE END, there was mostly silence. If he asked a question, I answered as briefly as possible: yes, no, I don't know. Finally he looked at his watch.

"You've broken the law," he said. "You are required to carry your passport, and you must request permission before you report. You are not allowed to sleep on a cultural relic. All of these things are against the law. You could be fined, but we will waive it today. You must never do this again. Do you understand?"

He escorted me to the police station's front gate. Four hours had passed since the police had picked me up at Xituogu. I didn't see the other cops; they must have instructed the young man to hold me a while longer, to teach a lesson. I caught a cab on the street. Driving out of Not-Old Station, I realized that the way I felt—filthy and tired, angry and frustrated—reminded me exactly of bad days as a schoolchild.

ARTIFACT H

The Word

ト ト ト ト

WORDS IN CHINA HAVE ALWAYS SEEMED ALIVE. THE VOCABULARY OF a calligraphy connoisseur is physiological: the "bone" and "breath" and "muscle" of a written word. The first Chinese character dictionary was compiled around A.D. 100, during the Eastern Han dynasty, and the author's afterword described the legendary invention of writing. The creator, Cang Jie, was a demigod with four eyes:

> He observed the footprints of birds and beasts, and recognized that meaningful patterns could be distinguished. For the first time he created graphs and tallies. . . . When Cang Jie first made graphs, he relied on categories and the imaging of shapes. Therefore they were called 文 [wen, "patterns"]. Later the "form and sound" graphs increased and these were called 字 [zi, "compound graphs"]. 文 are the roots and images of things. 字 means to be fruitful, multiply, and gradually increase. When written on bamboo and silk, they were called 書 [shu, "writing"]. "Writing" means "to resemble."

Animals leave tracks; tracks are copied into patterns; patterns combine to create new patterns. Words mate—pieces of one character are attached to pieces of another—to create new words. Writing originates from the world of living things and it behaves the same way.

After Cang Jie's invention, according to legend, the heavens rained millet and ghosts wept all night long.

* * *

AT THE UNIVERSITY of Washington at Seattle, I interview a professor of Chinese, and he mentions that Ken-ichi Takashima has just arrived to teach a summer course. The name sounds familiar, and then I remember David N. Keightley's story: Professor Takashima once tried to crack an oracle bone with a soldering iron.

I find the scholar in a temporary office, where he is unpacking some belongings. A native of Japan, he is a short, wispily goateed man in gold-rimmed glasses. He speaks fluent English with an accent, and his academic career has always involved crossing cultures. After studying at Japan's Sophia University, which is run by Jesuits, he attended the University of Washington for graduate school. Originally, he researched linguistics, but he became interested in Shang writing after studying under Father Paul Serruys, a Belgian priest and accomplished oracle bone scholar.

Like Keightley, Takashima's path to the bones was indirect, and he has often applied his background in linguistics to the study of Shang writing. Most recently, he and another scholar noticed that the inscriptions of different Shang diviners follow different grammatical patterns. This may reflect multiple dialects or languages—a possible sign that the Shang royal court involved more diversity than previously imagined.

The professor shakes my hand, and his face lights up when I mention that I'm researching the story of Chen Mengjia.

"Chen Mengjia was a great scholar," Professor Takashima says. "His 1956 general introduction to the oracle bones is still a chrestomathy."

From his mouth to my notes, the word mutates: "crestmathy." I stare at what I've written, and then I admit, "I've never heard that word before. What does it mean?"

"Masterpiece," he says. "Chen Mengjia's book is a masterpiece." The professor opens a dictionary, and then his face falls.

"My understanding of this word—" he mutters. "It's not my understanding . . ."

He shows me the printed definition:

a selection of literary passages used to study literature or languages.

He grabs another dictionary from the shelf. "It's the same thing," he says. "'A collection of passages from literature'. I wish I could find a better dictionary than this. I may have been misusing the word. I usually rely on the OED."

He fiddles with a computer. Today was his first day teaching; he is moving

into a new office; a journalist has just dropped in unexpectedly. But at this particular moment, the word is the biggest distraction of all. He tries to go on-line; he searches the office for a better dictionary. I wait in silence. I haven't spent much time in the company of scholars of ancient writing, but already I've learned that these people have a unique relationship with language. Professor Takashima speaks fluent Japanese, English, and Chinese; he reads ancient Chinese texts for a living. Words matter. Gently, I try to bring the interview back: "So Chen Mengjia's book was a masterpiece?"

"Yes, it's a masterpiece." He looks up. "People still use it. It covers almost everything; it's very comprehensive. When I'm researching something, Chen Mengjia's book is the one that I always go to."

Finally, the word is gone, and now he picks up another thread:

"When I was at Tokyo University, I heard some rumors about him. Some of the professors said that Chen Mengjia died fairly young, and they said it was not natural. There was something political about it. I don't know how to verify this or not. But usually the Japanese are pretty good about this. They won't tell rumors that aren't true."

He continues: "You know, he also wrote a book about Chinese bronzes. And the title, when translated into English, is something like *Chinese Bronzes Stolen by the American Imperialists*. It's a very hard-to-get book. A professor at Tokyo University reprinted it with the original title. Chen was calling the U.S. a kind of imperialist. I don't see why he titled it in that way."

I explain what I've learned about the book, and I tell Professor Takashima that Chen Mengjia committed suicide in 1966. I mention that, although I have only begun to research the story, some people have told me that Chen's troubles began when he opposed the reform of Chinese writing.

"Good for him," the professor says. The response is instinctive; immediately he catches himself. "That's not what I meant," he says quickly. "I understand that as a result he was put in a position where he had to commit suicide. That's terrible. I just mean that I also do not like the simplification of Chinese characters."

TAKASHIMA LAUGHS WHEN I mention the cracked bone. "Keightley quoted that in his book!" he says. "I couldn't believe it." He shakes his head, and then he tells the story:

In June of 1969, when Takashima was a graduate student, he decided to crack an oracle bone. He went to a Seattle meat shop, where he purchased some steaks and convinced the butchers to throw in a couple of meatless scapulas. ("They asked, 'What are you doing with this?' I said, 'I want to crack it.' They

gave it to me for free.") Along with his fellow students, Takashima hosted a party, where Father Paul Serruys occupied the Shang role of the "presiding priest"—the oracle bone diviner. Takashima was the technician.

"First I tried it with the soldering iron," he remembers. "It's electric and the heat was not intense enough. It just made a little scorch—that's it. So I used the electric soldering iron plus the burning charcoal. It made the bone really hot. And it made a terrible stench."

He continues: "Apparently there are different theories about how to prepare it—maybe you soak it in vinegar, or something like that. I had just dried the bone in the oven beforehand. And it wouldn't crack. Father Serruys and the other students were disappointed, so we just went back to eating and drinking. I gave up. I threw the scapula into the barbecue. We forgot about it, and then it started to crack like crazy. Pop pop pop! Historical linguistics are always trying to reconstruct ancient sounds. Well, that was a real reconstruction of the phonological system! It sounded like the Chinese word *bu*."

He pauses to write a character onto a scrap of paper. It means "divine; tell fortunes," and the shape resembles a crack in a bone:

卜

"In modern Chinese it's pronounced *bu*," he explains. "But in ancient Chinese it was *buk*. And the bone sounded just like that! More like a *p* sound, though—to me, it sounded like, *Pok pok pok pok*! It was a really sharp sound. I wrote a letter to Keightley, and he reproduced this in a footnote in his book *Sources of Shang History*. I couldn't believe it! And he said that Takashima has reconstructed the cracking in a Neolithic way!"

DESPITE THE SYMBOLIC neatness of the ancient Chinese theory about the origins of writing—from animal tracks to words—nobody knows how it really happened. Naturally, there aren't any records of how humans first learned to record things.

"It's such a giant step," Takashima says. "This step to writing, after thousands of years of oral communication. You know, the history of writing isn't that long. But once it began, civilization progressed by leaps and bounds. It's tremendous. Writing is really the great engine for progress in human civilization. Basically, that progress has been during the last three thousand years, whereas human history is fifty thousand, maybe seventy thousand years long. All of those years, they really didn't do much because there was no writing. What made people first feel the necessity to write things down?"

We talk about Chinese writing, and the professor mentions that he has

published a paper about the squareness of Chinese characters. Over the centuries, their form changed: Shang words were slightly elongated, but by the Han dynasty they had been pressed into a square shape, now known as *fangkuaizi*.

"I'm interested in the cosmography," he says. "I'm interested in the Chinese view of what the world is like. Where it comes from, I don't know. But it seems that they looked at things as if they were square. Not only the writing, but also in terms of the geographical."

In the oracle bone inscriptions, the Shang world is always described in terms of the four cardinal directions. Shang tombs and cities, and the walls that often surrounded them, were also arranged strictly according to the compass. Professor Takashima jots down the modern character *cheng*. It's often used as part of two terms: "city," and "city wall":

He notes that the ancient form of the character contained one element that is shaped like a box: 囗. When written alone, 囗 indicated a "squared area" or "demarcated area"—basically, a settlement. And the Old Chinese pronunciation of 囗 and 城 sounded similar.

"It's like the Greek idea of the barbarians," he says. "Those who are living within the city are civilized; those who are living outside of it are barbarians. 城 functions like that. And the city walls are square, basically. They were rectangular in the Shang, but it's essentially the same shape. There were never any round walls or any other shape. The Chinese must have had some very ingrained notion of what the world should look like."

He continues: "Maybe twenty or thirty years ago, the conductor of the New York Philharmonic Orchestra said something about Chinese music. He said that the music sounded like Chinese characters. What he meant was that the sound came in chunks. He said that Western music is not that way.

"When I heard this, I thought, what is he talking about? But when I was working on this idea of squareness, I suddenly thought that maybe it's not so far off. He was describing music as chunks instead of as a flow. It's very impressionistic, but I thought that perhaps he is hitting something really deep down in the primordial level of consciousness."

MORE THAN A year later, while reading David N. Keightley's *Sources of Shang History*, I reach page sixty-six, paragraph two. The first sentence is long and crawling with commas—a swarm of words across the page. One catches my eye:

The standard introduction to oracle-bone grammar, despite its unsystem-
atic and dated nature, is still the chrestomathy of Chen Mengjia, which
leads the student through word order, particles, time words, pronouns,
verbs, modifiers, numbers, demonstratives, connectives, prepositions, aux-
iliary verbs, negatives, omissions and abbreviations, and sentence types.

And even later, when I meet Professor Takashima again, he mentions that a Czech scholar named David Sehnal has successfully cracked a cattle scapula. The key was placing charcoal next to the bone and then blowing on it to make it even hotter. In the Czech Republic, the voice of the cracked bone sounded exactly the same as it had in Seattle: *Pok pok pok pok!*

15

Translation

April 1, 2001

IN THE WORLD OF U.S.-CHINA RELATIONS, IT WAS POSSIBLE FOR A disagreement to begin with a plane wreck and then, over the course of eleven days, to become distilled to an adverb and a noun. The event could have been an exercise in linguistics, or perhaps a fable—something out of *Chuang Tzu*, the ancient Taoist classic:

> *Once upon a time Chuang Chou dreamed that he was a butterfly, a butterfly flitting about happily enjoying himself. He didn't know that he was Chou. Suddenly he awoke and was palpably Chou. He did not know whether he was Chou who had dreamed of being a butterfly or a butterfly dreaming that he was Chou. Now, there must be a difference between Chou and the butterfly. This is called the transformation of things.*

* * *

ONCE UPON A time, on the morning of April 1, 2001, two military planes collided in international airspace high above the South China Sea. One plane was American, the other Chinese. The Chinese craft—an F-8 fighter—was badly damaged. The American plane was bigger: a Navy EP-3E Aries II, designed to gather the electronic communications of foreign militaries. After the collision, the Navy plane plummeted nearly eight thousand feet, regained control, and requested permission to make an emergency landing on China's Hainan Island. Airport control didn't respond; the plane landed anyway. The Ameri-

can crew consisted of twenty-four men and women, who were promptly taken into custody by the People's Liberation Army.

The Chinese F-8 was piloted by a thirty-three-year-old lieutenant named Wang Wei. His plane crashed into the sea.

None of these events was witnessed by an independent, nonmilitary observer.

Within hours, government officials of each country presented very different descriptions of the incident.

Neither nation's top leader issued a statement on the first day.

ON APRIL 2, President George W. Bush spoke. This was the first major foreign policy test of his presidency. The American media speculated that this incident could set the tone for the Bush administration's future dealings with the outside world.

Standing on the White House lawn, the president did not apologize for the collision, and he did not express condolences to the family of Wang Wei. His words were straightforward: "Our priorities are the prompt and safe return of the crew and the return of the aircraft without further tampering."

The president expressed concern that U.S. embassy personnel had not been allowed to meet with the American crew: "Failure of the Chinese government to react promptly to our request is inconsistent with standard diplomatic practice and with the expressed desire of both our countries for better relations."

Earlier, Admiral Dennis Blair, of the U.S. Pacific Command, had told reporters in Honolulu that there had been a "pattern of increasingly unsafe behavior" by Chinese pilots above the South China Sea.

AT THE BEGINNING, no high-ranking Chinese leaders made a public statement. That was typical: just as American values demanded a leader to act quickly, the Chinese generally waited for the wheels of bureaucracy to turn. And the plane incident had occurred at a particularly sensitive time. Beijing still awaited a decision on its Olympic bid, and the country was in the final stages of its application to join the World Trade Organization. Unlike in 1999, the government did not encourage or allow student demonstrations.

On April 4, President Jiang Zemin made his first statement, carried by the official Xinhua news agency: "The United States should do something favorable to the smooth development of China-U.S. relations rather than make remarks that confuse right and wrong and are harmful to the relations between the two countries."

In Beijing, the Chinese foreign minister issued an official demand for

an apology. Later that day, a high-ranking American official used the word "regret" for the first time. Secretary of State Colin Powell said, "We regret that the Chinese plane did not get down safely and we regret the loss of life of that Chinese pilot but now we need to move on and we need to bring this to a resolution."

On April 4, the *Beijing Youth Daily* ran a page-one headline:

PROOF OF BULLYING

On April 5, the *New York Times* ran a page-one headline:

BEIJING STEPS UP ITS WAR OF WORDS OVER
AIR COLLISION

On April 6, an American official announced that the two sides were drafting a formal letter that would end the crisis.

CHUANG TZU:

> Writing is that means by which the world values the Way, but writing is no more than words and words, too, have value. Meaning is what gives value to words, but meaning is dependant on something. What meaning depends on cannot be expressed in language, yet the world transmits writing because it values language. Although the world values writing, I, for my part, do not think it worthy of being valued, because what is valued is not what is really valuable.

* * *

ON APRIL 9, President Bush said that "diplomacy takes time."

The Chinese foreign minister said, "The U.S. side must apologize to China and adopt measures to ensure this sort of event will not reoccur."

The media of the two countries continued to describe the incident in completely different ways. The Chinese claimed that the American plane had swerved to collide with the F-8; American military officials claimed that the smaller Chinese craft had initiated the contact. For months, the Americans said, Chinese pilots had flown close to the surveillance planes, in an apparent attempt at intimidation.

Chinese military and commercial craft continued to search for Wang Wei in the waters of the South China Sea.

Reportedly, the letter was still being written.

* * *

ON APRIL 10, the Reverend Jesse Jackson offered to fly to China and assist in negotiations.

DURING THE CRISIS, as neither government said much of substance, the media of both countries used numbers to fill out stories. Each followed its own national obsession: Americans conducted polls; Chinese accumulated statistics. An ABC/*Washington Post*–sponsored survey asked the question: "Should the U.S. apologize?"

	% YES	% NO
Men	33	61
Women	46	47
Age 18–30	44	54
Age 61+	31	62

Xinhua reported that the search for Wang Wei involved 115 planes, more than one thousand ship patrols, and covered more than three hundred thousand square kilometers of ocean. That was more than eleven times larger than the Beijing city surface area that had been repainted for the I.O.C. inspection.

I KNEW ONLY three people named Wang Wei. One was an artist; another was an archaeologist; the third ran a bookstore. I should have known more. Wang Wei, my artist friend, knew five Wang Weis, and each of those Wang Weis probably knew five more, and each of them probably knew another five. Somebody named Wang Wei could be a man or a woman, urban or rural, rich or poor. The character for Wei could be 伟 or 为 or 卫or 未 or 唯 or 威 or 委 or 纬 or 尉 or 韦 or 微 or 炜 or 苇 or 玮. People in China do not use phonebooks in part because of names like Wang Wei.

CHUANG TZU:

> *A fish-trap is for catching fish; once you've caught the fish, you can forget the trap. A rabbit-snare is for catching rabbits; once you've caught the rabbit, you can forget about the snare. Words are for catching ideas; once you've caught the idea, you can forget about the words. Where can I find a person who knows how to forget about words so that I can have a few words with him?*

* * *

ON APRIL 11, both sides finally agreed on the letter. It had taken nearly a week to write 236 English words. Reportedly, the letter had passed through at least four drafts, and the final day of negotiations had resulted in the addition of a single adverb: "very." Off the record, some U.S. officials described it as "the letter of two 'very sorrys.'"

The American ambassador in Beijing signed the letter. It read, in part:

> *Both President Bush and Secretary of State Powell have expressed their sincere regret over your missing pilot and aircraft.*
>
> *Please convey to the Chinese people and to the family of pilot Wang Wei that we are very sorry for their loss.*
>
> *Although the full picture of what transpired is still unclear, according to our information, our severely crippled aircraft made an emergency landing after following international emergency procedures.*
>
> *We are very sorry the entering of China's airspace and the landing did not have verbal clearance, but very pleased the crew landed safely. We appreciate China's efforts to see to the well-being of our crew.*

The U.S. embassy translation used two different Chinese phrases for "very sorry." With regard to the family of Wang Wei, the Americans were *feichang wanxi*, "feel very sorry for somebody about something." With regard to China's airspace, the Americans were *feichang baoqian*, "be very sorry; feel very apologetic." But the Chinese Foreign Ministry released its own translation. "Very sorry" became *shenbiao qianyi*, "deep expression of apology."

After the letter was released, Colin Powell told reporters: "There was nothing to apologize for. To apologize would have suggested that we had done something wrong and we accepted responsibility for having done something wrong. And we did not do anything wrong. Therefore, it was not possible to apologize."

The following day, the *Beijing Morning News* ran the front-page headline: AMERICA FINALLY APOLOGIZES.

AFTER THE AMERICAN crew members left on a chartered flight to Guam, most U.S. newspapers reported that the incident had been ably handled by the new president, who showed flexibility. Analysts also noted that the dominant administration voice seemed to be Colin Powell instead of Donald Rumsfeld, the defense secretary. This was interpreted as a sign that President George W. Bush's foreign policy would be shaped by moderates rather than hard-liners.

∗ ∗ ∗

THE *BOSTON GLOBE* published two articles about the reaction of the average Chinese. The first story was by Indira Lakshaman, the Asia bureau chief, who was based in Hong Kong but had flown to Beijing to cover the event. On the evening that the letter was released, she went out into the city and showed people the official U.S. embassy translation. A Chinese assistant interpreted their responses. Lakshaman's article read, in part:

> *Younger residents parroted nationalistic sentiments that have been stoked by a government nurturing patriotism among its populace as a substitute for the waning of communist ideology over the past two decades. Older residents nostalgically recalled the rule of China's founder, Mao Zedong. . . . Wu Guoging [sic], a 45-year-old laid-off worker, bellowed: "Look at these cowardly leaders! First the embassy in Belgrade was bombed. Then our plane was hit. And what can they do? If I were in charge, I'd put the 24 crew members underground and hide the spy plane, and when the US came asking, I'd say: "What plane? We don't know anything."*

On the same evening, I reported the second *Boston Globe* article. I went alone to the old dumpling restaurant in Yabaolu, ordered dinner, and talked with people. I did not bring a copy of the American letter. My article read, in part:

> *"We should attack America," said Gao Ming, a 24-year-old restaurant owner, shortly after hearing about the release.*
>
> *But Gao became vague when asked the reasons for this retribution, and less than a minute later he was hedging his words. "This is a problem between the governments," he shrugged. "The American people are fine, just like the Chinese people. But the American government is very arrogant— why did it take them so long to apologize?"*
>
> *Like Gao, many Chinese citizens, sorting through often conflicting information from state-run media, the Internet, and word of mouth, are responding to the incident with as many questions as opinions.*
>
> *While initial comments tend to be angry and unequivocal—especially when addressed to members of the foreign press corps—longer discussions reveal frustration and powerlessness. . . .*

After the plane dispute was over, and I read both articles, I decided to stop writing newspaper stories.

* * *

I HAD ALWAYS been bad at daily journalism. I worked slowly; I dreaded dead-lines; I failed to cultivate contacts. I knew only three Wang Weis. I quoted everybody that a good journalist doesn't quote: cabbies, waitresses, friends. I spent a lot of time in restaurants. I avoided press conferences. I loathed talk-ing on the telephone—a crippling neurosis for a news reporter. In particular, I hated staying up late at night to call American academics so they could give me a quote about what was happening in China. I already knew what was hap-pening: normal people were asleep.

I had no infrastructure: no office, no fax machine, no assistant, no driver, no clipper. Officially, I was in charge of the Beijing operation of the *Boston Globe*, but it was nothing more than a paper bureau—*jiade*. I held a journalist license that misspelled the name of the newspaper (*Boston Global*), an offi-cial chop (an ink stamp used to certify formal correspondence), and an office registration card claiming the same address that was already occupied by the *Wall Street Journal*. Friends at the *Journal* let me use a room there if I needed it, and I picked up my mail a couple of times a week. Usually, I worked out of my home, a cramped third-story apartment in Ju'er Hutong.

I made three or four hundred dollars per story. It became a decent living only when news broke; if I played the game right, I could file a story at every new development: every official statement, every nuanced word, from "regret" to "sincere regret," from *wanxi* to *baoqian* to *qianyi*. But sanity has a price, and mine was more than three hundred bucks; if I had wanted to become a professional deconstructionist, I would have stayed in grad school.

Even if somehow I became good at daily journalism—if I acquired a real bureau, and real contacts, and learned to love the telephone—I had little faith in the format. I disliked the third-person voice: it was possible for two journal-ists to witness an event, interpret it completely differently, but adopt the same impersonal and authoritative tone. Writers rarely appeared in their stories, and they didn't explain their reporting techniques. In China, many foreign jour-nalists hired interpreters or "fixers"—assistants who tracked down potential interview subjects—but these contributors were rarely mentioned in the story. Even if you worked alone, your identity as a foreigner affected the responses of Chinese people, but it was hard to make this clear in a third-person story.

I had more patience for features, which sometimes ran at length in a news-paper. I had written about Old Mr. Zhao's courtyard for the *Boston Globe Magazine*, which gave the story plenty of space. But even long features could be limited by certain values of American journalism that didn't translate well

overseas. In Fuling, during my time as a teacher, I had seen what happened when such information moved in the opposite direction. My students used a textbook called *Survey of America*, which included a chapter about "Social Problems":

> In 1981, in California University, robbery and rape increased one hundred and fifty percent. In a Cathedral school of Washington District, a girl student was raped and robbed by a criminal with a hunting knife while she was studying alone in the classroom. In a California university, a football coach was robbed on campus by someone with a gun. It is said that, in South Carolina University, gangs of rascals have been taking girl students, women teachers and wives of teachers working in this university as their targets of rape, which has caused a great fear.

It was hard to teach from a book like that. The details themselves were probably true—certainly, there were rascals in South Carolina—but that didn't make this information a useful starting point for a student in a remote Chinese city. They needed context, not trivia; a bunch of scattered facts only confused them.

Probably, these details had been culled from American newspapers, where they had actually served a purpose. In the United States, journalists worked within a community, and often their stories inspired change. This was one of the noblest aspects of the field, as well as the most widely celebrated. Any American journalist knew the history of Watergate: how dedicated reporters helped bring down a corrupt administration. That was the model for a good journalist—if your community had a rascal problem, you exposed it, even if the rascal was the president of the United States.

At big papers, successful journalists became foreign correspondents, and then they brought their work patterns overseas. Usually, they searched for dramatic, unresolved problems; if they didn't speak the language, they hired interpreters or fixers. Sometimes, their stories made a difference. In African countries, journalists who covered famines or genocide could be instrumental in motivating international organizations to step in. Reporters functioned within an international community because the local community had broken down.

But China was completely different. The country received some international aid, mostly in the form of loans, but the economy had been built primarily through Chinese effort and determination. In the past, the American government had responded to Chinese human rights violations by periodic threats to impose economic sanctions, but those days were gone: trade had

become too important. Essentially, China had outgrown the traditional limits of a developing country. Despite its problems, the nation was stable, functioning, independent, and increasingly powerful. When Americans looked across the Pacific, the critical question wasn't how they could change China. It was far more important to understand the country and the people who lived there.

But most foreign journalists were stuck in the old mindset, the old file cabinets:

 DEMOCRACY
 DEMOCRACY PARTY
 DEMONSTRATIONS
 DISABLED
 DISASTERS
 DISSIDENTS

In a typical foreign bureau, Chinese assistants searched local newspapers for potential stories, and they received tips from disgruntled citizens. When something dramatic caught the foreigner's eye, he pursued it: child-selling in Gansu, female sterilization in Guangxi, jailed labor activists in Shandong. The articles appeared in American newspapers, where the readers couldn't solve the problems and didn't have the background necessary to keep everything in context. It was like the Fuling textbook: sometimes the more information you have, the less you know. And there is a point at which even the best intentions become voyeurism.

I didn't want to write such features, which meant that the main appeal of working for a newspaper was news. And news in China seemed pointless: the country changed every year, but the pace was steady and it moved subtly. There weren't any great leaders, and supposedly important events like the plane dispute fizzled out; they were like splashes of foam on the surface of a massive sea change. We had escaped history; news no longer mattered. Brave new world.

Anyway, that's how it looked before September of 2001.

ON MY COMPUTER, I pulled up old letters and made minor changes:

Dear Press Attaché,
 This document certifies that Peter Hessler is a fully qualified journalist whose experience is commensurate with the demands of working as a foreign correspondent. . . . The New Yorker wholeheartedly supports Mr. Hessler's nomination to serve as our Beijing correspondent, and we thank you for your consideration of this application.

Magazine work was a better fit. Stories were longer; you could write in the first-person voice; editors didn't care so much about news. They paid by the word, which was a lot better than the flat rate for newspaper freelancers. Magazines covered expenses. Because they moved slower, it was possible to research stories without ever using a telephone.

For the past twenty years, China's economic reforms have resulted in dramatic changes. . . .

It felt as ritualized as an oracle bone inscription: the same well-worn phrases, the same letters and documents. *The New Yorker* had never posted a full-time correspondent in the People's Republic, so I created an official *New Yorker* bureau, which happened to be located in the same place as the *Boston Globe*, which happened to be located in the same place as the *Wall Street Journal.* The paper piled up, but nobody at the Foreign Ministry seemed to care.

Everything proceeded smoothly until we reached the stage of translation. The Foreign Ministry announced that the magazine's Chinese name would be *Niu Yue Ren*, which translates directly as "New York Person." My name cards would read:

<div align="center">

New York Person
Peter Hessler

</div>

Every time I showed it to a Chinese friend, he burst out laughing. In Hong Kong, Taiwan, and other Chinese-speaking communities in the United States, the magazine was already called *Niu Yue Ke*. That was a phonetic transcription, pronounced "neo-you-ay-kuh"; it wouldn't cut it in Brooklyn but sounded a hell of a lot better than "New York Person."

When I mentioned the issue to Sophie Sun, the Chinese assistant at the *Wall Street Journal,* she offered to help. She thought that it would be better for a native to deal with the Foreign Ministry, but after one telephone call she was so angry that she could hardly speak. She told me that it was hopeless; they were as stubborn as only cadres could be.

Finally, I telephoned the official myself. His name was Shi Jiangtao; his voice sounded young but it went flat the moment I introduced myself. We spoke in Chinese.

"I've already discussed this with other people at the Foreign Ministry," he said. "We think that New York Person is a better translation. It's more exact."

"Is there any way that we can meet?" I said. "I'd be happy to go anywhere that's convenient for you. I think it would be better if we could talk in person."

The Foreign Ministry was located on the Second Ring Road. The massive building had a gray-windowed façade that bulged outward, as if the place had been packed so tightly with *jiade* paperwork that it was about to explode. Shi Jiangtao's voice didn't change.

"I can't meet today, or even this week," he said. "Maybe next week, but I'm not certain. In any case, it's not necessary for this matter."

"Well, the name is important to me. I want a name that's more recognizable; it will make my job easier."

He told me that that shouldn't matter because the magazine had not previously posted a resident correspondent in China.

"That's not true," I said. "There were reporters here in the 1940s."

"Well, that's a long time ago and nobody is going to remember that."

"I've seen *Niu Yue Ke* used on many Web sites and publications," I said. "And it's used by overseas Chinese."

"We don't care what people might use outside the Mainland," he said. "It doesn't matter what they do in Chinese communities in America or other places. This is for us to decide."

"That's not what I meant," I said. "*Niu Yue Ke* doesn't come from Taiwan or anything like that."

The man responded quickly: "Who mentioned Taiwan? I didn't say anything about Taiwan."

"I'm just saying that in other overseas Chinese communities, *Niu Yue Ke* is more standard. I'm not saying that it has anything to do with the Taiwan problem."

"Of course it has nothing to do with the Taiwan problem," he said angrily. "Why would it?"

IN THE END, it was their language and their decision. I tried to be philosophical: a fish trap is for catching fish; once you've caught the fish, you can forget the trap. I received my new visa, new journalist license, new office registration card, and new chop. The stamp said, in bright red ink:

美国纽约人

("American New York Person")

Every time I stamped an official document, I told myself that it didn't mean anything. I was still a proud Missourian, and the Reds could never take that away.

16

Flags

September 11, 2001

THE CAR WAS POLAT'S MOST VALUABLE POSSESSION. SOMETIMES, WHEN he felt restless, he took the Honda Accord for long drives into Maryland or Virginia. His English was still poor, but he could negotiate the roads without any trouble. He decorated the dashboard with two flags: one American, the other from the East Turkestan Republic. The East Turkestan flag featured an Islamic white star and crescent on a blue background, and it was banned in China.

The car was also Polat's best hope for permanent escape from the corner of Franklin and Rhode Island. He wanted to move out of the neighborhood, and he wanted to start working; the Honda would make it easier to do both, once his papers were in order. In May of 2001, he was interviewed by a representative of the Immigration and Naturalization Services. Brian Mezger, the lawyer, accompanied Polat, and the interview went smoothly. The following month, the United States of America granted Polat political asylum.

He immediately applied for his wife to join him. The paperwork would take time—maybe a year, maybe longer—and she seemed increasingly nervous about leaving Xinjiang. In the evenings, Polat often telephoned, trying to convince her that everything would work out. But she worried that the Chinese would revoke her passport, or that even if she made it to America, the adjustment to daily life would be too difficult. Polat avoided telling her much about the neighborhood where he lived.

He was between passports—no longer a citizen of the People's Republic,

and not yet an American—and so the United States government issued him a refugee travel document, which would allow him to cross international borders. He began planning a trip to Kazakhstan and Uzbekistan. He had friends there, and perhaps some trade possibilities would open up; he had already spent most of his Yabaolu savings. During the summer, he finally moved to an apartment in the District's Chinatown. For somebody who had fled China less than a year earlier, it seemed wrong to pay rent to a landlord from Guangdong, but Chinese was still Polat's most useful language.

In August, the U.S. government granted him permission to work. In the District, the Uighurs who didn't speak much English usually found jobs as deliverymen or restaurant kitchen staff. Polat wanted to see if anything else was available, and I put him in contact with a former college roommate named Bob Brashear. Bob ran a factory in Baltimore that made cans, and occasionally, they hired non–English speakers. Wages were low—the job involved moving boxes—but they provided basic benefits, including health insurance.

I also introduced Polat to Adam Meier, who had taught with me in the Peace Corps. Nowadays, Adam worked at the State Department, in the office of Colin Powell's spokesman. One evening in late August, Adam arranged a summit between Polat and Bob. Polat brought along another friend, a Uighur who had lived in the United States for twelve years. It was a mixed group: two political-dissident Uighurs, two Ivy League–educated white Americans. Naturally, they went to a Mexican restaurant. The next day, Adam sent me an e-mail:

> It was a "business" dinner in which a 45-year-old college-educated, multi-language-speaking, former teacher brings an entourage of two to discuss the prospects of getting work moving heavy boxes in a large un-air conditioned warehouse for $7 or $8/hour. Kind of a strange scene, all in all. The wait staff was very eager, and kept asking us if we "were familiar with their food." Polat in fact wasn't—he ordered some sort of enchilada/burrito, and he mentioned that it was his first time eating it. He polished off the plate of food. When we were leaving the restaurant, I asked him what he thought. He said again that it was his first time eating it, and that it wasn't so good.
>
> After we checked out the factory, we headed back to DC, and I asked Polat what he thought of the job. He said that it might be hard and tiring, but he would do it. He repeated a few times that he wasn't afraid of the job, although he had never done anything like it.
>
> He only has about $1000 left, and so he needs the job. He is going to

*look for a place in Baltimore, or Bobby may ask if anyone at the factory
can rent him a room. . . .*

*He doesn't like DC—he just moved out of his building which he hated
because he saw drug-use and crime and guns. He probably won't land in a
situation that is much better in Baltimore, especially at his budget level.*

The following week, Adam wrote again:

*Unfortunately, he got his car broken into. He was over at a friend's house
listening to some Chinese broadcast, and somebody busted his window to
get his stereo, which, I am sure, was worth about $15. He had to pay $230
to replace the window, and now he has no stereo.*

<p style="text-align:center">* * *</p>

ON THE MORNING of September 11, Polat drove back to Baltimore, to take
another look at the can factory. He had already installed a replacement car
radio, purchased secondhand for forty dollars, but on that Tuesday morning
he wasn't listening to the news. Later, he wasn't certain about exact times, but
he believed that he must have been at the factory before 9:37 A.M. The sky was
high and blue and there was not a cloud in sight.

He worried about the factory's location. He was willing to do manual labor,
at least until his English improved, but he didn't want to be isolated from the
local Uighur community. Most of his Uighur friends lived in the District, and
his new apartment was about an hour's drive from the Baltimore factory. After
making the trip on September 11, Polat decided that the plant was too far away.
He would find something closer to the capital.

That morning, he continued driving to Newark, New Jersey, where some
Turkish immigrants lived. During the 1990s, Polat had spent several months in
Turkey, and since the language is close to Uighur, he always felt comfortable
with the immigrant Turks. In Newark, he called up to their apartment, like he
always did. But for some reason the Turks didn't answer.

At about eleven o'clock, he finally gave up and headed back toward home.
On Interstate 95, he got caught in the worst traffic jam he'd ever seen in Amer-
ica. For a few hours, the cars crept along, and Polat noticed that other drivers
looked upset. He turned on the radio. From the news reports, he understood
two English words: "smoke" and "Pentagon." He had learned "Pentagon" from
driving around the capital, and Marlboro Light had taught him "smoke."

He pulled off at Towson, Maryland. In that city, he knew an ethnic-Korean
immigrant who had formerly been a citizen of China. The Korean had a tan-

gled family background that as a boy had somehow landed him in Central Asia: he had grown up in western Xinjiang, in the city of Kashgar, and his mother tongue was Chinese. Nearly a decade ago, he had received political asylum in the United States. Over the years, he had saved up money and finally opened a business. Naturally enough, it was a sushi restaurant.

The Korean told Polat about the attacks. Together, they sat in the sushi restaurant, watching television: the collapsing buildings, the burning Pentagon. News reports suggested that the attacks may have been organized by Islamic fundamentalists; there was speculation that more violence could follow. Across the country, flights had been grounded, and Polat decided to stay with his friend for a couple of nights. He was afraid that on the streets Americans might mistake him for a terrorist.

On the morning of September 13, he finally drove home to Chinatown. Along Interstate 95, there were lots of police cars, but few other drivers. The Pentagon still burned—smoke was visible from miles away. That month, Polat removed both flags from his car.

17

Straight to Video

September 12, 2001

THE MORNING AFTER THE ATTACKS, I CAUGHT A TRAIN SOUTH TO Anyang. The journey was familiar, its scenery as patterned as wallpaper: a peasant, a field, a road, a village; a peasant, a field, a road, a village. The sense of repetition jarred against the televised images of the previous evening. But there had been no reason to cancel the trip, which had been scheduled for months; the archaeologists always worked in early autumn. They spent the days out in the field, mapping the underground city, step by step. At night we watched television news. But the Chinese government limited the early coverage, and it was hard to find much information. I couldn't get a good Internet connection from my hotel.

After trying unsuccessfully for a couple of days, I finally called Polat's cell phone. He sounded fine, although he had temporarily given up on the job search. He still had some savings in China, and he said he might ask a friend in Urumqi to give me some cash that I could convert into a check. I told Polat that I'd probably visit Xinjiang soon, because of another writing project. That fall, I was traveling a lot—after Anyang, I planned to go to Wenzhou.

I asked Polat about the mood in Washington, D.C.

"I'm not sure how people are out on the street," he said. "I don't go out much, especially in the evenings. If somebody were to ask me what I'm doing, it would be hard for me to explain in English. That's the kind of thing I worry about."

"Have you seen the other Uighurs?"

"Yes, of course," he said. "None of us has had any problems so far. But people say it's better to be careful."

I LEFT ANYANG and flew to Wenzhou. It felt like another long trip—from the slow world of the archaeologists to the boomtown. In Wenzhou, the power of the economy was so intense that you felt it upon the moment of arrival, like the damp heat of a tropical country. At the Wenzhou airport, the baggage claim area featured eight different advertisements for shoe factories. I stepped outside the terminal and found myself facing a massive billboard: JIALAIDUN PISTON. My cab cruised beneath an English sign that had been erected by the Wenzhou government:

GOING ALL OUT TO SET UP THE LIGHT INDUSTRIAL CITY

I headed toward Yueqing, the satellite city where Willy and Nancy lived. Along the way, the cab passed through factory towns: Baixiang, which produced cheap suits; Liushi, home of low-voltage electrical appliances. Advertisements lined the highway: Brother Packing Machine, Tingyu Group Meters, Tongda Electric Wire. Many billboards had been designed in the boomtown-pastoral style that I remembered from Shenzhen: an obscure product superimposed atop a sunny green field. Tires, transformers, shock absorbers, electric outlet covers. Everything for export, everything in bulk. Brand names mixed parts of Chinese and English words: Jubang, Gelhorn, Shar Moon, Odkon. Dorkan: "King Shoes of China Genuine Leather."

In Yueqing, the video shops carried bootlegs of the terrorist attacks. After a couple of days in the city, it became an obsession; whenever I passed a store, I searched it for DVDs and VCDs. Shopkeepers told me that the first bootlegs had appeared only three days after the attacks.

They stocked them on the same racks as the Hollywood movies. Often, the 9/11 videos were located in the cheaper sections, alongside dozens of American films that I didn't recognize. Many of these obscure movies must have gone straight to video; the credit lines were unfamiliar, and cover blurbs usually promised sex and horror. At one shop, a film called *At First Sight* had a teaser in Chinese: "He Finds a Way to Make Huge Profits with Attractive Women." Next to that was *Reptilian*: "Tiny Insects Cause a Coming Atrocity for Human Beings." After that, a 9/11 video:

<div align="center">

Several Planes Attack America!
The World Trade Center Totally Destroyed
The Pentagon and Capitol Hill Attacked by Planes

</div>

White House Capitol Hill Continuous Explosions
Who is the Murderer? It's Still Unknown

The back of the package said:

Palestinians: "It Serves America Right!"
US Hegemony and Power Politics Make Too Many Enemies
The USA in Complete Panic

All of the 9/11 videos had been packaged to look like Hollywood movies. I found a DVD entitled "The Century's Great Catastrophe"; the box front featured photographs of Osama bin Laden, George W. Bush, and the burning Twin Towers. On the back, a small icon noted that it had been rated R, for violence and language. The English credit line was muddled:

TOUCHSTONE PICTURES presentsa JERRY
BRUCKHEIMER
production david TOM HANKS silen TWITNESS DAVID
MORSE PAME
BUSCEMI ving rhames

Chinese bootlegs often featured distorted credits, as well as other text and icons that didn't make sense. They only worried about the title and the pictures—as long as those basic elements were correct, the rest of the English text only needed to fill space. I found two different 9/11 VCDs that had copied the credit line from *Patton*: "Twentieth Century Fox Presents George C. Scott. . . ." For some reason, that was one of the most common templates in China—it appeared on all sorts of bootleg videos. Once I found the *Patton* credits on the package of a movie about high-school cheerleading.

The boxes of the 9/11 videos also duplicated bits of English summaries from random films. One featured a photograph of the second plane exploding against the World Trade Center, and then the text read:

In an energetic film of two tough brothers who are steelworkers in New-castle, New South Wales, BOOTMEN shows the way that they eventually go their separate ways. One brother, Sean leaves town in pursuit of a career in tap dancing. . . .

Another package had two pictures—a terrified woman pointing at the sky; a Manhattan cityscape marred by a plume of black smoke—and then a paragraph:

In addition, while economic modernization has in some ways "modernized" thinking about old-fashioned norms and mores, it has not truly "liberalized" men and women's perceptions of relationships, nor has it been able to brush aside age-old feelings and constraints about loyalty and betrayal.

<div align="center">* * *</div>

AFTER THE ATTACKS, the Chinese government had responded faster than usual. Within hours, President Jiang Zemin sent a message of condolence to President Bush, and by September 12 additional Chinese military police had been posted near the U.S. embassy in Beijing. That day, a Foreign Ministry spokesman said, "The Chinese government has consistently condemned and opposed all manner of terrorist violence." It was a clear expression of support for the United States, as well a subtle allusion to China's own attitude toward Xinjiang. For once, the governments of China and the United States seemed to have found common ground, and in the first few days after the attacks, the state-controlled media never implied that the Americans had gotten what they deserved.

But the average citizen said it, even to your face. In Anyang, a cab driver told me that now Americans understood what it was like for the Chinese to have their Belgrade embassy bombed. One morning in Beijing, I stopped by a neighborhood park and was greeted by a man who knew me only casually. "Oh, you're here!" he said, and then joked: "I thought you might have been killed." The openness startled me—I could only imagine how people talked when a foreigner wasn't around.

In Yueqing, the satellite city outside of Wenzhou, I shopped for 9/11 videos with William Jefferson Foster. He told me that most of his colleagues had been pleased by the attacks.

"There's one teacher who was especially happy," Willy said. "The next morning he told me that he couldn't sleep that night, because he was so excited and happy."

"What was he so happy about?"

"He doesn't like America," Willy said. "But mostly I think that he liked watching it."

"Liked watching what?"

"The buildings falling down," Willy said. "He thought it was interesting. A lot of people are like that. Everybody says it was like a movie. Another teacher told me, 'America always makes so many movies, but now they've finally made a great one!'"

I asked Willy how he had responded to such remarks.

"I don't know what to do," he said. "The day after it happened, I was very unhappy to be at the school, because everybody was talking about it and laughing. And actually for about a week I tried not to be in the same place as them. When that teacher said that he couldn't sleep, I felt very uncomfortable; I felt sick. I just wanted to be alone or with Nancy. It's different for us. The first thing that I thought about was Mr. Meier, because he lives in Washington and he works for the government. I was very worried until you told me that he was fine."

We stopped in a video shop and found another copy of a 9/11 disk. The store owner told me that the control seemed to be tighter than with regular movies. He remarked that big films like *Pearl Harbor* usually appeared within two days of the American release, and then they were sold everywhere; but the 9/11 videos were becoming hard to find. He sensed that the government was cutting off the distribution channels.

We left the shop and I asked Willy if my impression was accurate—that the state-run news hadn't used the attacks to criticize America.

"That's true," he said. "Many people believe that the government is actually very happy about it, but they can't say anything. People say that Jiang Zemin is a coward, a chicken. They say that there are too many countries with America right now, so it's impossible for China to stand alone."

"What do they think China could do otherwise?" I said. "Support the terrorists?"

"I don't think they know," Willy said. "It's just something people say."

In part, it seemed to be habit—so many years of anti-American propaganda had settled into people's minds. But it was also connected to everything that had been left out of the news. In the past, the media had rarely reported on tensions in Xinjiang—like Tibet, it was generally portrayed as a peaceful place whose indigenous people were happy to be a part of China. Few average Chinese knew that their own government was concerned about the spread of Islam in the West. I asked Willy what people thought about bin Laden.

"Some people say he's a hero," Willy said. "He comes from a poor country but he was able to cause a great problem for America. I've heard people say that now bin Laden is even more famous than Mao Zedong."

"So they like him?"

"Not really," he said. "They just say he's famous."

It reminded me of the way that Chinese people used the word *lihai*, "terrible, fierce." So many different things could be *lihai*: a flood, a war, a hero, a criminal, a victorious general, a woman from Shanghai. And you could describe

any influential person as *weida*, or "great": Mao Zedong, Mahatma Gandhi, Adolf Hitler, George Washington—all *weida*. It was completely amoral, as if the world were moved by massive events and personalities who were so distant that they couldn't be judged by normal people. If you were fortunate, you could stand back and watch.

We entered another video shop. "You know," I said. "Bin Laden actually isn't from a poor country. He's from Saudi Arabia. His family is rich."

Willy paused. "I thought he was from Afghanistan."

"He lives there now, but he's from Saudi Arabia."

"I didn't know that," he said. "Anyway, many people have this impression. They believe he's from a poor country but now he made America notice him."

That shop didn't carry any 9/11 videos, but they had an eight-disk documentary of the first Gulf War. The package featured an American flag, a photograph of Saddam Hussein, and a Chinese blurb:

> The World's First High-Tech Modern War!
> Will There Be Another Conflict in the Gulf?

"That's not new," Willy said. "That's been around for a while. Actually, I wanted to buy it before, because I'm interested in that. But Nancy wouldn't let me."

"Why not?"

"It's too expensive," he said.

I picked up a set—eight bucks. Later that evening we watched the 9/11 videos in Willy and Nancy's home.

THEY LIVED ON the fourth floor of an apartment building near the school. The complex was new but unfinished, in the boomtown style: the stairwell lacked railings, and blotches of dried paint criss-crossed the cement floor. Willy and Nancy's apartment consisted of a single room, painted in white and furnished with a bed, a color television, and a desk. A few dozen books lined wooden shelves: *Longman's English Grammar*, *Selected Readings in English and American History*, *A Dictionary of English Euphemisms*. A volume of Saul Bellow short stories sat next to an old hardback that Adam Meier had given to Nancy: *Nancy Drew and the Hardy Boys Super Sleuths*. Willy's three broken dictionaries lined the center of the shelf, like proud old soldiers.

It seemed like only yesterday that the young couple had been students in my Fuling classrooms: Willy in the last row, nose in a dictionary; Nancy following the lesson carefully, hoping that I wouldn't call on her. In Fuling, she had been

painfully shy, but the years away from home had changed her. When we talked, she looked me in the eye. She was firm with Willy—that was the biggest difference. In Fuling, she had always seemed intimidated by his intelligence, but now they had the easy banter of a couple whose differences have been softened to familiar jokes. Willy said that Nancy criticized him for arrogance, and I asked her if it was true.

"Of course," she said, dark eyes flashing. "He always thinks he's right. Always."

She tried to be patient with his obsessions. Earlier that year, Wenzhou television had started broadcasting China Central Television's Channel Nine, which is in English. Every night, Willy stayed up late, glued to the television, writing down new words. Nancy's sleep deteriorated into a haze of flickering light and Special English, and then, just when she thought they might need another room, the broadcasts stopped.

For a few days, Willy assumed that there was a technical problem. After a week, he telephoned the Yueqing Broadcasting and Television Bureau, whose representative told him that Channel Nine had been canceled because of a lack of local interest. After another week, Willy began calling and impersonating a Beijing accent. He claimed that he worked for an international trade company whose foreign representatives often traveled to Yueqing, where they had been deeply disappointed to find no more Channel Nine. The foreigners, who were investing heavily in Yueqing, would be thrilled to see Channel Nine again. For weeks, Willy waited hopefully—nothing. If Nancy was relieved, she was tactful enough to keep it to herself.

Like many Chinese women, she was tough about money. Willy had a tendency to spend freely, but Nancy reined him in. With regard to having a baby, she held a hard line: until they had saved one hundred thousand yuan, she wouldn't get pregnant (thus far, they had eighty grand). Technically, they were newlyweds—that May, they had finally registered as husband and wife. But they had never held a ceremony, because they were so far from Sichuan. After debating for years, they finally decided to skip the wedding and just get pictures instead. One day that summer, they went alone to a wedding photo studio in downtown Wenzhou.

They returned with an enormous framed portrait, which became the only decoration in their apartment: a soft-lens photo of Willy in a tuxedo and Nancy in a canary-yellow wedding dress with a string of pearls. They also bought an expensive photo album, which included a dozen more pictures, each featuring a different costume and background. It was as if they had had twelve separate weddings instead of none at all. The couple appeared in Wenzhou

parks and on busy city streets; their clothes shifted through different histori-
cal periods and international styles. In one photograph, Nancy even wore a
Japanese kimono.

"Everybody has a picture taken with that costume," she explained. "People
think Japanese women are very gentle, very kind-hearted. They take care of
their men."

The photo borders were decorated with English terms ("tenderness, chic,
charming, smart") and bits of poetry that sounded a lot like pop song lyrics:

> *I don't love diamonds you see through*
> *I want you to hold me I want you to be true . . .*

Another photo featured William Jefferson Foster dressed as a Ming dy-
nasty gentleman, fan in hand. *I wanna tell you baby the changes I've been
going through.* Another picture showed Nancy Drew in a lovely silk *qipao*.
Missing you listen you. There was a pastoral shot of the couple in modern
formal wear, sprawled on a sunny green field. *Until you come back to me I
don't know what I'm gonna do.*

THE 9/11 VIDEOS were hard to follow. They had been compiled hastily, and
it was impossible to tell who had published them; all of the Chinese credits
were fake. The DVD—*The Century's Great Catastrophe*—consisted mostly of
footage taken from ABC News. Occasionally they dubbed in American movie
soundtracks; at one point, they played the theme song from *Raiders of the Lost
Ark*. Movie gunfire and explosions accompanied the second plane as it crashed
into the World Trade Center. The north tower collapsed, in slow motion, to
music from *Jaws*.

Another video was entitled *Surprise Attack on America*, and the open-
ing adopted a documentary tone. A voiceover introduced Manhattan and the
World Trade Center, and there were scenes from daily life in New York. Busi-
nessmen in suits crossed streets; rows of traders stared at computer monitors.
Suddenly, an image caught my eye: a banker hurrying from one desk to an-
other, carrying a sheaf of papers. For some reason he looked familiar, and I
wondered if he was somebody I had known in college.

I turned to Willy: "Can you play that back?" He fiddled with the remote
and then the banker reappeared. He was onscreen for only five seconds, but
something clicked in my head: it was a splice from the movie *Wall Street*.

Hollywood movies kept cropping up in *Surprise Attack on America*. Some-
times the inserts were so short that I couldn't tell where they had come from,
and the effect was unsettling: a flicker of ambiguity between fact and fiction.

Other cut-ins weren't so subtle. The collapse of the towers was followed by a quick scene from *Godzilla* in which the monster lays waste to Manhattan. A Chinese commentator intoned: "Only in horror films can we see this kind of destruction . . ." Abruptly, the video segued to a somber President Bush giving a press briefing. None of his words appeared on the soundtrack; the Chinese commentator spoke instead: "The question remains: Is American democracy safe?" After that, the scene merged into a bombing sequence from *Pearl Harbor.*

The second half of the video described the history of terrorism. The narrator cited incidents from the past, ranging from the Serbian assassination of Archduke Francis Ferdinand to the activities of the PLO. Quick scenes flashed by: marching rows of Nazi soldiers, the bombed-out Federal Building in Oklahoma City, a protest in Taiwan. The commentary claimed that terrorism was spawned by a mixture of colonialism and capitalism. "Terrorists are not happy with superpowers like America," the narrator said. "There are many reasons for their dissatisfaction, and the most important one is that the powerful nations push their principles on other countries." The film described the aftermath of the 1998 attacks on United States embassies in Africa. America's retaliation—the unsuccessful bombing raid in Afghanistan—was illustrated by a glimpse of missiles whizzing over San Francisco Bay: a scene from *The Rock.*

AFTER THE ATTACKS, Phoenix Television had cut advertisements and broadcast live for thirty-six hours. That was the only privately owned Chinese-language news station that broadcast on the mainland, and it was also the only network that covered the event so closely. Rupert Murdoch's News Corporation owned 40 percent of Phoenix, which was based in Hong Kong but targeted mainland cable subscribers. The station hoped someday to become the CNN of China. Phoenix's access to the Chinese market depended on a good relationship with the Communist Party, and sometimes the private station's coverage was even more nationalistic than that of the government stations. Because of better production values and an ability to respond quickly to breaking news, Phoenix had already distinguished itself, and the station reached an estimated forty-two million households on the mainland.

One of the VCDs that I found in Yueqing had been compiled mostly from Phoenix broadcasts. Whereas the government news had avoided any criticism of America, Phoenix's tone was completely different. In the hours after the attacks, the station featured a man named Cao Jingxing, who was identified only as a "Political Commentator." He said, "Why aren't other countries hated like the United States of America? Let's try to think about that." He commented

on the hijackings: "Why were the hostages taken so easily? The glory of the Americans was lost in just a few seconds."

The VCD had been poorly cut, and periodically it shifted abruptly between Chinese commentators and footage from the United States. At a press conference, Bush spoke a sentence—"Freedom itself was attacked this morning by a faceless coward"—and then disappeared. There was a fragment of a statement from Colin Powell: "Once again we see terrorism, terrorists, people who don't believe in democracy, people who somehow believe that with the murder of people they can—" Bush again: "Freedom itself was attacked this morning by a faceless coward." They played that clip three times, and then the Phoenix commentators reappeared.

The Chinese-language station used Fox footage of New York and Washington, D.C., which was almost as disorienting as the Hollywood cut-ins. The Fox logo appeared in the corner, and the images were the same as the ones that Americans watched, but here the shots were joined by the anti-American commentary in Chinese. I remembered Willy's comment about the Chinese government being unable to express the way that it really felt. That was politics, but this was business; the media gave the people what they wanted. News Corp. used the same footage to sell patriotism in America and in China, and in both places the people bought it.

WILLY'S CLASSROOM WAS decorated with a Chinese flag and a framed quote from Zhou Enlai: STUDY HARD FOR CHINA'S REVIVAL. The campus was small but neat: new six-story buildings, a rubberized sports field that glistened in the light Zhejiang rain. The hallways were lined with framed examples of children's artwork. That was unusual in China, where public schools usually decorated with stern portraits of the politically correct: Chairman Mao, Sun Yat-sen, Karl Marx, Vladimir Lenin. When I asked Willy about the children's artwork, he told me that it was a type of advertising. "They want the parents to know that it's a good school," he said.

One morning, I sat in on his seven-thirty class. They were eighth graders: thirty boys and girls in white uniform shirts and blue pants. Willy stood before them and asked a few simple questions; they answered in English. He said, "The students in the next class, their classroom is like a . . ."

"Pigsty!" the boys and girls called out in unison, laughing.

"Very good," Willy said. "Now let's begin."

The textbook was *Junior English for China*, and the day's lesson had been designed for the new economy. It consisted of a short passage in Special English:

Uncle Wang owns a factory. He opened his factory in 1989. The factory makes ladders. One day, I visited Uncle Wang at his factory . . .

Willy read the passage aloud, and then he jotted some vocabulary onto the board. He shot me a look.

"Nineteen eighty-nine was an interesting year," he said. "Some very interesting things happened in Beijing that year. Now, repeat after me . . ."

None of them caught the allusion, which disappeared into the harmony of reciting voices. Willy turned to one boy: "What are they doing at the factory?"

The boy stood up: "They are seeing the machines."

"Very good. You may sit down."

Another student rose; Willy gave me another glance.

"Are they making toothbrushes at the factory?"

"No, they are not," the boy said.

"What are they making?"

"They are making ladders."

"Very good. You may sit down."

For half an hour, the class was taught on two levels. The textbook lesson unfolded—Mr. Wang, ladders, factories, the joys of the export economy—but periodically Willy included some remark that was strictly for my benefit. He dropped English translations of Sichuanese slang; he alluded to shared memories from Fuling. When another part of the lesson mentioned 1989, Willy paused once more. "I wonder if Uncle Wang's factory was opened in *June* of 1989?" he said, and then moved on. The students had no idea that a private line of English stretched above their heads, going straight to the foreigner in the back of the classroom.

Traditionally, a Chinese teacher remained behind the lectern, but Willy walked freely among the students. He never spoke in Chinese, but the class kept pace; their English was good. When he pulled out a few of them to act out a dialogue, he added a simple prop: a blindfold. The boys picked up on it quickly, and soon they enacted a blind inspection of Uncle Wang's ladder factory. The classroom rang with laughter; with five minutes left, Willy closed the textbook and walked between the rows.

"What do your parents do?" he asked a girl.

"They own a factory."

"What does the factory make?"

"The factory makes parts of televisions."

One by one, the other students answered questions about their parents:

They raise fish. They do trade in Beijing. They work for a company. They own a factory. The bell rang; the language shifted back to the Wenzhou dialect; the sounds of break-time chaos echoed from the hallway. Watching my former student teach that lesson was the best thing that happened to me all September.

DURING MY LAST day in Zhejiang, the Wenzhou government tested the air raid sirens. Taiwan was just off the coast, and usually the tests signaled some military exercise in the strait, or perhaps a political event on the island. But there hadn't been any recent flare-ups in China-Taiwan relations, and the next Taiwanese election was still two months away. The air raid sirens probably meant that the government was trying to prepare itself for anything that might happen in the post-9/11 period.

In the city, I visited another former student named Shirley. In 1997, she had migrated to Zhejiang, and she had often sent long letters to me and Adam. She described details from her voyage east—a malnourished baby on the train, a conversation with a Zhejiang native during which Shirley pretended that she wasn't Sichuanese. She wrote beautifully in English, and I always remembered the ending of one letter:

> *Adam, these stories are the ones that touch me deepest and make deepest impression on me. All of them are true.*

Not long before my trip to Wenzhou, Shirley had sent me a note announcing her marriage. Originally, she had taught at a private school, but recently she had found a job as a foreign-trade representative at the Tiger Lighter Company. Tiger was the most famous of the countless Wenzhou factories that produced cigarette lighters. With a salary of over two thousand yuan a month, or $250, Shirley was one of the most successful of my former students.

She gave me a tour of the factory, starting with the executive offices where she worked. Display cases featured high-end products: gold-colored lighters studded with fake diamonds, special barbecue lighters that telescoped out for hard-to-reach places. A metal ashtray was equipped with a tiger's mouth that breathed fire when you pressed a button. On the wall, the factory had hung a piece of Jiang Zemin's calligraphy; the president had visited in May of 2000.

On another wall, an enormous world map illustrated the company's export patterns. Wenzhou sat in the center of the world, and a web of arrows fanned out in all directions: to the United States, Great Britain, Brazil, India, and dozens of other countries. Outside, at the entrance to the production floor, an English sign proclaimed:

LET TIGER BRAND CREATE WORLD FAMOUS BRAND
LET THE WORLD FURTHER UNDERSTAND TIGER BRAND

That evening, I had dinner with Shirley and her husband, Huang Xu. He was also Sichuanese, and he developed software for a local company. We talked about the recent events in America, and they both agreed with Willy's observation that most people in Wenzhou hadn't been sympathetic.

"When I first watched it, I didn't really feel sad," Shirley said. "I admit that I've always had a prejudice against America, because it's so powerful and it always uses its power in other parts of the world. But the more I thought about what happened, the more sympathy I felt for all those innocent people. It just took some time before I could think about that."

Her husband had been following Internet chat rooms, which were strongly anti-American. "A lot of people connect it to the bombing of our embassy in Yugoslavia," he said. "There have been so many problems with America over the years."

Since the attacks, I couldn't stop thinking about the videos. The 9/11 scenes were jarring; it was a shock to see such violence taking place in my home country. I was accustomed to dramatic footage coming from the developing world: flooded cities, body-strewn battlefields. Now that I was in China, the distance was the same, but the images moved in an unfamiliar direction. We watched in safety while Americans died.

And there was something particularly warped about the images being sold as movies in a city like Wenzhou, which had so many trade links with the outside world. A basic premise of the United States' globalism had always been that the spread of American culture and products would naturally lead to greater international understanding. There wasn't much need for Americans to travel personally; products moved much more easily. In theory, it made sense, but now the lack of a human dimension was obvious. In China, most people had contact with American brands and products, but it was still rare for a Chinese to have any personal interaction with a foreigner. Willy was unusual: he had foreign friends, and a key part of his identity was wrapped up in another language.

For most Chinese, though, the outside world was still abstract—something at the end of an imaginary arrow that began at the local factory. It wasn't surprising that the attacks became just another American-style product. Over the next month, I collected other 9/11 goods: a "Bush vs. bin Laden" video game, Osama bin Laden key chains. I purchased plastic sculptures of buildings with oversized planes sticking out like tree branches. A Wenzhou lighter company produced a model where the flame shot out of the top of Osama bin Laden's

head. A company in southern China produced "Monster Candy," which featured bin Laden's image on the wrapper and was marketed to children.

I watched the videos over and over, trying to figure out their meaning. During one clip of the Phoenix news broadcast, an anchorwoman named Chen Luyu said, "We are astonished, but we are not astonished." Like the other commentators, she repeatedly compared the terrorist attacks to scenes in *Pearl Harbor* and other movies. In a sense, that wasn't different from the Americans, who also tended to slip into Hollywood language. Sometimes, President Bush spoke as if he were in a Western—"dead or alive"—and the early titles for the American military response would have fit perfectly on Wenzhou's bootleg racks: Infinite Justice, Enduring Freedom.

During my dinner with Shirley and Huang Xu, I asked if they thought that the events would affect them. "We don't export much to America right now," Shirley said. "Actually, some people have been saying that if the dollar drops it will help our exports to other parts of the world."

Her husband added that even the possibility of an economic downturn didn't frighten his friends. "It's all relative," he said. "The Chinese often say that you only feel poor if you're next to somebody who isn't poor. If the whole world drops and we drop with it, then things haven't really changed."

Initially, I had trouble believing this—I doubted that somebody in Wenzhou would agree to reduce his income if that meant that people in America would suffer more. But then I realized that this wasn't viewed as an active choice. The Chinese looked at distant, uncontrollable events and searched for some consolation in the worst that might happen. It was a passive, remote worldview, and it came from a hard history, but it had also been encouraged by a distinctly human gap in the flow of goods and culture. The world might not seem a smaller, more understandable place if you sent off cigarette lighters and received Hollywood in return.

Near the end of the meal, I asked Shirley how she imagined the average American would view her. She was twenty-six years old, with big black eyes and an easy smile. Back in Fuling, I had known her as the best student in her class, but now she seemed to describe somebody else.

"I'm sure they'd say I'm poor, and backward, and of a low education level," she said. "I think that Americans look at Chinese like this. They wouldn't know where Wenzhou is—in their eyes, it's just another city in China."

AFTER THE ATTACKS, William Jefferson Foster became even more dedicated to studying English. Almost every evening, he wrote in his journal, tracking events and compiling vocabulary lists:

milestone
maul
lounge
lodger
lobe
kidney
keepsake
jockey

In addition to transcribing the Voice of America, he also translated articles from the Wenzhou newspapers:

Mid-east area countries are our city's important trading partners. Wenzhou-made clothes, lighters, leather shoes, small medals are exported to these area countries via shipping. . . . After 9-11 terrorist attacks in U.S.A. the situation in Afganistan has intensified. Wenzhou's exported products will be asked to give extra wartime money according to international regulation.

When he translated items from the national wires, he signed them proudly at the bottom:

Xin Hua News Agency
U.S. President George Bush made adress at the press confrerence in the White House on late evening of October 11th, he said that Sudam is an evil person. Because he has been trying to make large-scale deadly weapons since the Gulf War.
Bush says that these days' attack is aiming at Afganistan. But shortly after that the anti-terrorism attacks will be extended to other countries in the world. . . .
Bush says American has known that that Sadam has been concentrating on producing massive deadly weapons and says Sadam is an evil. Meanwhile Bush urged Iraq give permission to UN weapon inspectors' entry to Iraq.
Translated by William Jefferson Foster

The Horse

比尔盖茨

THE HORSE IS A DIVERSION. IN THE MIDDLE OF A LONG JOURNEY ACROSS northwestern China, I decide to stop in Wuwei, a small city in Gansu province. Wuwei is not my final destination, and the interlude isn't planned; but the basic routine is familiar. Sometimes, while traveling through a place known for some important archaeological discovery, I'll stop and ask questions about the find. Invariably, my perception of the artifact changes dramatically in the course of a few hours.

Wuwei is known as the home of the Flying Horse. The object is now exhibited in the provincial capital of Lanzhou, but it was originally discovered in Wuwei, where a tomb contained a procession of bronzes: thirty-eight horses, twenty-eight foot attendants, seventeen warriors, fourteen chariots and carts, and a single ox. The tomb dated to the third century, near the end of the Eastern Han dynasty.

Of all the figures, one stands out. The horse is less than two feet tall, but its shape is magnificent: in full stride, nostrils flaring, tail blowing in the wind. Three hooves are in midair; the fourth rests lightly upon the back of a sparrow. It's become known as the Flying Horse. China Tourism has adopted the artifact as its national symbol; everybody recognizes it as an icon of Chinese culture and history. That's the image in my mind when I arrive in Wuwei.

* * *

THE WUWEI CURATOR is named Tian Zhicheng. We meet in the local museum, which is located in a massive fifteenth-century Confucian temple complex. Its size is a testament to the former importance of this Silk Road city. But the days of trade along the Gansu Corridor are long gone, and Wuwei has faded: dusty, remote, forgotten. The temple buildings are rotting; the wood is cracked and the paint peels. Tian explains sadly that the city doesn't have enough money to maintain the complex. He pours me a cup of tea, and then he tells the story of the Flying Horse, which was discovered at the height of the Cultural Revolution.

"They found the horse on September thirteenth, 1969," he says. "Marshal Lin Biao had told the Chinese people that they should dig air raid shelters, in case China was attacked by the Soviet Union or America."

Tian explains that local peasants were shoveling under a Taoist temple when they stumbled onto the tomb. Because of the anarchy of the Cultural Revolution, archaeology was essentially nonfunctioning, and the peasants handled the excavation. Afterward, they kept the bronzes in their homes until somebody from the Wuwei cultural relics bureau finally collected everything. Eventually, the artifacts were taken to the provincial museum in Lanzhou, where they were forgotten in a storeroom.

"They didn't recognize the value of those pieces," Tian says. "Nobody really noticed them until the early 1970s, when Guo Moruo accompanied Prince Si-hanouk of Cambodia on a trip through Gansu. They toured the museum, and afterward Guo Moruo asked to see the storeroom. The moment he set eyes on the Flying Horse, he knew that it was something special. He said that it was by far the best object in the museum. And that's how it first became famous."

Guo Moruo: romantic poet, oracle bone scholar, historian who was compromised by his association with the Communist Party. Prince Sihanouk: exiled

king, friend of China, notoriously mercurial figure. Somehow, they make a perfect pair, traipsing through the museums of the Silk Road during the Cultural Revolution.

After talking with Tian, I visit the empty tomb, which has been restored for tourism. At the ticket booth, I ask if any of the original peasant excavators still live around here, and a woman gives me a name: Wang. The man's home is nearby, a simple dugout that has been carved into the dry Gansu soil. It's essentially a cave with windows and a door. The man's wife plants herself firmly at the entrance.

"He can't talk to you," she says.

In the countryside, when women reach middle age, they often acquire a certain solidness that seems to draw from the earth itself. It's also true that in these areas a foreigner tends to attract a crowd. The more people who show up, the more solid Wang's wife becomes. She stands in front of the door, arms crossed. She remarks that the excavation was unofficial; she doesn't want trouble. I try to reassure her: there's no risk; this is a story about history; it will only take a minute.

"He's too drunk to talk to you," the woman finally says.

A ripple of laughter passes through the crowd. It's three o'clock in the afternoon, and, at an altitude of over five thousand feet, the desert sunshine falls like a hammer. Obviously, the woman is grasping at straws, and so I keep trying: I've come all the way from Beijing; I won't stay for long; I just want to ask a few questions. The crowd murmurs support, and finally the woman shrugs: "Go ahead."

Inside: as dank as a tomb, as dirty as a dump. A half-dressed man sprawls on a wooden chair—skinny arm dangling, white head lolling. Mr. Wang, amateur archaeologist, discoverer of lost treasures, liberator of bronze armies, is snoring. The cave reeks like a *baijiu* distillery. That's the image in my mind when I leave Wuwei.

IN 1987, VICTOR H. MAIR, a professor of Chinese at the University of Pennsylvania, led a Smithsonian tour group through Xinjiang. In Urumqi, at the provincial museum, he happened to wander into a back room and saw three bodies under glass: a man, a woman, and a small child. They had long noses, deep-set eyes, and blond hair. They were remarkably well preserved—the most intact ancient corpses that Mair had ever seen. A curator told him that dozens of such bodies had been discovered recently in Xinjiang.

They were accidental mummies: preserved by the environment rather than technique. Xinjiang's Tarim Basin is as far as you can get from an ocean, and

rainfall is rare; winters are brutally cold. A body buried in the salty soil can last for centuries, or even millennia; some of the Xinjiang corpses are over three thousand years old. Their clothing is remarkably intact. They wear fur-trimmed coats, felt boots, and long stockings. Their wool patterns are plaid. They have blond or red hair, full beards, and features that look European. They seem completely out of place in a desert of western China.

Like many artifacts, the corpses were essentially excavated by Reform and Opening. In the 1980s, as the national economy grew, the government pumped investment into Xinjiang. There was a political motivation: officials hoped that rising living standards would placate the Uighurs, and meanwhile Han Chinese migrants were encouraged to settle in the region. Xinjiang was the only place in the country where significant numbers of migrants arrived to farm. Sometimes, when they tilled a new field or started a construction project, an ancient corpse appeared. As more Chinese arrived, more foreign-looking bodies came out of the earth. The symbolism could have been uncomfort-able—while modern Xinjiang became more Chinese, the ancient past looked more foreign—but initially nobody made much of the artifacts. The mummies were essentially unknown to the outside world when Victor H. Mair visited the Urumqi museum.

During the early and mid-1990s, Mair returned repeatedly, escorting foreign specialists. Working with Chinese and Uighur archaeologists, they collected samples, and it turned out that the corpses' clothing contained par-ticularly useful information. The twill weave—a plaid design of blue, white, and brown—was extremely similar to textiles discovered in the ancient tombs of Germany, Austria, and Scandinavia. The clothes seemed to confirm Mair's first impression: these people were Indo-European.

The Tarim Basin sits near the exact center of the biggest land mass on earth. Like many parts of Central Asia, the formal history is thin and scattered; the past seems as empty as the landscape. All you need is a spark—some amazing artifact—and then the human imagination begins to fill all that space.

In 1994, the mummies were featured in *Discover* magazine, and then *Reader's Digest* reprinted the story. Other publications followed suit, speculating that the corpses could be evidence of early contact between East and West. Televi-sion crews traveled to Xinjiang; the Discovery Channel titled their program *The Riddle of the Desert Mummies*. A PBS documentary was hosted by Alan Alda, *M*A*S*H* alumnus. The Uighurs began to call the corpses the "Uighur mummies"; in their view, the bodies were excellent evidence that the Chinese had no right to be in Xinjiang. In fact, Mair and other scholars speculated that the corpses may have been the ancestors of the Tocharians, an ancient people

who disappeared around the ninth century A.D., when the Uighurs' Turkic ancestors first arrived in significant numbers. The Turkic settlers may have even wiped out the Tocharians, absorbing some of their genetic material along the way—a possible explanation for why some Uighurs have fair features.

None of the theories appealed to the Communist Party. As the mummies became more famous, the authorities began to restrict access to them, and soon Mair and his colleagues weren't allowed to take more samples out of the country. Foreign journalists were turned away; photographers were restricted. Alan Alda, *M*A*S*H* alumnus, reported that his camera crew had been kicked out of a museum. But it was too late for the Chinese to control the meaning of the mummies, which had already reached the point where less research only meant more imagination. Nowadays, thousands of mummy theories serve thousands of agendas. White supremacists love the corpses as much as the Uighurs do. If you go on-line, you find people like the Pastor Bertrand L. Comparet, who explains the mummies' origin in an article entitled "What Happened to Cain?" The pastor is a native Californian, a Stanford alumnus, and (his own words) "a tried and true Christian and a loyal and patriotic American, a believer in a Sovereign America under Constitutional government." He also believes that after the Fall, Adam and Eve fled east of Eden to Xinjiang, where, beneath brilliant desert skies, Eve gave birth to two boys.

VICTOR H. MAIR: "Yo-Yo Ma contacted me after reading about some of this stuff, and after reading about the mummies. That's partly how he got interested in the Silk Road. You know who else is fascinated by the Xinjiang mummies? Bill Gates. He went to see them on his honeymoon. He came to Beijing, rented Mao's private train, and rode it to Urumqi. He went with his wife, his father—a bunch of people. They had six hours in Urumqi. Guess how they spent them? They spent three hours with Rabiya Kadeer, and three hours with the mummies. Gates knew about the mummies from the articles that came out about my research. There's a great photo from the trip; I wish I could publish it. There's a mummy in a case. Here's Bill Gates, looking at it, and here's Bill Gates' father. Here's Melinda Gates, the wife. She has her hand over her mouth. It looks like she's afraid she'll get some terrible disease. I wish I could publish that."

VICTOR H. MAIR is one of the all-time great archaeological conversationalists. The previous paragraph is typical: Xinjiang mummies, Yo-Yo Ma, Bill Gates, and Rabiya Kadeer, the Uighur businesswoman who later became a political prisoner. Her husband is Sidik Haji Rouzi, the Voice of America cor-

respondent whose presence in Oklahoma City inspired Polat and other Uighur émigrés to make their way across the Great Plains. It all connects perfectly, at least during a conversation with Mair.

The professor's specialty is ancient Chinese. He has translated the *Tao Te Ching* into English, and he has written a beautifully idiosyncratic translation of *Chuang Tzu*. (I used Mair's version, *Wandering on the Way*, when writing about the spy plane dispute.) *Chuang Tzu* is an unusual, shapeless text, a collection of apparently unconnected parts, and sometimes it seems that Mair's mind functions the same way. In conversation, he jumps from topic to anecdote, anecdote to topic. His research is equally unpredictable: he translates ancient texts, studies Xinjiang mummies, and compiles Chinese dictionaries. He was the driving force behind the creation of the alphabetical index for the *Hanyu Da Cidian*, the twelve-volume dictionary that is a rough equivalent to the *Oxford English Dictionary*. Other scholars sometimes complain that Mair spreads his net too wide, and he has a flair for publicity that is not typical of academia. But it's also true that a broader vision turns up unexpected connections. If it weren't for Mair's response to a chance museum visit, the Xinjiang mummies might have remained unknown to the outside world.

He frequently passes through Beijing, and we often meet for dinner. He is also a former Midwesterner who joined the Peace Corps—a native of Canton, Ohio, Mair served as a volunteer in Nepal during the mid-1960s. Before that, he was the captain of the Dartmouth varsity basketball team, and he still carries the tall, spare frame of a forward. During one of our conversations about the ancient past, he remarks that once he stole the ball from Bill Bradley at mid-court during a game at Princeton's Dillon Gymnasium. His riff on the other Bill does not end with Melinda and the Mummy:

"You know, Microsoft contacted us and asked if they could buy our first dictionary when it came out in 1996. It had seventy-four thousand terms, all in alphabetical order. They offered me forty thousand dollars. I said I wouldn't think about it for less than two hundred thousand.

"Last year we came out with the alphabetical index for the *Hanyu Da Cidian*, which has three hundred and seventy thousand Chinese terms. It took ten years of work, and probably fifty thousand of my own dollars. Monumental task. Now Microsoft is using various ways to try and get hold of that list. The value is incredible, but they're trying to get it out of me for nothing. They would have to pay me at least a million. Once they get hold of it, it will revolutionize the software. There are twenty-three thousand different characters. The existing Chinese software only has twenty thousand, so we had to custom-

design three thousand characters. That was a mind-boggling problem. When I came back to America, scholars started asking, can I use the disk? And I know that some of these guys have Microsoft connections."

BACK TO THE horse. Professor Mair has published a paper: "The Horse in Late Prehistoric China: Wresting Culture and Control from the 'Barbarians.'" According to the archaeological record, the people in the central plains of China—the ones who eventually became "Chinese"—were relative latecomers to riding. Their nomadic neighbors led the way; by the fourth century B.C., northern tribes began using mounted archers in battle. According to traditional history, the nomad warriors represented the greatest threat to the farming people of central China for the next two thousand years. It wasn't until the eighteenth century, when the Europeans arrived in force, that the Chinese empire met a more formidable opponent.

In Anyang, archaeological digs have uncovered the earliest evidence of horses in the central plains: animal skeletons, as well as the "ghosts" of buried chariots. The Shang seem to have imported both the horse and the innovation of the chariot from the steppes of the north. But archaeologists have found relatively few horses or chariots, and there is little evidence that the Shang actually used the vehicles in battle. They may have been strictly for display, and there are signs that the Shang experimented with sheep-drawn carriages. Even in the centuries that followed, the Chinese didn't seem quite at home on horseback. Rulers worried that by adopting Central Asian innovations—mounted warfare, the fashion of trousers—the Chinese might be tainted by "barbarian tribes." In his paper, Mair describes the Chinese as having a "strained attachment to the horse."

But he believes that the animals served a key cultural function, because they motivated the Chinese to exchange with other groups. In Mair's view, traditional history overemphasizes the threat of the northern "barbarians": the Chinese glorify the Great Wall, and they often note that dynasties made their capitals in the north in order to defend against outsiders. This is where Mair applies the neat twist of the iconoclast: maybe defense wasn't as important as trade. Perhaps Chinese culture took root in the northern regions of the central plains *because* of contact with outsiders. He also notes that, in the twentieth century, the nation's political geography suddenly shifted, with leaders coming from the southern regions: Sun Yat-sen, Chiang Kai-shek, Mao Zedong, Deng Xiaoping, Jiang Zemin, Hu Jintao. Is it coincidence, or a reflection of the south becoming the new contact point with the outside world?

One evening in Beijing, during a particularly wide-ranging conversation, Mair tells me another theory about the horse: it may have played a role in the origins of Chinese writing.

"IN CHINESE ART, it's almost always a foreign groom who is standing with the horse. When you look at paintings, the groom is usually a Sogdian, or a Uighur, or some other group. The Sogdians were from what is now Iran. The Chinese had to trade with all of these groups to get horses. In some periods they were trading with the Uighurs, sometimes for tea. The Uighurs went nuts for tea. There was a huge trade with them during the Song dynasty, which was bankrupting itself buying horses from the Uighurs. They traded silk and tea for horses. Someday, I want to write something about this. I'll call it *The True History of Tea*."

Listening, I shudder through a clipper's flashback:

 STUDENTS
 STYLE
 SUPERPOWER—"NEW THREAT"
 SUPERSTITION
 TEA

Professor Mair keeps talking. "There are all of these misconceptions about tea," he says. "Until the Tang dynasty, the Chinese saw it as a barbarian drink, a southern barbarian drink. The Buddhists were the first to give it legitimacy. And it became economically legitimate during the mid- to late-Tang, because of trade with the Uighurs. In the earlier periods, though, it was barbarian. There are Chinese texts that compare it to urine.

"That's a book I'll probably write after I write *The Origins of the Chinese Writing System*. I believe that the writing system came as part of a package deal. The horse, the chariot, the bronze technology, the writing—they all came together. They all appeared during the Shang, in a space of about four hundred years. If you get really strict about the useful appearance of these things, then it's a window of about two hundred years. Two of these things almost certainly came from the outside: the horse and the chariot. And now there are even some Chinese archaeologists who are writing about the possible Western introduction of bronze technology."

In all my conversations with scholars, I've never heard anybody theorize that Chinese writing wasn't homegrown. Mair's theory is that writing developed through contact, direct or indirect, with literate cultures of the Near East. I ask Mair how others in the field react to the theory.

"I don't even like to talk about this," he says. "The writing system is the culture; it's the civilization. It's very touchy. In 1987, I analyzed part of the oracle bone writing, and I produced a three-hundred-page manuscript, but I felt like it wasn't finished. I wanted to put it into archaeological context. I think it's the most important thing I'll ever write. But I've been interrupted by the mummies, the dictionary.

"I believe that there was a lot of traffic across the steppes. I think the Iranians were the unsung heroes of East-West communication. The Sogdians. I believe that one of the latest-period mummies that we found in Xinjiang was a Sogdian. A huge guy, about six-four. But in history they were totally invisible. So many things that were essential to Chinese culture have not been well known in history."

WHEN I WRITE a short piece about the bronze horse of Wuwei, the *New Yorker* fact-checks the story, making late-night phone calls to the Silk Road. The tale of the accidental rediscovery—Guo Moruo and Prince Sihanouk in a museum storeroom—is independently confirmed by officials in both Lanzhou and Wuwei. Everything looks good, and then, just after the magazine has gone to press, a note arrives from Thailand:

> *Dear [New Yorker]:*
> *Thank you for your message.*
> *As I have found no reference to HM King Sihanouk meeting the poet Guo Moruo during my research, I have submitted your message to His Majesty who replies that he never encountered such occurrence.*
> *I hope this is helpful.*
> *Sincerely,*
>
> *Julio A. Jeldres*
> *Official Biographer of HM Samdech Preah Norodam Sihanouk*
> *The King Father of Cambodia*

18

Wonton Western

November 7, 2001

BEFORE GOING TO THE MOVIE SET, I MET POLAT'S FRIEND. WE TOOK every possible precaution, especially with regard to telephones. After my plane landed in Urumqi, I took a cab into town, found a pay phone, and hung up after one ring. He called back with a one-sentence message: the name of a public park. I didn't turn on my cell phone, in case the authorities tracked the receiving station. Reportedly, the Chinese had tightened security in Xinjiang; just across the western border, the war in Afghanistan was less than a month old.

Near the gate of the public park, I recognized him by his blond hair. We had met once before, in Yabaolu; he was the Uighur who occasionally played a foreigner in Chinese movies. We shook hands and found a bench at the back of the park. He pulled out an envelope: twenty hundred-dollar bills. I put the cash in my money belt.

"I'll mail the check this week," I said.

"When are you going back?"

"Not until January," I said. "I'll see him then. But I'll send the check to a friend of mine in Washington."

The man kept glancing around. In Xinjiang, where there are so many ethnic groups, neither of us looked completely foreign. But anybody who heard us speaking Chinese would know immediately that at least one of us had come from the outside. He asked me how Polat had seemed during my last visit.

"OK," I said. "He was in a bad neighborhood, but he's moved. I haven't seen him since the terrorist attacks."

"Is he going to have problems with his documents?"

"I don't think so. He already has asylum. He was lucky they approved him before September eleventh. I'm sure it's a lot harder now."

"His wife is nervous," the man said. "I think she's afraid to go."

I had decided not to visit her because it was best to minimize my contact during this period. A foreign journalist in Xinjiang was too conspicuous; handing over the cash was enough of a risk. I asked the man about the political climate.

"Let's walk around the park," he said. "It's better if we don't sit here too long."

HE TOLD ME that Polat's family hadn't had any problems, although they had been questioned when he didn't return to China. The family had friends in the Urumqi police force, which helped. In any case, the authorities now seemed concerned with bigger issues. Polat's friend had heard about a Uighur being imprisoned in Kashgar because the government believed that the man's sons had trained with Al Qaeda. I asked if there were many Uighurs who had joined the Taliban.

"Not many," he said. "But there are some. Anyway, it's a good excuse for the government."

We returned to the park entrance. I asked if he had appeared in any movies lately.

"No," he said, laughing. "It's bad money anyway. I hope to do some export trade in Dubai next year. What's the movie you're writing about?"

I was in Xinjiang to research a story about Jiang Wen, one of China's most famous actors, who was appearing in a Chinese Western.

"Where are they filming it?"

"In the countryside outside of Shanshan," I said. "In the desert. It's supposed to be good scenery."

I asked the man what he thought of Jiang Wen.

"He's better than most Chinese actors," he said. "But I won't watch any movie they film out here. I'm sure it will be nonsense."

We shook hands and the man apologized for not being able to invite me to his home. After leaving the park, I switched on my cell phone. The following morning I hired a cab and drove for five hours. We skirted the north rim of the Tarim Basin, watching the scenery grow increasingly desolate until at last we reached the edge of the Flaming Mountains.

✻ ✻ ✻

DURING MY SECOND day on the movie set, on the fifth take of the last scene, just as the late-afternoon sun was turning desert orange, an actor rode his horse straight into a wooden beam. The object was part of an entrance gate, and the set designer had made a critical mistake: for a man on horseback, the beam was exactly neck-high. The rider tried to get his hands up at the last moment. He was one of six actors who were riding abreast and moving fast; in the movie they played renegade Tang dynasty soldiers who, in hopes of protecting a Buddhist relic, were attempting to escape an oasis called Big Horse Camp. The Tang had ruled from A.D. 618 A.D. 907, and that was the period that witnessed the flourishing of Buddhism in China. The Tang also produced some great poetry. The actor hit the ground hard and didn't move. There was a lot of dust, and the air was growing cool; the sun hung low and sharp above the Gobi Desert. You couldn't have asked for better light.

The scenery was perfect, too. The Flaming Mountains were treeless, scarred by ridges and gullies, and the dry flanks changed color—brown to red to gray—with the day's dying light. A trace of snow ran white across the highest peaks. Down below, past the entrance gate, lay the graveled expanse of the Gobi. The desert stretched flat into the horizon, broken every now and then by a pale patch of alkali. The emptiness of this landscape had always been good for films. During the 1950s and '60s, when the nation was closed to much of the outside world, Chinese filmmakers sometimes went to Xinjiang and other western regions when they wanted to depart from the norm. They made substitutes for foreign movies: domestic exotica.

Now the movie crews had returned to western China, but this time they hoped to export the scenery. A year earlier, *Crouching Tiger, Hidden Dragon* had been hugely successful in the United States, earning over 120 million dollars at the box office. Some of the most striking scenes had been shot in the desert, and now it seemed like everybody in the industry was back in the west. Miramax had invested in an action movie called *The Touch*, which was currently being filmed in Gansu. The director Zhang Yimou was shooting another foreign-funded martial arts film called *Hero*, which was set partly in Gansu and Inner Mongolia.

Here at the edge of the Flaming Mountains, Columbia Pictures was making *Warriors of Heaven and Earth*, which was billed as a Chinese Western. They had a big budget, by Chinese standards—six million dollars—and the cast was excellent. Zhao Wei, one of China's most popular actresses, played the female lead. Kiichi Nakai, a Japanese star, had been imported to play a villain. But the big news was that Jiang Wen was working again. A year and a half earlier, he had won the Grand Prix at Cannes for *Devils on the Doorstep*, a war movie

that he had directed. The Chinese government had banned the film, accusing Jiang Wen of disrespecting the nation's history, and since then he hadn't been allowed to act or direct in a big-budget production. The Western was an attempt at a political comeback—an action film set in a remote time period that wouldn't threaten the Communist Party.

The movie's subject was safe, but the horses were another issue. Earlier on the day of the escape scene, the Japanese actor had been injured while riding. A couple of weeks before that, a Chinese actor named Li Bukong had dislocated his shoulder after being thrown by a horse. Wang Xueqi, another actor, had taken a bad spill and cracked some ribs. Wang played a Turkic bandit leader—he wore hair extensions and blue contact lenses. One stuntman was still in a hospital near the Kazakhstan border. A crew member in charge of food services had broken his ankle. Even the production coordinator had been thrown by a horse. Jiang Wen, who was thirty-eight years old, had injured his knees and back during sword fighting scenes, but thus far he was one of the few actors who hadn't fallen off his horse.

His wife, Chenivesse Sandrine, had recently arrived on the set, along with their young daughter. Chenivesse was a tall, strikingly beautiful French woman who held a doctorate in religious anthropology from the Ecole Pratique des Hautes Etudes. I was standing next to her when they filmed the escape scene. We communicated in Chinese: I spoke no French; she didn't feel comfortable using English. Between takes, I asked about the French reaction to Jiang's Grand Prix, and she smiled with the memory. "After Cannes, we went on vacation to the south of France," she said. "Everywhere we went, people recognized us. They'd say, oh, we saw you on television. Congratulations! If we went to a Paris café, people stopped drinking coffee and asked for autographs."

That was the scene: the brilliant light, the endless Gobi, the blonde woman speaking Chinese with a French accent. The director called for the fifth take; everybody became silent. A soft breeze blew. The nearest town was an hour's drive across the desert. There wasn't a doctor on the set. The actor rode straight at the beam.

CREW MEMBERS SPRINTED over to where the man lay in the dust. Somebody shouted that it was Harrison Liu, who played a soldier in Jiang Wen's renegade band. The fallen actor tried to stand but then fell back in the dust. He was holding his neck.

Jiang Wen swung his horse around hard and skidded to a stop, dismounting quickly. His face was black with anger—all day, the frustration had been building, because of all the accidents and delays. The son of a People's Libera-

tion Army officer, Jiang was a large, barrel-chested man with a scraggly beard. The Chinese often said that he looked like a *liumang*, a "thug": short-cropped hair, bulging eyes, hard chin. His shoulders were broad. He smoked constantly. He had a deep and resonant voice—every word sounded like it started low in the gut and then rose through years of old cigarette smoke. But despite the *liumang* façade, he was well educated in film: a graduate of Beijing's Central Drama Academy. In addition to his acting, he had directed two critically acclaimed movies.

Jiang Wen helped Harrison to his feet—at first, the man didn't seem to be badly hurt. The two of them joined the other actors, who had gathered around He Ping, the director. They watched the playback monitor, trying to figure out what had gone wrong. It was growing cold; there wasn't much daylight left. In front of the monitor, a horse sidled over and pissed triumphantly. A crew member in a PLA greatcoat began sawing off the treacherous wooden beam. Harrison was still rubbing his neck.

"We'll have to shoot that scene over again," He Ping said.

"My neck hurts," Harrison said.

"You were riding too fast," one of the other actors said.

"*You* were riding too fast," Harrison shot back.

Jiang Wen stalked away from the monitor. He wore a helmet, gauntlets, and knee-high riding boots. His leather shoulder guards were studded with strips of armor. He clutched a whip in one hand. His face looked like he was about to explode. He turned to his personal assistant and barked, "Give me a cigarette!"

The man pulled out a package. The brand name was Snow Lotus and on the front there was a picture of a pretty white flower. "*Wo cao*," Jiang said. "Fuck me. What kind of cigarette is that?"

"It's the local brand."

Jiang Wen stared at the cigarettes and finally grabbed one. He spun on his heel and walked off, muttering to himself. He lit the Snow Lotus and jammed it into his mouth. He sucked in hard.

LIKE ANY GREAT actor, Jiang Wen had a knack for occupying roles that captured the mood of a nation. During the first blossoming of Reform and Opening cinema, filmmakers celebrated the countryside of the loess plateau—the traditional heart of Chinese culture, the home to cities such as Anyang and the scarred landscapes of the Yellow River. In 1988, Jiang Wen starred in *Red Sorghum*, which was directed by Zhang Yimou and also starred Gong Li, who would eventually become China's most internationally famous actress. In the

film, the woman's character rejects the advances of a peasant played by Jiang Wen. Stubbornly, the man returns to the woman's liquor distillery, where she and her employees stand in awkward silence. Jiang Wen stares at them defiantly, with a sense of violence in his posture. Finally, he turns and pisses into the bottles of fermenting alcohol, one by one. Then he picks up Gong Li, hoists her onto his hip, and marches off to the bedroom. Throughout the scene he hardly says a word. The alcohol turns out to be the best the distillery has ever produced. Gong Li's character bears a son. *Red Sorghum* became immensely popular with Chinese audiences, as well as a great success at international film festivals.

Within five years, the fascination with the loess plateau had faded. In the early 1990s, in the wake of the crackdown on the pro-democracy demonstrations, a wave of anti-foreign nationalism settled onto the Chinese intellectual climate. In 1993, a television series called *Beijingers in New York* tracked a group of immigrants whose stereotypically Chinese character—cultured, moral, upright—was challenged by the stereotypically empty materialism of the United States. Jiang Wen played a transplanted artist who struggles to adapt to his new world. At one point, he hires a white prostitute, throws dollar bills at the woman, and orders her to say, in English, over and over: "I love you, I love you, I love you!" *Beijingers in New York* became immensely popular with Chinese viewers.

Those were only two of Jiang Wen's best-known characters, and neither of them trapped the actor. That often happened in Reform and Opening — China changed so quickly that many artists had their moment and then slipped out of touch. But Jiang Wen remained popular, and he played roles from the full range of Chinese history. Over the years, he played Qin Shihuang, the ruler who first unified the Chinese empire, and he played Puyi, the impotent last emperor who watched the Qing dynasty fall apart. Jiang Wen played an imperial eunuch; he played peasants and policemen; he played petty crooks and small-time businessmen. He captured something fundamental about the psyche of the modern Chinese male: his aspirations and fears, his dreams and insecurities.

In 1994, Jiang Wen directed his first feature film, *In the Heat of the Sun*. Based on a short story by the well-known writer Wang Shuo, the film was set in Beijing during the Cultural Revolution. Often, historical movies are strongly narrative—characters' lives intertwined with important events—but *In the Heat of the Sun* is driven by imagery. The movie's first "script" consisted of pictures that Jiang Wen had sketched into a notebook: a teenaged boy peering at a group of dancing girls. In the film, the boy is often observing—he gazes through a telescope; he stares out from under a girl's bed; he snoops through

his parents' belongings. The sweeping political campaigns disappear, and the standard Cultural Revolution mood—suffering, sadness—is replaced by adolescent yearning and sexual awakening. The boy, along with his friends, is basically unsupervised; their parents are distracted by political events. The film became an enormous success, especially among young people who had come of age during the 1980s.

Like many movies, it contained allusions to other films, but they all belonged to the Communist world. The teenaged characters reenact scenes from Soviet propaganda films such as *Lenin in 1918*. Hollywood seems far away, as it did to Jiang Wen when he was growing up. In the 1970s, he lived in remote Guizhou province, where his father was stationed with the PLA. Theirs was a railroad town: trains from Beijing passed through on their way to the southwest. Movies provided the only glimpse of the outside world.

"We lived in a big building that was like an old barn," Jiang Wen told me once. "Right out in front was the town square, where they showed movies at night, twice a week. They showed them outdoors. I could see them from my bed, looking out the window. They fascinated me, because they came from so far away—places like Albania, Romania. I still remember *The White-Haired Girl*—that was a beautiful movie. Before that movie, I'd never seen ballet before. And the first time I ever saw Latin letters was in a movie. They were the letters *U S* on the helmets of American soldiers.

"Mostly, though, I remember all the pretty girls from those movies. Often they weren't wearing many clothes—their shorts would be cut off, and their sleeves ripped off, and they'd have a revolutionary uniform belt tight around their waist, like this, and they'd be standing there with a gun. God, they were beautiful. I remember one particular scene from a movie about the Nazis and the Albanians. An Albanian woman had her shirt unbuttoned partway, and she was playing a guitar—I'd never seen a guitar before. I still remember that song distinctly."

IN XINJIANG, AFTER finishing the escape scene, the actors rode a van for an hour across the Gobi, bouncing over rocks and sand. All of us were staying at the PetroChina Tuha Oilfield Company, a massive complex that was doing exploratory work in the region. After dinner, the pain in Harrison Liu's neck worsened, and he wanted to see a doctor at the hospital in the oil complex. Jiang Wen, whose back and knees hurt, decided to accompany Harrison. Wang Xueqi figured he'd tag along, too; his ribs could use a checkup. Another actor wasn't feeling so great, either. By the time we got to the hospital, there were six of us. It was after ten o'clock.

Somebody paged the vice-director of the general medicine department, whose name was Cao Jie. The actors apologized for bothering him so late; the doctor said that it wasn't a problem. He remarked that he had always enjoyed Jiang Wen's films.

Jiang Wen took off his shirt and Dr. Cao pressed points along his back, asking if they hurt. After the frustration of the day's filming, Jiang Wen finally seemed relaxed; he cracked jokes with the other actors. His knees were black and blue. He pressed one of the bruises and farted loudly.

"That's strange, doctor," Jiang Wen said thoughtfully. "If I push here, I fart." He pressed again but nothing happened. "Never mind," he said.

Dr. Cao kept complaining about all the recent injuries. For days, a steady stream of actors and crew members had been making their way to the hospital. That afternoon, a man had appeared with a fractured ankle.

"He aggravated it by not going to the hospital sooner," Dr. Cao said. "What exactly are you doing out there?"

"It's an action film," Jiang Wen said.

Dr. Cao opened a medical book and showed us exactly where the ankle had been broken. "His foot swelled up like a steamed roll," the doctor said. "I just don't understand this. Why didn't he go to the hospital earlier?"

"I've been saying that we need a doctor on the set," Jiang Wen said.

"It's dangerous with the horses," Harrison Liu said.

"You know what the main problem is?" Jiang Wen said. "The stuntmen don't always go through the horse scenes first, and even if they do, they aren't riding specialists. They're martial arts specialists."

An actor pulled out a pack of Zhongnanhai Lights and asked if they could smoke in the examination room. Dr. Cao took a cigarette as well, and all six of them lit up. The tiny room quickly filled with smoke.

"I'm telling you, I've never seen anything like this," Dr. Cao said.

"I think it's a human rights issue," Jiang Wen said.

Dr. Cao fitted a neck brace for Harrison Liu. Like Jiang Wen, Harrison was a big man, and his girlfriend was also a blonde foreigner—a Belgian. In the Chinese arts community, it was a sign of success to have foreign girlfriends. Often the women were budding academics who had come to China to research a thesis about anthropology or sociology. Harrison Liu wore cowboy boots. After the 1989 crackdown, he had received political asylum in Canada, where he was now a citizen. He had taken his English name from the Beatle. Occasionally, he acted in Canadian or American films; in 1991, he had played a native Huron in *Black Robe*, which tells the story of the first missionary to Quebec. If you watch the movie closely, you might notice that one member of

the Huron tribe looks Chinese. Harrison still remembered a line that he had spoken in the Huron language. He told me that it meant, "We don't need to go with this white man."

The doctor finished with the neck brace and announced that Jiang Wen and Harrison needed CT scans. Jiang Wen glanced at his watch.

"Look, it's November seventh," he said. "The anniversary of the Russian Revolution." He hummed the "Internationale" on the way to the X-ray center. He showed me a text message that had just appeared on his cell phone, from a Beijing talk show host: "I've just found *Devils on the Doorstep* on bootleg."

"I get messages like this every day," Jiang Wen said proudly. His movie had never been shown in Chinese theaters, but two weeks earlier it had suddenly appeared on the streets. The actor smiled. "Look at everything that just happened," he said. "We got hurt, we went to the hospital, we're getting X-rays, it's the anniversary of the Russian Revolution, and now there's a message about *Devils on the Doorstep*. We could make a movie out of this."

A technician scanned Harrison's neck and said it looked like a sprain. Dr. Cao examined the pictures of Jiang Wen's knees and back. He thought there might be a problem with the fifth and sixth vertebrae; tomorrow a specialist would examine the actor. Before we left, Dr. Cao asked Jiang Wen to autograph three photographs of the doctor's daughter and niece. It was nearly midnight. They were typical Chinese pictures: two tiny girls staring at the camera with startling animosity. On the back of each photo, the actor wrote: "Jiang Wen—the fifth and sixth vertebrae."

DEVILS ON THE DOORSTEP, Jiang Wen's second effort as director, is set in rural Hebei province, in 1945—the final year of the Japanese occupation. Like the Cultural Revolution, this sensitive period tended to be portrayed in set ways. Chinese films showed the brutality of the Japanese, as well as the heroic resistance of everyday people. There were staple heroes, like Wang Erxiao, the Chinese shepherd boy who led Japanese troops into an ambush.

In Jiang Wen's film, the war shrinks to a single Chinese village and a single Japanese garrison, isolated together in the remote countryside. The movie opens with a sex scene: a peasant named Ma Dasan is having an affair with a young widow. Suddenly, there is a knock on the door, and an anonymous Chinese resistance soldier delivers a Japanese prisoner and his interpreter. The men are bound; Ma is instructed to interrogate the prisoners and keep them hidden from the local Japanese garrison. Terrified by the responsibility, Ma, who is played by Jiang Wen, asks his fellow villagers to help.

Instead of working together, the villagers bicker over petty issues: whether

Ma should be sleeping with the widow, how much flour the wealthiest woman in town has hoarded. Virtually every character is motivated by self-interest, greed, stubbornness, or cowardice. The Japanese prisoner, who is initially determined to die honorably, quickly loses his pride, and eventually the villagers feel sorry for the man. They end up trading him to the Japanese garrison for six cartloads of flour. In celebration, the occupiers and the occupied meet for a banquet, which is interrupted by the news that Japan has surrendered. In an escalating panic of fear and shame, the Japanese soldiers slaughter the unarmed villagers.

During the filming of *Devils on the Doorstep*, Jiang Wen refused to shoot outtakes. If a small part of a scene was unacceptable, he insisted on reshooting the entire thing from the beginning. In the film industry, this practice is unheard of, and Jiang Wen reportedly used every roll of Kodak black-and-white movie film that was available in China—five hundred thousand feet, or roughly five times the amount required for the average feature film. The rural set could be reached only by boat, and the actors worked in brutal cold. There were local distractions: one village sued another over who had the right to lease land to the film production company. The movie cost an estimated five million dollars, twice the original budget, and it was two hours and forty-four minutes long. Even when it was victorious at Cannes, most critics thought that it needed another edit. Internationally, it was released in only nine countries, and nobody in China ever saw it in a public theater. When I interviewed people who had worked on the film, they invariably asked to speak off the record, because of the political problems.

Before traveling to Xinjiang, I visited the location in rural Hebei where *Devils on the Doorstep* had been filmed. From Beijing, it was a five-hour drive, followed by a thirty-minute boat ride; the set was located on the banks of Panjiakou Reservoir. It consisted of a dozen houses surrounded by rugged mountains and a crumbling stretch of the Great Wall.

The village had been constructed solely for the movie. In China, where labor and materials were cheap, there wasn't a specialty industry for set design: directors simply used real things. Near the Flaming Mountains, one of the horseback injuries had occurred when a log fell on an actor's leg while he was riding. On a Hollywood set, the object would have been made of Styrofoam, but in China they just used a real log. At the Panjiakou Reservoir, all of the houses were made of granite, brick, and tile; they had working fireplaces and stoves. In a country where so much was *jiade*—knockoff brands, shoddy restorations of ancient structures, fresh paint on the façades of old buildings—the film sets were real. Sometimes they lasted longer than the movies themselves.

It had been two years since *Devils on the Doorstep* had been filmed, and nobody was living in the film set; the soil on that side of the reservoir was too rocky for farming. But peasants from a village across the water were trying to turn the place into a tourist attraction. They had set up a ticket gate and charged about seventy-five cents for admission. When I purchased my ticket, the man at the gate had nothing nice to say about Jiang Wen.

"He's a swindler," the old man said. "He was supposed to pay us a hundred thousand yuan for the use of the land, but he didn't. Also, they borrowed some tools that they didn't return."

I went to the nearby village, where a number of peasants had appeared in the movie. Jiang Wen liked casting both professional actors and average people, because of the way it changed the dynamics on the set. A Hong Kong film consultant had explained to me that this strategy made the movie "less fictionalized, more real," and this certainly seemed true, at least from the perspective of the villagers. One woman named Zhang Fuhong told me proudly that she had been handpicked by Jiang Wen and his advisors. "They chose me for a big scene because of my long hair," she said proudly. She was twenty-five years old; when I interviewed her, she was making dumplings in her kitchen. She said she had liked Jiang Wen because he was friendly. In the movie's pivotal scene, the woman had been killed by the Japanese. "I was the one who tried to run away at the end," she said.

On a footpath heading back to the reservoir, I met another peasant woman who had also been killed in the movie. "I was a little scared," she admitted. She told me that she had been impressed by Jiang Wen's high standards. "There was one scene that they spent days filming, and he still didn't accept it," she said.

None of the villagers had seen the finished movie. They had only watched some clips on the monitor, during the filming, and their sense of the plot was incomplete. They didn't realize that Jiang Wen's character had also been killed, because those scenes had been filmed elsewhere. Many of the peasants weren't even aware that *Devils on the Doorstep* had been banned. One woman said that she didn't understand why it hadn't appeared on television yet. The few tourists who stopped by were confused: they knew that a Jiang Wen movie had been made there, and they knew that there had been a problem, but they didn't understand exactly what had happened.

The only person who seemed to know everything was a twelve-year-old boy named Zhou Baohong. When I traveled in the countryside, I sometimes ran into kids like him: well-spoken, knowledgeable, and obsessed with things beyond the village. If a foreigner appeared, such children latched on immedi-

ately. Invariably their conversation included long descriptions of recent examination scores, as well as the odds of getting into a good high school. If I left my phone number, they called me at regular intervals for weeks and sometimes years. Those kids always reminded me of William Jefferson Foster.

Dressed in a filthy blue suit, Zhou Baohong was trying to earn extra money on the weekends by serving as a guide for the movie set. I hired him, and he took me on a tour of all the abandoned houses and objects. He knew how much each prop had cost—he pointed out a fake tree made from cement, which had cost six hundred yuan to make and another two hundred to transport. An extra tower on the Great Wall had cost one hundred thousand yuan. (Jiang Wen hadn't been satisfied with the real Great Wall.) The boy took me to the empty home of Jiang Wen's character, and then we paused by a small clearing. "This was the killing field," the boy said solemnly. "All the villagers died here."

I asked what had happened to the movie itself.

"Jiang Wen didn't go through our nation's Cultural Bureau for approval," the boy said. "Then he went to France and won a prize. So our nation's government banned it." The boy hadn't seen the finished film, but he said he knew why it had been censored. "The peasants didn't resist," he said. "There was no Red Army, no Workers' Army, no guerillas—none of them showed up. That's the problem with the movie."

AFTER JIANG WEN won at Cannes, the Chinese media kept silent—always a bad sign in the People's Republic. The ban was never officially proclaimed, although two mysterious documents were leaked to Web sites. Supposedly, they had come from the Film Bureau. One was entitled "Propaganda Briefing No. 28," and it noted that the government was "suspending Jiang Wen for all film- and TV-related activities inside China."

In China, all movies had to be cleared twice: first at the script stage, and then again after filming. The second leaked document—"Comments from the Film Censorship Committee"—identified twenty specific places in which Jiang Wen had changed his script without permission. The sex scene was inappropriate: "The strong imagery and explicit sound stimulates the sensory organs in a vulgar manner." The committee also complained about the end of the film, which showed the Kuomintang controlling postwar China without resistance from the villagers: "It severely distorts the history. It doesn't achieve the goal of criticizing and sneering at the KMT."

But the biggest problem was the passivity of the film's Chinese villagers.

The document noted that one scene portrayed them giving good food to the Japanese prisoner and the Chinese collaborator:

> *Objectively it shows that even during the times of war, under such difficult living conditions, the Chinese civilians do not hate the Japanese invaders, on the contrary, they try their best to satisfy the prisoners' needs. . . . This violates history severely.*

Censorship was a curious issue. In my Beijing neighborhood, I sometimes found bootleg DVDs whose covers advertised, in English, "Banned in China." Nobody seemed to control the bootleggers for long; even a movie such as *Devils on the Doorstep* eventually appeared on the streets. Filmmakers themselves could be nonchalant about the issue of censorship. One young director told me that the Film Bureau officials reminded him of his grandparents—aging authority figures whom he patronized.

After half a century, many features of Communism had become like that: the Party had power without respect, and it was tolerated rather than feared. The Film Bureau's oppression was often passive-aggressive; silence was a potent weapon. They avoided official statements, and they never told Jiang Wen how long he was banned from appearing in movies and television programs. In fact, the officials refused to meet with him at all. The goal was simply to make him worry and wait.

After the movie was banned, Jiang Wen repeatedly told foreign reporters that this was a case of life imitating art: the Cannes prize, like the prisoners in the movie, was a possession that only led to trouble. He said that the censorship reminded him of the Cultural Revolution. Such remarks were not appreciated by many of his colleagues in the world of Chinese film. Jiang Wen had always had enemies—his charisma and fame gave him enormous influence, and he had a quick temper and a streak of stubbornness. Now that he had angered the government, other filmmakers worried about a possible tightening of the rules. One producer in Beijing told me, "If he publicly insists that he didn't do anything wrong, it will hurt the whole industry in China."

For a while, Jiang Wen gloried in the role of the oppressed artist, but then his attitude seemed to change. One of his friends told me that, as time passed, Jiang admitted privately that he had brought some of the trouble onto himself. Finally, he stopped making inflammatory statements. After a period of silence, he began to explore the boundaries, appearing on a couple of television award shows. Then he acted in a low-budget film with a first-time director. At last, he signed on to the Western. He had never been an action star, and it was obvious

that he didn't enjoy the work, but it was necessary for political rehabilitation. Xinjiang was his first step back from exile.

ONE EVENING IN Xinjiang, after another long day of filming, I met with Jiang Wen in his hotel room. I asked how viewers were supposed to interpret the historical perspective of *Devils on the Doorstep*. Carefully, the actor leaned back in his chair—his spine was still aching—and lit a cigarette.

"I never said that this movie was supposed to represent history," he said. "I believe that a director is supposed to show things inside the heart. Maybe it has something to do with inheritance. I was born near that place in Hebei, and so there is lots of history inside of me. In a way, I think the movie is autobiographical."

I mentioned that some critics believed the movie was inaccurate because it didn't portray the Chinese as victims of the war.

"I agree that the Chinese people have been victims," he said. "But we have our own faults; we need to look hard at a mirror and think about why we became victims. You can't simply point to others and say that they're evil—you can't point at Lin Biao, or Jiang Qing, or the Japanese. That's too simple."

He rubbed his scraggly black beard. He wore old sweatpants and Nike sneakers; his eyes looked tired.

"Think of China as a field," he continued. He gestured with one hand, as if he were planting a neat row of rice in the hotel room carpet. "The Kuomintang, the Communist Party, Lin Biao, Jiang Qing—all of them are seeds in the earth. They grow in different ways; some grow well and others do not. Some become bad. When the Japanese arrived, you could safely say that they were already bad—they were fascists. But why did they get worse after they got here? We Chinese need to talk about this, because so many bad things got worse and worse.

"What most people say is so simple—'they're devils, we're victims.' But this history is the same as an individual's life. I've had friends say that I should work in the Film Bureau, because then that institution would become more tolerant. I tell them that it would only make me a worse person. If you have a guard at the gate, then the guard becomes oppressive. It doesn't have anything to do with the person; it's the system, the environment."

He told me that many Chinese needed psychological help. "People should spend more time looking inside themselves," he said. "A person and history are the same—by that, I mean that a personal history is enormous. An individual can be even more complicated than a society. But there isn't any time for the Chinese to examine themselves like that. Everybody is too busy; there's not

enough quiet for reflection. In the distant past, the country was peaceful and stable, but now it changes so fast. Certainly that's been the case since Reform and Opening, but to some degree the past two hundred years have been like that. We don't know where we are. We haven't found our road. In the early part of the twentieth century, the Chinese tried; some of them tried to find it in our own traditions, while others looked outside the country. This debate is still going on."

He continued: "Chairman Mao is a perfect example. He often said that he didn't like Chinese history, and the Communists initially succeeded because they were untraditional. But Mao used traditional Chinese language to oppose the old things, and he became a traditional emperor. It's not as if he decided to do this; he just didn't know any other alternatives. He's a tragic figure—the most tragic in Chinese history. He's like a seed that grows big, but in a twisted way, because the seed can't overcome the soil."

I asked the actor what could be done about that.

"You have to change the soil," Jiang Wen said.

The room was silent; he paused to light another cigarette. "I want to make a movie about Mao," he continued. "Mao was more tragic than Hamlet. Mao was an artistic person, not a political person. He should have been a poet and a philosopher; he should have been creating things instead of dealing with politics."

Jiang Wen laughed and acknowledged that such a film wasn't going to be made in the near future. He had no idea when he would direct again; he was still feeling out the political climate, step by step. But the character of Mao Zedong fascinated him nonetheless. "I think Mao has something to do with every Chinese person," Jiang Wen said. "He represents many Chinese dreams and many Chinese tragedies."

THE FILM SET swallowed the outside world. Some scenes included turbaned bands of Turkic warriors; off-camera, the actors referred to these extras as "Taliban." Apart from jokes like that, it was hard to remember that there was a war happening on the other side of Xinjiang. My meeting with Polat's friend seemed just as far away: the only reminder was the stack of hundred-dollar bills.

During the filming, we rarely saw Uighurs. Han Chinese ran the oil company, and the movie's horseback extras—the Taliban—were actually Kazaks. The Big Horse Camp scenes were filmed near a small oasis that was home to one Uighur family, but they kept out of the way, tending to their flock of two hundred sheep. One afternoon, I visited their home and talked to a young

Uighur in his twenties, who told me sleepily that he liked Jiang Wen. But he preferred American movies—*Twister, Terminator*, anything with Arnold Schwarzenegger. He said he had liked the part in *Titanic* when the boat snaps in half.

When I asked He Ping, the director, about the difference between an American Western and a Chinese Western, he had a well-polished answer. "American Westerns are about taking culture to the west," he said. "It's about one culture going to another place; they're taking law and order to the west. A Chinese Western is totally different. It's about exchange between different cultures." He also told me that in order to make the film more "postmodern," he had cast an actress with a shaved head as a Buddhist monk.

They used a body double for Harrison Liu. The doctor told him to stay off horses for a while; he needed to recover in order to film a subsequent scene in which his character would be killed by a Taliban-Turkic-Kazak band. He was fated to die with one arrow through his chest and another through his knee. Many months later, when I saw the death on a movie screen, I thought immediately of the Huron of *Black Robe*.

AT THE END of my last day on the set, I rode away with Jiang Wen in his private van. He had spent part of the afternoon leading a camel train across the Gobi. Harrison's body double had taken up the back of the procession, so nobody would notice him.

The van bounced across the blackened desert. No trees, no grass—nothing but a flat dead horizon. I asked the actor about his favorite movies, and he told me that as a young man, over a period of ten years, he had repeatedly watched *Raging Bull*.

"When I saw that movie," he said, "it wasn't as if it was an American movie, or a movie about a boxer. I felt like it was about my home."

I asked if his copy had had Chinese subtitles, and he shook his head. "I only understood ten per cent of it," he said. "But really it's just a matter of seeing it and understanding the mood. I liked the shades, the blacks and whites, and I liked the atmosphere. And I liked Robert De Niro, because in that movie he reminds me of my mother. His attitude reminds me of her."

I asked, somewhat carefully, "What's your mother like?"

"Too complicated to explain," he said. "That's another movie I'll make someday."

The van bumped forward. The sun hung low and then disappeared; oil well burnoffs flamed a dull orange in the distance. Jiang Wen's cigarette glowed the same color. He talked about foreign directors who had encouraged him—he

had met Martın Scorsese twice, and Volker Schlöndorff, the director of *Tin Drum*, had helped Jiang Wen get funding for his first movie. Jiang Wen struggled to explain how much he loved making films, and at last he pointed to the cigarette.

"It's like smoking," he said. "I need to make movies like I need to smoke."

At first, I wasn't sure what he meant—whether filmmaking was an addiction, or a necessity that had been denied, or a profession that, one way or another, through fame or censorship or horses, seemed destined to finish him off. But then I noticed his smile—the sweetest look I'd ever seen on his hard face. He liked it all.

19

Election

December 1, Ninetieth Year of the Republic

ONLY ONE OF THE ORIGINAL ANYANG ARCHAEOLOGISTS WAS STILL
alive. In the summer of 1936, Shih Chang-ju had overseen the excavation of
the largest cache of oracle bones ever found. The following year, when the
Japanese occupied Nanjing, and the Kuomintang fled west. In 1949, they were
driven to Taiwan by the Communists. That was the story of Shih Chang-ju's
life—a nomadic archaeologist, displaced repeatedly by war. There was some-
thing poignant about his published description of the excavations of June
1936, when the season's last dig uncovered the oracle bones:

> *But, indeed, facts are stranger than fiction. The actual pleasure of discovery
> far exceeded our anticipation!*

After archaeologists in Anyang told me about Shih, I telephoned the Aca-
demia Sinica in Taiwan. An assistant answered the phone. "He won't be in
today until about three o'clock," she said. "He's busy with meetings this
week."

I explained that I wanted to schedule a visit to Taiwan. Such trips required
time; direct flights weren't allowed between the island and the mainland, so a
traveler had to change planes in Hong Kong. I asked if Professor Shih might be
available next month for an interview.

"Oh, I'm sure he can do it anytime," she said. "He's here every day."

I asked, "Is this the same Professor Shih who excavated in Anyang in the
1930s?"

"Yes, that's right."

"He still goes to meetings?"

"Only if there are visitors in town. This week we have some people in from the mainland."

"How old is he?"

"He just celebrated his hundredth birthday this year."

"How is his health?"

"Very good!" she said. "He has a problem with his eye, and his hearing isn't great, but otherwise he's fine. He comes to work every day, like the rest of us. You can say he's the oldest worker in the office!"

BY A WESTERN calculation, Professor Shih was ninety-nine—the Chinese considered a person to be one year old at birth. He was a native of Henan province, where he had first made his name as an archaeologist, but after 1949 he hadn't returned to the mainland. Since arriving in Taiwan, Professor Shih had focused primarily on organizing, analyzing, and publishing all of his old research notes. It was virtual archaeology: if you could no longer excavate in Anyang, then at least you could excavate your notes from Anyang. In 2001, at the age of ninety-nine, Professor Shih published his eighteenth book: *Hou Chia Chuang (The Yin-Shang Cemetery Site at Anyang, Honan), Volume X*. When I visited his office, he proudly gave me a copy, inscribed and dated in a shaky hand. The material had been researched more than sixty years ago.

His desk looked like one of those still-life memorials to a famous writer who has passed away. An old leather-bound field notebook lay open, its yellowed pages showing an ink sketch of a tomb: two prone skeletons, a rounded vessel. The notebook was dated 1936. It sat beside an article that the archaeologist had published in the 1970s: "A Study of the Chariot of the Shang Dynasty." (In Anyang, Shih had excavated and analyzed the "ghosts" of some of the earliest-known chariots in China.) Well-worn tools sat on the desktop—magnifying glass, ruler, T square. Everything seemed old, except for a couple of computer printouts that showed various models of digital cameras. The assistant told me that the professor was trying to decide which one would be most useful for his future research.

The man weighed less than ninety pounds. He had sunken cheeks and wispy white hair and thin spidery fingers that clutched at his cane. Because of a cataract, his right eye was usually closed, but it flickered half open if he became excited. He still spoke with a heavy Henan accent. Sometimes his assistant had to repeat my questions into his ear, but the old man always answered immediately. His younger colleagues called him the "Living Dictionary," because his

memory was so quick and exact. If I mentioned a specific artifact, he instantly recalled the year and the place where it had been excavated. Like everybody in Taiwan, he dated events from January 1, 1912—the founding date of the Republic of China. Traditionally, each Chinese dynasty had marked time from its founding, and although the Communists had done away with this system, the Taiwanesse still used it. That was their version of the Year of Our Lord, a sacred reference point; Professor Shih told me the oracle bone cache had been discovered in the "twenty-fifth year of the Republic," which meant 1936. He remarked that during that week in June they had excavated a clump that contained exactly 17,756 oracle bone fragments.

When I mentioned the name of Chen Mengjia, the oracle bone scholar, the lid of the old man's cataracted eye wavered.

"I remember him," Professor Shih said. "We met at National Associated University, in Kunming. He was brilliant, although I didn't know him very well. His teaching position wasn't in the Academia Sinica, which might have been one reason why he didn't come along with us to Taiwan. Later I heard that the Communists killed him."

DURING THE WAR with Japan, the Chinese made every effort to keep the oracle bones and other artifacts out of enemy hands. They packed up tons of objects and moved them by train and truck and boat, always one step ahead of the Japanese. After that war was finished, and the struggle with the Communists picked up, the artifacts gained even greater symbolic value. The Kuomintang had a proud heritage—the political party had been founded by Sun Yat-sen—and the weaker it became, the more important it was to curate China's past. In 1948 and 1949, when the Kuomintang finally fled to Taiwan, moving the ancient treasures was a top priority. Archaeologists had two options: they either followed the best artifacts across the strait, or they stayed in the mainland, where all the good sites were.

The Kuomintang claimed that residence on the island would be temporary. They believed that they would eventually return victorious to the mainland, and the United States and most other nations continued to recognize Taiwan as the seat of China's rightful government. For decades, Taiwan sent representatives to the United Nations, which, like most international organizations, refused to recognize the People's Republic. The Communists boycotted the Olympics for more than two decades because the I.O.C. allowed Taiwanese athletes to compete under the flag of the Republic of China.

Over time, this vision of China became increasingly awkward—a massive nation supposedly ruled by a few exiles who were actually stranded on an

island at the edge of the South China Sea. In July of 1971, Henry Kissinger visited Beijing, taking the first step toward U.S. recognition. Kissinger later wrote in his memoirs that "no government less deserved what was about to happen to it than that of Taiwan." By the end of that year, the Taiwanese delegation had been expelled from the United Nations, and in 1972 President Richard Nixon signed the "Shanghai Communiqué" with the People's Republic. In that document, the United States acknowledged "that all Chinese on either side of the Taiwan Strait maintain there is but one China and that Taiwan is a part of China." On one level, the stance was uncontroversial: both the Communists and the Kuomintang were adamant that Taiwan and the mainland belonged together. But they had very different ideas about who should rule this imaginary reunited nation, and the United States tried to position itself on the peripheries of this concept. In 1979, when the United States formally recognized the People's Republic, Congress also passed the Taiwan Relations Act, which established that Taiwan's future should be determined "by peaceful means." The Americans reserved the right to defend the island if it were invaded, and they continued to sell military hardware to Taiwan.

Over the years, the situation remained stable, but the indignities steadily chipped away at Taiwan. Barred from the United Nations and most international organizations, the island watched its political allies slip away one by one. By 2001, fewer than thirty nations recognized Taiwan, a sad coalition of the willing: small countries such as Burkina Faso, São Tomé, Swaziland. Taiwan was allowed to send athletes to the Olympics, but their flag was strictly banned. At the Atlanta Games, during a Ping-Pong competition, American police officers handcuffed a Taiwanese fan and escorted him out of the stands, simply because he had waved his island's flag.

But they still had the artifacts. Regardless of international humiliation, the Taiwanese could take pride in the fact that they had done a far better job of protecting China's past than the Communists. The Kuomintang built beautiful institutions such as the Palace Museum, where some of the most impressive artifacts were exhibited. And they provided excellent funding for archaeology and history, allowing a man like Professor Shih to spend decades excavating his notes.

The old man's office was located in the Institute of History and Philology, where a younger archaeologist gave me a tour of the storage room. The room was climate-controlled and neat; artifacts had been carefully organized into drawers and boxes. Bronze spears from the Shang rested in bundles of ten. On the floor sat a two-hundred-pound bronze *ding*, or cauldron, that had been excavated from a royal tomb in Anyang. There were two big boxes of the oracle

bone fragments that had been discovered in 1936. The young archaeologist picked up one of the tortoise shells, which had been blackened by the diviner's tool thirty centuries ago. He gave me a colloquial translation of the parallel statements that had been inscribed into the object:

> *In these days our country will be good.*
> *In these days our country will not be good.*

The shelves also held an antique Royal typewriter, a tape measure, and a surveying tool whose old-fashioned label read KEUFFEL & ESSER CO., NEW YORK. The young man told me that the items had been used by Professor Shih in Anyang. His excavation tools had also become artifacts, catalogued and preserved in the same storeroom as the ancient bronzes and oracle bones.

PROFESSOR SHIH TOLD me that the move to Taiwan had been an easy decision. "I came here in January of 1949, from Nanjing," he said. "I had become a sort of refugee, moving constantly. I had already moved eight or nine times. Taiwan was just one more transfer. Think of it this way—if somebody moves all of your research materials, your life's work, then what do you do?"

In the 1990s, when the mainland's Institute of Archaeology invited him back for conferences, he decided that he was too old for the trip. But he still kept up with recent discoveries, and he responded immediately when I asked if he had heard about the mapping of the underground city.

"Tang Jigen is in charge of it," the old man said. "I've been told that they're still in the research stage, but they found a big wall and they think it's a city. That's something we never discovered. We never had an opportunity to excavate and study a walled city like that."

He paused, and then he looked at me with his good eye. "Beijing doesn't have a city wall anymore, does it?"

I told him that the Communists had torn it down almost forty years ago.

He said, "But Xi'an still has its wall, doesn't it?"

"Yes. They've protected it."

He paused again, as if shifting his mental image back to Anyang and the underground city. His right eye remained shut. "Well, we never had the opportunity to research something like that wall," the old man said. "We conducted some surveys there but never found the city. There was already so much for us to do at Xiaotun. They have time to do it now. Of course, when I was there it was only countryside; there wasn't any airport."

I was impressed at his knowledge of the site—the airport had been built

by the Japanese, after archaeologists like Shih had fled to the southwest. Much later, when I was back in the mainland, I mentioned the interview to Tang Jigen, the young director of the current Anyang excavations. Tang was in his late thirties, a rising star of Chinese archaeology; he had done graduate work at the University of London. He had never met Professor Shih—once, when Tang hoped to attend a conference in Taipei, the Taiwanese had denied him a visa. But he wasn't surprised by my report about Professor Shih's familiarity with the current survey. Tang told me that he had faxed maps of the underground city to Taiwan, so Professor Shih could keep pace with the new discoveries. That link between generations was another type of virtual archaeology: the young men in Anyang, reading the earth cores; and the old exile in Taipei, reading the faxed maps and remembering the fields that he had abandoned so long ago.

PROFESSOR SHIH'S WIFE met us for lunch. Juan Hsing was an elegant woman of eighty-five years, with perfectly coiffed white hair. She was sharp-eyed and alert; during lunch, she kept glancing at a canary-yellow cell phone. Throughout the meal, she used her chopsticks to select appropriate bits of food for her husband.

Everybody was solicitous around the old man—at the institute, he had two full-time assistants, and the younger archaeologists spoke of him fondly. It was tempting to view him as a type of mascot, a link to an age that had become sentimental in the eyes of Taiwanese whose families had come from the mainland during the mid-century. And his body was so frail that the clarity of his memory seemed as oracular as the Shang bones. Whenever he spoke, I had to remind myself that these weren't simply stories; he was remembering a life that had been permanently disrupted by politics and history.

It was election week, and at lunch the younger people talked about a fight that had broken out at a rally the day before. They were excited—the young Taiwanese loved the political campaigns. Juan Hsing frowned and remarked that she disliked talking about such matters, and her husband agreed.

"My research is about ancient times, and that makes contemporary events seem far away," he said. "My understanding grows smaller all the time. I listen to the news, but not too often."

He told me that he enjoyed watching a television show called *Wonders of the Mainland* because it featured places that he had known as a young man. When I asked if he would vote, he shrugged. "I'm not sure," he said. "Saturday is my wife's day. She decides what we do on Saturdays."

I asked, "If you vote, whom will you vote for?"

"I haven't thought about it," he said, and then grinned. "Anyway, it's a secret."

Juan Hsing fussed that the old man should eat more. Near the end of the meal, I asked him what year they had been married.

He looked up—silence. For the first time, the professor was stumped by a date. He muttered to himself, counting the years, and then his wife cut in.

"It was the forty-fourth year of the Republic," she said.

"So it was after you had already moved to Taiwan?"

"That's right," she said.

THE ISLAND'S HISTORY was layered with arrivals from abroad. Aboriginal tribes had lived there since Neolithic times, and then, during the seventeenth century, significant numbers of settlers began arriving from the mainland. In the second half of that century, the Qing formally incorporated Taiwan into the empire, but the island wasn't administered closely. It became a base for traders and frontier-style settlers, many of whom had originally come from Fujian.

In 1895, after being defeated by Japan in a series of battles, the Qing ceded Taiwan to the victors. (The Qing statesman who negotiated the treaty explained that the loss wasn't so bad because on Taiwan "the men and women are inofficious and are not passionate either.") The Japanese ruled the island, known in those days as Formosa, until the end of the Second World War. Unlike Nanjing and other mainland cities, where Japanese occupation was short and brutal, Taiwan functioned as a colony for half a century. The Japanese built roads, railways, and other basic infrastructure, and their schools prepared the native elite to be part of the empire. Even today, many Taiwanese speak positively of the Japanese—an attitude that seems completely foreign to a mainlander.

After the Japanese surrender and the Chinese civil war, the Kuomintang introduced another layer of colonialism to the island. When Chiang Kai-shek's government fled to Taiwan, the newcomers were outnumbered, but they ruled with a firm hand. The Kuomintang maintained a state of martial law; the press was strictly censored and political dissidents were imprisoned. But the economy flourished, in part because the free market had strong links with the United States. Over time, the United States became less comfortable with its role: American military support protected Taiwan, and trade benefited the island, but the Kuomintang reflected none of the political ideals that America supposedly valued.

During the 1980s, U.S. officials pressed for reform. Chiang Ching-kuo, the

son of Chiang Kai-shek, developed into the sort of figure who is rare in small, repressive countries: a dictator who essentially paved the way for the defeat of his own system. In 1987, the Kuomintang lifted martial law, and two years later they legalized opposition parties. Over the next decade, the Democratic Progressive Party, or DPP, became the most powerful opposition group to the Kuomintang. The DPP was supported primarily by native Taiwanese who had no interest in the "one China" concept, and in 1999 their party platform began describing Taiwan as an independent country. In 2000, the DPP candidate, Chen Shui-bian, won the presidency.

As politics shifted toward the native population, perspectives on culture and history changed accordingly. The Taiwanese began to emphasize the island's native past instead of the traditional dynasties of the mainland, and history books were rewritten from Taiwan's point of view. Schools began teaching Minnan, the native tongue of most Taiwanese, which previously had been banned by educational institutions. The island commemorated its own sensitive date: February 28, 1947, when the Kuomintang had responded to anti-government demonstrations by massacring thousands of Taiwanese civilians.

In some ways, the Taiwanese historical lens was still essentially Chinese: they tended to perceive themselves as innocent victims who had been misunderstood and traumatized by outsiders. It was the same basic perspective, but now the outsiders, instead of being Japanese or British or American, were the Communists and the Kuomintang who had arrived from the mainland. The Taiwanese had turned Chinese history against China.

They also used democracy in ways that made American leaders nervous. As the DPP gained power—by 2001, they held the presidency but still lacked a majority in the legislature—they became increasingly adamant about independence. DPP leaders threatened to call a popular referendum on the issue. The Communists made it clear that they would respond to such a vote with military force. Trapped by its promises, the United States let it be known that they would not support any Taiwanese provocation, even if it took the all-American form of a popular vote on the independence issue.

The DPP became adept at using pro-independence statements to antagonize the Communists, who often responded with some heavy-handed act, like preelection missile tests in the strait. Such moves invariably backfired, winning more votes for pro-independence candidates. It was hard to tell how much of the DPP strategy was simply gamesmanship. In Taipei, when I visited Wilson Tien, the DPP's director of international affairs, he handed me an official statement, in English, entitled "The DPP's Position on Cross-Strait Relations":

How does [the DPP] plan to face China's "one-China" principle? Is a conflict inevitable in the Taiwan Strait?

Before answering these questions, we need to explain how the DPP views Taiwan's relations with China.

First, we understand that Taiwan's geographical position can not be moved around.

Perhaps some people think it is funny when I mention this fact; no tectonic plate can be moved freely. Indeed, it is extremely meaningful to recognize this fact when formulating our China policy.

If there were quite a distance between Taiwan and China, Taiwan would have more freedom and space. The reality, however, leaves Taiwan relatively fewer choices given its physical proximity to China.

"If the Chinese leaders had more confidence, that would really help," Wilson Tien told me. "The basic problem is that they have been bullied in the past, so when they look at themselves, they really don't think that they're a great country. If you have confidence, then you don't worry about Taiwan leaving, and you don't worry about what Japan did to you in the past. The problem is that China still doesn't feel like it's respected."

He could as easily have been describing his own party, his own island. After years of humiliation, Taiwan had finally distinguished itself: the only true democracy in the Chinese-speaking world. But every election was held with an eye across the strait, and the deeper issue—what it meant to be or not be Chinese—was more complicated than anything that could ever be put to a vote. You could elect your own leaders, and you could write your own history, but human psychology was as inescapable as plate tectonics.

THREE DAYS BEFORE the election, I drove to a DPP rally in the city of Hsinchu. From Taipei, sections of the highway ran straight as an arrow: it had been designed to double as a landing strip in case the Communists bombed the airport. Hsinchu still looked prosperous—its high-tech processing district was massive—but the Taiwanese economy was mired in its worst recession ever. In 2001, the Taiwanese GDP had shrunk for the first time since 1949, and unemployment rates had risen every month. Plants and jobs were making an exodus to the mainland, where labor was cheaper.

Growing Taiwanese investment in the mainland had added a new dimension to cross-strait relations. Since the beginning of Reform and Opening, economic links had been one of the Communists' strategies for regaining Taiwan (one explicit goal of the Special Economic Zones was "the return of Taiwan to

the Motherland"). Twenty years later, this appeared to be the only mainland tactic that might pay off. Intimidation and threats had never worked, but the economic power of the People's Republic was becoming increasingly difficult for Taiwanese to ignore.

After the Hsinchu rally, I met with the vice-mayor, Lin Cheng-chieh. He told me to call him by his English name, Jacky Lin. Like every political figure I met in Taiwan, he immediately agreed to an interview and spoke openly. The Taiwanese had quickly grown accustomed to a free press, and there was none of the mainlander's fear of a foreign reporter.

Jacky Lin's father had been a Kuomintang special agent. In 1956, the Taiwanese government instructed the man to sneak across the Hong Kong border and set up a secret radio broadcast station in Jiangxi province. It was a dangerous, difficult mission, and the man was caught in less than a week. For a while, the Communists held him in a southern prison, and then they sent him to a labor camp in remote Qinghai province. Back in Taiwan, there was no news at all, and the Kuomintang informed the family that the man had been killed. But his wife refused to remarry, and she always told Jacky and his three siblings that their father would someday return. When his father disappeared into the mainland, Jacky was four years old.

He was twenty-seven when the first letter arrived. His father was alive and out of jail, but now he was stranded in the Fujianese countryside, trying to convince the Communists to let him go home. By the early 1980s, the Communists agreed, but now the problem was the Kuomintang, who feared a double agent. Finally, in 1983, both sides agreed to the transfer, and Jacky's father returned to Taiwan.

He arrived just in time to see his son get into political trouble. Jacky became one of the early leaders of the DPP, known for his skills at organizing street protests. He spent time in prison; his father, although a staunch Kuomintang supporter, was sympathetic ("he told me to do whatever I believed in"). In jail, knowing that his father had had it much worse, the young man looked on the bright side ("it wasn't so bad. I could read books, and I didn't have to answer the phone").

Despite his early commitment to the DPP, Jacky renounced his party membership in 1991. He disliked the infighting that had overtaken Taiwanese politics—like many fledgling democracies, the island had experienced political fragmentation, and now there were five major parties and a host of smaller groups. People often voted according to when their ancestors had arrived on Taiwan; the DPP catered to natives, while the Kuomintang appealed to those whose families had fled the mainland in 1948 and 1949.

Jacky also disagreed with the DPP's push toward independence. He remained on good terms with his former political allies, but he had no formal allegiance to any party. He was a minor city official: a small, balding man with a mustache and a paunch. His father had passed away a year earlier.

"If my family had been in Taiwan for eight generations, then I'd be more inclined to support independence," Jacky told me. "You have to look at people's experience before you can figure out how they'll respond. The Chinese were put here in Taiwan because of a historical event. As a result, we had a chance to build a democracy and become a functioning capitalist society. We can say that it's a mission for the rest of China. If I look at the great Chinese leaders—Sun Yat-sen, Chiang Kai-shek, Mao Zedong, Deng Xiaoping—all of them had the same goals. They all wanted to modernize China. And yet all of these leaders were eventually defeated. Deng had some success, but it was incomplete. So that's our mission. Taiwan is an experimental region—it's an experiment for the mainland. Because of that, even though we are just a small island, our democracy is important to the future of China."

He spoke softly, with none of the condescension that Chinese intellectuals sometimes showed when talking to a foreigner about history. The Chinese often bragged about the length of their past, but they could be remarkably humble about the present: they readily admitted that, after thousands of years, they still hadn't figured out how to make China work. They were still trying—the experimental cities, the experimental island. Just give us some more time. China wasn't built in a day.

"I think that Chiang Ching-kuo was like Deng," Jacky continued. "Both of them had true vision. They didn't have much charisma, but they were very practical. You know, they're kind of similar—short guys who were practical. We need more little guys like that."

NO PARTY CARRIED the election. For the first time, the Kuomintang lost outright control of the legislature, and the DPP gained seats, but it wasn't enough for a majority. Alliances would have to be hammered out between the four biggest parties.

On the evening that the results were announced, I attended a press conference held by Sisy Chen, an independent who had won a seat. A native Taiwanese, she had been a founding member of the DPP, but two years ago she had left the party. She was flamboyant—a popular talk show host who had become one of the island's most controversial politicians. Her campaign posters featured a series of four portraits that superimposed her head onto the bodies of famous foreigners. Three were iconic Westerners: the Mona Lisa, Queen Eliza-

beth, and Winston Churchill. The fourth campaign sign featured Sisy Chen bearded, wrapped in a turban and with her right index finger upraised: Osama bin Laden.

She was a woman who, having once been attractive, confronted middle age with outright defiance. At the press conference, she wore a black dress with a low-cut front; a string of pearls had been wrapped twice around her neck. She had dyed red hair, and her false eyelashes were nearly two inches long. Under the photographer's lights her thick makeup glowed a soft orange.

It was hard to imagine a victor who showed less respect for the election that she had just won. After the press conference, she told me that Taiwan's constitution encouraged elected officials to build narrow bases of support, since that was adequate in the fragmented political field. In her opinion, Taiwan aped democracy: they had the rallies and the speeches, but they lacked values and lucidity.

"This is the most ridiculous system in the world," she said. "The constitution is a very valuable tradition, but there's no such common value in the third world. In Taiwan, democracy becomes another tragedy of the third world experience. In country after country, it's the same. Democracy doesn't mean coherence; it means a political tool used to divide the country. The state can only buy votes or please voters in cheap ways. They just take care of their one-third voters and neglect the others."

She continued: "The fundamental reason is that we're not in the tradition of the European democracy. The third world leaders' fundamental idea is to design a constitution that allows them to stay in power. In the U.S., the institution is more important than the elected leaders. It's not that way in Taiwan. It's not that way in Indonesia. It's not that way in the Philippines."

She spoke excellent English; she had studied at the University of California at Berkeley and at the New School University in New York City. When I asked about the campaign posters, she smiled.

"It's a kind of art of imitation," she said. "I like Queen Elizabeth because she made Britain become an important country. And I had my portrait done as Mona Lisa because she is an older woman but she still looks proud. That was three years ago, and I did it because I was forty and was getting fatter and fatter. I had to face the fact that I didn't have a good figure anymore.

"I like Churchill because he was such a strong leader, and a man's leader. I wanted to see how people would respond if I dressed up as a man. And Osama bin Laden—I just wondered what would happen if I put my face on his head. I think of him in a different way from most people. He's a terrorist, but he's also showing a kind of anger to the Western governments.

"I disagree with what he did, of course, but I was very conflicted when it happened. I hate this kind of behavior, and I hope that this cycle of terror can be stopped. But on the other hand I have very strong sympathy for the Muslim story, and I don't like this simple thought that the Muslims are bad. It's a kind of orientalism, I think. Edward Said, the Palestinian, described how people see this world through the eyes of the Westerner, taking the historical stance of the Westerner. By using this method we just spread the prejudices of the Westerners. They decide how we look, and I have a lot of problems with that.

"I'm not a person who says things quickly. This is evil! This is good! I'm a person who needs deeper thought. People here have very strong sympathy for New York, but they don't understand why bin Laden is such a hero to the Muslim states. I try to explain that even though he is wrong, there are reasons why he is a hero. There are historical reasons. The words of history are also the words of war. All of our memory is recorded by war. You say who you are—I grew up during World War One, or I grew up during World War Two, or I grew up during the cold war. That's who we are."

THE DAY AFTER the election, I said goodbye to Professor Shih. His son, Shih Lei, a retired anthropologist at the Academia Sinica, escorted me to the elderly couple's apartment. On the way, he told me that they had voted after all.

"They voted for the Kuomintang, as they always do," Shih Lei said. "They're quite traditional, you know—most people of that generation are. They're very nationalistic."

I asked him if he was the same.

"I'm *Zhongguo zhuyi*," he said with a smile. It wasn't a real phrase; he was making a play on words that sounded roughly like "Chinese-ism." I asked what it meant.

"It means I support China," he said. "But I won't support a party blindly because it's supposed to be patriotic. I support China, but I also support democracy. And I think that Taiwan should return to the mainland eventually. Those are my politics. I don't support either the Kuomintang or the DPP."

We entered the apartment, where the elderly couple sat in the living room. I had brought a *National Geographic* article that I had written about Xi'an archaeology, and I gave it to Professor Shih. He studied the tomb diagrams.

"The orientation is always interesting," the old man said. "In Anyang all the royal tombs are oriented in the same direction, angled slightly to the west. I think it's because of the sun—at a certain time of day, the shadow moves in that direction."

We talked about archaeology, and then Juan Hsing mentioned the election.

"We lost," she said. "It was a bad result. More support for independence."

She asked if I had interviewed any candidates, and I mentioned Sisy Chen. "She's interesting," the old woman said.

Professor Shih seemed to have fallen asleep—his eyes were closed and the open magazine rested on his birdlike chest. His son said that he agreed with Sisy Chen's politics, and then the old man's left eye suddenly flickered open.

"Is the Yangling tomb west of Changling?" he asked, referring to the Xi'an region.

I said that I didn't know for certain.

"I went there in the thirty-second year of the Republic," he said. "I also visited Wu Zetian's tomb. That's a beautiful spot. Have you been there?"

I told him that I had.

"And I saw Qin Shihuang's tomb," he said. "But of course there wasn't anything in that area back then. They hadn't discovered the terra-cotta warriors yet."

The tiny man grew silent. I said that I should go, and I shook his hand—skin as cool and thin as paper. Outside, his son escorted me to the street, and I asked which year he had been born.

"Twenty-third year of the Republic."

I did the calculation—1934. Confused, I added again, and then I said, "But Juan Hsing said they weren't married until after they came to Taiwan."

"That's right," Shih Lei said. "She's not my mother. My father's first wife—my mother—died more than ten years ago, on the mainland. She never made it to Taiwan. In 1949, she wasn't in Nanjing, because she was caring for her father-in-law. She stayed behind and hoped that we'd be able to return."

On the street a light rain was falling. Now I realized why Professor Shih hadn't recalled the year of his marriage as promptly as the dates of the found artifacts. That was Chinese history: things you remembered and things you tried to forget. His son turned to me while we waited for a cab.

"I came to Taiwan a little bit later than my father," he said. "Before I left the mainland, my mother gave me a message for him. She said that if something happened, and they were separated for good, then he should go ahead and remarry. I think she sensed that the country was going to be divided."

PART FOUR

20

Chinatown

January 2002

POLAT'S SECOND LANDLORD WAS CHINESE-AMERICAN. THE MAN HAD grown up in Guangdong, and during the Cultural Revolution, his father had fled in a rowboat to Hong Kong. Eventually, the father received political asylum in the United States, and then he brought his sons over. For a while, one son ran a Chinese restaurant in the Washington, D.C., area. After selling the restaurant, he invested in a pair of red-brick row houses on Sixth Street NW. The landlord and his family lived in part of one house, and they rented the rest out to other immigrants.

For two hundred and sixty dollars a month, Polat occupied a room on the second floor of the Chinese family's home. His lodgings were square—nine feet by nine feet—and nothing had been hung on the walls. The room contained a color television, a hot plate, a water boiler, and an electric radiator. All five of his books were English study texts. On the desk, a Chinese tear-away calendar had been frozen on a random date: October 14, 2001. The single window looked out through the thin parallel bars of power lines.

The room was cramped, and Polat would rather not have shared a bathroom with a Chinese family. They rarely spoke—in fact, Polat and the landlord never even exchanged immigration histories. Polat avoided talking to Chinese people about his political background, and the landlord had no interest in sharing his story, either. Polat learned about it from other residents.

The relationship was awkward, but the location was a big improvement over the corner of Franklin and Rhode Island. In the District's grid, Polat had

moved toward the center; his row house stood near the intersection of Sixth and Q. In the past, this neighborhood had been called Shaw or Mount Vernon, but nowadays it was becoming known as part of Chinatown. The area was changing: the new Washington Convention Center was being built nearby, and the government was about to convert some of the local subsidized housing to conventional market rentals. The neighborhood had been predominately black and poor, but it was becoming more mixed. A number of immigrants had moved in—many of them Chinese—as well as some young middle-class whites. A few blocks away from Polat's home, a gay congregation had founded the Metropolitan Community Church.

These were early signs of gentrification, and perhaps Sixth Street might eventually gain the kind of prosperous diversity that was rare in an American urban neighborhood. But you could still see the old divides between black and Chinese when you walked south from Polat's apartment. Sixth Street had few business establishments, and a number of row houses were in bad repair. The best-kept plots belonged to traditionally black churches: Springfield Baptist, First Rising Mount Zion Baptist, Galbraith A.M.E. Zion. On the corner of L Street stood the Eritrean Culture and Civic Center, and then on I Street, painted onto the side of a brick building, was an old sign: FUJIAN RESIDENTS ASSOCIATION.

After that, the neighborhood shifted to the heart of the District's small Chinatown. Restaurants and shops lined the streets—China Boy Delicatessen, Chinatown Market—and here almost everybody flew an American flag, which was rare in the black neighborhood. Along H Street, flags hung thick and signs were bilingual: China Doll Restaurant (麗華園), Eat First Restaurant (食為先), Wok N Roll Restaurant (珍味樓). Near the corner of H and Seventh, a Chinese-style *pailou*, or entrance gate, had been erected. Inscriptions noted that the structure had been dedicated in 1986 as a "friendship archway" by Chen Xitong and Marion Barry, the mayors of Beijing and Washington, D.C. The *pailou* had gained unexpected resonance when, in the years following the dedication, both mayors went to jail. In 1990, Barry was convicted of possession of crack cocaine; eight years later, a Beijing court found Chen guilty of corruption. But that particular U.S.-Sino link was left uninscribed on the *pailou*, another irregularity that lurked beneath the capitals' neat grids.

The Chinatown signs also shifted unevenly between two worlds. The jokey racism of the English names vanished in translation: in Chinese, the China Doll Restaurant blossomed into "Beautiful Chinese Garden," and the China Boy Delicatessen gained a measure of dignity (as well as an entirely different product line) with "Chinese Child's Fresh Noodles." The Wok N Roll Res-

taurant transformed itself into "Hall of Precious Flavor." At H and Eighth, an English sign advertised CHINATOWN GIFTS, but the Chinese sign—出國 人員服務中心—meant something completely different:

SERVICE CENTER FOR PERSONNEL LEAVING THE COUNTRY

 * * *

"I THINK THAT'S the sort of business that works with *jiade* visa companies like the one I used in Beijing," Polat said one evening, when we drove past the Chinatown sign. "Those companies need to have contacts in America, and I think that's probably what they're doing at that shop. They arrange letters like the ones I had from Los Angeles. On that sign, when they say 'country,' they mean China. Why would anybody need help getting out of America?"

It was a cold January afternoon, and I was accompanying Polat to work. In October, he had found his first American job: a delivery position at a downtown restaurant called Café Asia. Some of his Uighur friends already worked there, and it was a relatively convenient job for an immigrant who didn't speak much English. Deliverers worked evenings, which left the days free for language classes. Polat had recently completed a two-month course, and he understood a fair amount of English—he often listened to the radio news while driving. But he still didn't feel comfortable speaking the language, and he preferred using Chinese when possible.

His driving, though, had already acquired the distinctive fluency of a working immigrant. He knew the quirks of the Washington grid—the one-way streets, the sections that locked down during rush hour—and he also knew how to curb-sneak and pass illegally and slide through stop signs as if he didn't mean it. He could swing a U-turn pretty much anywhere. He kept an eye out for cops, and he was expert at spotting parking places while making a delivery run. When nothing was available, he improvised: stop the car, flash the hazards, hustle and hope. That was one word he always spoke in English—while driving, he muttered it over and over, like a mantra: "Parking, parking, parking." Since starting the job, he had paid over six hundred dollars in fines. Thus far, his single-day record was three tickets: a pair of twenty-dollar parking violations and then a fifty-dollar penalty for cruising a yellow that went red. At Café Asia he made seven dollars an hour, plus tips.

He had had one accident. Back in December, while making a delivery, he stopped at a light on Pennsylvania Avenue and got hit from behind. The other driver had been going too fast, and, after they got out of their cars, Polat

smelled alcohol on the man's breath. The man had knocked the back bumper clear off Polat's Honda.

"When he started talking to me, he was very nice, but once he realized that I was a foreigner with bad English, he intimidated me. He told me, don't call the police, it will cause too much trouble. He said I could fix the car and he'd pay half. I agreed, although now I realize that I should have called the police. At the time, I was also thinking that if the police came, then I'd have to call a friend who speaks English, and that's a hassle for him. Afterward all of my friends told me that I should have called the police. I have insurance, a license, and I didn't break any laws. They told me that I shouldn't trust any African people."

A new bumper would have cost one thousand dollars, and the other driver initially offered five hundred. But the check never arrived; when Polat visited the man's office, the man dropped the figure to three hundred. Reluctantly, Polat agreed, and then he waited—nothing. The next offer was one hundred dollars, and then Polat threatened to get a lawyer. Finally, the man gave him one hundred and fifty, cash, and Polat found a Chinese mechanic who did a cut-rate repair. It cost three hundred.

Polat still had the driver's card, which listed an address on 13th Street NW.

"I think his business involves cheating people," Polat told me. "That address is just a normal house where he has a table and a telephone. He doesn't even have a computer or a printer or anything like that. I think the business supposedly has something to do with construction."

Nevertheless, Polat hadn't been tempted to push for more money. He could drive perfectly, but that fluency disappeared once he stepped out of the car. And he knew that his own record wasn't perfect. In addition to all the tickets, there was always a chance that somebody might look into his Virginia driver's license and realize that it had been acquired with a bogus affidavit. That particular loophole had been closed ten days after the terrorist attacks, because seven of the nineteen hijackers had boarded the planes with identification cards that had been acquired illegally from the state of Virginia.

THE SIGN IN front of Café Asia advertised EXOTIC CUISINE. The menu was mostly Japanese, but it also listed dishes from all over the East: Singapore Noodle, Thai Basil, Penang Ha Mein, General Tao Chicken. In the kitchen, the cooks were Thai, Indonesian, and South American. Mexicans washed dishes. On the first evening that we delivered, the sushi chefs were Malaysian and Cantonese. The men wore white Japanese *happi* coats and they worked in a well-lit window that fronted the street. It looked warm from where we were standing.

That night, all of the Café Asia deliverers were Uighur. The temperature was in the twenties, and four of us stood in a huddle, waiting for orders to come in. Like Polat, the two other Uighurs had recently arrived in the United States. One had journeyed from Xinjiang via Kazakhstan and Uzbekistan, and the other had grown up in Turkey, where his family had settled as refugees.

"I came here because I don't want to do military service," he explained. "In Turkey, every man has to do it. Life is not so easy, you know."

The Uighur said it lightly, grinning at the cold. He was a tall, handsome man with short black hair. I asked him how old he was.

"Twenty-three old years."

His mistake was unintentional, but I liked the turn of the phrase—the old years of a young émigré. I asked him how long a Turkish citizen was required to serve in the military.

"Two old years," he said.

"Is it dangerous?"

"It used to be more dangerous, because of the terrorists in the north, but now it's not so bad. Mostly I do not want to do it because it is boring."

Polat handed out Marlboro Lights, and the Uighurs turned their backs to the wind and lit up. Inside, the restaurant was busy—most customers were young professionals who had just gotten off work. Couples hurried through the cold, walking past our clump of smoking Uighurs. Next door, there was another Asian restaurant—Star of Siam—and Armand's Chicago Pizzeria. Each establishment had an American flag: since the attacks, it seemed that anybody doing business had to have at least one.

Polat telephoned a Uighur friend who worked nearby, at Radio Free Asia, and the man joined us. His name was Alim Seytoff, and he told me that he was the only Uighur with an American journalism degree. He had studied broadcast journalism at the University of Tennessee at Chattanooga (before that, he had attended an Adventist college in Tennessee). He was thirty-two old years: a slight, serious man in a black leather jacket. He spoke bitterly about the international ignorance of the situation in Xinjiang.

"We have more problems in China than any other ethnic group," he said. "Much more than the Tibetans. But they get more attention because they have the Dalai Lama. My father was a political prisoner for ten years. The first time I saw him, I was eleven. My father knew people who were executed."

A white woman walked out of Café Asia, carrying takeout boxes. She caught Alim's last word and snapped her head. She studied the huddled Uighurs for a moment and then continued down the street, walking faster. Alim didn't seem to notice. "Almost every Uighur family has somebody who has

spent some time in jail," he continued. "It surprises me that they are still so quiet."

Another Uighur returned from making a delivery. He was in his twenties, a long-nosed man in a Pure Playaz baseball cap. When Polat left to feed the Honda's meter, Pure Playaz grinned knowingly and said, "Parking." That was the only English word I ever heard him say. Polat told me that the man had sneaked into America five months ago, from Canada, and he had come from such a remote part of Xinjiang that he didn't even speak Chinese.

After a while, the men decided that it was time for dinner. They could eat for free at Café Asia but preferred not to. ("If I have Japanese food once a year, that's enough for me," said Polat.) We went next door to Armand's Chicago Pizzeria, which was staffed by Moroccans. They greeted the Uighurs warmly— Islamic immigrant connection—and gave us a discount on slices. Pork-free, just like in Chicago. I asked Alim what he thought of the war in Afghanistan.

"I think it's great," he said. "I hate the Taliban more than the Americans do. If they didn't get rid of the Taliban, then people might have connected that group with the Uighurs. That's what the Chinese want. They jumped onto the wagon of this war on terrorism. They were pretty slow to respond; at first I don't think they knew what to do. Then they thought, how can we take advantage of this opportunity?"

ONE STRATEGY WAS to give a new name to an old problem. After the attacks, Chinese officials and the state-run press began referring to "East Turkestan terrorists" who had trained in Afghanistan and other Central Asian countries. In the past, they had usually described Uighur dissidents as "Xinjiang separatists." The new term sounded more foreign, and it seemed designed to make Americans more sympathetic to the Chinese: threatened by an Islamic threat from the outside, as opposed to coping with an unhappy native minority. In November of 2001, when the Chinese foreign minister reported on terrorism to the United Nations, he emphasized China's problem with "East Turkestan terrorists."

China requested that Uighur groups be listed as enemies in the war on terror, but there was resistance in the United States. Some of the Uighurs' staunchest allies were conservatives. In October of 2001, the *Washington Times* published an op-ed by Senator Jesse Helms:

> If the U.S. should end up receiving any kind of support from Beijing for our anti-terrorist efforts, it will almost certainly come at the price of acquiesc-

ing in China's crackdown on the Uighurs (as well as its attempts to crush
Tibet and isolate Taiwan).

 That would be a moral calamity, for there is no justification in lumping
the Uighurs with the murderous fanatics who demonstrably mean us harm.
The Uighurs are engaged in a just struggle for freedom from Beijing's tyran-
nical rule, for the most part peacefully. . . .

Senator Helms was also a major supporter of Radio Free Asia's Uighur
broadcasts. The station was similar to the Voice of America, but much newer;
RFA had started broadcasting in 1996, in a range of Asian languages, includ-
ing Mandarin Chinese. In 1998, the Uighur language service was added. Every
day, it broadcast two hours of news and programming, to be picked up by
shortwave radios in Xinjiang and other parts of China. Funds for RFA some-
times functioned as a counterweight to the grudging acceptance of China as
a world power. In May of 2000, when the House of Representatives passed
the bill that established permanent normal trade relations with China, it at-
tached a provision that expanded the funding for RFA and VOA. This helped
appease anti-China sentiment in Congress: the Americans accepted the reality
of China's economic power, but they expressed disdain for its political system
by supporting independent broadcasts.

 One problem, though, was that virtually nobody in America understood
what went out over the airwaves. A scholar of Central Asian studies told
me that the RFA Uighur broadcasts were far more radical than anything on
the Mandarin or Tibetan services, and he worried that such material served
only to antagonize the Chinese government. He was also concerned that the
Uighurs overestimated the support of leaders like Senator Helms. In Cen-
tral Asia, that was an old story: A common United States tactic had been
to encourage ethnic or religious groups that resisted bigger powers like the
Russians or the Chinese. Once the geopolitics shifted, the support ended,
and the resistance groups were forgotten. This American pattern of encour-
agement followed by neglect had contributed to the rise of the Taliban in
Afghanistan.

 That was one price of obscurity—a small, remote group like the Uighurs
were almost never perceived on their own terms. The Chinese saw them as
ethnic minorities of the People's Republic; Turkic groups saw them as Turks;
Islamic fundamentalists saw them as Islamic; Senator Helms saw them as anti-
China and pro-America. They were like the Xinjiang mummies—there was so
little information about them that anybody could remake the ethnic group in

his own image. And there were plenty of disaffected Uighurs who were ready to be swayed by any kind of foreign support.

In Washington, D.C., I met with Mehmeh Omer Kanat, an RFA correspondent who had reported on the recent war. In Afghanistan and Pakistan, Kanat had interviewed a half dozen Uighur prisoners who had been captured after fighting alongside the Taliban. He estimated that hundreds of Uighurs may have been trained in Afghanistan at some point. The prisoners whom he spoke to were all young men in their twenties or early thirties, and they came from the full range of traditional Uighur social classes: peasants, traders, intellectuals. One prisoner held a degree in economics from a Chinese university. Eventually, they were to be sent to the American interrogation center at Guantanamo Bay.

"They didn't want to be known as terrorists," Kanat told me. "They said they didn't have anything to do with the Arabs, with Al Qaeda. They said they fought with the Taliban only because they had been training when the war started. They said, this is a civil war and we don't want to have anything to do with it. We want to fight China. We came here to use the opportunity."

I asked Kanat what their attitude had been toward the United States.

"They weren't angry at America; they were happy," he said. "They told me that maybe America would build bases in Afghanistan, and then America would be a neighbor to China. They were very hopeful. They hoped that America would help fight against China."

AFTER 7:30 P.M., the Café Asia deliveries picked up. Polat's first order was for 1900 K Street, an office building whose signboard listed some law offices and a branch of Price Waterhouse. He parked illegally on K and left the lights flashing. The blonde woman who picked up the order was missing part of her right hand. She tipped a little more than two dollars.

"I always feel bad about taking tips from her," Polat said, as we walked back to the Honda. "She's always very nice and she's handicapped."

"I wouldn't worry about it," I said. "I think she's a lawyer. She probably makes a lot of money."

"I know," he said. "But I still feel bad."

The second order took us up L. Polat turned on Thirteenth and checked his mirrors.

"I'm going to break an American rule," he announced. "There's a double orange line here. If a cop sees it, he'll fine me thirty dollars."

He swung the U-turn and parked illegally in front of the Homer Building. No cops. More law offices: a twelve-story atrium decorated with a huge

American flag and a bronze sculpture entitled *The Spirit of American Youth*. An inscription noted that it had been originally designed for the Omaha Beach Memorial in Normandy, France. The security guard smiled when we entered.

"This guard is nice," Polat said, while we waited for the customer. "I come here a lot and he's always very kind to everybody."

The middle-aged guard chatted with a younger man. The two black men spoke as if we weren't standing beside them; many Americans talked like that once they heard us speaking a foreign language. At the Homer Building, the men discussed a woman, and the security guard gave advice.

"You play cool," the older man said.

"I play cool," the young man agreed.

"You play cool," the older man said again, with a knowing smile.

The evening became busy, and there was always another order waiting when we returned to Café Asia. California Roll, Lo Mein Beef, and Shrimp Tempura Roll to Nicole Erb. Hot and Sour Soup, General Tao Chicken, and Seaweed Salad to Sophie Kojuch ("that name looks Turkish," Polat said). At most buildings, he called up on the intercom, using exactly two English words: "Hello, delivery." Many customers were lawyers working late; they came down, bleary-eyed, fumbling with wallets and purses. None of them looked at us twice. It would have been a lot for them to process if they had known all the baggage that accompanied their General Tao Chicken. That name was a misspelling of General Tso, or Zuo Tongtang, the brilliant and ruthless Qing general who had expanded the Chinese empire. Under Zuo's command, in 1884, Xinjiang had become a Chinese province; and now Uighurs were delivering his namesake chicken in the American capital. General Tso and Colonel Sanders: great chicken imperialists. Don't eat Kentucky, Don't eat Xinjiang.

Our last run took us to 1701 Massachusetts Avenue. Polat parked in front of a NO PARKING ANYTIME sign, and then walked into the lobby, past another sign that said POSITIVELY NO DELIVERY THROUGH THE LOBBY. The woman tipped Polat two dollars and twelve cents. On Twenty-fifth Street he left the Honda in the fire lane. Returning on Nineteenth, we were cut off by a cabbie.

"I've never seen a white person driving a cab," Polat remarked. "It's always foreigners. They have a really bad influence on the city's traffic. The cabbies drive even worse than I do."

He clocked out at ten o'clock. It was payday—inside Café Asia, the Mexican dishwashers lined up to collect their checks. The Uighurs pooled their tip money and split it five ways: twenty-six dollars each. Polat's two-week take was $544.38. We headed outside to a pay phone across the street, so he could

call his wife; he was using calling cards because his cell phone bills had been so high lately. The wind was bitterly cold and a wild-eyed black man in a parka stumbled up to us.

"You want some Tylenol?" he said. "Three dolla a box."

Polat and I stared at the man.

"Tylenol!" he shouted. "Three dolla a box!"

"No, thank you," I said, as politely as possible. The man staggered down the street, muttering angrily to himself.

"Are you sure this is a safe place to use the phone?" I asked.

"It's fine," Polat said. He pressed the numbers—somewhere in Urumqi, a phone rang, but nobody answered. We drove back to his row house, searching the side streets. Parking, parking, parking. Finally Polat found a spot, but the hood of the car remained directly in front of a NO PARKING notice.

He said, "As long as most of the car is behind the sign, it's OK."

A huge American flag decorated the front bay window of Polat's row house. He had invited me to stay in his room; he planned to sleep next door on the couch of his Uighur friend. We walked inside, where the Chinese landlord was sitting in the living room. The man did a double-take once he saw me.

"This is the friend I told you about," Polat said. "He's American."

The man studied me, eyes uncertain. "We're friends from Beijing," I said, smiling. "I live there, but I'm American. I'm here visiting."

"Oh, you speak Chinese," the landlord said. He smiled, but his mouth had tightened into an expression that I recognized from China. He asked Polat if they could speak privately.

I waited in Polat's tiny room. A moment later he joined me.

"He won't let you stay here," he said. "He says you're a *wairen*."

He spat out the word. In China, I was accustomed to being a *waiguoren*, "foreigner," but here in Chinatown the issue wasn't *guo*, "nationality." *Wairen* simply meant "stranger."

"It doesn't matter," I said. "I can stay at a hotel just as easily. I don't want to cause you trouble."

"He said you can stay next door with my friend. He just doesn't want you in their house."

"I understand. They don't know who I am."

Polat cursed angrily. He said, "Chinese are the same everywhere."

AT NIGHT POLAT delivered, but the days were free. We cruised the city in the Honda—he introduced me to Uighur friends, and he showed me some of his regular haunts, like the farmer's market in northeastern Washington where

a lot of immigrants shopped. It was too cold for outdoor sightseeing, but he liked visiting museums, and one afternoon we went to the Smithsonian. The exhibit was entitled "Field to Factory," and the introduction read:

> *The United States has been a haven for millions of immigrants fleeing war, poverty, and discrimination, or seeking freedom. But in some places, at some times, American society has oppressed its own people.*

One exhibit described black migration to the North during the period from 1915 to 1940. There was a display of a cramped boarder's room: bed, nightstand, closet. We stood before it in silence, both of us thinking the same thing. Finally, Polat laughed and said it: "That's probably better than my room."

Nearby, another section was labeled WAS IT WORTH IT?, and it quoted an anonymous letter that had been collected in *The Negro in Chicago*, a book by the sociologist Charles Spurgeon Johnson:

> *I thought [Chicago] was some great place but found out it wasn't. Uncle told me he was living on Portland Avenue, that it was some great avenue; found nothing but a mud hole. I sure wish I was back home.*

Polat never talked about going back—that was impossible after taking the step of political asylum. He often remarked that his timing had been bad; he wished that he had been more settled when the attacks occurred. So far, though, there hadn't been many incidents of open prejudice. Once, a few weeks after 9/11, he had tried to enter a gas station in Essex, Maryland, but some white people asked him to leave. Other Uighur friends had had minor problems, and the ones with Islamic-sounding names noticed that it was becoming harder to find jobs. But the distrust was mostly unspoken, a certain feeling that hung around the city. "Americans won't tell you to your face that they don't like you," Polat said. "It's not like the Chinese—if they don't like you, then it's always very clear. Americans are smart enough to hide those feelings."

His biggest worry was that his wife wouldn't make it out. His lawyer had filed the necessary paperwork for her visa, but nobody knew how long the approval would take; all of these procedures were undergoing significant changes in the wake of the attacks. The lawyer thought it would be at least a year, maybe two, maybe more. In the meantime, it was getting harder to convince her that things were fine. During the month of October, after the attacks, Polat had rung up a cell phone bill of $488.75.

In the District, I stayed with Polat's Uighur friend in the neighboring row house. The place was packed: three Mexicans in the basement, one Uighur on the ground floor, and nine Chinese in the upstairs bedrooms. All but one of the

residents worked in the food industry, and there was little interaction between them. Nobody seemed to care that a *wairen* was sleeping on the couch in the downstairs bedroom.

The Uighur was forty-eight years old, and he had also received political asylum. He was waiting for visa applications to be processed for his wife and twin sons. They were in Turkey; the man hadn't seen them in more than two years. He requested that I not use his name if I wrote about him.

The walls of the man's room were decorated with signs in different languages: English (STOP CHINA'S PERSECUTION OF THE UIGHURS), Arabic (ALLAH IS GREAT), and Chinese (MAY ALL YOUR WISHES BE GRATIFIED). On the door hung a Japanese Kabuki calendar from Hibachi Brothers, the restaurant where the man delivered. He held a degree in electrical engineering from a university in Xi'an. Recently, his car had been stolen—the neighborhood might have been in the early stages of gentrification, but it still had a ways to go.

One morning, the three of us talked, and the Uighur said that he was interested in the way Americans perceived culture. He said it was different from anything he had seen in Xinjiang or other parts of China. "I deliver to a lot of homes during my job," he said. "Usually, they don't ask me in, but sometimes they do and I can see what it's like. You know, a lot of them have Chinese paintings in their homes. That tells me that a lot of Americans like China."

I asked if that bothered him.

"No," he said. "It's fine to appreciate another culture. Probably it just shows that Americans have broad tastes. I also see a lot of African masks in people's homes."

I asked Polat's opinion, and he frowned. Over the years, he had always spoken of culture as sacred, something that was more fundamental than economics or politics. Once he had told me that that was the problem with blacks in America—it didn't matter that they lived in a country with a good economy and a free political system. Slavery had destroyed their language and culture, and that was different from somebody who emigrated freely. In his opinion, blacks would always struggle to recover from that loss.

Now he spoke slowly, thinking hard. "Those Americans have their own culture, the European culture, and it's also great," he said. "But I don't see them with so many European things in their homes. Why do they like China so much? I know that the Chinese say they have five thousand years of culture, but is that really true? Or is it just something that they say over and over again?"

He continued, "I see these Chinese paintings and it makes me think of the restaurant I work for. It's not real Japanese food—it's *jiade*. The people who

make the food are not real Japanese. They're Malaysian and Chinese who are dressed up as Japanese. I don't see Japanese eating there. It's all Americans."

"Well, a real Japanese restaurant probably wouldn't deliver," the other Uighur said. "They're very particular about things being fresh. So my restaurant isn't a real Japanese restaurant, either. Actually, the owner is Vietnamese."

"I think it has to do with American freedom," Polat said. "If you can find a way to make money, then you do it. That's what matters, and there's nothing wrong with that. But no Japanese ever eats there. And it bothers me when they dress people up as Japanese. That reminds me of those Uighur restaurants in Beijing, where they have Chinese dressed as Uighurs."

FOR POLAT'S BIRTHDAY, he took the day off work. In the morning, we drove around the city, running a few errands and visiting the farmer's market. Polat pointed out the government building where he paid his parking tickets. On the radio, an announcer referred to a story in the *Washington Post* about the expulsion of illegal immigrants. It was a cold, clear day; few people were outside. Polat had turned forty-six old years.

After the errands were finished, I asked if we could see the Pentagon. Earlier that month, in New York City, I had visited Ground Zero. Living in China had made the attacks seem so distant—the bootleg videos, the unsympathetic responses—and now I felt that I should witness these sites. We circled the Pentagon a couple of times before finding a Citgo gas station with a clear view across the Columbia Pike. As we pulled up, the national anthem was playing on the radio. Polat told me that since the attacks it had become a tradition to broadcast it every day at noon.

The Pentagon's damaged wing had been boarded up, and the scaffolding was topped with American flags. Overhead, helicopters buzzed on patrol. Three Norwegian tourists had also found their way to the Citgo station and we stood near the foreigners. Polat kept glancing back at the Honda.

"It's fine," I said. "They don't give parking tickets at gas stations."

"This one might be different," he said.

I went inside the gas station and bought a *Post*. The front-page headline read:

U.S. SEEKS THOUSANDS OF FUGITIVE DEPORTEES
Middle Eastern Men Are Focus of Search

I summarized the article for Polat: the Justice Department was cracking down on people who had ignored deportation orders.

"I support that," he said. "People's visas expire all the time and the govern-

ment doesn't do anything about it, which allows them to do something bad." He shifted to English. "Too much freedom," he said slowly, and then switched back to Chinese. "It shouldn't matter what race a person is; if they come here and obey the laws, then they should be allowed to stay."

I asked what he wanted for his birthday lunch. He told me that there was an Iranian restaurant that made good lamb kabobs, like the ones in Xinjiang. We drove past the statue of Simon Bolivar, past the World Bank, past Pennsylvania Avenue. Parking, parking, parking. While searching for a spot, Polat told me that life in the District was bound to get easier. "I just need to have courage," he said. "I had courage in Beijing and that's how I made so much money there. And it took courage to leave."

He paused behind a black Lexus, waiting to see if it would pull out of a space. The car didn't budge; we moved on. "You know, I look at the people here, and a lot of them aren't as smart as me," Polat said. "Some aren't as educated; some are older. It's not as if everybody in America is intelligent. But, you know, a lot of the people who aren't so smart still have a good life. I figure that if they have a good life, why can't I?"

After a few more minutes of searching, Polat found a parking spot and we walked to the restaurant. It was called Moby Dick House of Kabob. Polat smiled and waved when he entered. Another Uighur stood behind the counter, working the grill.

The Criticism
自我批评

THE STORY OF CHEN MENGJIA SEEMS TO CHANGE WITH EVERY TELLING. Because so little has been written about the end of the man's life, I am forced to rely on interviews, memories, rumors. Most people whom I talk to are older than seventy. Old Yang tells me that Chen was accused of having an affair; Old Mr. Zhao says that he got in trouble for defending traditional writing; Professor Shih has heard that the Communists killed him. Others have their own versions, sometimes secondhand. In my notebooks, words accumulate and contradict:

> *"Chen Mengjia struck me as remarkably handsome. I remember thinking, a bit incongruously, that he could have been a movie star."*

> *"I heard from somebody who knew him that the affair was with a Peking Opera actress."*

> *"Many things were said at that time. They might criticize something personal—that was simply their method. Of course, it was nobody's business. If his wife didn't bring this up, why should they?"*

> *"I don't know if this tallies with what you've heard, but it is said that Chen committed suicide over an affair with a movie actress. I certainly do not want to be identified as the source of this allegation. It came to me from X, who heard it from Y in the context of Y's defense of Z."*

"This is a historical problem and it's not something for us to talk about."

"He had a poet's temperament. If he had an opinion, he said it. He was xinzhi koukuai—*he had a straight heart and a quick mouth."*

<div align="center">* * *</div>

ON THE FOURTH floor of the Shanghai Museum, I find a permanent exhibition of Chen's Ming dynasty furniture. There is always something sad about furniture in a museum, and Chen's collection seems particularly lonely: empty chairs, vacated tables, incense stands that hold nothing. One chair, made of rare yellow rosewood, is decorated with a single carved character: 壽. "Longevity." The exhibit label says nothing about the man's life or death:

THE FURNITURE IN THIS ROOM WAS ORIGINALLY COLLECTED
BY MR. AND MRS. CHEN MENGJIA

Ma Chengyuan is the oldest curator at the museum. He is seventy-five years old, officially retired but still active. When I request an interview, he responds eagerly; he was friends with the oracle bone scholar. The curator tells me that they first met in 1955. In those days, the Shanghai Museum was a much smaller institution; the beautiful new complex was opened in 1996. During the 1950s, Ma and other curators bought bronzes from local antiquities markets, and they often called in specialists to examine the pieces.

"Chen Mengjia visited the museum several times," Ma says. "He had a cultured air, but he was very straightforward. He always told his true opinions. Eventually, that's what got him into trouble. He believed that Chinese writing is beautiful, and he opposed the reforms that were proposed in the 1950s. I heard from others that he spoke openly about this during some meetings in Beijing. That was dangerous, because the government was behind the plans to reform writing. In other words, he wasn't just opposing the writing reform; he was opposing the government. To be honest, I also didn't like the idea, but I never said anything. All of that was happening in Beijing and I had nothing to do with it."

Ma continues: "I always enjoyed showing Chen our collection when he visited Shanghai. Sometimes his wife came with him. I think that her personality had changed from before—I heard this from others. She didn't talk very much. I think there was some kind of pressure on her spirit. I know that they wanted to have a child but couldn't. At one point they looked into adopting, but it was too complicated—there's not a tradition of that in our China. And I think

their home was lonely without children. Chen told me once that they couldn't have children, although he never spoke about it in detail. Of course, I would have been too embarrassed to ask."

The curator tells me that the last time he saw Chen was in 1963. "By then, he had already had political problems," he says. "I was visiting Beijing, and I went to his home to look at his furniture. There were so many beautiful pieces, and I remember noticing one in particular, the yellow rosewood chair that has 壽 carved into it. We ate dinner at his home, and he gave me a copy of his new book, *Our Country's Shang and Zhou Bronzes Looted by American Imperialists*. You have to understand that that title wasn't Chen's choice!

"That was when he first told me that he wanted to give his furniture to the Shanghai Museum. He was very concerned about their protection. He never specifically mentioned that he feared political problems. But I know that any collector would have wanted to live with those pieces. So why did he want to give them to the museum? We can only guess. Later, he wrote a letter about the donation and sent it to me. I still have the letter—I'll find it for you. And that was the last time I saw him."

Ma mentions that Chen's political problems started in the late 1950s. "Some of the younger academics wrote articles criticizing him," the old man says. "Some of them were very harsh."

I ask if he remembers the names of any of the critics.

"Li Xueqin," he says. "He wrote something saying that Chen's research on the oracle bones was wrong."

"Was the criticism accurate?"

"No," says the curator. "And he shouldn't have written that paper at that particular time. Chen already had enough trouble."

"What's Li Xueqin like?"

"Li Xueqin—" Ma shakes his head and thinks for a moment. "*Buhao shuo*," he says. "It's not easy to say. But now Li Xueqin is at the top of the field of archaeology. For a period he was Chen Mengjia's assistant."

THE CURATOR WON'T say more about the criticism. He drops the name and leaves it at that, knowing that my curiosity has been raised. He has a reputation for being politically savvy—during the Cultural Revolution, he reportedly saved the museum's artifacts by covering them with banners of Mao Zedong slogans. Ma knew that Red Guards wouldn't destroy the Chairman's words, and the Shanghai collections emerged intact. Today, the museum is considered to be the best in all of China, and Ma is given credit for guiding the institution's expansion.

There are rumors that the museum actually profited from the Cultural Revolution, when many intellectuals and wealthy people lost their belongings. I ask the curator about this, and he takes the question in stride. "I was also criticized," he says. "We were just concerned with survival." He tells a story about a "struggle session" in which the curator and other museum staff were lifted to a height and then dropped onto the marble floor. Ma says that he was bruised but intact; another colleague landed on his head and died. The tale is short but effective: I'm not going to ask any more questions about whether the Cultural Revolution was good for the Shanghai Museum.

Before I leave, the curator photocopies Chen Mengjia's last letter. The handwritten document is dated January 26, 1966, the year that the scholar committed suicide. The handwriting is beautiful, and there is no mention of fear or political trouble. The characters are arranged as neatly as the furniture in the Shanghai exhibit, and they feel just as empty:

> We had a very pleasant talk last time, maybe you've forgotten, but it's a pity that we didn't record it. You came to my home and the time was too rushed. . . .
>
> That yellow rosewood chair, it might date to earlier than the Ming dynasty, and of course it should be donated to the Shanghai Museum. If you like the other pieces, they can be donated as well. I hope that someone from the museum can come here and pack them up. . . .

*　　　　*　　　　*

IN BEIJING, I find a copy of the criticism. It was published in 1957, shortly after Chen Mengjia had been named a Rightist and an enemy of the Party. The article consists of a long review of Chen's book on oracle bones: the chrestomathy. The review is sharply critical of Chen's scholarship, and then, at the end, the attack becomes personal:

> Chen has not presented anything substantial enough to match his arrogance. Chen has an extreme tendency to boast. For example, in the twenty chapters of the book, Chen neglects many essays and theories of other scholars, instead collecting only his own ideas. . . . This self-boasting attitude should not be accepted by us.

It's not hard to find more information about Li Xueqin. In the fields of archaeology and history, his name is everywhere—he publishes about oracle bones, ancient bronzes, bamboo documents. He is brilliant and prolific; a

number of scholars tell me that he has the rare ability to do excellent research while also deftly satisfying the Communist Party. One scholar of ancient Chinese tells me bluntly that Li is a "toady"; a number of people mention his criticism of Chen Mengjia.

In recent years, Li has been the director of the Xia-Shang-Zhou Chronology Project. Initiated in 1995, and funded by the central government, the project was designed to establish exact dates for China's early cultures. Previously, the earliest date in Chinese history for which there was ample archaeological and textual evidence was 842 B.C., but the Chronology Project came up with a new timeline. Internationally, the project has been heavily criticized—many foreign scholars believe that the Chinese are attempting to fortify their history in ways that are more nationalistic than academic. Some say that the project was motivated primarily by a sense of competition with the West, which has earlier recorded dates for cultures such as ancient Egypt. During the Chronology Project, academic differences about ancient dates were sometimes resolved by voting—Chinese scholars gave their opinions, and the year with the most votes won. Domestic press reports were often bizarre:

> *CHINA DAILY (December 16, 1998)—A PROJECT TO BRIDGE gaps in China's ancient history has made remarkable progress after two years of research. China is world-famous for its 5,000-year history as a civilized nation. Unfortunately, a 2,000-year gap in China's development has concealed the country's true age. . . . The missing 2,000 years include the Xia, Shang and Zhou dynasties and the time before that dating back to well before 2100 B.C., says Li Xueqin, history researcher with the Chinese Academy of Social Sciences in Beijing. . . .*
>
> *The exact time marking the beginning of China's ancient history will be published late next year, said Li.*

*　　　*　　　*

AFTER RESEARCHING LI XUEQIN's career, I arrange a meeting with a friend who is a Chinese journalist. He works for Xinhua, the Party news service, but in his free time he researches history and archaeology. He uses his official position to access restricted documents and explore forgotten events; someday he hopes he'll be able to publish it all. He likes to say that his left hand works for Xinhua but his right hand works for himself. We are the same age: early thirties, born in the Year of the Rooster.

I ask my friend for advice about approaching Li Xueqin, and he tells me not

to mention Chen Mengjia. I should arrange an interview on another pretext, and then bring up the criticism.

I ask, "What if he refuses to answer?"

"Well, he might do that. But if you take him by surprise, maybe he'll respond."

"What do you think he'll say?"

"There's a Chinese saying—'Like the sun at high noon.' That's where Li Xueqin is right now. He's at the high point of his career. When he looks at that review, I doubt that he thinks, 'I shouldn't have attacked my teacher in this way.' Instead, he probably thinks, 'Look how much I understood when I was so young.'"

The reporter continues, "Scholars in this country are like that. It's a very dark group of people—many of them did things that they shouldn't have done. I've heard that after Chen Mengjia killed himself, scholars went through his office, reading his notes, and some of them later published his ideas as their own. There are many scholars who did things like that in the past, but they won't admit it. The Chinese don't like to examine themselves in this way. It's rare for them to admit that they were wrong."

At the end of the conversation, my friend encourages me to pursue the story; he says that too much history of this sort slips away in China. "This isn't something that a Chinese journalist can do," he says. "I couldn't do it for Xinhua, of course. But as a foreigner, you can do it."

I MEET LI Xueqin in his office at Tsinghua University. He is almost seventy years old, with a high forehead and heavy bags beneath his eyes—the face of a hardworking scholar. He wears a gray woolen suit, red tie, and slippers. He tells me that he has spent time in the States, including a sabbatical at Dartmouth; he speaks good English. I have told him that I'm interested in the Xia-Shang-Zhou Chronology Project.

"It started with a man named Song Jian," he says. "He's a specialist in cybernetics, but he's always been interested in archaeology. In the early 1990s, he traveled to Europe and the Mediterranean, and he visited many museums, especially in Egypt, Greece, and Israel. Afterward, he thought, 'Foreign chronology is much clearer than in China.' He came back and talked to me and other scholars, asking if there was anything we could do. Basically, we decided to get scientists more involved in archaeology and history."

The professor explains that astronomers have helped track eclipses that were recorded in ancient documents, and other scientists have contributed their skills to carbon 14 dating. He points out that the project funded work in

Anyang—the surveys that first turned up evidence of the underground city.

"There isn't such a big difference between our chronology and the previous views," he says. "For example, let's look at the end of the Shang dynasty, when they were defeated by the Zhou. This is a critical moment in history, but in the past there have been forty-four significant different opinions about the date, involving a range of one hundred and twelve years. Using the most reliable sources, we narrowed it down to a range of thirty years—1050 to 1020 B.C. We decided that the most exact date was 1046 B.C. Now we aren't saying that this is *definitely* correct. But from the information we have right now, it's the most appropriate.

"This is really just a start," he says. "We're preparing for another project about the origins of Chinese civilization. Of course, some people have said that we are trying to extend Chinese history, but that isn't true. We just want to figure out how China developed. It's no different from studying ancient Greece, or Egypt, or Israel. These other ancient cultures have all been studied more than China. And Chinese civilization has a special characteristic: it still exists, whereas the others have all disappeared."

I WAIT FOR half an hour before changing the subject. I take the critical review from my bag and set it on the table between us. If Professor Li has any initial reaction, he keeps it hidden.

"I was reading some of your articles," I say, "and I noticed this one about oracle bones. I also saw that K. C. Chang praised your theory about the Shang sacrificial names."

"Yes, that meant a lot to me," the professor says with a smile. "But I didn't even see what he had written until much later. He was in Taiwan when he first read my paper, and of course there wasn't any contact in those days. I never actually saw his remarks until 1971."

I point to Chen Mengjia's name, which appears in the title. "I'm also interested in this oracle bone scholar," I say. "I've heard about him from people in Anyang and also in Beijing. Were you his student?"

"He was a teacher here at Tsinghua, but I wasn't formally his student," Professor Li says, and then he explains his background. Originally, Li Xueqin had studied mathematical logic, but then, in the years after the Communist victory, Beijing's universities were reorganized. During an interruption in his formal coursework, the young logician pursued his hobby of studying oracle bones.

"I had been interested in them since I was eighteen or nineteen," he says. "When I was young, I was interested in anything that I didn't understand. It might sound strange, but whenever anything struck me as symbolic or compli-

cated, I wanted to figure it out. That's what attracted me to logic. And when I first looked at the oracle bones, I couldn't understand them, and that made me want to know more."

He continues: "When the Kuomintang fled the mainland, they had taken the oracle bones with them, but rubbings had been published in books. Many of them hadn't been studied carefully or even pieced together. In my spare time, I worked on this; I arranged the broken pieces, figuring out how they fit together. I had some success, and eventually it was brought to the attention of Chen Mengjia and others. They asked me to work on the oracle bones at the Institute of Archaeology. I was essentially a research assistant to Chen Mengjia."

There's a slight shift in the man's voice. His expression is unchanged—the tilt of his jaw is the same, and his eyes hold steady. But he speaks faster now and the pitch of his voice has risen. He tells the story:

"After 1957, he was named a Rightist—they put that hat on him. Those were difficult years for him. And during the Cultural Revolution, people who had been Rightists had even more serious problems. That was why he killed himself.

"At that time, I was at a different research institute, so we weren't at the same place. I believe that he killed himself in the summer of 1966, but I didn't hear about it until the winter. When I found out, I was very upset. He was a great scholar. And after the Cultural Revolution was finished, we took good care of his things, his notes and books."

His story is finished, but I open the review. In the center of the last page, the personal attacks on Chen Mengjia stand out in ugly phrases:

"自命甚高"
"竭力鼓吹自己"

The professor's gaze settles somewhere between the document and the floor. "This isn't something that we should talk about," he says. "Chen Mengjia was a great man, and I'd rather not discuss these things."

"I'm just trying to understand what happened," I say. "I've seen many criticisms of him, and most of them were much worse. Everybody tells me that it's the way things were at that time. As a foreigner, it's hard for me to understand this kind of thing, so I wanted to ask you about it."

Now the professor realizes why this interview is taking place. But the emotions that I expected to see—annoyance, defensiveness, even anger—haven't materialized. If anything, the man just looks tired, the bags sagging heavy beneath his eyes.

"It's not difficult just for foreigners to understand," he says. "It's difficult for young Chinese to understand. At that time, there was a kind of pressure on us to write this sort of thing. The Institute of Archaeology asked me to write it. I was very young and I couldn't refuse. You'll notice that I avoided saying anything political. I never used the word 'Rightist,' or any of those terms. And I put all of that criticism into a single paragraph, at the end."

He's right: the personal attack is condensed into a space of only five lines.

"I didn't want to do it," the professor continues. "There was no problem with the scholarly points that I made in the other parts of the essay. But the personal criticism was something that I didn't want to write. After that essay was published, I rarely saw Chen Mengjia. But occasionally in the early 1960s, I encountered him at the Institute of Archaeology, and whenever that happened, I didn't feel comfortable speaking to him. I just couldn't hold a conversation, because my heart felt bad. I always regretted that article."

He continues: "I think that people understood. Much later, after he was dead, I still had contact with his friends, and occasionally I saw his wife. None of them ever attacked me. I think they understood what had happened, but I still felt bad. *Mei banfa.* There was nothing I could do about that."

Throughout the interview, I have been writing, and now Professor Li looks at my notebook.

"I would prefer that you not write about this in the *New Yorker*," he says slowly. "It's a personal problem. I'd rather you just wrote about the chronology project and those things that we talked about earlier."

I say that I won't write about it unless I can explain everything fully.

"It's hard to understand, apart from the fact that it was a horrible period," he says. "By the time the Cultural Revolution happened, if people criticized you, then you truly believed that you were wrong. I was also criticized at that time, and I believed the things that people said. Everybody was like that; it was a type of social psychology. There were so many enemies—everybody was an enemy, it seemed."

AFTER THE INTERVIEW, I wander through the Tsinghua campus. It's a sunny morning, and the snow on the ground melts away into uneven patches of gray. The campus is beautiful, and in addition to its excellent academic reputation, the university stands as a monument to recovery. In 1901, after foreign troops put down the Boxer Uprising, the occupying armies forced the Qing to agree to reparations of 330 million dollars. The Americans dedicated their share to Chinese education; eventually, some of the money was used to found Tsinghua.

Near Professor Li's office, I visit an old tablet dedicated to the memory of

Wang Guowei, one of the early oracle bone scholars. A ring of pine trees surrounds the ten-foot-tall tablet. The inscription is dated in the old Kuomintang style: the Eighteenth Year of the Republic. That was 1929—two years after Wang Guowei drowned himself out of despair at the fall of the last emperor. Back then, one of his friends wrote a memorial essay:

> *Whenever a culture is in decline, anyone who has received benefits from this culture will necessarily suffer. The more a person embodies this culture, the deeper will be his suffering.*

My Xinhua friend was right—some things are easier for a foreigner. But perhaps they are easier for the wrong reasons. On my way to Tsinghua, I had told myself that it was necessary to take the professor by surprise, because otherwise this detail of the past might disappear. But it would have felt better if the man had become defensive or angry; it was much worse to see the regret. The author of that criticism had been twenty-four years old.

21

State Visit

February 23, 2002

PRESIDENT GEORGE W. BUSH SPENT THIRTY HOURS IN CHINA. ON THE way, he stopped in South Korea, where he stared through binoculars across the Demilitarized Zone. Less than a month earlier, the president had declared that North Korea, along with Iran and Iraq, constituted the "Axis of Evil." At the DMZ, somebody mentioned that a North Korean museum across the border included a display of hatchets that, in 1976, had been used to kill two American servicemen. "No wonder I think they're evil," President Bush said.

The trip to Beijing coincided with the thirtieth anniversary of President Nixon's first visit to China. During President Bush's visit, two events were open to journalists and were televised live across China: a joint press conference with President Jiang Zemin, and a speech by the American president at Tsinghua University. At the press conference, the two men smiled and spoke around each other, the way that leaders of these nations always had. President Bush mentioned Taiwan:

> "We believe in the peaceful settlement of this issue. We will urge there be no provocation. The United States will continue to support the Taiwan Relations Act. China's future is for the Chinese people to decide, yet no nation is exempt from the demands of human dignity. All the world's people, including the people of China, should be free to choose how they live, how they worship and how they work."

President Jiang, when asked about the possibility of regime change in Iraq, said:

> "I think, as I made clear in my discussion with President Bush just now, importantly that peace is to be valued most. . . . Let me conclude by quoting a Chinese proverb: 'More haste, less speed.' That is to say, despite the fact that sometimes you will have problems that cry out for immediate solution, yet patience is sometimes also necessary."

That evening, at a state banquet, President Jiang Zemin entertained the guests by singing "O Sole Mio." He took turns dancing with Laura Bush and Condoleezza Rice. The following morning President Bush went to Tsinghua University.

THE FOREIGN JOURNALISTS met at the Shangri-La Hotel, where the government provided special buses to take us to Tsinghua. I found a seat behind two members of the State Department press corps. Like most of the Washington reporters, they were white men with short hair and dark suits. They talked constantly about politics and journalism. Eavesdropping was easy because they ignored anybody who was not a member of the State Department press corps.

"Powell's a smart guy."

"I always think of him as the adult supervision of the administration."

"I don't think he has a Kissingerian sense of the big picture, though."

It was 8:25 in the morning and the bus idled out in front of the Shangri-La. We had been scheduled to leave at eight.

"Bush's view comes from Marvel comics. Evil one, evil leader. But Powell looks at the whole thing holistically."

"Bush wants to make sure that everybody is—like us, basically."

"If you look at who's actually killing people, I'm not worried about Osama bin Laden. I'm worried about Colonel Sanders, the Bud Man, and the Marlboro Man."

"Why can't they find him? He's six-four and he walks with a limp."

"Maybe he's gone to a place with lots of tall people."

"Where are all the bicycles around here?"

"It's a Potemkin village, writ large. REALLY large. This is China."

"Why are we sitting here so long?"

"Welcome to China. You have to learn to wait fast. When the security zealots at the White House and the control freaks here get together—Security City."

From the back of the bus sounded the harried clatter of somebody typing fast on a laptop.

"There have been several fights between Ashcroft and Rumsfeld, Rumsfeld and Powell."

"People often say that O'Neill is going to go."

"Last year I covered the APEC finance ministers meeting in Suzhou."

"Where's that?"

"Ninety miles from Shanghai. Beautiful place."

At exactly 8:38 the bus pulled away from the Shangri-La.

"I think journalists underrate Mr. Bush because they value minds like their own."

"I covered Gore for a year—you could diagram his sentences and teach English from them. But I could never understand what he was saying. Once they asked a question about domed stadiums. Gore said a paragraph: the Astrodome was the first dome, the Kingdome is the largest enclosed space—all this kind of stuff. Then Bush said, 'I like to watch baseball outdoors.' Who's smarter?"

"Does Arlington have a dome?"

"No."

"I don't think I've ever been in a motorcade like this one before."

A row of black sedans led us north across the Second Ring Road. Dark-coated cops stood along the streets, clearing traffic. Pedestrians stared. The sky was perfectly clear.

"I've been to Yucca Mountain. I've been down inside Yucca Mountain."

"Vegas is a real booming city."

Signs along the road:

BEIJING WEST AUTO PARTS MART

BEIJING RURAL CREDIT COOPERATIVE

SINOPEC

"The French reprocess the waste into plutonium."

"There's a journalist here named Jasper Becker who found a thirty-million gap in the Chinese demographic. Thirty million! It makes you wonder what the other journalists are doing."

The bus crossed the Fourth Ring Road. An enormous English sign read:

IMPLEMENT NEW TRADEMARK LAW TO FACE THE CHALLENGE
OF THE WTO ENTRY

"Look at all the bicycles! That's what I've been wanting to see!"

"The *Post* guy, Tom Ricks, is terrific."

BEIJING CHEMICAL INDUSTRY RESEARCH INSTITUTE

"He was the first guy to realize that satellite photographic technology could be a really useful journalistic tool."

The bus entered the back gate of Tsinghua University.

"And for a network, a thousand dollars a picture is no big deal."

Pines, lawns, old brick buildings. Statues and monuments.

"They built it with money from the Boxer Indemnity."

"Was he the round peg when we needed a round peg?"

"I only covered him for a couple of months."

"I was on a plane once and I was reading Seamus Heaney, the Irish poet. Clinton came back and asked what I was reading. And he could talk about it. He's very gifted but . . ."

WELCOME US PRESIDENT GEORGE W. BUSH
TO TSINGHUA UNIVERSITY

* * *

RELATIONS WERE ON the upswing, and so was China. In the past, the Chinese had always sought things from the outside world: recognition, trade relations, WTO membership, the Olympics. Often the United States held the cards that mattered, but now the situation had changed. The Americans needed things from China. The People's Republic was the only country that had good relations with North Korea, and in the post-9/11 period, the Chinese presence in Central Asia mattered. If the U.S. intended to take the Iraq issue to the United Nations, China's support would be critical.

And the Chinese economy had become too powerful to ignore. Sometimes, it was hard to believe that only two years had passed since Polat had spent long evenings out in Yabaolu, changing money at 9 percent above the official bank rate. In those days, people had speculated that the Chinese would devalue their currency; now people wondered if it would be *revalued*. Property markets were booming; the trade surplus grew every year. Soon the Americans would be asking the Chinese to add value to their currency, because trade had become so imbalanced.

During President Bush's visit, all the old conflicts—the embassy bombing, the spy plane incident—seemed a century away. At the joint press conference, President Bush's remarks were broadcast in their entirety on Chinese television.

That was another good sign: in the past, words had always disappeared. In 1984, when President Reagan quoted Abraham Lincoln—"no man is good enough to govern another man without the other's consent"—the phrase was excised from the tape-delayed broadcast. In October of 2001, when President Bush visited Shanghai for the Asia Pacific Economic Cooperation summit, several key phrases disappeared from his televised press conference. Twelve of the lost words were: "the war on terrorism should not be used to persecute ethnic minorities."

As a journalist, you tracked trivia. Occasionally, you looked up from the routine of patchwork news stories and realized that somehow, imperceptibly, the whole picture had changed. At those moments—wearing the suit and tie, boarding the press bus with other white guys in suits and ties—you wondered: Is this what it all comes down to? Does the world actually move forward through these meetings and speeches, the thirty-hour stopovers?

But that was the job, and so you collected the fragments—the issues, the background, the color—and you organized them into stories. The United States wanted China to stop exporting missile technology to Pakistan. China wanted the United States to stop planning a missile defense system in the Pacific. The United States wanted to export soybeans. The thirtieth anniversary was a nice detail. Since foreign journalists almost never had the opportunity to speak with President Jiang Zemin, and he appeared to be even blander than everybody else in the current Chinese leadership, it was useful to mention his habit of singing during state dinners. Other good details floated around. Beijing had eighteen PriceMarts. China was home to six hundred KFC franchises. More than forty Chinese Christian activists were reportedly placed under house arrest during President Bush's visit. The *New York Times* reported that a recent survey had shown that nearly half of all Chinese children under the age of twelve believed that McDonald's was a domestic brand.

A few months earlier, during President Bush's visit to Shanghai, William Jefferson Foster's VOA journal had included one of the longest sentences ever to appear in Special English:

> *During the press conference, China U.S.A. are two major influences in the world common responsibilities and interested two side's move forward smoothly as long as the two sides stick to the common interest and handle the bilateral tie property perticu with regard to the Taiwan issue Taiwan issue has been the most sensitive issue in relation hope us to adhere to one-China principal and abibe by the three joint communiques*
>
> *On anti-terrorism. China is always opposed to any form of terrorism and support effort fight it.*

VICE-PRESIDENT HU JINTAO introduced President Bush. The Chinese official was a Tsinghua graduate, but there were other reasons that he made the introduction. President Jiang Zemin was scheduled to step down later that year, and many predicted that Vice-President Hu would become the nation's leader. The foreign press had been watching him carefully since May of 1999, when he had been the first high-ranking Chinese leader to appear on television after the NATO bombing. It was a well known fact that Hu Jintao enjoyed ballroom dancing.

In his brief introduction, Vice-President Hu mentioned the anniversary. "Thirty years are just a moment in human history," he said. "But the great changes that have occurred during this period in the two countries' relations will go down in history."

President Bush thanked Hu Jintao and said, "This university was founded, interestingly enough, with the support of my country, to further ties between our two nations."

The small auditorium was poorly heated, and the audience consisted of three hundred students. The Communist Youth League had selected them carefully from every department at Tsinghua. I stood with the other journalists in the back, jotting down bits of President Bush's address, to be checked later against the official State Department transcript:

"As America learns more about China, I am concerned that the Chinese people do not always see a clear picture of my country. This happens for many reasons, and some of them are of our own making. Our movies and television shows often do not portray the values of the real America I know."

"If you travel across America—and I hope you do some day if you haven't been there—you will find people of many different ethnic backgrounds and many different faiths. We're a varied nation. We're home to twenty-three million Americans of Chinese ancestry, who can be found working in the offices of our corporations, or in the cabinet of the president of the United States, or skating for the America Olympic team. Every immigrant, by taking an oath of allegiance to our country, becomes just as American as the president."

"Change is coming. China is already having secret ballot and competitive elections at the local level. Nearly twenty years ago, a great Chinese leader,

Deng Xiaoping, said this—I want you to hear his words. He said that China would eventually expand democratic elections all the way to the national level. I look forward to that day."

<p align="center">*　　*　　*</p>

AFTER THE SPEECH, the ritual shifted to the deconstructionist phase. Reportedly, all questions had been vetted in advance by the Party. The first student rose and said, in English: "Whenever you talk about the Taiwan issue, you always use a phrase just like, 'peaceful settlement.' You never use the phrase, 'peaceful reunification.' What's the difference and why?"

President Bush's response repeated some form of the *p* word—peace, peaceful, peacefully—ten times. But he did not say "peaceful reunification." Another student popped up:

Q: It's a pity you still haven't given us—sorry—give us a clear question about whether you always use the "peaceful settlement." You have never said "peaceful reunification." It's a pity.

PRESIDENT BUSH: We're back on Taiwan again—[laughter]—go ahead.

Q: This is a question our Chinese people are extremely concerned about.

PRESIDENT BUSH: Yes, I know.

Q: Three days ago, during your speech in the Japanese Parliament, you said the United States will still remember its commitment to Taiwan.

PRESIDENT BUSH: Right.

Q: But my question is, does the U.S. still remember its commitment to 1.3 billion Chinese people? [Applause] Abiding by the three joint communiqués and three notes. Thank you.

President Bush used *p* three more times: "peaceful resolution," "peaceful dialogue," "peaceful dialogue." Still no peaceful reunification. He said, "And, secondly, when my country makes an agreement, we stick with it." The questions lurched ahead. After a while, somebody asked if President Bush had noticed any changes since his first trip to Beijing in 1975, when his father was the U.S. ambassador to China.

"In 1975, everybody wore the same clothes," President Bush said. "Now people pick their own clothes. Just look here on the front row, everybody's dressed differently. Because you thought, this is what you wanted. You made the decision to wear a beautiful red sweater. And when you made that decision, somebody made it.

"And, in other words, the person, the individual, the demand for a product

influences the production, as opposed to the other way around. Recognizing the desires of the individual in the marketplace is part of a free society. It is a part of the definition of freedom."

HIS LAST WORDS were, "God bless you all." I skipped the journalist bus and had lunch at one of the small cafés just outside the Tsinghua gates. The restaurant was packed and I didn't hear a single student talking about the state visit.

ARTIFACT K

The Lost Alphabets
斯大林

ONE PARTICULAR DETAIL REAPPEARS IN MANY OF THE MEMORIES. Each old man has his own perspective on the suicide, and often he emphasizes something that the others neglect—the reputed affair, the criticism, the years in America. But the majority of them mention Chen Mengjia's involvement in writing reform. Follow this strand, and it leads farther and farther back in time, past the old men and past the poet-scholar and past the Anyang excavations, past the dynasties and even past the oracle bones. And that's where it ends: at the absolute beginning.

PEOPLE DREW. IN ancient times, they simplified and standardized; the sketches became pictographs. It worked until they reached the undrawable—abstract concepts—and that's when they turned to sound.

Imagine that three simple pictures represent the English words "leaf," "bee," and "eye":

Now, reorganize the three pictographs:

Speak the words quickly: "*Eye-bee-leaf*; I believe." That takes care of two abstractions: the first-person noun and the verb of faith. If you want, you can add simple markers that will allow a reader to distinguish "eye" from "I" and "believe" from "bee-leaf":

In such a system, the writer listens for connections between words—homonyms, near-homonyms, rhymes—and then expands the vocabulary of the original pictographs. The key element is sound: a symbol represents a spoken sound rather than a picture. And that's when you have writing, strictly defined: the graphic depiction of speech.

Nobody has found direct evidence of these early stages—it's not the kind of thing that would have been recorded—but experts believe that's roughly how it happened. The earliest known writing in East Asia is already a fully functioning system by the time it appears on the oracle bones. The Shang characters are not pictographs, although many of them contain links to that earlier stage. The Shang word for "eye" is written:

This kind of writing system is called logographic. Each character represents one spoken syllable, and syllables having the same sound but different meanings—homonyms—are represented by different characters. For example, the modern Chinese 伟 ("great") is written differently from 萎 ("wilt") and 伪 ("false"), despite the fact that all three are pronounced exactly the same: *wei*. The other known ancient scripts, Sumerian cuneiform and Egyptian hieroglyphics, also first appear on the archaeological record at the logographic stage. (Sumerian is the earliest known script, appearing roughly 1,700 years before the oracle bone inscriptions.) Most scholars believe that Chinese developed independently, although Victor H. Mair and a few others theorize that the Shang had contact with the writing of the Near East.

None of these early scripts is easy. In a logographic system, thousands of symbols must be memorized, and a reader often can't pronounce an unfamil-

iar word without looking at a dictionary. During the second millennium B.C., Semitic tribes in the Near East converted Egyptian hieroglyphics into the first alphabet. An alphabet allows a single syllable to be broken into even smaller parts, which gives far greater flexibility than a logographic system. With an alphabet, it's possible to distinguish homonyms in subtle ways ("see" and "sea") instead of writing completely different characters. Unfamiliar words can be sounded out, and an alphabet shifts more easily between different languages and even dialects. For example, one can listen to somebody from the American south say "I believe," and then, using the Latin alphabet, describe his pronunciation of each syllable: "Ah bleeve."

A logographic system can't capture that level of nuance. And an alphabet requires the memorization of only two or three dozen symbols, instead of thousands of characters. That's why, in the Near East and the Mediterranean, the old systems didn't survive. There are no direct descendants of Sumerian cuneiform, and Egyptian hieroglyphics remain with us only indirectly, as the inspiration for the first alphabet.

But the Chinese still write in characters. In the history of human civilization, written Chinese is unique: a logographic script whose fundamental structural principles haven't changed in more than three thousand years. Even the characters themselves are remarkably timeless. Today, when a Chinese writes *mu*, or "eye," *yu*, or "rain," *niu*, or "ox," the modern words stand beside the Shang characters like close relatives:

 * * *

NOBODY KNOWS WHY the writing system remained so stable. The spoken language of ancient China was chiefly monosyllabic (most words consisted of only one syllable), and it was uninflected (no changing endings for plurals or verb tenses). Some linguists note that these qualities made Chinese naturally suited to a logographic system. The Japanese, whose spoken tongue is highly inflected, originally used only Chinese characters but then converted them into a syllabary, a simpler writing system that makes it easier to handle changing word endings.

Other scholars point to cultural reasons. Ancient Chinese thought was deeply conservative—the ancestor worship, the instinct for regularity, the resistance to change, the way that Confucianism idealizes the past—and such

values naturally would make people less likely to modify their writing system. But that's a chicken-and-egg theory, and the fundamental issue isn't why the writing system remained stable. The key is how this written stability shaped the Chinese world.

For most of China's history, official writing used classical Chinese. By the time this language was standardized during the Han dynasty, more than two thousand years ago, it existed only in written form. People wrote in classical Chinese, but their day-to-day speech was different. Over time, as the spoken languages evolved, and the empire expanded, encompassing new regions and new tongues, classical Chinese remained the same. A citizen of the Ming dynasty spoke differently from a citizen of the Han—they were divided by more than ten centuries—but they both wrote in classical Chinese. The native language of a Fujianese was different from that of a Beijing resident, but if they both became literate, they could understand each other's writing. Classical Chinese connected people across space and time.

It would have been harder to maintain such literary stability with an alphabet. In Europe, Latin was the written language of educated people for centuries, but they always had the necessary tool to shift to the vernacular: the alphabet made it linguistically easy. (Of course, cultural and social reasons delayed the transition.) In China, there was also some vernacular writing, but it was limited. Vernacular writing is less likely to develop in a logographic system, which simply can't shift as easily as an alphabet among different languages and dialects.

But Chinese characters had other benefits. They provided a powerful element of unity to an empire that, from another perspective, was a mishmash of ethnic groups and languages. Writing created a remarkable sense of historical continuity: an unending narrative that smoothed over the chaos of the past. The characters were also beautiful. Calligraphy became a fundamental Chinese art, much more important than it was in the West. Words appeared everywhere: on vases, on paintings, on doorways. Early foreign visitors to China often remarked the way characters decorated everyday objects such as chopsticks or bowls. At Chinese temples, prayers were traditionally written rather than spoken; fortune-tellers often made their predictions by counting the strokes of a written name. In the nineteenth century, social organizations were devoted to collecting scraps of paper that had been dignified by writing; they couldn't bear to see them tossed away like trash. Communities erected special furnaces to give these words a proper cremation.

Of course, writing was hard. To achieve literacy, a Chinese student had to memorize thousands of characters. Without alphabetic order, categorization

was complicated. (Even today, file cabinets are an adventure, and few Chinese books have indexes.) The first Chinese dictionary organized words by shape. Over time, many characters had acquired secondary elements—now known as "radicals"—that helped distinguish and classify words. But even radicals were complicated: the first Chinese dictionary identified 540 radicals, and more than 9,000 characters.

But motivation was high in a culture that identified itself so strongly with the written word. By the seventeenth century, China already had a well-established commercial press, and literacy seems to have ranged more widely across class groups than it did in many parts of Europe. Foreign travelers noted that even in the countryside, it was common to find books—often manuals that showed peasants how to write simple contracts. Evelyn S. Rawski, a historian at the University of Pittsburgh, has estimated basic literacy rates for Chinese males in the eighteenth and nineteenth centuries at between 30 and 45 percent—comparable to those for males in preindustrial Japan and England. Rawski concludes that, although China failed to industrialize as rapidly as those nations, the disparity shouldn't be blamed on literacy problems.

TO OUTSIDERS, THOUGH, the Chinese writing system seemed badly in need of reform. One sixteenth-century Jesuit missionary described learning to write Chinese as "semi-martyrdom," and it wasn't surprising that the Jesuits were the first to develop systems that used Latin letters for Chinese. Over the centuries, as more foreigners arrived, they often believed that alphabetization would benefit the people. Of course, it would also benefit the foreigners and their churches. In the nineteenth century, as the Opium War treaties allowed more foreigners to proselytize in China, Christians published Bibles in the native dialects. Alphabetization became a key part of missionary work, and by the end of that century, foreigners and Chinese converts had developed alphabetic systems for all major dialects.

Meanwhile, Chinese intellectuals were undergoing their crisis of cultural faith. Having been defeated repeatedly by the foreigners, they began to question everything traditional, including the cherished script. At the same time that scholars were rediscovering the oracle bones, many Chinese were thinking about doing away with the characters entirely. In the 1910s, Qian Xuantong, a prominent philologist, proposed that China switch, in both spoken and written language, to Esperanto.

Most solutions were less radical. A number of intellectuals proposed using the same characters but shifting from classical Chinese to the vernacular. This proposal gained support in the late 1910s, eventually becoming incorporated

into the May Fourth Movement of 1919, which called for the reform and modernization of many aspects of Chinese politics and education.

Eventually, reformers successfully did away with the tradition of writing in classical Chinese. Schools, government bureaus, and books and newspapers began using a writing system that followed Mandarin, the vernacular of the Beijing region. This was different from what had happened in Europe, where Latin was replaced by multiple vernaculars: French, Italian, Spanish, and other languages. In China, largely because there was no alphabet, the shift to the vernacular was made without sacrificing literary unity. All educated Chinese still learned to write the same way.

Reformers believed that another step was still necessary. They pointed out that most southerners wrote in what was essentially a second language. For a native of Wenzhou to become literate, for example, he first had to learn Mandarin. It was the equivalent of an English-speaker being forced to use Dutch in order to read and write. In southern China, there was one major exception: Hong Kong writers had developed a system that allowed them to write their native Cantonese using Chinese characters. Even so, the traditional characters were so badly suited to Cantonese sounds that the Hong Kong system required more than a thousand additional symbols, many of them specially designed for the language. Such systems had not been developed for the other major Chinese languages, which remained unwritable, and it would have been an immense project to adapt characters to each spoken tongue.

With an alphabet, though, it would be far simpler—foreign missionaries had already proved this with their dialect Bibles. Across China, many intellectuals called for alphabetization, believing that the characters were an impediment both to literacy and to democracy. Lu Xun, who lived from 1881 to 1936, and was perhaps China's greatest modern author, advocated a shift to the Latin alphabet. He wrote (in characters, as he did until his death): "If we are to go on living, Chinese characters cannot. . . . The characters are a precious legacy handed down by our ancestors, I know. But we can sacrifice our inheritance or ourselves: which is it to be?"

In 1930, Chinese Communists living in the Soviet Union developed a system that used the Latin alphabet for Chinese. Writing reform became a key Communist project; in 1936, as the revolutionaries were gaining power, Mao Zedong told the American journalist Edgar Snow that alphabetization was inevitable. "Sooner or later," Mao said, "we believe, we will have to abandon characters altogether if we are to create a new social culture in which the masses fully participate." The Communists described the characters as "a Great Wall" that "has been erected between the masses and the new culture."

They even blamed writing for the post–Opium War decline, claiming that the characters had "facilitated the imperialist invasion of the Chinese nation."

In the Communist-controlled regions of the north, the new alphabetic script was granted legal status in 1941. Contracts and government documents could be written in the Latin alphabet as well as in characters. By the time the Communists gained control of the country, writing reform seemed imminent. In 1950, an American linguist named John DeFrancis published a book in which he predicted that the end was near for Chinese characters.

JOHN DEFRANCIS IS still bitter about that prediction. When I interview the scholar at his home, he becomes visibly agitated every time we touch on the subject. He was wrong, but he wasn't—in his heart, he knows that the Chinese *should* have gotten rid of the characters, and they *should* have done it immediately after the Communists came to power. Unexpected events are always frustrating, and sometimes the memory burns for more than half a century.

The professor is ninety-one years old and in good health. He still researches his Chinese dictionary projects, although he is formally retired from the University of Hawaii at Manoa. He lives and works in a beautiful Japanese-style house set into a hillside of the Manoa Valley. There's a rock garden in the back, centered around a tiny pagoda, and the sweet smell of bougainvillea drifts into the open house. To the south, the brown-green peak of Diamondhead is visible. For a scholar who wants to spend his final years halfway between the two mainlands, this is the ideal place to do it.

DeFrancis first went to China in 1933, after graduating from Yale. His original plan was to pursue business opportunities, but everything changed after he arrived in Beijing. "I lost all interest in the American business community starting from my first day," he tells me. "We were at a restaurant, and at the end of the dinner, an American businessman tipped the Chinese waiter by taking a banknote, tearing it in half, and throwing it at his feet. I didn't want to become part of that."

The poverty in China disturbed the young man, who believed that the country badly needed reform. Like many foreigners at that time, he thought that the Kuomintang were hopelessly corrupt. He studied Chinese, and in Beijing he became friends with another idealistic young scholar named George A. Kennedy. The Rockefeller Foundation gave Kennedy a grant to establish a Chinese language program at Yale, and his prize purchase in Shanghai was a Chinese printer's font. Kennedy planned to ship the pieces to New Haven, reassemble them, and publish textbooks for American students. He asked John DeFrancis to help.

"I became in effect his right-hand man and his assistant," DeFrancis remembers. "We set it up in the basement of Harkness Hall at Yale. Imagine a room of this size, if not larger, filled with V-shaped wooden trestles. If I'm standing up, they come to my chin. The trestles are divided to hold trays that are ten inches by twelve inches, which are further divided into little squares of two inches by two inches. Each square contains individual characters, arranged by radical. It was my job to set up the printer. I would take a composing stick, go pick up a character under the 'person' radical, 亻, and then go get another character under the 'field' radical, 田. I'd walk back and forth, back and forth. I'd put a few sentences together and take them to the printer, who made a metal cast. Our characters were so limited that I had to continually compose and then break it down, compose and break it down. We were taking stories from classical Chinese and putting them into modern colloquial Chinese."

Every foreigner who studies Chinese has a formative experience involving characters—the "semi-martyrdom"—and John DeFrancis's was particularly scarring. After years of searching wooden trestles for tiny pieces of metal organized by shapes such as 亻 and 田, he became a passionate advocate of Chinese writing reform. (His colleague, George A. Kennedy, became the main designer of the Yale romanization system for Chinese.) In 1950, after predicting the characters' demise, DeFrancis waited in America, eager to hear news of change. That summer, Mao finally issued a command:

> The writing system must be reformed; it should take the phonetic direction common to the languages of the world; it should be national in form; the alphabet and system should be elaborated on the basis of the existing Chinese characters.

The directive took everybody by surprise. DeFrancis and other scholars had expected that the Communists would simply adopt the Latin script, but the 1950 command sent the movement in a completely new direction. Mao Zedong wanted a Chinese alphabet.

THE CHAIRMAN'S COMMAND represented a critical turning point. Afterward, Chinese linguists spent years trying to create a distinctly Chinese alphabet, and in the meantime, they lost the momentum for change. In John DeFrancis's opinion, it was a missed opportunity, and that's what makes him so angry. Several times, he tells me that he didn't return to China for forty-nine years because of his bitterness over the failure of writing reform.

The motivation for Mao's command, like so many of the Chairman's decisions, remains a mystery. Once, when I telephone DeFrancis to talk about this

period, he theorizes that perhaps the Korean War or some other aspect of U.S.-China relations had influenced Mao, turning him against the Latin script. De-Francis urges me to visit with the surviving Chinese linguists who were involved in the project; in particular, I should meet with Zhou Youguang, who is in his late nineties. Back in 1982, when DeFrancis finally made his grudging return visit to China, he had asked Zhou Youguang about that key moment in 1950.

"He said that he knew why Mao made that decision, but he wasn't free to talk about it," DeFrancis tells me on the phone. He suggests that China's increased openness, combined with Zhou's advanced age, might make the man more disposed to speak freely about the past.

I BEGIN ON the first floor. Zhou Youguang, along with two other aging linguists, lives in the dormitory at the State Language Commission in downtown Beijing. All three men share the same entryway. It's a traditional Communist work unit arrangement, a throwback to the days of the planned economy. For reporting, it couldn't be better. All I have to do is go up and down the stairs, and I'll meet the most important writing reformers still living in China. The entryway becomes a tower of time and language: the afternoon passes; the reformers get steadily older; their memories shift restlessly through the years of the failed campaign.

At seventy-two, Yin Binyong is the youngest, and he lives on the first floor. For months, he has battled liver cancer, and his body is wasted: tiny chest, brittle limbs. His face is heavily lined, and he has the eyebrows of a Taoist god, great clumps of white that shadow his yellowed eyes. But if the man is in pain, he never shows it. He greets me warmly, pulling out the letter of introduction I have sent. Another scholar had suggested that I contact the reformers by writing a note in Pinyin, the script that uses the Latin alphabet for Chinese. Yin is thrilled that I got in touch without writing a single character.

Half a century ago, he graduated from Sichuan University with a degree in mathematics, and for a spell he was a middle-school math teacher. But he researched linguistics on the side, publishing articles, and eventually he was invited to work on the Beijing writing reform committees. His background is not uncommon—many linguists have skills in math or logic.

"There's definitely a link," he says. "You can often use mathematical methods and apply them directly to the study of language. I'll give you one simple example. Consider animals—which animal has the closest relationship to human beings? You can probably narrow it down just by thinking: cow, horse, dog, pig. But which one is the most important to the way that people live? What do you think?"

"Dog," I say.

Yin smiles; the eyebrows dance. "That's your guess," he says. "But how can you tell for certain? One method is to analyze writing through statistics and frequency studies. This is something that we did during the 1950s. We examined texts, both modern and ancient, to see which animal name appears the most frequently. For all periods, it was the same: the horse. So we concluded that the horse had the most important relationship to human society in China."

Visions flash before my eyes: a bronze artifact, a buried chariot, a man on horseback riding straight at a wooden gate. Yin continues, "I wrote a paper about this in the 1950s. I also did a study with English and Japanese texts, and they were both the same. But the second-closest animal was different. In English, it's dog. For us Chinese, it's cow."

After the horse diversion, he discusses the challenges of Chinese writing reform. Some people claim that Chinese has too many homonyms to be written with an alphabet; the characters are necessary to distinguish like-sounding words. Yin acknowledges that this is true for classical Chinese, but not for the modern languages. It's no different from listening to a radio broadcast—Chinese can understand their languages on the radio, without seeing the characters, and that means they could also understand an alphabetized script.

"Of course, that's theory, and practice is different," he says. "It's hard to get people to change when they've been using characters for so long. And it's true that if you shift to an alphabet, you have problems with the old texts. Look at *The Dream of the Red Mansion*, where all of the people of the same generation have names that use the same radical. You lose details like that if you change the writing system. Mostly, though, it's hard to change old habits. Look at your language—English writing also needs reform. George Bernard Shaw thought it should be changed."

Spoken English has about forty sounds, which are too many to be handled efficiently by the Latin alphabet—thus the often illogical spelling. George Bernard Shaw, who wrote everything in shorthand, specified in his will that future royalties from his works be used to fund the creation of a new alphabet. In 1958 and 1959, a public contest drew 467 proposed English alphabets, of which four were selected as winners. One of these systems, which had been designed by an architect, became the basis for the "Shavian" alphabet of forty-eight letters. A print run of a single book was published using the new system, a special edition of Shaw's *Androcles and the Lion*. The four English words of that title appeared as:

⅃⅃ↄⅎ↺ⅽ⅄Ƨ ⅃ ρ ↄℲⅼ⅃

By coincidence, the Chinese were also constructing alphabets in the 1950s. But their project was much more serious; it had been commanded by the Chairman, and linguists across the country created more than two thousand proposed Chinese alphabets. Some used Latin letters; others used Cyrillic; a number of proposals incorporated the Japanese syllabaries. There were Chinese alphabets in Arabic. Yin remembers one system that used numbers. Another method combined Latin letters with the Chinese radicals. Under this system, the Chinese character 法, which is pronounced *fa*, would be written:

ﻰfa

Linguists tinkered with the Latin alphabet itself. One system proposed four new letters that would represent specific Chinese sounds: *zh*, *ch*, *sh,* and *ng*. Under the proposal, *ng* would be written like the symbol of the International Phonetic Alphabet:

ŋ

"The East Germans heard about this," Yin says. "They quickly designed a typewriter that included those letters, and they sent it to our bureau. They said that if we adopted that system, their factories could produce typewriters. I think that was around 1952, although I can't remember for certain. I do remember that the typewriter was still sitting around the bureau in the late 1950s. It was a beautiful machine; I have no idea what happened to it."

In 1955, the reform committee narrowed the field to six alphabetic finalists. One system used Cyrillic letters, and another used the Latin alphabet. The other four finalists were completely new "Chinese" alphabets that were based on the shapes of characters. But a year later, Mao and other leaders decided that the Chinese alphabets weren't yet usable. They sanctioned the Latin system—the one known as Pinyin—for use in early education and other special purposes, but it wasn't granted legal status. Meanwhile, they decided to simplify a number of Chinese characters, reducing the stroke counts. For example, *guo*, which traditionally is written 國, was changed to 国. 龍 became 龙; 偉 became 伟; 夢 became 梦. A total of 515 characters were simplified, as well as a number of radicals. At the level of individual characters, it was a

significant change, but the basic writing system remained intact. Chinese was still logographic, and most dialects were still unwritable.

The committee described simplification as an "initial reform stage." They still hoped to introduce an alphabet, but it seemed that Mao wanted more time to consider the options. Meanwhile, the relatively optimistic early years of the People's Republic were coming to an end. In April of 1957, the Communist Party launched the "Hundred Flowers" campaign, during which intellectuals were invited to speak their minds, however critical. The response was overwhelming: thousands of Chinese commented publicly on all sorts of topics. Writing reform became one target of dissatisfied intellectuals, and dozens of commentaries appeared in the popular press:

> *Chinese is a tool for uniting our people. . . . The only reason that we could continue to be a united people is that Chinese characters held us together.*

> *The Latin alphabet is not our national product. . . . If we Latinize Chinese writing, then we will be fighting the world for Latin writing!*

> *Ours is a democratic country which carries out peaceful policies; it cannot justify the adoption of the historically aggressive Latin writing. . . . Whenever one thing in China is inferior to that in foreign countries, Chinese people feel that everything is inferior to that in foreign countries.*

<p style="text-align:center">✻ ✻ ✻</p>

UNTIL THE HUNDRED Flowers, Chen Mengjia hadn't been active in the debates over writing reform. His department, the Institute of Archaeology, was separate, and the oracle bone scholar never had the opportunity to speak out. But in the new climate of openness, his words suddenly appeared everywhere in the popular press. In an essay in *Guangming Daily*, he wrote, "There must be objective reasons why we are still using these characters after more than three thousand years." In *People's Daily*: "It seems there is a new type of dogmatism; some people take the leaders' words as the golden rule and ignore reality." Chen complained about the common practice of reporting on others for political mistakes; he remarked that many officials had little or no knowledge of the fields that they administered. He suggested that the Communist Party could use a better sense of humor. He remarked, "I dislike dogma very much, and in my writing I seldom quote Marxist-Leninist phrases." In a published speech, he declared:

With today's "Hundred Flowers Movement," I think the time is perfect to discuss honestly the future of Chinese characters. I am going to present a different opinion, without any reservations. . . .

We have used characters for over three thousand years, and there hasn't been anything wrong with them. . . . In the past, foreign devils said that the Chinese language was bad. Now more open scholars from the capitalist countries don't say so anymore. . . .

Recently I wrote an article and caused some disturbances. I am willing to make troubles like this, because I want to contribute. . . . I predict that we will still be using these characters for a number of years, and we should treat them as if they were alive. They are our cultural inheritance.

He was right—the Chinese would continue to use characters for many years—but he was wrong about this being the perfect time to speak openly. After only five weeks, Mao terminated the Hundred Flowers, and soon it was replaced by a new movement: the anti-Rightist campaign. By the end of 1957, more than three hundred thousand intellectuals had been labeled Rightists; many were sent to jail or labor camps. The same newspapers that had published Chen's opinions now ran angry headlines:

CRITICIZE CHEN MENGJIA

REFUTE THE RIGHTIST ELEMENT CHEN MENGJIA'S ABSURD THEORY

CONTINUE THE PURSUIT AND ATTACK OF THE RIGHTISTS: CRITICIZE CHEN MENGJIA AND GUAN XI

One article proclaimed, "The Rightist Element Chen Mengjia, a blade of grass that is poisonous . . . should never be allowed to root deep." Another described him as a "cow demon" with an "evil scheme": "Why do counter-revolutionaries of all eras hate simplified characters? Do they really want to return to antiquity?" Somebody wrote, "Chen is still picking up the morsels of the Western capitalist sinologists, and treating them as delicacies." It was during this campaign, in 1957, that Li Xueqin published his criticism of Chen's chrestomathy.

And from Chen—silence. The authorities sent the oracle bone scholar to Henan province, the cradle of Shang culture, to be reformed through manual labor. For the next five years he was banned from publishing in the People's Republic.

AFTER SPEAKING WITH Yin Binyong, I climb three floors and gain eight years in writing reformer age. Wang Jun is eighty, and he smiles when I mention Chen Mengjia. "He was my teacher during the war, in Kunming," Wang says. "He taught bronze inscriptions. It was a small class, only three students. He was like an older brother to us."

From newspaper archives, I have collected a number of criticisms of Chen, and now I show them to Wang, asking if he remembers any of the authors. He leafs through the pages, noting that several are obvious pen names. Then he recognizes a couple: a phonologist from Nanjing, a linguist from Fujian. Both scholars have been dead for years.

"You shouldn't worry about these criticisms," Wang says. "The things that people said and wrote in those days don't count. They had no freedom. If the Communist Party wanted to criticize somebody, everybody had to do it. I was also criticized that year. I made a comment during the Hundred Flowers, and then my institute held a special meeting to criticize me. Even the people who didn't know me had to say something. The ones who criticized me the harshest, I hardly remember them. I don't hate them. So you shouldn't be concerned about who wrote these articles."

I nod, and we chat for a while about the writing reform movement. At one point, during a discussion of prominent opponents, I mention the name Yuan Xiaoyuan.

Wang Jun's head becomes very still. He says quietly, "What do you know about her?"

"Not much. John DeFrancis said that he didn't like her. He said that she opposed writing reform."

DeFrancis had described Yuan Xiaoyuan as a consummate opportunist. She had spent much of her life abroad as a diplomat for the Kuomintang—she was China's first female consul, having served in Calcutta—but then she switched her allegiance from the Kuomintang to the People's Republic. Out of gratitude, the Communists granted her favorable business licenses, and she made a fortune. She funneled some of her money into a journal that opposed the writing reform movement. After the crackdown on the pro-democracy demonstrations of 1989, Yuan Xiaoyuan immediately appeared on Chinese television to condemn the protestors.

"That woman is a liar," Wang Jun says. "She lies about everything, including her age. She's ninety-five years old, but she says she's one hundred."

Something about the man's face has changed. He still smiles, but his jaw has tightened and there is a light behind his eyes.

"She used to be younger than Zhou Youguang," he says. "Now she's older than Zhou Youguang. How do you think that happened?"

I say that I have no idea.

"Simple," he says. "She lies. She lies about everything."

The man is still smiling, and I smile back. Less than ten minutes ago he was talking about forgiveness.

"I have evidence," he says. He walks to a cabinet and retrieves a folder. It contains a sheaf of photocopies and yellowed newspaper clippings. The man's eyes brighten.

"First, look at this." He hands me a page from a government yearbook, which features a photograph. A grandmother: soft smile, permed hair, bad glasses. Her birthdate is listed as 1907.

"Now," Wang Jun says triumphantly, "look at this!"

The newspaper clipping is from the year 2000. The headline reads:

YUAN XIAOYUAN, POET AND CALLIGRAPHER,
CELEBRATES HER HUNDREDTH BIRTHDAY
IN BEIJING

The next clipping is from the year 2001:

ONE-HUNDRED-YEAR-OLD YUAN XIAOYUAN
TALKS ABOUT HER HEALTH

Sections of the articles have been meticulously underlined, in red ink. One underlined sentence identifies Yuan's birth year as 1901. Another sentence notes that she is 101 years old. In the margin, somebody has written "94" in tight red script, like a correction on a school assignment.

"It's in the newspaper every year," Wang Jun says. "She lies about it every year. That's how she became older than Zhou Youguang."

He points to another underlined section.

"She claims that she used to be a professor at 'West-East University' in New Jersey," he says. "Who ever heard of 'West-East University'? What a stupid name! She also claims to have taught at 'San Francisco University.' There is no San Francisco University!"

In the articles, each academic institution has also been underlined in red. Later, I'll learn that "West-East University" is actually the Chinese name for Seton Hall, where Yuan Xiaoyuan once taught. But Wang Jun is convinced that she fabricated her résumé, along with her age. Before I leave, he hands me the clippings; he suggests that exposing Yuan Xiaoyuan's lies would make an

excellent detail for my *New Yorker* article. The last thing he tells me is, "She writes well. Actually, she's a good poet, and she has very good calligraphy. But she is a liar."

<p style="text-align:center">* * *</p>

IT'S DARK BY the time I reach the third floor. Sixteen more years: Zhou You-guang is about to turn ninety-seven, a frail, stooped man who is dressed in sweatpants and slippers. The skin on his bald head is perfectly smooth, as if polished by the decades. When we speak, I have to lean close and shout while the man cups a hand around his hearing aid. But his mind is sharp, and he still remembers English. In the 1940s, he was a banker in New York.

"I used to read your magazine in the Banker's Club!" he says.

I yell at him: "It's changed since then!"

The man can't stop laughing after he sees my name card, and I explain the Foreign Ministry translation. "New York Person!" he says in Chinese, his tiny body shaking like a willow in the wind. "New York Person! How funny!"

Like many patriotic young Chinese who had been living abroad, Zhou returned to China after the founding of the People's Republic. Originally, he intended to help the new government establish its banking industry, but he quickly sensed that there wasn't much of a future in Communist banking. He switched to his hobby of linguistics, and eventually became the main architect of Pinyin.

I ask Zhou what happened to the four new distinctively "Chinese" alphabets that had been chosen as finalists in 1955. He remembers them vaguely—one alphabet, the old man recalls, had been designed by a physicist named Ding Xilin. But apparently all records of those alphabets had been destroyed. "It was easy to lose things like that during the Cultural Revolution," he says.

The Cultural Revolution is perceived in different ways: some blame Mao; others blame his wife and the Gang of Four. But a longer perspective views the period as a climax of China's long disillusionment with its own traditions. For more than half a century, the Chinese had chipped away at their culture, trying to replace the "backward" elements. During the Cultural Revolution, this process became so fervent that it reached the point of pure destruction: people hated everything Chinese, but they also hated everything foreign.

Ironically, the Cultural Revolution protected at least one Chinese tradition: the characters. Along with the Great Leap Forward, the chaos of the period prevented the writing reform campaigns from moving forward. By the time Mao died, the Chinese had lost their appetite for radical cultural change. They had passed from crisis to ideology to nihilism—and then they came out on

the other side, settling on pragmatism and the slogans of Deng Xiaoping. Be practical and realistic. Seek truth from facts.

Nowadays, practically nobody in China talks about alphabetization, apart from the old men who live in one entryway of the State Language Commission dormitory. Even these scholars speak of it sadly. Zhou Youguang tells me that China won't give up its characters for at least another century, if ever. Like most linguists, he describes the simplification of the characters as a failure. There's no evidence that simplification has improved literacy rates, because the fundamental structure of the writing system didn't change. If anything, character simplification only divides the Chinese literary world. Taiwan, Hong Kong, and most other overseas Chinese communities still use the traditional characters. For years, it was illegal for a Taiwanese to import a book that contained simplified characters. That restriction was politically motivated, but nowadays the disgust is mostly aesthetic. For a traditionally educated Chinese, writing simplified characters is like walking thru the Kwik-mart 2 by sumthing.

I ASK ZHOU YOUGUANG about the critical moment, Mao's call for a Chinese alphabet in 1950. To my surprise, the old man takes the question in stride.

"Of course, the Party was already using a Latinized system in the 1940s," he says. "So it seemed natural that they would make a change. But once they came to power, they were more cautious. They had so many other things to take care of. That was one factor in the delay.

"But another very important factor was Mao's first trip to the Soviet Union, in 1949. At that time, Mao respected Stalin as a leader of the Communist world. He explained that China was going to undertake writing reform, and he asked Stalin for advice about it. Stalin told him, 'You're a great country, and you should have your own Chinese form of writing. You shouldn't simply use the Latin alphabet.' That's why Mao wanted a national-in-form alphabet."

I ask if the Korean War played a role, and he shakes his bald head. The old man smiles when I shout out Chen Mengjia's name.

"I liked him a lot," Zhou Youguang says. "But, to be frank, his opposition had no impact on any of this."

BACK DOWN: THIRD floor, second, first. The entryway opens to a city that feels as big as the world. Of all the details that swirl in my mind—the human-horse relationship, the shifting birthdate of Yuan Xiaoyuan, the lost alphabets—I'm most struck by the realization that Chen Mengjia's defense, however brave and however much it cost him, was completely unnecessary. Joseph Stalin had already saved the Chinese characters.

22

Encapsulate Prime

June 2002

IN THE MONTHS AFTER 9/11, WILLIAM JEFFERSON FOSTER CONTINUED to follow the news closely. Sometimes he telephoned me in Beijing, often with a question about the situation in Afghanistan or some other development in the war on terror. At night, he listened to the Voice of America, writing in his journal:

> *US fighter-jet resumes it's mission on Afganistan*
> *More anthrax cases surface in U.S.A.*
> *Pakistani police clash with anti-protestant*
> *Peaceful anti-war demonstration in New York, Berlin*
> *God Bless George W. Bush*

He also translated commentaries from the local press:

> *It's interesting that the two brother cities, Ningbo and Wenzhou, are both aimed at becoming the China's Milan. There must be fierce competition between the two cities. Wenzhou wants to be the capital of clothes as well of leather shoes. "Dressing in Wenzhou" is a quite eye-catching slogan in downtown Wenzhou.*

And occasionally he wrote English "news" stories in his journal, based on his own experiences:

> *Last year this school achieved great success. Some 25 students were recruited to the only key high school in this city. This year the school is*

facing fierce challenge from the outside society—a public newly-built
school which is aimed at making our school go bankrupt. . . .

Competition was everywhere. Willy and Nancy's school competed with the
public school; their city competed with Ningbo; China competed with the out-
side world. One of Willy's most powerful childhood memories was watching
his father initially succeed and then fail with his contracting work, a victim of
his own illiteracy. That was the story of Willy and Nancy's generation: they
had grown up with China's reforms, children of the market economy.

At the start of the 2001–2002 academic year, Willy's headmaster gathered
all the instructors together and gave a motivational speech. He exhorted them
to battle the public school on three fronts, just as the Communists had fought
the Kuomintang during the civil war. Later, when Willy told me about the
speech, he couldn't remember exactly what the school's three fronts were. Over
the years, there had been so many Chinese slogans with numbers—the three
this, the five that—and inevitably they blurred. The important point was that
the struggle between the schools had become a war. In one letter, Willy wrote:

> *Hi yagao [toothpaste]:*
> *I am sure that this Spring Festival I will stay in Zhejiang. We are*
> *required to give so-called extra lessons to the Yahoo students. . . . The*
> *year 2002 this school will have fierce competition and challenges from the*
> *fucking Public Boarding school that I hoped will be bombed by Osama*
> *Bin Laden. By the way, how is your family? And what's new in there?*
> *I want to bye to you now. Right now I have to coach my top students*
> *who are my money and hope in the new year of 2002.*

A couple of months later, after Willy and Nancy's bank account finally
cleared one hundred thousand yuan, the stakes became even higher:

> *Hi peter*
> *How is it going with you in Beijing? First I wil tell that possibly in*
> *one year I will be a yahoo's father. That's to say Nancy is in the family*
> *way here in Wenzhou.*
> *These days I am quite busy with the coming High School*
> *Examination. This year rather crucial for me. I was told that if we can let*
> *more students go to the only key school, I can get a decent bonus for this.*

Willy and Nancy had decided to return to Sichuan eventually. They weren't
certain when, and it was possible that Nancy and the child would go back to-

gether, leaving Willy to work for a while longer in the better economy of Zhe-jiang. Divided families were common in China, especially among migrants. Most people believed that it was better to raise a child near their hometown, where the culture was familiar and parents and other relatives could help if necessary. Willy and Nancy liked the idea of settling in the small city of Nan-chong, which wasn't far from Willy's native village. As teachers, they could find work anywhere, and they'd return with plenty of savings, especially if the exam bonus panned out.

The tests were scheduled for two days in June. Over the final weeks, Willy held extra classes, drilling his students, and he kept an ear out for tips about the exam material. Once again, his school bribed the Wenzhou education of-ficial, and once again the man gave them nothing but elliptical comments. Willy hated this part of the routine—the leaks invariably favored the public schools, especially the ones in downtown Wenzhou and the bigger cities. But he couldn't do anything about it, other than become cynical about the system and the nation. In early June, after watching the World Cup, he sent me an e-mail:

> *I am very glad that China Soccer Team was defeated by Costa Rica. During the two halves I cheered for Costa Rica it was just because I was once a spanish learner. Chinese players will be ashamed of it's shitting perfor-mance on the court.*

After the first day of exams, the father of a student approached Willy. The man seemed nervous, and he asked to speak privately. Once they were alone, he revealed his tip: a reliable source had told him that Beethoven and Bill Gates would appear on tomorrow's English test.

Willy walked a safe distance from the school and found a photocopy shop. From his students' textbook, he copied two passages, each of which profiled a famous foreigner. That afternoon, he gave his students strict instructions: study this, and don't breathe a word to anybody else.

The following day, the exam's reading comprehension section included a direct excerpt from Lesson 90, in the distinctive cadence of Special English:

> *Bill Gates was born on October 28, 1955. He grew up in Seattle, Washing-ton. Bill Gates was named William Henry after his father and grandfather. He was a very clever boy. . . .*
>
> *When he was 13 years old, Bill started to play with computers. At that time, computers were very large machines. Once he was interested in a very old computer. He and some friends spent lots of time doing unusual things*

with it. In the end, they worked out a software program with the old machine. Bill sold it for 4,200 dollars when he was only 17. . . .

Bill married Melinda French on January 1, 1994. They have two children, a daughter and a son. Bill enjoys reading very much. He also enjoys playing golf and bridge.

Do you want to be a person like Bill Gates? Why or why not?

Later that summer, when the examination results came out, Willy's students scored the highest of any class in the school. The headmaster rewarded Willy with a bonus of six thousand yuan—roughly two months' salary. He might have done even better, but it turned out that Beethoven had been a false lead.

IN THE SPRING of 2002, Emily decided to spend a semester outside of Shenzhen. She came to Beijing, where she enrolled in a private English course in the university district. During the weekends, she sometimes visited me downtown, and we had lunch and went sightseeing. One afternoon, she stopped by my apartment to pick up a copy of the article that I had written about her for the *New Yorker*. She had read an early draft, to help me fact-check, but this was the first time she had seen the published version. Of course, like anything written about China, certain details had already become historical. Nowadays, citizens could enter Shenzhen without the special border passes, and the government was discussing the possibility of tearing down the city's fence. Another era had passed for the Overnight City.

Emily sat on my couch and opened to the first page, which featured an artist's sketch of her. Laughing, she covered her mouth: "The face is so big!"

The artist had worked closely from a photograph: the high cheekbones, the rounded mouth. A vague outline of factory dormitories rose in the background. She turned to the next page, where there was a typical *New Yorker* cartoon: a couple arrived at a dinner party; the caption read: *"'Please forgive us for being so late—we had parking issues.'"*

She leafed through the magazine, pausing every once in a while to study something: a detail in the article, a cartoon, a poem. After she finished, we went out to a park, and I asked her if there had been anything in the article that she disagreed with.

"I think you were too critical of the boss," she said.

I replied that she had never spoken positively of him, especially after all of his attempts to sleep with the young women in his factory.

"I know," she said. "I didn't like him. But I knew there was nothing he

could do to me. The more I think about it, the more I feel sorry for him. He was pathetic."

IN FULING, EMILY had been one of my most motivated students, the kind of person who was full of questions about American culture. Back then, she had always seemed to be searching for something: once, she sent a letter to the Country Music Association, in Nashville, Tennessee, because she was curious to know what country music was like. (They never responded.) Her journal entries were usually the most thoughtful in the class. As a teacher, I had hoped that she could find some way to continue her education.

In Beijing, though, she seemed distracted, and I sensed that she wasn't particularly engaged in her English studies. It reminded me of something she had written for my class back in 1996, a story about her sister's decision to move to Shenzhen:

Now my sister has been in that prosperous city for five months. I wonder if she still remembers that conversation, and if she is still full of energy.

Several times, she told me that the emptiness of the future depressed her. In the Overnight City, she had succeeded—she had a good teaching job at the private school, and her boyfriend was doing well at the appliance factory. At twenty-five, she had reached the age when most of her friends were marrying, buying apartments, and raising their only child. But for some reason she couldn't bring herself to do it. She had trouble explaining herself; whenever we talked about it, she could say only that normal life seemed bleak and petty—a steady accumulation of possessions. She hated the way that people in Shenzhen thought constantly about real estate, buying an apartment and then trading up, and then doing it all over again. It was the worst of both worlds: trapped in these little spaces that you owned, but with the insecurity of constantly trying to move into the next one.

Her younger brother had never been able to hold down a regular job, because of his psychological troubles, and this weighed heavily on her. A while back, she had asked me for the phone number of Hu Xiaomei, the Shenzhen radio show host. Emily promised that she'd use it only in an emergency. In Beijing, she told me that she had finally called the woman last year, when her brother was going through a particularly bad spell.

"Was she helpful?" I asked.

"Yes," Emily said. "We talked about it and she made me feel better."

"Did she give you any advice?"

"She told me to have confidence in myself," Emily said.

In Emily's opinion, her brother would have been fine if others had been more accepting of his differences. In high school, people had labeled him as strange, and the teachers had allowed the other students to bully him. She asked me how disabilities were handled in the United States, and I gave her some articles about the issue. But mostly I felt helpless; her world had become far more complicated than the one we had known in Fuling.

I thought that it might help for her to talk with other foreigners, and in Beijing I introduced her to a Chinese-American friend named Mimi Kuo. That June, while I was on a trip to the States, Mimi sent me an e-mail: "I saw Emily the other day and she seemed to be doing ok. We had a nice afternoon—she came over for lunch and we hung out for a while, talking and listening to music (she wanted to know what country music was like)."

A couple of days later, Emily wrote:

> *Mr. Hessler,*
>> *How's everything going?*
>> *I visited Mimi on Sunday and had a very good time talking with her. She has the nature of putting people at ease, I think. We chatted about a lot of things, including "Country Music," which I found quite different from what I had imagined. I had literally taken it for granted that Country Music was about flowers, grass, brooks, sunshine, country people and their plain love, and everything beautiful and happy.*

That summer, she returned to Shenzhen, but she didn't marry and she didn't buy an apartment. She worked for another year, studied in her spare time, and tested into graduate school in Chongqing. It was a new program that trained teachers to work with disabled children. When Emily called to tell me that she had been accepted, it was the happiest she had sounded in years.

ONCE, WHILE SHE was still working in Shenzhen, Emily had written a letter that mentioned my research for the magazine article:

> *Your appearance lightened up my college life. It's you that let me know that a teacher could get along with his students that way. You never know how much fun I took in reading your feedback in my journal book. It could ease my worries and make me think.*
>> *I always enjoy talking with you, you are the one who knows my everything. . . . But everytime you went back to Beijing [after reporting in Shenzhen], I felt the panic of hollowness. As if I had given everything out but gotten nothing in return.*

When I had first arrived in Beijing, the transition from teacher to writer hadn't seemed so difficult. The basic role was similar: I was the outsider who sifted information between worlds. But over the years, as I thought about what Emily had written, I realized that there would always be something unnatural about being a foreign correspondent. As a teacher, I had taken information from far away—American culture, English literature—and introduced it to a classroom of living Chinese students.

But a writer's work moved in the opposite direction. I started with living people and then created stories that were published in a distant country. Often, the human subjects of my articles couldn't even understand the language in which they were written. From my perspective, the publishing world was so remote that it seemed half real. Once a year, I visited editors in New York, and I rarely heard anything from readers of the magazine. Usually, I wrote only two or three articles a year, which was adequate to live simply in a country like China. The fee for a single published word in the *New Yorker*—more than two dollars—was enough to buy lunch in Beijing. With one long sentence, I could eat for a week. Those were the exchanges of a freelance foreign correspondent: people and places were distilled into words, and the words were sold.

Whenever I received copies of my *New Yorker* articles, I found myself flipping through the pages, thinking about the gap between the world where I lived and the world where I published. I traded on that gap—that was my margin, and the advertisements reflected the breadth of the divide. In one published story, anecdotes about Fuling students were interspersed with ads for Orb Silversmiths, the Tribeca Grand Hotel, and Wildflower Log Homes ("lots starting at 49k"). The article about Polat was entitled "The Middleman," and it began with the sentence, "You can buy anything in Yabaolu." On the facing page, an ad said:

> Every year the world's leaders join 400 of the brightest
> business students at the Yale School of Management to
> discuss the challenges and opportunities
> facing business and society today.
> Be a part of it.

More than a year after Beijing won the right to host the 2008 Olympics, I received an e-mail from the daughter of Driver Yang. I had written about him in the *New Yorker*, too. His daughter went by the English name Cindy, and she was enrolled in a graduate program in engineering at the National University of Singapore. She wrote: "Do you know Sinapore English is difficult to understand. We call it Senglish. when I talk with Sinaporean I always can not

understand enough them. I hope can improve my English via communicating with you."

It was hard to believe that the simple man in his surplus military uniform had a daughter who had gone abroad to study. When I asked about her work with computer languages, she responded:

All my work is under Linux, because under Linux the graph is more stable. Now I am doing my project about mixed reality. The meaning is virtual reality and augmented reality mixed together. I work in a special room. On the top of this room have the tracking system. They can send ultrasonics, and same time if take a wand the tracking system can find track your position. Because the wand can receive the ultrasonics. . . .

So in my project I and my friend will to go virtual world from augmented world to rescue our friend. We will have a fight with the enemy in the virtual world. If we win we can take our friend to come back the augmented world. I am very interested in my research work.

* * *

EVERY SEMESTER, I sent off one hundred letters to my former students, and every year I made at least one trip back to Fuling. Sometimes I visited former students in the schools where they now taught—remote places where the schoolchildren gathered around, wide-eyed and laughing, amazed at the visitor. Often they had studied English for four or five years without setting eyes on a foreigner.

I wrote the letters and made the trips because I enjoyed going back, but it was also a way of reminding myself of the limitations of a foreign correspondent. The distance was unavoidable; that was the nature of writing and you had to find ways to balance it. And I always remembered that there was at least one faith that connected the teacher and the writer. Whenever a person studied another language, and went to another place—or even imagined it—there was a chance that he would gain a new perspective. He might misinterpret information, and the material might confuse him; I had seen that happen time and time again. But if there were patience and determination and honesty, then a glimpse outside might help somebody become more comfortable with his place in the world.

In 2001, the Chinese Ministry of Education published a plan to expand the study of English. The subject would become compulsory from the third grade on; eventually, more than two hundred million Chinese children would be studying English, as well as every Chinese college student. (In contrast,

less than 9 percent of American undergrads are enrolled in a foreign-language course.) In the new Chinese curriculum, the ministry emphasized the usual reasons for studying English, namely to prepare young people for interacting with the outside world. But the curriculum also noted that teaching the foreign language would "develop individuality."

In Beijing, I met with a ministry official named Zhang Lianzhong to talk about the new plan. He had attended graduate school in England, and he spoke fondly about his years abroad. When I asked him about that word—"individuality"—he acknowledged that it was a new concept in Chinese education. "It's like the French idea of humanism," he said. "In the document, we never use the word 'individualism,' because that has negative connotations in China. So we go around it. We say that learning a foreign language can help develop independent people. We want to emphasize the uniqueness of each person."

Over the years, I received hundreds of letters from Sichuan and Chongqing. Former students wrote, but it was even more common to receive letters from their own students. The postmarks came from all over, a blur of tiny villages and forgotten townships, but each child used the language in her own distinct way:

I have made some progress in English. But I find some idioms and useful expressions hard to learn. For example "have a cold" and "catch a cold." "Have a cold" is something you have and "catch a cold" is something you do. First you must catch a cold. Could you give me some advice? Please?

My aunt even told me that I must study English hard. If I study it well, I can go to the capital of Norway—Olso. I want to learn English better in order to go to Olso. But I'm worrying about if I can learn it well. I hope you hepe me. And give me some advices.

I'm a Chinese girl and studing in No. 1 Middle School of Xiushan in ChongQing. Your student Zeng Bing is my English teacher. I'm sixteen years old, but I only 1.45 metres tall. Some classmats laughed at me, but I didn't angry. I'll say to them, I'm encapsulate prime. I think this is self-confidence. I need it, because self-confidence is first cecret of success!

<div align="center">* * *</div>

IN OCTOBER OF 2002, William Jefferson Foster purchased a new notebook for his Voice of America journal. The entries became longer and more detailed, and then, in November, they gained a new element:

November 2, 2002

"And in the name of freedom, the United States of America will lead a coalition to disarm him."

An American worker can make 25 cars a year compared to 1.5 cars by a Chinese counterpart.

November 10, 2002

My daughter was born at 2:25 PM in Yueqing. I am too excited.

Phillipphines. A small plane crashed today early before it took off killing at least 14 people on board. . . .

November 14, 2002

My daughter is fine today. Mum told me she cried for a short time last night. She enjoyed milk very much and had much. She is lovely.

. . . . The announcement came during the closing session of the 16th communist party congress. . . . Chinese officials in Xinhua News Agency confirmed that Chinese president Jiang Zemin is retiring. . . .

UN Secretary general Koffi Anna says Iraq's cooperations with weapons inspectors on the ground is a big issue.

November 19, 2002

Today I don't have many classes. My daughter is pretty fine. Nancy and I have finally decided her name in Chinese—Dai Yuecan. Which means that she was born on a Sunday. She will have a promising future and she will be happy all her life. Several of my collegues come to see my daughter. They speak highly of her. I'm very happy.

President Bush is on his way to po where he will take part in the NATO summit and ceremony inviting several central East European Countries to join the alliance. . . .

December 15, 2002

Today we took a pedi-cab to the local hospital to get my daughter vaccicated against hepatitis. But the fucking doctors were off work on weekends.

December 19, 2002

Tomorrow marks the 40th day's anniversary of my daughter's birth, we will go to the photography shop to take pictures of our daughter. These pictures are very important. Because these pictures will be the first one since Yuecan was born. . . .

> *Bush is expected to make his first public comments on Iraq's weapon declaration today.*

During one of my visits to Wenzhou, Willy showed me the journal, and I asked why he combined the diary of fatherhood with the VOA notes. He told me that when his daughter got older, she might find it interesting. "It will help her recall many things that happened in the past," he said. "Maybe the world will be very different by then. It's a real history book for her, about herself as well as the world."

AT THE END of that school year, before the exams, one of Willy's colleagues received the best tip yet. It was an actual government document—something that had been leaked from the Wenzhou educational authorities. The paper clearly outlined one section of the examination.

Once again, Willy took the document and walked some distance from the school. But this time he faxed it to a Wenzhou cable television station, which ran an exposé program called *Zero Distance*. Such programs were becoming popular across China. The journalists weren't allowed to directly attack the Party or the highest levels of government, but they often exposed local corruption.

Willy followed up the fax with a phone call. He was careful to use a public telephone, and he refused to give his name. He identified himself only as "a teacher from the countryside." He recommended that the station send a reporter to interview students as they left the examination halls. With the document in hand, they could prove that there had been a leak.

After *Zero Distance* exposed the cheating, a number of regional newspapers picked up the story. *Nanjing Weekend* ran an article:

INVESTIGATION OF LEAKS AT THE WENZHOU HIGH SCHOOL ENTRANCE EXAMINATION

AT 2:34 IN THE AFTERNOON OF JUNE 12, *the office of Wenzhou cable television's "Zero Distance" program received a telephone call from a middle-school English teacher who did not want to mention his name but provided some unusual facts. . . .*

During the reporter's investigation, she understood that the mysterious man who had sent the fax was very careful. The fax and telephone calls were both made from public telephones. The reporter was unable to find the man.

Willy didn't tell me about what he had done until many months later. He said that after the story broke, security officials appeared in the local schools, asking questions. But it was clear that they were trying to trace the original leak, not the anonymous fax, and he hadn't been particularly worried. When I asked why he had taken the risk, he said, "I did it because of the countryside students. Whenever this happens, it's only the cities that get the information. It's not fair for the students who come from the countryside."

The Misprinted Character
毛主席无岁

ONLY ONE OF CHEN MENGJIA'S SIBLINGS IS ALIVE. FOR SOME REASON, Old Mr. Zhao never mentioned that there was another relative, but the curator of the Shanghai Museum tells me that a younger brother still lives in Beijing. His name is Chen Mengxiong—all five Chen brothers had that same character, *meng*, or 夢, in the first part of their given names. It means "dream."

Mengxiong—"Dream of a Bear"—is a retired hydrogeologist, and a member of the Chinese Academy of Sciences. In 1946, he performed surveys in the Three Gorges region of the Yangtze; back then, the Kuomintang was preparing to build a dam with the assistance of American engineers. In English it was known as the Yangtze Valley Authority, named after the Tennessee Valley Authority. Mengxiong evaluated the risk of earthquake along potential sites.

At eighty-five, he is still a big man: tall, white-haired, with thick hands that fiddle restlessly while he speaks. We meet in the living room of his small apartment on the Third Ring Road. His wife brings two cups of tea and greets me politely before disappearing into another room. Mengxiong remarks that he is fighting a cold. He looks tired and slightly wary; I sense that this will be a short interview.

He shows me the only photograph that was ever taken of the entire Chen clan. Of all the ways that one can capture a sense of time, the most powerful might be a picture of a big family, and this is particularly true of China in the 1920s. In the Chen family photo, the two parents sit in the center, dressed in

dark robes of silk. The father's black skullcap is of a style that recalls the days of the Qing dynasty. At his feet, Mengxiong and his youngest sister are dressed in the loose gowns of young children. Mengjia (Dream of Home and Wealth) and his next brother (Dream of a Scholar) wear the traditional long black gowns of Chinese students. Their oldest brother (Dream of a Hero) looks completely different, in tinted glasses and a Western suit and tie. The oldest sister—lipstick, styled hair, well-tailored coat with thin lapels—wouldn't have looked out of place in an American city. A family in transition; a nation on the move. Dream of the future. 夢.

MENGXIONG TELLS ME that in 1957, after his brother had defended traditional Chinese writing, he was labeled a Rightist. The Party sent him to Henan province, where he was to be reformed through labor.

"He spent two or three years there," Mengxiong says. "I'm not sure exactly what kind of work he did, but I know that he also found a way to do some archaeological research while he was there. I was quite busy during those years. I had a lot of responsibility, which was why the Party didn't give me a hat. You know what that means? *Dai maozi*—to put the hat on somebody. Once you wore the hat of the Rightists, then you couldn't work. Fortunately, my job was needed, so they didn't put a hat on me."

He continues: "I don't remember exactly when Mengjia came back. But they didn't remove his hat until 1963. We didn't see each other much in those days. In the past, he had always been outgoing, but when he returned he didn't talk much."

The old man coughs and takes a sip of tea. We have been chatting for half an hour, mostly about the family and Mengxiong's research, and this is the first time that he has touched on politics. But now the story wanders off again; he remembers his brother's broad interests, ranging from the oracle bones to Beijing opera. He talks for a while about the Ming dynasty furniture, and then his face hardens.

"My brother always said that he wanted to donate that collection to the nation," he says. "But in the end Old Mr. Zhao sold them to the Shanghai Museum. Originally I was friends with him, but not after that. Mengjia wanted that furniture to be donated, not sold. I never talked to Old Mr. Zhao after that."

In Shanghai, the curator had told me that Lucy Chao initially agreed to give the furniture to the museum in exchange for a relatively small sum of money. But she abruptly withdrew the offer, and the curator believed that Old

Mr. Zhao had convinced her to do so. Later, after Lucy's death, Old Mr. Zhao made the donation and received a significantly higher amount. I ask Mengxiong why he had done that.

"He's greedy," Mengxiong says flatly. He explains that some of Chen Mengjia's letters and photographs also appeared for sale in Panjiayuan, a local antiquities market. Old Mr. Zhao claimed that a maid had stolen them from the courtyard home, but the incident infuriated Mengxiong. Articles about the dispute appeared in the Beijing press.

The Shanghai museum curator had given me a copy of the letter in which Chen Mengjia had declared his intention to donate the furniture. I have the document in my bag, and I hand it to Mengxiong. The old man puts on glasses. Suddenly the room is very quiet.

"Where did you get this?" he says.

"Ma Chengyuan gave it to me," I say.

Mengxiong gazes at his brother's handwriting; the minutes pass slowly. Softly, he reads aloud the date: 1966. That was the year of the suicide. The old man says, "I've never seen this letter before. Can I have a copy?"

IN CHINA, PEOPLE often speak circuitously when confronted with an uncomfortable memory. The narrative emerges loosely, like string falling slack onto the floor; the listener has to imagine how everything connects. Sometimes the most important details are omitted entirely. But when the Chinese do decide to speak openly, their directness can be overpowering. Often, there is no visible emotion: just the simple straight words. And something about seeing his brother's letter causes Mengxiong to pick up the story and pull it taut. For the next hour he speaks without fatigue.

"Once Mengjia returned from being a Rightist, he just wrote every day," the old man says. "He wrote constantly about the oracle bones and archaeology. He didn't seem to care about anything else. There were so many materials left when he died; much of it hadn't been published."

He says that Lucy was also writing during those years. But in the summer of 1966, it became impossible to find refuge in work anymore. And Mengjia's personal history made him a natural target: he had spent years in the United States; he was a collector of antiquities; and he had defended the Chinese characters.

"That August, the Red Guards started their campaign against old things," Mengxiong remembers. "I was being struggled against. My oldest son was about nine, and I told him to go over to Mengjia's home and warn him. Mengjia

had so many old paintings and books and things; I told him to throw them out or hide them. My son returned and said that everything was fine."

The old man gazes out the window, his thick hands fidgeting.

"I believe it happened that night," he says softly. "I can't remember for certain—"

He thinks for a moment. "I'm certain," he says finally. "That night was the first time Mengjia tried to kill himself. He took sleeping pills, but he didn't die. They took him to the hospital. The next day I heard the news, and I went to his home. There were Big Character posters on the door, criticizing Mengjia. I entered and realized that the courtyard was already occupied by Red Guards. They were using it as a kind of neighborhood base. And I was captured immediately. 'Good,' they said. '*Zi tou luowang.* You've cast yourself into the net.'

"Mengjia's wife was there, too, and they seated her and me on chairs in the courtyard. The first thing they did was shave off half our hair. At that time, it was called the Yin-Yang Head, and it was a common punishment. After that, they took off their leather belts and started beating us. First they used this part—"

The old man touches the leather tip of his belt. Then he slides his hand to the buckle. "After a while, they used this part, the metal. That's when I started bleeding. They were beating me on the head, and I was wearing a white shirt—it was summertime. It turned entirely red with blood. They weren't beating Lucy on the head like that. After a while, I was getting seriously hurt, and I asked them to let me get some bandages at the local clinic. I explained that otherwise I was going to bleed too much, and I promised to return immediately. Finally, they agreed. But while I was at the clinic, I made a phone call to my work unit, and they immediately sent some people over. They explained that I was a good person, and the Red Guards let me go. On my way home I saw my wife—not the same wife you've met, but my wife at the time. I told her to hurry home. That was a terribly dangerous time. That evening you could hear them all night long, knocking on doors and beating people."

He continues: "Mengjia was in the hospital for a while, but they expelled him because of his background. And I didn't go back to his home; it just wasn't possible. After about a week, he killed himself. They had a live-in maid, and I think she was the one who found him. When I heard about it, I couldn't go to his home, because I was being struggled against. There wasn't any funeral."

CHEN MENGXIONG IS a member of the Communist Party. He was not a member when his brother committed suicide, and he was not a member in 1970, when the government sent him back to the Three Gorges to work at a dam site called Gezhouba. His job, once again, was to evaluate the risk of

earthquake, but this time he performed his task under the Communists instead of the Kuomintang. The Yangtze Valley Authority was but a memory; in New China, nobody would allow an American-inspired name.

Hydrogeologists use a standardized numbered system to indicate earthquake risk, and Chen Mengxiong rated the Gezhouba site as a six. It was a borderline figure: at seven, dams have to be designed with extensive anti-earthquake features. After Mengxiong's evaluation, the vice-director of the project told him to change the rating to a five. Mengxiong refused, and for a while he worried about possible repercussions. But there were so many other distractions that nobody organized a political campaign against him.

The cadres at Gezhouba followed a strategy known as the "Three Simultaneous." This involved simultaneous surveying, planning, and construction. In the past, people had viewed these elements in a linear fashion: first you survey, then you plan, finally you build. But none of the old rules applied during the Cultural Revolution, and the cadres believed that surveying, planning, and construction could be performed simultaneously. And so people dug holes while Mengxiong surveyed, and engineers planned while still more holes were being dug. In 1973, Zhou Enlai finally commanded that the project be abandoned. In three years, they had accomplished nothing. Work on the dam wasn't resumed until Reform and Opening, and it was finally completed in 1988.

That was the same decade that Chen Mengxiong, past the age of seventy, finally joined the Communist Party. He did not become a member out of faith; he joined simply because, in the Ministry of Geology, he had reached a level that required membership. Otherwise he wouldn't be allowed to attend certain meetings. Like so many Chinese nowadays, Chen Mengxiong's true politics are those of the pragmatist.

When you look at a photograph of a big family in the 1920s, and see the Qing-style gowns and the Western suits, the bright young faces and the proud old parents, you wonder what the hell happened to all that time and talent. 夢.

MENGXIONG'S STORY DOESN'T end with his brother's death. He pauses to sip more tea, and then he continues.

"My wife had problems that year," he says. "She had a bad class background. Her father was a famous calligrapher, and he had been in the Kuomintang administration. So she always had lots of problems. When the political campaigns started in 1957, I happened to be away for work, and she was alone in Beijing with our child. She was so frightened by the anti-Rightist campaign that she became mentally ill. She spent a year in the hospital, and then she

recovered somewhat. Previously, she had been a physics teacher, but afterward she couldn't handle that. She joined another work unit.

"In 1966, not long after Mengjia died, her work unit asked her to copy revolutionary songs onto carbon paper. She wrote the lyrics: 'Ten thousand years to Chairman Mao, ten thousand years, ten thousand years! Ten thousand years to Chairman Mao, ten thousand years, ten thousand years!' It was the same thing over and over. But she made a mistake on one word. She wrote *wu* instead of *wan*."

Mengxiong inscribes two characters into my notebook:

万岁

Wan sui. Ten thousand years. Then he writes two more:

无岁

Wu sui. In their traditional forms, *wan* and *wu* look nothing alike: 萬 and 無. But the simplified characters are easily confused, and in 1966, Chinese had been writing the new forms for less than a decade. *Wu* is defined as "nothing, nil." The woman's mistake meant: No years to Chairman Mao.

"She was immediately taken into custody," Mengxiong says. "For about five years, she was held in Hebei province. For some of that time, she was kept in a pigsty. After she came back, in the early 1970s, she was never the same. Eventually, her health deteriorated even more and she was in a vegetative state for the end of her life. She died in 1982."

The old man gives a dry Chinese laugh that has nothing to do with humor. "That was an awful time," he says. "Many people died. There were so many famous scholars and artists who were lost. Nowadays, the young people in China don't know anything about Mengjia. They don't know his poems or his scholarship. It's been almost forty years since he died."

23

Patton's Tomb

June 2002

SIGHTSEEING HAD BECOME ONE OF OUR ROUTINES IN THE DISTRICT. Whenever I came to town, we spent at least a day out in the city, visiting the places that interested Polat. Arlington National Cemetery was one of the last destinations on his list. He picked me up in the Honda, and we stopped for lunch at an outdoor café. It was a perfect day in June.

He had recently switched apartments and jobs. He still lived in Chinatown, on Sixth Street, but now he had moved into the adjoining building. He was upstairs from his Uighur friend; it was much better than sharing space with the Chinese landlord. Polat still delivered, but now he worked for Spices, another Asian restaurant, which drew higher tips. The boss was Singaporean Chinese. When the Singaporean had first come to the United States, he had washed dishes at a Vietnamese restaurant; now he was a millionaire who ran his own business. The boss had made a point of telling this story to Polat when he started work there. At Spices, deliverers made five dollars an hour, plus tips.

Over the past two months, the Honda had required a number of repairs (a thousand dollars), and the parking tickets continued to accumulate (another three hundred dollars). But Polat's English was improving and he felt more confident when problems arose. One recent evening, he had delivered to a man who attempted not to pay. The customer simply took the food, thanked Polat, and shut the door. Polat waited outside for a while, and then he began knocking. Finally, the man returned, explained that he had no money, and closed the door again. Polat knocked some more, and then he yelled out that he was

going to call the police. After that, the man paid. He said that he had been "only joking."

In Polat's opinion, immigrants who looked Middle Eastern or Central Asian had it the worst of all the minorities in the District, at least since the attacks of September 11. "It's gotten harder for Uighurs who are looking for jobs," he said. "One of my friends is named Mohammad, and he was applying for a position recently. There was a white person taking the application. The white person looked at the form, and then he noticed the name and looked up: 'Oh—Mohammad.' He said he'd call, but he never did. This happens a lot."

I said that it would probably get easier over time, but Polat shook his head.

"Something like this doesn't just go away," he said. "I don't believe that those feelings will just disappear. Actually, they get deeper and deeper over time. Every time that people see the pictures on the television, and every time they hear the words 'bin Laden' or 'Islamic' on the news, it adds to those feelings."

He still hadn't heard anything about his wife's application for a visa to join him in the United States. The immigration bureaucracy had slowed down, and for months it had been the same—tense late-night phone calls from Chinatown to Xinjiang.

Halfway through lunch, he got up to check the parking meter. After the meal was finished, we sat talking in the sunshine, and I asked if he had any regrets about coming to America.

"There's a Uighur saying," he said. "'A man with regrets is not a real man.' There's no use worrying about that. And I believe that every immigrant who comes to America has a difficult time at first. The early years must be difficult for everybody."

THE CHINESE GOVERNMENT had continued to push for the United States to include Uighur independence groups in the war on terror. In late January, China's State Council released a report claiming that an organization known as the East Turkestan Islamic Movement, or ETIM, had received funding and weapons from Osama bin Laden. According to the Chinese government, the ETIM had been responsible for a number of terrorist acts in Xinjiang during the past few years.

The day after the report appeared, the leader of the ETIM granted a telephone interview to Radio Free Asia. The man's name was Hasah Mahsum, and he refused to disclose his location; he could have been anywhere in Central Asia. On air, he emphasized that his organization had received no financial

assistance from Osama bin Laden or Al Qaeda. "We have no organizational relations with the Taliban," Mahsum said. "We have enough problems to deal with."

Almost nothing was known about Mahsum, or the ETIM, or many of the other Uighur groups that had been identified by China's State Council. Over the past decade, attacks in Xinjiang had been sporadic and anonymous; formal organizations didn't take credit for the violence, which made it difficult to analyze. There were only scattered pieces of information, and often they didn't make sense. It seemed odd that a supposed Islamic fundamentalist terrorist would choose to make his case on an American-funded station—that was the equivalent of Osama bin Laden sending his tapes to the Voice of America instead of Al Jazeera. The connections didn't add up: the Chinese claimed that the ETIM was linked to Osama bin Laden; the ETIM made its case on Radio Free Asia; Radio Free Asia was supported by Jesse Helms and other patriotic American conservatives. Something was getting lost in translation.

EVERY TRIP BACK to the United States reminded me that, from my perspective, there would always be a hole in the nation's history. I saw the new flags, and the increased security at airports, and the barricades that had been erected in cities like New York and Washington, D.C. The language had new phrases: the war on terror, the Axis of Evil, code orange, the Patriot Act. I boarded the plane in the Motherland and disembarked in the Homeland. I had always thought it was a bad sign for nations to use words like that, and living in China had convinced me that it was unhealthy when people became obsessed with days on which terrible things had occurred. But this observation was easily made from a distance. On September 11 of 2001, when history happened in America, I hadn't been home.

In China, that had always been my perspective as a foreigner. I had arrived in a country that was recovering from trauma, where the people sorted through echoes and memories. The actual events were unknowable but the shadows were alive; artifacts mattered, and so did stories. Coming from the outside, I was often impressed by the arbitrariness: the coincidences and confusions, the events that mattered and the ones that were allowed to disappear. The divide between meaning and chaos often blurred.

My journeys between China and the United States came to feel the same way—a blurring of old boundaries and distinctions. When I first lived in China, I was mostly struck by differences, but over time the similarities became more obvious. Americans and Chinese shared a number of characteristics: they were pragmatic and informal, and they had an easy sense of humor. In both nations,

people tended to be optimistic, sometimes to a fault. They worked hard—business success came naturally, and so did materialism. They were deeply patriotic, but it was a patriotism based on faith rather than experience: relatively few people had spent much time abroad, but they still loved their country deeply. When they did leave, they tended to be bad travelers—quick to complain, slow to adjust. Their first question about a foreign country was usually: What do they think of us? Both China and the United States were geographically isolated, and their cultures were so powerful that it was hard for people to imagine other perspectives.

But each nation held together remarkably well. They encompassed a huge range of territory, ethnic groups, and languages, and no strictly military or political force could have achieved this for long. Instead, certain ideas brought people together. When the Han Chinese talked about culture and history, it reminded me of the way Americans talked about democracy and freedom. These were fundamental values, but they also had some quality of faith, because if you actually investigated—if you poked around an archaeological site in Gansu, or an election in Florida—then you saw the element of disorder that lay just beneath the surface. Some of the power of each nation was narrative: they smoothed over the irregularities, creating good stories about themselves.

That was one reason why each country coped so badly with failure. When things went wrong, people were startled by the chaos—the outlandish impact of some boats carrying opium or a few men armed with box cutters. For cultures accustomed to controlling and organizing their world, it was deeply traumatic. And it was probably natural that in extreme crisis, the Americans took steps that undermined democracy and freedom, just as the Chinese had turned against their own history and culture.

Even the worst moments, though, were but a glimpse of how history seemed to a marginal group like the Uighurs. From Polat's perspective, the world had always been arbitrary and unpredictable, and it always would be. Later that summer, in August, he would telephone me in Beijing and say that his wife had asked for a divorce. She was tired of waiting, and emigration from Central Asia to the United States seemed far less appealing than it had two years before.

Later that same month, the American deputy secretary of state, Richard L. Armitage, would visit Beijing and announce that the United States had named the Uighur group known as the ETIM as an enemy in the war on terror. Many analysts would criticize the decision, believing that it gave the Chinese more license to oppress native groups in Xinjiang. But the United States needed to prepare for the debate on Iraq in the United Nations, where China held a per-

manent seat on the Security Council. In Beijing, Armitage told reporters, "All in all, I think the counterterrorism cooperation is a pretty good picture for the U.S. and China."

But that was still in the future on that June afternoon in Washington, D.C. It was a gorgeous day; there wasn't a cloud in sight. Polat drove the Honda across the Potomac and into Arlington.

WE STOOD FOR a long time at the tomb of John F. Kennedy. The cemetery was crowded, but people grew silent when they saw the eternal flame. There were only whispers and the shuffled sound of footsteps on granite.

After we walked away, Polat's eyes were bright. "Twenty years ago, I said that I wanted to visit Kennedy's tomb, and today I did," he said proudly. "When I was in Xinjiang, I saw movies about him and read books; I remember reading all those theories about his death. Some people said it was the KGB or the CIA that killed him. But those weren't the things I cared about. I always felt that Kennedy was a man who believed in freedom. He was a man who shouldn't have died."

I asked if he wanted to see anything else at Arlington. He told me that he had always wanted to have his photograph taken next to the tomb of General George S. Patton.

"The Patton movie was translated into Uighur in the early 1990s," he explained. "It had a big influence on us. There's one part where Patton talks about how much he hates Communism. He says something about how he wants to destroy every Communist place. That meant a lot to the Uighur intellectuals, because we'd been dealing with it for fifty years. My friends and I used to talk about that part of the movie."

I found a cemetery employee and asked him for directions to Patton's tomb. The man stared at us.

"It's not here," he said.

"Where is it?"

"Patton is buried in Luxembourg."

Polat had been following the exchange and now he looked confused. I tried to explain, but I didn't know how to say Luxembourg in Chinese.

"It's a small country in Europe," I said. "It's near Belgium. Maybe Patton died there—to be honest, I'm not sure."

Polat shrugged, and we spent the next half hour wandering through the cemetery. The rows of tombstones shone as white as bones in the afternoon sun. We found the Honda in the parking lot and then, as the shadows began to lengthen, we drove back to Chinatown.

The Sold Words

爱信仰命运上帝耶稣

AS A CHILD, IMRE GALAMBOS LIVED FOR FIVE YEARS IN MOSCOW, WHERE he enjoyed a series of Soviet Westerns. "They were called 'The Uncatchable Avengers,'" he remembers. "There were three or four of them. They have all the elements of good Western movies: the same cowboys, and they all ride horses. But it's all about the civil war in Russia, the period from 1918 to 1922. There was shooting, and the good guys always managed to get away. They were kids—teenagers who were sabotaging the White Army's movement. There was a Gypsy, a girl, an intellectual. They were these archetypes of politically correct people in Russia."

Galambos was nobody's archetype: half Hungarian, quarter Kazak, quarter Tatar. He spent most of his childhood in his native Hungary, which was Communist at the time. In college, he went to China to study, and then he attended graduate school at the University of California at Berkeley, where he wrote a Ph.D. dissertation about the development of ancient Chinese writing. He now works at the British Library, curating the Dunhuang manuscripts, a collection of thousand-year-old Buddhist texts that were rediscovered in the west of China during the early 1900s.

For the Chinese, it's a point of great sensitivity that these documents reside in the British Library. People often describe them as "looted," but Galambos believes that this word is used too loosely. During the Kuomintang years, when the government was weak and corrupt, officials approved the sale and export

of the artifacts to foreigners. Regardless of how one feels about the morality of these acts, they were legal: fully documented exchanges of manuscripts for money. Nowadays, Galambos works in conjunction with the National Library in Beijing, creating a "virtual library" of Dunhuang manuscripts on Web pages. The real artifacts remain in London, but their images can be accessed by a computer anywhere in the world.

Galambos's interests are not limited to antiquity. He studies texts of all kinds: past and present, formal and informal. He is skilled in computer languages, and he is studying Tangut, a dead language that survives in inscriptions found in the west of China. He is learning Uighur. During his visits to Beijing, he collects restaurant menus, to analyze the ways in which average people write characters. He is particularly interested in departures from the norm—mistakes and miswritings. Sometimes he buys bootleg DVDs and watches the Chinese-made English subtitles, which often create an entirely different narrative from the movie. Galambos once transcribed a Beijing bootleg of *Simone*, comparing the audio English to the written English:

> *[audio] "I was the keynote speaker, you must remember my speech: 'Who Needs Humans?'"*
> *[subtitle] "I was the king of speed, you must my speed means humans."*
>
> *[audio] "Simone has the voice of the young Jane Fonda, the body of Sophia Loren, the grace of, well, Grace Kelly, and the face of Audrey Hepburn combined with an angel."*
> *[subtitle] "Simone has the voice of a young clone flouter, the body of safalaring, the grace of well grace Kelly, and the face of Artyphapen combined with in angle."*

It's all connected: menus and bootlegs, history and movies, language and archaeology. Texts create meaning, regardless of how arbitrary the process may seem. "What is reality?" Galambos asks, during one of our conversations in Beijing. "It's this huge amount of data. There's this philosopher who had a lot of influence on me, Ernst Cassirer. He wrote this book called *Language and Myth*. Basically, his idea is that language itself creates reality. For example, in order to have words like nouns, you have to have concepts. When you form concepts, that's when you're creating stuff—it's a creative process. You pick out certain things from the environment, and you give them labels, and you create this reality around you. When you're a kid, you're not just learning how to speak; you're learning how to perceive a reality. It's almost like a computer language, an internal code that makes you able to think.

"From a linguistic point of view, this is a very old concept, and a lot of people nowadays don't believe it. But I think it's probably to some degree true. Perhaps if you don't have a word for a certain feeling, or a certain color of the sky, then you don't notice it. It doesn't stick out from the background. That's what words do: they make things stick out. Otherwise, it might just be a big haze of data. In a computer language, you'd call it uninterpreted data. So a language is your browser."

GALAMBOS SPEAKS FIVE languages fluently: Hungarian, English, Chinese, Japanese, and Russian. His motivation for new tongues has rarely been academic. He studied Chinese in order to escape the Hungarian army; he learned Japanese when he had a Japanese girlfriend. His English became fluent after he moved to the United States to be with a Chinese wife. Today, those women are gone from his life, but the languages remain.

In his twenties and thirties, Galambos moved around the world, picking up new languages and new skills, and in the meantime the countries of his childhood changed. Russian children no longer watch Soviet Westerns; Hungary isn't Communist anymore; there is no mandatory military service. In recent years, Galambos began keeping a home in Budapest, where he spends time whenever his job allows him to leave London. In Budapest, he lives with a woman who, twenty years ago, was a high-school classmate. When I ask him why he returned, he says simply, "I haven't been home for my entire adult life, so I decided to stay home."

After all the years abroad, he is good at comparing different cultures. He taught both Chinese and American students, and he tells me that Americans don't have the same relationship to the written word that he noticed among the Chinese. For the Chinese, writing seemed to be the root of their cultural identity, but many of his American students were unfamiliar with their nation's literary classics. I ask him if anything in American culture might be the rough equivalent of writing in China.

"Maybe it's movies," he says. "I think the movies are incredibly important in America. That's how people acquire information about the world. If you ask an American about a subject—say, Buddha—the answer is always through the movies. They'll talk about 'The Little Buddha' or some movie they saw."

He continues: "I think the movies create this web that texts traditionally created in China. Within the Chinese texts, there was a view of reality, which was a view of other texts. The scholars who lived in this world, they saw their culture as a web. They didn't live in this physical world; they didn't talk about the physical world. It was all about history and writing. And America is the

same way about movies. People in the movies talk about other movies all the time. There's an enormous reality, like 'movie space' or something, in America. By this time, it's really built up, and it's a world that exists on its own. A lot of people experience reality through that. It's true for me when I'm in America. I watch a lot of movies when I'm there, and I feel like reality is American movies. You might say something and then I'll say, oh, that reminds me of something in a movie. It's like dreams and realities, all blending together. You have this feeling, this déjà vu feeling about everything.

"The movies are writing. They serve the same purpose; it's just a different language. In China, they wrote the most in the times when they most needed to redefine themselves. It's not passivity; it's creativity. It's not taking notes. It's about rethinking the past and creating the present. It's about justifying the present, creating the ideology. So in America they have these movies that make people feel American. Like *Pearl Harbor*. It's similar to writing, to books. But the movies stay in the mind longer, maybe because it's a more visual language. And it becomes a way that people determine their values. You have these models and patterns that are ready to use. They give you a language, just like books do. They give you a language to parse out your personality, to understand it, or display it, or express it."

I ORIGINALLY MET Galambos on the Internet. One afternoon, a Google search turned up a Chen Mengjia quote that had been posted at www.logoi. com, and I contacted the editor: Imre Galambos. It turned out that we knew people in common—at Berkeley, he had studied under David N. Keightley, the oracle bone scholar.

Galambos established his Web site in order to sell language-learning software, and he also posted information about the Chinese writing system (thus the Chen Mengjia quote). Soon, though, he began to receive e-mails from young Americans, often with a certain request:

HI! IM DOING A REPORT AND I NEED THE CHINESE AL-
PHABETE FROM A-Z. IF YOU COULD HELP ME IT WOULD
BE GREAT.
THANK YOU.

im lookin 4 an alphibet of chinese writing or fonts which seems extremely
hidden on the web to me if u can point me in the right direction it would
b much obliged
thank you

I am getting a tattoo in memory of a friend who was recently murdered. I would like to know the characters, symbols, or letters to get the tattoo. DeAndra, Love and Angel. I want these in Chinese writing or symbols for me tattoo. can you please help me?

Galambos responded by e-mail, and he also posted additional information on his Web site. He explained that Chinese does not have an alphabet; it's a logographic system with thousands of characters. But that turned out to be a mistake. By combining the words "Chinese" and "alphabet"—even in the context of denying that there was such a thing—he was guaranteed to get Googled by anybody searching for it. Now the requests appeared in a flood:

could some one send me either the chinese alphabet or at least three of the letters. . . . I need a (C) a (D) and a (G) thank you my daughter wants these letters so she can have them tattooed on her back.

I really need the letter R in chinese. it would be great if you could let me know where i can find it. thank you very much!

Can you give me happy birthday in chinese by 12:00 today? Thanks

My cat smokey has just recently past away. i would like to have the chinese symbol for smoke or smokey put on the box with his ashes can you help me

please send me info on the Chinese Army

Hello i've been looking Hi and Low for some chinese lettering for a tattoo. if you can please help me. "Fear no Man", "Only the strong Survive" please write back.

I think you should have something about hte people in China. Like who the first emporier was, and important people like that. I went to this site to look for the first emporier. But, I can't find it. And I don't think this stuff is "anceint".

The symbol for "House Music" is what??

Galambos tried to be patient—Chinese does not have an alphabet; it's a logographic system with thousands of characters—but people refused to take no for an answer. They became angry:

Your sight SUCKS! Iwant the Chinese Alphabet Now!

GET SOME CHINESE NAMES I THINK IT STINKS

YOUR WEBSITE S CKS THE BIG ONE !!!!

Hi I would like to make one comment on your web site. You are fucking stupid to name your website the chinese alphabet where is it. The reason because people are trying to find it not an explanation on why it is not around people just want the alphabet, so give it to them.

One of Galambos's friends agreed that that was a good idea. "He said, 'Why don't you just give it to them?'" Galambos remembers. "So we sat down and tried to figure out what can pass for the Chinese alphabet. Somebody suggested that we send them the Chinese encoding page. It's the Unicode values, the numbers for each character. Or send them the entire set of thirteen thousand characters and destroy their in-box."

In the end, Galambos refrained from aggression. Nevertheless, he is slightly embarrassed about his response; after all, he is a serious scholar and a curator of ancient texts. But Americans kept asking him for Chinese writing: there was a clear demand, and it was up to him to supply something.

On his Web site, he posted Chinese versions of some English names—Cecilia, Jeremy, etc.—and priced them at ten dollars each. At first, business was slow: two hundred dollars a month. He redesigned the site, adding Chinese characters for things other than personal names. He also structured the site strategically, so that it would appear whenever somebody typed "Chinese symbols" into Google.

"It went up to about six hundred dollars a month," he says. "I thought that was cool. Then I redesigned it again and it went up to about fifteen hundred dollars a month. In August it was about two grand for Chinese symbols. They're just English words, more than a hundred. You choose the ones you want and you can buy them. You get a Web page that stays up for two weeks and you can download it or whatever. The most popular ones are 'love,' 'faith,' 'fate,' 'friend,' 'brother,' 'elder brother,' 'younger brother,' 'sisters'—this sort of thing. Sometimes 'God' and 'Jesus.' I had the Holy Ghost up, but nobody bought it so I took it down. I put up the Western zodiac and that day everybody was buying them, so I was like, cool. So then I translated the page into Spanish and we have people ordering in Spanish as well. And I had an idea and I put up the Japanese symbols, and now maybe about twenty percent are coming from that. It's two dollars and fifty cents per word, four symbols minimum. 'Fate' is $2.50.

"My sister in Hungary is not doing well, so I gave her the Web site. We split the money. Next I'm putting up the Egyptian symbols, and the Mayan symbols. Why not? Most people buy them for tattoos, but I get a few designers as well."

He continues: "The site has been up for about a year, and since then I've seen some Chinese who are starting to do the same business on the Internet. But the Chinese cannot sell the characters by themselves. They have to put the character on a cup, or a pen, or a T-shirt, or whatever. They cannot seem to grasp the idea—people don't need the cup or the T-shirt; they just need the fucking character. It doesn't make sense to the Chinese. It's like you selling the letter *B* to Mongolians."

24

Tea

June 2002

A FRIEND OF THE OLD MAN DELIVERED THE TEA TO ME IN BEIJING. The package consisted of two bags of dried leaves that had been picked from the Yellow Mountains of Anhui province. Late spring is the best season for tea and the sharp fresh smell filled my luggage during the flight across the Pacific.

While visiting Polat in Washington, D.C., I made a side trip to a retirement home in Reston, Virginia. Blue carpet, white walls, wheelchair rails—the place felt uniform and dull, the way that old age often appears from a distance. I followed silent hallways to apartment 823. A sticker on the door featured an American flag and the words "SEPTEMBER 11, 2001."

Wu Ningkun answered my knock, laughing with delight when I gave him the bags. "This is what they used for court tea in the old days," he said. "Look at the green color—isn't that beautiful? Later it will turn red, but when it's fresh it still looks like this."

He said the tea was something that he missed from China. Other than that, he didn't have many complaints about his new American life. I sat down and he poured two glasses of Raynal French Brandy.

WU NINGKUN LIKED to describe himself as a "war profiteer." In 1937, the Japanese invaded his home province of Jiangsu, where, in the capital city, they committed the Nanjing Massacre. Wu, who was seventeen years old, fled westward. His childhood had not been happy—his mother committed suicide

when he was seven—and the life of a refugee gave the young man a new start. After finishing high school in Sichuan, he entered college in Kunming, where he studied English. He served as an interpreter for the volunteer pilots of the American "Flying Tigers," who were fighting the Japanese from their base in Sichuan. After the war, Wu received a scholarship to Manchester College, in Indiana, where he was the only foreign student on campus. In 1948, he began to pursue a doctorate in English literature at the University of Chicago. Those were Wu Ningkun's war profits—strictly educational.

After 1949, like other young Chinese in the United States, Wu was faced with a difficult decision. A number of Chicago grads returned to the New China, including Lucy Chao. From Beijing, she encouraged Wu to come back and teach, and finally he agreed. His dissertation—"The Critical Tradition of T. S. Eliot"—was left unfinished. One of his graduate-school friends, a young physicist named T. D. Lee, came to San Francisco to see him off. Wu asked his friend why he had decided to stay in the States. T. D. Lee replied, "I don't want to have my brains washed by others."

And so the story went. In 1955, Wu was named a Counter-Revolutionary; in 1957, he became a Rightist; in 1958, he was sent to a labor camp. For most of the next two decades, he lived either in jail or in exile in the countryside. Several times he nearly starved to death. But he survived, and so did his wife, Li Yikai, who, despite all the campaigns and punishments, never renounced her Catholic faith.

In 1990, Manchester College awarded Wu Ningkun an honorary Doctor of Humane Letters. At the college's invitation, he stayed on campus to write a memoir in English, *A Single Tear*, which was published by Atlantic Monthly Press. After the book came out, Wu's work unit in Beijing revoked his pension and housing rights. He and his wife decided to stay in the United States, where their three adult children had already settled after studying abroad. In 1996, Wu Ningkun and Li Yikai became naturalized citizens.

Occasionally, Wu contributed reports to the Voice of America ("they pay for my drinks"). In one broadcast, he reviewed my first book, and then he sent me a printed copy of the commentary. That chance contact pointed me toward the past: after Wu told me about his graduate-school friendship with Lucy Chao and Chen Mengjia, I became determined to pursue the story of the oracle bone scholar.

Wu Ningkun was eighty-two years old, with thick white hair, and he had a disarming tendency to laugh when he talked about the past. The years of awful persecution didn't seem to weigh on him. He liked to tell another story

about T. D. Lee, the young physicist who had stayed in America because he preferred not to be brainwashed. In 1957, the year that Wu was named a Rightist, T. D. Lee became the second-youngest scientist ever to win a Nobel Prize.

"LET'S DRINK TO Chen Mengjia and Lucy Chao, my big sister," Wu said, using the common Chinese term of affection for a female friend. We raised our glasses, and then he stood up and went to his desk. He handed me two letters. "These are very personal," he said.

Both had been handwritten in Chinese by Lucy in the early 1990s. One letter referred to Wu's book, as well as the ancient courtyard that I had seen destroyed. She wrote:

> *I'm still excited about your publication. . . . You and Yikai can stay with me if you come to Beijing. Now I have a guest room in the west wing of the courtyard which is well equipped. And you can take meals with me.*

"I was always sympathetic to her," Wu said. "I didn't think Old Mr. Zhao treated her very nicely. According to Lucy, her father wanted to leave the house to her, but at that time she was with Chen Mengjia, so she let her brother have the family home. And then Chen Mengjia killed himself, and she lost their house, so she had to move in with her brother and his wife. They occupied the best part and only gave her a small building. They didn't treat her very nicely; the three of them didn't even eat at the same table. A widowed sister, just after the Cultural Revolution—they should have been more solicitous of her! She just had these two little rooms."

He continued, "Their characters were totally different. Old Mr. Zhao and his wife liked to play mah-jongg. And he liked playing tennis with Wan Li and other big shots. He didn't really care about teaching English. They were busy playing mah-jongg while Lucy was translating Whitman!"

Wu took another sip of brandy. His small apartment was crowded with the decorations of two cultures, and the bookshelves shifted between languages: Joseph Brodsky, 張紫葛, Vladimir Nabokov, 徐志摩, John Keats. A photograph of Li Yikai with the pope hung on one wall, near pictures of the couple's three children and their families. Two of Wu and Li's children had married white Americans. ("Those are hybrids," Wu said, pointing at his grandchildren's photos.) On another wall hung a scroll of calligraphy written by the poet 王曾祺:

往事回思如細雨
舊書重讀似春潮

*(Our memory of things past is like a light rain
Old books re-read are like the spring tide.)*

I asked Wu Ningkun when he had first heard about Chen Mengjia's suicide.

"Before the Cultural Revolution was over," he said. "I heard through the grapevine when I was in Anhui. He was not the only one. I wouldn't have done it. I could have been killed easily, because the Communists had all the bullets. They could have killed me anytime they wished, but I would not have done it myself. My mother did that and I wasn't going to do it like that."

He said that after the political struggles finally ended, he didn't see Lucy again until 1980.

"We didn't even mention Mengjia's name," Wu said softly. "That would have been one of the hardest things for me to say—if I had said I was sorry about what had happened. I knew how futile and meaningless those words were, and I was glad she didn't mention it. She didn't cry. She was very strong-willed."

AFTER THE CULTURAL Revolution, Lucy Chao suffered from schizophrenia. Eventually, she recovered enough to teach and write, and during the 1980s she translated the first complete Chinese edition of Walt Whitman's *Leaves of Grass*. In 1990, she visited her alma mater, the University of Chicago, to lecture on her translation. The following year, the university granted her its Distinguished Achievement Award. She died in 1998, the year before I moved to Beijing.

My glimpses of the woman had been secondhand. Some were brutal—Mengxiong's memory of her seated in the courtyard, having her head shaved by Red Guards. Wu Ningkun described her refusal to talk about the past, but there had been moments when the façade slipped. Elinor Pearlstein, a curator at the Art Institute of Chicago, had escorted Lucy on a tour of the institute during her visit in 1990. Pearlstein told me that the old woman was charming and buoyant until they came upon some of the Shang bronzes that her husband had researched in the 1940s. Once Lucy saw the artifacts, she became so emotional that she had trouble speaking. She said that her copies of Mengjia's book—*Our Country's Shang and Zhou Bronzes Looted by American Imperialists*—had been taken away during the Cultural Revolution.

From the beginning of my research, I had known that it was too late to discover what had really happened to Chen Mengjia. His tale had disappeared

with the old political campaigns, and he was of a lost generation: the educated elite who had struggled through the last century. Today's China was a story of the future, and it was moved by the new middle class; pragmatism had replaced the idealism of the past. The boomtowns and the migrants mattered—young people like Emily and William Jefferson Foster, finding their way in a changing country. As a reporter, it helped to be young, too. The work required energy and freedom; it was necessary to keep pace with everybody who was on the move. I traveled light: I had no family, no permanent home, no office. My bureau fit in a pocket—a chop and a few sketchy licenses.

But the longer I pursued Chen Mengjia's story, searching out old memories, the more I appreciated the survivors. That generation had wandered, too—they had fled war and famine and politics, and they had tried to reconcile Western ideas with Chinese traditions. Most of them had failed, but they hadn't lost their dignity, and somehow a spark of their idealism had survived. I recognized it in young people like Emily and Willy, who, despite the overwhelming pragmatism of their era, still cared about right and wrong.

And somehow the members of the earlier generation had achieved a stability of their own. One way or another, they had all come to rest, and there was something calming about that. After every interview with an older person, I returned to the world of daily events—the overnight cities, the breaking news—with a different perspective. All of this will pass with time.

Each elderly person handled the memories in his own way. Professor Shih worked patiently in Taiwan, excavating his old Anyang field notes. Wang Jun collected an old woman's lies in a manila folder; Mengxiong had joined the Communist Party. Li Xueqin had climbed the tower of academia, but he wasn't too proud to regret the criticism that he had written as a young man. And Old Mr. Zhao—sometimes, when others accused him of disrespecting his sister and the memory of his brother-in-law, I wondered if the destruction of the courtyard had been some form of cosmic retribution.

But each story has several points of view, and in Beijing I had also met a former student of Chen Mengjia's named Wang Shimin. Wang had served as an intermediary in the negotiations between Old Mr. Zhao and the Shanghai Museum, and he said that nobody should blame the man for accepting money for the furniture. "He had the right to do that," Wang told me. "And to be honest, other people shouldn't judge whether it's good or bad." I saw his point: instead of trying to decide who was in the wrong, it was far more important to understand how the political campaigns had damaged lives and friendships and families. And I understood why Old Mr. Zhao preferred to play tennis instead of dwelling on bad memories. That was true for all of them—I never met a sur-

vivor whose response seemed foreign. The historical events were unimaginable, as if they had come from another world, but the people's reactions were perfectly understandable. Recovery, in all its varied forms, is simply a human instinct.

But I particularly respected Wu Ningkun's calmness. His memoir hadn't been a best seller, but he had put the past in order. For any writer, that's a fundamental motivation, especially for somebody who has suffered. Writing could obscure the truth and trap the living, and it could destroy as well as create. But the search for meaning had a dignity that transcended all of the flaws.

During our conversation, the old man said that he had no regrets about his life. "If they hadn't had the Cultural Revolution or the anti-Rightist campaign, then I might have been a better scholar," he said. "I might have produced a couple of books about English or American literature. But so what? There are already so many books. *A Single Tear* might be more important."

WE WERE STILL drinking brandy when Li Yikai returned to the apartment. She had attended a local Catholic Church function—the ordination of sixteen new deacons—and she wore a gold cross around her neck. When she heard her husband talking about the past, she shook her head.

"Maybe it's because of age, but I'm so forgetful," she said. "I forget where I put things, and I forget the new things. But I still remember all the old things. Sometimes I can even remember the details, the date, the time. My daughter says, how can you remember all of these details?"

Wu Ningkun laughed and sipped his brandy.

"Such as the date my husband was arrested," she continued. "April seventeen, 1958, in the afternoon, at two o'clock. I'll always remember the time. And I remember the three visits I made to the prison in Hebei."

I asked Wu how he had kept his spirits up during the years in jail and labor camp.

"I used to think of Du Fu, Shakespeare, Dylan Thomas," he said. "Do you know the one Dylan Thomas wrote when his father was dying? That line— 'twisting on the racks.' From 'And Death Shall Have No Dominion.' It had to do with the way we behave, the way we should behave. Although we were suffering, although we were being tortured, death shall have no dominion. You know, I heard Dylan Thomas recite his own poems in Chicago. I think it was in 1950. It was very touching."

I asked Wu if he had spoken with the Welsh poet.

"No, I was just in the audience," he said. "And he was more than half drunk. He didn't know how to take care of himself. He was suffering—life was such a burden to him, I suppose."

　　　*　　　　　*　　　　　*

WHEELCHAIR RAILS, WHITE walls, blue carpet. Outside of the retirement home, I stood blinking in the afternoon light. Before me stretched a strip mall of Americana: Burger King, Safeway, Hollywood Video, Lido Pizza, Cincinnati Cafe. I wandered into a convenience store, bought a drink, and returned to a bench in front of the retirement home. The public bus was scheduled to arrive in a few minutes. Three old ladies sat on a bench nearby. They weren't waiting for anything but a conversation.

"Is it good?" one of them asked. I nodded and put down the drink.

"Watch your figure," another woman said dryly. She had a heavy New York accent.

"Who did you come here to see?" the third one asked.

"Wu Ningkun," I said. "Mr. Wu and his wife, Mrs. Li. Do you know them?"

"Of course!"

"Everybody knows Mr. Wu!"

I asked why, and the three old women stared at me as if I were an idiot.

"Because of his book, and because he went to the University of Chicago," a woman said, matter-of-factly. Her words sounded familiar—the flat accent of the Midwest. I asked if they had read the book, and then I realized that that was another dumb question. In this particular corner of Reston, Virginia, Wu Ningkun was a hometown author.

I asked the women what they had thought of the memoir.

"I liked it," said one.

"He had a hard life," said the Midwest.

"Especially when they threw him into a labor camp," said New York.

The bus pulled up; the door hissed open. Suddenly the image was clear: three elderly sisters, spinning, weaving, snipping. I paused, unsure how to end the conversation.

"You better get on that bus," said New York, and I did.

IN THE LIBRARY of Peking University, a friend helped me find a two-volume Chinese version of *Leaves of Grass*. It had been published in 1991, and the title page prominently listed Lucy Chao as the translator.

In 1994, Kenneth M. Price, an American Whitman scholar, visited Lucy in Beijing. Their conversation was published in the *Walt Whitman Quarterly*. During the interview, Price asked how she had translated the first stanza of "Out of the Cradle Endlessly Rocking," in which a long sentence builds for twenty-two lines before the subject and verb appear.

Lucy answered, "There is no way of keeping the sentence together as one sentence because I must say that, though I want to be faithful, I also want my Chinese to be fluent."

I reread Whitman's original, and then I picked up the Chinese volume. Using a dictionary for the hard characters, I did my best to bring the woman's last three lines back into English:

> 我,痛苦和欢乐的歌手,今世和来世的统一者,
> 所有暗示都接受了下来,加以利用,但又飞速地跃过了这些,
> 歌唱一件往事.

> I, *the singer of painful and joyous songs, the uniter*
> *of this life and the next,*
> Receiving all silent signs, using them all,
> *but then leaping across them at full speed,*
> Sing of the past.

An oracle-bone scholar once said: Those are the notes. We have to provide the music ourselves.

Sources

IN *RIVER TOWN*, I USED THE PSEUDONYM "ANNE" FOR EMILY, BECAUSE of concern about how people in Fuling might react to my writing. In the years since, I realized that I erred on the side of caution, and for *Oracle Bones* I decided to do away with the pseudonym (and to restore her to the appropriate Brontë). I apologize for any confusion; my only excuse is that the political climate in China creates many uncertainties for a writer.

In English publications, the oracle-bone scholar's name is sometimes written as Ch'en Meng-chia. For this book I have used the standard Pinyin, Chen Mengjia.

The city of Beijing was known as "Beiping" during the Kuomintang period, when Nanjing became the capital. For the sake of clarity, I have used only one city name, "Beijing," throughout this book.

I have not included footnotes, because they are distracting in a work of narrative nonfiction, and the vast majority of my research involved personal interviews and observation. But I also benefited greatly from written materials, and I want to identify the sources that were most useful to each section.

"The Underground City"

Clifford, Nicholas R. *"A Truthful Impression of the Country": British and American Travel Writing in China, 1880–1949*. Ann Arbor: University of Michigan Press, 2001.

I am grateful to David N. Keightley, who allowed me to read and quote his unpublished letters from China.

"The Middleman"

For information about the NATO bombing and subsequent protests, I consulted accounts in the *Wall Street Journal*, the *Far Eastern Economic Review*, the *Washington Post*, the *New York Times*, and the *Observer* in London. The Chengdu protests are described in Craig Simons's Master's dissertation ("He Who Climbs On a Tiger Might Have Trouble Getting Off: Chinese Nationalism, Protest and Control." Harvard University, 2001).

For Uighur history, I depended most heavily on one book:

Benson, Linda. *The Ili Rebellion: The Moslem Challenge to Chinese Authority in Xinjiang 1944–1949*. Armonk, New York: M. E. Sharpe, Inc., 1990.

"The Written World"

Sima Qian. *Historical Records*. Translated by Raymond Dawson. Oxford: Oxford University Press, 1994.

Galambos, Imre. "The Evolution of Chinese Writing: Evidence from Newly Excavated Texts (490–221 BC)." Dissertation. University of California, Berkeley, 2002.

"The Voice of America"

Heil, Alan L., Jr. *Voice of America: A History*. New York: Columbia University Press, 2003.

I am grateful to William Jefferson Foster, who helped me interview his parents and relatives about the oral history of Number Ten Village.

"The Overnight City"

For the history of Shenzhen and China's Special Economic Zone strategy:

Reardon, Lawrence C. *The Reluctant Dragon: Crisis Cycles in Chinese Foreign Economic Policy*. Seattle: University of Washington Press and Hong Kong University Press, 2002.

———. "The Rise and Decline of China's Export Processing Zones." *The Journal of Contemporary China* 5 (November 1996): 281–303.

"Hollywood"

For background on contemporary Uighur culture and the class system:

Rudelson, Justin Jon. *Oasis Identities: Uyghur Nationalism Along China's Silk Road*. New York: Columbia University Press, 1997.

For background on Falun Gong and the government crackdown:

Johnson, Ian. *Wild Grass: Three Stories of Change in Modern China*. New York: Pantheon Books, 2004.

"The Voice of the Turtle"

For the history of Chinese archaeology, the Anyang excavations, and the early oracle-bone scholars:

Bonner, Joey. *Wang Kuo-wei: An Intellectual Biography*. Cambridge: Harvard University Press, 1986.

Lawton, Thomas. "A Time of Transition: Tuan-fang, 1861–1911." *The Franklin D. Murphy Lectures XII*. Lawrence, Kansas: Spencer Museum of Art, University of Kansas, 1991.

Li Chi. *Anyang: A Chronicle of the Discovery, Excavation, and Reconstruction of the Ancient Capital of the Shang Dynasty*. Seattle: University of Washington Press, 1977.

Liu E. *The Travels of Lao Can*. University Press of the Pacific, 2001.

Trigger, Bruce G. *A History of Archaeological Thought*. Cambridge: Cambridge University Press, 2000.

For background on Shang culture and the oracle-bone inscriptions:

Chang Kwang-chih. *Shang Civilization*. New Haven: Yale University Press, 1980.

Keightley, David N. *The Ancestral Landscape: Time, Space, and Community in Late Shang China (ca. 1200–1045 B.C.)*. Berkeley: Institute of East Asian Studies, University of California Press, 2000.

———. *Sources of Shang History: The Oracle-Bone Inscriptions of Bronze Age China*. Berkeley: University of California Press, 1985.

Loewe, Michael and Edward L. Shaughnessy, eds. *The Cambridge History of China: From the Origins of Civilization to 221 B.C.* New York: Cambridge University Press, 1999.

"At Night You're Not Lonely"

Miao Yong. *Wode Shenghuo Yu Ni Wu Guan*. Guangzhou: Huacheng Chubanshe, 1998.

"The Courtyard"

For background on the history of Beijing and the destruction of the old city, I relied on Ian Johnson's *Wild Grass*, as well as:

Wang Jun. *Chengji*. Beijing: Sanlian Shudian, 2003.

For background on Liang Sicheng and Lin Huiyin:

Fairbank, Wilma. *Liang and Lin: Partners in Exploring China's Architectural Past*. Philadelphia: University of Pennsylvania Press, 1994.

"Bronze Heads"

Bagley, Robert, ed. *Ancient Sichuan: Treasures from a Lost Civilization*. Seattle: Seattle Art Museum in association with Princeton University Press, 2001.

———. "Shang Archaeology." *The Cambridge History of China: From the Origins of Civilization to 221 B.C.* Edited by Michael Loewe and Edward L. Shaughnessy. New York: Cambridge University Press, 1999.

Von Falkenhausen, Lothar. "On the Historiographical Orientation of Chinese Archaeology." *Antiquity* 67 (1993): 839–49.

"The Book"

Chen Mengjia. *Yin Xu Buci Zong Shu*. Beijing: Kexue Chubanshe, 1956.

Kaogusuo, bianji. *Mei Diguo Zhuyi Jieluede Wo Guo Yin Zhou Tongqi Tulu*. Beijing: Kexue Chubanshe, 1962.

Paper, Jordan. "The Meaning of the 'T'ao-T'ieh'." *History of Religions* 18 (1978): 18–41.

Wu Ningkun. *A Single Tear: A Family's Persecution, Love, and Endurance in Communist China*. New York: Atlantic Monthly Press, 1993.

"The Uncracked Bone"

Chen Mengjia's poetry has not been published in English. I am deeply indebted to Frances Feng, who translated many of Chen's poems so they could be reprinted in this book. All of my quotes are from Frances Feng's translations.

Chen's poems and other writings in the original Chinese may be found in the following sources:

Chen Mengjia. *Chen Mengjia Juan*. Wuhan: Changjiang Wenyi Chubanshe, 1988.

Chen Mengjia. *Tie Ma Ji*. 1934.

Xin Yue Shi Xuan. Shanghai: Xin Yue Shudian, 1933.

Elinor Pearlstein of the Art Institute of Chicago researched Chen Mengjia's years in the United States, visiting the archives of the Rockefeller Foundation and many museums. She generously allowed me to read her manuscript, "Chen Mengjia in the West: Scholarship Realized, Lost, Preserved." I am indebted to her for many of the details of Chen's American and European travels. My quotes from Chen's letter to the Rockefeller Foundation and from Langdon Warner's letter to Chen are from Elinor Pearlstein's paper.

I am also grateful to Jason Steuber of the Nelson-Atkins Museum of Art, who provided me with copies of Chen's letters from 1945, which are in the museum archives in Kansas City.

I also relied on the following Chinese publications:

Wang Shimin. "Chen Mengjia." *Zhongguo Shixuejia Pingzhuan (Xia Ce)*. Beijing: Zhongguo Guji Chubanshe, 1985.

Zhao Luorui. *Wode Du Shu Shengya*. Beijing: Beijing Daxue Chubanshe, 1996.

For the oracle bones and other aspects of David N. Keightley's research, I relied on the previously mentioned volumes (*Sources of Shang History* and *The Ancestral Landscape*), as well as the following:

Elvin, Mark. *The Pattern of the Chinese Past: A Social and Economic Interpretation*. Palo Alto: Stanford University Press, 1973.

Keightley, David N. "Art, Ancestors, and the Origins of Writing in China." *Representations* 56 (1996): 68–95.

———. "Clean Hands and Shining Helmets: Heroic Action in Early Chinese and Greek Culture." *Religion and the Authority of the Past*. Edited by Tobin Siebers. Ann Arbor: University of Michigan Press, 1993.

———. "The Making of the Ancestors: Late Shang Religion and Its Legacy." *Religion and Chinese Society*. Edited by John Lagerwey. Hong Kong: The Chinese University Press, 2004.

———. "The Origins of Writing in China: Scripts and Cultural Contexts." *The Origins of Writing*. Edited by Wayne M. Senner. Lincoln, Nebraska: University of Nebraska Press, 1989.

———. "Shamanism, Death, and the Ancestors: Religious Mediation in Neolithic and Shang China (ca. 5000–1000 B.C.)." *Asiatische Studien Études Asiatiques* LII.3 (1998): 763–831.

———. "What Did Make the Chinese 'Chinese'?: Musings of a Would-Be Geographical Determinist." Warring States Working Group, Amherst, Massachusetts. 8 October 2000.

"The Games"

Bredon, Juliet. *Peking*. Shanghai: Kelly & Walsh, 1920.

Chinese Olympic Committee, eds. *5,000 Years of Physical Culture & Sports in China*. Beijing: Beijing Physical Education University, 1996.

Jennings, Andrew. *The New Lords of the Rings: Olympic Corruption and How to Buy Gold Medals*. New York: Simon & Schuster, 1996.

Senn, Alfred E. *Power, Politics, and the Olympic Games: A History of the Power Brokers, Events, and Controversies That Shaped the Games*. Champaign, IL: Human Kinetics, 1999.

"The Word"

Lewis, Mark Edward. *Writing and Authority in Early China*. Albany: State University of New York Press, 1999.

Takashima, Ken-ichi. "A Cosmography of Shang Oracle-Bone Graphs." *Actes du Colloque International Commémorant le Centenaire de la Découverte des Inscriptions sur Os et Carapaces*. Edited by S. C. Yau. Paris: Cenre Recherche Linguistiques sur l'Asia Orientale, 2001.

"Translation"

Chuang Tzu. *Wandering on the Way: Early Taoist Tales and Parables of Chuang Tzu*. Translated by Victor H. Mair. New York: Bantam Books, 1994.

"The Horse"

Hadingham, Evan. "The Mummies of Xinjiang." *Discover* April 1994: 68–77. (A condensed version of Hadingham's article was subsequently published in *Reader's Digest*, August 1994)

Mair, Victor H., ed. *The Bronze Age and Early Iron Age Peoples of Eastern Central Asia: Volume I*. Washington, D.C.: Institute for the Study of Man in collaboration with the University of Pennsylvania Museum Publications, 1998.

———. "The Horse in Late Prehistoric China: Wresting Culture and Control from the 'Barbarians.'" *Prehistoric Steppe Adaptation and the Horse*. Edited by Marsha Levine, Colin Renfrew and Katie Boyle. Cambridge, UK: McDonald Institute for Archaeological Research, 2003.

———. "Mummies of the Tarim Basin." *Archaeology* March/April 1995: 28–35.

———. "The North(west)ern Peoples and the Recurrent Origins of the 'Chinese' State." *The Teleology of the Modern Nation-State: Japan and China*. Edited by Joshua A. Fogel. Philadelphia: University of Pennsylvania Press, 2005.

———. "Prehistoric Caucasoid Corpses of the Tarim Basin." *The Journal of Indo-European Studies* 23 (1995): 281–307.

Wang Binghua. *The Ancient Corpses of Xinjiang: The Peoples of Ancient Xinjiang and Their Culture*. Translated by Victor H. Mair. Urumqi: Xinjiang Renmin Chubanshe, 1999.

"Wonton Western"

For Jiang Wen's role in the Chinese intellectual climate of the early 1990s:

Barmé, Geremie R. *In the Red: On Contemporary Chinese Culture.* New York: Columbia University Press, 1999.

"Election"

Shih Chang-ju, with the assistance of Liu Hsiu-wen, Feng Jong-meei, and Lai Shu-li. *Hou Chia Chuang (The Yin-Shang Cemetery Site at Anyang, Honan): Volume X: Descriptions of Small Tombs: One.* Taipei: Institute of History and Philology, Academia Sinica, 2001.

The following book, whose title translates as, "The Returned Swan: Memoirs of an Intelligence Agent Who Worked Behind Enemy Lines," tells the story of Jacky Lin's father:

Lin Kunrong. *Gui Hong: Yige Dihou Qingbaoyuan de Huiyi.* Taipei: Renjian Chubanshe, 1989.

"The Criticism"

Li Xueqin. "Ping Chen Mengjia *Yin Xu Buci Zong Shu.*" *Kaogu Xuebao* Di San Qi (1957): 119–29.

Wang Shixiang. *Classic Chinese Furniture: Ming and Early Qing Dynasties.* Translated by Sarah Handler and Wang Shixiang. Hong Kong: Joint Publishing, 2000.

———. "In Memory of Mengjia." *Journal of the Classical Chinese Furniture Society* Summer (1991): 70-72.

"The Lost Alphabets"

For background on the Chinese spoken languages, the writing system, and the reform movement:

Boltz, William G. "Language and Writing." *The Cambridge History of Ancient China: From the Origins of Civilization to 221 B.C.* Edited by Michael Loewe and Edward L. Shaughnessy. New York: Cambridge University Press, 1999.

———. *The Origin and Early Development of the Chinese Writing System.* New Haven, Connecticut: American Oriental Society, 1994.

DeFrancis, John. "China's Literary Renaissance: A Reassessment." *Bulletin of Concerned Asian Scholars* 17.4 (Oct.-Dec. 1985): 52-63.

———. *The Chinese Language: Fact and Fantasy.* Honolulu: University of Hawaii Press, 1986.

———. "Language and Script Reform." *Current Trends in Linguistics: Linguistics in East Asia and South East Asia.* Edited by Thomas A. Sebeok. The Hague: Mouton, 1967.

————. "Mao Tse-tung and Writing Reform." *Perspectives on a Changing China*. Edited by Joshua A. Fogel and William T. Rowe. Boulder, Colorado: Westview Press, 1979.

————. *Nationalism and Language Reform in China*. Princeton: Princeton University Press, 1950.

Mair, Victor H. "Review of *The Representations of Cantonese with Chinese Characters* by Cheung Kwan-hin and Robert S. Bauer." *Journal of Chinese Linguistics* 32.1 (2002): 157–67.

Rawski, Evelyn Sakakida. *Education and Popular Literacy in Ch'ing China*. Ann Arbor: University of Michigan Press, 1979.

Rohsenow, John S. "The Second Chinese Character Simplification Scheme." *International Journal of the Sociology of Language* 59 (1986): 73–85.

————. "Diagraphia in China." *The International Journal of the Sociology of Language* 150 (September 2001).

Su Peicheng. "Diagraphia: A Strategy for Chinese Characters in the 21st Century." Translated by John S. Rohsenow. *The International Journal of the Sociology of Language* 150 (September 2001).

Zhou Youguang. *The Historical Evolution of Chinese Languages and Scripts*. Translated by Zhang Liqing. Columbus, Ohio: National East Asian Languages Resource Center, The Ohio State University, 2003.

For background on the life of Zhou Youguang:

Zhang Lijia and Calum MacLeod. *China Remembers*. Oxford: Oxford University Press, 1999.

For Chen Mengjia's involvement in the Hundred Flowers Movement and the debates on writing reform:

Chen Mengjia. "Chai Qiang He Liu Xian: Kaogu Xuejia Chen Mengjia Xiansheng Fangwen Ji." *Renmin Ribao*. 17 May 1957.

————. "Guanyu Hanzi de Qiantu." *Wenzi Gaige* Di 82 Qi (19 May 1957).

————. "Liang Dian Xiwang." *Wen Hui Bao*. 6 May 1957.

————. "Lüe Lun Wenzixue." *Guangming Ribao*. 4 February 1957.

————. "Women Dang Bianji de." *Wen Hui Bao*. 19 April 1957.

Hong Duren. "Jianhua Hanzi Bu Shi 'Zheng Zi' ma?" *Meishu Luntan* 1 (1958).

Huang Cuibo. "Bochi Youpai Fenzi Chen Mengjia 'Hanyu Jueding Hanzi' de Miulun'." *Jiang Hai Xue Kan* 5 (July 1958).

Qin Hua. "Jixu Zhuiji Youpai: Bochi Chen Mengjia, Guan Xi." *Zhongguo Yuwen*. 10 Hao 1957.

Seybolt, Peter J. and Gregory Kuei-ke Chiang, eds. *Language Reform in*

China: Documents and Commentary. White Plains, NY: M. E. Sharpe, 1979.

Shi Zhenye. "Ye Tan Guanyu Jie Ci Jiegou Zuo Wei Yu." *Zhongguo Yuwen* 60 (June 1957).

"Encapsulate Prime"

Chen Lei. "Wenzhou Zhongkao 'Xiemi Shijian' Diaocha." *Nanjing Zhoumo*. 25 June 2003.

"The Misprinted Character"

For information about the history of the Three Gorges Dam:

Chetham, Deirdre. *Before the Deluge: The Vanishing World of the Yangtze's Three Gorges*. New York: Palgrave Macmillan, 2002.

"Patton's Tomb"

"Uyghur Separatist Denies Links to Taliban, Al-Qaeda." *Radio Free Asia Uyghur Service*. 28 January 2002.

"Tea"

Price, Kenneth M. "An Interview with Zhao Luorui." *Walt Whitman Quarterly Review* 13 (Summer/Fall 1995): 59–63.

Walt Whitman. *Cao Ye Ji (Leaves of Grass)*. Translated by Zhao Luorui. Shanghai: Yiwen Chubanshe, 1991.

Wu Ningkun. *A Single Tear: A Family's Persecution, Love, and Endurance in Communist China*. New York: Atlantic Monthly Press, 1993.

Acknowledgments

AS A RESEARCHER, I HAVE MANY LIMITATIONS: I DO NOT SPEAK UIGHUR; I do not read oracle bones; and I did not grow up in Number Ten Village. I have approached such subjects as an outsider, discovering how those with more immediate knowledge present their scholarship, memories, and opinions. It's through such exchanges—from the expert to the writer, from the writer to the reader—that we create meaning. It's also how we make mistakes. I have tried to be as accurate as possible, and I have benefited from the advice of many reviewers, but I want to emphasize that any errors are my own.

Victor H. Mair was kind enough to read the manuscript and provide many corrections and recommendations. David N. Keightley patiently answered countless phone calls and e-mails, and I appreciate his helpful comments on my chapters about the oracle bones. John DeFrancis gave excellent guidance with regard to my research on Chinese writing reform (I've never known another ninety-four-year-old who responds so quickly to e-mails about morphemes). I also appreciate the assistance of John Rohsenow, who helped me track down the Beijing-based reformers and mailed me useful research materials. Imre Galambos kindly reviewed a draft of the manuscript.

I owe an enormous debt to everybody at the Anyang Archaeological Work Station, especially Tang Jigen, who was generous with both his time and access to the excavations. Jing Zhichun was an excellent guide to the Huanbei site, and I appreciate his review of the chapters about the mapping of the underground city. In Anyang and in Beijing, I benefited from conversations and interviews with Rip Rapp, Jim Stotlman, Yang Xizhang, He Yuling, Jonathan Mark Kenoyer, and Ken-ichi Takashima.

I am grateful to all of my former students who have stayed in touch over the years. Emily was a wonderful host during my visits to Shenzhen, as was Shirley in Wenzhou. It was a pleasure to visit Nancy Drew and William Jefferson Foster in Yueqing. Willy's parents, Dai Xinghui and Liu Guiqing, were generous hosts during my trip to Number Ten Village.

I was fortunate to arrive in Beijing under the unofficial auspices of the *Wall Street Journal*, whose well-run and knowledgeable bureau made for an ideal base. Over the years, many *Journal* and *Far Eastern Economic Review* reporters were generous with their expertise and advice: David Murphy, Karby Leggett, Charles Hutzler, and Peter Wonacott. Sophie Sun and Lily Song helped me in many ways, and Kersten Zhang fact-checked countless details from interviews and reporting trips. Jason Dean, who is familiar with both Taiwan and Hollywood, was kind enough to review the manuscript.

I worked as a clipper in the 1999 *Journal* bureau of Ian Johnson, Matt Forney, Dou Changlu, and Xu Jiang—a wonderful crew, all filed under "J." Matt's experience and kindness helped me make the transition to Beijing during that eventful first spring, and I have valued his friendship ever since. Ian's expertise, judgment, and humor were invaluable to me as a young reporter, and I much appreciate his careful review of this book.

I was fortunate to work on various projects with Mark Leong, whose photographs can bring anything to life, even starch and oracle bones. Lou Mazzatenta did a marvelous job in recording Anyang artifacts (and archaeologists). Mimi Kuo documented the final moments of Old Mr. Zhao's courtyard, and I greatly appreciated her friendship over the years (especially in Sancha). Shawn McDonald kindly showed me around Nanjing. Jen Lin-Liu hosted me in Shanghai and was generous to Willy during his stay in Beijing. I was grateful to share some of my time in Ju'er Hutong with Mary and Adam Weiss, and then with Travis Klingberg. Other former Peace Corps colleagues who made it back to China—Adam Meier, Craig Simons, Rob Schmitz, and Tamy Chapman—helped me stay in touch with Sichuan in various ways. Mike Goettig was the best traveling companion in all the best places, from Inner Mongolia to Kham.

I am greatly indebted to Mike Meyer and Frances Feng for friendship, encouragement, and the most sensitive attention to the way that words move between China and America. I am particularly grateful for Meyer's editing comments, and for Frances's research assistance and translations of the poems of Chen Mengjia.

As a freelancer, I have benefited from the generous support of editors and

publishers. I am grateful to Tim Duggan, my editor at HarperCollins, as well as Gordon Wise at John Murray. I am thankful to William Clark, my agent, for his early faith in this project. I appreciated the opportunity to write about Old Mr. Zhao's courtyard for the *Boston Globe Magazine,* and David Arnold of *Worldview* commissioned an early profile of William Jefferson Foster. At *National Geographic,* I was fortunate to work with Oliver Payne, and Bernard Ohanian had the foresight to allow an expansion of our research on the Shang (all the way to Taiwan). I am especially grateful to David Remnick for the opportunity to write for the *New Yorker,* whose scope and range allowed me to pursue many of the subjects in this book.

Nobody understands the struggles and rewards of writing better than John McPhee, New Jersey Person, and I am thankful for all the good advice over the years. My best and most faithful editor has always been Doug Hunt of Columbia, Missouri. Since I began writing from China, he has been generous with his time and comments, and this book was improved immeasurably by his thoughtful readings.

My parents have been patient with my long absences, and their own work—the sociologist and the historian—has influenced me from afar. Amy helped me stay organized; Angela drew a beautiful map; and Birgitta kept copies of early drafts. I much enjoyed the Beijing visits of Gary and Matt and Andrea, and it was always a pleasure to return to Missouri and see Connor and Heidi. My grandmother Doria Hessler hosted me on many jet-lagged journeys between the Motherland and the Homeland.

And for Leslie T. Chang—no words are enough for somebody who knows what it's like to track the past and the present in a country of floating lives.

ALEX GRAF OF Columbia Pictures was helpful during my research on Chinese film, and I was saddened by the news of his tragic death in Qinghai province. I wish that I could have thanked him in person. The same is true for others who were interviewed for this book: Ma Chengyuan of the Shanghai Museum, Yin Binyong of the writing reform committees, and Shih Chang-ju of the Academia Sinica. In a perfect world, Shih would have lived long enough to meet Tang Jigen, the excavator of the underground city. But even one hundred and one years couldn't outlast the complexities of politics and history. Tang's first application to visit Taiwan was rejected, and by the time he finally received permission, it was too late to meet his predecessor. And so the young man went to the cemetery in Taipei, burned offerings of incense, and kowtowed before the grave.

Index

treatment of, by brother Zhao Jing-
xin, 453
visit of, to Chicago Art Institute, 454
Wu Ningkun on, 452, 453, 454
chariots, Shang civilization, 223, 331,
332, 353
Chen, Sisy (Taiwan politician), 362–64,
365
Chengdu, Sichuan province, anti-Amer-
ican protests in, 16
Chen Luyu (TV commentator), 323
Chen Mengjia (scholar), 222–30, 243–
48, 383–92, 431–34, 454–55
advocacy for retention of traditional
writing system by, 228, 384, 412–
13, 417
book on oracle bones and Shang civi-
lization by, 248
book on Shang and Zhou bronzes by,
221–22, 248, 385, 454
brother Chen Mengxiong on, 431–
34, 436
contradictory accounts of, 383–84
Cultural Revolution and persecution
of, 224, 225, 229, 229, 243, 433–34
death of, 223, 224–25, 390, 434, 454
family, early life, and education of,
243–45, 431–32
labeled as Rightist and sent to labor
camp, 413, 432
Li Xueqin on, 388–92
Li Xueqin's 1957 criticism of, 385,
386–87, 391, 392, 413
Ming dynasty furniture collection
belonging to Lucy Chao and, 228,
384–86, 432–33, 455
reported illicit affair of, 224, 229
K. Takashima on, 290–91
Shih Chang-ju on, 354
Wang Jun on, 414
wife [*see* Chao, Lucy (scholar)]
Wu Ningkun on, 226–27, 452, 453, 454
Zhou Youguang on, 417
Chen Mengxiong (hydrogeologist),
431–36
on brother Chen Mengjia, 432–34
career of, 434–35, 455

on collection of Ming-era furniture,
432–33
on Cultural Revolution, 433–34
on persecution of wife, 435–36
Chen Shui-bian (Taiwan president), 359
Chen Xiandan (museum official),
196–97
Chen Xitong (major of Beijing), 370
Chen Zixiu (Falun Gong believer), 125
Chiang Ching-kuo (Kuomintang Tai-
wan leader), 358–59
Chiang Kai-shek, 190, 194, 331, 358,
359, 362. *See also* Kuomintang
government
China
aircraft-collision incident with U.S.,
295–305
George W. Bush state visit to (2002),
393–400
civil war in, 247, 354, 358
domination of leadership from
southern regions in, 194–95, 331
economic links between Taiwan and,
360–61
establishment of Republic of (1912),
141
ethnic diversity of, 208–9
government policy toward Uighur
minority, 29, 313, 374–76
modern economy and currency of,
396
19th-century foreign intrusions into,
136–40
response of, to 9/11 terrorist attacks,
313, 314
China Daily (newspaper), 20
China Sports Museum, 265
China Tourism, 325
Chinatown, Washington, D.C., 369–71
Chinese culture and civilization
ancestor veneration, 85, 251, 252,
253, 403
author on American and, 439–40
compared to Western culture, 143,
252–54
Confucianism, 143, 251, 252, 266, 403
conservatism of, 253, 266

About the author

About the book

Insights,
Interviews
& More . . .

Read on

Meet Peter Hessler

Mark Leong

I GREW UP in Columbia, Missouri, where my father was a professor of sociology at the University of Missouri. My mother teaches history at Columbia College. I attended the local public school, Hickman High School, where I first became interested in literature and writing. My sophomore year English teacher, Mary Racine, encouraged me to consider a career in writing. Over the next two years, I studied under two other excellent English teachers, Mary Ann Gates and Khaki Westerfield. By the time I graduated in 1988, I knew that I wanted to become a writer.

At Princeton University, I majored in English and Creative Writing. As an undergraduate, I focused primarily on fiction. I studied under Russell Banks, Stuart Dybek, and Joyce Carol Oates. My senior thesis was a collection of short stories set in Missouri.

As a junior, I took John McPhee's seminar in nonfiction writing, which helped me realize the possibilities of narrative nonfiction. The following summer, I worked as an ethnographer for the Kellogg Foundation,

66 I took John McPhee's seminar in nonfiction writing, which helped me realize the possibilities of narrative nonfiction. 99

writing a long ethnographic study about Sikeston, a small town in the southeastern Missouri boot heel. The paper was published in *Journal for Applied Anthropology*, and the experience was a valuable introduction to research and writing in a small town.

I graduated from Princeton in 1992, and then I attended Oxford University, where I studied English Language and Literature. After graduating from Oxford in the summer of 1994, I returned to the United States via the East. For six months, I traveled from Prague to the Gulf of Thailand, all by train and bus and boat. During that trip, I took the trans-Siberian train to China—my first introduction to a country I had never really thought about. That journey also led me to travel writing; after returning to the States, I published stories about my travels in various American newspapers, including the *New York Times* and the *Philadelphia Inquirer*.

In 1995, I received a Friends of Switzerland grant, which funded two months of hiking and writing in the Alps. For most of a year, I worked as a teacher and freelance writer, publishing travel essays and features. In the summer of 1996, I joined the Peace Corps and was sent to China.

While in Fuling, I freelanced the occasional story for American newspapers, but mostly I focused on teaching English and studying Chinese. After leaving China in August of 1998, I returned to Columbia, Missouri, where I spent the rest of the year writing about my experiences in Fuling. After completing a draft of *River Town*, I tried unsuccessfully to find a job with a major American newspaper or magazine. Finally, in March of 1999, I decided to return to China independently and try to establish myself as a writer. I settled in ▶

> "In March of 1999, I decided to return to China independently and try to establish myself as a writer."

Beijing, where I worked part-time for the *Wall Street Journal* as an assistant (or "clipper"). Most of my time was spent freelancing. In 2000, I began writing for *National Geographic* and *The New Yorker;* the following year, I was accredited as *The New Yorker*'s resident China correspondent.

I've always liked the freedom of writing, as well as the fact that there's no set route for the career. There isn't a necessary degree or a qualification, and each writer figures out his own path. For me, some of the less formal educational experiences have turned out to be the most valuable. I learned more in the Peace Corps than I did at Oxford, and my summer job as an ethnographer was one of the best writing experiences of my undergraduate years. Nowadays, I try to approach narrative nonfiction with the lessons of both literature and the social sciences. I'm particularly interested in what social scientists call a "longitudinal study"—following a subject through time. In China, I've often kept in touch with people and places over a span of years, recording how they respond to a fast-changing society.

Since 1999, I've lived in Beijing, where I have an apartment in a *hutong* neighborhood. I also keep a home in the countryside north of the city, in the village of Sancha, which is just beyond the Great Wall. In the summer of 2006, I married Leslie T. Chang, a writer formerly with the *Wall Street Journal*. Leslie is now working on a book, part of which is about her grandfather. He was a member of the first generation of Chinese to go abroad to study—in the 1920s, he came to the United States to pursue a degree in mining engineering. At one

❝ In the summer of 2006, I married Leslie T. Chang, a writer formerly with the *Wall Street Journal*. **❞**

point he visited Columbia, Missouri, as part
of a tour of American mines and industry.
His brief diary, in Chinese, reminds me of
the place where I grew up: "April 9, 1927: In
the afternoon we walked outdoors and took
photographs. There are two women's schools
and a university here; it is very nice and a
good place to study." ⌒

Writing *Oracle Bones*

I WROTE MOST of *Oracle Bones* in my Beijing apartment, about a mile north of the Forbidden City, on the edge of an alleyway so tiny that it had no posted name. The alley's shape was distinctive—it passed through three ninety-degree turns—and it belonged to one of the few Beijing neighborhoods whose basic layout had survived the centuries. The earliest detailed map of the capital was completed in 1750, under the reign of the great emperor Qianlong, and on that document my alley is easily recognized— the same twisted shape, the same ninety-degree turns. When I lived there, locals called it Little Ju'er, because it connected to Ju'er Hutong.

Little Ju'er was too small for cars, which was what I liked about it. I've always hated the rumble of busy streets—there's something awful about the endlessness, the way that one car's roar immediately gives way to another. The sounds of Little Ju'er, though, were clear and distinct. Usually, I began writing at dawn, and sitting at my desk I could hear the alley come to life. The earliest noises belonged to the public toilet. Many of my neighbors didn't have indoor plumbing, and they chatted as they made their way down the street, chamber pots in hand. By some miracle of Chinese architecture, these sounds reached me with perfect clarity—voices floated across the alley, bounced off the cement wall of a nearby building, and echoed into my open window. Every morning, at about 6:30 A.M., one elderly man would spend a full ten minutes in the toilet. He was a grunter—low, rhythmic

> 66 Usually, I began writing at dawn, and sitting at my desk I could hear the alley come to life. The earliest noises belonged to the public toilet. 99

growls, one after another, as steady as a drumbeat. At an earlier time in my writing life, the sound would have driven me nuts, but this was my second book and I had learned something along the way. There's a pace to writing, a certain day-to-day routine, and it was impossible to be resentful of somebody else with tempo. The elderly man was engaged in his project, and I was engaged in mine. I knew it would be a good day if I had already produced a couple of paragraphs before the grunts began.

Often I had finished a page by the time the vendors appeared. They pedaled through the alley on three-wheeled carts, each announcing his or her product with a trademark cry. The beer woman was the loudest, singing out again and again, *"Maaaaaiiiiiii piiiiijiuuu!"* At eight in the morning, it could have posed the ultimate distraction for a working writer—"Buuuuyyyyy beeeeeeeeer!"—but I focused on the music rather than the words. There was a harmony to the hutong, and every vendor contributed. The rice man's refrain was higher-pitched; the vinegar dealer occupied the lower scales. The knife sharpener provided percussion—a steady click-clack of metal plates. The sounds were soothing, a reminder that, even if I never finished my book and never left my apartment again, life would be sustainable, albeit imbalanced. From my doorway, I could buy cooking oil, soy sauce, and certain fruits and vegetables in season. In winter, I could find strings of garlic. A vendor of toilet paper pedaled through every day. There was no shortage of coal. Occasionally, somebody came past with candied apples.

I could even earn income from the freelance recyclers. On the average, a recycler passed through every half hour, riding a flat-bed tricycle. They purchased cardboard, paper, Styrofoam, and broken appliances. They bought old books by the pound and dead televisions by the square inch. Appliances could be repaired or stripped for parts, and the paper and plastic were sold to neighborhood recycling centers for the barest of profits—the margins of trash. Sometimes, when the writing was slow, I had visions of giving up and selling everything in my apartment. I'd start with the furniture—I had never particularly cared for it—and then I'd sell the metal pots. I'd have to think hard about which would go first, the television or the refrigerator. After that, I'd discard my library, book by book. My notes were next—file cabinets packed with massive folders that, by sheer weight, would keep me solvent for a while. The last thing to go would be my computer.

One morning, having sustained this fantasy for months, I finally piled a bunch of useless possessions in front of my doorway, to see exactly what everything was worth. A stack of old magazines sold for sixty-two cents; ▶

Writing *Oracle Bones* (*continued*)

a burned-out computer cord was worth a nickel. Two broken lamps were seven cents, total. A pair of shoes that had belonged to my former roommate: twelve cents. Two broken Palm Pilots: thirty-seven cents. I gave one recycler a marked-up manuscript of *Oracle Bones*—this must have been at least the tenth draft—and he took out a scale, weighed the pages, and handed me fifteen cents.

After a long day of writing, I sometimes took a walk south, passing through a half-dozen hutongs before reaching Kuanjie intersection. On the corner stood a branch of the China Construction Bank. The building was undistinguished: a squat wide entrance, flanked by pillars of cheap beige marble, and topped with blue-tinted windows. Every time I looked at the place, I remembered what had formerly stood there: Old Mr. Zhao's courtyard home. I remembered the long autumn of 2000, the crisp clear-skied days when I'd visited the retired teacher, listening to his updates about the lawsuit. And I remembered the October morning on which the building had finally been demolished. Even in the midst of the destruction, workers had carefully set aside any bricks and wood pillars that were still intact—objects that would be sold to construction crews in other parts of the city. Somewhere, pieces of that home still exist, just as the memory is still vivid in my mind.

Time in China feels like that. Before I came to the country, I conceived of the past as finished, and I imagined history as a straight line of cause-and-effect. Historians choose the events that matter, put them in the proper order, and then move on. But the longer I've lived in China, the less neatly everything lines up. Because of Reform and Opening, people move more freely, and you can meet the ones who formerly lived on the margins. Most of the people I've written about are somehow "unhistorical": Polat belongs to an unknown ethnic group; Emily lives in a city without a past; Willy was raised by parents who couldn't even write, in a village that had been numbered rather than named.

For the first time, average Chinese are gaining control of their personal lives. Migrants make important decisions—whether to leave the countryside, and where to go, and what kind of job to accept. These choices are stressful and often traumatic, but they teach people to see themselves as individuals. When I interviewed Willy's parents, I was struck by how they always told stories in the first-person plural: We held a memorial service for Chairman Mao. The village did this; the

family did that. Everything revolved around the group, but Willy's memories are different—when he speaks, the "I" matters. It's not a coincidence that each of the main characters in this book has named him or herself.

Chen Mengjia had also chosen his own name—"The Wanderer." He belongs to an earlier generation of Chinese who left home, although their experiences often ended in tragedy. When survivors talk about the past, they leave much unsaid. Stories skip certain details—the hard years of political struggle and economic disaster. In China, the issue isn't necessarily what happened, but rather how it's remembered. And that particular exchange—the way the present views the past, and the way the past shapes the present—is a constant, ever-shifting negotiation. If I live in an ancient neighborhood, I can expect to see old landmarks disappear, and sometimes their pieces will be sold to create the new city. And if I write my own account of this process, and print it out, and then sell the pages to be recycled in that same neighborhood—well, that's simply another part of the exchange.

When I was about halfway finished writing the book, Zhou Baohong called and said that he had to come to Beijing because of a medical problem. The boy was polite—he called me "Uncle," as he always did—but it was clear that he was upset. He'd sustained a blow to the head a couple of weeks ago, and he was still suffering headaches. A doctor had recommended that he travel to the capital to get X-rays and other tests, and he had nowhere to stay.

I didn't know him well. I had met the twelve-year-old boy while researching the background of *Devils on the Doorstep*, a film that won the Grand Prix at Cannes and was subsequently banned by the Communist Party. In a sense, the movie was also "unhistorical"—the Communist Party had decided that the film's depiction of the past was politically incorrect, and it had never been shown in a Chinese theater. But the set where it had been filmed was still intact, on the banks of a reservoir in a lonely corner of Hebei province. When I visited, the local peasants couldn't tell me much about the film, and none of them seemed to understand the politics involved, with the exception of Zhou Baohong. He was one of those remarkably bright and friendly children that I sometimes met in the countryside, and I had given him my phone number. When he called to say that he and his mother were coming, ▶

I said they could stay in my apartment, along with his mother. I gave them the lower floor, where I usually wrote; I could work in my upstairs bedroom.

It was their first visit to the big city. The woman had a thick accent, and she spoke at full volume, the way countryside people do after years of holding conversations across the fields. As a house gift, they gave me a huge sack of walnuts, which they had dragged all the way across Hebei. Out of politeness, they refused to sleep in the spare bed, insisting on the couch. On the first evening, I was awakened at 2 A.M. by a panicky voice— "Uncle! Uncle!"—and realized that they had locked themselves in my television room. The next day they broke the toilet. One morning, my editor from *The New Yorker* called, and Zhou's mother answered the phone, shouting over and over, in her rough Chinese, "Who are you? Who are you? Who are you?"

Upstairs, I tried to write. I was approaching the chapter in which Zhou would appear, and I wondered whether that was good or bad karma, to have an unwritten character living downstairs, awaiting medical treatment. The boy looked fine; he seemed hopeful that the news would be good. But one doctor led to another, and an application had to be made for a certain type of X-ray; a week passed without resolution. Finally, the mother returned home—there was work to do in the fields—and then a second week slipped by. The writing went nowhere. In the mornings, formerly soothing sounds began to veer toward distraction ("Buuuuyyyyy beeeeeeeeer!").

And then he was gone. I returned from a day of errands and found the downstairs empty; an hour later, the phone rang. It was Zhou: the tests had come back normal, and he had decided to catch the earliest bus out, to get back to school. He thanked me and said that if I ever visited Panjiakou Reservoir, I'd have a place to stay.

The boy traveled light, and he had abandoned a number of possessions in my apartment. Over the next few days, I found a bag of rice, a dirty shirt, some worn loafers. In my television room I discovered a stack of video disks that the boy had purchased in the Beijing bootleg shops, where you could buy anything, even the movies that had been banned from theaters. Sure enough, right on top of the stack was *Devils on the Doorstep*.

I left everything outside in the alley, where the recyclers would be sure to find the pile. Probably they'd sell the plastic cases for scrap, but I hoped

that one of them would keep the disk and watch the movie. As for hosting an unwritten character in my apartment—good karma, definitely. That chapter came easy and a few months later, when Zhou telephoned again— "Uncle!"—he said the headaches were gone for good.

Beijing
October 2006 ∾

Author's Picks
Books About China

SOUL MOUNTAIN, by Gao Xingjian

He's the only Chinese writer to have won the Nobel Prize, and this is his best book. It reflects the period in the 1980s when the reforms first started to take hold and Chinese like Gao began to travel and gain a new sense of their country.

RED DUST, by Ma Jian

Like Gao's book, *Red Dust* describes the travels of an artistic young man during the 1980s. But Ma Jian's book is nonfiction and he gives a fascinating glimpse of society during that period—for example, the cross-country contacts of the intelligentsia, who protected and supported each other. Many parts of the book are also quite funny.

YANGTZE: NATURE, HISTORY, AND THE RIVER, by Lyman P. Van Slyke

In my opinion, this is the best history book about the Yangtze. It's not weighed down by a need to be relentlessly comprehensive or authoritative; *Yangtze* feels like the work of a historian who simply loves the texture of the river's past.

A SINGLE PEBBLE, by John Hersey

In Hersey's novel, the Yangtze world is romanticized and dramatized—his trackers' paths, for example, are a lot more treacherous than the actual cliffside routes that were used by many travelers. But the book is well written and gives a powerful sense of the early dream

❝ In my opinion, this is the best history book about the Yangtze. **❞**

of the Yangtze dam. In *A Single Pebble*, the foreigners are the ones pushing the idea; by the time it was actually built, foreigners had become the loudest critics.

WAR TRASH, by Ha Jin

This novel describes a Chinese soldier's experience in the Korean War (in Chinese, it's known as "the War to Resist America and Aid Korea"). This perspective is rare in both the U.S. and in China, where histories gloss over the ways in which this conflict damaged so many Chinese lives.

1587: A YEAR OF NO SIGNIFICANCE, by Ray Huang

This history book's subtitle is "The Ming Dynasty in Decline," and it describes in wonderful detail a ruler who is losing his grip on the empire. Some aspects of this book—the weight of bureaucracy, for example—are still recognizable to anybody who lives in China. Chinese histories can be so overwhelming, and I find this book valuable because its narrow focus actually allows for a broader scope: a powerful sense of time, authority, and empire.

GOD'S CHINESE SON: THE TAIPING HEAVENLY KINGDOM OF HONG XIUQUAN,
by Jonathan D. Spence

I like many of Spence's books, and this is probably my favorite. It describes a bizarre moment in Chinese history, when an obscure aspirant to the civil service suffered a breakdown and, in a series of visions, came to believe that he was Jesus's Chinese brother. He gained thousands of followers, as well as military control over much of China's ▶

[God's Chinese Son] describes a bizarre moment in Chinese history, when an obscure aspirant to the civil service suffered a breakdown and came to believe that he was Jesus's Chinese brother.

southeast before the rebellion was finally put down. The story shows how foreign ideas sometimes retain their power but become warped when they move between cultures.

SIX RECORDS OF A FLOATING LIFE, by Shen Fu

This is a small, quiet book—the reflections of an obscure government clerk who was born at the end of the eighteenth century. Unlike most records from that period (or any period in Chinese history, for that matter), this book is intensely personal; Shen Fu describes his love for his wife as well as his relations with various courtesans. It's a rare book, and it makes the reader realize how many details of everyday life weren't recorded or preserved in a culture whose literary tradition tended to be quite formal.

RED AZALEA, by Anchee Min

There's something mesmerizing about this book, which covers a devastating period in short sentences, one after another, until the Cultural Revolution is broken down into a train of impressions and emotions and visions of brutality. That's how an anti-individual political campaign appears to somebody who is fiercely individual.

WILD GRASS, by Ian Johnson

This is an excellent book for anybody who is writing about contemporary China. Johnson gives a sense of his working methods without dominating the story, and his portraits of individual Chinese are moving. In particular his section on Falun Gong is an example of narrative nonfiction at its best.

**COMING HOME CRAZY, by Bill Holm, and
IRON AND SILK, by Mark Salzman**

These are extremely different books, and people who live in China tend to have strong reactions to them, both positive and negative. I list them together because they are both about teaching English in China, and also because they weighed on me when I wrote *River Town*. I knew that I wanted to write something different. But back when I lived in Fuling, and the pressures of writing were the last thing on my mind, I thoroughly enjoyed both of these books. They reminded me that the experience of teaching in China had been shared by many, but also that each teacher had his own story. ❧

> 66 These are extremely different books, and people who live in China tend to have strong reactions to them, both positive and negative. 99

Have You Read?

RIVER TOWN

In the heart of China's Sichuan province, tucked away amid the terraced hills of the Yangtze River valley, lies the remote town of Fuling. Like many other small cities in this vast and ever-evolving country, Fuling is shifting gears and heading down a new path, one of change and vitality, tension and reform, disruption and growth.

Its position at the crossroads came into sharp focus when Peter Hessler arrived as a Peace Corps volunteer, marking the first time in more than half a century that the city had an American resident. Hessler taught English and American literature at the local college, but it was his students who taught him about the ways of Fuling—and about the complex process of understanding that takes place when one is immersed in a radically different society. Poignant, thoughtful, funny, and enormously compelling, *River Town* is an unforgettable portrait of a city that, much like China itself, is seeking to understand both what it was and what it someday will be.

"Tender, intelligent, and insightful, [this] is the work of a writer of rare talent; it deserves to become a classic."
—Simon Winchester, author of *The Professor and the Madman*

"A vivid and touching tribute to a place and its people."
—*Kirkus Reviews* (starred review)